this S

Saturday the 12th.

WILL U

Pay to me
eggs .5
butter .12
milk .26
amt .43

der and

Abide with me,
fast falls the ev'en tide
etc.

want

2 this

day the 13th at 9 A.M.

Nearer my god to thee
Nearer to thee
etc.

2 wear A Boy Scout. Uni

SOON

ALSO BY DEBORAH SOLOMON

*Utopia Parkway: The Life and Work of Joseph Cornell*
*Jackson Pollock: A Biography*

# AMERICAN MIRROR

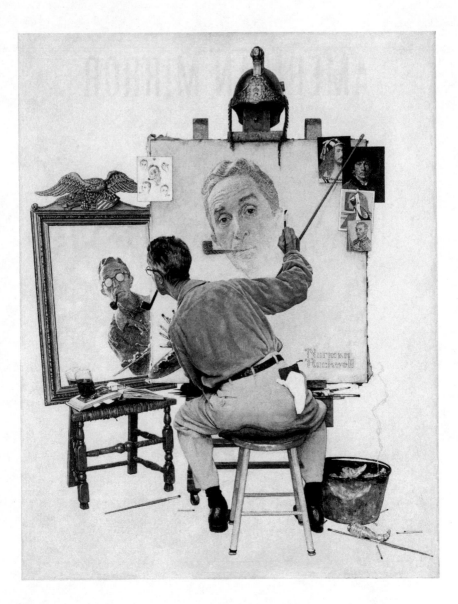

# AMERICAN MIRROR

## THE LIFE AND ART OF
# NORMAN ROCKWELL

## DEBORAH SOLOMON

FARRAR, STRAUS AND GIROUX

NEW YORK

Farrar, Straus and Giroux
18 West 18th Street, New York 10011

Library of Congress Cataloging-in-Publication Data
Solomon, Deborah.
American mirror : the life and art of Norman Rockwell / Deborah Solomon.
— First edition.
     pages   cm
Includes index.
ISBN 978-0-374-11309-4 (hardback)
1. Rockwell, Norman, 1894–1978.   2. Painters—United States—Biography.
3. Illustrators—United States—Biography.   I. Title.

ND237.R68 S65 2013
759.13—dc23
[B]

                                                                  2013021682

Designed by Jonathan D. Lippincott

Farrar, Straus and Giroux books may be purchased for educational, business,
or promotional use. For information on bulk purchases, please contact the
Macmillan Corporate and Premium Sales Department at 1-800-221-7945,
extension 5442, or write to specialmarkets@macmillan.com.

www.fsgbooks.com
www.twitter.com/fsgbooks • www.facebook.com/fsgbooks

1   3   5   7   9   10   8   6   4   2

Frontispiece: *Triple Self-Portrait*, 1961 (Norman Rockwell Museum,
Stockbridge, Massachusetts)

FOR THE BOYS—
KENT, ELI, AND LEO SEPKOWITZ

There are two ways of spreading light:
to be the candle or the mirror that reflects it.
—Edith Wharton

# CONTENTS

# LIST OF ILLUSTRATIONS

COLOR INSERT

# AMERICAN MIRROR

# INTRODUCTION:
# WELCOME TO ROCKWELL LAND

I did not grow up with a Norman Rockwell poster hanging in my bedroom. I grew up gazing at a Helen Frankenthaler poster, with bright, runny rivulets of orange and yellow bordering a rectangle whose center remained daringly blank. As an art-history major, and later as an art critic, I was among a generation that was taught to think of modern art as a kind of luminous, cleanly swept room. Abstract painting, our professors said, jettisoned the accumulated clutter of five hundred years of subject matter—from languid Madonnas and racked saints to tabletops laden with curvy fruit—in an attempt to reduce art to pure form.

Rockwell? Oh, God. He was viewed as a cornball and a square, a convenient symbol of the bourgeois values modernism sought to topple. His long career overlapped with the key art movements of the twentieth century, from Cubism to Minimalism, but while most avant-gardists were heading down a one-way street toward formal reduction, Rockwell was driving in the opposite direction—he was putting stuff *into* art. His paintings have human figures and storytelling, snoozing mutts, grandmothers, clear-skinned Boy Scouts, and wood-paneled station wagons. They have policemen, attics, and floral wallpaper. Moreover, most of them began life as covers for *The Saturday Evening Post*, a weekly general-interest magazine that paid Rockwell for his work, and paychecks, frankly, were another modernist no-no. Real artists were supposed to live hand to mouth, preferably in walk-up apartments in Greenwich Village.

The scathing condescension directed at Rockwell during his lifetime eventually made him a prime candidate for revisionist therapy, which is to

say, an art-world hug. He received one posthumously, in the fall of 2001, when Robert Rosenblum, the brilliant Picasso scholar and art-world contrarian in chief, presided over a Rockwell exhibition at the Solomon R. Guggenheim Museum in New York. It represented a historic collision between mass taste and museum taste, filling the pristine spiral of the Goog with Rockwell's plebeian characters, the barefoot country boys and skinny geezers with sunken cheeks and Rosie the Riveter sitting triumphantly on a crate, savoring her white-bread sandwich.

I first wrote about Rockwell in 1999, in an article for *The New York Times Magazine*.[1] The day after it was published, Jarvis Rockwell, an artist himself, called me up out of the blue and mentioned that a serious biography of his father remained to be written. I had written biographies of Jackson Pollock and Joseph Cornell, members of the American avant-garde whose work embodied the romance of New York bohemia at mid-century. I decided to write this book because I was curious about the part of American culture that did not unfurl in Greenwich Village or represent the counterculture, about the part that lies beyond (some would say beneath) the official story of art.

To be sure, the basic outlines of his life have been visible at least since 1960, when, with the help of his writer-son Thomas Rockwell, he published his autobiography, *My Adventures as an Illustrator*. Through no fault of Tom's, who assembled the book from a series of anecdotes his father recorded on a Dictaphone, the omissions are fairly enormous. Although Rockwell offers lengthy descriptions of his Navy buddies and his acquaintances at a New York boardinghouse, such as the pseudonymous middle-aged women who came to meals in their bathrobes and hairnets and never failed to raise hell about specks of dirt on the silverware, he barely mentions his marriages, his politics, his psychiatrists, or his constant treks to Southern California. He forgets to mention when people close to him, including his wives, die. And, perhaps out of modesty, he doesn't see fit to discuss the meaning of his work.

The great subject of his work was American life—not the frontier version, with its questing for freedom and romance, but a homelier version steeped in the we-the-people, communitarian ideals of America's founding in the eighteenth century. The people in his paintings are related less by blood than by their participation in civic rituals, from voting on Election Day to sipping a soda at a drugstore counter. Doctors spend time with patients whether or not they have health insurance. Students appreciate

their teachers and remember their birthdays. Citizens at town hall meetings stand up and speak their mind without getting booed or shouted down by gun-toting rageaholics. This is America before the fall, or at least before searing divisions in our government and general population shattered any semblance of national solidarity.

Which is not to suggest that Rockwell was a man with an overtly political agenda, a Thomas Jefferson with a paintbrush, contriving to improve the character of our national life. His political sensibility was elusive and lay dormant for decades. He first registered to vote in 1926, with the Republican Party. It was the era of Calvin Coolidge, who is linked to only one famous comment ("The business of America is business"). In those days the Republican Party stood for moderation. This heightens the poignancy of Rockwell's transformation, decades later, into a man who championed nuclear disarmament, voted for Lyndon Johnson for president, and produced the single most memorable painting to emerge from the civil rights movement.

Who was Norman Rockwell? A lean, bluish man with a Dunhill pipe, his features arranged into a gentle mask of neighborliness. He went on television talk shows and came across as sane and personable, a cracker-barrel philosopher in a tweedy jacket and bow tie, chuckling heartily, the famous pipe jutting.

But behind the mask lay anxiety and fear of his anxiety. On most days, he felt lonesome and loveless. His relationships with his parents, wives, and three sons were uneasy, sometimes to the point of estrangement. He eschewed organized activity. He declined to go to church. For decades he had a lucrative gig providing an annual painting for the Boy Scouts calendar, but he didn't serve as a troop leader or have his own children join the Scouts.

He was more than a bit obsessive. A finicky eater whose preferred dessert was vanilla ice cream, he once made headlines by decrying the culinary fashion for parsley.[2] He wore his shoes too small. Phobic about dirt and germs, he cleaned his studio several times a day. He washed his brushes and even the surfaces of his paintings with Ivory soap. As he grew older, it occurred to him that he was spending a greater proportion of his time cleaning up and a diminishing proportion of time at his easel. He joked that one day he would only clean up.

At age fifty-nine, he entered therapy with Erik Erikson, a celebrated psychoanalyst and German intellectual who came to this country as a

refugee from the Nazis. Erikson, who coined the phrase "identity crisis" and had been an artist in his wandering youth, met Rockwell after he joined the staff of the Austen Riggs Center, in Stockbridge, Massachusetts. Finally, Rockwell found someone in whom he could confide his feelings of inadequacy and despondency, who could normalize them and allow him to become more direct and emotional in his art.

Underlying Rockwell's every painting and gesture was his faith in the redemptive power of storytelling—stories, he believed, were a buffer against despair and emptiness. Each of his *Post* covers amounts to a one-frame story complete with a protagonist and plot. Among his earliest inspirations was Charles Dickens, who taught him how to espy stories on every street corner. In some ways, Rockwell's paintings, which are grounded in the rendering of particulars, demand to be "read" like a story. The experience they offer is literary as much as it is visual, in the sense that he cared less about the sensual dazzle of oil paint than the construction of a seamless narrative. The public that saw and appreciated his paintings walked away from them thinking not about about the dominance of cerulean blue or cadmium yellow but about the kid on the twenty-foot-high diving board up in the sky, terrified as he peers over the edge and realizes there is only one way down.

Which is not to diminish Rockwell as an oil-on-canvas painter. He was a master technician. In the heyday of Abstract Expressionism, when artists dripped and spattered pigment and took pleasure in the dramatic, death-defying sweep of an extra-large brush, Rockwell favored tiny paintbrushes and punctilious craftsmanship. He would knock himself out trying to conjure the texture of a brick wall or a wicker basket, transporting the objects of this world into the world of painting with an attention to detail that can be viewed as masterful—or neurotic.

He had the misfortune to come of age at a time when realist painting was written off as less "authentic" than abstract painting. Critics denounced him as insufficiently angst ridden and overly cheery. What somehow got lost in the critical discussion is this: looking is an act of passion if you look hard enough.

It probably didn't help that Rockwell was all too willing to make light of his work. The performer in him relished invitations to speak, be it in front of twelve parents at a monthly PTA meeting, a class of students at the Otis Art Institute in California, or a convocation of the National Press

Club in Washington. His voice, a deep baritone, was as resonant as a radio announcer's. His modesty was legendary. He had the largeness of spirit to pretend that he had no largeness at all. "It was hard to stay in awe of him because he was so little in awe of himself," recalled Kai T. Erikson, a sociologist and the son of Rockwell's therapist.[3]

He liked jokes less than he liked humorous stories, but he was not joke averse. In January 1955 he jotted down a joke he had heard and sent it to his wife's therapist, Dr. Robert P. Knight. Here it is: A man flies back from an African safari for the express purpose of asking his psychiatrist two questions. The psychiatrist scoffs at his abruptness, but allows the man to pose the two questions.

The man asks, "Is it possible for a man to fall in love with an elephant?" The psychiatrist assures him no, it is not possible.

Then the man asks: "Well, the second question is—Do you know anyone who want [sic] to buy a large engagement ring?"[4] At the risk of overinterpretation, you can read the joke as a story about a man in love with an overly large object. A joke about impossible love. It acknowledges that intense feelings can flourish outside of socially sanctioned relationships, in the wilderness of the self. Recently, I came across a reference in a newspaper story to "the kind of family tranquility Norman Rockwell depicted in his paintings." It is one of the many fallacies surrounding his art. Rockwell was not, in any sense, a painter of families. To the contrary, his work demonstrates how easy it is to opt out of the model nuclear family and find pleasure in alternate attachments.

Of Rockwell's 323 covers for *The Saturday Evening Post*, only three portray a conventional family of parents and two or more children (*Coming and Going*, of 1947; *Walking to Church*, of 1953; and *Easter Morning*, of 1959). Not a single cover shows a mother alone with a daughter or a son. There are no fathers providing advice to daughters. Instead, Rockwell culled the majority of his figures from an imaginary assembly of boys and fathers and grandfathers who convene in places where women seldom intrude.

Boyishness is presented in his work as a desirable quality, even in girls. Rockwell's female figures tend to break from traditional gender roles and assume masculine guises. Typically, a redheaded girl with a black eye sits in the hall outside the principal's office, grinning despite the reprimand awaiting her.

It is not a coincidence that Rockwell kept returning to the world of

A man flew back from Africa to see his psychiatrist. He said he had only two questions to ask and then fly straight back to the safari.

The psychiatrist said he couldn't help him in this manner but said to go ahead with the questions.

The man asked, is it possible for a man to fall in love with an elephant.?

The psychiatrist assured him it was impossible.

Then the man said. "Well, the second question is,—Do you know anyone who want to buy a large engagement ring.? "

Rockwell wrote out this joke about an elephant and gave it to a psychiatrist.

boyhood in his art. As a child, he had to play second fiddle to his older brother, Jarvis, a boy's boy, an athlete with fearsome confidence. Norman, by contrast, was a ninety-nine-pound weakling, forever disappointed with his body and given to resentment. Growing up in an era when boys were still judged largely by their body type and prowess at sports, he felt, as he once wrote, like "a lump, a long, skinny nothing, a bean pole without the beans."[5]

He was always seeking, it seemed, the protecting wing of a brother. Even after he became famous, he required the nearly constant companionship of men whom he perceived as physically strong. He sought out friends who went fishing in the wilderness and trekked up mountains, men with mud on their shoes, daredevils who were not prim and careful the way he was. Although he married three times and raised a family, he acknowledged that he didn't pine for women. They made him feel imperiled. He was a man of extreme dependencies and complicated proclivities. He was given to affections that do not fit any known label, and his life was not made any easier by having been lived in an era when a man was expected to share his life with what used to be called a "swell girl."

•

What's interesting is how Rockwell's personal desire for inclusion and normalcy spoke to the national desire for inclusion and normalcy. In the early twentieth century, immigrants pouring into this country were eager to become American citizens and assume the trappings of national identity. But what does an American look like? On the surface, there was little to connect the farmer roping a cow in Oklahoma to the Polish-Jewish tailor eking out a living in the Bronx to the Spanish-speaking bodega owner in California. Unlike most other countries, America was made up of hundreds of ethnic and local subcultures. Because it lacked homogenous, universally shared traditions, it had to invent some. So it came up with Thanksgiving, baseball—and Norman Rockwell.

When Rockwell published his first cover for *The Saturday Evening Post*, in 1916, there was no radio, television, or Internet, and the *Post* was the national frame of reference. As the the largest-circulation magazine in the country, it helped spawn a new kind of culture: mass culture. Millions of Americans who loved Rockwell's work never saw an original painting of his. Instead, they sat at their kitchen tables poring over the latest issue of *The Saturday Evening Post* and "reading" his images, a number of which, by

the way, portrayed people who themselves were engaged in the act of reading or trying to decipher messages on paper. For instance, a boy studies a lunch bill in a railroad dining car, trying to calculate the tip. Two cleaning women lean into each other in an empty theater, reading a *Playbill* that someone better-off left behind. A handsome, long-limbed grocery clerk spends his lunch break engrossed in a law book as the face of Abraham Lincoln (a former grocer) hovers beneficently from two tacked-up photographs on the wall behind him.

Where do all these scenes take place? Nowhere you could drive to. Nowhere on a map. Rather, Rockwell Land is its own universe, freestanding and totally distinct. It can put you in mind of the invented terrain of Thornton Wilder's *Our Town* (which is set in the made-up town of Grover's Corners in New Hampshire), or Frank Capra's film *It's a Wonderful Life* (which is set in made-up Bedford Falls in upstate New York). Although Rockwell's paintings are presumed to portray smallish towns in New England, he rarely clues you in on the location, in part because *The Saturday Evening Post* was trying to appeal to readers across the country. Rockwell invented the small town that is located nowhere in particular. The small town that is large enough to encompass the entire population of the United States.

The title of this book, *American Mirror*, is not meant to suggest that Rockwell held a mirror up to American life and painted a literal, mimetic version of it. Rather, his work mirrors his own temperament—his sense of humor, his fear of depths—and struck Americans as a truer version of themselves than the sallow, solemn, hard-bitten Puritans they knew from eighteenth-century portraits. When you gaze into a mirror, the writer Anne Hollander notes, you are imagining rather than seeing. Mirrors, she writes, are a means "for creating satisfactory artistic fictions."[6] Interestingly, at least a dozen of Rockwell's paintings feature people studying their faces in mirrors, including his famous *Triple Self-Portrait* (frontispiece), which captures the comedy of trying to capture yourself.

Did Rockwell have his limitations? Of course. As his critics are quick to point out, he turned his back on modernism and remained a happiness maximizer. Where, in his work, are disease and death? Where is his sense of existential dread? I would argue that angst is probably overrepresented in modern art. Surely we can make room for an artist who was more interested in running toward the light. Unlike his fellow realist Edward Hopper, whose work abounds with the long shadows of late afternoon,

Rockwell prefers the light of morning; his work can put you in mind of that sunny, hopeful moment right before lunch.

Though ridiculed by art critics and literary critics for much of his life, Rockwell commanded respect among painters and sculptors across the stylistic spectrum. Willem de Kooning openly expressed his adulation for him. Andy Warhol bought two of his paintings. Much about Rockwell's approach to art—the storytelling, the jokiness, the staged scenes and costumes, the reliance on photography—is standard practice among artists today. You cannot make a modern artist out of Rockwell. But you can make a postmodern artist out of him; he shares with the current generation a historically self-conscious approach to picture making.

In interviews, Rockwell always declined to describe himself as an artist of any sort. When asked, he would invariably demur, insisting he was an illustrator. You can see the comment as a display of humility or you can see it as a defensive feint (he couldn't be rejected by the art world if he rejected it first). But I think he meant the claim literally. While many twentieth-century illustrators thought of commercial art as something you did to support a second, little-paying career as a fine artist, Rockwell didn't have a separate career as a fine artist. He only had the commercial part, the illustrations for magazines and calendars and advertisements. He didn't make pictures to show in galleries or to sell to collectors. When he parted with one of his paintings, it was often as a gift to a friend or neighbor.

Surely he would be incredulous at the prices his pictures go for these days. In 2002, burnished by its appearance in the Guggenheim show, *Rosie the Riveter* was sold at Sotheby's for $4.9 million. In 2006 *Breaking Home Ties* was auctioned off for three times as much, $15.4 million, which remains the record price for a Rockwell. (Prices from private sales might be higher, but are never disclosed.) One mentions this reluctantly, for prices mislead. Prices are merely decorative stickers attached to works of art, not an expression of their essence. High prices indicate that an object is fashionable, that collectors clutch at it, whether brilliantly or blindly.

By now, it seems a bit redundant to ask whether Rockwell's pictures are art. Most of us no longer believe that an invisible red velvet rope separates museum art from illustration. No one could reasonably argue that every abstract painting in a museum collection is aesthetically superior to Rockwell's illustrations, as if illustration were a lower, unevolved life form without the intelligence of the more prestigious mediums.

The truth is that every genre produces its share of marvels and master-pieces, works that endure from one generation to the next, inviting attempts at explication and defeating them in short order. Rockwell's work has manifested far more staying power than that of countless abstract painters who were hailed in his lifetime, and one suspects it is here for the ages.

# THE BIRD MAN OF YONKERS

## (1830 TO 1888)

For every Rembrandt, for every artist whose work shines across the divide of centuries, there are thousands of artists whose names have been forgotten. Their work remains invisible to us, shuttered away in moldering basements and junk shops where no one has bothered to dust it off and look at it for decades. It's not a tragedy. It's simply the law of the art jungle: lesser artists fall into obscurity over time. And then there's even a lower category, those who never had the good fortune to climb to a respectable professional height from which to plummet.

Such an artist was Howard Hill, who endured most every disappointment that can attend the artistic life. Today, you won't find his paintings in any museums and he isn't mentioned in any books on American art. This is not entirely unjust. An intense, wounded man with a drinking problem, he was too overwhelmed by the demands of daily living to sustain the discipline needed for art. He died a pauper in 1888 and is buried in Yonkers, New York, in an an unmarked grave.

Hill was Norman Rockwell's maternal grandfather; he died six years before Rockwell was born. Yet, an absence can be more vivid than a presence, and Hill would exert a large influence on his grandson. As Rockwell grew up, he had ample opportunity to look at any number of Hill's paintings that were hanging in his home or in those of his relatives, and to hear his mother recall the flamboyant life that had produced them.

Born in London in 1830, Hill spent most of his career as an artist-émigré in Yonkers, New York, painting pictures of animals. Not elegant English animals, like the queen's spaniels or the glossy-haired horses of

George Stubbs. Rather, he was fascinated by barnyard birds of the scruffiest sort: ducks and grouses and quail, even roosters and chickens. He might portray a mother quail with a covey of little chicks standing in tall grass, at the edge of the woods, a meadow and sky unfurling in the distance. Bird painting, let's call it, occupied its own tiny niche in the market for landscapes that had been opened up by the painters of the Hudson River School, which, of course, was not a school but the first-ever bona fide art movement in America.

Was Hill a neglected master? Hardly. Rockwell, for one, referred to his pictures as "pot-boilers." But as a child who was gifted at drawing and uncommonly observant, he took note of certain similarities between his work and that of his grandfather. Hill, he saw, drew with care and loaded up his pictures with minute detail. Perhaps Rockwell had inherited Hill's precisionist way with a pencil or perhaps he had consciously appropriated it. "I'm sure all the detail in my grandfather's pictures had something to do with the way I've always painted," he once noted. "Right from the beginning I always strived to capture everything I saw as completely as possible."[1]

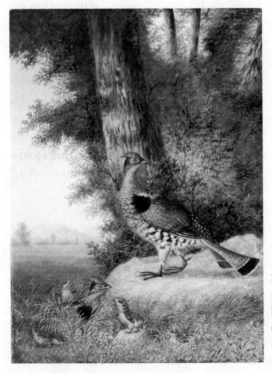

Rockwell wondered if he inherited his drawing skill from his grandfather, Howard Hill, creator of *Family of Grouse in a Landscape.*

In his later years, when Rockwell was seventy-three and working out of a barn-turned-studio in Stockbridge, Massachusetts, he was informed that one of his grandfather's bird paintings (*Game Bird and Family*) was coming up for auction at Parke-Bernet in New York. Although he was not a sentimental person and in fact could be callous with relatives, he called the auction house and then confirmed in a letter: "As you advised, I am willing to make a bid of $250, and more if necessary, because I want to get the picture." He wound up paying $350.[2]

Who's to say why one realist painter lives and dies in unrelieved obscurity while another enjoys the opposite fate—that is, rises out of nowhere to become wealthy and famous and is invited to dine with the president at the White House? This is not a question that Rockwell was likely to contemplate. He was not inclined to look back. He was one of the most efficient artists who ever lived. He never wasted a day. Is it possible to make art without risking failure? He would find a way. This, too, was part of his inheritance from Hill, whose fate alerted him to the hazards of the artistic life.

•

This story begins in London, on July 16, 1851, a Wednesday. That was the day on which Hill married a young dressmaker. Her name was Ann Patmore and she was the daughter of a servant. She had just turned twenty-two; he was slightly younger. At the time, he was living with his parents at 10 Smith Street, in a dingy brick house in Chelsea. On the marriage certificate, Hill listed himself as "Artist." His father had to sign the document as well and gave his occupation as "House decorator," which at the time referred to a tradesman who knew how to hang wallpaper and paint wood.

Painters in London were not a homogenous group. A hierarchy ruled. The ship painter was rated below the house painter, who in turn was rated below the sign painter. The mural painter and easel painters were at the top of the heap. In describing himself as an "artist," Hill was referring, perhaps, less to his achievements than his plan for the future: he did not intend to wind up painting houses like his father.

In the seven years following their marriage, Howard and Ann remained in Chelsea and three children were born: Susan Ann, Thomas, and Amy Eliza.[3] During that time, Hill's career had its ups and downs, and probably more of the latter. When their first child was baptized, Hill

and his wife were living on Jubilee Place and he listed his trade as "decorator," as if momentarily knocked off his perch. When their second child was baptized, he was back up to to the status of "artist." And when their third child was born, they did not bother having her baptized, perhaps because they were in the process of packing up their meager possessions and preparing to sail for America, where his parents had already settled.

Leaving England by crowded steerage, Hill—accompanied by Ann and their three young children—sailed from Liverpool and arrived in this country on March 22, 1858. The trip in second cabin took eight days and when they docked at the pier in New York Harbor, they arrived in a city teeming with immigrants. The streets were thronged with horses and wagons and pushcart vendors from whom you could buy a pickle or a cabbage or a live chicken. If you walked uptown on Broadway, the crowds and big buildings dwindled after Fourteenth Street, and the area known as Herald Square was considered the countryside. Up on Fifty-ninth Street, a beautiful park was about to open. It was modeled on a picturesque park in England that Hill knew well, Birkenhead Park, and perhaps he wondered why it had no name, other than "the central park."

Our first indication of Hill's whereabouts in America surfaces in the 1860 federal census. He and Ann were living in Yonkers, north of the city, a stretch of verdant dairy farms. Moving into the home of his widowed father, they stayed long enough for a daughter to be born in 1861. Immediately afterward, he moved his family to Hoboken, New Jersey, which was closer to the city, directly across the river from Manhattan, on the west bank of the Hudson. White-painted ferries and steamships glided by all day. Throughout the Civil War, Hill lived in Hoboken, an artist-immigrant gazing out over the river.

He got off to a promising start. He landed a job with Currier & Ives, the famous printmakers, who were based in Manhattan. Neither Nathaniel Currier nor James Merritt Ives was actually an artist. Rather, they were marketing wizards who employed dozens of artists and devised the ingenious idea of advertising their art inventory in attractive catalogs they published themselves. Some of the prints were engraved copies of paintings, but most of them were original images drawn by artists who remained unacknowledged. The prints were run off in black-and-white and then, after drying for a day or so, were finished by low-paid women who sat at long tables with stencils and pots of brightly colored inks.

The shop at 152 Nassau Street advertised itself as a "Grand Depot for

Cheap and Popular Prints," which was actually true. Anyone could drop by and browse through the racks of hand-colored lithographs. The inventory was constantly changing, although certain motifs were nearly sacrosanct, such as rural landscapes with two-story farmhouses and split-rail fences and horses trotting along a dirt road. Many of the prints seem to say, "We'll all feel better with some fresh country air." An inexplicably large number portray snow-covered farmhouses, with light playing off the rooftops and ground, as if it were possible to leach the grayness not only out of art, but out of winter as well.

The prints may have been technically awkward or unpolished, but they were usually lively, jammed with lots of informative details. And they were certainly reasonable. Prices, according to the firm's 1860 catalog, started at eight cents and went up to more than three dollars. Any housewife could afford to buy a lithograph to frame and hang in the parlor.

Moreover, you could have the pleasure of exercising your taste by picking out one from among hundreds, preferably one that expressed "the sincere ideas and tastes of the house and not the tyrannical dicta of some art critic or neighbor," as Harriet Beecher Stowe put it in her bestselling advice book, *The American Woman's Home*, in 1869. Her comment remains the only takedown to dismiss art critics and neighbors with equal harshness.

Nothing is viewed as more quintessentially American than Currier & Ives prints, but the irony is that most of the firm's illustrators were British émigrés. Many good scenes of the Rocky Mountains were produced by Currier & Ives artists who had trained in London and never traveled very far west of the Hudson River.

Hill did not last long at the Currier & Ives shop. Whether he was too mercurial to hold down a job or too self-regarding to submit to the drudgery of copying paintings by other artists, he soon went off on his own. This is the period when he started painting groupings of ducks and quails in scenic landscapes, and it seems likely that he was influenced by James John Audubon's famous illustrations. It had been a generation since Audubon had published his *Birds of America*, with its hand-colored engravings of every species he could find. Some of Hill's paintings combine images of Audubon birds with a woodsy landscape setting. Most of his paintings were done on small canvases, about ten by twelve inches, and some are just six by eleven inches. They're painted in a tight, detail-laden style and when they err, it is on the side of preciousness.

In New York the economy boomed during the Civil War and Hill prospered. He took a studio in Manhattan and was listed in the city directory as "Howard Hill artist 609 Broadway, residence Hoboken." In 1865, four of his bird paintings were included in the most important survey show of the year—the fortieth Annual Exhibition at the National Academy of Design, which had just moved into a grand new building on East Twenty-third Street. At the time, the Academy was the foremost art school and museum in the city; in fact, it was the only art museum. There was no Metropolitan Museum of Art. There were no public rooms where you could see a Rembrandt or a Vermeer or even minor Dutch masters. The Manhattan art world then consisted of little more than the National Academy and some commercial shops down on Nassau Street where middling paintings were auctioned off like so much old furniture. There were a few art dealers, but their loyalty was to fashionable French artists, such as Adolphe-William Bouguereau, who painted female nudes with silky skin and cherubs fluttering in the sky. American artists were left to dispose of their work at group exhibitions, the most important one being the Academy's annuals.

On April 27, 1865, less than two weeks after the assassination of President Lincoln, the Academy held an opening reception for its fortieth Annual Exhibition. Despite the recent tragedy, it proved to be a glittery social event. A writer for *Harper's Weekly* took note of the "gay and flashing groups" of visitors. The women wore gowns; the men were in frocks and silk top hats. They gathered in sumptuous rooms with Persian carpets to look at paintings that were hung salon-style, from floor to ceiling. More than a hundred artists were in the show, all of them at the mercy of the Hanging Committee, as it was called, somewhat ominously. Artists who had prayed to God that their work would be granted a central eye-level spot were likely to have spent opening night wondering why their pictures had been relegated to the hazy margins. Humbler painters, on the other hand, were no doubt thrilled to find themselves in such prestigious company. The speakers that night included William Cullen Bryant, the long-bearded nature poet and newspaper editor, who praised the Academy as an institution that had finally reached its "ripe maturity."[4]

So, for one all-too-brief moment, Hill was a man whose career appeared to be ascendant, a British émigré whose life intersected with the brightest stars in American art. Winslow Homer, Albert Bierstadt, George Inness, and Sanford Gifford were among his coexhibitors at the Academy,

and he may have personally met them at the opening reception. Perhaps he shook their hands or even had a chat. Or perhaps he didn't and was sick with regret when he got home that night.

This was the heyday of landscape painting in America and Bierstadt was the most celebrated of the lot. He painted sweeping views of the American West, scenes of tall cliffs and orange-y sunsets that seemed designed to show space at its most abundant, to insert miles of dewy vapor between you and the mountain peaks.

One of the mysteries of Hill's career is that he did not endow his pictures with similar grandeur. Although he lived on top of the Hudson River—in Yonkers to the east and then in Hoboken to the west—he never painted a river view. Perhaps he was indifferent to romantic vistas. Perhaps, instead of inspiring him, they intimidated him. Distant views, especially those of mountains, diminish the observer to a tiny speck, to insignificance. Hill preferred things you can see at close range. Not views, exactly, but objects within your own space, the space you inhabit every day from the moment you get out of bed and feel the floorboards beneath your bare feet. He preferred his birds. He had a real sympathy for them. Not swift ones tearing through the sky, but birds that exhibited no desire to fly, that were content to bump around on the ground.

No photographs of Hill are known to survive. No letters either. As a result, his appearance and his ideas about painting remain largely unknown to us, and his life story must be jiggered together from family stories and whatever scant mention he received in newspapers and other documents. After appearing in two annuals at the National Academy in as many years, his name disappears for a while. It pops up again in 1868 and 1869, in small-print classified advertisements in *The New York Herald*. The ads were placed by the auctioneer Philip Levy, who sold "choice Oil Paintings" at the Artists' Salesroom on Nassau Street; Hill was one of the artists in his stable.[5]

He surfaces next in the 1870 census, which describes him as a forty-year-old "artiste," as if he were French. His wife gave her occupation as "keeping house." They were no longer in Hoboken, but one town over, in Jersey City. The value of his personal estate was estimated at $300 and unlike some of his neighbors, who included a brick mason and a produce dealer, Hill did not own his house.

He had a large brood by now: six children ranging from an eighteen-year-old daughter to a baby boy. The three oldest children had been born

back in London, the fourth in Yonkers. The two youngest, Annie and Percy, were born in New Jersey. Annie was Norman Rockwell's future mother. She was named for her own mother, Ann Hill. She would be called Nancy to minimize confusion. Which actually maximized confusion.

The Jersey City years appear to have been a relatively prosperous and halcyon time. Hill was still selling an occasional picture. In May of 1873, he appeared in a show at the Brooklyn Art Gallery. The show was called, with more than a bit of hyperbole, Modern Oil Paintings of the Highest Class and included Hill's *Bevy of Quail*.

Just four months later, in September, a terrible depression swept the country. The Panic of 1873 began with the collapse of the Philadelphia investment house of Jay Cooke & Co., which had financed the construction of the country's railroads and assumed with unearned confidence that money for laying down new tracks would never run out. Its miscalculation resulted in its ruin, set off other bank failures around the country, and brought on what remains known as the Long Depression. Hill, chased by creditors and unable to make his rent, moved his family back to Yonkers, where his widowed father still resided, albeit in rather modest circumstances. The father rented a room in the home of an English-born couple and scraped by as "a furniture dealer."[6]

Howard Hill rented a poky little dwelling on Woodworth Avenue, which ran along the banks of the Hudson.[7] His immediate plan was to earn a living by obtaining commissions from well-to-do farmers in Yonkers. He would traipse from house to house, offering his services and mentioning his unique talent for painting hens and roosters. On countless afternoons he could be found sitting in a barnyard, sketching and sketching, trying to capture a pair of white chickens scratching in the packed dirt or a large dog sleeping in the shade of a tree. Compared to his earlier work—the cozy families of grown birds and chicks—some of his later paintings convey a nervous energy. The animals can seem more isolated: a chicken pecking beside an open barn door, a rooster with a spiky red crown appearing a little alarmed.

He became known as the town eccentric, a moody, unkempt man who alienated most everyone he met. Evenings, he would head into town and make the rounds of the taverns. Invariably, he would return home sloshed, tripping over kitchen chairs and muttering obscenities. His children were woken in the middle of the night by the sound of him clomping around and grew to fear him.

Stories circulated about his lapses and misadventures. He once took his children into the village and returned home without them. When he was in high spirits, he liked to buy up surplus goods. There was the time he returned from a shopping spree with twelve pairs of children's shoes, all of them the same size.

Inevitably, his career withered. He sold so few pictures he was reduced to painting houses to make ends meet. Then he had an idea: perhaps there was profit to be made in turning out paintings in bulk. He would devote himself to "schemes to fill a salable rectangle," as the critic Julian Bell once said of another artist, in another context. Borrowing the production-line method he had learned during his stint at Currier & Ives, he enlisted his children as his staff artists.

And so he became the head of a workshop, putting his children to work in the production of sentimental pictures of Indian maidens on moonlit lakes and tearful mothers bidding their grown sons farewell. His usual practice was to have the children sit at a long wooden table. Hill would sit at the head of the table and pass along a canvas on which he had laid in the background. One child would add a moon, another a lake, another a forest, and so on, until the painting was almost done and Hill had only to add a few touches and his signature. He was paid as much as twenty-five dollars for a picture that came with a frame.

By now his older children were out of the house and faring well in the workaday world. His oldest son, Thomas J. Hill, had an art career of his own. He had trained in his father's studio as an *animalière*, or animal painter. The first painting he exhibited at the National Academy—this was in 1876—was listed in the catalog as *Chipmunks Home* and offered for sale, for one hundred dollars. Unlike his father, who had made his second and last appearance at the National Academy in 1866, the younger Hill would continue to show in its annual surveys.[8] Although he lacked his father's depth as a painter, he was a considerate and thoughtful man who was well-liked by his peers, traits which in art, as in everything else, can carry a person a certain distance.

Howard Hill's problems worsened considerably in 1886. On the morning of April 25, his wife died of pneumonia, aged fifty-seven. Pneumonia before the discovery of penicillin was a devastating disease that brought on violent fevers and sweats. It could kill you in a matter of days and Ann Hill's death certificate notes that she had been sick for only "Seven or Eight days."[9] She died at home, on Woodworth Avenue, and was buried in

the yard of the Episcopal church to which she belonged. The stone that marks her grave bears a pithy, poignant inscription: "Momma."

Four months later, another tragedy befell Hill. Thomas J. Hill—his eldest son, the artist, now twenty-nine—died of the same disease that killed his mother. He had been sick with pneumonia for only "Three days," according to his death certificate.[10]

These were grievous times for Howard Hill. His wife was dead and his son Tom had joined her, both of them lying in the small, grassy churchyard in the middle of town. Unable to keep house, exhausted by the pressures of trying to earn his living as an artist, Hill spent his last year and a half reduced to living as a vagrant. Traveling with little more than his jars of paint and his brushes and his candles, he moved between rooming houses in New York and Yonkers. He had no home address because he had no home. It went on that like that, week after week.

One Monday in February 1888, Hill went to New York "on business" and returned to Yonkers one week later, at midnight. The morning after his return, according to the local newspaper, "he was found in an epileptic fit"—presumably he suffered a stroke. He died a day later, on March 6, 1888, at five o'clock in the morning, at the boarding house of Mrs. Nagel, on New Main Street. He was fifty-seven years old. He was buried at St. John's Cemetery, in an unmarked grave.[11] Two days later, the Great Blizzard of 1888 descended, terrifying the people of Yonkers with howling winds and endless snowfall and causing all the birds to freeze to death.

•

Here, then, is Norman Rockwell's mother. Here is Nancy Hill. Born in Hoboken on March 6, 1866, she was the fifth of Howard Hill's six children. The Tuesday on which her father died was her twenty-second birthday. From that day on she was an orphan. At the time, she was living in a boardinghouse on Ravine Avenue in Yonkers, sharing a room with her older sister Katie, a teacher.[12]

A petite, darkly pretty woman, Nancy already had a boyfriend who was precisely what she wanted: he was kind and dependable. He was someone who could carry her away from the squalor of her past, away from the drinking binges and the chickens and roosters, away from the whole miserable experience of art. She never wanted to inhale the greasy scent of oil paint again.

•

Nancy found the perfect suitor when she met Jarvis Waring Rockwell—
Norman Rockwell's father—who went by his middle name. He was a
salesman for a textile company in Manhattan. He, too, grew up in Yon-
kers, but in the good part of town, in a stately house at 98 Ashburton Av-
enue, never having to worry about money.[13]

Waring had a handsome face with brown eyes and a substantial mus-
tache kept neatly trimmed. His speaking voice was deep and he sang bass
in the church choir of his youth. When he was in his early twenties, he
joined several amateur singing groups and his appearances were noted
respectfully in the pages of *The Yonkers Statesman*. He warbled with the
Canoe Club Quintet and sang in Gilbert and Sullivan operettas, includ-
ing the first production of *The Mikado* in Yonkers.

Born on December 18, 1867, the youngest of three children, Waring
grew up in a family that thankfully for him was less colorful than his
wife's. His father, John William Rockwell, was a wholesale coal dealer
who ran his own business out of a landmark building, 1 Broadway in
Manhattan. His mother, Phebe Boyce Waring, can fairly be described as
Yonkers aristocracy. She was descended from the founder of the Waring
Manufacturing Company, which was once the nation's largest hat maker
and at its peak turned out seven thousand hats a day.

In the summer of 1891 Waring was twenty-three; Nancy was twenty-
five. It is not known how they met, only that they had been dating for a
few years and their relatives wondered if they would ever marry. Waring
was willing to do whatever Nancy wanted. She wanted to marry that sum-
mer up in Crompton, Rhode Island, where she was living in the house of
her older sister. And she wanted to marry in the Episcopal Church, which
was fine with Waring although he had grown up attending services at the
First Presbyterian Church. News of the nuptials made page one of *The
Yonkers Statesman*, which reported, "The bride was attired in a handsome
costume of white, with veil, and carried a bouquet of white roses . . . After
a wedding tour, Mr. and Mrs. Rockwell will reside in New York City."[14]

The newlyweds rented an apartment on the Upper West Side of Man-
hattan, in a narrow brownstone at 206 West 103rd Street, off Amsterdam
Avenue. They had been married for little more than a year when Nancy
gave birth at home to their first son, Jarvis Waring Rockwell, Jr., on Sep-
tember 29, 1892.

In less than a year, Nancy was pregnant again. On February 3, 1894, a second son was born. It was her turn to pick a name. Astoundingly, instead of naming him after her artist-father Howard or her adored brother Thomas J. Hill, she named him after a man she had never met—one Captain Norman Spencer Perceval, a minor British nobleman who had married her mother's sister. The captain was still alive at the time, ensconced on Lowndes Street in London, and he appealed to Nancy's nostalgia for an England she had never visited except in the mists of her imagination. Perhaps she hoped that Captain Perceval would leave some money to her son, or perhaps it was enough for her to know that she and her newborn, Norman Perceval Rockwell, by virtue of the name she had given him, were now linked for the ages to a name out of British royal history. She no doubt would have been thrilled to learn that Captain Norman Spencer Perceval was linked to the future Diana Spencer, princess of Wales, by a mere twenty-one degrees of genealogical separation.[15]

Rockwell always hated his middle name and believed that Perceval was about as embarrassing as any word ever appended to a boy.[16] His mother was constantly reminding him to spell it correctly, the way that

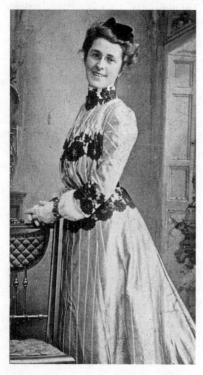

Mary Ann Rockwell, the artist's mother, later known as Nancy

Captain Perceval did—the captain spelled it *Perceval*, as opposed to the common spelling of *Percival*. This may explain why Rockwell actually misspelled his own middle name in his autobiography. He spelled it throughout as *Percevel*, as if so anxious about overlooking the letter *e* that he inserted one in the place of every vowel.

.

People need something to carry their fantasies, and for Nancy Rockwell the lines and bloodlines of family trees were a convenient conveyor. In later life, she came to believe that her father, poor Howard Hill, was descended from British royalty. "My father's great, great, great grandmother was Lady Elizabeth Howard, she was beheaded," she noted in a letter to her daughter-in-law in 1946. At the time, she was reading a new historical novel about the girlhood of Elizabeth I, *Young Bess*, by Margaret Irwin. She highly recommended it, "if you wish to read something about my father's ancestors."[17]

Rockwell, by contrast, had little interest in his ancestors. When he thought of his origins, he preferred to dwell on his artistic origins and various painter-gods to whom he felt connected. They were a far-flung lot, ranging from European masters like Pieter Bruegel the Elder, Rembrandt, and Jean-François Millet to the American illustrator of pirates, Howard Pyle. The history of painting is its own extended family and the one from which Rockwell believed he inherited his best qualities.

# NOT A NORMAN ROCKWELL CHILDHOOD

## (1894 TO 1911)

In his later years, when Rockwell tried to picture his parents, one memory invariably sprang to mind. It is early evening in New York City and Norman, who is maybe ten or eleven, is sitting in the dim stairwell of the brownstone building where the family lived. He hears the front door of the building creak open and the sound of his father coming up the stairs. Waring, a textile salesman, is tired from his day at work and the hour-long ride on the trolley. He enters the apartment and Norman can hear him ask in his deep baritone, "Well, now, Nancy, how are you?"

"Oh, Waring, I've had such a hard day. I'm just worn out."

"Now, Nancy, you just lie down on the couch there and I'll get a cold towel for your head."

Waring would close the door and all Norman could hear was the sound of his mother's lamentations. To his annoyance, his father would sit at her side, hat in his hand, dark eyes filled with understanding and sympathy, as if he had never heard her story before.

Rockwell had a surprisingly unsentimental view of his childhood. He wrote his autobiography, or rather dictated it to his son Thomas Rockwell, in 1959, by which time his parents had died. He characterized his father as weak and ineffective. He spoke of his mother as a hypochondriac who occupied her days visiting doctors. She passed countless afternoons lying in bed or on the parlor sofa, the lamp turned low, a table of pills beside her. Rockwell later insisted that she spent most of his childhood supine. He wanted her to stand up. He wanted her to ask him about his day.

"I was never close to my mother," Rockwell noted matter-of-factly.

"When I was a child she would call me into her bedroom and say to me: 'Norman Perceval, you must always love and honor your mother. She needs you.' Somehow that put a barrier between us." He believed she had taken over his father's life, reduced Waring to her nurse. It seemed to him that women were self-absorbed and men were the caring ones. Men were the ones to whom you could entrust your well-being.

His father worked for the New York division of a Philadelphia-based cotton-goods company, George Wood Sons & Co. Every so often he would come home from the office beaming. And Norman knew instantly what had happened that day. Sitting down to dinner, after Nancy had said grace, Waring would unfold his napkin and arrange it carefully across his knees. Then he would announce with satisfaction, "Mr. Wood was in the office today." And he would recount his conversation with Mr. Wood verbatim.

Growing up, Rockwell felt neglected by his parents and overshadowed by his older brother, Jarvis, a first-rate student and athlete who was one year ahead of him in school. Norman, by contrast, was slight and pigeon-toed and squinted at the world through owlish glasses. His grades were barely passing and he struggled with reading and writing—today, he surely would be labeled dyslexic.

"I wasn't a regular Huckleberry Finn or Tom Sawyer," he later re-called. "I wasn't an excessively brave kid. I wasn't very healthy. My brother was quite the opposite, and this had a lot to do with my life. He later played semi-professional baseball and football. He was the real boy's boy." After reading *The Little Lame Prince*, a short story by Dinah Maria Mulock Craik, Rockwell tried to garner notice by walking around school with an exaggerated limp and pretending to have just one hand. "I wanted to be an artist, or I wanted to be noticed as lame, or anything, because I felt I couldn't compete with my brother because he was so strong and husky."[1]

Rockwell spent his first twelve years in a series of cramped apartments in Upper Manhattan. When he was two years old, the family left West 103rd Street and moved up to 789 St. Nicholas Avenue in Harlem, which was considered a better neighborhood. Then, when he was six years old, he and his family moved in with his father's elderly parents, at 832 St. Nicholas Avenue, on the corner of 152nd Street.[2] It is not clear how Rockwell felt about his paternal grandfather, the coal dealer from Yonkers, whom he once described in an unpublished essay as "quite a swell" and "a gay blade" despite his financial losses in the depression-addled 1890s.[3]

He bequeathed Rockwell a hand-me-down that became the bane of his childhood: a "pretentious" double-breasted overcoat with a moss-green velvet collar that elicited mocking laughter from his classmates.

Rockwell made no mention of the sadder events that occurred around this time. Grandma Phebe died in March 1903 and the funeral service was held in the apartment.[4] Two winters earlier, there had been another death in the family: that of Rockwell's Aunt Grace, not yet forty, his father's sister and the mother of two boys, Sherman and Halsey, all of them ensconced in that same building on St. Nicholas Avenue.[5]

Rockwell was a turn-of-the century kid, born just in time to observe the arrival of the twentieth century. Historians tend to describe this period as if everything considered modern—subways, movie theaters, tall buildings—arrived on cue with the new century. Yet the nineteenth century, with its bumpy cobblestones and gas lanterns, its dim apartments in which mothers gave birth, continued well into the twentieth century. And up on St. Nicholas Avenue, the nineteenth century had not fully departed. In the mornings, the men rushed to catch the trolley to work and the women stayed home, leaning on the sills of open windows and counting the errands that had to be done.

Rockwell didn't view his childhood as the beginning of the modern era. He didn't see it as the beginning of anything. But perhaps it seemed like a time of endings. He was six years old when Queen Victoria, an ancient matriarch whose name had come to be identified with an entire age, died.

Later that year, President William McKinley was visiting Buffalo, New York, when he was shot by an assassin. Rockwell never forgot "the horror in the streets" on the night of the president's death, with newsboys shouting "Extra, extra" as people rushed from their apartments and huddled beneath the yellow glare of gas lamps to read the news; no one had a radio yet. The next day, Norman went to church with his family, and both of his parents cried.

A devout Episcopalian, Nancy required her sons to say grace before dinner and to attend church. The family worshiped at St. Luke's Episcopal Church on West 141st Street and Convent Avenue[6]—for Norman, a dreary obligation that instilled in him a lifelong aversion to organized religion. He sang in the all-boys church choir year after year. This required three rehearsals during the week after school, the last of which, on Friday evenings, was a dress rehearsal. On Sundays, when Norman and Jarvis

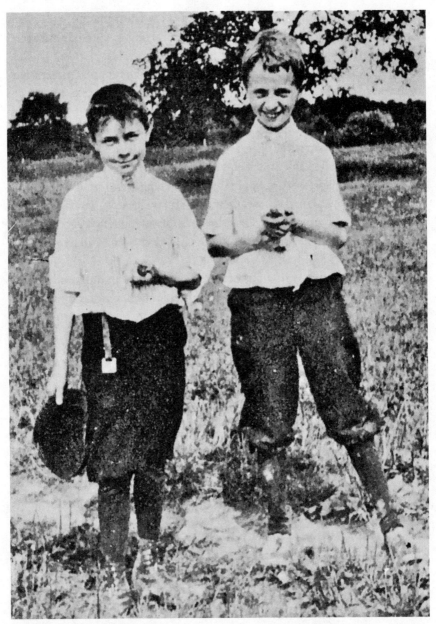

Norman (right) and his older brother, Jarvis, display frogs they caught during one of their summers in Warwick, New York. Although Norman was taller than Jarvis, he claimed to feel physically outmatched by him.

returned from church, the boys were forbidden from playing with their toys. Nor were they allowed to look at the funny pages. "We couldn't read them until Monday," Rockwell recalled.[7]

There was one part of his childhood for which he retained affectionate memories. In the summer, the family would take a two-week vacation in the Adirondack Mountains, on a working farm that rented out rooms. The place was owned by the sprawling Jessup family and located in the town that is now Warwick, New York. Years later, Rockwell recalled indolent afternoons when the grown-ups played croquet and the children were free to do as they pleased. What he seemed to cherish was the communality of it all. He warmed to the memory of hayrides on which everyone squeezed into a wagon and sang as the horses trotted along country roads. He recalled "the excitement of eating lunch with the threshing crew at the long board tables."[8]

The Jessup children thought of him as less hearty than the other children. "Norman was considered delicate and had to have eggnogs between meals," Phebe Jessup noted years later. "One of my duties was to prepare them."[9]

•

When did Rockwell realize he wanted to be an artist? He first demonstrated a talent for drawing when he was "six or seven," as he recalled.[10] His father was a casual smoker and in those days each pack of American Fleet cigarettes came with a trading card that portrayed a model of a battleship. Kids liked to collect the cards. Norman, instead, liked to copy them. With his pencil and eraser, he worked with great industry and concentration, careful to get every detail right. There was much smudgy erasing.

His brother, Jarvis, was impressed by the drawings, so much so that he and his friends targeted them for immediate destruction. They would assemble whole fleets on the floor and, boom, declare war, trying to destroy each other's ships with a pair of scissors. "It was a sort of frustrating art form for me," Rockwell later said.[11]

Actually, Jarvis drew pictures of ships as well, one of which can be found among the Rockwell family papers. It's a charming crayon drawing, a battleship on stormy waters, four flags waving in the breeze. Although Norman always spoke of his brother as the family athlete, all brawn and strutting pride, the label was reductive. Jarvis was a dexterous

child, good with his hands and fond of building. In later life, he ended up designing toys for a living.

Norman soon graduated from sketches of battleships to scenes culled from literature. On weekday evenings, after he and Jarvis had finished their homework, the boys would sit at the dining room table as their father read novels to them. There was lots of Charles Dickens. Norman, hunched at the table, the ever-present pencil in his right hand, took great pains with his drawings. He worked slowly, revising as he went and seeming to erase almost as many lines as he drew.

He later recalled sketching a likeness of Mr. Micawber while his father read *David Copperfield*, only to erase the head and ask his father to read the pertinent description again, the passage about Mr. Micawber's bald cranium. So his father read it again, the sentence about this "stoutish, middle-aged person . . . with no more hair upon his head . . . than there is upon an egg."

Rockwell won his first prize in December 1905, for a now-lost drawing he entered in *The New York Herald*'s Young Contributors Contest. He was eleven years old.[12]

•

Despite his early interest in art, Rockwell did not visit a museum until he was quite a bit older. When he felt like looking at pictures, he scarcely needed to venture to the Metropolitan Museum. Instead, he might sit down at the dining room table and open up the latest number of *Collier's* or *Harper's Monthly* or *St. Nicholas Magazine* and pore over the illustrations, line drawings and paintings by Howard Pyle or Frederic Remington or Edwin Austin Abbey. In truth, there was more new art by American artists to be found in magazines than there was on the walls of museums.

This was the period known as the Golden Age of Illustration, although it was only in nostalgic retrospect that the phrase encompassed events in America. Initially, it referred to a movement that began in London in the sixties—the 1860s, that is—when leading English artists tried their hand at wood engraving in order to furnish pictures for books and magazines. At the time, an artist could cross from easel painting to illustration with impunity. No one thought less of Sir John Everett Millais because he drew illustrations for Trollope novels that were published serially in the magazine *Once a Week*, although eyebrows did go up when he committed the

mercenary sin of allowing his painting of a very blond, bubble-blowing boy (*Bubbles*) to appear on the wrapper of Pears' soap.

In America, magazine illustration didn't gain much aesthetic momentum until the 1880s. It had to wait for the arrival of Howard Pyle, a brilliant Quaker artist and writer. He is often called the father of American illustration—a dreary cliché, but a fittingly patriarchal image for a man who spawned a progeny of famous illustrators, from N. C. Wyeth on down, and ran a school out of his studio in Wilmington, Delaware. More important than the school was Pyle's own oeuvre: a shelf of children's classics that elevated American illustration to the level it enjoyed in Europe. His admirers included Vincent van Gogh, who once wrote, in a letter to his brother: "Do you know of an American magazine called *Harper's Monthly*? There are things in it that strike me dumb with admiration, including sketches of a Quaker town in the olden days by Howard Pyle."[13]

Pyle was Rockwell's favorite, hands down. Rockwell would study reproductions of his paintings of Colonial America and marvel at their vividness. When Pyle painted the story of the American Revolution, he imported the lofty goals of history painting—that is, factual accuracy—into the realm of popular illustration. He would track down the right musket and the right tricorn hat. He would labor to paint the right number of bricks in a background wall a hundred feet off.[14] He wanted to relate the past at its most present, its most lifelike. His painting of George Washington at Valley Forge makes you feel the wind blowing through double-breasted buttoned-up coats, the crunch of boots on snow. When unsure about a certain detail, he might "run down to Washington and take a photograph."[15] And perhaps it was his camera eyes as much as anything that fascinated the young Rockwell.

He particularly loved Pyle's pirates, those long-haired, eye-patched thugs who kept their stolen booty in trunks. Here were Blackbeard and the rest, the seamen who terrorized the early American colonists. Although they came with the same guarantee of historical-authenticity-or-your-money-back as his other motifs, Pyle's pirates—with their head scarves knotted in the back and hoop earrings—have since been exposed as mostly fiction. Their clothing has less in common with actual pirates' duds than with the flamboyant outfits of Spanish gypsies. They reveal Pyle as a second-rate researcher but a fabulous illustrator and they became the go-to images for most every film about pirates.

In 1959 Rockwell's painting *Family Tree* graced the cover of *The Saturday*

*Evening Post.* It traces a little boy's genealogical origins back several generations, to, of all people, one of Pyle's black-bearded pirates. Readers of the *Post* interpreted the painting as a joke about unsavory relatives, but it was also a touching acknowledgment on the part of Rockwell that he saw Pyle as the patriarch of his family, that is, the family of illustrators with whom he felt closely identified.

Perhaps Howard Pyle struck him as the realized version of Howard Hill. The two Howards. One a pauper, the other a legend and an appropriately potent figure for a boy to want to claim as a forebear.

•

In September 1906 when Rockwell was twelve years old, his city days came to an end.[16] Later, he tended to speak of New York City as a menacing place and shuddered at the memory of a scene he had witnessed one winter afternoon—not a violent crime, just a couple having a drunken argument in a vacant lot. Brandishing an umbrella, the woman struck the man until he fell to the ground. She "became my image of the city," Rockwell wrote, as if the woman were the evil twin of the Statue of Liberty.

But one shouldn't read too much geographical bias into this, because Rockwell would come to feel similarly imperiled in Mamaroneck, New York, a quiet, woodsy suburb where his family settled. Grandpa Rockwell made the move with them, into a rented house whose address is now 415 Prospect Avenue, near the corner of Fenimore Road.[17] Though hardly grand, at least it was a house, a spacious white clapboard with a long front porch and a garden in the back. It had three bedrooms and sunny windows. When Norman stood on the corner and looked south, he could catch a glimpse of Long Island Sound; in the summer the water was full of sails.

He went through public school in Mamaroneck and already art was his main interest.[18] It was, in truth, the only subject on which he could concentrate, that forced his sprawling thoughts into focus. Whenever a teacher turned to face the blackboard, or looked down at a lesson book for any length of time, he would resume drawing on the pad that he carried with him. He was still going through his Howard Pyle–pirate phase and most of his drawings involved tautly muscled men and eye patches and sword fights.

In October 1906 the family joined St. Thomas Episcopal Church, a handsome country church in Mamaroneck on a hill overlooking the sound.[19] For the next year and a half, until his confirmation, Rockwell

attended services every Sunday and once again sang in the choir. It was "less arduous"[20] than the choir at his previous church, which was a relief. Yet he did not seem to care for the rector, the Rev. Frank F. German, and was bothered by his method for polishing the cross on the altar. "He'd spit on it and rub it with a soiled cloth," Rockwell recalled, and you suspect the gesture was less an affront to his spirituality than to his sense of cleanliness, which was already becoming obsessive.[21]

He found his own house shabby. He later recalled the "pinched and faded tidiness" of the front parlor, with its yellowed, washed-out antimacassars on the sofa. He even remembered the texture of the bath towels, which his mother didn't bother to replace "until the nap was worn away and you could see through them."

His parents were always scrimping and saving, fretting over pennies. His mother would ask, "Waring, should we have a roast this Sunday?" And Waring would reply, "Not this week, I think, Nancy." Instead they had stew. Hardly a catastrophe, this business of stew, but Rockwell, like many boys, was beset by exaggerated feelings of deprivation.

As he entered adolescence, he came to believe that in every way that mattered he was powerless. He harbored no hope that he might ever possess the physical prowess of other boys. He did not train for any teams and learned to accept the bitter fact of his brother's seemingly effortless popularity. "Bob Titus, a big, handsome athlete who had been my closest friend," Rockwell lamented of a boy who lived on his block, "drifted away from me and began to hang around with Jarvis."[22]

It did not help that he grew up at a time when the male body—as much as the mind—had come to be viewed as something to be improved and expanded. In addition to celebrity bodybuilders like Eugen Sandow, better known as Sandow the Magnificent, President Theodore Roosevelt himself was an advocate of body modification. Much of Rockwell's childhood (ages seven to fifteen) took place during the daunting athleticism of Teddy Roosevelt's presidency. All of America knew the story of how he had transformed "his 'sickly, delicate,' asthmatic body into the 200-pound muscular, barrel-chested figure of a supremely strong and energetic leader," as historian John F. Kasson puts it.[23] He was the naturalist-president who hiked for miles and hunted big game; after leaving office, he sailed to Africa and posed for photographers in a pith helmet and safari gear. In the T.R. era, the well-developed male body became a kind of physical analogue

to America's expansionist, big-stick foreign policy. To be a good American was to build your deltoids and acquire a powerful chest.

Rockwell tried exercising, hoping for a transformation. In the mornings, he diligently did push-ups, knee bends, and jumping jacks in front of the half-length mirror in his bedroom. But the images he glimpsed in the mirror—the pale face, the narrow shoulders, and the spaghetti arms—continued to strike him as wholly unappealing.

At least he had art. He was beginning to get recognition for it at school. Miss Julia M. Smith, his eighth-grade teacher, a single woman in her late thirties, would ask him to come up to the front of the classroom and draw pictures in chalk on the blackboard as the other students watched. When she was lecturing on American history, he drew Revolutionary soldiers and covered wagons, the sort he knew well from the work of Pyle. When the subject turned to science, he drew birds and lions and other members of the animal kingdom.

Miss Smith fussed over his drawings. She made him feel that he was artistic and hence special and not required to live by the rules, that being artistic somehow made up for his failure to excel at baseball. He would keep in touch with her for the rest of her life, and she is the one of the few people from his childhood for whom he admitted to feeling a special fondness. Later, he would marry three times and each time he married a schoolteacher.

On September 7, 1909, Norman began his freshman year at Mamaroneck High School and three years of unremitting academic struggle. His school transcript is an alarming document, lined with grades that hovered just a few points above passing. Compared to Jarvis, a solid student, Norman was always perilously close to flunking. During his freshman year he was required to take Latin and perform dreaded feats of memorization. Later, he took two years of French and felt overwhelmed by irregular verbs.

The subject that gave him the most trouble was math. In his sophomore year, he studied algebra and was confounded by the flurry of $x$'s and $y$'s that were suddenly descending in the spaces where numbers used to be. He got a grade of 50 in algebra his first quarter, which must have seemed like a new low, until his third term when he scored an impressively abysmal 28.

During his high school years, he drew caricatures and imagined becoming a professional cartoonist. His mother's cousin John Orpen, the

president of the Providence Ice Company, was amused by sketches that portrayed him as a lowly laborer, "chopping ice behind the ice wagon." When the Mamaroneck High School opened, it was reported, Rockwell "did the mural decorations, which consisted of charcoal and pencil sketches, mostly caricatures of the teachers on the newly kalsomined walls."[24]

It was the heyday of humor magazines, which were well-stocked with caricatures and cartoons. *Life* was the most genteel of the lot (it was unrelated to the magazine of the same title founded later by Henry Luce). *Judge* was a cheap-looking rival with bad-taste jokes about women, blacks, and immigrants. *Puck* was located in the landmark building still known as the Puck Building on Lafayette Street in New York. One day when he was in the city Rockwell went around to all three magazines and showed his drawings to various art editors. They were very kind, insisting that his work showed the greatest talent. Then they recommended that he go to art school. He was crushed.

•

Rockwell perpetuated certain inaccuracies concerning himself and his life. He preferred to make make his life into a comic story and so took liberty with facts. For instance, although he described his mother as a self-absorbed invalid, she and Waring were both inordinately supportive of his efforts at art. His mother, especially, raved over his pen-and-ink drawings. She was sure he had inherited his talent from her father and her brother. She thought even his most tortured drawings showed promise and preserved the ones he did not throw out, pasting them into scrapbooks.

"I regret to tell you, for fear of spoiling a good story," Rockwell said in one of his earliest interviews, decades before his autobiography offered a conflicting account, "that both my parents encouraged my drawing energetically from the time I was a small boy."[25] Moreover, when he entered Mamaroneck High School, his mother "made arrangements" with his teachers to have him excused early so he could take classes at prestigious art schools in New York City. Initially, he went once a week to the New York School of Art, popularly known as the Chase School, after its founder, William Merritt Chase. Then he switched to the National Academy of Art, where he enrolled in the antique class and found himself seated in a large room ringed by white casts of Venus and Hercules. "The

reason why you're studying in what they call antique class is because the model doesn't move," Rockwell later explained.[26]

The 1910 census listed the Rockwells as a large clan. Waring continued to scrape by as a "salesman, dry goods." His widowed father, John W. Rockwell, was still living with the family, and Mrs. Rockwell's thirty-year-old niece, Eva Milnes, was also listed as a boarder. Norman was now sixteen years old, and Jarvis, at seventeen, was described as a "clerk, shoe store."

The detail is puzzling. Jarvis selling shoes. Although he had been an excellent student, he dropped out of high school after his junior year. "Entered business in New York City," reports a note on the back of his school transcript. His parents never considered sending him to college. College, as they saw it, was for boys from rich families. Like many other financially strapped parents of their time, Waring and Nancy expected their sons to enter trades as soon as they could and help supplement the household income.

Norman, too, felt pressured to earn money and was working at various part-time jobs. In the summer of 1910 a wealthy matron mentioned to the Rev. German at his church that she and a friend were thinking of taking art lessons. The friend turned out to be Ethel Barrymore, whom Rockwell was happy to oblige. Barrymore, at the time a young Broadway actress who spoke in a noticeably throaty voice, had just bought a summer place in Mamaroneck, in the exclusive Orienta section, a strip of shoreline fringed with mansions. She had already been sketched by portraitists including John Singer Sargent, although it did not occur to sixteen-year-old Rockwell to ask her to pose. Instead, he was content to carry her paint box and paddle the two women in a canoe across Mamaroneck Harbor to Hen Island. He would set up their easels and supplies and watch as they dipped the tips of their brushes in little mounds of pigment that he had taught them how to mix. After an hour, it was time for a picnic lunch and then the return trip.

At the end of that summer, he secured another job serving Mamaroneck's elite. He took over the mail route in Orienta. It was too far from downtown to be serviced by a regular mailman, so residents paid for private delivery. On weekday mornings, before school, Norman would bicycle to the post office, load a pile of letters into his shoulder bag, and head off on his route. He liked bicycle riding—liked whisking through town in the pale light of early morning.

In May 1911, at the end of his junior year, Norman dropped out of high school and made plans to study art in New York. He claimed in his autobiography that he dropped out in the middle of his sophomore year, perhaps an innocent confusion of dates.[27]

He was seventeen years old and his boyhood was over. But it would live on in his paintings. Boyhood would be one of the great themes of his art and it would give him the chance to rewrite the whole story.

# THE ART STUDENTS LEAGUE

## (SEPTEMBER 1911 TO 1912)

In October 1911 Rockwell enrolled at the Art Students League of New York, which occupied a palatial building on West Fifty-seventh Street. The League liked to think of itself as a progressive place, the antiacademic academy. It issued no grades, kept no attendance records, and prescribed no specific course of study. Students could sign up on a monthly basis with any artist-professors who interested them or drop classes with impunity. For Rockwell, the League was appealing because it was the only art school in the city where book illustration was taken seriously. Howard Pyle had been a student a generation earlier, as had Frederic Remington, and Rockwell was eager to will himself into their lineage.

At the League, Rockwell found himself among teachers and art students who provided him with his first taste of New York bohemia. Everyone, it seemed, espoused radical politics and read poetry and had seen the latest issue of *Mother Earth*, Emma Goldman's anarchist magazine. This is not to imply that Rockwell became a teenage bohemian. At seventeen, he was one of the youngest students at the League, just out of high school and inexperienced in the ways of the world. Most of his classmates were in their twenties and living on their own. They came to the League not only to study art, but for the privilege of being young and penniless in New York. Rockwell, by contrast, was still living with his parents in sleepy Mamaroneck and commuting to the city by train. On Fridays, he would diligently lug home his portfolio and show his parents his latest figure studies. Against all reason he hoped to impress them, to justify his presence at school. Unlike the National Academy of Design, the League charged

tuition—eight dollars a month for each class, which was a sacrifice for his family.

Among his classmates, he quickly became known as an exceptional draftsman if a somewhat awkward presence. At this point, he had curly hair and was so gangly he appeared to be taller than he was (he stood just under five foot eleven). He concentrated on his work with a single-mindedness that earned him the nickname "The Deacon." Women were among the students at the League, but he was not friendly with any one in particular. By his own admission, he was surprised by the work habits of his fellow students, so many of whom seemed capricious, even reckless, working when the whim took them, even in the middle of the night. Rockwell, by contrast, would never work through the night. And he would never miss lunch.

He was aware he was different from the other students, perhaps more ambitious, or just more inhibited, and he felt excluded from the camaraderie of school life. The third-floor lunchroom was the League hangout and, throughout the day, students and teachers along with art-class models who had tossed on bathrobes conversed over coffee and cigarettes. Once, Rockwell was taken aback when a stylish art student with longish hair visible beneath a wide-rimmed hat, accosted him in the lunchroom and remarked unkindly, "You know, if I worked as hard as you, I could be as good as Velasquez." Rockwell replied, "So, why don't you?"[1]

In truth, he was bothered by his punch-the-clock work habits and wondered if his regular hours suggested some flaw in his nature. He once read somewhere that Sir John Everett Millais, the Pre-Raphaelite painter, had swooned when he first saw the *Mona Lisa*. Rockwell later joked that he would go up to the Metropolitan Museum, stand in front of a Rembrandt he loved and order himself, "Swoon, damn you, swoon."[2]

•

The League offered two courses in "Illustration and Composition" and, on his first day of school, Rockwell signed up for both of them.[3] But the nuts and bolts of illustration turned out to be less compelling than he had anticipated. A few weeks later, he dropped Ernest Blumenschein's illustration course and signed up instead for "Life Drawing for Men," which was taught by George Bridgman, the most celebrated teacher at the League, and certainly the one who was to have the largest influence on Rockwell.

Bridgman was then in his forties, a short, stocky, cigar-smoking aes-

thete who swore liberally. His class met every afternoon, from 1:00 to 4:30, and was limited to male students; women had their own life-drawing class, in order to be spared the impropriety of viewing an unclothed model in mixed company. The classes always began on time and Rockwell was predictably punctual, rushing to retrieve his supplies—his charcoal and scrapers and Michalat drawing paper—from his locker and then joining his classmates as they took their places on hardwood chairs arrayed in three long rows in front of the model, who was elevated on a platform. Rockwell, like the other men in the class, showed up in a button-down white shirt and a vest, no smock.

The mood in Bridgman's class was hardly relaxed. Too many young men, sometimes as many as forty, were crowded into the airless studio, all of them sketching the same model. Every Friday afternoon, Bridgman ranked the students and their drawings; each young man desperately wanted to be number one, to be confirmed in his belief that art was his obvious destiny. Each student sought to produce what his teacher called, with more than a little vanity, a "Number 1 Bridgman drawing," as if that represented a new plateau of human achievement.

In reality, a Bridgman drawing was pretty much like the standard academic drawing of that era, or really of any era. For centuries, figure drawing had been the foundation of art education and its fundamentals were essentially the same. Bridgman, as much as Thomas Eakins in the nineteenth century or Leonardo in the sixteenth, approached the human body as a feat of engineering, stressing its mechanics and basic dynamics instead of surface modeling. For students, the goal was to capture not merely the curve of a torso or a thigh, but to understand the muscles and bones that lay beneath it and gave the body its shape, to become acquainted with the tibia and the ulna and the femur and the humerus—a roster of Latinate words that had to be memorized. Bridgman wrote many manuals for artists, one of which was devoted exclusively to the human hand.

From one week to the next, Rockwell was able to produce a Number 1 Bridgman drawing—a technically polished, if emotionally void, figure study, one whose separate elements he had painstakingly executed over four or five days at a specified rate of progress. Even so, Rockwell was a nervous artist. His success at drawing never struck him as guaranteed. Each new figure study posed its own risk, opened up the possibility of getting everything wrong.

Besides, Bridgman was as tough with him as with anyone else. The

teacher didn't hesitate to correct directly on the students' work, redrawing an awkwardly pitched shoulder or a badly proportioned leg. Once Rockwell showed him what appeared to be an adequate study, only to hear: "You haven't got the main line of action. Look here. Down through the hip." And then the teacher demonstrated, drawing a heavy black line down the middle of the figure. Rockwell spent the next day trying to erase Bridgman's corrections so his parents wouldn't think he was failing at school.

•

Over the years, many artists have described their astonishment at first sketching a female nude, the rush of pleasure and embarrassment, the intense awkwardness pervading the studio as a group of young men shyly looked and lost their visual virginity en masse, their cheeks blushing, their hands trembling. Inevitably, they botched their first drawings. ("His face was redder than it had ever been before in his life," the artist Guy Pène du Bois wrote of himself in the third person.[4])

Rockwell, however, treated the subject with curious remove. He later

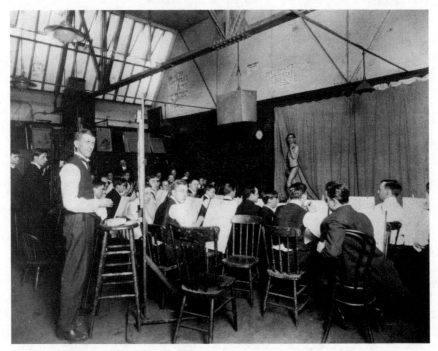

George Bridgman's drawing class at the Art Students League in the fall of 1912 (Courtesy of the Art Students League of New York)

claimed that he and his classmates were so engrossed by the demands of drawing that "we just didn't think of the model as a woman." The comment might sound like a prudish feint, so much defensive posturing. But Rockwell probably spoke with some truth, if not for his classmates, then for himself. He found it more interesting to draw a model named Antonio Corsi, who was known to have posed for Sargent and Whistler. ("His dark-skinned body was lithe, strong, and supple—wonderful to draw," Rockwell recalled.[5]) Tense as he was about the female body, he was less guarded about acknowledging the beauty of the male body.

In the end, what Rockwell took away from Bridgman probably had less to do with the human figure and the bones running through it than the romance of his chosen field. Bridgman, the least snobby of aesthetes, revered the heroes of the Golden Age of Illustration. After class was over, he would linger and talk to a few students and never seemed to be in a rush to ride the train home up to Pelham. He would reminisce about Howard Pyle and Edwin Austin Abbey while sipping on a beer and sketching distractedly on a scrap of paper.

Rockwell wanted to believe that illustration was a noble calling. And in Bridgman's company he did believe it, believed that illustrators were the equal of fine artists. True, they committed the mercenary sin of earning money. But they did something socially valuable and uplifting; they recorded scenes from American history and literary classics. But the Golden Age of Illustration of which they aspired to be part was already nearing extinction. An entire generation seemed to disappear while Rockwell was in school. Frederic Remington, who had immortalized the Wild West in his magazine illustrations, died in 1909 in Ridgefield, Connecticut. Winslow Homer, an undisputed master who had begun his career as a painter-journalist covering the Civil War for *Harper's Weekly*, died in his studio in Prouts Neck, Maine, in 1910. John La Farge wrote an obituary for Homer and expired six weeks later in Newport, Rhode Island. The following summer, Edwin Austin Abbey, a native Philadelphian known for his elegant line drawings of scenes culled from Shakespeare, troubadours and the stage, died in London.

But the death that registered the most sharply at the League was surely that of Howard Pyle—Rockwell's personal favorite. On November 9, 1911, just a month after Rockwell started school, Pyle died suddenly at the age of fifty-eight from a kidney infection. He had been living in a villa outside of Florence, studying mural painting, haunted by a sense that a

lifetime's worth of illustration was not enough to guarantee his place as an artist.

It wasn't just the loss of prodigiously gifted artists that was draining illustration of its early luster. It was also the rise of advertising. What had begun in America in the late nineteenth century as a cerebral populism—beautiful illustrations in books and literary magazines made possible by advances in photomechanical reproduction—by now had devolved into an exercise in hard-sell consumerism. Magazines were growing thick with advertisements for bicycles and upright pianos, for Knox Gelatine and Pears' soap. Illustrators who had dreamed in their youth of providing elegant etchings for books by Dickens or Shakespeare instead found themselves trying to draw a Swift's Premium Ham and persuade the public of its tastiness.

As a student, Rockwell resolved to avoid the coarser outskirts of his field. "In art school," he noted, "the illustration class was just as highly respected as the portrait or landscape classes. Art Young, Charley Kuntz, and I signed our names in blood, swearing never to prostitute our art, never to do advertising jobs, never to make more than fifty dollars a week."[6] He was referring to his illustration class with Thomas Fogarty, which met on weekdays from 8:30 to 12:30. Fogarty was the opposite of Bridgman—neat, tiny, nervous and literal minded, a professional illustrator, the son of Irish immigrants.[7] He pointed his students straight to the marketplace. His own pen-and-ink illustrations appeared regularly in books published by Doubleday, Page and other leading houses, and he generously shared his contacts with his students, encouraging them to search out assignments for themselves and start building relationships with art editors and book publishers.

In class, he trumpeted one message: pictures are the servants of text. He gave his students hypothetical magazine assignments. They read short stories and poetry and picked out lines or verses to illustrate, preferably ones that exuded a bit of drama, that portrayed characters who might be dueling or reveling or sobbing into a handkerchief. The drawings would be judged and graded as much for their artistry as for their fidelity to the text. The goal was to italicize the narrative, to banish vagueness from the words and bring characters into sharp relief.

All in all, Rockwell's first year at the League was an indisputable success. In May 1912 the school held a big exhibition and gave out prizes. Rockwell won the Thomas Fogarty Illustration Class Award, and his name was mentioned in the *Brooklyn Daily Eagle* and *The New York Times*.[8]

This charcoal drawing remains Rockwell's earliest known work. It has never been repro-
duced before. He intended it as an illustration of a scene in Oliver Goldsmith's poem
"The Deserted Village." (Courtesy of the Art Students League of New York)

His winning submission was an illustration for "The Deserted Village," the eighteenth-century pastoral poem by Oliver Goldsmith. It remains Rockwell's earliest known surviving work. The Art Students League kept it for its own modest collection when it awarded him the prize, and thus it was spared the fate of innumerable early Rockwells that were lost or destroyed over time.

Rockwell was seventeen years old when he made the drawing, and it is a marvel of precocious draftsmanship. It takes you into a small, tenebrous, candlelit room where a sick boy lies supine in bed, a sheet pulled up to his chin, the contours of his body visible through the fabric. A village preacher, shown from the back in his long coat and white wig, kneels at the boy's side. A grandfather clock looms dramatically in the center of the composition, infusing the scene with a time-is-ticking ominousness; a chair in the right foreground invites you to linger and look. Perhaps taking a cue from Rembrandt, Rockwell is able to extract great pictorial drama from the play of candlelight on the back wall of the room, a glimpse of radiance in the unreachable distance.

Although Rockwell had been taught that pictures are the "servant of text," here he breaks that rule. His illustration for "The Deserted Village" has less to do with Goldsmith's vision than his own. Traditionally, illustrations accompanying "The Deserted Village" have emphasized the theme of exodus, portraying men and women driven out of an idyllic, tree-laden English landscape. But Rockwell moved his scene indoors and chose to capture a moment of tenderness between an older man and a young man, even though no such scene is described in the poem.

Two lines from "The Deserted Village" are inscribed along the bottom of Rockwell's drawing: "But in his duty prompt at every call / He watched, he wept, he prayed and felt for all." The words refer to a preacher in the poem but can serve as a job description of the artistic calling as well.

•

Rockwell's family life, in the meantime, had become a bit sadder and unanchored. His mother, who was now in her midforties, felt overmatched caring for her family as well as for her father-in-law, John, the coal dealer from Yonkers, who was still living with the Rockwells. Nancy Rockwell claimed she could no longer keep house and was tired and miserable all the time; her husband was sympathetic. Early in 1912, six years after they had left New York City and moved to Mamaroneck, the Rockwell family

moved back to New York.[9] Their new residence was Mrs. Frothingham's boardinghouse, which occupied two adjacent brownstones on the Upper West Side and offered furnished rooms and three meals a day.

Although living in the city freed Rockwell of his hour-long commute to Mamaroneck, he took a dim view of his new lodgings. In the evenings, when his classmates at the League might go out for a drink, Rockwell would return to Mrs. Frothingham's, where dinner was served punctually at 6:30 in the cellar dining room. He and his brother and their parents had a table of their own, a corner affair where they said grace and talked among themselves over plates of knockwurst and mashed potatoes and canned fruit for dessert.

Here he was, a young artist living not in Greenwich Village or the Latin Quarter, but in a boarding house among his parents and a dozen or so middle-aged lodgers of whom he was not exactly enamored. They included the "pitiful Misses Palmers," two sharp-boned spinster sisters who shared a little room on the second floor and had jobs selling lingerie at B. Altman's. Whenever he left his room, it seemed, they would poke their heads out the door and implore, "Oh, Mr. Rockwell, please stop by for a cup of chocolate." He would decline politely, explaining that he had a pressing deadline.[10]

He was no more fond of Mr. Leffingwell, "the star boarder," deserted by his wife, loudly expounding on his political views, or Dr. Boston, a white-bearded Scotsman who had an unsightly spot on the back of his head where hair refused to grow. In his autobiography, Rockwell was so indiscreet about the Palmer sisters and Mr. Leffingwell and Dr. Boston that his lawyer, who was shown an early draft, suggested he change the names of the boarders and delete certain comments about drinking binges and other unsavory habits. He obliged and the boarders in his autobiography remain pseudonymous.[11]

Adding to his frustration was the lack of privacy in the boardinghouse. He shared his bedroom with his brother Jarvis, whose shelves were jammed with trophies and mitts and all sorts of sports paraphernalia. Norman felt like he did not have enough room for his desk, which he used as his drawing board and also to store his art supplies. He could scarcely turn around once he opened his folding easel in the corner of his room.

When summer came, Rockwell arranged to study for a few weeks in Provincetown, Massachusetts, with Charles Hawthorne, a disciple of the American Impressionist William Merritt Chase, whose school Rockwell

had attended in his youth. Hawthorne, too, had his own school, the now-historic Cape Cod School of Art. Rockwell heard about it from classmates at the League, who had made it sound impossibly idyllic, this casual academy where you lived and painted and had your crits given out of doors, on Saturdays, within view of the harbor.

Renting a room in Provincetown, Rockwell was glad to be out of New York that summer, extricated from his social encounters with the loquacious Palmer sisters and the rest. In Cape Cod, he befriended the other art students in his rooming house, including a young woman from Chicago named Frances Starr. In the afternoons, they would walk to the seaward side of the Cape and swim in the breakers and sometimes lie around the sand for hours. "Evening we'd sit in the kitchen of the boardinghouse and stretch canvases," he later recalled.[12] Then eighteen years old, Rockwell was finally free from the constraining gaze of his parents, living on his own. But as much as he liked Frances, he had no interest in pushing the relationship beyond the platonic. "I never tried to kiss her," he later noted. "I didn't even hold her hand. Somehow I felt that would ruin things."[13]

He never did cotton to his teacher, Mr. Hawthorne, as the students called him. His philosophy of art drew heavily on French Impressionism, with all that implies about painting without preparatory sketches. In addition to drawing from the model, who was usually a Portuguese fisherman, he required his students to traipse through Provincetown in search of stimulating motifs. It could be anything: a sailboat, the facade of a squat cottage, children picking up shells. He wanted them to work quickly from direct observation, without revising, to be trained in the technique of *premier coup*, to relish the immediacy of a brushstroke and see how each mark commits you to a certain range of options, narrows your path. He urged them not to make "pictures" but rather to focus on their process, to lay down brushstrokes as if each one represented its own event.

The technique did not appeal to Rockwell and by temperament he was too nervous to embrace an aesthetic of spontaneity. He was less interested in the *premier coup* than the second coup and the third coup and the ten thousandth coup, in painting and repainting the human figure until his initial marks were buried beneath a blizzard of revisions and something interesting had emerged. Oil paint, in its own way, was a forgiving medium because you could always repaint what you had done the day before. For this reason, he did not like working in watercolor, which left too many visible tracks.

When the summer ended, Rockwell promised his friends he would return to Provincetown the following summer. Perhaps he meant it at the time, thinking of the free, open-ended and interesting life he had discovered with his artist friends. But in the end, it was not freedom from routine that he sought. It was the chance to advance in the world, and he would not return to Provincetown.

# THE BOY SCOUTS VERSUS THE ARMORY SHOW

## (SEPTEMBER 1912 TO DECEMBER 1913)

Rockwell began his second year at the Art Students League as monitor of Bridgman's class, an honor reserved for the best student. Monitors assisted with teaching demonstrations, in exchange for which their tuition was waived. At the end of class, Bridgman would hand Rockwell a "model"—an actual human skeleton—and ask that he put it away, which could be unnerving. It was kept in a locker, and Rockwell usually had to make a few attempts to hang the skeleton by its hook and close the locker door without having the limbs fly out. He prayed he wouldn't crush a humerus or an ulna or some other precious bone in the process.

As a budding artist, Rockwell had no particular allegiance to the League. On October 28, he also enrolled in a life-drawing class across town, at the National Academy of Art, where he had taken classes in high school and which did not charge tuition.[1] But most of his time was spent away from classrooms, trying to secure paying assignments. He had been an art student for all of one year and already felt eager to be done with it, eager for the future to come. He relied, for contacts, on a list of names from Thomas Fogarty, which got him only so far. New York was the center of the book trade, but appointments with art directors were not easily arranged. Rockwell had to be persistent. He had to climb the steep stairways of brownstones in Greenwich Village, wander hallways, knock politely, hope someone would agree to see him for a minute or two and look at his portfolio of sample illustrations. Although Rockwell was not dashing, he dressed neatly and had a nice personal manner. He said hello in a

resonant baritone and shook hands firmly, with the deliberateness of a shy man who was looking for something to hold onto.

His business card left no doubt that he was eager. In the center of the card, in bold capitals, was NORMAN P. ROCKWELL. Then running down the left side he listed his multitiered occupation: "Artist, Illustrator, Letterer, Cartoonist, sign painting, Christmas cards, calendars, magazine covers, frontispieces, still lifes, murals, portraits, layouts, design, etc."

He was routinely rejected before he even applied. Pretty secretaries seated behind wooden desks would look up at him, a scrawny teenager and, their eyes brimming with regret, inform him that Mr. X was not available to see him. Sorry, Mr. Y was tied up in a meeting. Mr. Z was vacationing upstate.

New York, the city of a million doors, was also the capital of the closed door. But Rockwell was willing to endure a hundred "nos" for the chance of hearing one "Yes, Mr. Rockwell" and was forever plotting new ways to be seen.

During his first year of school, Rockwell had visited the American Book Company, a textbook publisher with offices on Washington Square. Early one morning, he persuaded a janitor to let him into the anteroom outside the art director's office. For the next few days, he returned to the same spot and tried to talk to the art director, who would zip past him, appearing annoyed. One day, the art director said with exasperation, "If I give you a job will you permit me to digest my breakfast in peace?"[2]

And so he received what would be his first-ever published assignment: a set of illustrations for Fanny Eliza Coe's earnest history book, *Founders of Our Country* (1912). Rockwell was asked to illustrate the chapter on the explorer Samuel de Champlain and for this he produced five black-and-white, pencil-and-wash scenes.[3] After he sent them in to the art director, one came back with scathing criticism and instructions to redo it. He immediately saw the problem. Although he had portrayed Champlain standing on the high rocks of Quebec, pointing to ships gliding down the river, the river was on the same level as his feet! Rockwell wondered how he could have done this. After that, he never let an illustration leave his studio until he had checked and rechecked it innumerable times.

•

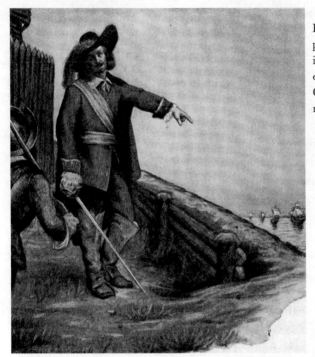

Rockwell's first published book illustration showed the explorer Samuel de Champlain on the rocks of Quebec.

It was Fogarty who sent him down to McBride, Nast & Company, on Union Square North, in the heart of the book publishing industry. After showing his portfolio, Rockwell was asked to illustrate a children's book, *The Tell-Me-Why Stories*, by C. H. Claudy. It was published in the fall of 1912 and on the cover is a watercolor of a smoldering volcano. He signed his first book cover Norman P. Rockwell.

He also undertook non-art jobs during his time at school. He was busing tables at Child's restaurant when his classmate at the League, Harold Groth, an extra at the Metropolitan Opera House, dragged him along one night to audition. Rockwell, whose musical experience was limited to singing in the church choirs of his youth, wound up on stage as an extra.[4] In later life, he loved to recall his encounters with Enrico Caruso, the famous tenor, who happened to have a second, admittedly less celebrated career as an artist who specialized in caricature. In addition to publishing his work in the Italian magazine *La Follia di New York*, Caruso liked to dash off sketches of his fellow performers and always seemed busy with a pen. Rockwell thought he had draftsmanly potential and was glad to provide a nod of encouragement.

•

In October 1912 Rockwell visited the Boy Scouts of America, which had its headquarters on the eighth floor of the so-called Fifth Avenue Building, at Twenty-third Street. The two-year-old organization was loosely affiliated with the scouting movement founded in England in 1907 by Lord Robert Baden-Powell. An unusual eccentric even by British standards, Baden-Powell was a decorated military hero who became obsessed with the character of Peter Pan after seeing J. M. Barrie's play at a London theater in 1904. He returned the next day to see it again and went on to construct "a highly successful career out of his idealization of boys and boyhood," as the literary scholar Marjorie Garber observes.[5]

Today, in our boy-centered universe, it is hard to imagine that American educators once worried that boys were not aggressive enough. But such was the case circa 1910, when it was said that the comforts of modern life were sapping boys of their masculinity. For one thing, the demographic shift that moved families from farms to the city was depriving boys of exercise and fresh air. Moreover, the notion of men as the stronger sex was under siege from the suffragist movement.

In America, the success of the Boy Scouts was almost guaranteed. Americans were already sold on Teddy Roosevelt's belief in the rugged, well-oxygenated life. What was Roosevelt if not a Boy Scout grown up? The former U.S. President was named "chief Scout citizen" and honorary Scout vice president when the movement was founded in America, and his name appeared on the masthead of *Boys' Life*, which was published once a month in New York.

Each issue of *Boys' Life* contained a mix of adventure fiction, scouting news from around "the world" (meaning, primarily, England and Scotland), and how-to articles that encouraged boys to master feats that almost seem designed to drive mothers to the brink of despair. Learning how to earn a merit badge in knot tying or stamp collecting is one thing. But do boys really need to know, for instance, "How to Wear a Blanket as an Overcoat," to cite the title of an article? And surely the family yard could not have been the same after a boy had perused an article entitled, "Your Own Hockey Rink, and How to Make It."

But the heart of the magazine consisted of juvenile fiction, short stories written by novelists of various ability. Every issue included a few adventure tales, the kind that situate young men in physical jeopardy in the pristine

out-of-doors, stories in which boys were shipwrecked on foggy desert islands or forced to ward off a pack of wolves at a campsite. From one story to the next, boys fell off cliffs and searched for their satchels and limped along winding trails with a full moon beaming down. Of course they triumphed in the end. Most of the stories were set in North America, west of the Rockies.

Acting on a tip from Fogarty, Rockwell arranged to see the magazine's editor. Edward Cave had grown up in Ontario, Canada, and prided himself on his skills as a hunter and fisherman. He had previously edited various magazines devoted to the outdoors, most notably *Recreation*, which billed itself as "The Been There" sportsman's magazine. By coincidence, Cave lived with his family in Mamaroneck, just a few blocks from where the Rockwell family had lived. Although his one child was a daughter, he served as Scout master of Mamaroneck's then-new Troop 1.[6]

Rockwell left Cave's office that day with a plum assignment. He was handed a typed manuscript of "Partners," a short story by Stanley Snow, a regular writer for the magazine, and asked to illustrate three scenes of his choice.[7] Rockwell returned home to his room at Mrs. Frothingham's boardinghouse and carefully read "Partners." Then he read it again, just as Fogarty had taught him to do at school. Like most other boys' stories, it was set on the frontier, in this case the Canadian wilderness in the winter, and it didn't have any female characters. The two "partners" of the story's title are Tommy Watkins, "a raw English boy of 18," and Blackbirch, a Cree Indian whom he befriends and saves from a sneering (white) bigot.[8] Rockwell picked out three scenes to illustrate; his pencil-and-wash drawings show husky, muscular figures carrying a toboggan and crouched and twisted in the snow.

Rockwell quickly endeared himself to Cave.[9] He was asked to assist with *The Boy Scout's Hike Book*, a manual that would require more than a hundred pen-and-ink drawings. Moreover, Cave bestowed a title upon Rockwell—he became the magazine's first "art editor" and was paid a decent salary of fifty dollars a month. Which is not to say that he had an office or was an employee. He went into the magazine's offices about once a week, to handle production details and hand out assignments to other illustrators, and the rest of the time worked on his own drawings at home.[10]

The job had its limitations. The magazine's circulation was modest then (about sixty thousand) and not every Boy Scout automatically received a copy. You had to subscribe, which cost a dollar a year. And Rockwell's name and title were not listed on the lofty masthead.

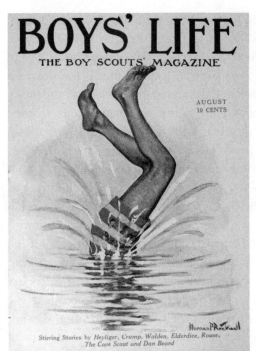

With its striped swimming trunks and cropped legs, Rockwell's *Boys' Life* cover, from August 1915, strips away moldy detail in favor of modern spareness. (Courtesy of the National Scouting Museum, Irving, Texas)

A scout named Gailey is ridiculed for bringing pink pajamas to camp in this 1913 illustration, which Rockwell drew for Edward Cave's *Boy Scout Camp Book*.

But it was a regular job, and for that he was grateful. In the next three years, he would produce a profusion of illustrations for *Boys' Life*, both inside-story illustrations and an occasional cover. The inside drawings were in black and white, but the covers were in color, if that is the word for "duotone" affairs in red and black and the mixed gradations—grays, dusky pinks, and roses—they could yield. The covers usually had seasonal themes. A plump boy wolfs down a turkey drumstick (November). A bundled-up boy skates on a frozen country pond (January). And, in one starkly modern image, a pair of striped swimming trunks and male legs disappear with a visible splash into the depths of a pond (August). The *Boys' Life* illustrations are not Rockwell's best work; they're the formative efforts of an artist trying to find his voice. Rockwell's name, of course, continues to be associated with the Boy Scouts, largely because he produced one painting per year for the annual Boy Scouts calendar, which was published by Brown & Bigelow. But that started a bit later; the Boy Scouts released the first of their calendars in 1925, and Rockwell would furnish the paintings for half a century.

Rockwell was never a Boy Scout himself; the organization did not exist for most of his childhood. But he had not been a Boy Scouts type of boy anyhow. He wasn't outdoorsy. He didn't go camping or know how to tie esoteric knots. By his own admission, he "didn't know a red maple from a brown bear." He would go to the Central Park Zoo and locate models for his animal pictures when he was assigned to draw one. He had even less interest in the social side of scouting, its quasi-military regimentation, complete with uniforms and badges. Scouts had to "Be Prepared," a slogan that suggested an imminent if nonspecific catastrophe, as well as Baden-Powell's initials. Rockwell never became a Scout leader or got involved with activities other than promotional ones, which required showing up in large, crowded halls to give an award or to receive one.

And yet it makes sense that his first job was with the Boy Scouts, with its vision of an all-male Arcadia. From the start, he seems to have been searching for an ideal boy in his work, of conjuring an athletic boy and keeping him close. His every illustration for *Boys' Life* started with the same basic image: a figure of a boy on a sheet of white paper. As he made adjustments to the figure—the head tilts, an arm bends—the paper became a space that the boy inhabited. In addition to creating space, a figure on a sheet of paper could conjure the plotlines of a story. And, as an illustrator, Rockwell was professionally obliged to be more concerned with the quality of his storytelling than with the quality of his space. His

job was to pick scenes from short stories and make them as immediate and present as possible. There was skill in all this, and pleasure as well.

To his relief, his monthly paycheck from the Scouts allowed him to rent a studio away from the boardinghouse. He shared his first atelier, in the West Forties, off Broadway, with E. F. Ward, a future illustrator whom he had met at the League. But the boys fled in a matter of days, after realizing the building housed a brothel.[11] Next they moved, easels and all, to the collegial terrain of the Brooklyn Art School, behind the arches and shimmering cables of the Brooklyn Bridge. They shared the room with other art students and pooled the cost of hiring models, until they were evicted for sweeping mounds of dust and trash down the hall, in front of the door of a well-known artist. So Rockwell moved his easel back home, or rather to the second floor of a deserted brownstone next door to Mrs. Frothingham's boardinghouse, and acquired a small coal stove to heat the space.

But the problem was that his first illustrations for *Boys' Life* appeared in the January 1913 number—just a month before the Armory Show opened in New York. Rockwell had the misfortune to begin his career at the precise moment that storytelling in art was about to get clobbered by a new generation of modernists.

•

At the Art Students League, he had learned that illustration was a division of art. Yet outside the cocoon of the League, the gap between fine art and illustration widened immeasurably in 1913. Almost overnight, it seemed, illustration broke off from the mainland of art and became its own island. Actually, it wasn't just illustration but the old belief that art existed to tell stories that suddenly fell out of favor. An avant-garde invasion had arrived from Paris and students seemed to talk of little else.

The Armory Show opened on February 17, 1913, in the armory of the 69th Regiment of the National Guard, on Lexington Avenue at Twenty-fifth Street. It remained on view for only a month. The exhibition was gargantuan and, although most of the work in it was by American artists, it was the European presence that made the show so incendiary. American viewers who had failed to follow new developments in art, and who thought that modernism at its most brazen consisted of Cézanne's blue mountains or the curling brushstrokes in van Gogh's skies, were more than a bit taken aback by the radical abstractions of Picasso, Braque, and the rest. The new avant-garde was rendering nature and the visible world

wholly unrecognizable. The defining image of the Armory Show was Marcel Duchamp's *Nude Descending a Staircase, No. 2*, which caused a stir precisely because no one could locate the female nude ostensibly tucked in there somewhere, amid the welter of brown planes. You suspect the piece would have passed practically unnoticed had it been titled Composition No. 2.

Rockwell was a fervent admirer of Picasso, whom he called "the greatest of them all." He made the comment in later life, by which time he had come to believe that abstract painting and figurative painting were not as easily divisible as critics pretended. But, in 1913, as a young illustrator just beginning his career, abstract painting did not speak to his needs. Abstraction broke the smooth surface of art, searched out depths; Rockwell, a repressed nineteen-year-old, was scared of depths. He preferred the reassuring pleasures of the unbroken surface.

Still, the Armory Show reminded him of the possibilities of painting, the largeness and radiance of it, beside which life seemed so precarious. On March 18, 1913, just as the show closed, his grandfather John W. Rockwell died suddenly at Roosevelt Hospital in New York. This was the grandfather who years earlier had bequeathed Rockwell the hand-me-down coat that he saw as emblematic of his shamed boyhood, the too-large overcoat with the moss-green velvet collar that had elicited mocking laughter from his schoolmates and which, in the end, he had burned.[12]

Most students at the Art Students League stayed for three years, but, according to school records, Rockwell was there for less than two.[13] By the time the Armory Show closed, he was feeling restless not only with his studies but with his job at *Boys' Life*. He longed to do more meaningful work, to reflect contemporary life, and to have his art seen by someone besides twelve-year-old Boy Scouts.

To this end, he befriended John Fleming Wilson, a popular novelist and Princeton graduate who lived in Riverside, California, and was roughly twenty years his senior. Wilson's stories appeared in *The Saturday Evening Post*, which gave him a near-heroic stature in Rockwell's eyes. His lesser stories ran in *Boys' Life*, and Rockwell came to know him after illustrating his story, "Waves of the Moon," for the September 1913 issue. For this he provided a painting of a lanky Scout in a pointed felt hat, holding the steering wheel of a ship. It was his first-ever magazine cover.

He later recalled meeting Wilson on one of the writer's many trips to New York over a breakfast of two fried eggs and a double whiskey—Wilson ordered for both of them. In coming months, Wilson urged Rockwell to

shed his cloistered ways. Let me show you life, he would say, and Rockwell would laugh tensely. Their jaunts around Manhattan took Rockwell away from his studio, away from his fixed routine. But he believed something large was at stake.

Wilson promised to help get him an assignment at a major magazine. Perhaps at *The Saturday Evening Post*, where he had published the first of his many "Tad Sheldon, Boy Scout" stories. Wilson also wrote pieces of reportage and he mentioned to Rockwell that he was planning a trip down to Panama, to report on the construction of the canal and the thousands of men involved in the effort. The previous year, his article "Panama, City of Madmen," had appeared in *Lippincott's*.[14] Wilson suggested that Rockwell come along on his next Panamanian expedition and do the illustrations. Rockwell acquired a pith helmet and a pair of leather sandals, imagined his first ship journey, counted the days until their departure.

But then one day he visited the hotel on Broadway where Wilson had been staying; the writer had checked out and left no forwarding address. "I was crushed," Rockwell recalled. "I went home and sat in my empty studio amidst the litter of my tropic gear. My mind was empty. Everything— all my dreams of becoming a great illustrator, of working for the big magazines—shattered, lost.

"I guess I came as near to having a nervous breakdown as I ever have. I couldn't work. Or sleep. Or eat. Or go out anywhere. I wouldn't talk about it. I just sat in my studio, staring at the pigeons strutting on the ledge outside my window.

"Finally, my father sent me away to the mountains for a month," Rockwell recalled. He stayed in a room on the Jessup farm where his family had summered long ago, up in Warwick, New York. "I took long walks through the snowy countryside," Rockwell recalled, "trying not to think."

He never forgave Wilson for leaving him stranded. For leaving him to continue his quest by himself, in the unforgiving city. Stranded like a boy in one of those shipwreck stories in *Boys' Life*, but without the resourcefulness to know what to do next.

# NEW ROCHELLE, ART CAPITAL OF THE WORLD

## (1914 TO 1916)

It is frequently the case that an artist who moves to a new city pursues a new direction in his work. A stay in Paris has altered the lives of so many artists it sometimes seems as if a whiff of French air is enough to turn any provincial into a modernist. Think of New Rochelle, New York, as Norman Rockwell's Paris.

Early in 1914, Nancy Rockwell decided to leave Manhattan and move the family into Brown Lodge, a rooming house in New Rochelle. It was listed in directories as a hotel and she considered the arrangement more prestigious than having her own house. Undine Spragg, the spoiled heroine of Edith Wharton's *Custom of the Country*, felt her family "could not hope to get on while they 'kept house'—all the fashionable people they knew boarded or lived in hotels." The novel was published in 1913, just a year before the Rockwells moved into their own hotel, or rather into Brown Lodge, a white-shingled house on a quiet street. It was just around the corner from Main Street, where trolleycars clanged and fine shops stretched on block after block. You could buy a player piano at Baumer, have your parasol repaired at the Umbrella Hospital, or see the latest Charlie Chaplin movie at the Loew's Theatre.

After the ordeals of the previous months—her son's aborted Panama trip and all the rest—Mrs. Rockwell thought that New Rochelle would be an ideal place to live. For starters, it was home to about a dozen illustrators of some renown, men who contributed to magazines that everyone read, like *Collier's* and *The Saturday Evening Post*. Its origin as an art colony went back to 1890, when Frederic Remington, the legendary painter of

the Old West, gave up his apartment in New York City and purchased an estate in New Rochelle. Many of his paintings of the untrammeled frontier were done not in Wyoming or Montana but at his atelier on Webster Avenue, where he kept horses and became a suburban cowboy.

Rockwell arrived in New Rochelle just in time to participate in a show that was quite prestigious—the first annual juried exhibition of the New Rochelle Art Association. It opened in May 1914 in the fine arts room at the brand-new New Rochelle Public Library, a handsome pale-brick structure that owed its existence to a grant from Andrew Carnegie. At age twenty, Rockwell was the youngest artist in the show.[1] He exhibited two works, which were identified on a checklist, rather unhelpfully, as "Illustration" and "Sketch." He was still Norman P. Rockwell, an artist who used his middle initial when he signed his name. Rockwell's coexhibitors at the library were an illustrious (and initial-heavy) bunch, including Frederic S. Remington, who by then had died; J. C. Leyendecker; Frank X. Leyendecker; and C. Coles Phillips.

Of all the artists in New Rochelle, Rockwell was the most taken with Joseph Leyendecker (pronounced LINE-decker), the star cover artist for *The Saturday Evening Post*. Today he is remembered as the creator of the Arrow Collar Man, a handsome, square-jawed figure and the first preppy in American advertising. But in his time, Leyendecker was beloved for his *Post* covers. A German immigrant and master draftsman, he used a crisp, spiky Northern European line to portray scenes of American life, many of them tied to national holidays. His covers might show a New Year's baby bestriding a globe, a pilgrim hunting a Thanksgiving turkey, or elves pummeling Santa with snowballs.

In contrast to most other illustrators, who specialized in pretty-girl covers, Leyendecker favored genre scenes. "Girls' heads are being overdone," he said in a rare interview that appeared in *The Sun* in 1913.[2] "The simple reason is that composition involves difficulties which many illustrators prefer to avoid. In painting a girl's head, they have only one problem to face: to make it as beautiful as possible. In drawing pictures that require composition, it is necessary to practice control and eliminate everything that is superfluous."

In dismissing the fashion for girls' heads, Leyendecker was presumably dismissing his fellow illustrators at *The Saturday Evening Post*. So many covers from that period show bust-length portraits of women with powder-white skin and beet-red color on their cheeks. They peer out from beneath the

wide, tilted brims of fashionable hats. Their gaze tends to be dramatic, perhaps in emulation of the new silent film stars. If they are engaged in an activity, it is likely to be one that requires little in the way of physical exertion, such as admiring a dove or a parakeet.

But perhaps the fashion for "girls' heads," as Leyendecker called them, was winding down. "People are now demanding pictures that have some larger meaning," he insisted, "illustrations with an idea behind them and humor whenever possible."

Both Leyendecker and his artist-brother Frank X. Leyendecker were homosexual and, to shield themselves from discrimination, concealed their sexual identity not only from their readers but from their editors as well. They lived with their father and their sister, Augusta, in a Renaissance-style chateau they had just built on Mt. Tom Road, on the southern edge of New Rochelle. Rockwell often wondered about the lives unfolding behind the iron fence that rimmed their estate. Walking along Mt. Tom Road on evening strolls with his parents, he would pause in front of the house and glance up at the lighted windows, where a figure might slip into view.

Rockwell worshiped Leyendecker's covers and considered him the single best illustrator in the country. He shared with Leyendecker a love of narrative illustration, as well as an impatience with girls' heads. But several years would pass before Rockwell befriended Leyendecker. For now he simply watched him from afar. In the morning, walking to his studio, he sometimes noticed the brothers at the New Rochelle train station, on the way to their studios in New York City. There they were, Joe and Frank, emerging from their limousine or standing on the platform in their matching blue blazers and white flannel slacks.

•

As much as Leyendecker, the other illustrators who lived in New Rochelle owed their prosperity to the "slicks," as the new general interest maga-zines were known. They included Orson Lowell, Edward Penfield (the father of the American poster), and Fred Dana Marsh (the father of the social-realist painter Reginald Marsh). With his tripartite name, Marsh was sometimes confused with Charles Dana Gibson, who was the most famous of all. Gibson was the creator of the ubiquitous Gibson Girl, that fashionable belle with pointy breasts and an hourglass waistline and a

The illustrator Charles Dana Gibson specialized in images of busty women with big hair.

tremendous amount of long, wavy hair that is usually pinned up in what was called a pompadour; it can put you in mind of a robin's nest or swirls of soft ice cream. In her heyday, she was viewed as an icon of female independence, a woman willing to express an opinion or have a drink without parental consent.

Coles Phillips created another female icon: the Fade-Away Girl, a tall figure with shapely legs who derives her singularity from sophisticated visual tricks. Swatches of her dress are cut away, exposing the background of the composition, which in turn becomes an integral part of the dress. Your eye fills in the presumed outlines. The effect is striking, and turns every housewife into a Houdini equipped with the ability to appear, disappear, and reappear in the clean, rectangular space of a magazine cover.

Compared to his fellow illustrators in New Rochelle, symbols of success who lived in Tudor mansions overlooking the Long Island Sound or rolling woodlands in the Wykagyl neighborhood north of downtown, Rockwell lived modestly. He did not own a tract of land. He did not employ servants. Rather, he was still residing with his penny-scrimping parents and his brother, Jarvis, at Brown Lodge, in the city's business district.

On weekday mornings, Rockwell's father and brother commuted by train into New York City, to their respective jobs in Lower Manhattan. Rockwell did not have to venture that far. He could walk from Brown Lodge to the studio he rented at 78 North Avenue. He usually started his work day by drinking a bottle of Coca-Cola, which helped him wake up, and mulling over the painting in progress on his easel. He would try to figure out which part of it didn't work and he always found something. This provided him with an entry point back into the painting and opened up a space of concentration into which he could disappear for hours.

He was separated from the other illustrators in New Rochelle not only by his youth and his inexperience, but by his lack of interest in their notion of glamour, their sense of the things that make life worthwhile. For starters, he did not care for golf and could not understand how certain men played round after round at the Wykagyl Country Club. Most of them were married and their wives and girlfriends were themselves somewhat celebrated and ogled—they were the women who had modeled for the Gibson Girl and the Fade-Away Girl and all the other new kinds of modern girls.

Rockwell, by contrast, continued to work seven days a week and to produce illustrations of boys. Skating boys and brawling boys and boys sitting around the proverbial campfire. He had already drawn more baseball diamonds than he could count. Ditto for shipwrecks and deserted islands. In the two years since he had left the Art Students League, he had come to know the art editors at various magazines and secured a steady influx of assignments. His work for *Boys' Life* led to assignments from other children's magazines, such as *St. Nicholas* and *The Youth's Companion*, and though the magazines were competing for junior subscribers, no one stopped Rockwell from publishing his work in all of them.

The now-forgotten *Youth's Companion*, a weekly priced at seven cents an issue, had the largest circulation of the children's magazines. It was published in Boston, by Perry Mason & Co. (from which the television attorney derived his name). *St. Nicholas*, by contrast, a New York–based monthly priced at a relatively steep twenty-five cents, continues to be called the best children's magazine ever. Published by Century Company, it was the little person's version of *The Century Magazine*, a mix of literature and beautifully drawn illustrations in which Rockwell along with the rest of his generation gained his first excited glimpse of pictures by Howard Pyle and Maxfield Parrish.

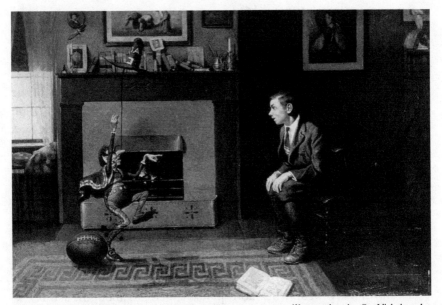

*The Magic Football ("I thought you were wrong")* ran as a story illustration in *St. Nicholas*, the best of the children's magazines, in December 1914. The medium is oil on canvas *en grisaille.*

Rockwell was pleased when he was given a full page in the Christmas 1914 issue of *St. Nicholas* magazine.[3] His illustration, which accompanied a story called "The Magic Football," shows a boy of perhaps twelve or thirteen perched on the edge of a Windsor chair, mesmerized by the appearance of a male fairy with pointy ears, a long nose, and a tall black hat floating a few feet above his head. Sunlight pours into the study from a window on the left and fades as it moves across the room, touching the boy's face and the arms of his chair. The picture is astonishingly precocious. Departing from the text of the story he was purportedly illustrating, Rockwell furnishes the room with the trappings of a cultured life—there are leather-bound books arrayed above the mantelpiece, as well as framed reproductions of museum paintings, including a Rembrandt self-portrait and Jean-François Millet's *Gleaners.* What's interesting is how Rockwell takes an assignment for a commercial magazine and bends it to accommodate his own artistic preoccupations. Everything is here—his love of Millet and Rembrandt, his clarity, books, a boy, a magic hat. A story can be an opportunity for self-expression, even if the story was written by someone else.

•

In addition to its illustrators, New Rochelle also had an impressive population of cartoonists. They included Frederick Opper, Clare Briggs, and Clyde Forsythe, all of whom had gained a new visibility as a result of the circulation fight pitting Joseph Pulitzer's *World* against William Randolph Hearst's *New York Journal*. Like a character in a cartoon strip of his own devising, Hearst was constantly scheming to lure cartoonists away from *The World*. It was the age of "yellow journalism," a phrase that originated from the popular *Yellow Kid* strip that for a while appeared—in competing versions—in both the Hearst and Pulitzer newspapers.

Rockwell, who had drawn caricatures in his childhood and had a natural gift for comic anecdote, was well aware of the artistic possibilities of the Sunday funnies. He recognized that comic strips were not just a series of laugh-out-loud jokes; they represented a morally coherent universe. In what is probably his most-quoted statement about his art, Rockwell wrote in his autobiography: "Maybe as I grew up and found that the world wasn't the perfectly pleasant place I had thought it to be I unconsciously decided that, even if it wasn't an ideal world, it should be and so painted only the ideal aspects of it—pictures in which there were no drunken slatterns or self-centered mothers, in which, on the contrary, there were only Foxy Grandpas who played baseball with kids."[4]

Self-centered mothers? He certainly described his own that way. Foxy Grandpas? Rockwell was presumably referring to Carl Schultze's *Foxy Grandpa*, one of the early classics of the Sunday funnies. It first appeared in *The New York Herald* in 1900, when he was six years old; its protagonist was a clever old man who, from one day to the next, outsmarts his two pesky grandsons, Chub and Bunt. Unlike other cartoon strips, whose humor derived from subversive acts or emotions—rage, madness, sloppiness, screaming, etc.—Foxy Grandpa offered up a gentler universe in which any threat of chaos was neatly resolved by its elderly hero.

•

Once he settled in New Rochelle, Rockwell quickly became best friends with the cartoonist Clyde Forsythe, who happened to have a studio in the same building as he on North Avenue.[5] At lunchtime, Rockwell would walk down the hall to talk to Forsythe, who would regale him with amus-

ing stories. Then he would try to drag Forsythe back to his studio, so he could see what he was working on. Rockwell was always asking people what they thought of a particular painting. He had an enormous need for reassurance and found friends who could bolster him up, who were sufficiently accepting to find his insecurity charming. "Give it time," Forsythe would tell him. "Hell, Lincoln was fifty-one before he was elected president."

Forsythe was quite a bit older than Rockwell, nine years, and already established in his career. His daily strip about boxing, *The Great White Dope*, ran in Pulitzer's paper, *The Evening World*. Soon he would create *Joe's Car*, which in turn evolved into *Joe Jinks*, whose title character was a cartoon Everyman, a balding, agitated, henpecked husband with a passion for cars. The strip paid well, but Forsythe's ambition was to be a painter of the southwestern desert. Every Christmas, he packed up a few canvases and as many rifles and went out west to work on his landscapes. He disparaged his cartoon work and was constantly threatening to give it up and move back to his native California.

At five each day, Forsythe would walk home to his house on Elm Street and be greeted by Cotta, his wife. Rockwell stayed in his studio until around six or, in the dead of winter, until daylight gave out, and then returned home to spend the evening with his parents. In the summer of 1915, after a little more than a year of life at Brown Lodge, they moved to a rooming house they considered a bit nicer: Edgewood Hall, at 39 Edgewood Park, near Webster Avenue and the trolley. It was run by a married couple, Fred and Sadie Miller, and advertised as "a quiet family hotel," with "handsome furnished rooms."[6]

In October, the local paper reported that "Jarvis Rockwell, of Edgewood Hall, was tendered a birthday party by his fellow guests at the hotel."[7] Some of the lodgers, including Jarvis's girlfriend and future wife, were young women living on their own, but there were also families with school-age children. It was here, at Edgewood Hall, that Rockwell met Billy Payne, a young lodger who would come to play a large role in his work, a handsome, athletic eleven-year-old with reddish-blond hair and a generous smattering of freckles.

Rockwell was relieved to have found a model as talented as Billy, who soon was dropping by his studio almost every day after school. He didn't have much family in town. His only sibling was a much-older half sister

from his father's first marriage; she lived in Indiana and saw him infrequently. Rockwell, by contrast, seemed to have unlimited time for Billy, so long as the boy was willing to hold still as Rockwell sketched.

To be sure, Billy was not the most disciplined model. He could tire of holding expressions and poses, or be overcome with a sudden and irrepressible desire to throw an object across a room. But Rockwell devised a way to help him concentrate. Instead of writing a check at the end of the day—the pay was fifty cents an hour—he piled up a stack of quarters on his work table. Billy received a quarter every thirty minutes, presuming he was still on the modeling stand and not making water balloons at the sink. The method was surprisingly effective and Rockwell used it with repeated success.

•

In February 1916 Rockwell turned twenty-two and appeared in a three-man show at the New Rochelle Public Library, along with Clyde Forsythe and a young artist named Ernest Albert, Jr. While his coexhibitors were represented by a few dozen landscapes—Forsythe's entries included such western scenes as *Santa Monica Shore*, *Redondo Cliffs*, and *Twin Peaks*—Rockwell had zero interest in painting pictures devoid of people, which is how he thought of landscape painting. Art without a face. He had fifteen works in the show, a mix of illustrations from *St. Nicholas* magazine and portraits of acquaintances, including a sensitive portrait of his young friend Billy Payne.

The show generated a flurry of publicity, at least locally. *The New Rochelle Tattler*, which, conveniently, was located in an office adjacent to Rockwell's studio, gave him a full page. It probably helped that Adelaide Klenke, who wrote the piece and edited the *Tattler*, already knew and liked Rockwell. She was a few years older than he, blond and still single, the daughter of German émigrés, and he found her amusing. He frequently quoted a less than flattering comment she had made about his appearance. She told him he had "the eyes of an angel and the neck of a chicken."

In her article for the *Tattler*, she was not so mocking, describing Rockwell as tall and thin, with a "big, bass drum laugh."[8] Although he had never been west of New Jersey, his comments made him sound like a world traveler. "I intended giving up illustration this winter and going to Norway for several months and studying the Norwegian and Swedish genre painters," he announced, "but my contracts interfered and my work

piled up." He added that he hoped to go to Norway in the spring. Perhaps he genuinely wanted to study the work of Adolph Tidemand and other nineteenth-century Norwegian genre painters, or perhaps he was merely letting readers know that he was the sort of man who was capable of taking off without warning.

Just a few days later, the *New Rochelle Pioneer* ran a front-page story with the perky headline: NORMAN P. ROCKWELL MAKING A SUCCESS AT ILLUSTRATING.[9] The article made no mention of Norway and, to the contrary, emphasized the substantial if unspecified income that Rockwell was earning from magazines. Rockwell, by contrast, claimed to be motivated by something more personal. "I like the boy stuff," Rockwell told his interviewer. "There is not so much money in it as in adult stuff, but it is more interesting. I do many adventure stories and specialize in the historic."

•

On March 1, 1916, Rockwell and Forsythe moved into a studio that had initially belonged to Frederic Remington. His former house, Endion, a so-called Gothic cottage, occupied three acres at 301 Webster Avenue.[10] A photograph taken before 1909, the year of his death, shows Remington standing on his front lawn in a derby hat, holding the reins of his horse, the bright winter sun casting long shadows on the grass. Remington had built a sculpture studio on the property, the "shanty," as he called it, which was made of corrugated iron and was basically a big, generic shed. But the interior was spacious, with a seventeen-foot-high ceiling, and it was here that Rockwell set up his easel and worked for the next year. Forsythe decorated the place with relics of the American West he brought back from California, including cowboy saddles, sagebrush, and cacti. Rockwell did not care for the plants. "Every once in a while you'd go to grab something and you would grab a cactus," he recalled.[11]

He was well-acquainted with Remington's work and his sad ending. In addition to painting cowboys for his own pleasure, Remington was one of the biggies of magazine illustration. Toward the end of his life, he signed a lucrative contract with *Collier's Weekly* and turned out cowboy centerfolds, two-page spreads that provided Americans with intimations of a shared heritage. In reality, their common heritage consisted less of lassoing horses in Cody, Wyoming, than in staying home and reading *Collier's Weekly*.

Despite his success, Remington felt conflicted about his work as an illustrator. Shortly before his death, in 1909, he lit a bonfire on his property

and incinerated sixteen paintings. He wanted to be a fine artist, not an illustrator. In his last decade, he had tried loosening up his brushwork and brightening his palette; he want to be admitted to the ranks of the American Impressionist painters who were his friends. Like so many illustrators, he was haunted by feelings of failure, believing that magazine work was trivial and possibly meretricious beside the lofty tradition of easel painting.

Rockwell, for now, did not have this conflict. He did not feel divided between illustration on one hand and landscape painting on the other. In this he was different from so many illustrators who split themselves in two, devoting one half to commercial art and the other half to art with a capital *A*. Such was the dilemma of Clyde Forsythe and Frederic Remington and even Rockwell's hero Howard Pyle, who had died in Florence, where he had sailed in the last year of his life, despairing over his illustrations and deciding to study mural painting. It was the illustrator's curse: you had something great, but pined for something you could never have. Rockwell, by contrast, wanted mainly one thing: he wanted to be a famous magazine illustrator. And once he was living in New Rochelle, it was clear to him that he had to get to one magazine in particular.

That, of course, was *The Saturday Evening Post*, which did not come out on Saturdays, but on Thursdays. No one waited until the weekend to open it. Husbands and wives and precocious children vied to get hold of the latest issue in much the same way that future generations would vie over access to the household telephone or the remote control.

Unlike other magazines, the *Post* didn't come in the mail. After school let out every Thursday, thousands of *Post* boys across the country slung canvas bags over their shoulders and set out on their neighborhood routes. They tossed the *Post* onto wide front porches and narrow city stoops as moms in dresses stepped outside as if on cue to retrieve the latest issue and perhaps glance at the cover illustration as they walked back inside. The *Post* boys were the embodiment of the magazine's belief in the American dream of upward mobility, proving that anyone—so long as he was at least ten years old—could improve his financial lot if he were willing to work for it.

A copy of the *Post* sold for a nickel and the boys could keep two cents of every copy they sold. They also delivered *Ladies' Home Journal*, which paid them twice as much. Those who sold the most subscriptions were honored with the coveted title of Master in the League of Curtis Salesmen. As in so

many other fields of endeavor, the successes were mythologized while the failures drifted off without a trace. It is impossible to know how many *Post* boys dreaded their routes, had trouble adding numbers, and feared for their futures as they searched the depths of their trouser pockets for missing nickels they swore they had put there just ten seconds earlier.

In 1915, when Rockwell looked at an issue of the *Post*, any issue, he would have seen a magazine that offered a lot of entertainment value for a nickel, mixing journalism and financial investment tips with original fiction by authors who were famous or about to be. That year, he could have read the first story by P. G. Wodehouse featuring Jeeves and Wooster. Or one of Ring Lardner's *You Know Me Al* baseball tales. Or a serialized mystery by Mary Roberts Rinehart that opens with the histrionic lamentation, "I've thought the thing over and over, and honestly I don't know where it went wrong."

Every issue of *The Saturday Evening Post* came with an illustrated cover that was a stand-alone work of art, unrelated to the stories that ran inside. When Rockwell looked at the cover, he saw an illustration that measured about eleven inches wide and fourteen inches tall and that, in his eyes, was the biggest thing in the world.

•

In order to vault his work onto the cover of the *Post*, Rockwell figured he would have to go against his instincts and paint at least one sample image that had a gooey romantic theme. So he tried painting a picture of a gentleman in a tux leaning over the back of a couch to flirt with a woman; then came a second painting in which a young ballerina takes a bow. When he showed the paintings to Forsythe, his friend offered his candid opinion: they were terrible. He wondered only half-jokingly why Rockwell seemed incapable of painting a female figure who gave off any hint of sensual allure. His ballerina looked like a schoolboy in a tutu.

"Do what you're best at," Forsythe counseled. "You're a terrible Gibson, but a pretty good Rockwell." So Rockwell called in Billy Payne, his young model. He started with a pencil sketch which he translated into charcoal. The painting was done in the required two-color palette: red and black oils and the surprising range of tones—diaphanous grays, salmony pinks—you can get by mixing in a few daubs of white.

He wound up with two excellent covers. *Boy with Baby Carriage* (see color insert after page 238) was followed by another painting for which

Billy Payne modeled, *The Circus Barker (The Strongman)*. Both were around twenty-one by twenty inches, almost square, and larger than an actual *Post* cover. It was a lesson he had learned at school. The rule was to work one-third up from the size at which a picture is to be reproduced. You don't want to work at actual size—to make your illustration the same size as the cover—because the image might look crude when it is reproduced, and you don't want to work on too large a scale because then the project monopolizes too much of your time.

Years later, Rockwell wrote: "I didn't start the vogue for *Post* covers of kids, Clyde Forsythe did."[12] This comment has been misconstrued; much of the biographical material on Forsythe claims that he introduced the young Rockwell to editors at the *Post*. Yet Forsythe never worked for the *Post* and had no contacts there. What Rockwell meant, in that one sentence, is that he felt indebted to Forsythe for having pushed him to submit work to the *Post*.

•

By 1915 New York City was the book publishing capital of the country. But Philadelphia had the edge in magazines. It was home to Cyrus H. K. Curtis, a self-made, self-promoting showman who founded the Curtis Publishing Company and seemed to love his three magazines equally. *The Saturday Evening Post* came out once a week and its sister magazines, *Ladies' Home Journal* and *The Country Gentleman*, came out at the beginning of each month. Curtis maintained that you could tell who read his magazines by looking at the ads. And when he looked through the latest issue of his magazines, he paused to look at each and every ad. He thought they were far more alive on the page than the dull gray articles wedged in between them.

Of course, most publishers set out to make money, and today we take it for granted that magazines are kept afloat by advertising revenue as opposed to circulation revenue. A magazine that costs five dollars an issue to produce (counting paper, postage, office rent, writers' fees, etc.) can sell for a dollar and be vastly profitable if it attracts enough advertising. But this knowledge was something of an epiphany in 1897, when Curtis acquired *The Saturday Evening Post* and dropped the cover price to a nickel. At the time, the leading illustrated magazines—*The Century, Harper's,* or *The Atlantic*—sold for thirty-five cents an issue in newsstands. Other monthlies, like *Pall Mall, Scribner's,* or *McClure's,* could be had for a quarter. But a

mere five cents? Curtis wanted a mass readership rather than a class readership. Within a few years the *Post* was the largest-circulation magazine in the country.*

Initially, when Curtis acquired the *Post*, it was a dying magazine with fewer than ten thousand subscribers. Its only bankable attributes were a nominally recognizable name and a dubious connection to Benjamin Franklin. To be sure, Curtis insisted that the *Post* had been "founded A.D. 1728 by Benj. Franklin"—to quote the line that he added to the inside cover of every issue of the *Post* starting in 1899. Moreover, Franklin's jowly face, his spectacles, and his flowing hair, became part of the logo on the editorial page. Franklin, of course, was a printer by trade; he ran his own print shop on Market Street and published *The Pennsylvania Gazette*, the best-read newspaper in the colonies. Its only connection to the *Post* was that it ceased publication in 1815—after Franklin's death—in the same print shop where the *Post* would be launched six years later.

Curtis's appropriation of Ben Franklin as a founding father of the *Post* was reinforced in concrete in 1911, when he put up a building in Philadelphia's historic center. The Curtis Building, as it came to be known, took up a whole block of Walnut Street and was designed to echo Independence Hall, the national landmark across the street, a redbrick, white-trimmed Georgian structure summoning visions of parchment and ornate, old-fashioned signatures. Curtis made his building twelve stories high, so that it towered above Independence Hall. The birth of America, the birth of the *Post*—it is not clear which event Curtis considered to be of greater consequence.

Thankfully, he installed an editor in chief who was devoted to the labor-intensive demands of editing as well as to the financial welfare of writers. At the time he became editor, George Horace Lorimer was an unknown cub reporter. But he would rise to become the most celebrated magazine editor of his age. Born in Kentucky, the son of a well-connected Scottish minister, he studied at good schools (Colby and Yale) and was given to spouting folksy aphorisms. "The prime qualification of being an editor," he said, "is being an ordinary man."

If that were true, it would have disqualified him from day one. A

---

*The Curtis formula would prevail in publishing until the twenty-first century, when the digital revolution caused newspapers and magazines to lose much of their classified advertising to craigslist, and editors seemed to talk about nothing so much as the need to find a "new business model."

patrician figure, he had a passion for "antiqueering," as it was called. He owned, in addition to your average millionaire's trove of Chippendale dining chairs with claw-and-ball feet, a peerless collection of British and American antique glass. He eventually bequeathed some six hundred glass objects—prerevolutionary pitchers and the like—to the Philadelphia Museum of Art. He was also a champion of the national parks and enjoyed touring the mountainous West, so long as he was driven every inch of the way by his chauffeur, George Smyth, with whom he proudly developed his own road maps.

Lorimer lived in Wyncote, Pennsylvania, a well-to-do neighborhood on the edge of Philadelphia, as did his boss, Cyrus Curtis. By coincidence, one of their neighbors was the young Ezra Pound, who grew up on nearby Fernbrook Avenue. Lorimer routinely took a shortcut through the Pounds' backyard and paused for an affable chat with Homer Pound, the poet's father. Lorimer was never a fan of modern art or experimental poetry, and one wonders if he read Pound's future masterpiece, *Cantos*. In it, Lorimer makes a comic appearance as a self-absorbed editor proudly recounting how he stalked a U.S. senator to get a story out of him.

As Pound writes in Canto LXXXI:

> *George Horace said he wd/ "get Beveridge" (Senator)*
> *Beveridge wouldn't talk and he wouldn't write for the papers*
> *but George got him by campin' in his hotel*
> *and assailin' him at lunch breakfast an' dinner*[13]

•

From the time he was a young man, Rockwell had an ironclad rule that a finished painting must be framed, even if the frame consisted of the simplest wooden strips. He thought it was the proper way to treat any work of art. A framed painting, however, cannot fit between the two flat boards of your average artist's portfolio, which helps explain why Rockwell designed a special wooden case in which to carry his work to the office of George Horace Lorimer. The box became an essential detail in the quasi-comic, oft-told story about how he made his first-ever trip to the editorial offices of *The Saturday Evening Post*. He had the box custom built by a harness maker in New Rochelle. It was covered in black oilcloth and measured three by four feet, about the size of a kitchen tabletop. It was this clunky object that Rockwell lugged on the train from New Rochelle to

Grand Central Terminal. Unable to maneuver the box through the door of a bus or even a cab, he walked the long, crowded blocks to Penn Station and boarded the next train to Philadelphia.

Conveniently, the Curtis Building was just a short walk from the train station. You couldn't miss it. It was raised a few steps above Walnut Street, with a row of white marble columns flanking the entranceway. The atrium was Vegasoid before Vegas existed. On the back wall, fountains and a goldfish pool provided the luxe setting for what was described as the largest Maxfield Parrish mural in existence. It was certainly the wettest mural in existence. Hanging above the fountains, forty-nine feet wide, *The Dream Garden* offered an iridescent view of mountains and greenery that had been translated by Tiffany Studios into glittering glass. Water from the fountains ran down the sides of the mosaic and oozed from openings in its surface.[14]

As he made his way into the building and took in its opulent decor, Rockwell suddenly thought of a comment that Adelaide Klenke had made. That line about his angel eyes and chicken neck. He almost turned around and left.

Lorimer's office was on the sixth floor, along with the rest of the editorial department. The hallways were covered in cork (for quiet) and the well-appointed reception area was much nicer than the anterooms at other magazines. It was there that Rockwell learned that one did not ever see Lorimer without an appointment. "I just stood there in that fancy room," he recalled, "and I guess I would have cried if people weren't watching me."[15]

A secretary suggested that he talk to Walter H. Dower, the art editor of the *Post*, an illustrator in his early thirties who had recently started his job. Dower stepped out into the reception area and took a look at the contents of the black case, saying nothing and maintaining a poker face as he assessed the work. Then he asked Rockwell to wait and carried off the two framed paintings to an office. The humor writer Irvin Cobb, chomping on a cigar, noticed Rockwell sitting there anxiously with his massive black case. He asked him if he had a body inside.

When Dower reappeared, he had excellent news. Lorimer had looked at the two paintings and liked both of them very much. Dower handed Rockwell a slip of blue paper. It was a check for $150, payment for the two paintings. Lorimer believed that a magazine should pay its writers and artists on acceptance, as opposed to on publication, and pay them liberally,

which was virtually unprecedented and added to the crazy excitement of having your work accepted by the *Post*. As the writer Roger Butterfield once noted, in an observation that applies as easily to illustrators, "Writers dreamed of selling to the *Post*, whose scales turned Grub Street into Park Avenue."[16]

•

On May 20, 1916, Rockwell's first cover appeared in the *Post* (see color insert). It remains one of his most psychologically intense works. A boy who appears to be about thirteen is taking his infant sister out for some fresh air when he bumps into two friends. The boy is mortified to be witnessed pushing a baby carriage. While his friends are clad in baseball uniforms and heading off to a game with their mitts, the babysitting boy is dressed formally, complete with a starched collar, derby hat, and leather gloves. A glass milk bottle protruding from his breast pocket endows him with an oversize female-looking nipple and makes his humiliation complete.

The image has a pleasing symmetry about it and is far more structured than you might expect of a magazine cover. The center of the composition is occupied not by a figure but by the wicker carriage. It is painted in a way that borders on obsession: the wicker is rendered in such detail that you can make out the individual strands of woven fiber and imagine the tiny paint brushes the artist used to lay out all those thousands of lines bundled together into a ribbed pattern. Great care has also been expended on the space inside the carriage—a shadow-filled, rectangular recess that divides the painting into two zones. The baseball players, one tilting forward, the other back, are on the left of the carriage. Their bodies appear lithe and elastic compared to the boy with the carriage, who holds his arms close to his sides. His eyes are averted and almost downcast as he hurries along, as if it were possible to physically escape the mocking gaze of his tormentors.

In his boyhood, Rockwell had bemoaned his lack of aptitude for baseball and his overall exclusion from the realm of male athleticism. "The fear of being tagged and shamed as a sissy is the overriding concern in this picture," the artist Collier Schorr observes, "and it is the story of Norman Rockwell's early years."[17] You can also read the painting as a birth narrative, at least of the breech variety. Note how the infant is coming toward us feet first—he or she is hidden from view, except for the bootie-clad foot jutting out of a curving opening. The baby looks as if it is about to emerge

from a birth canal; the shadowy recess of the carriage suggests a womb. Maybe Rockwell is saying that humiliation is the emotion out of which his art is born.

•

In those early days, *The Saturday Evening Post* did not have a letters-to-the-editor column. So readers were not given the chance to offer their opinions of Rockwell's first cover in any forum more public than the street corners or grocery counters where they chatted with each other. But the reaction must have been wholly positive, because by the summer of 1916, Rockwell had published two more *Post* covers and was appearing in the magazine as regularly as J. C. Leyendecker. His accomplishments were noted by his local newspaper: "Some of the cleverest magazine covers this year have been designed by Norman P. Rockwell of this city. His two-color cartoons on the cover of the *Post* have made many laugh. They seem to catch the boy idea and are making a hit."[18]

That item appeared on August 4, and by then his debut in the *Post* was hardly the only news in his life. A month earlier, he had decided on the spur of the moment to get married.

# IRENE O'CONNOR, OR UNCLE SAM WANTS YOU

## (1916 TO 1918)

On a Saturday evening in February, 1916, Rockwell attended an engagement party for his brother. Jarvis was now twenty-three and had risen from his first job as a shoe clerk to a well-paying position as a bond salesman on Wall Street. He and his parents still lived at Edgewood Hall, as did his fiancée, Miss Caroline Cushman. She was pretty and dark-haired, an aspiring actress who was just a few months younger than Jarvis. They had been dating for about a year and a half and seemed inseparable. Jarvis fell easily into the role of the romantic suitor.

Only a week after the engagement party, Norman made his fateful trip to the Philadelphia offices of *The Saturday Evening Post*. Perhaps his brother's wedding plans left him yearning for a similar respectability. There was a sense in the boardinghouse, according to one observer, that Caroline had picked the "right" Rockwell brother—a bond salesman as opposed to a raffish artist. One never knew what an artist would amount to, assuming he amounted to anything at all.

Caroline later recalled a day when she was sitting in her room at Edgewood Hall, fixing herself up at her dressing table. Norman barged in, triumphantly carrying a hat stuffed with money. He had just returned from Philadelphia and changed his $150 check into one-dollar bills. Bond salesmen, he reminded her, were not the only ones who prospered. She was distressed to realize that he was proposing marriage to her.[1]

Norman and Jarvis looked nothing alike. Norman was pale and lanky and stood just under five foot eleven, with a long face and a pole neck. Jarvis was shorter and compact, five foot seven,[2] with handsome features.

Together they had endured the frequent moves, the years in boarding-houses where they had shared cramped bedrooms and sat down to dinner in musty dining rooms, exchanging comments about their fellow boarders under their breath.

Nonetheless, Norman never felt close to Jarvis. Things came so easily for him. At the time of his wedding engagement, he was working in the bond department of William Morris Imbrie & Co., a brokerage house on Wall Street. On weekends, he enjoyed the diversions favored by privileged men, the sort he had never known in his youth. He raced his sailboat (*Rocky*) at the Orienta Yacht Club in Mamaroneck. He put on snazzy clothes to play golf, a young man in knee pants and a sweater knocking balls around a green.

He was constantly writing love letters to his fiancée. He sent her letters from his office. He dashed off mash notes while waiting for the evening train at Grand Central Terminal. When he had to leave town on business, naturally he wrote more, mailing his letters with two-cent stamps bearing the stony profile of George Washington. Judging from the mound of his surviving correspondence, Jarvis daydreamed about Caroline all the time and proclaimed his devotion as frequently as possible. He came to believe that his life was divided into two opposing halves: the long, dull years before he made her acquaintance and the contented moments since. "My dearest Sweetheart," he cooed in a typical letter. "I don't see how I ever had a good time before I met you. I am sure now that I never really had a good time."[3]

Norman's love life, by comparison, was predictably stark. Nothing that can be described as a love letter survives among his papers. It seems un-likely that he ever wrote one. He had his male friends for company, or rather, he had Clyde Forsythe, enlivening the atmosphere in his studio with his comic strips and his stream of jokes. And that was about as much intimacy as Norman seemed to need.

•

Norman, amazingly, would marry four months before Jarvis, as if marriage were simply another competition between brothers. He was twenty-two years old and not interested in a long courtship or even a short one.

Irene O'Connor was a third-grade teacher at the Weyman School in New Rochelle. He had seen her around the boardinghouse where she, too, lived, floating through the hallways in her ankle-length skirts and sitting

down for dinner at the table next to his family's. She had a large pretty face, with blue eyes and dark hair and thick eyebrows that she left untweezed. She was twenty-five then, a few years older than Rockwell.[4]

She came from a tiny town upstate, Potsdam, New York, which was not near anything, other than Canada. Her father, Henry O'Connor, who was Irish-Catholic and Canadian-born, had owned a grocery store in Watertown during her girlhood.[5] Irene was the first of his four children, and she proved to be an excellent student with a gift for writing. In 1911 she graduated from the State Normal School in Potsdam, which specialized in preparing women for careers as teachers.

Rockwell later claimed that he proposed to Irene on his way home from Philadelphia, after selling his first cover to *The Saturday Evening Post*. He got off the train in Atlantic City, the fabled seaside resort and, flush with excitement, called Irene from a pay phone. She declined his proposal, claiming to be engaged to another man. This was true. In September 1914 Irene's local newspaper ran a short item announcing her engagement to one Merton S. Moore, of Potsdam, New York, who had studied agriculture and dairy farming at the University of Wisconsin.[6] She had known him for years and he had spent some time vacationing with her family at a summer cabin in Sylvan Falls, New York.[7]

In a matter of days, however, Irene came back with a yes to Rockwell. She would marry him. He suspected she was still in love with Merton Moore, but decided to marry him because he offered her the promise of a more worldly future.

She resigned her teaching position at the end of the school year, and that same week, on June 30, she and Rockwell applied for a marriage license.[8] It was a Friday and her birthday was coming up that weekend, and their plan—if that is the word—was to marry right away. Irene wanted to be married by a Catholic priest and Rockwell was happy to oblige her. He was not devout. He saw himself as a collection of frailties and deemed all faiths equally ineffective for his personal needs.

"The marriage of Miss Irene O'Connor . . . and Norman Rockwell, the artist, will take place today, the arrangements upon last night not being completed," the local paper reported on July 1, 1916.[9]

Indeed, they were married that morning by the Rev. B. J. Eustace, in his "parochial residence" at the Church of the Blessed Sacrament, in New Rochelle. In other words, they were married in the pastor's modest house rather than in the church, perhaps because Rockwell was an Episcopalian.

With no time to be fitted for a wedding gown, Irene wore a navy-blue suit trimmed in white, and "a large white picture hat." Her sister Marie was the maid of honor and Rockwell's brother was his best man. There were only a handful of guests—Rockwell's parents; his brother's fiancée, Caroline; and Clyde and Cotta Forsythe.

After the ceremony, the newlyweds returned to Edgewood Hall for "a wedding breakfast" with their fellow boarders and friends. Then, Norman and Irene set off on their honeymoon—along with her sister and the Forsythes. First they "motored" to Jersey City, where they boarded a train for a mountain resort, Lake Minnewaska, near New Paltz, New York. Their final destination was Potsdam, where Rockwell belatedly met Irene's parents and the rest of the O'Connor clan. He was amused by Irene's two kid brothers, who liked to recount their duck-hunting adventures and whose presence ensured that he never had more than a moment alone with his new bride.

•

Returning to New Rochelle on July 15, the newlyweds moved out of Edgewood Hall and into their own apartment. There were problems from the beginning. The two-bedroom apartment, which was located on the third floor of a building at 31 Coligni Avenue, felt unbearably hot even with the windows open all the way. Irene decided to spend the summer the same way she had when she was single. She was going back to Potsdam, to stay with her parents.

Rockwell described the situation, give or take a few major facts, in his autobiography:

> One week after we were married Irene left to visit her parents in Potsdam, New York, for two months, leaving me alone in the dingy third-floor apartment we'd rented in New Rochelle. Four days later, I discovered cockroaches in the ice box.
>
> I mention the fact because it sort of typifies our marriage. It wasn't particularly unhappy, but it certainly did not have any of the warmth and love of a real marriage.[10]

Rockwell viewed his wife as a defector. He claimed she abandoned him, leaving him stranded with nothing to eat. He had always seen his mother in similarly disappointed terms, believing that Nancy was too self-centered to give any thought to the duties of care.

•

Rockwell did make an early attempt to fit himself for the role of the conscientious husband. With the arrival of fall, he decided he would work at home. He optimistically moved his easel and paints out of Frederic Remington's studio and into a spare room in his apartment. Irene resigned her teaching job at the Weyman School, with the intention of serving as her husband's secretary.

They both thought it was a promising plan. Irene could take over for his teenage factotum, Franklin Lischke, and run his studio a thousand times more efficiently. She could answer the phone and talk to art editors and set up appointments with models. Moreover, he imagined her at her desk answering his correspondence, typing up short, concise letters that were free of spelling mistakes, attesting to her distinction as a former teacher.

But the home-studio arrangement didn't last long. There were too many interruptions. The doorbell would ring and he would tense up. If it was the grocery boy, he had to lay his wet brushes on a hardwood chair and walk down the hall to let him in, thinking morosely that he would never regain his concentration. He decided he needed to return to the studio he had shared with Clyde Forsythe and Irene could continue to take care of his business correspondence at her desk at home.

Even so, Irene found that she was extraneous as she had never been in a classroom. The public stature that she garnered as Mrs. Norman Rockwell did not compensate for the empty space at the center of their marriage. His every waking moment, it seemed, was spent in his studio, with no time left for bridge parties or golf or the theater. Even on Sundays, when their neighbors went to church, he was in his studio by eight in the morning. "After we'd been married awhile I realized that she didn't love me," Rockwell later wrote.[11] He never seemed to flip the question and contemplate whether or not he loved her.

•

In 1916 Woodrow Wilson had won a second term with the slogan, "He kept us out of war." But on April 6, 1917, the United States declared war on Germany. Patriotic fervor gripped nearly everyone. The war, Ernest Hemingway wrote, was "the most colossal, murderous, mismanaged

butchery that has ever taken place on earth. Any writer who said other-wise lied. So the writers either wrote propaganda, shut up, or fought."[12] The same was true of American painters and sculptors, many of whom were enlisted to create propaganda during World War I.

Posters were needed to sell Liberty Loan bonds and War Savings Cer-tificate stamps, to assist the Red Cross with its fund-raising drive. They were needed to urge Americans to conserve coal and wheat. Posters were needed to persuade young men consumed by the fate of the Chicago White Sox or the New York Giants to think instead of the fate of their nation and to join the armed forces.

And so posters were printed by the millions and pasted up like national wallpaper. James Montgomery Flagg emerged almost overnight as Amer-ica's preeminent poster artist. As official military artist of New York State, Flagg (which was his real name, conveniently) designed some forty-six posters, including the iconic image of Uncle Sam sternly admonishing, "I Want YOU for the U.S. Army."

There he was in every shop window, it seemed, Uncle Sam, a craggily attractive patriarch with deep-set eyes and fierce eyebrows and longish white hair. He points his finger a bit accusingly. Actually, he looks more like a man throwing you out of the Army for an infraction than someone welcoming you in.

Flagg had initially created the image as a magazine cover. It came out in *Leslie's Weekly* the first week in July 1916, which is why Uncle Sam is dressed to celebrate the Fourth—he is wearing a navy-blue jacket and a white top hat ringed by a blue band with extra-large stars going all the way around. After the Army adopted the image for its recruiting cam-paign, some four million posters were printed and they were credited with making a crucial difference in enlistment numbers. Earlier, in the nine-teenth century, Uncle Sam had tended to be portrayed as a lean, whis-kered gentleman in clownish red-and-white striped trousers. Flagg's Uncle Sam, by contrast, is a virile pitchman for war. The artist was about forty years old when he painted the image. He used himself as the model for it, exaggerating his naturally rugged features and adding the goatee. He lived in New York, in a stylish duplex in the Atelier Building at 33 West Sixty-seventh Street and he was known as a fashion plate and a playboy. His recruiting poster turns an erotic come-on ("I want you") into a patri-otic come-on.

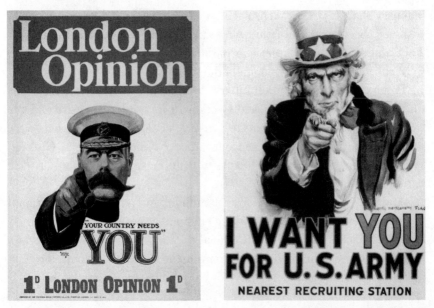

James Montgomery Flagg inserted his own face into his portrait of Uncle Sam in his Army recruiting poster of 1916 (*right*). He was influenced by the British poster of Lord Kitchener created by Alfred Leete (*left*).

The image, by the way, was borrowed at least partly from a British recruiting poster, by Alfred Leete, that shows Lord Kitchener in a similar finger-pointing pose. Kitchener was Britain's revered minister of war and the poster of him pointing was created in 1914, only two years before he met a ruinous end. He drowned at sea when his ship was sunk by German mines.

•

Rockwell's best *Post* cover from this period is a wonderful spoof on Flagg's Uncle Sam. Entitled *The Clubhouse Examination* (June 16, 1917), it shows two schoolboys staging a make-believe recruitment test in a backyard after school. A hand-lettered recruitment poster in the yard advertises, "Men Wanted for Army." Billy Payne posed for the recruitment officer; he is wearing a dashing uniform pieced together from bits of Boy Scout and military regalia. He is lording his masculinity over a less confident peer—a chubby and nervous boy who is standing on tiptoe against a barn door, only to find that he still falls short of the five-foot height requirement. His fine clothes emphasize his softness.

*The Clubhouse Examination*, 1917, riffed on James Montgomery Flagg's recruiting poster.

His pomaded hair is parted down the middle, with a silly wave at the top of his forehead. He is so small he looks as if he belongs to a different painting.

Uncle Sam wants you—but only if you measure up. Here Rockwell takes the side of the boys who fail to qualify, capturing the anxiety of being tagged and shamed as only half a man.

•

Rockwell felt a sense of patriotic duty but hardly considered himself built for the physical demands of service. In his autobiography, he mentions that he enlisted in the U.S. Navy in June of 1917, soon after the United States entered the war. In reality, he enlisted more than a year later, just moments before the war ended. His Navy service lasted less than three months.

According to government records, he first tried to enroll in the U.S. Naval Reserve Force on July 30, 1918, visiting a recruiting station at City Hall in lower Manhattan. The doctor who examined him noted that he had "sallow" skin and suffered from rashes. He stood five foot ten and a half, and weighed 131 pounds—seventeen pounds underweight for his height.

"We can waive ten pounds," a Navy surgeon told him, "but not seventeen." In his autobiography, Rockwell claimed that, on the doctor's orders, he sat in the office stuffing himself with seven pounds worth of bananas, doughnuts, and warm water, until he thought he would burst. Then he got back on the scale. It worked.

Yet, on August 5 the local newspaper related a different version of events, claiming that Rockwell, having flunked the physical exam, finagled his way into the Navy by showing some of his drawings and paintings at a naval hearing. He was hoping to join the camouflage corps. Instead he was admitted as the next best thing: "Landsman Quartermaster Painter and Varnisher." He believed he would be shipped to Ireland to paint and varnish ships.

On August 23 Rockwell was called for active duty and sent to a training camp in Charleston, South Carolina. He never got across the Atlantic. His superiors were delighted to discover that they had a *Saturday Evening Post* cover artist in their midst. He asked if he could go home to New Rochelle to fetch his art supplies and they granted the leave. "Norman

Rockwell, of the Naval Station at Charleston, S.C., is spending a ten-day furlough with his parents," it was reported in the New Rochelle paper, just a month after he was called to duty.[13]

Assigned to *Afloat and Ashore*, the Navy newspaper, he obliged with a series of cartoons. His witty riffs on Navy life tend to feature the same unnamed protagonist, a spindly sailor with a tiny head and very long bell-bottoms who finds it hard to maintain his dignity. A typical cartoon, drawn in a clean, flowing pen line, follows a sailor from five to seven in the evening as he stands on the mail line, praying for a letter that he never receives and which in fact exists only in his daydreams.

Rockwell's newspaper job took up two days a week and his superiors found other ways to keep him artfully occupied. He was asked to paint a few portraits of visiting foreign admirals. He also accommodated many ordinary sailors who wanted pictures for their sweethearts "back home," even though they were home, more or less, having never left American soil.

The rest of the time, Rockwell was free to do his own work, and the truth is his career remained uninterrupted by the Great War. He swung a deal with his superiors, getting special permission to continue painting magazine covers for the *Post*—so long as they pertained to the war. And so long as they depicted sailors and marines, as opposed to Army guys.

Out of this injunction came a Navy-themed painting, *Sailor Dreaming of Girlfriend*, which graced the January 18, 1919, cover of the *Post*. Like so many other of Rockwell's works from this period, it juxtaposes two men of different size and scale; one looms powerfully over the other. Here, two sailors dressed in their Navy uniforms sit side by side on a bench, the porthole behind them indicating they're on a ship. The figure on the left is the larger, better-traveled, and more experienced one, as his tattoos suggest. His face is severe; his hands are gigantic and laced with veins. The sailor on the right, by contrast, has tiny clawlike hands with long nails. He is bright-eyed and all hopped up over a photograph of a brunette that arrived in the mail. He is holding it tilted downward, so that the viewer can make out the hand-written inscription: "Love to my Sailorboy from"—the signature looks like "Irene." Although the cover is traditionally described as a tribute to the girl back home, there is something clouded and ambiguous about it. The smaller sailor, who is resting his arm on the other sailor's thigh, seems unknowable,

perhaps because you wonder why a young man who is supposedly think-ing about his girlfriend appears so comfortable sidling up to his hunky male friend.

Typically, recalling his Navy days, Rockwell dwelled on his friendship with an Irish cab driver from Chicago, "a burly, rough-tough sailor named O'Toole." Rockwell speaks of their adventures as if O'Toole represents a strong and knowing brother who made his life complete. "I was real proud of O'Toole," he notes. "He was the he-man who knew how to han-dle himself. I was the 'pale artist plying his sickly trade.' He took good care of me."[14]

Rockwell's Navy adventures ended abruptly on November 12, 1918, just one day after the fighting ceased. With the signing of the armistice, he was anxious to be discharged as quickly as possible. His command-ing officer was willing to accommodate him, but there was a price. In-stead of an honorable discharge, he would have to receive an "inaptitude discharge."

The commander who filled out his papers noted: "Rockwell is an artist and unaccustomed to hardship and manual labor. His patriotic impulse caused him to enlist in a rating for which he has no aptitude. Moreover, he is unsuited to naval routine and hard work."

·

On November 13, 1918, Rockwell returned home from the Navy. Getting off the train at the New Rochelle station, he walked along the broad, tree-sheltered sidewalks to his apartment on Coligni Avenue, tossed down his seabag, and pecked Irene on the cheek. Then he walked to Meadow Lane, where he and Forsythe had rented a studio earlier that year, after the lease on the Remington studio ran out. Rockwell later recalled his momentous joy at unlocking the door and finding everything just the way he had left it three months earlier. He glanced at his brushes, which were clustered by the dozens in jars. He glanced at his easel, on which he had painted the words "100 percent" in gold pigment along the top, not that he needed a reminder to work harder.

The local newspaper took note of his return, in an article that ap-peared beneath a droll headline: ROCKWELL BACK, SO WAR STOPS.[15] It claimed that Rockwell "has received his full and honorable discharge," although this was not the case.

"I am glad to get back to New Rochelle," Rockwell told a reporter, as

During his stint in the Navy, Rockwell received permission to continue painting magazine covers—so long as he portrayed sailors.

he lighted his pipe. The article was the first to note his habit of pipe smoking. "You know, I left here on Forsythe's birthday. That was the birthday present I gave him—my absence."[16]

World War I is sometimes described by historians as the first full-blown mass media event in America, the first in which newspapers and national magazines (no one had radios yet) manufactured a narrative that encouraged a certain reading of events. There was the war, and then there was the media war—a barrage of patriotic posters and magazine illustrations that played up the notion of heroic sacrifice to keep Americans from seeing the war as a senseless waste of money and of lives. In this regard, World War I instructed Rockwell in the power of art as a means of persuasion. The war had been fought at home not with weapons but with images.

After the war, many illustrators continued to lend their services to government projects, especially the Victory Loan drive. Rockwell would have read, in the local paper, about the seven New Rochelle artists, including Clyde Forsythe and the Leyendecker brothers, who signed on with the Division of Pictorial Publicity.[17] It was responsible for Forsythe's popular poster, "And They Thought We Couldn't Fight," which shows an American soldier tromping home with a rah-rah expression despite the head bandage beneath his helmet; it was intended to silence those Germans who had accused Americans of being weaklings.

Peacetime, as much as wartime, needed its own images and optics. And, in coming years, no one would visualize the aspirations of American life more effectively than Rockwell. Later on, Rockwell felt he had acted immaturely during World War I and should have tried to contribute posters. He would more than make up for it during World War II.

# BILLY PAYNE

## (MAY 1919 TO SUMMER 1920)

Journalists who interviewed Rockwell invariably took note of his pen-
chant for physical cleanliness. A reporter who visited his studio in May
1919 found him dressed in "a well-daubed white sailor's suit." During the
interview, Rockwell puffed on his pipe and stood at the sink washing up
"a few thousand odd brushes."[1]

Rockwell, the article noted, was not a Greenwich Village type with
long hair and a flowing smock, but an antibohemian. At age twenty-five,
he seemed indifferent to the European ideal of the artist as a demiurgic
creative force, preferring to ally himself with practical and industrious
American types. Asked how one becomes an artist, Rockwell replied,
"I agree with Thomas Edison when he says that genius is one percent
inspiration and ninety-nine percent perspiration."

His studio, too, which then occupied two rooms at 78 North Avenue,
was a distinctly American place. Anyone, technically, could pose for a
painting. To qualify as a Rockwell model, you didn't have to be classically
beautiful, a Venus or a ballerina. You need not have founded a railroad
company or be in possession of a vast fortune. Of course, having freckles
was a definite plus.

When people thought of the typical artist's studio, they were likely
to think of a carnal space, a setting where women displayed themselves in
various stages of undress. Rockwell, by contrast, purged the studio of its
sexual overtones. Instead of a pear-shaped woman reclining on a divan,
he passed his days in the company of schoolboys like Billy Payne. No one
posed in the buff in Rockwell's studio, no one swilled whiskey and chomped

a cigar. An afternoon modeling session was less likely to end with a round of drinks than with Billy Payne remembering to do his math homework.

True, there were grown-up models as well, like Dave Campion, a lean, wisecracking man who owned a newsstand on Centre Avenue that Rockwell passed every day on his way to work. It was where he could go to see his own *Post* covers. It was his museum.

When interviewing kids for the job of model, Rockwell always asked one question: Can you raise your eyebrows? The test, he believed, was simple but infallible. Those who could raise their eyebrows halfway up their foreheads could do most anything. Their faces were sufficiently mobile to assume most any expression.

In the spring of 1919, when Rockwell tapped fifteen-year-old Eddie Carson for a Boy Scouts recruiting poster of which more than a million would be printed, he praised the boy's skill as an actor. Eddie was Billy Payne's best friend and the son of a jeweler. Billy could not help but feel a little jealous when the *Evening Standard* did a whole story on Eddie, describing him as "an intelligent model who falls naturally into the pose as soon as the idea is given to him. He does not have to be shifted and told to hold his hand 'so,' to raise his right eyebrow and lower his left ear."[2] Although Eddie posed in full Scout regalia, he was not in fact a Boy Scout, which no one found objectionable.

•

Why did Rockwell paint so many images of boys? people wondered. At least one (female) reader posed the question directly to the artist, in writing. His wife, Irene, kindly answered:

Dear Miss Evrett,
    That was a very nice little letter Mr. Rockwell received from you and he thanks you . . . No, he doesn't dislike girls. In fact he very much likes them but he likes to paint boys better. They are easier for him to paint. He is doing a picture now for the Saturday Evening Post and the girl has the prominent part in it.[3]

When you look at Rockwell's pictures of boys, you're aware of the pleasure he took in drawing them. He was extraordinarily observant and he had a precise feel for clothing, skin, and the surfaces of things. He found evident satisfaction in rendering corpulent boys and rail-thin boys, in

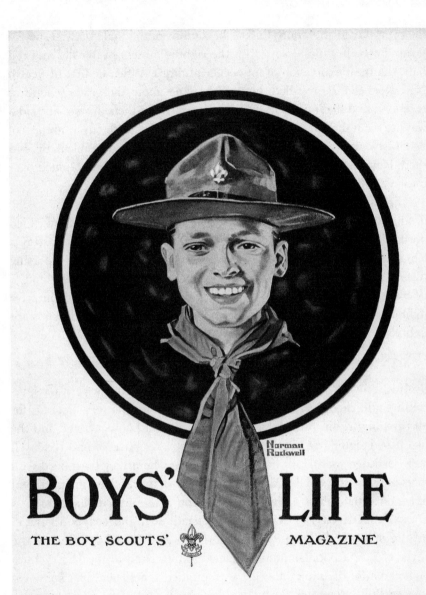

Billy Payne's best friend, Eddie Carson, posed for a Boy Scouts recruiting poster, which also ran as the cover of the July 1919 issue of *Boys' Life*. (Courtesy of the National Scouting Museum, Irving, Texas)

the everyday formulations and deformations of the male body. True, he favored certain types—boys with the right allotment of freckles and red hair, the right expression of innocence and grit. When he first moved to New Rochelle, he recalled, he would "hang about the grade schools at recess . . . and stop little boys on the street, turning them around and sideways to see if they were the type I wanted."[4] Today, with our awareness of pederasty scandals, this kind of behavior might sound problematic, but there is nothing to suggest that Rockwell's love of boys ever spilled over into inappropriate touching.

Girls, by contrast, he hardly seemed to notice. In 1919, for instance, he produced an impressive output of eleven covers for the *Post*, eight of which portray boys or old men alone or together. None of the covers portray a female figure by herself, but in three covers girls are given supporting roles. The girls are less vivid than their male counterparts. They tend to be bland, boneless figures, as vague as clouds, with none of the descriptive richness you find in Rockwell's renditions of boys. They take the substantiality out of what Rockwell does best.

•

By 1919 Billy Payne had posed for several dozen of Rockwell's works, including fifteen covers for the *Post*. He had posed for the very first one, for all three figures in it, the shamed boy pushing a baby carriage and the two boys laughing at him. It had been five years since he and Rockwell met—at Edgewood Hall, the boardinghouse where they both lived with their parents. Rockwell had since married and moved into an apartment of his own, but Billy still lived at Edgewood Hall and remained NORMAN ROCKWELL'S FAVORITE BOY MODEL, as a headline in the local paper put it, in July of 1918.[5] Billy had just appeared in a Rockwell painting on the cover of *Life*, a popular humor magazine unrelated to the Henry Luce publication of the same title that was founded years later. The *Life* cover showed Billy dressed up for his middle school graduation, in a blue serge suit with a stiff collar and a red tie.

Billy was about to enter New Rochelle High School, and his relationship with Rockwell had changed over the years. When they first met, Billy had been ten years old, a redheaded lad of Scottish descent, rowdy and seemingly fearless. But now Billy was fifteen and, in Rockwell's eyes, he had outgrown his role. It wasn't something Rockwell cared to admit, that he tired of even his favorite models after a while, needed new ones to excite his gaze.

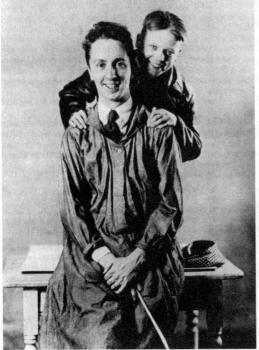

Rockwell poses with his model
Billy Payne, circa 1917.

During his freshman year of high school, Billy still frequented Rockwell's studio, where he might see a friend on the modeling stand. He made his peace when Eddie Carson posed for the Boy Scouts poster in the spring. But what he could not abide was the apotheosis of chubby Buddy Ogden, who appeared on a *Post* cover on September 6, 1919. It portrays a moment of summer languor: a farm boy sits outdoors snoozing, in the middle of the day. With his hippo's neck and sweating cheeks, his mouth hanging open, the farm boy might not seem likely to incite envy. But Billy was "terribly jealous," as Rockwell recalled, materializing at his studio on North Avenue demanding to know why he would use "a lunk" like Buddy Ogden as a model. Why wasn't Rockwell using him instead? "Don't need you," Rockwell curtly told him, hoping Billy would leave him alone.[6] But Billy was furious and inconsolable. He stalked Buddy Ogden, who was four years younger than he, and beat him up.

Billy's parents, distressed to see their only son picking fights and turning into a discipline problem, decided to send him to boarding school. He was pulled out of New Rochelle High School that September, just a few weeks into his sophomore year. On October 6, Billy started classes, a bit

late, at a private school in rural Maryland: the Tome School for Boys, which was isolated on a high bluff overlooking the Susquehanna River and the town of Port Deposit.

When Billy's father filled out the Tome School application, he was asked to provide references. He listed five. Rockwell, curiously, was not among them.[7] Perhaps Mr. Payne, an insurance agent, thought that artists were social liabilities whose names could only jeopardize an application. Or perhaps he was cross with Rockwell; Billy's experiences as a "favorite boy model" had no doubt hampered his academic progress. Billy had missed countless days of school posing for Rockwell, who was too absorbed by his work to give any thought to the problem of Billy's attendance. In his freshman year at New Rochelle High, his grades were mixed, at best: a B+ in science, but a C– in English, an F in Spanish, and an incomplete in plane geometry.[8]

Mr. Payne was possibly not the most sensitive father. The application for the Tome School asked parents which of the four churches in town they wanted their sons to attend—Episcopal, Methodist, Presbyterian, or Catholic. He scrawled in response: "Not Catholic."

Billy had been at the Tome School for two months when he returned home, to Edgewood Hall, for winter break. It is not known how he fared at the new school, only that he left for vacation on December 10 and planned to return in January. On New Year's Eve—an icy Wednesday night—he stayed in. But then, at some point, he decided to climb out of the window of his third-floor room, onto a little ledge, reportedly to play a prank on a little girl by sneaking into the window of her room and hiding her box of candy.[9] In the midst of the high jinks, he slipped and fell to a concrete porch on the ground floor.

"No one saw him fall,"[10] the paper reported, but two maids in the house heard his body strike the porch. They went outside to look and saw him lying there in a pool of blood. He had cracked the base of his skull but was still alive. Sadie Miller, who ran the boardinghouse, rushed him in her car to New Rochelle Hospital.

An operation was performed and Billy remained hospitalized for nearly a month. At the end of January, he was sent home and seemed to be improving, but he was having frequent headaches. Doctors were summoned from New York; they advised against a second operation. Early in the morning of February 26, he died from acute meningitis, in his bed at Edgewood Hall.[11] The funeral was held on Sunday, at Trinity Church in New Rochelle, and Billy's friends served as the pallbearers.[12]

•

Eddie Carson was Billy's best friend and, as Rockwell recalled, "he was grief-stricken. I never saw a kid take on so; he mooned about for weeks, wouldn't pose or eat much, just sat in his room." Rockwell himself was more measured. "I was sort of struck by Billy's death, too," he noted in his autobiography. "He was a swell kid, a regular rapscallion. I missed him a whole lot."[13]

It was a cool response, a nonresponse. He does not mention when he last saw Billy or whether he attended his funeral. He does not say whether he paid a sympathy call to the grieving parents, William and Mabel Payne, whose only other child was a grown daughter from Mr. Payne's first marriage. Moreover, Rockwell makes many careless errors in the section on Billy in his autobiography. He misspells Billy's last name as "Paine." He says he he died "a few days" after the accident, when in fact it was eight weeks later. He claims Billy was then thirteen years old, when in fact he was almost sixteen.

The history of art abounds with tales of cast-off models who met tragic ends, such as Camille Claudel or Dora Maar, who posed for Rodin and Picasso, respectively. The experience of an artist's model can amount to its own intense drama: the thrill of capturing an artist's gaze, the pain of losing it.

Rockwell, by his own admission, abruptly rejected Billy after cultivating his affection for five years. He made Billy a cover boy and then he made him invisible. Perhaps he felt a sense of self-reproach for refusing the boy the friendship he needed, for ignoring him when he could no longer turn him into art. It is possible that Billy's fall from the rooftop was not an accident, but a suicide. As the papers reported, no one saw him fall.

•

Although Rockwell was sorely unable to articulate his feelings over Billy's death, he did paint a moving portrait of him that spring. It ran as a *Post* cover and amounts to a tender elegy. He presumably used his many long-existing sketches of Billy to create it. *Boy with Dog in Picnic Basket* shows Billy sitting in a high-backed seat on a train, his ticket stub tucked behind the red ribbon on his hat. Dressed nicely in a black jacket and knickers, he is traveling with his black-and-white dog and presumably plans to be away for a long while. A large, buckled suitcase is stowed beneath his

black-stockinged legs. A package resting on his right is wrapped in white paper and tied in string—a spare and lovely object, its contents unknowable. It reminds us that Rockwell's art, however accessible, keeps his deepest inspirations hidden from view.

As he sits in his train seat, Billy is a looming presence. His hat extends above the double line of the *Post* logotype and his shoes are cut off at the bottom, as if he is too big to be contained by the edges of a magazine cover. Naturally, the picture comes with a story. Billy has sneaked his dog onto the train in a lidded picnic basket, and now the dog is climbing out and whining, threatening to expose them both. Billy is shushing him as if worried that someone will hear. An honest boy is committing a small crime and you feel he is basically justified in doing it, that maybe the rules about pets are too strict. The dog is a charismatic creature. With its wide brown eyes and dangling pink tongue, its two front paws pushing out of the basket, it is an irrepressible force. It has already broken the twine tied around the basket—a loose strand falls between Billy's legs.

A manila shipping tag is tied to the basket. It's the kind with a reinforced hole, a bright red ring that echoes the color and shape of Billy's shushing lips. Although the shipping tag is curled, you can make out part of the address, which is written in black script: "Billy Pay . . . 39 Edgew . . . New R."

Where is he going? Perhaps he is journeying to the kingdom of heaven, and sneaking along his dog for company. The painting graced the cover of the *Post* on May 15, 1920, just two days after what would have been Billy's sixteenth birthday.

•

When you think back to the early years of *The Saturday Evening Post*, two figures spring to mind: Rockwell and F. Scott Fitzgerald. In 1920, by which time Rockwell had been at the *Post* for four years, Fitzgerald, a twenty-three-year-old Princeton graduate, published his first novel, *This Side of Paradise*, and began contributing short stories to the *Post*. George Horace Lorimer believed his stories could bring the magazine a new generation of readers, whose spending habits were giving rise to an advertising market whose dollars he also hoped to attract. Fitzgerald's famous story the "Bernice Bobs Her Hair" ran in the issue of May 1, 1920, and caused an uproar. Parents who read it took offense, while their daughters thrilled to its implicit endorsement of women who wear lipstick and stay

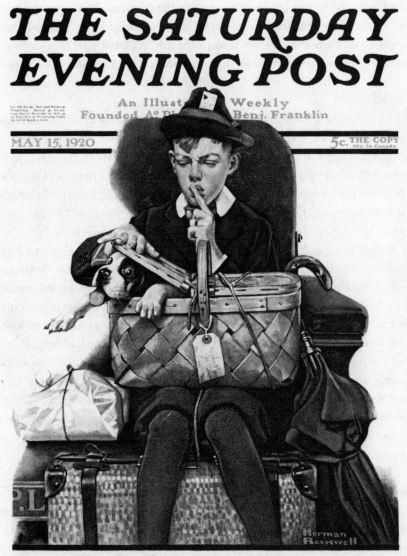

**THE SATURDAY EVENING POST**

An Illust[rated] Weekly
Founded A° D[...] Benj. Franklin

Vol. 192. No. 46. Published Weekly at
Philadelphia. Entered as Second-
Class Matter, November 18, 1879, at
the Post Office at Philadelphia, Under
the Act of March 3, 1879.

MAY 15, 1920

5c. THE COPY
10c. in Canada

Herman
Rockwell

Beginning: **The Man From Ashaluna**—By Henry Payson Dowst

*Boy with Dog in Picnic Basket* ran on the May 15, 1920, cover of *The Saturday Evening Post* and amounts to a tender elegy for a boy who fell to his death.

out late. The cover, that week, happened to be Rockwell's *Ouija Board*, which referred to one of the first crazes of the twenties. In it, a young man and woman face one another over a fashionable Ouija board, resting their hands on that wooden pointer thing (officially, a planchette) that can supposedly summon spirits and answer questions. It is gravitating to the part of the board that conveys an unambiguous, permission-granting, postwar YES.

That summer, Scott and Zelda Fitzgerald were living in a rustic cottage in Westport, Connecticut, newlyweds who claimed to be seeking quietude. One night Rockwell and Irene were at a dinner in New Rochelle when they piled into someone's car and were driven to a party in Westport where the guests were dressed in pink jackets and riding habits. "I thought it was all very grand," Rockwell recalled years later, "because I met F. Scott Fitzgerald, the famous writer, and heard him sing a rowdy song."[14]

It was their only encounter. Rockwell remained impervious to Fitzgerald's allure and perhaps disapproved of the writer's beyond-your-means hedonism. Rockwell always believed it was dangerous to court unwarranted pleasures. He had to hold himself in readiness for the art of painting, his raison d'être. Besides, he continued to prefer the company of kids. That summer, he was inseparable from Eddie Carson, who had been Billy's best friend and had none of his academic problems. Eddie would be leaving for Harvard in the fall, at the age of sixteen. He posed, that July, for a painting that appeared on the cover of the Christmas issue of *American Boy* magazine. He is shown delivering a pile of wrapped Christmas presents when his mutt plays a little trick on him, yanking on its leash and entangling the boy's legs.

An article in the same issue focused on Eddie's experiences as a model for Rockwell. Rockwell drove Eddie to the interview in his new car, a black Franklin touring affair. The conversation began playfully enough, but then Rockwell started talking about his models. "Bad as they are, I like 'em," he said.[15] "Billy Payne was the worst of all. Full of mischief every minute. A few months ago he started to play one of his good-natured tricks on another boy. He climbed out of one window at his home and started to climb into another. He fell three stories. When they picked him up, they found his skull was fractured." The original newspaper story had reported that Billy was playing a trick on a girl, not a boy, but Rockwell stuck with the boy version in his future accounts.

The conversation shifted to other subjects and Rockwell made it sound

as if his days in the studio passed in nonstop merriment. The banter between him and Eddie was brotherly and relentless. The reporter asked if Eddie has any bad habits. "He has just one that I know of," Rockwell replied in a deadpan. "When he goes camping, he shoots mud turtles."

When the interview ended, Rockwell and Eddie headed off together, and the reporter was struck by their closeness. As he noted: "They were clambering into the car like two kids—talking, laughing, taking a swat at each other as the occasion offered." It was, in its way, an astonishing scene. Rockwell seemed more like a camp counselor than a famous artist.

In the next few years, he continued to be known as the Boy Illustrator. When *The Boston Globe* interviewed him, in 1923, the headline proclaimed DRAWS BOYS AND NOT GIRLS.[16] The article reported: "His favorite subject is boys, good, wholesome boys not of the Smart Alec type." The integrity of the boys was never in question. But his own character was not nearly so straightforward.

# MISS AMERICA

## (1922 TO 1923)

There are very few photographs in which Rockwell and his wife Irene appear together. The most legible was taken in April 1920, by a society photographer at the first-ever Artists' Ball in New Rochelle. Rockwell, who loved costume parties, is togged out for the occasion as a Spanish matador. He smiles wanly from beneath a goofy hat with pom-poms dangling from the brim.[1] Irene stands beside him, a large-boned brunette with a huge, lipsticky smile. She is dressed in a festive if generic costume that does not make it clear who she is supposed to be.

Rockwell was not eager to fill in the outlines. What we know of Irene comes mostly from his autobiography, where, fairly or not, she is characterized or rather caricatured as a conventional woman who liked to lunch at the Bonnie Briar Country Club. He drove her there even on Sundays, then turned around and went back to his studio. Items in the society column of newspapers attest to Irene's love of bridge parties. At various times she was a member of the all-women's Monday Afternoon Bridge Club, the Thursday Afternoon Bridge Club and the Friday Afternoon Bridge Club. Every so often, she entertained "the girls" at her home. She and Rockwell were then living in a two-family, redbrick house at 218 Centre Avenue, not far from the train station.[2]

Irene seldom posed for Rockwell, but she did make a memorable appearance on the cover of the January 29, 1921 issue of *The Literary Digest*. It shows a dark-haired woman looking in on her young son and daughter, who are asleep in the same bed. Irene modeled for the mom—a peculiar role for a woman who never bore children. Portrayed in profile, she leans

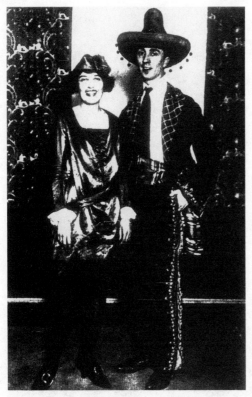

Rockwell dressed up as a Spanish
matador for a costume party in
April 1920, with his wife, Irene.
(Photograph by Paul Thompson)

over the daughter's side of the bed, gently pulling up the edge of the quilt.
The boy, slumbering on the far side of the bed, near a window, lies outside
the cone of the woman's gaze. The girl is bathed in adoration, but who
will save the boy?

•

After the death of Billy Payne, Rockwell continued painting scenes of
boys and their loyal mutts, and he continued to form friendships with his
young models. Initially, nothing seemed to change. His new favorite boy
model was Franklin Lischke, a "narrow-shouldered, stringy" boy of
twelve and a neighbor of his in New Rochelle. Early in 1921, Rockwell
moved his studio into a barn directly behind the Lischke house, at 40
Prospect Street. He rented the second floor from the boy's father, George
Lischke, an accountant whose family was part of New Rochelle's large
German-American contingent. As was his habit, Rockwell renovated his
new studio, installing heat, electricity, and a large picture window that

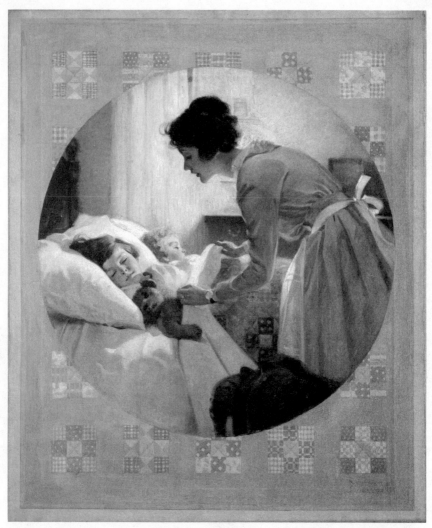

Irene Rockwell seldom modeled for Rockwell and made one of her few appearances on the cover of a 1921 issue of *The Literary Digest*.

faced north and provided the light most artists favor, a light that is even, is not too bright, and casts the least number of shadows.

Every morning, before the local businessmen were astir, Rockwell left home and walked the four blocks to his studio, "rushing up Centre Avenue as though it were about noon and he had already wasted the whole morning," as a reporter noted.[3] By now he was a local legend. Schoolboys and their parents recognized him. "Every dog in New Rochelle knew him," remarked Clyde Forsythe, with only partial exaggeration.

After he had modeled for a few Rockwell paintings, Franklin Lischke was promoted to the position of "studio boy" and paid the princely sum of five dollars a week. He came by every day after school to help out. One of his responsibilities was answering the phone (telephone number 375) and shielding Rockwell from unwanted callers, who included, much to the boy's amusement, important editors in Philadelphia and New York. When an editor called to inquire into a painting that was due or slightly overdue, Franklin was instructed to say that Rockwell was out. To his relief, Franklin was not charged with cleaning the studio. Rockwell preferred cleaning it himself. He swept the floor several times a day and washed his brushes in an oversized sink with turpentine and Ivory soap. He swore by Ivory soap. "I'm very tidy," he once said. "I like picking things up off the floor. It's a rest from working. You get to do something else."[4]

The main part of Franklin's job was locating props. You never knew what crazy object Rockwell might need for a painting. It might be a Victorian couch or a rolltop desk that had to be carried up the creaky flight of stairs to his studio. It might be a cello or a rag doll, and not just any cello or doll, but the right one, the one that looked like it belonged to someone instead of looking like it had been purchased at a store and unpacked from a box three seconds earlier. It was what Rockwell had learned at school: to work from life, to seek "authenticity" above all else.

Once, Rockwell sent Franklin to the store to buy some fresh trout for a painting of a fisherman. Franklin obliged, but instead of thanking him, Rockwell, who had a sensitive nose, complained that the fish was smelling up the studio. He asked Franklin to take the fish home and bring it back the next day. "Put these in your mother's refrigerator," he said. Franklin once again complied, only to hear his mother shriek when she opened the fridge that night.

When Rockwell finally finished the painting, he instructed Franklin to bury the fish. "I did," he later recalled, "but I did not dig deep enough."[5]

Sometimes Rockwell's model was a mutt. When he sketched a picture of a dog, he used a real dog as a model. It would have been easier to draw dogs from memory, but Rockwell chose not to work that way. He liked having objects in front of him, stuff to look at; he liked observing the world's rich physical evidence. Dogs could be made to hold a pose, or at least hold still, if plied with the right reward. Rockwell kept a sack of bones in the studio, although old dogs, he quickly learned, could not be so easily bribed. They'd snatch a bone and retreat under the sink, snarling when he came near.

Few of the readers of the *Post* could have realized how much effort and labor went into a Rockwell cover. Every cover was its own production, with all the theatrical activity that implies. He conceived his own stories, scouted out models, and tracked down props. He wanted his models to be dressed a specific way and he had a substantial costume collection that he stored in his studio.

If he could not buy the right props or costumes, he rented them. He and Franklin would sometimes drive into New York City, to a shop called Charles Chrisdie & Company, which was located behind the old Metropolitan Opera House. Rockwell was amused by the couple who ran the shop. In a matter of seconds, they could locate the perfect pirate's cape or pilgrim's knickerbockers in a room crammed with thousands of costumes hanging from racks in no discernible order.

One of Rockwell's most famous paintings has less to do with putting on a costume than taking it off. Franklin Lischke became a symbol of American boyhood when he modeled for *No Swimming*, which ran on the cover of the *Post* on June 4, 1921. Set on a warm afternoon, it shows three boys who are perhaps twelve or thirteen on the run, fleeing an unseen pursuer. A hand-painted sign in the background clues you in on their infraction. Franklin is the central figure in the painting, the long-limbed boy who appears to be naked and is clutching his bundled-up clothes as he runs. He frantically turns his head and looks over his left shoulder to see if anyone is following them. His eyebrows are raised all the way up, and his lips are pursed in an *O* shape, as if he is thinking, "Oh no."

What did the boys do wrong? You assume they're trying to dodge an authority—a policeman, perhaps, and certainly an adult—who spotted them skinny-dipping in a private lake. Various scenarios are imaginable. Perhaps the boys are playing hooky from school. Or perhaps they violated Prohibition and bought a bottle of something alcoholic.

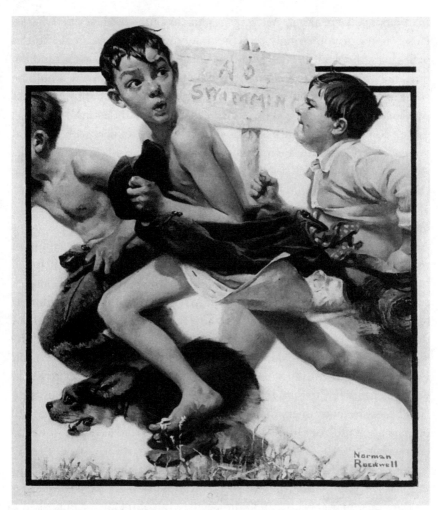

*No Swimming*, 1921: One of Rockwell's most famous paintings has less to do with putting on a costume than taking it off.

Technically speaking, *No Swimming* has its bumps. The critic Charles Rosen notes disapprovingly that the anatomy of the three male figures defies logic. Look at the left leg of the central figure: It extends behind the boy and stretches on for so long that if he brought it forward it would be twice as tall as his right leg.[6] Moreover, the thigh of the chubby boy looks swollen and undefined, as if he had contracted elephantiasis. Nonetheless, there's so much going on in the boys' faces—they're alert with fear and vulnerability—that their expressions alone carry the piece and give it its striking immediacy. It's a painting that wins you over by capturing the thrill of getting away with it.

·

As his fame at the *Post* increased, Rockwell received a steady influx of requests from advertising executives eager to commission him to help sell products. The work paid well and money struck him as a good enough reason to do something. With only minimal guilt, he undertook paintings to promote Orange Crush soda and Fisk tires and Interwoven socks. At this point he was getting three hundred dollars for a *Post* cover—an advertisement, by comparison, paid more, as much as one thousand dollars, and required less time. Many of the ads appeared first in the *Post*, where Rockwell was himself a trusted brand name, the illustrator who did boys. He could reassure consumers that Jell-O ("It's So Simple" the type boasted) or Carnation milk or Grape-Nuts cereal would not lead to bodily or moral dissolution.

Unlike J. C. Leyendecker, who was happy to be known nationally as the Arrow Collar Man, Rockwell didn't want to be associated with a particular consumer good. In 1923 the writer Malcolm Cowley published a witty collage, "Portrait of Leyendecker," which consisted entirely of cut-up advertisements from a single thick issue of *The Saturday Evening Post*.[7] A portrait of Rockwell, by contrast, even a humorous one, could not reasonably consist of a medley of ads. Magazine covers were his priority and his great love. Ads and calendars would always be the part of his career that he liked least.

Unlike his magazine covers, for which he usually generated his own story ideas and presided over their progress from roughs to charcoal layouts to framed paintings, ad agencies furnished him with ready-made ideas and expected him to illustrate them to specification. For this reason, he believed his *Post* covers had creative integrity and the potential for

some kind of greatness, while dismissing his ads as hackwork undertaken strictly for the money.

This is an important distinction, because the phrase "commercial art" can refer to an undifferentiated mass of magazine illustrations, brochures, greeting cards, advertisements—stuff printed on paper. But Rockwell put magazine covers on a higher creative plane and staked his career on them. The irony is that his *Saturday Evening Post* covers, which earned him his fame as an illustrator, are not in the technical sense illustrations: they do not illustrate a writer's story. He had learned at art school that images were always subordinate to an author's text, but when he did a *Post* cover, *there was no text*. Rather there was a stand-alone image of which he was the sole author, although at times he did take suggestions for story ideas from editors.

In the fall of 1921 Rockwell made his first trip to a foreign country at the invitation of an advertising client, Edison Mazda Lamp Works, which was part of General Electric. He had recently done some work for their advertising campaign—paintings whose subjects were generously lit by electric bulbs. Typical, perhaps, was *And Every Lad May Be Aladdin*, which shows a boy reading in bed at night beneath his patchwork quilt, his dog curled at his feet, light pouring out from beneath the crooked shade of his lamp, a twentieth-century magic lantern that makes every boy as lucky as Aladdin.

Tom McManis, the art director at Edison Mazda, invited Rockwell to accompany him on an extended expense-paid jaunt to South America, ostensibly to inspect Edison Mazda plants.[8] "Mac" as he was nicknamed, was the type of man Rockwell admired: a toughie like his brother, Jarvis, "a brawny, barrel-chested fellow with a face like an old-line Irish police sergeant," as he later wrote.

Rockwell and Mac sailed south on November 5 on the USS *Philadelphia*, changing boats at Curaçao, in the Dutch West Indies.[9] Their destination was Venezuela, where most of their time would be spent up in the jagged mountains around Caracas. There, they attended a bullfight, peered across barricades at revolutionaries, and were trailed by secret-police men. Rockwell claimed in his autobiography that he had enough after nine days. "I'm going home" he told Mac, leaving his friend behind. But immigration records indicate that the two men sailed back together, from San Juan in Puerto Rico, on November 23, two and a half weeks after they left home.[10] A small lie. Perhaps he was embarrassed by the amount

of time he spent away from Irene. Or perhaps with that first trip out of the country he realized he wanted to travel much more.

•

His growing renown as an illustrator also brought invitations to speak to groups and judge contests. On September 6, 1922, he headed to Atlantic City for the three-day Miss America beauty contest, which had been founded only a year earlier by a group of businessman hoping to extend the summer-tourism season into September. The board of judges was comprised of eight purported experts on female beauty, all of them male, including the illustrators C. Coles Phillips and Howard Chandler Christy and the theater producer Lee Shubert. That Rockwell should be tapped as a connoisseur of the female form might seem unlikely, and he did not give any interviews that weekend, gladly deferring to Phillips, his much-older friend and neighbor in New Rochelle. Phillips, the creator of the Fade-Away Girl, held forth in Atlantic City about female beauty and the search for a new, post–World War I ideal.

An implicit goal of the contest was to select a woman who defined "American-style beauty," as if physical appearance, as much as a plate of food or a statue of a leader, could be uniquely American. This helps explain how the judges, after watching a bathing suit parade along the boardwalk led by the sea god Neptune, wound up tapping as the new Miss America sixteen-year-old Mary Katherine Campbell of Columbus, Ohio, "a real outdoor girl" who "swims, shoots and rides."[11] In other words, she could not be mistaken for one of those jittering flappers who were modernizing womanhood. With their cutoff hair and androgynous bodies, flappers represented an assault on the model of elegant, cello-shaped womanhood defined a generation earlier by Charles Dana Gibson, and the Miss America pageant wanted nothing to do with them.

Later, looking back on his first pageant, Rockwell described a pathetic incident. One afternoon he went for a dip in the ocean with his fellow jurors. They were splashing around in the surf when a few of the beauty contestants sauntered by. The women, svelte and leggy, teased: "You're judging us? Look at yourselves. Old crows and bean poles." They laughed playfully. A harmless enough scene, but Rockwell felt mortified.

He had always been acutely self-conscious about his underdeveloped biceps and pigeon toes. He also had a pot belly that he wished he could

flatten. Later that day, he visited a "corsetorium" in Atlantic City and tried on a few small corsets, as the female shoppers in the store giggled.

"After I had tried on four or five corsets," he recalled, "I found one I liked. It was pink and laced up the middle but it wasn't bulky and I decided that no one would be able to tell that I was wearing it." Rockwell, naturally, tries to milk his purchase for laughs, and his story ends on a vaudeville-like note. A few weeks later, he threw away the corset after a friend was alarmed to spot "two tiny pink silk laces with metal tips" hanging out of his shirt.[12]

The anecdote certainly invites interpretation and overinterpretation. If nothing else, it marks Rockwell's official entry into the world of cross-dressing. And it brands him as an unreliable Miss America judge who felt threatened by the beauty contestants and spent the pageant fussing over his own physique.

•

In his youth, he had wanted to be a celebrated illustrator but, once he became one, he hardly felt like a hero. The rise of advertising had altered his field almost beyond recognition. On some days, he was not sure if illustration was (a) an art form, (b) an art that was tethered to commerce, or (c) pure commerce minus the art.

He had enough doubts about illustration in those days to wonder if he should try harder at fine art. Or at least go to Paris. He had never been to Europe, and he was eager to see the Louvre and wander through rooms lined with Old Master paintings. Everyone else, it seemed, was doing just that, going to Paris, not least because of the favorable exchange rate after the war. The dollar was stronger than it had ever been. American prosperity in the twenties served the interests of American bohemia and enabled a whole generation of kids to flee what they regarded as the barrenness of American prosperity.

He broached the subject with Irene one morning over breakfast. She gave him a funny look. She reminded him that he owed some ads to his friend Tom McManis at Edison Mazda. She liked her life in New Rochelle and the fall bridge season was just about to begin.

Besides, her father had recently died and, as the oldest of her parents' four children, she felt she should stick around and help her widowed mother.[13] In August, her parents had been on vacation upstate when her

father fell ill with "liver trouble." He died in the hospital two weeks later, at age sixty-five.

No matter. Rockwell decided that he would sail to Paris by himself and stay for the winter. He left at the end of October, at which point his mother-in-law closed up her house and moved to New Rochelle, where, as the papers announced, she "will spend the winter with her daughter, Mrs. Norman Rockwell."[14]

On his first night in Paris, he walked for hours, getting his first glimpse of Sacré-Cœur and the Opéra and the Louvre, which struck him as "immense and silent." Rockwell had been in Paris less than twenty-four hours when he bumped into a friend from the Art Students League, Edmund Greek Davenport, who, along with his wife, Sarah, had come to Europe to study and travel for a year. They invited him to accompany them to Italy and tour churches and tombs, so he took a detour. His goal was to practice sketching the figure, to draw from life, which he could do anywhere.

Back in Paris, he enrolled in one of the "free academies" that charged a small fee for the chance to sketch from a model. The Académie Colarossi offered little more than a space to work in—it is here that Rockwell enrolled. On his first day of school, he was shocked to look over at other students' drawings and realize he could not discern any heads in them. The student on his left had painted a picture contrived from a jumble of mud-colored cubes. The student on his right had produced a Fauvish landscape dominated by a cadmium red tree trunk. But of course he had enrolled precisely for this, for the chance to be shocked by the tilting planes of abstract art.

By the end of the day, Rockwell had thrown away his drawing and decided he needed to learn more about modern art. All in all, he stayed in Paris for six months, and he did not record much information about the trip, never even indicating where he lived during this period or how he continued to furnish the *Post* with occasional covers. It is one of the least documented phases in his life and is memorable mainly as a time when Rockwell confronted the illustration versus abstract art question. He had made his first trip to Europe and taken in the latest developments. The future of art was here and it did not look like the Boy Scouts manual.

On April 21, 1923, Rockwell sailed out of Cherbourg, France, aboard the RMS *Aquitania*, a grand Cunard ocean liner.[15] It took six days to cross the water. The trip served as the queasy inspiration for his *Man in Steamer Chair (The Cruise)*, a *Post* cover that would appear in the fall. It shows an

elderly man sitting in a deck chair, holding his stomach and looking uncomfortable, a red-plaid blanket spread over him.

His studio was still in the barn on Prospect Street and he was welcomed home by his assistant Franklin Lischke. He later recalled that the first painting he completed post-Paris was an abstract composition. He was eager to go to Philadelphia to show the canvas to George Lorimer. He thought it could make for an interesting *Post* cover.

Lorimer, however, was nonplussed when he saw the painting. He did not care for abstract art, which he viewed as a European import and thereby deficient. "I don't know much about this modern art," he lectured, "but I know it's not your kind of art. Your kind is what you've been doing all along. Stick with that."

Rockwell later described it as one of the most shamed moments of his life. It wasn't just that he had let down the boss. He had tried something different and daring—made an effort at Art with a capital *A*—and it had failed. It was as if Lorimer's comment confirmed Rockwell's fears: he was not a real artist with a vision, just an illustrator of boys and dogs. He had gone to Paris for the first time and tried his hand at fine art, but his efforts had been laughed off.

•

In September 1923 he was invited back to Atlantic City to judge the Miss America contest for the second time. Once again, the contestants paraded along the boardwalk behind the sea god Neptune, and once again the winner was announced on a Saturday night in the Million Dollar Pier Ballroom. The judges decided to recrown the previous year's winner, Miss Columbus, who was not a flapper with bobbed hair, but "had an abundance of long tresses."

The next morning, as a perk, Rockwell and the other judges were offered free rides in a brand-new seaplane that took off from the pier and generated much excitement. Rockwell went up with his friend Dean Cornwell, the president of the Society of Illustrators, and it was his first time on a plane—the kind of plane that was so bumpy it required that he don a helmet and sign a preflight release form. After they landed, he and Cornwell relaxed by standing on the boardwalk with a crowd of onlookers and watching the plane go up again. But within seconds, everything turned catastrophic. The plane flipped over on its side, floated down like a spiraling leaf and crashed in a meadow, killing the two men inside.[16]

Later, Rockwell was surprised when Cornwell showed him some sketches he had drawn of the wrecked plane, a tangle of metal and debris.[17] "It seems cruel, but this is how an artist looks at life," Rockwell later commented. "You realize the suffering, but you are always thinking, 'Would this make a picture, or wouldn't it make a picture?'"

In this case, Rockwell decided it would not make a picture.

# THE ARROW COLLAR MAN

## (1924 TO 1925)

During his early years in New Rochelle, when Rockwell was working mainly for *Boys' Life* magazine, he had little contact with the famous illustrators who lived in town. They were a generation older than he and infinitely more established. Most daunting of all was Joseph C. Leyendecker and his younger brother, Frank X. Leyendecker, who continued to live reclusively in a hilltop mansion on Mount Tom Road.

Like the Brontë siblings, the Leyendeckers were very much of the nineteenth century in the abundance of their domestic eccentricities. Their devotion to each other was touching. Joe and Frank shared their home with two pet collies and their sister, Augusta, who was slightly older than they and was charged with the job of family hostess.

The Leyendeckers posed for few photographs, and granted few interviews. But in 1918 they permitted photographs of their house to appear in decorating magazines.[1] The pictures from *House & Garden* still astound: the cavernous living room with its dark wood paneling and hand-carved oak tables, its massive fireplace and tapestries everywhere—a handsome example of Arts and Crafts design that gives off a whiff of haunted-house creakiness.

The living room opened onto a wide terrace that overlooked a sunken garden composed of hundreds of pink and red rosebushes. For his daily exercise, J. C. Leyendecker would walk back and forth across the terrace then down the steps to the garden, strolling briskly on a brick path laid in a herringbone pattern, past the long rows of hedges, past the gazebo and the fountain and the shallow reflecting pool stocked with water lilies.

The house was frequently likened to Versailles, for lack of a more precise metaphor.

Rockwell first met Leyendecker in the summer of 1920 at a charity dinner organized by the New Rochelle Art Association to raise money for the construction of a local war memorial. Two days later, after "picking up and putting down the telephone a hundred times," Rockwell invited J.C. to dinner. He arrived on a Tuesday evening with his brother Frank, inaugurating a friendship that would always matter enormously to Rockwell and had the traits of both an artistic apprenticeship and an unclassifiable romantic crush.

At the time they met, Rockwell was a twenty-six-year-old contributor to the *Post* who was known for amusing scenes of freckled boys and their mutts. Leyendecker was forty-six and at the peak of his career, a gay, German-Catholic immigrant whose identity left him perpetually on the margins of the vision of holiday togetherness he promoted in his work.

•

In a reversal of the usual hierarchies, it was Leyendecker's advertising images, as opposed to his *Post* covers, that proved to be his most enduring work. He was the brand name who created brand names. His Arrow Collar Man was a bona fide sensation—a handsome, square-jawed man in a freshly pressed shirt, his hair glinting like blond metal. A generation of college men regarded him as the go-to authority for fashion advice. Leyendecker single-handedly changed advertising by switching the emphasis from text to image and making his pitch in emphatically visual terms. Earlier, in the nineteenth century, most printed advertisements had been crammed with tiny, hard-to-read type imploring you to buy effective or ineffective remedies for your headaches and nerves and itchy skin. The Arrow Collar Man, by contrast, was selling a vision as much as a product. He was selling the notion that any man could acquire instant class by spending twenty cents on a detachable collar.

What should an American male aspire to be? In the years when Rockwell was growing up, President Theodore Roosevelt made manhood almost indistinguishable from a love of nature and the outdoors. Real men, he seemed to say, went hiking and knew how to pitch a tent, a vision that Rockwell had helped promote in his years as art editor of *Boys' Life* magazine. But the Arrow Collar Man reframed masculinity in urban terms. He does not own a rifle. He does not wish to shoot every elephant in Africa.

The Arrow Collar Man, as created by J. C. Leyendecker, was selling not just a shirt but the promise of urban sophistication. This advertisement appeared in 1912.

His idea of being shipwrecked is to find himself on the cusp of a date without a freshly ironed shirt. He looks less like an explorer than a business major, a lean, clean guy with polished shoes who might be portrayed in a college lounge, reading a newspaper or even a book. F. Scott Fitzgerald refers to the Leyendecker ideal of male beauty in his short story "The Last of the Belles," which ran in the *Post* in 1929. In it, a young woman mourns her dead athlete-brother: "She showed me his picture—it was a handsome, earnest face with a Leyendecker forelock."[2]

The Arrow Collar Man predated *The Great Gatsby* by almost twenty years, and you wonder if he exerted any influence on Fitzgerald's conception of male glamour. With his pomaded hair and gray eyes, Fitzgerald himself looked like an Arrow Collar Man. "Scott, sober, was certainly the most attractive man I can find in my whole gallery of memory images," Arnold Gingrich of *Esquire* once wrote, "short of the idealized Leyendecker creation, the original Arrow Collar Man, for whom indeed Fitzgerald might have posed."[3]

Leyendecker created the Arrow Collar Man in 1905 for the menswear manufacturer Cluette, Peabody & Company. In those days, men's shirts came without collars. The detachable collar—a swatch of linen that you affixed to your shirt with buttons—was a sign of good grooming, imply-

ing, however nonsensically, that the shirt beneath the gentleman's jacket must be equally clean.

Over the years, several men posed for the Arrow Collar Man, but the one most associated with him was Charles Allwood Beach. He was Leyendecker's longtime lover. In addition to the house in New Rochelle, Leyendecker maintained a studio in Manhattan, in the Bryant Park Studio Building at 80 West Fortieth Street, where he led another life, a freer life perhaps. Beach lived in the studio and served as his secretary. He was a striking, broad-shouldered Canadian who spoke in a clipped British accent. It was Beach who always answered the phone and talked to art directors and arranged for models to come pose. George Horace Lorimer, the editor of the *Post*, once remarked, "I never met Leyendecker. All our business was conducted by phone with his agent."

In the beginning, the Leyendecker brothers struck many people as almost interchangeable. Although Joe was two years older, they were known as the illustrator twins. Born in Germany, raised in Chicago, they both studied at the Art Institute of Chicago and the Académie Julian in Paris before beginning their careers in adjoining studios in New York. They both specialized in advertising posters and, during World War I, when Germany was the enemy, volunteered to make patriotic posters for the U.S. government.

But by the early 1920s dramatic differences came to mark them. Joe Leyendecker was rewarded with meaningful work and love. Frank Leyendecker was not so fortunate. He suffered from depression and developed a ruinous morphine habit. He was erratic in his work habits and seldom able to meet a deadline, which left him short of cash.

The closeness between the brothers eroded as Joe became more attached to his lover, who was seven years his junior. In 1921 Beach moved into the house in New Rochelle and his presence threw everything off kilter. By Rockwell's account, Beach was a manipulative and petty man whose behavior could rival that of the most possessive artist's wife. He was not particularly nice to Augusta and Frank and antagonized Leyendecker's few friends as well.

No one elicits more disapproval from Rockwell in his autobiography than Beach. Once, when he and Irene were visiting the mansion on Mount Tom Road, sipping tea in front of the enormous carved fireplace in the living room, Frank Leyendecker asked Beach to add a log to the fire. Beach snapped in his British accent, "Put it on yourself." Rockwell was

stunned by the impudent comment. He felt that Beach was unworthy of Leyendecker's affection. He thought of him as "a real parasite—like some huge, white, cold insect clinging to Joe's back."[4]

Rockwell claimed that he was the one true friend the brothers had. Whether or not this is accurate, you suspect that he wanted it to be true. He erased from his recollections their mutual friends among New Rochelle illustrators, namely, Coles Phillips and Orson Lowell, the latter of whom had known the Leyendeckers since their Chicago days. And naturally he discounted Beach. "Beach always acted jealous of me," Rockwell wrote, never specifying what Beach might have envied.[5]

Eventually, the tension on Mount Tom Road became so unmanageable that Augusta Leyendecker, whom Rockwell described as "hot-tempered and intensely loyal to her brothers," spit at Beach.[6] Joe asked her to leave the house, and Frank left with her.[7]

•

In 1923, after he returned from his extended trip to Paris, Rockwell became close to Frank Leyendecker and took it upon himself to care for him. He found Frank poignant. Once Rockwell accompanied Frank to a session with his psychiatrist. Rockwell told the doctor he considered Joe's relationship with Beach pathological. It was not unusual, the doctor explained to him, "for a stupid person with only one idea in his head to gain control over a sensitive, timid person."[8] That struck Rockwell as about right.

Rockwell rented a single room above a garage next door to his own studio on Prospect Street, hoping to provide Frank with an incentive to continue painting. Frank had his bedroom furniture moved in, incongruously furnishing a garage loft with a baroque Italian bed and hand-carved chairs of the same vintage. He hung a heavy medieval crucifix above the bed.

Frank would materialize at Rockwell's studio in the mornings, around ten, knocking on the door and politely asking if he could come in. He would sit quietly in the corner, sometimes with a book. It seemed to Rockwell that Frank was "watching the shadows crawling on the floor," as he put it. Only later did he learn that Frank was addicted to morphine. When he stared at shadows, he was, perhaps, staring at the visions that morphine can induce, a profusion of darkness settling everywhere. At the end of the day, as Rockwell was sweeping out the studio in the half-light of dusk, Frank would ask the same question, "Do the dark corners bother you?"[9]

Rockwell would reply, "What dark corners?"

Frank: "Don't the corners get all black, as if there was a pit behind them?"

Frank X. Leyendecker moved back to Mount Tom Road shortly before he died, on April 18, 1924, a day after suffering a cerebral hemorrhage. It was Good Friday and he was forty-eight years old. The newspaper obituaries were vague, attributing his death to an unspecified illness he had contracted four months earlier, perhaps referring to his morphine addiction. In his will, he slighted Joe and bequeathed everything he owned to his sister, Augusta. After his debts were paid, his estate amounted to a paltry $1,981.[10]

That winter, Augusta organized a memorial exhibition at the New Rochelle Public Library. An opening reception was held on the night of December 8 and Rockwell and Irene were among the hundreds who crowded the library to pay tribute to Frank X. Leyendecker. Irene, in fact, was one of the handful of "selected hostesses."[11] The show consisted mostly of magazine illustrations, paintings of tall, well-built flappers who might be festooned with feathers and jewels. His best-known cover ran in *Life* in 1922 and shows a statuesque blonde sprouting a pair of resplendent butterfly wings that fill the page.

In a brochure accompanying the show, Regina Armstrong, a friend of the Leyendecker family who lived in New Rochelle, wrote a touching tribute to Frank. "He found his metier in the pomp and pageantry of the court life of France before the 18th century, of the period of Watteau, with its shimmering beauty."[12] She could not imagine that he might ever be forgotten.

•

A new year arrived and, eager for some kind of break, Rockwell and Irene traveled to Southern California in January. Their departure was noted in the *New York Herald Tribune*, but little is known about the trip.[13] They stayed with their friends Clyde and Cotta Forsythe, and two surviving photographs show the men palling around without their wives. They played golf at the San Gabriel County Club and visited a film set where Rockwell shook hands with the silent film star Buddy Rogers. When he returned from California, his marriage was in a state of serious disrepair. Irene's mother, widowed since 1922, had decided to close up her house in Potsdam and spend the winter in New Rochelle. Irene's three siblings, who were younger than she and still single, would converge on the house

On a visit to Clyde Forsythe (far right) in Southern California, Rockwell is introduced to the actor Charles "Buddy" Rogers, a silent film star. (Norman Rockwell Museum, Stockbridge, Massachusetts)

as well. "To tell you the truth," Rockwell recalled, "I was supporting a good part of her family."[14]

One Sunday, when he was leaving his studio and preparing to head home for lunch, he noticed Franklin Lischke, his studio assistant and teenage landlord, standing with his mother and brother on the driveway, waiting for Mr. Lischke to back the car out of the garage. For some reason, the sight made Rockwell snap. "I can't stand it anymore," he thought to himself. "I can't go home and sit down at the table with Irene's brothers and sister and mother again." He cites this moment as the turning point when he realized he could no longer live with his wife. He wanted a separation. He wanted a respite from family obligations. In a letter to Franklin Lischke, Rockwell canceled the lease on the studio, offered a few months extra rent, and assured him that if he ever returned to New Rochelle, "I will drop in and have a reunion."[15]

In February 1925 Rockwell took a studio in Leyendecker's building in Manhattan, the Bryant Park Studio Building, on the southwest corner of Sixth Avenue and Fortieth Street. The 1901 landmark had been designed

with the needs of easel painters in mind (think high ceilings). In the course of his work day, Rockwell would frequently trot down the hall to visit Leyendecker, whom he found amusing. On the occasions when Rockwell asked Leyendecker for his professional opinion of an illustration in progress, J.C. would usually study it in silence for a few seconds, then conclude he should destroy it. It was his idea of a joke.

At the end of the day, they would have a drink together in J.C.'s studio. The building had a functioning dumbwaiter and although Prohibition was in effect, contraband liquor continued to be delivered from the Beaux Arts Café in the basement to the studios upstairs. Not wanting to brand Leyendecker a Prohibition violator, Rockwell later described visiting an unidentified "friend" in the building who would help himself to drinks as they rumbled upward on the dumbwaiter. On one occasion, the friend reached for a bottle of champagne, commenting, "I don't know, but let's not let an opportunity like this pass unmolested."[16] Interesting choice of words. It raises the question of whether J.C. was referring to the champagne or to Rockwell himself. Clearly Leyendecker had a teasing way with words and could be flirtatious with Rockwell. After their drinks, J.C. would return home to his estate in New Rochelle and Rockwell would be left to face the evening alone.

By then, Rockwell was appearing in the *Post* at least as often as Leyendecker. In 1925 Leyendecker had six covers for the *Post*. Rockwell had ten. The two artists used some of the same models. Rockwell's favorite was James K. Van Brunt, a small, slight man in his seventies, with a formidable white mustache that drooped at both ends. In his prime, Van Brunt had been a real-estate agent in New Rochelle, which no doubt added an extra layer of irony to his first appearance in a Rockwell cover, in October 1924, as a homeless tramp. Seated by a tin-can fire, he is holding a stick and roasting two hot dogs, one for himself and one for the black-and-white mutt that is squeezed between his legs and straining to get the best view possible of the grill.

In addition to the hobo, Rockwell did covers during this period in which elderly men variously appear as an office clerk, a storekeeper, a train conductor, and a fisherman. In *Bookworm* of 1926, Van Brunt poses in front of an outdoor bookstall, a distracted-professor type in mismatched shoes, his nose buried in a book. Presumably he is meant to be on his way to the grocery store, to pick up a few things for his wife. ("Don't forget matches and cheese," she admonishes in a note pinned to his basket.) Rockwell's old

men tend to be meek and wispy. They have less in common with the elders in high-art paintings, the biblical prophets with their streaming beards, than with the henpecked husbands who populate newspaper cartoons.

When Rockwell painted a figure, he always worked from a model. And old men, he thought, made for superior models. They were infinitely more patient than the schoolboys who had horsed around in his studio. Van Brunt didn't fidget in his chair. He didn't wonder why he had to hold his right arm above his head or squat on the modeling stand for another thirty minutes. Sometimes, if a pose was less strenuous and didn't involve his face, he closed his eyes and took a nap as Rockwell sketched him. His wife, Ella, had died suddenly in December 1923 and he had no children, so he was never in a hurry to leave the studio.[17]

Both Rockwell and Leyendecker did humorous paintings of him that involve cross-dressing. Some of the pictures are mere one-liners, but Rockwell achieved something genuinely quirky in *Three Gossips* of 1929, in which Van Brunt is disguised as three different women, all of them homely, middle-aged busybodies dressed in old-fashioned petticoats and crinoline. They sit in a tight circle, leaning forward to exchange gossip, their heads almost touching. The women's faces are barely visible, but somehow you know them from their body language, or think you do.

All in all, it is one of Rockwell's more Leyendeckerish covers. While Rockwell tended to concentrate on faces and (later on, ultimately) backgrounds, Leyendecker concentrated on cloth and sinuous necks. He used to say that a really essential thing in a pretty woman was a nice back of the neck. With their white skin and shiny clothing bent into so many sharp folds, his figures can put you in mind of Meissen porcelain figures.

Leyendecker's champions habitually insist that Rockwell stole the older artist's ideas without acknowledgment or credit. They characterize their relationship as a kind of *All About Eve* rivalry that began when Rockwell moved to New Rochelle "to be near Leyendecker." They state that Rockwell carefully studied Leyendecker's subjects, style, and technique, and "imitated Joe so completely the public became confused as to the source. Leyendecker's career stumped thereafter."[18]

Every young artist borrows from other artists, absorbs and synthesizes various influences. Rockwell took from Leyendecker's work what he needed and ignored the rest. He was moved by the vividness of Leyendecker's figures and the storytelling aspect of his work. But he ignored the

Gothic part of Leyendecker, the elongation of the figures and spiky line.
He basically Americanized him.

•

In later life, looking back on his separation from Irene, Rockwell spoke of
it as "a terrible time." At first he had relished his freedom, the release from
familial obligations. But he had no talent for living on his own. Eating
dinner alone in restaurants, he would order a main course and then feel
inexplicably self-conscious, hurry out "before the waiter brought it to the
table." His level of anxiety was punishing and he did not want to think
about its possible sources. When he wasn't painting, he seemed to have no
idea what to do with himself.

To help keep himself sane, he arranged to teach an evening class on
illustration, at the New School of Design, a short-lived institution at
Broadway and Fifty-third Street.[19] The class met five nights a week, but
Rockwell had to be there only for the twice-a-week crits. During that
term, Mark Rothko and Arshile Gorky, the future Abstract Expression-
ists, were enrolled as students. It is unlikely that they signed up for Rock-
well's class. But perhaps they passed him in the hall and took note of him,
a cover artist for *The Saturday Evening Post* who, despite the humor quotient
in his work, could be every bit as gloomy as themselves.

In June he was interviewed by a reporter from the *Brooklyn Daily Eagle*,
Ruth Brindze, who arrived at the Bryant Park Studio Building to find
Rockwell sitting with a model who had posed for a good many of his
"old-man pictures."[20] Probably James K. Van Brunt. "Rockwell has a wide
grin which makes him look younger than the thirty-one years of which
he boasts," the reporter noted. "He never seems to take himself seriously.
He regards his skill as an illustrator as 'something to knock wood about,'
and he often thinks, 'I'm about through.'"

Asked about his artistic production, Rockwell said that he completed
about twenty-five pictures a year. "That includes doing some pictures over
two or three times." He estimated that it took about ten days to paint a
picture. "I really have it much easier than the cartoonists," Rockwell said.
"They have to get a good idea every day. I only have to get twenty-five a
year. But that is even hard."

Indeed, the gestation of ideas was arduous and his least favorite part
of making art. He devoted two nights a week to it. On the first night, he
went into a spare room free of distraction and stayed there from about eight

to eleven, when, more often than not, he left in a fit of discouragement, convinced that he would never have an idea for a painting again.

The second night, after a few minutes, the thoughts began to present themselves. He had a trick to help him focus his mind, to access the storehouse of his imagination. Proust had his madeleine and Rockwell had his lamppost. He saw it clearly before him, a lamppost on a quiet street. Then he imagined what could happen to it. A boy climbs up it, a boy falls off of it; someone chases the boy around it. He did this all the time, envisioning the lamppost and waiting for a scene to emerge, a boy or two, a certain facial expression, a story. He sketched a bit with pencil and paper, but no real drawing was begun on the thinking nights.

Once he knew enough about the scene, he deleted the lamppost. Then he did a rough sketch—a rough, as he called it—which he submitted to an art editor at any one of a number of magazines, seeking permission to proceed.

He mentioned: "I can't draw a pretty girl, no matter how much I try. I'm afraid that they all look like old men."

The reporter noted: "He stuttered a little as he said this because he felt that he had said something that he should not have." Perhaps he felt that he had confessed to his lack of interest in women.

Whatever he had hoped to find by leaving his wife eluded him. He claimed he had wanted to escape his in-laws. But in the process he found himself without anyone to depend on besides Leyendecker, who had his own obligations and hardly had time to minister to Rockwell. Leyendecker asked him whether he knew his skin was sallow, "sort of all yellow and green," and exhorted him to take up exercise. So Rockwell joined the YMCA, but quit in short order, saying he felt painfully self-conscious in front of the other men at the gym. He later recalled that they stared at his spindly body in disbelief when he told them he was "reducing."

He and Irene appear to have reconciled by May 1925, when they surfaced in society-news columns as guests at a surprise party for Emil Fuchs, a Viennese-born society portraitist whose studio was then in the Bryant Park Building.[21] By Rockwell's account, the marital separation lasted seven months, until July, when illness brought them together. He complained of a sore throat that would not go away and landed in the hospital with tonsillitis. Irene promised to nurture him back to health. She suggested he spend the summer recuperating at her mother's riverside cottage in Louisville Landing, up on the Canadian border, an invitation

he accepted with relief. He got along well with his mother-in-law so long as their encounters took place in her home, not his, and he included her kindly, gray-haired likeness in several paintings from this period.

During the summer, Irene decided that she and Rockwell had spent too many years as renters. On August 28, they purchased their first house, a stucco number on the southern tip of New Rochelle, in an area known as Davenport Neck.[22] Rockwell spoke of it as a "cheaply-built imitation English cottage," not exactly a propitious description. Irene's signature is the only one on the land deed, perhaps because Rockwell was still recuperating upstate on the Friday morning when it was signed.

Rockwell's plan was to resume working in his former studio in New Rochelle, the barn on Prospect Street behind Franklin Lischke's house.[23] In a letter written late that summer, Rockwell informed his assistant: "Dear Old Franklin, I will be home Saturday the 12th. Will you telephone Bill Sundermeyer and tell him I want him to pose this Sunday the 13th at 9 am. Tell him to wear a Boy Scout uniform."[24] The letter is written not in words, but as a pictograph and remains a singularly charming document, with a drawing of a deer substituting for the word *dear*, an eye substituting for the word *I*, a Franklin car substituting for the boy's name, and so on.

Bill Sundermeyer was then fourteen, three years younger than Franklin.[25] Rockwell was using "Old Franklin" as a model less frequently. Franklin didn't take it personally. Unlike Billy Payne, he could see Rockwell's side. He knew that he had reached the point where he was "too old to be a kid model and not good-looking enough to be an Arrow Collar Man."[26]

# DIVORCE

## (1926 TO 1929)

On February 6, 1926, *The Saturday Evening Post* officially retired its duotone covers, the two-color affairs that required illustrators to limit their palette to red and black. Rockwell was tapped by George Lorimer to do the first four-color cover. For this he chose a humorous scene set in the ruffled eighteenth century: a New England sign painter who is maybe sixty, or a little past sixty, sits perched on a three-legged stool, tilting forward as he applies a final daub of pigment to his latest creation. He is painting a wooden sign, the kind that once swayed over the doors of inns. The sign includes a likeness of George Washington with a white flip wig and too much red paint on his lips, beneath the hand-painted letters: "Ye Pipe & Bowl Tavern, 1785."

If the cover was the first in four colors, it was also the first in which Rockwell went Colonial. The twenties may be known as the era of jazz, bathtub gin, and late-night parties, but it was also distinguished, as if in a rite of expatiation, by a fashion for history and the trappings of eighteenth-century New England. Much was made of the sesquicentennial of the signing of the Declaration of Independence on July 4, 1926, which spawned a fashion for antiques. The rich began collecting early American furniture and the middle class began collecting reproductions of it. People who owned cars began setting out on weekends to visit restored houses in New England.

In Europe you could see castles and ruins. In America there were none, so business leaders and philanthropists competed to create instant historical sites. John D. Rockefeller, Jr., launched Colonial Williamsburg

in Virginia. Henry Ford started Greenfield Village in Dearborn, Michigan, where he relocated or reconstructed some one hundred buildings including the courthouse where Abraham Lincoln practiced law. "The term *Americana* comes into the English language at this point," notes the literary scholar William P. Kelly.[1] "There's a desperate desire to find a there there."

In the next decade, Rockwell would produce many *Post* covers and advertisements featuring pilgrims and founding fathers. In the process, he acquired an extensive collection of Colonial costumes. His studio became a place where models changed into long waistcoats and shoes with pewter buckles. Open a closet door and a tricorn hat might tumble out.

•

The Colonial Revival movement found its most powerful expression in the hands of home builders and architects, who turned it into the default style of the American suburbs. Fittingly, in March 1927, Rockwell purchased a Colonial house—an impressive, white-painted, four-bedroom house with green shutters and a grand curving staircase that rose up from the foyer, at 24 Lord Kitchener Road in New Rochelle. (The house is still standing.) It had been built just a few years earlier, as part of an upscale residential development called Bonnie Crest in the northern end of New Rochelle, whose street names paid tribute to the Allied victory in World War I.

Irene poured all her energy into the new house. She retained a decorator and gave extended thought to wallpaper patterns. For the main hall alone, she chose wallpaper "with a reproduction of a quaint landscape,"[2] and ordered thirty-six rolls of it, in addition to paste and lining paper.

Rockwell, in the meantime, was consumed by the construction of a studio on the property, which became its own slowly evolving artistic creation. It was built onto the detached garage and remained entirely separate from the house. Dean Parmelee, the architect who had designed his house, returned now to design the studio. He and Rockwell came up with the idea of replicating an inn in Colonial America.

This required historical research, and Rockwell happily obliged. He and Parmelee drove to the Boston area to look at restored houses including the Wayside Inn, in Sudbury, an old tavern that Henry Wadsworth Longfellow had immortalized in his *Tales of a Wayside Inn*. They stayed overnight to better imbibe the atmosphere as well as Henry Ford's renovations to the building. Rockwell slept in a room where Paul Revere had once supposedly slept. The next morning he joked to the desk clerk that

the bed was so uncomfortable he could see why Revere chose to ride at night.

Rockwell's studio, in the end, was a two-story structure with rough fieldstone walls and a high beamed ceiling. A redbrick fireplace, much like the one at the Wayside Inn, was large enough to roast a pig. Rockwell's easel and palette table occupied the center of the room. A staircase on the left side led to a second-floor balcony, with a protective railing composed of old wooden spindles. Upstairs, if you lifted the trap door, you would find a veritable storehouse of costumes and props he had amassed for his paintings, including a canon, a fireman's ax, and an old rocking chair. "It ended up as a $23,000 love affair with antiques," Rockwell noted of his studio, "and left me up to date in an antique way."

It was the spring of 1927, and Charles Lindbergh was monopolizing headlines, with his plan to fly nonstop across the Atlantic. Rockwell observed the milestone with a newsy *Post* cover, *Pioneer*.[3] It shows the young, idealistic face of an aviator—not Lindbergh's, as is commonly assumed—with his glasses pushed up on his head, centered against a radiant blue ground. To meet his deadline, Rockwell hired a model, located an aviator cap, and worked on the image for twenty-six consecutive hours before staggering off to bed. Lorimer was so pleased with the results that he offered Rockwell a raise. "My dear Rockwell," he wrote on June 30, " 'Pioneer' is just about [the] high water mark for Post covers and on the strength of it we are going to raise the ante $250 per."[4] In other words, the *Post* was doubling his fee, to five hundred dollars per cover. Probably there were other factors contributing to the raise. At this point, Rockwell had been at the *Post* for eleven years and other magazines were pursuing him, especially *Liberty*, which was stocked with art by Rockwell imitators.

Irene, who still handled her husband's business correspondence, penned a thank-you note to his boss. "Dear Mr. Lorimer, Your kind letter with the announcement of a raise was gratefully received. It comes too at a most opportune time for buying a house and building a studio does take a lot of cash."[5] Then she signed Rockwell's name, a task he had entrusted to her along with every other part of his life that did not involve paintbrushes.

That summer, Rockwell and his fellow illustrators in New Rochelle were shaken by the death of Coles Phillips, who was only forty-seven and had been suffering from kidney disease. He was famous for his Fade-Away Girls, with their crisp outlines melting into the background, and for which his wife, Teresa, had been his model. He died on a Sunday night in June

and the next morning, his dear friend J. C. Leyendecker arrived at his home, on Sutton Manor Road, and insisted on helping. He took the four Phillips children into Manhattan to see what promised to be a historic event, the ticker-tape parade up Broadway welcoming Colonel Lindbergh back to the city from which he had begun his flight.

•

A year passed and Rockwell's new studio was finally finished. Instead of inhabiting it, he went away for the summer. He and his architect, Dean Parmelee, sailed to Europe in grand style, leaving New York on July 21, 1928, aboard the *Olympic*, the sister ship of the *Titanic*. Rockwell would be gone for two months. It was the second time he was going abroad without his wife. Irene was happy to make her own summer plans. After Rockwell sailed, she accompanied Coles Phillips's widow on a two-week trip to the home of friends in Loon Lake, in upstate New York, then continued on, by car and ferry, to her mother's riverside cottage in Louisville Landing, on the Canadian border.[6] News of her summer surfaced occasionally in the local paper, in connection with either her brothers' duck hunting or luncheons she attended with her mom and sister at the Massena Country Club.

In addition to Parmelee, Rockwell was traveling with Bill Backer, a well-to-do building contractor and neighbor of his. It is odd to think of three married men (two of whom had young children) leaving their wives for two months to frolic in Europe—the twenties sometimes seem too silly for words. Their fellow first-cabin passengers on the ship included William Randolph Hearst, whom Rockwell spotted "playing cards with his bodyguard, his long, unhappy, horse face bent over the table."[7] Also on board was Fred Astaire, who was on his way to London to start rehearsing for a stage production of *Funny Face.*[8]

The trip, as Rockwell later described it, was "a sunny, carefree interlude." He was glad to have a respite from his married routine of "deadlines, money, bills, the right flannel trousers, and the country club."[9] He had come to Europe, at least partly, to seek ideas for covers and would sketch copiously throughout the trip. He never went a day without sketching and developed a quick sketching technique. At night, in his hotel room, he would complete the rough sketches he had done during the day, adding little touches of watercolor here and there.

At the end of the trip, he was in Madrid when he lost his sketchbook. He had used the same one throughout the trip and by then it was packed

full of drawings of things he had seen, including paintings in museums. "Dean, Bill and I treasured it," he later recalled. "I still almost cry when I think about it." He had placed the sketchpad beside him on a bench in the Prado, but could not find it after he got up to look more closely at Velázquez's *Topers*. Dating from 1627, it was one of his favorite paintings, an all-male paradise featuring six rugged townsmen who meet up with the Greek god Bacchus in a wooded area. You can see why Rockwell would love *Topers*—it's the masterpiece version of a *Boys' Life* cover.

Rockwell and his two friends sailed out of the port of Gibraltar on September 14, 1928, in the first-class section of the Italian ocean liner *Conte Biancamano*. Although he cursed himself for losing his sketchbook, he had absorbed enough Old Master painting over the summer for the images to remain clear in his head when he got home. He immediately set to work on *Doctor and Doll*, one of his greatest early paintings, which would run on the cover of the *Post* on March 9, 1929.

•

*Doctor and Doll* shows a girl of perhaps six standing in a doctor's office, holding an unlikely patient—her cloth doll—as the doctor pretends to listen to its heartbeat. You assume the girl is there for her annual checkup. She probably arrived just moments earlier because she is still wearing her raincoat and rubbers. Her red beret is pulled down over her head.

You can almost hear the conversation. The doctor, noticing the girl's doll, inquires in a deeply concerned voice: "How is your doll feeling today?" The girl says that she isn't sure. The doctor offers to check with his stethoscope. No doubt he will tell the girl that the doll is in excellent health, thanks to her ministrations.

The furnishings in the office have their own tattered charm. The office is not the callously antiseptic chamber of modern medicine, but a comfortably lived-in place that could use a little straightening up. An area rug, instead of lying flat on the floor, is bunched up in one spot. The doctor sits on a Windsor chair whose black paint has rubbed off on the parts where his body makes the most contact, such as the arm rest. On top of the desk, a row of books is casually arrayed, the last two tilting haphazardly to the left. Pewter candlesticks hold half-burned tapers.

The books and tapers are a nod to Dutch still-life painting, a point driven home by a work of art in the doctor's office—a reproduction of what appears to be a Rembrandt, with a group of men in white collars.

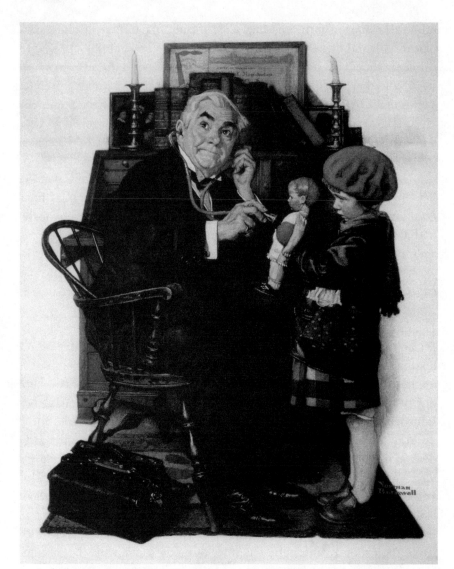

*Doctor and Doll*, 1929, acknowledges Rockwell's affection for Rembrandt's *Anatomy Lesson*.

(Norman Rockwell Museum, Stockbridge, Massachusetts)

The prodding at Dutch painting is a bit heavy-handed, but it can be forgiven because *Doctor and Doll* was done by a relatively young (thirty-five-year-old) artist who is delighted to realize how Old Master painting, with its great contrasts of darkness and light, can inform popular illustration.

As usual, there's enormous intelligence in Rockwell's picture construction, and it is not a coincidence that his doctor is facing in the same direction, with his head at the same angle, as the heads of the Dutchmen in the reproduction. And like the Dutchmen, the doctor is dressed in velvety black, with a white collar peeking out. Rockwell was always fond of doctors and felt like he needed one half the time, to attend to his ailments. He had painted an earlier, less satisfying doctor-and-doll in 1923, for the cover of *The Literary Digest*. In both his art and his life, he was perpetually returning to the doctor.

•

From the outside, it looked like a real marriage and no one but he and Irene needed to know that it wasn't. In February 1929 their house was featured in *Good Housekeeping*, in a story called "A House with Real Charm." Throughout that spring, Irene appeared in a national advertisement for Cantilever shoes. There she was "Mrs. Norman Rockwell, wife of famous artist," as the copy said, standing at the stove in her apron, stirring a pot while wearing her sensible Cantilever shoes. "Their comfort is doubly appreciated on Thursday nights" the ad reads, because Thursday was the night when the maid was off and she prepared a little "artistic supper."

In June 1929 Rockwell sailed to Europe again. For the first time, he and Irene went abroad as a couple. She had an incentive. Three couples from New Rochelle were going abroad together; she thought it would be fun to travel with friends. "Again Irene stayed home," Rockwell noted in his autobiography, perhaps because he wished she had. But U.S. immigration records reveal she was on the boat both ways.[10]

It was as luxurious as a trip could be. They stayed at the George V Hotel in Paris and at the Ritz in London along with the other couples, whom Irene knew from bridge. Later, describing the trip in his autobiography, Rockwell devoted only one grumbling paragraph to it and made his traveling companions sound like philistines. One day in Paris he proposed to the group, "Let's go to the Louvre." And he was told, "We've been to the Louvre," as if there was no point in seeing a museum more

than once. The four couples boarded the ocean liner SS *Paris* in Plymouth, England, on July 5, and arrived in New York five days later.

When they returned from Europe, he retreated to his studio and his mound of assignments and assumed that Irene would similarly return to where she left off. He assumed she would continue to host bridge parties and meet friends for lunch at the Bonnie Briar Country Club. He assumed that he would see her over dinner every night at home on Lord Kitchener Road, in that lovely white-painted Colonial where a certain kind of American life was supposed to unfold.

But he assumed wrong. Irene was leaving him. They had been home from Europe for about a month when Irene told her husband she had fallen in love with a man she had met at the club. He was the older brother of her dear friend Edna (Hartley) Peck, one of the friends who had been on the trip to Europe. Francis Hartley, Jr., was a well-off chemical salesman in Boston. He held degrees from the best schools: Andover, Yale, and the Harvard Business School. He had flown combat missions in the war.

He sounded formidable on paper, but Irene probably knew there was something off about him. At age thirty-four, he had never been married and his reputation was shadowed by an unsettling event that had occurred during his student days at Yale. One Saturday night, in a hotel lobby in New Haven, he was arrested when he accosted an actress after her performance that night. The incident was witnessed by J. J. Shubert, the famous theatrical producer, who smacked him in the face. Hartley was charged with breach of peace.[11]

Rockwell was well-acquainted with Edna Peck, with whom he had chatted amiably on the cruise to Europe. But he did not know her older brother and was stunned by his wife's request for a divorce. He asked her if she was sure. Although he knew he had been a lackadaisical husband, he did not want the marriage to end. He would have happily stayed married to Irene. No, not happily. But he would have stayed married. He was not a romantic.

Irene informed him that her plan was to leave New Rochelle immediately and move into a furnished apartment in the Allerton House in New York City until the divorce came through. She intended to marry Hartley the moment it was legally possible.

One night as they sat in the living room Rockwell asked once again if she was sure. She said that she had never felt more sure about anything. "How can you leave all this?" he asked, waving his hand at the furniture

and then picking up a Royal Doulton porcelain figurine from the mantel-piece. "Can you really give all this up?"

He found it dismaying, not that she would leave him, but that she would leave the furniture. It had taken so long to assemble, the handsomely appointed rooms with their patterned wallpaper and choice antiques. He had made it possible. The rooms had been decorated at great expense. He had fulfilled his husbandly obligations but now he saw it was all for naught. He threw the figurine at the wall.

In mid-August she went upstate to be with family and this time Rockwell did not accompany her. She returned to New York three weeks later.[12] She told Rockwell that she and her mother, Catherine O'Connor, widowed but still vigorous at seventy, had made plans to travel by train to Reno, Nevada, the divorce capital of America.

And so ended his life with Irene. It came at one of those rare moments when one's personal sorrows are echoed by events in the wider world. A decade was ending, as was the longest stretch of prosperity in the nation's history. Irene had been in Reno for a week when the Wall Street crash, on October 29, further severed her from her life with Rockwell and made them see how innocent they had been, acting as if bridge parties and antiquing sprees and trips on luxurious ships could continue forever.

Rockwell was among the fortunate. At the time, he banked at Chase National and owned stock in about a dozen companies, including American Telephone & Telegraph and Columbia Gas & Electric. In May 1930 his stocks and bonds were worth $38,000, and his portfolio would decline by about a third in the next year.[13] He was not destroyed financially. Far from it. He had just rented out his house in New Rochelle to a family named Bliss and moved into an apartment in New York to begin his new bachelor life.

•

The Hotel des Artistes was not a hotel but an elegant apartment house at 1 West Sixty-seventh Street, with amenities including maid service, a swimming pool, and squash courts. Most of the units were spacious duplexes with double-height studios designed expressly for well-heeled painters and sculptors, if that's not a contradiction in terms. In its early years, the building was also home to many writers and actors, including Rudolph Valentino and Isadora Duncan, both of whom met tragic deaths a few years before Rockwell moved in.[14]

Rockwell's new apartment was a two-bedroom duplex, but he had no interest in the sybaritic lifestyle that was supposed to go with it. He did not attend grand parties or stay up late. At thirty-five years old, he had lived alone only once before, when he was separated from his wife in 1925 and ensconced in Leyendecker's studio building. In general he disliked being by himself, at least when he woke up and went to sleep.

In the morning, when he got out of bed, he stepped out onto a little balcony that overlooked his studio. He would gaze at the things he had brought from New Rochelle—his wooden easel, his sturdy Windsor chair, his palette table. It was a perfect artist's lair, but without another person to keep him company, he found the tranquility unnerving. It became his habit to consume his breakfast standing at the counter, "so as to get through with it as quickly as possible."[15] For dinner, he usually went to Schrafft's, on Fifty-seventh Street, across from the Art Students League, sitting alone at a little table.

That fall, when he visited the editorial offices of *The Saturday Evening Post* in Philadelphia, everyone seemed familiar with the details of his personal life. George Lorimer asked him why he was getting a divorce. "My wife fell in love with another man," Rockwell confessed. When Lorimer asked him what he was going to do about it, he replied, "Well, nothing."

"In my day," Lorimer said sternly, "we'd have shot the man."

"That made me feel like a fool," Rockwell later recounted. It was embarrassing enough to be cuckolded by your wife of fourteen years. It was even more embarrassing that he didn't really care. And Lorimer knew he didn't care.

It was a lonely time for him. He had no social circle and found himself writing letters to people too young to count as his peers, such as his former models in New Rochelle.

On November 12, 1929, he sat down with a sheet of Hotel des Artistes stationery and wrote a charming letter to Franklin Lischke, who by now had finished high school and was studying art. "Dear Old Frank: Here I am all set up in a New York studio. Life's a mighty funny proposition after all. I wish you would come in and see me sometime. Come in some afternoon about half past four or five."

He was relieved in December when he was visited by his cartoonist friend Clyde Forsythe and his wife, Cotta, with whom he had remained close in the decade since they left New Rochelle and moved to Southern

California. On this latest trip, they slept in his guest room and were suitably dazzled by his eighteen-foot-high studio ceiling. They suggested that Rockwell return to California with them, play some golf at the San Gabriel Country Club. They mentioned that he could find new models, revitalize his work. Moreover, they said they knew the perfect girl for him, Mary Barstow, a daughter of friends who had just graduated from Stanford.

•

On February 11, 1930, a surprising headline appeared on page one of the *Los Angeles Times*: ROCKWELL MAY DECIDE TO REMAIN. He had arrived in Los Angeles by train the day before and, as the story reported, "began doing the town in tow of Vic Forsythe." He had come west, he told the reporter, in the hope of finding new models and revitalizing his work. He acted as if his only goal was to colonize Hollywood as a subject for his *Post* covers.

Forsythe lived and worked in Alhambra, and that winter Rockwell stayed in his house on Almonsor Avenue; they shared a studio over the garage. They had worked side by side years before, when they rented Frederic Remington's studio in New Rochelle. In those days, Forsythe had an impressive career as a newspaper cartoonist and Rockwell was just a tyro illustrator about to sell his first cover to the *Post*. Now, in 1930, Forsythe was still turning out a daily strip about a bumbling, bubble-nosed character, Joe Jinks, but continued to believe that his true calling was desert painting.

He had settled in Alhambra in the early twenties with his friend Frank Tenney Johnson, who is probably the most compelling and undervalued painter of the American West. Compared to the usual galloping horses and stop-action scenes, Johnson's pictures of cowboys and Indians have a wonderful stillness about them. He is known for night scenes that capture the diaphanous beauty of moonlight shining down on a deserted street. But he also painted day scenes that might show a cowboy sitting on a palomino horse, smoking a cigarette beneath a sky whose intense light seems to frame and isolate him. You can't imagine the Marlboro man (who was created later, in 1954) without him.

Johnson lived at 22 Champion Place, right off Main Street. His studio, an attractive space with an enormous two-story window and Indian rugs and artifacts on the walls, occupied the building next door. His address

soon became shorthand for a fraternity of western painters who built homes and studios on the same street. Champion Place was just a block and a half long and surrounded by eucalyptus and pine trees. It offered an unobstructed view of the San Gabriel Mountains.

In the twenties, western paintings were snubbed by most art dealers, who preferred scenes of verdant French gardens to those of cacti and rocks. American artists were still regarded as uneducable yahoos compared to their European counterparts. To improve the image of local art folk, Johnson and Forsythe helped found a cooperative gallery in downtown Los Angeles.[16] The Biltmore Salon, as it was called, sounds like the name of a beauty parlor. But its mission was unquestionably noble. It opened in December 1923, in the then-new Biltmore Hotel on Olive Street, whose management had generously agreed to turn over a spacious, velvet-covered room to local artists, most of whom had no place else to show.[17]

Soon after Rockwell arrived in Alhambra, he became friendly with Johnson and his wife, Vinnie. Johnson was twenty years older than Rockwell, a handsome, soft-spoken aesthete who stood six foot two and who wore his jet-black hair parted down the middle.

When Johnson painted a night sky, he would usually put some stars in. They glitter like jewels from a distance, but when you look at the stars up close, you might be surprised to see, in the place of a crisply drawn object, a thick gob of white pigment. Johnson had his own idiosyncratic painting techniques. He would begin every painting, he once explained to Rockwell, by applying a white base mixed with a small amount of vermilion or Spanish red. That was the underpainting, and he would leave it to dry for one full year. Crazy but not crazy. He believed it accounted for the luminosity of his canvases.

Rockwell tried a version of the technique himself and in some ways it was the last thing he needed. He was constantly losing sleep over his encroaching deadlines and his anxiety over whether he could meet them. In contrast to other illustrators who learned how to be more efficient over time, Rockwell kept finding new ways to make his paintings harder to do and take longer to dry.

"If you see Frank Johnson," he wrote a bit later to Forsythe, "tell him I'm using his sani-flat technique, which make the originals weigh about ten pounds more and also makes them look much more arty." The Sani-Flat to which he refers was a type of oil-based house paint made by

Benjamin Moore that could be washed with water over and over, without losing its "eggshell sheen."[18]

Besides his knowledge of new pigments, Rockwell came away from his stay in Alhambra with a clear understanding of the distance that separated him from western artists. They were constantly driving off to the desert with enough equipment to set up easels and paint anywhere. Rockwell, by contrast, did not get his material from the landscape. He got his ideas for his paintings by locking himself in a spartan room after dinner, sitting at a table with a pencil and sketchpad, and not letting himself out for three hours.

Besides, he had never done a painting of a horse. In truth he remained wary of horses. During his bachelor days at the Hotel des Artistes, to get some exercise, he would rent a horse at Dorlan's Livery Stable and go riding along the bridle paths in Central Park. But he found the experience nerve-racking. One day his horse reared up and took off, galloping around the reservoir in the park as Rockwell held on for dear life. "Horses frightened me," he later said. "It's like eating dinner with a madman; every time he picks up a knife you don't know whether he's going to cut you or his meat."[19] In his paintings, he had no interest in glamorizing the lore of the West. He was too intent on poking fun at himself to pretend to be a potent cowboy, or a potent anything. He could laugh off the whole cowboy thing, and maybe laughing at cowboy legend was more authentically American than worshiping it. That is what happened on his trip to California. He did a great funny-debunking painting called *Gary Cooper as The Texan*.

•

Rockwell conceived the painting after contacting a friend of a friend at Paramount in search of a male actor, any actor, who might be willing to model for a *Post* cover. Gary Cooper jumped at the chance and arrived at the studio in Alhambra the next morning. He was in his late twenties, and his first talking picture (*The Virginian*) had come out the previous November, right after the crash and just in time to provide the country with much-needed reassurance. His new film, *The Texan*, would be out in May.

Cooper posed for Rockwell in his cowboy garb over the course of three days, entering fully into the spirit of the project. He preferred posing to giving interviews, which he found unbearably taxing. Cowboys were

supposed to be lean and laconic, men of action and few words, which Cooper was by temperament. He managed to survive entire radio interviews saying little more than "yep" and "nope."

As it happened, Cooper was the first-ever movie star to appear on the cover of *The Saturday Evening Post*. The issue came out on May 24, 1930, three weeks after *The Texan* opened. It was regarded as a publicity coup for Paramount, although today the painting is far more famous than Paramount's movie. Rockwell chose to depict the actor in his dressing room, getting made up for a scene. Cooper leans forward, his lips pursed as he receives the finishing touches on his lipstick from a grizzled makeup man with a cigar stub in his mouth. Painted at a time when America's relationship with the West was largely adoring, *Gary Cooper as The Texan* daringly pokes holes in the frontier myth. Cooper, the quintessential cowboy, is exposed as a guy who wears lipstick and whose virility is literally a put-on. (See color insert.) Note the hat in the lower left of Rockwell's painting. Instead of crowning a male head, the Stetson lies on the floor, a cast-off object that appears to be tilting into our space. Cooper doesn't need it. You can have it. It's just a prop, a clunky, obstreperous cliché.

The hat, by the way, is physically closer to the viewer than anything else in the composition. Rockwell often does this. He inserts an object or a figure into the foreground of his painting, between the viewer and the scene that is unfolding in the middle distance. The cowboy hat is a marker of the impossibility of entering fully into the warmth of the picture.

It is one of the tensions in Rockwell's art. He paints objects with the kind of fastidious realism intended to bring you closer to the touchable, handleable world. But then he paints a barricade in the foreground to keep you from touching. He cannot allow himself to touch what he wants.

•

Even in the winter, when the temperature could drop below zero, Reno, Nevada, was jammed with new residents. The majority were women who were there to end unsuitable marriages. They wanted out and felt they had made at least one good decision as they sat in hotel lounges and counted the days until they could put on a hat and gloves and appear before a judge. In 1929 you could get an uncontested divorce in a relatively short time. A three-month stay and the ability to pay your legal costs were all that was required.

"Mrs. Irene O'Connor Rockwell has been in Reno with her mother for about two months and has engaged the services of counsel," it was reported in the *Reno Evening Gazette* in December, one week before Christmas.[20]

On Monday morning, January 13, 1930, Irene appeared at the Washoe County Courthouse with her attorney and presented her case to a judge. She was the plaintiff and Rockwell was the defendant. Rockwell did not appear and no evidence was introduced on his behalf.

MRS. ROCKWELL GETS DECREE ON CHARGE THAT ARTIST SAID THEY WERE UNSUITED TO EACH OTHER, trumpeted *The New York Times* the next day.[21] The headline in the New York *World* was even more discomfiting: ACCUSED ARTIST OF MENTAL CRUELTY. Indeed, those were the grounds on which the divorce was granted. Irene charged that her husband was so absorbed in his work that he had barely looked at her in the fourteen years in which she had tried to share his life.

A property settlement was reached out of court and Irene received an undisclosed bundle of money. Rockwell kept the house on Lord Kitchener Road, the roomfuls of early-American furniture, the antique cherry clock, and the Duncan Phyfe–style dining table with the claw-and-ball feet.

She wasted no time in leaving Reno and beginning the next chapter of her life. Only five days after the divorce, on January 18, she married Francis Hartley, Jr., the chemical salesman from the Boston area. It was not easy finding a minister willing to perform the ceremony; her divorce stood in the way. After trying two other churches, the couple succeeded at the end of the day in getting a Dr. Moor to marry them at the Madison Avenue Baptist Church.[22]

Irene's wedding would have been hard for Rockwell to ignore. It was a headline in the morning paper. MRS. IRENE ROCKWELL WED, announced *The New York Times*.[23] She and her new husband settled near Boston, in Brookline, where they lived in Longwood Towers, a baronial apartment building that had just gone up. She had not wanted children with Rockwell and she would not have any with her second husband.

Rockwell never saw Irene again, but he remained on amiable terms with her brother George and was well aware of the fate that befell her. Only four years after the divorce, on a Friday in November, Irene's lifeless body was found in the bathtub by her husband. Her death certificate lists the cause as "accidental drowning."[24] In reality, it is nearly impossible for

an adult to drown in the shallow water of a tub because of the strength of physical reflexes that alert you to danger. But the firing of reflexes can be blocked by various factors, such as the consumption of too much alcohol. In Irene's case, it cannot be known whether drinking played a role; no autopsy was performed. She was forty-one years old.

# MARY BARSTOW

## (SPRING 1930 TO SEPTEMBER 1932)

Mary Barstow wore glasses and smoked Lucky Strikes. At twenty-two years old, she had a round face and frizzy hair that fell to her shoulders. She had graduated from Stanford the previous spring, in the class of 1929, a class composed mostly of men. That year, Stanford awarded 141 bachelor's degrees to women, out of a total of 878 degrees, which led people who met Mary Barstow to assume that she possessed a great store of confidence. They assumed incorrectly.[1]

Born in Wheaton, Illinois,[2] the oldest of three children, Mary had grown up in a prominent midwestern family. Her mother was the niece of Judge Elbert H. Gary, the chairman of U.S. Steel and also a native of Wheaton. Mary was still in grade school when her father, a lawyer, decided to move the family to Southern California. The Barstows lived in Alhambra at 125 Champion Place, in a house that was modern for its time, a long, low, prairie-style house at the end of the street where Forsythe and his artist-friends had their studios.

When Rockwell met her, Mary Barstow was living with her parents and teaching at a school in San Gabriel. She disliked the job and wanted to quit. The problem, she believed, was that she had been assigned to teach students in the seventh grade, the one grade she had skipped in her academically precocious girlhood. She had never learned fractions and now she had them coming out of her ears. Three-fourths is equal to how many eighths? She could not care less. She felt fragile enough without having to perform daily in front of a room of children and draw diagrams, on the blackboard, of circles severed into parts.[3]

At Stanford she had studied creative writing with Edith Mirrielees, an authority on the short story whose students included John Steinbeck. Mary's real interest was English literature and she imagined becoming a writer of fiction. Literature was the opposite of fractions; it combined the broken shards of daily experience into a seamless whole. She read voraciously and haunted bookshops, from which she usually came away with a few books at a time, purchases that filled her with a sense of possibility, a momentary belief that life grants you sufficient time to read everything you want.

•

By Rockwell's accounting, he met her at dinner at the home of Clyde and Cotta Forsythe. She was wearing "a bright orange dress," he recalled, skimping on his usual outlay of anecdotal detail. He called and asked her to dinner. She was busy. He asked her again. They went out. He had known her for exactly two weeks when he asked her to marry him. He had wed his previous wife with similar haste, as if the notion of a proper courtship was simply a pointless expenditure of time.

On March 19, 1930, he and Mary went downtown to the Los Angeles County Courthouse to apply for a marriage license. When he filled out the form, he gave his address as 1 West Sixty-seventh Street, in New York, the Hotel des Artistes. That part was true. He gave his age as thirty-three, chopping off three years, perhaps because he could not imagine why a fetching woman like Mary Barstow would want to marry a panic-stricken divorcé who had already crossed the divide separating thirty from forty.

News of the engagement was carried in newspapers around the country. the *Los Angeles Times* noted, "Miss Barstow, a graduate of Stanford University and member of Kappa Kappa Gamma Sorority, met Rockwell here through mutual friends two weeks ago."[4]

In a picture accompanying the article, they stand side by side, gazing directly at the photographer. Readers must have felt a quick moment of happiness for her, this local girl who had won the affection of a famous artist from New York. He towers over her in his suit and tie, a long man with a high forehead. Mary is blooming. In gloves and a floppy felt hat, she is lovely, lit up, her face as round as an apple.

News of their two-week courtship could have led anyone to imagine a whirlwind romance. He was, after all, an artist, with all that implied about a passionate nature and a willingness to flout convention. "Visitor's

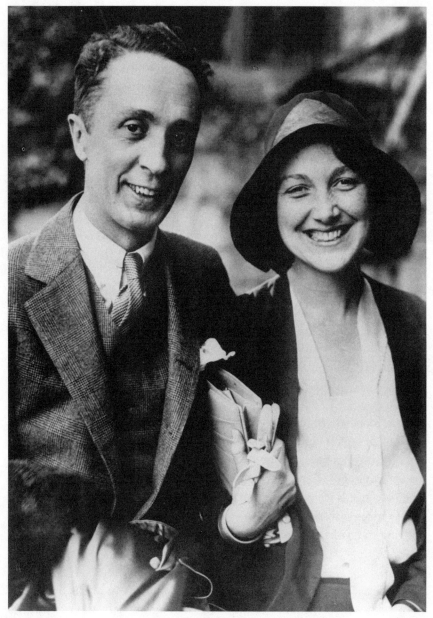

Norman and Mary in Los Angeles, on March 19, 1930, the day they applied for a marriage license

Romance Disclosed." So read the caption beneath the photograph, as if the relationship had been conducted clandestinely.

Yet readers who saw the announcement in the *Times* and then read the rest of the paper might have been surprised to find Rockwell mentioned in a second story. As it happened, he had spent the evening of his wedding engagement at a Boy Scouts event in Alhambra. The occasion was the awarding of Eagle Scout badges to two men in the same family, a troop leader and his teenage son, which was apparently some kind of first. "The presentation was made by Norman Rockwell," the paper reported, "who is spending the winter here."[5]

Mary had reason to feel slighted, but surely she held her tongue. She was good at putting on a cheerful front. She had been engaged for less than twelve hours and already he had to miss dinner and be somewhere else.

•

They were married on April 17, 1930, late on a Thursday afternoon, at her parents' house on Champion Place. It was a radiant day, and the ceremony was held in the garden, beneath the branches of pepper and eucalyptus trees.[6] The minister was Presbyterian, in deference to Mary's religion. Her sister Nancy was her only attendant. Clyde Forsythe was the best man.

Afterward, Mr. and Mrs. Barstow hosted an informal reception in their garden, where they received about 140 of their friends and relatives. Most of the guests had known Mary since she was a little girl, but were just meeting Rockwell for the first time. His parents did not come west for the wedding, nor did his brother. There were no plans for a honeymoon. The newlyweds were leaving immediately for New York, where Rockwell was to resume work. Already she must have known that artists are high matrimonial risks who save the best part of themselves for their art.

•

Arriving in New York, they settled into his apartment at the Hotel des Artistes. It was spring and the Upper West Side was leafy and bright. The Great Depression seemed to be happening somewhere else. Mary, who had never been in Manhattan before, was amused by the sight of men wearing black top hats in the middle of the day. "People didn't wear top hats in California," Rockwell explained on her behalf. Within two months, he was feeling restless. He missed his studio in New Rochelle and

wanted to return to it. Since his divorce, he had rented out the house to a Mr. and Mrs. Edward Leicester Bliss. They must have been quite good-natured because now, at his request, they agreed to let him use the studio.

For sleeping arrangements, he rented yet another commodious white Colonial directly across the street from his own.[7] But within six months, he managed to oust the Blisses from his house altogether. "He could not find another house with a studio he liked as well, so we broke our lease and we moved two streets away," Muriel Bliss, the couple's daughter, noted in a letter.

So there he was, back at 24 Lord Kitchener Road, with a new wife and the same old collie, the same telephone number (7383), the same early-American tea tables, the same antique candlesticks. Mary did not bother to redecorate, leaving everything the way it had been when Irene was last there less than a year earlier. One reporter who visited mentioned "dozens and dozens of genuine hook rugs strewn around on apple green velour carpeting." An insurance appraisal from 1931 confirms the presence of "high-pile Wilton carpet, green"[8] throughout the house, including the master bedroom, conjuring visions of a golf course.

Their first summer together should have been a season of possibility. Instead, Rockwell entered what he described as the worst depression of his life. It would not lift completely for four years. As had happened at various points in his past, he felt beset by feelings of inadequacy and unable to make even the smallest decision. "I began to go out to the studio at all hours to look at my picture and reassure myself that it wasn't as bad as I'd suddenly remembered it to be," he recalled. "But when I'd get out there, I couldn't tell whether it was good or bad. Or if I decided that it was bad I couldn't figure out why."[9]

•

Within the first year of their marriage, Mary began to feel excluded from her husband's company. It wasn't just that his work required him to close the door of his studio and make himself unavailable. It was also that he seemed to need a male artist to buck him up. He derived something intangible from his assistant Fred Hildebrandt that she could not provide.[10] Fred, a young artist in New Rochelle who earned his living modeling for illustrators, was attractive in a dramatic way, tall and slim, his luxuriant blond hair combed straight back. "He had marvelous bone construction," recalled the illustrator Mead Schaeffer. "He was a lifesaver for Norman."

Like Leyendecker, for whom he frequently posed, Fred was the son of German immigrants, Chicago-reared, and had settled in New Rochelle with his parents.

In 1930, Rockwell hired Hildebrandt to run his studio, which required that he help with all manner of tasks, from building stretchers to answering the phone to sitting on a hardwood chair for hours, holding a pose. Rockwell turned thirty-six that year, and Hildebrandt turned thirty-one. In photographs from the period, Hildebrandt is the image of athleticism, a handsome, well-built man in a checkered flannel shirt, smiling gamely as he puts a worm on a hook or tosses his fishing line into a lake.

He and Rockwell had first met at Forsythe's house out in Los Angeles, and Rockwell, jittery spouse that he was, had invited Fred to accompany him and Mary on the rail journey back to New York. But Hildebrandt declined to join the honeymoon. As he later recalled, Rockwell "was about to start a *Post* cover for which he wanted me to pose. However I felt the competition was too strong as Gary Cooper had posed for the one he had just finished. Anyway I had a date in Mexico, so I told him I'd see him back home later."[11]

The following year, they did travel together to California. In April 1931, by which time Mary was four months pregnant, she and Rockwell returned to her parents' house in Alhambra. During their three months in California, Mary made no mention of her pregnancy in letters to girlfriends but acknowledged her husband's wanderings. "Fred is with us a good deal," Mary noted to her friend Muriel Bliss on May 7. "He and Norman play squash after work and go off hiking in the mountains."[12]

At the end of May, Rockwell and Fred went off on a camping trip that lasted for two weeks.[13] They were trout fishing in Bishop, near Yosemite, when they decided to go climb Mount Whitney, which has an elevation of about fourteen thousand feet. It was enough of an accomplishment to merit a mention in the local newspaper: "Many people attempt the climb through the snow, though few gain the top, but the two men persisted in overcoming the difficulties of altitude and gained the highest point in the United States to gain a view of the surrounding country. Mr. Rockwell and Mr. Hildebrandt then started on their trip to Mexico where they are at present."[14]

Later that summer, the *Post* published a new Rockwell cover, *Colonial Couple* (July 25, 1931), in which a slender, poised man in a tricorn hat and stockinged legs tilts forward to kiss a blond milkmaid. It is the only *Post* cover by Rockwell in which a man and a woman kiss. He later noted with

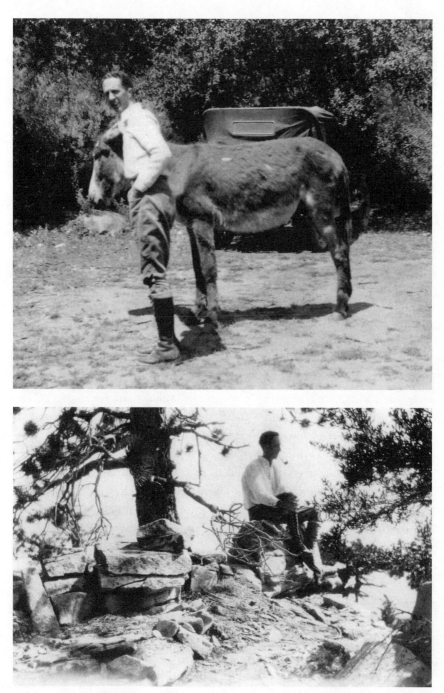

Fred Hildebrandt took pictures of Rockwell on their treks through the San Gabriel Mountains. (Courtesy of Alexandra Hoy)

Fred Hildebrandt, an artist, worked as Rockwell's studio assistant and model for a decade. (Courtesy of Gary Hallwood)

amusement that Fred, apparently a famous ladies' man, had kissed three women while posing for him—the first in New Rochelle; the second in Chicago, where they had stopped on their way out west; and the third when they reached Hollywood.

Mary was less appreciative of Fred, describing him as "a dead drag as far as work goes." But looking back on the trip out west, she did not regret it. The following spring, writing to her parents, she noted appreciatively, "California last year came in the nick of time, but that was only a temporary respite."[15]

•

His parents, in the meantime, were saddled with the problems that come with age. In the fall of 1930 Nancy Rockwell—then living in a rooming house called Barberry Bush, in Mount Vernon, New York—had summoned a "specialist" from Manhattan to her bedside. The doctor could find nothing wrong. He then had a chat with the good-natured Waring, who, in all his years of marriage, had been so preoccupied by his wife's ailments that it did not occur to him to harbor any of his own. But in fact

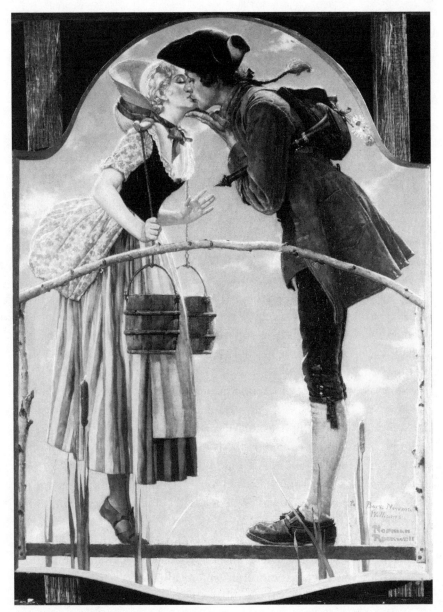

*Colonial Couple,* 1931 (Norman Rockwell Museum, Stockbridge, Massachusetts)

he was perilously ill with cancer of the esophagus. Though his chances for recovery were slender, he and his wife abruptly left home that winter and moved to sunny De Land, Florida, just north of Orlando.

He died a few months later, on July 3, 1931, a holiday weekend. He was sixty-two. Although he had been the most solicitous husband, he unnerved his wife by neglecting to arrange for his final care. For this she enlisted her artist-son. Rockwell had just returned from his stay with his in-laws in Alhambra when he rode the Atlantic Coast Line Railroad from New York down to Orlando to help out his mother. According to the obituary that appeared on page one of *The De Land Sun-News*, "Mrs. Rockwell and Norman Rockwell were with Mr. Rockwell when death came." A service was held at a church in Florida and then Waring's body was sent back to his native Yonkers, where he was buried on July 8 on the grounds of St. John's Episcopal Church, among the members of his wife's family.

In a letter to Clyde Forsythe, Rockwell reflected on his father's death with equanimity. "Pa was one of the gentlest and kindest men that ever lived, as you know. But he was suffering so much physically and he was so unhappy mentally because he could not work that his passing was really a blessing."[16]

Nancy Rockwell was now sixty-five, a widow without a home. Unwilling to stay in Florida, she briefly moved in with her son Jarvis, whose own life was in a state of upheaval. After prospering on Wall Street in the twenties, he had been ruined by the Depression. Early in 1931 he and his wife and two sons settled in in Kane, Pennsylvania, a small lumber town in the western part of the state. He took a job as a toy designer for the Holgate Company, which was creatively satisfying but forced him to live more modestly than he wished.

No sooner had she arrived in Kane than Nancy Rockwell realized she did not want to live there. Her grandson, Richard Rockwell, a future cartoonist who was then a boy of eleven, recalled her as a difficult, self-absorbed woman with no discernible affection for children. One night when his parents went out, "she demanded a babysitter because she didn't want to be left alone with the boys."[17]

"Jarvis tried to prove that he was the more loving son," Richard Rockwell continued. "He made the effort to have her come to Kane. But then she went back to Norman's area, New Rochelle. She favored Norman, because he was the baby."

Even so, there was no possibility that she might move in with Norman, who, like most artists, needed to avoid distractions in order to do his painting. She wound up moving back to Rhode Island, where she had lived briefly before her marriage and where she had a nephew she liked, John Orpen, who was in the ice-making business. Although Jarvis had supported their mother throughout the twenties, he no longer had the means to do so. The responsibility now fell to Norman, which created friction between the brothers.

On September 3, 1931, two months after his father's death, Rockwell became a father himself. He named the baby after his father, Jarvis Waring Rockwell, no matter that it was also his brother's name. To avoid confusion, Rockwell and Mary called their son Jerry. Rockwell was thirty-seven and glad to finally achieve some kind of paternal status after the ordeal of his childless first marriage. Mary noted that the two months before the baby arrived marked the first time she and Norman "were really on a normal sort of life."

Over time he would prove to be an ineffectual and distracted father. In his autobiography, the birth of his first child elicited no more than a passing reference to "Jerry, our eldest son, born in 1932"—the date was off by only a year.

Unlike his first wife, Mary knew about art and its history and was interested in hearing his ideas about art. He subscribed to the values of a classical art education, which means that he viewed drawing from the human figure as supreme. Yet he was also open to the adventure of abstract art. When Nancy Barstow, his wife's younger sister and an art student in California, mentioned in a letter that she was studying "abstract design," Rockwell replied that abstraction was "something I missed almost entirely in my early training and which I am just beginning to get interested in." That was on February 1, 1932. He dictated the letter and Mary typed it up, pleased that he was willing to respond so thoughtfully to her sister.

He added that he had recently been to the Museum of Modern Art, in Manhattan, where he saw the Diego Rivera show. It had opened the previous December, and Rivera was only the second artist to be given a full-dress retrospective at the two-year-old museum. (Matisse had been the first.) It may seem surprising that Rockwell was drawn to Rivera, a member of the Communist Party who intended his work as scathing social commentary. Yet the two artists had much in common. Both had a powerful narrative approach and saw themselves as storytellers. Both worked

in a populist idiom, presenting common people in strong, legible compositions. The difference was that Rivera was a history painter, recording such key events as the Mexican Revolution, while Rockwell painted a history of the American people that had never happened.

Walking through the show at the Modern, Rockwell was particularly struck by Rivera's early works, in which the artist wasn't afraid to be derivative and jump into the minds of the masters he loved. "He has studied in Spain, France and Mexico, and in each case he has allowed himself to absorb the qualities of the schools of art in each locality and you can see in his work how he has experimented with them," Rockwell notes in his letter.[18] "But in the end you see him painting his own art, to which he has brought all this knowledge and experience." He added that this is "a dangerous method," because if an artist "isn't strong enough," he will be overpowered by outside influences and never develop his own sense of style.

Rockwell, who was eight years younger than Rivera, had studied in similar places—he had done a stint in Paris and visited Madrid, wandering the long halls of the Prado and admiring the smoky Goyas. But what had he learned from his travels? He had not "experimented" the way Rivera had experimented. The thought put him in a rueful mood. He believed his failure to test different styles had prevented him from finding his own style, his true voice.

The Rivera show, it appears, converted him virtually overnight to the power of new art. Not long after seeing the show, he was interviewed by a reporter from the New Rochelle newspaper. He and Mary mentioned that they had been up late the night before listening to a talk about modern art on the radio. "I find the radio is one of the things that keeps me modern," Rockwell told the interviewer.[19] "When I say it keeps me modern," he continued, "I don't mean in the sense of futuristic art. I mean an artist's work has to keep abreast of the spirit of the times, no matter what his mode of expression may be. If he is unable to do this, it is a very sad thing."

He decided suddenly they would pick up and go abroad. Within the space of just a few weeks, Rockwell would be living in Paris. As Mary wrote in a letter, he was hoping to "experiment with all sorts of things" and hence "become an artistic artist rather than a commercial one."

•

On February 26, 1932, Norman and Mary sailed for France, along with six-month-old Jerry and Raleigh, their long-haired collie. It was the bleakest

winter of the Depression, with fifteen million men out of work and a third of the nation's factories shut down. But the Rockwells, who didn't have to worry about money, traveled in high style. They crossed the Atlantic in five days, aboard the luxurious RMS *Mauretania*, a British ocean liner on which Mary was delighted to discover such amenities as an oak-paneled reading room, a live orchestra that performed even in the morning, and the chance to play Ping-Pong on the promenade deck "to get up an appetite."

For most of March, they looked for an apartment in Paris, during which time they stayed at the Hotel Wagram on the Rue de Rivoli, in two rooms overlooking the geometric greenery of the Tuileries garden. Rockwell wasted no time in renting a studio on the Avenue de Saxe, in the Seventh Arrondissement, a quaint space with "a couch and shelves in a corner all covered with deep wine colored velvet."[20] On April 11, they settled on a residence, signing a six-month lease for a furnished home at 12 Villa de Saxe, "just one long block" from his studio and complete "with a garden for Raleigh and Jerry."[21]

About once a week, Mary would sit down with a pack of Lucky Strikes and confide in her "Dearest Mother and Daddy," sending her parents detail-laden letters that sometimes ran to ten pages. About thirty letters survive from this period and they capture the strains of an artistic marriage. On most days, it seems, Rockwell was consumed by problems he was having in his work, while Mary took care of their baby and tried to maintain a cheerful tone. Most everything, as described in her letters, was "swell" or "grand" or "glorious."

They lived well, with a retinue of paid help. A French housekeeper and cook, Amelian, "an absolute jewel,"[22] arrived every morning to do the cleaning and laundry and marketing. She won raves from Mary for her *poulet blanc* and "kidneys cut up in gravy in some delectable way." A tutor visited twice a week to help her master the French subjunctive. A tailor, "Paquin's head cutter," came by to fit her for a suit.

She visited the American Library in Paris, where she borrowed, among other things, *Robinson Crusoe* and *The Vicar of Wakefield*, favoring eighteenth-century literature with an emphasis on manners and morals. She wanted to do everything right—to read the classics, to dress smartly, to socialize with "interesting" people, to smoke less and exercise more, and "to lose some waist band," as she wrote.

In her letters, Mary offered few anecdotes about her husband, perhaps because she wanted to share only good news. He could be irritable and

judgmental about small things, and she felt hurt when he criticized her clothing: "Norman informed me this morning that the green suit . . . was never to be put on again, even in the remotest Brittany!"

Physical ailments added to his moodiness. His back was "still troubling him from the time he lifted a ping pong table" a few weeks before they left home. He suffered sharp shooting pains, lumbago as the doctors called it, and saw an osteopath once a day for some kind of adjustment.

To be sure, there were some cozy moments, such as a morning when Mary sprang from bed to check on little Jerry, cleaned him up, and carried him back into her room. "Norm was still in bed," she noted, "with Raleigh in my place." She rested the baby between her husband and the collie and "my three men had a beautiful time."[23]

She had at least one friend in Paris, Louise Connett, a well-to-do American expatriate whose husband was in the export business. Rockwell and Mary met the couple coming over to France on the *Mauretania*. The Connetts entertained frequently, and it was Mrs. Connett who gave Mary her first taste of champagne, at a luncheon for the members of the American Women's Club. Mary felt thrilled to be included in such an impressive group, "just as though I were a *person*," as she noted in a letter.[24]

Perhaps she felt like less of a "person" with her husband, who resisted her efforts at socializing and who cared little for the patrician Connetts. "Norman was all down on society as represented by Mrs. C.," she reported. He preferred the company of Alan Haemer, an art student, "to any one in better circumstances."

Indeed, no sooner had Mary settled into the apartment on the Avenue de Saxe than Rockwell gave up his studio on that street and acquired a new one in Haemer's building. It was smaller than his previous studio, a ten-minute tram ride over the Seine, near the Pont de Grenelle. Although Mary was vexed by her husband's attachment to yet another worshipful young friend who distracted him from his marriage, she tried to be understanding. It was "awfully nice," as she wrote, for him to have "some one near him, a man, and an artist with whom to talk things over."

Haemer, at the time, was twenty-two, a Brooklyn native with broad shoulders and a strong jaw. He was the sort of masculine artist Rockwell was always seeking out, a brother and protector. Haemer had made headlines when he arrived in Paris—paddling from Holland, alone in a flat-bottomed canoe, which took forty-one days and set a record of some sort.[25] At the time, he had just graduated from Syracuse and won a fellow-

ship to study painting at the Sorbonne. He eventually became an accomplished commercial artist, designing the jackets of hundreds of novels, including those of Howard Fast. But for now he had little in the way of income or reputation and all the time in the world to sit and puff his pipe with Rockwell. They would often talk late into the night and wander over to Les Halles after midnight for a bowl of onion soup.[26]

During the day, Rockwell, who was zealous about sketching, might invite his friend on a sketching trip. One memorable afternoon, they lugged their portable easels and paint boxes to the banks of the Seine. Haemer began work on a "random landscape,"[27] as Rockwell undertook a portrait of a French fisherman who had agreed to pose for him. By late afternoon the light was fading and Rockwell, not yet finished with the portrait despite his concentrated effort, asked the fisherman to surrender his hat. He figured he could take it back to his studio and complete the painting there. The hat was badly stained and he felt he hadn't rendered the stains as accurately as possible. "Monsieur," Rockwell proposed, "I would like to offer you a day's wages for your hat." The fisherman declined, so Rockwell, visibly agitated, offered him a week's wages. When the fisherman again declined, Rockwell became enraged. It was one of only two or three times in his life when anyone saw him lose his temper.

He did not get the hat.

•

He had gone to Paris, the international capital of art, to reinvent himself, to escape his pressure-cooker schedule and nonstop cycle of deadlines. He was tired of owing things to magazine editors and art directors at advertising agencies. He wanted to be a "real" painter, as Mary noted in a letter, to strive for something large instead of batting out covers.

On the other hand, he did feel genuinely connected to the *Post*. One day when he ducked into the gift shop at the Louvre, he bought Mary a miniature sculpture, "a six inch reproduction of Benjamin Franklin by Houdon," as she noted. It had more significance for her husband than for her—Ben Franklin was purportedly the *Post*'s founder, as it said on the cover every week. Perhaps the bust was a symbol of Rockwell's career, one he wished his wife could enjoy.

Mary, however, did not regard the *Post* highly. In her letters, she comes across as a woman who harbored the upper-class biases of her time, which led her to dismiss magazine illustration as a small, coarse thing. She

remarked in one letter, rather insultingly, that the two weeks Rockwell allotted to complete each of his covers was too long, "out of all proportion to their value."[28] It is not clear if she was referring to financial value or aesthetic value. Either way, she seemed to believe commercial art was trivial, and her attitude exacerbated Rockwell's already substantial insecurities about his chosen métier.

On some days, it all seemed perfectly clear to him. He imagined breaking his relations with the *Post*. He swore he would never open another letter from an advertising agency. Such a moment occurred on April 26, two months after he arrived in Paris, when Mary noted that "the preliminary struggle—nearly two years long, has ended at last, and he knows what he wants to do." Or rather what he did *not* want to do. After much deliberation, he sent a telegram to Snyder & Black, the advertising agency, "refusing to do the Coca Cola." In earlier years he had done several calendar illustrations for the company, painting a series of country boys with bare feet and sandy coloring, grinning from beneath straw hats as they held up their bottles of Coke.

Moreover, Rockwell notified his editors in Philadelphia that "he has indefinitely postponed his Post covers," as Mary put it. "I personally rather doubt if he'll do any more." Indeed, there would be a hiatus of ten months, the longest of his career, when his work did not appear in the *Post*.

Instead he resolved "to experiment," to leave the cocoon of the *Post* and cross a threshold into an unknown world. He imagined trying his hand at portraits that had some of the bravura brushwork of French Impressionism or the drunken color contrasts of Fauvism. But the problem continued to be that he found himself blocked in the absence of a deadline. He could produce when he had assignments, but was paralyzed without them, as if afraid of what he could lose if he chose to paint for his own pleasure. The hazards were substantial. He could lose his hard-earned reputation as a painter. He could lose his shirt. He could lose a system of belief that was premised on his genuine reverence for Howard Pyle and the Golden Age of Illustration.

Or perhaps his resistance to experimentation was rooted in his general cautiousness. Prim and repressed, he had no use for modernism's inside-out forms and disrupted narratives. He wasn't interested in cracking open the surface of art, exposing it as artifice. He had more in common with premodern artists, such as the British Pre-Raphaelites, whose detail-laden surfaces conspired to create beautiful facades and illusions.

As the months passed, Mary continued to assure her parents that Rockwell was trying new things in his work, even if only in his *Post* covers. "Norm is simply getting along marvelously now," she noted in August. "He just sent off two Post covers, and now, having found a different technique in which he feels there are possibilities, he feels free to experiment to his heart's content, which means he is really going to be an artist."

In the course of 1932, Rockwell completed only three covers for the *Post*. They were not memorable, except as a reflection of his discontent. *The Puppeteer* (October 22, 1932), shows an elderly craftsman standing in the center of the composition, his sleeves rolled up and his shoulders hunched as he demonstrates his handiwork. He is pulling the strings of two wooden marionettes, a Colonial-era man and woman dressed like George and Martha Washington, who face one another as they hover slightly above the ground. Rockwell's friend Alan Haemer carved the heads of the puppets, and also posed for the hands of the puppeteer.[29]

The male puppet, dressed in ruffles and a red waistcoat, has removed his hat and bends toward the woman at a sharp angle. The female figure, who is wearing a big, puffed-up Creamsicle-orange dress, responds with a curtsy. You can read the cover as an allegory of an unhappy marriage, capturing a man and a woman who are forced to play roles and bow to social conventions that are not of their choosing.

•

On September 17, a week before Alan Haemer left Paris and returned to the States,[30] Rockwell and Mary and their son and their collie sailed out of Cherbourg aboard the SS *Berengaria*. They arrived at the port of New York six days later. Rockwell was, by his own admission, "in a worse state than before." Despite Mary's much-stated optimism, here he was, back in his studio on Lord Kitchener Road in New Rochelle in the cool, crisp days of early fall, thinking that his eight months in Paris had been for naught. He had failed to experiment, to become a modernist, to be freed from his indenture to the *Post*.

# THE NEW DEAL

## (1933 TO 1935)

March 12, 1933, fell on a Sunday. At ten that night, the new president, Franklin D. Roosevelt, delivered the first of his fireside chats, a radio broadcast from his study in the White House. "My friends," he began in his reassuring voice, "I want to talk for a few minutes with the people of the United States about banking."

Among the millions of listeners was George Horace Lorimer, who was now sixty-five, an enormously wealthy man still living in Wyncote, Pennsylvania, in a house cluttered with pressed-glass pitchers and other Colonial-era antiques. In his three decades as editor of *The Saturday Evening Post*, he had thickened considerably, perhaps because he prided himself on always having a box of Wilbur Buds chocolate candy within reach. Lorimer was responsible for the weekly editorials that ran on page 22 of the *Post* and he could be bitterly partisan. Although he had initially devoted his magazine to championing the interests of businessmen, he became more doctrinaire as time went on. He was unhappy to see President Herbert Hoover succeeded by a Democrat and insisted that Roosevelt's image as a protector of the common man was nothing but a sales job. He wrote off the New Deal as a raw deal, so much "socialist claptrap" that went against the American belief in free enterprise, individualism, and self-reliance.

Lorimer's altercation with President Roosevelt set him at odds with the progressive minds of his generation. And it put Rockwell in an awkward position, which is not to say that he was a crusading Democrat. His political sensibility, at this point, was nonpartisan and almost nonexistent. According to election records, when Rockwell registered to vote in the

1932 presidential election, he registered as a Republican, as did Mary Rockwell.[1]

But his *Post* covers were always small-*d* democratic, which is true of genre painting generally. It is, by definition, egalitarian at its core, lavishing attention on ordinary people and suggesting that every life deserves its own spotlight. That message hardened into an official art movement during the Depression, when regionalism became the prevailing "ism." The farmers who populated the work of Thomas Hart Benton and Grant Wood were extolled as evidence of the workaday heroism of midwesterners and the can-do spirit that would rescue America from its economic woes.

For Rockwell, whose work was in sync with the populist core of regionalism, the Depression years should have been a productive period. Yet they turned out to be a singularly fallow time for him. He claimed to be racked with his own depression, consumed by "an all-around feeling of dissatisfaction," as he put it. His editors at the *Post* regularly sent him flattering telegrams and imploring letters, hoping to pull more covers out of him. He confessed to friends that he had no idea what to paint—humorous illustrations seemed irrelevant, indecent, when the rock-hard realities of the Depression had left so many people suffering.

Moreover, he was grappling with the pressures of a marriage and children and the suspicion that he did not feel any more attracted to his second wife than he had to his first wife. He still cultivated close relationships with men outside of his family, men who put him at ease and, during this period, his studio assistant Fred Hildebrandt assumed a central role in his affections.

On September 3, 1934, Rockwell and Hildebrandt headed off on a two-week fishing trip in the wilds of Canada. Oddly or not, the day he left was his son Jerry's third birthday. Mary stayed behind in their white Colonial house on Lord Kitchener Road, to take care of the boys. In addition to Jerry, there was now eighteen-month-old Tommy—Thomas Rhoads Rockwell, born at New Rochelle Hospital on March 13, 1933, the day after President Roosevelt held his first fireside chat.

Rockwell brought along a medium-sized spiral sketchpad that he wound up using as a diary on the trip. Perhaps he was taking his cue from Hildebrandt, who kept a journal of his fishing exploits and liked to catalog his every catch, to specify whether he landed a brown trout or a red trout, a pike or a walleyed pike, whether it measured twelve inches or fourteen,

whether the weather had cooperated or whether a cold lashing rain had forced him to fish from the safety of the river bank. Rockwell's journal is a different creature altogether, providing a revealing glimpse into his jumpy and obsessive state of mind.

As Rockwell noted, he and Fred began their sojourn in Montreal, walking around in the rain while awaiting a train that was scheduled to depart that afternoon. Consumed by the cleanliness of his shoes, Rockwell stopped to have them polished, more than once. As he noted in his diary, "had shoes shined 3 times"—a perhaps unnecessary start to a trip that would take them trekking through untold quantities of mud.[2]

From Montreal, they rode an overnight train that took them four hundred miles farther north, to the tiny Bourmont rail station in the middle of the unspoiled wilderness of Quebec. The area was inaccessible by road. There they stayed at a camp run by a Mr. Segouin, who, Rockwell was amused to learn, "was not sure whether he had 10 or 11 children." To judge from Rockwell's diary entries, the trip was genuinely rugged and devoid of

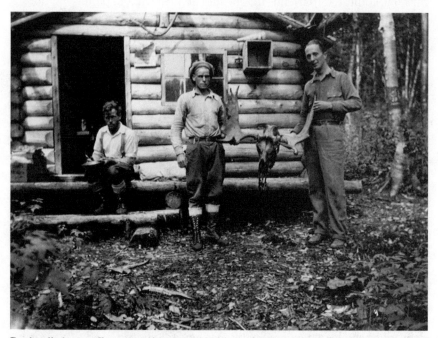

Rockwell shows off a moose head outside his cabin at the Segouin camp in Quebec, where he was assisted by two French-speaking guides. (Photograph by Fred Hildebrandt; courtesy of Alexandra Hoy)

further shoe shines. He and Fred, accompanied by a pair of French-speaking guides named Dan and Pete who knew almost no English, used a log cabin at the Segouin camp as their base and did a lot of canoe paddling in the rain, most of it in high and remote lakes rimmed by dense forest.

Although Rockwell lacked Hildebrandt's stamina, complaining of sore muscles and needing to nap every day after lunch, he seemed to enjoy the trip. From one day to the next, he and Fred set out in their canoes, paddled for miles and caught fish. Their meals were predictably heavy on fish. Rockwell might wake to find "pike frying in the pan," and then end the day with "a swell dinner of trout, potatoes and baked beans" that had been cooked by the two guides.

Rockwell was then a married man of forty. Fred was a single guy of thirty-five. Reading through their diaries, it is hard to ignore the homoerotic aspects of their camping trip. On September 6, his second day at the camp, Rockwell is delighted to wake up in the early morning cold air and spot his friend lounging around in a new outfit. "Fred is most fetching in his long flannels," he notes appreciatively.[3]

That night, he and Fred played gin rummy until eleven, sitting by the stove in the cabin and using a deck of cards that Rockwell had made himself. "Then Fred and I get into one very narrow bed," he noted, referring to a rustic cot made from a hard board and a sprinkling of fir branches. The guides climbed into a bed above them, and "all during the night pine needles spray us as they drop from the guides' bed."

Two nights later, Rockwell and Fred played "rummy by candlelight til 9:30 p.m., then to bed. Guides insist on roaring fire in cabin stove, and window and door closed. Fred and I very hot and dream no end."

On the morning of September 11, they went out for a swim. "We paddle to portage near waterfall. I strip and frollick about—see photos." All of this is suggestive material, up to and including the "lick" in his spelling of "frollick."

The trip raises a complicated question: Was Rockwell homosexual? It depends on what you mean by the word. He demonstrated an intense need for emotional and physical closeness with men. From the viewpoint of twenty-first-century gender studies, a man who yearns for the company of men is considered homosexual, whether or not he has sex with other men. In Rockwell's case, there is nothing to suggest that he had sex with men. The distinction between secret desires and frank sexual acts, though perhaps not crucial to theorists today, was certainly crucial to Rockwell.

Granted, he married, but his first marriage and to some extent his second were not happy. They seem less like genuine unions than a strategy for "passing" and controlling his homoerotic desires, whose expression he confined to his art. He was afraid of all physical intimacy, male or female, but decidedly more comfortable in homosocial male groups than in any standard domestic role, be it that of husband, father, or man of the house.

•

As Rockwell caroused with his male friends, Mary felt as if he had slipped across some invisible divide. From one day to the next, she consumed large quantities of "caffeine pills," a precursor of antidepressants. And she was constantly reaching into her purse or yanking open drawers in search of a Lucky Strike cigarette. Her children would come to think of her as more affectionate than their father and more curious about their day-to-day lives. But she, too, could be distracted. "She wasn't interested in child-rearing," her son Jarvis recalled without bitterness. She did not cook or keep house and she had enough money not to have to think about those things. A British couple, Florence and Jack Currie, had been hired to help her out. Mrs. Currie did the cooking and her husband, a former milkman, took care of the gardening. Mary seemed happiest when she was reading. At night she would snuggle up in bed with the boys and read aloud. At times she read to her husband as well, perched on a stool in his studio. They made it through *War and Peace* twice, according to family lore.

Around this time, Rockwell acquired a police dog, a massive German shepherd.[4] He had owned a police dog once before, in the mid-twenties, before he acquired his collie Raleigh, the one that had sailed to Paris with him. Despite the plethora of playful mutts that appear in his paintings, when Rockwell got a dog for himself, he got a purebred. He named the new one Raleigh, the same as his previous dog. Raleigh II had a *Post* cameo in *Man Hiking with Dog*, one of those seasonal covers so beloved by Lorimer, who seemed ready to claim the arrival of fall as an American holiday.

Rockwell's neighbors knew to stay away from Raleigh, who would growl when strangers stepped near. They assumed Rockwell acquired his new German shepherd because he felt spooked by the kidnapping of the Lindbergh baby, which was just being tried in court. "The dog had a tremendous head," recalled Norman Kreisman, who was then a schoolboy living across the street from Rockwell.[5] Kreisman had a dog, too, a small mutt, and one day it wandered onto the Rockwells' front lawn. "My dog

came within an inch of being killed," he later recalled. "Raleigh took a real chunk out of him and he had to be hospitalized." When the family received a very large bill from the veterinarian, Mrs. Kreisman called Rockwell and asked him whether he would pay for half. To her relief, he graciously assented.

•

On May 18, 1935, it was reported that Rockwell and his family were on their way to California, where they expected to stay for five months. For the first time, they traveled by airplane. "Fred Hildebrandt," the article noted, "also an artist and a close friend of the Rockwells, left in their car, taking their dog, and will join them there."[6] They stayed, once again, with Mary's parents in Alhambra, which was fine with Rockwell. With two sons under the age of four, a wife who tended to feel overmatched, and a widowed mother who looked upon babysitting as hard physical labor bordering on punishment, he was receptive to his in-laws' generosity and calm, uncomplicated company.

Besides, Los Angeles was its own trove of humorous story ideas. Rockwell's oft-repeated plaint about being unable to paint a glamorous woman was instantly disproved in *Movie Starlet and Reporters*, a wonderfully vivid painting that graced the cover of the *Post* on March 7, 1936. (See color insert.) A redheaded Hollywood star, who is traveling to promote her latest film, is shown in an unnamed city, being interviewed by the local press corps. Six male reporters in fedoras and dusty overcoats form a tight circle around her. You know from the actress's bouquet of welcome roses that she arrived in town only moments earlier, perhaps after a transcontinental rail journey. Her monogrammed suitcase and matching hatbox declare her point of origin in crimson type: HOLLYWOOD. The reporters' faces, for the most part, are blocked from view, but their eagerness is conveyed in the choreography of their leaning bodies, raised pens and note pads held at the ready. To the right stands a radio reporter, a bulky man in a black trench coat with a ragged hemline. He holds up a mic—a silvery circular thing, an old-fashioned carbon microphone that hovers in the center of the composition like a metal screw holding it together.

David Rakoff, the writer and essayist, wittily observed: "The reporters all seem poised to ask the same question, which is, 'And how do you like it here, Miss Film Star?'"[7]

Will she answer their query? Or will she imperiously decline to be

interviewed? The painting pits the evolving technology of sound transmission against the possibility of sound failure; the actress reserves the right to say "no comment" and thereby defeat old media (pencils and note pads) and new media alike. You could say that Rockwell here uses the press (that is, the cover of the *Post*) to poke fun at the press. His send-up of the celebrity news business has lost none of its relevance in the seventy-five-plus years since it was painted.

The starlet, it has often been noted, bears a resemblance to Jean Harlow, but Rockwell used an aspiring actress, Mardee Hoff, the daughter of illustrator Guy Hoff, as his model. In general, he disliked using famous people as models. Their presence in a painting was distracting and constraining and kept him from making stuff up. Besides, he could hardly expect Harlow and her celebrated ilk to stand in his studio for four days, holding her head at the requested angle until he was done trying to render it as accurately as pencil will allow.

That August he visited the Paramount lot in search of a model for a new painting. He could have picked anyone, but he picked Charles King, an older, underused Broadway actor and vaudevillian who was milling around the set of the movie *Annapolis Farewell*. Rockwell was delighted by his big belly. He hired him to pose for a week, seated on top of an English stagecoach that looks like something out of Dickens.

*Dover Coach*, as it was called, is a six-foot-long, horizontal painting that ran as a two-page spread inside the *Post*'s Christmas issue that year. Here they come: a rotund coachman swaddled in his ankle-length traveling coat, a few women in bonnets, a bony gentleman who is clearly in agony as a boy blasts a trumpet in his face. They're crowded onto the outside of a stagecoach like a row of figures arrayed on a Greek frieze.

Later, in 1939, Rockwell donated *Dover Coach* to the Society of Illustrators, in honor of its new building, an elegant limestone edifice on East Sixty-third Street in New York. For years the painting hung on the fourth floor, on the wall behind the oak-wood bar, between shelves stocked with drinking glasses. It became a local landmark, especially among illustrators, who, when trying to figure out where to meet one another, were known to suggest, "Let's meet under the Rockwell."

•

By his own account, Rockwell claimed he fell into a depression in the early thirties and didn't come out of it until 1935, when he returned home

from California and embarked on a project that had nothing to do with *The Saturday Evening Post*. George Macy, an independent publisher and scion of the department-store family, had just started the Heritage Press as a division of his Limited Editions Club. His goal was to bring out illustrated classics and he thought Rockwell would be perfect for Mark Twain's *Adventures of Tom Sawyer*.

Rockwell initially declined, or rather said that he needed at least a year before he could even think about such a daunting project, which would require eight color paintings as well as drawings for the chapter headings. Macy said he would wait. Rockwell had not attempted book illustration since his art student days some twenty years earlier. It paid far less than magazine work. But it allowed him to reconnect with his childhood reverence for illustration, his belief that he had embarked on a noble pursuit enlarged by its proximity to literature. And he felt especially connected to Twain. Rockwell's mischievous boys are descendants of *Huckleberry Finn*, the most famous of all Missouri boys. He is "free of school, free of female relatives, of houses, of manners . . . free from having to grow up," as the critic Noel Perrin writes of Huck. "He was to remain forever prepubescent."

In mid-October, Rockwell mentioned in a letter to Macy that he was planning on visiting Twain's Missouri on his way home from California. Conveniently, he had his station wagon with him in California and so was able to drive at the end of the month to out-of-the-way Hannibal, the old river town where Twain had spent much of his childhood and set *Tom Sawyer*. Rockwell's goal was to gather "authentic details" for his illustrations, and he considered it a point of pride that he was the first in a long line of Twain illustrators to conduct research in Hannibal.

During his stay he visited the mandatory pilgrimage sites—Twain's white frame home, the old picket fence (still standing, with a little help from restorers), and the cave with its winding passageways where Tom and Becky had gotten lost (it was on private property and cost fifty cents to enter). He sketched the bedroom window from which the young Sam Clemens used to climb, perhaps remembering the window in New Rochelle from which his model Billy Payne fell to his death fifteen years earlier.

Within a few days he had filled his sketchbook with hundreds of "authentic details," as he called them. He had also acquired an assortment of costumes to bring home for his models. Huck, as described by Twain, was always dressed "in the cast-off clothes of full-grown men." Rockwell loved

to tell the story about how he persuaded the citizens of Hannibal to sell him their old clothes. Young men and old men thought he was kidding when he stopped them on the street and offered them as much as five dollars for their threadbare overalls. Among his purchases was a floppy straw hat that was, as he noted, "in a beautiful state of decay—sun-bleached, ragged."

In reality, the clothing that Rockwell glimpsed in Hannibal in the autumn of 1935 had nothing to do with the clothing worn by Twain's characters. *The Adventures of Tom Sawyer* is set in the 1830s and 1840s—a century before Rockwell arrived in Hannibal and collected clothing and props. But he did enjoy acquiring clothing from men who caught his eye, as if it were possible to acquire the less tangible parts of them as well.

As to his own wardrobe, he was by no means a dandy. He tended to dress neatly but inconspicuously, in Brooks Brothers shirts and khakis and loafers. He dressed, in other words, like a man who was far more interested in looking at people than in being seen. Revealingly, a tax return from this period indicates that he spent $423 on costumes in seven months and $12 on his own clothing.[8]

•

On November 19, 1935, Pete Martin, the art editor of the *Post*, wrote to Rockwell from his office in Philadelphia: "Don't let anyone sidetrack you from POST cover work for the next few months, because we need some more Rockwell covers very badly."

A new year arrived, and Martin wrote again: "We are looking forward in 1936 to seeing you complete the swell array of ideas Mr. Lorimer okayed on your last visit. I hope you don't get sudden flashes of inspiration on other ideas that will interfere with the program you mapped out."

Indeed, by now Rockwell was consumed with his work on Tom Sawyer and it would take him a year to finish. He knew whom he wanted to pose for Huck. He was driving through New Rochelle when he first spotted him, milling on a street corner with a group of boys, ice skates slung over his shoulders. Charlie Schudy was short and athletic, with red bangs that fell in a straight line across the forehead of his sweet, round face. Pulling over to the side of the road, Rockwell invited Charlie to his studio. The boy declined.

"Those were the years of the Lindbergh kidnapping," Schudy later

recalled, "when you weren't supposed to talk to strangers."[9] Intent on persuading the boy to come with him, Rockwell suggested that he bring along his friends, who happily piled into his station wagon.

Charlie was then a sixth-grader at Holy Family, a Catholic parochial school in New Rochelle, and for the rest of that year Rockwell would regularly summon him from classes. The nuns would inform Charlie that he had a visitor and he would head outside to find Rockwell parked at the curb, sitting alone in his car. Unlike most of the other children who modeled for Rockwell, Charlie Schudy disliked the process. When Rockwell asked a kid to hold a pose, he expected him to listen. And Charlie could not for the life of him understand why he had to stand for two consecutive thirty-minute sessions with a matchbox tucked under his big toe. The point of the matchbox was to make his toe curl away from the rest of his foot, as if it were being tickled by grass. "It was a horrible ordeal," he later recalled, only half-jokingly. On the plus side, Rockwell paid well. Charlie's sessions of modeling netted close to one hundred dollars, which he used to purchase a Schwinn bike.

Another twelve-year-old, Richard Gregory, posed for Tom Sawyer. He first met Rockwell in November 1935, when his younger brother Don, a *Post* delivery boy, fell ill and asked him to fill in for him on his route. It happened to be raining hard. Richard, not wanting to toss the magazines into puddles, knocked at front doors and handed the magazine to whomever answered. Rockwell answered at 24 Lord Kitchener Road.[10] He was delighted by what he saw. A boy in a shiny rain slicker, a wet boy with blond hair and a wide grin and a chipped front tooth (the result of a sledding accident). On the spot, Rockwell asked, "Would you pose for Tom Sawyer?"

Richard Gregory wound up posing on Saturdays over the course of six months, an experience about which he had mixed feelings. He, too, found posing to be physically arduous and developed a crick in his neck after standing in place for three thirty-minute sessions with his head tilted back, his mouth agape, awaiting the spoonful of castor oil which Aunt Polly was about to deliver. He never actually met Aunt Polly, who posed in separate sessions.

Of all the illustrations, surely the most interesting is the one that shows Tom Sawyer sneaking out of the upstairs window of a white-shingled house in the middle of the night. As he perches on a window ledge, shadows cast by tree branches reach toward him like dark, elongated fingers. The piece

An illustration for *The Adventures of Tom Sawyer* harks back to the tragedy of Billy Payne.

sends a shiver down your spine, mainly because it harks back to the death of Rockwell's model Billy Payne, who had climbed out a window and fallen to his death fifteen Aprils earlier.

Tom Sawyer's window charade is hardly a major scene in the novel, and in fact is mentioned only passingly ("a single minute later he was dressed and out of the window and creeping along the roof of the 'ell' on all fours. He 'meow'd' with caution once or twice, as he went"[11]). It is interesting that Rockwell chose to depict it. His interpretation of it departs dramatically from Twain's story line. In Rockwell's illustration, Tom is transported to a suburban house with another house visible next door and, as he climbs out of the window, he pauses and cries out into the night.

●

In later years, in the seventies, Rockwell received an admiring letter from Cyril Clemens, a cousin of Twain and the editor of the *Mark Twain Journal*, in Kirkwood, Missouri. He had seen Rockwell's *Tom Sawyer* as well as the *Huck Finn* volume that followed, and he wrote to "applaud your wonderful work in the memory of Mark Twain."

But Rockwell would have none of it. "As much as I loved the books," he replied in a letter to Clemens, "it was a long time ago and I did not realize the deep significance in them and did not portray, particularly Huckleberry Finn, with the depth of understanding that I should have."

That was true. The Heritage editions of *Tom Sawyer* and *Huck Finn* each contain eight color plates and they do not represent the artist's best work. They are more impressionistic than his *Post* covers, and the facial expressions are cartoony. But soon he would find his mature voice.

# HELLO *LIFE*

## (FALL 1936 TO 1938)

In September 1936, George Horace Lorimer retired as the editor of *The Saturday Evening Post* after a reign of almost four decades. He handpicked a successor who inherited his corner office on the sixth floor of the Curtis Building in Philadelphia. Wesley Stout was forty-seven, a dark-haired, preppy-looking newsman from Junction City, Kansas, who had been with the *Post* for more than a decade. He shared Lorimer's Republican politics and animosity toward the New Deal. "To succeed squarejawed, hardworking, conservative Mr. Lorimer," *Time* magazine reported mockingly, "the Curtis directors ratified the retiring editor's own choice of a square-jawed, hardworking, conservative colleague."[1]

Wes Stout would stay on as editor of the *Post* for five years and make a remarkably small dent. Unlike Lorimer, he was not paternal and lacked what is probably an editor's most important attribute: the ability to create an atmosphere in which writers can do their best work without distraction. As F. Scott Fitzgerald noted bitterly in a letter to his wife, Zelda, "The man who runs the magazine now is an up and coming young Republican who gives not a damn about literature."[2] Rockwell disliked Stout, too, and considered him a cold, conventional bureaucrat who was was insensitive to the needs of artists.

Rockwell claimed there there was always something that Stout wanted changed in a cover when it was started and something he didn't like about it when it was finished. Once Rockwell was told that a painting was perfect, except for the shoes. Without explanation, Stout requested that a boy's brown shoes be changed to black. "I wasn't able to paint a cover

with any conviction because I knew that some little thing would be wrong with it," Rockwell recalled. "His constant nagging sapped my inspiration, made me unsure of myself."[3]

Stout hoped to attract a new generation of young readers, the coveted demographic for advertisers, and it did not occur to him that Rockwell could help do that. He began his tenure by tearing into Rockwell's *Ticket Agent*, which shows a clerk with a thin, tired face on a regular work day, inside his little booth, his head resting in his hands, a patch of white scalp visible beneath his combed-over strands of brown hair. Sitting behind a barred window, he is caged in every way, tethered to his ho-hum job and unable to avail himself of the kind of vacations advertised in the posters surrounding him. Seven or eight travel posters thumbtacked around the window conjure the pleasures of mountain resorts and blue skies, of cruises to Europe and even the Orient. You suspect that transatlantic cruises and maybe love affairs were not so easy when the ticket agent was young. It was one of Rockwell's abiding themes: the feeling of having missed out on something.

Wes Stout did not care for the painting. His criticisms were passed along in a letter to Rockwell on December 4. The ticket agent, Stout complained, was "a hick" in a ramshackle office. "We feel it would be more typical of millions of our citizens," Stout wrote, "if he worked in a town of between ten and fifty thousand inhabitants and not such 'Mi gosh' and 'by-heck' surroundings."[4]

Now that's funny. Although Rockwell's detractors have often accused him of being a propagandist for the *Post*'s beneficent fantasy of small-town America, even the editor of the *Post* thought his images were too provincial. What Stout did not understand is that Rockwell had zero interest in tailoring the content of his paintings to the demographic particulars of Mr. Typical *Post* Reader. Rockwell was well aware that most Americans, in 1936, did not live in small towns, that there were bigger and grander lives out there, not least of all his own in New Rochelle, New York. But the genius of his narratives lies in their seeming familiarity. In contrast to the countless magazine covers that portrayed a vision of affluence and aspiration—tuxedoed men and their dates swirling drinks in high-ceilinged rooms—Rockwell's covers refer to a plainer America. This is not a life you aspire to have, but the one you already have, and most any adult in America could think of someone he or she knew who had a ho-hum job like the ticket agent.

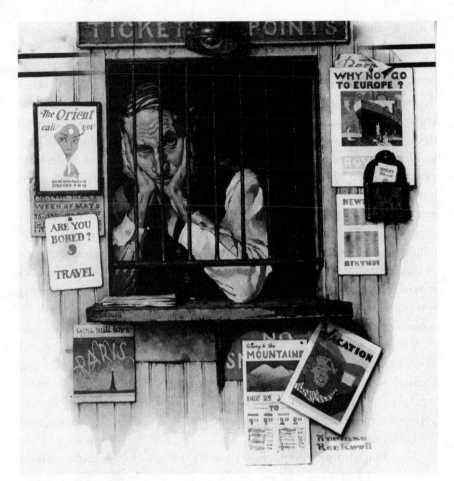

*The Ticket Agent,* 1937

Why did Rockwell work for *The Saturday Evening Post*? If you said he desired fame and attention, you would not be wrong. His longing for re-assurance was insatiable. But since the outset of his career, Rockwell had been able to do the double duty of fulfilling the requirements of magazine illustration while staying true to his artistic instincts. On most days, he didn't see his work for the *Post* as a soul-crushing endeavor in which his need for self-expression was constantly being sacrificed to the opposing needs of a profit-driven magazine. Rather, the thrill of his work is that he was able to use a commercial form to thrash out his private obsessions, to turn a formula into an expressive personal genre.

Rockwell's *Ticket Agent* appeared on the cover of the *Post* on April 24, 1937. Just a month later, in the issue of May 29, Stout tried putting a color photograph on the cover, the first ever, openly flouting Lorimer's policy of reserving the cover for a hand-drawn illustration. The photograph, by Ivan Dmitri, was timely, but astonishingly dull. Coinciding with that year's Indianapolis 500, it shows a race car driver sitting in his sleek red vehicle in the moments before the race begins. It is shot from above, and angled so that a taut stretch of red—the car's hood—dominates the photograph.

Truth be told, it wasn't just Rockwell's fixation with small-town geezers that disenchanted Stout. It was the whole tradition of magazine illustration, which now had to compete with photography. Henry Luce's *Life* magazine made its debut on November 23, 1936, inciting a state of alarm in the Curtis Building that could not have been greater had a meteor crash-landed in Independence Square.

*Life* was priced at ten cents, twice as much as the *Post*. Physically, it was slightly larger. The first issue of *Life* measured fourteen inches tall by ten and a half inches wide. It was, revealingly, the same width as the *Post* but taller—half an inch taller, as if to ensure that it did not go unseen behind the profusion of competing weeklies on newsstands. The logo, a red box, can put you in mind of the geometric graphics of the Russian Construc-tivists. It remains the most recognizable magazine logo in history, that tomato-red rectangle with the word LIFE spelled out in blocky bright-white letters, as flat and striking as a stop sign.

For the first issue, the editors chose a cover image that was starkly modern and almost abstract: Margaret Bourke-White's photograph of the Fort Peck Dam in Montana, which was then under construction, a key piece of President Roosevelt's public-works projects. The photograph, shot

at a wide angle, shows three concrete structures rising a bit ominously into the sky. Topped by turrets, the dam resembles nothing so much as the ramparts of a medieval fortress. Where are the thousands of WPA workers employed on the project? Not here. The image is spookily depopulated, like one of Giorgio de Chirico's plazas. In that sense, it was a peculiar choice for a magazine that would soon become known for its close-ups of faces. On the other hand, the image of the impenetrable fortress says something authentic about Henry Luce's Time Inc., the parent company of *Life*, which exuded a sense of power that was almost feudal.

If *The Saturday Evening Post* was known for one image, it was J. C. Leyendecker's *New Year's Baby*, which, since 1906, had been bouncing joyously onto the cover in top hats and various getups. Now *Life* had a baby, too. The first photograph inside the first issue, on page 2, showed a doctor in gloves and a surgical mask standing in a crowded delivery room. He is holding a newborn boy upside down by his feet. The caption ringingly declares: "LIFE Begins."[5]

The caption might have read instead, in the interest of accuracy, "LIFE Begins Yet Again." The magazine's title was purchased from a previous *Life*, an inspired humor magazine founded in the 1880s in an artist's studio in New York. The original *Life* was styled after *The Harvard Lampoon*, which itself was styled after the British magazine *Punch*. When he was just starting out, Rockwell published about two dozen illustrations in the original *Life*. Its covers featured a good amount of impressive artwork, including the sparely modern, pancake-flat drawings of flappers by John Held, Jr. But humor magazines faltered during the Depression and by 1936, the original *Life* was willing to part with its title and dismantle itself for a small, sad sum of money.[6]

The new *Life* was an instant sensation. Its print run, projected at 250,000 copies, had nearly doubled by the time the first issue appeared. A year later, *Life*'s circulation had spiked to 1.2 million, surpassing that of Luce's own *Time* (672,000) and the elite *New Yorker* (135,000). But there was one magazine it couldn't touch, at least not yet. *The Saturday Evening Post* remained the most popular magazine in America, with a paid circulation of more than 3 million.[7]

Even so, the founding of *Life* shifted the traditional balance between text and image in journalism, giving images a new prominence. Photographs had the advantage of instant authority (see for yourself). And they were sexy (showing skin). To be sure, magazines had been using photo-

graphs to illustrate stories for decades. "But using photographs to illustrate a periodical was not the same as making photographs the principal subject of a magazine,"[8] as the historian Alan Brinkley notes in his biography of Henry Luce. Indeed, *Life* showed that journalism could be a purely visual medium, that sometimes the most compelling essay is a photo essay without any text.

*Life* represented a direct threat to the tradition of magazine illustration. It signaled the triumph of the camera over the paintbrush, of the machine over the hand, of the darkroom over the atelier, of speed over slowness, of New York's Rockefeller Center (where Time Inc. soon moved) over Philadelphia's Independence Square, of Henry Luce over Cyrus H. K. Curtis, who had died in 1933 and been replaced as publisher by his son-in-law.

In homes throughout the country, Americans accustomed to looking at handmade illustrations were suddenly poring over big, glossy black-and-white photographs that offered a seemingly unimpeded glimpse into previously closed worlds. As its name proclaimed, here was LIFE, not some make-believe simulation of it, not drawings by Howard Pyle, with his pirates and trunks of stolen booty. Not Leyendecker's fluttering putti. Not the Gibson Girl with her hair piled up to the sky. No, here were "things thousands of miles away, things hidden behind walls and within rooms, things dangerous to come to," as the magazine's credo boasted, in jazzy language written with the help of the poet Archibald MacLeish.[9]

How did Rockwell survive this? He did not, of course, claim to offer the rewards of factuality. He did not claim to bring news of dams and European kings and world summits to anyone's doorstep. But "art is no less real for being artifice," as the critic Clive James once observed.[10] Rockwell offered engrossing fictions about everyday life and its comical bumps. He offered the rewards of a story well told, a story that could seem remarkably complete and true despite the absence of words. He felt that if a painting of his needed a title, he hadn't properly done his work. Which did not keep his editors from titling his every painting.

•

The new trout-fishing season began in the Northeast in April, and Rockwell was still accompanying Fred Hildebrandt on regular trips into the woods. It had been a few years since their two-week sojourn in Canada

and their outings were now closer to home. They liked to drive to north-western Connecticut, to Mrs. Kirk's place, as it was known, a camp with three cabins on the banks of the Housatonic River presided over by a woman who would cook that day's catch for them.

Sometimes they made the trip with two friends, Mead Schaeffer and Charles DeFeo. The men knew each other through Hildebrandt, who seemed to be every illustrator's favorite model. Schaeffer, who had a studio in New Rochelle, had already furnished the book illustrations for a popular edition of *Moby-Dick*. DeFeo was equally fish-minded. He lived with his cat in Manhattan and was known as a master flytier, which requires an ability to work with precision on frustratingly tiny objects. You make a fly by affixing bits of hair, fur, feathers, and other materials to a metal hook. DeFeo designed and tied thousands of visually striking flies in a style that has variously been described as rococo, Victorian, or just ridiculously complicated.

His friends considered Rockwell basically unserious about fishing. They were expert anglers and he, at best, was along for the ride. While they were off at the river casting for salmon, setting their dry flies on the water, he was liable to be walking around on his own. "Norman was no fisherman," recalled Mead Schaeffer. "He liked to go with the boys, but his mind wasn't on fishing. To us, fishing was our whole lives, outside of painting. We tried desperately to get Norman interested in fishing, but he just was not the material for it all. He liked walking uphill."[11]

That view was confirmed by Hildebrandt, who could be patronizing about Rockwell's lack of sportiness. In 1936, after the four men drove up to Connecticut, Hildebrandt noted in his diary that Rockwell declined to get a fishing license from the state. "Norm didn't intend to fish and was a bit confused with all of the talk about fly fishing."[12]

Rockwell did not care for drinking, either. He was the designated driver in the group. On April 14, after three days of trout fishing in rainy Connecticut, the men "started home about three p.m.," Hildebrandt noted in his journal. "Norm driving and Schaef and I finishing up a half a bottle of scotch. Got back to Norm's at about 7 p.m. and all had supper there." You can imagine how much Mary Rockwell loved sitting down to dinner with her husband and his two inebriated, mud-caked friends.

•

Fred Hildebrandt was still Rockwell's favorite model and that spring he posed for a painting of Yankee Doodle, which made them both chuckle. Rockwell had accepted a lucrative commission to paint a thirteen-foot-long mural for the eighteenth-century Nassau Inn, in Princeton, New Jersey. Edgar Palmer, an heir to a zinc fortune and Princeton alumnus, had read about the restoration of Williamsburg, Virginia, by John D. Rockefeller, Jr., which gave him the idea of showcasing Princeton's own inheritance of Colonial structures, even if he had to build them himself. He decided on a sham-Colonial town square. This entailed moving the old Nassau Inn to a prominent spot on the brand-new Palmer Square and persuading Rockwell to festoon the taproom with an episode from Yankee Doodle's life.

Today, the song "Yankee Doodle" conjures images of patriotic uplift, but it was originally a satirical ditty sung by British soldiers to poke fun at the provincialism of Colonial armies. Apparently, Yankee soldiers were such yahoos that they affixed feathers to their hats and thought they therefore looked as stylish as the Italian men known as macaronis.

Rockwell's mural portrays Master Doodle in the midst of an awful pony ride. He's an object of ridicule, a blond fop in an elegant green velvet waistcoat riding past a rowdy crowd. The British redcoats are hooting and jeering at him and clearly need to cut back on their drinking.

The mural was the subject of an amusing item in *The New Yorker* in July. Rockwell was planning to stencil the song lyrics across the bottom of the mural, and "couldn't decide whether it should read 'Yankee Doodle *came* to town, or *went* to town,'" as the magazine reported.[13] Princeton's board of trustees took a vote; it resulted in a tie. Rockwell settled on the word *came*. Interpret at your own risk.

•

Mary Rockwell, in the meantime, continued to be exposed to the neglect that marriage to a famous artist can create. Rockwell's long disappearances into his studio, coupled with his convivial devotion to his male friends and all-around inattention to family life, made her feel invisible. Every so often she thought back to her teacher at Stanford, Edith Mirrielees, who had told her that she was sufficiently gifted to become a writer. Instead, she had become a suburban housewife who berated herself for too much smoking and drinking and for misplacing things. In addition to Raleigh, the Rockwells now had a mutt named Mostly and one afternoon there was

a mishap with the dog. Mary was mortified when the local newspaper wrote it up: "Mrs. Norman Rockwell took him shopping Thursday. Somewhere en route he disappeared. The dog, whose return is anxiously awaited by the Rockwells, is about Scottie size, black, with straight hair."[14] The dog was never recovered.

In the winter she learned she was pregnant again. She already had three young children. Jerry was seven; Tommy was five; and Peter was two. It is not known whether it was she or Rockwell who started the conversation about abortion. It was 1938 and abortion was illegal in the United States, so they decided to take a "vacation" in the English countryside. No one in England read *The Saturday Evening Post* or knew who he was; it was safe. They would wind up staying out of the country for six weeks. Their middle-aged housekeeper, Mrs. Florence Currie, a proper Englishwoman, made the trip with them, primarily to care for the boys.[15]

They sailed on a wintery March evening, aboard the SS *Bremen*, a German ocean liner.[16] Three years earlier, a group of Jewish protesters in New York had made headlines when they boarded the *Bremen* to take down its Nazi flag and throw it into the Hudson, but one assumes that Mary and Norman did not realize the import of such events. In a photograph taken at sea, Mary poses on the deck with her three boys and an unknown girl who jumped into the picture. She smiles broadly and appears amused, perhaps because she has put down her pocketbook to scoop chubby Peter into her arms. They docked in Southampton on April 7 and were discreet about their plans. Asked by British agents to provide their temporary address, they provided only Europe on Wheels, on Regent Street in London, which was not a hotel but a forerunner of the rental-car industry, allowing tourists to motor through England on their own. When Rockwell materialized at the office, he found a cable from his accountant about a left-behind suitcase. In his haste to catch the ship, he had failed to notice the suitcase standing on his front lawn, perhaps because he had been frazzled, or because he simply was the kind of man eager to jettison baggage.[17]

Mary disappeared into a hospital in Oxford, an hour northeast of London, and Rockwell and the boys and Mrs. Currie awaited her recovery at the Old Swan & Minster Mill, an inn with a long history. Located in the rolling countryside of the Cotswolds, it consisted of a Tudor mansion plus an eighteenth-century mill whose bedrooms abounded with the sort of "authentic" trimmings Rockwell loved—exposed beams, open log

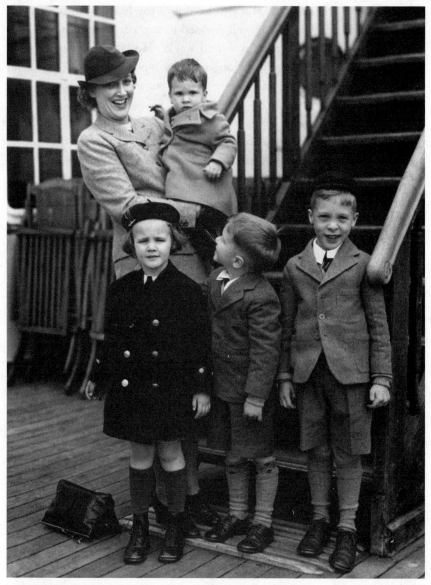

Mary Rockwell, her three sons, and an unidentified girl aboard the SS *Bremen*, en route to London, March 1938 (Courtesy of Jarvis Rockwell)

fires and worn stone floors. Mary came out of the hospital in mid-April, daffodil season. She and Rockwell decided to stay on at the inn, with the boys and Mrs. Currie, for a few added weeks. He later recalled the trip fondly, remembering bicycling along country lanes and wondering if he should leave New Rochelle and move to the countryside somewhere.

•

Passing through London toward the end of the trip, Rockwell thought he might contact a few British illustrators whom he had never met but whom he counted as his forebears. He had a small collection of illustrators' work and wanted to buy a few pieces in England. He sat down in his hotel room and tried to summon the appropriately respectful tone with which to introduce himself to Arthur Rackham, George Belcher, and Edmund Dulac, the last of whom had just designed the coronation postage stamp for Queen Elizabeth, the wife of George VI. After producing "ten stiff and awkward drafts," he threw them away and picked up the phone and called Rackham directly.

Rackham, at the time, was seventy, a vastly influential children's book illustrator. No one brought a stricter sense of realism to scenes of fairies and gnomes. Invited to his studio late one afternoon, Rockwell found a poignant figure, "a little bit of a man with a thin face," as he described him. The next day, May 6, Rockwell returned for tea. He purchased two ink drawings, one of which bore the unsettling title, "A House with Rats." Rackham gave him a copy of a book he had illustrated, *Tales of Mystery and Imagination* by Edgar Allan Poe. "To Norman Rockwell," he wrote inside, and then added a sketch of a man being woken from sleep by a devil looming at the foot of his bed.[18] Rockwell kept the book to the end of his life, a reminder of a charmed encounter and also of his artistic allegiances. Revealingly, he had not called upon Britain's modern artists, such as Ben Nicholson and Barbara Hepworth, who were living together in Hampstead. Nor had he attempted to look up any relatives—he was, after all, of English stock. The only family in which he could comfortably imagine himself was that of his fellow illustrators.

He and his family left England on May 12, sailing from Southampton aboard the SS *Europa*, the sister ship of the German liner on which they had come over. They were back in New Rochelle five days later, with their three small boys. Mary picked up Raleigh from a kennel in Ossining and her life resumed its normal shape. Summer was approaching and she fre-

quently swam at the Wykagyl Country Club. She was relieved to see she would not be punished for what she had done, the unborn child. She could continue buying hats at Saks and browsing at the New Rochelle Book Store, from which she came away in those months with books on religion and George Meredith's *Diana of the Crossways*, a protofeminist novel about an unhappily married woman.[19]

Rockwell immediately turned his attention to a painting called *Blank Canvas*.[20] His first (known) self-portrait, it shows him as a painter-goofball trying in vain to generate an idea for a *Post* cover as a deadline looms. He portrays himself from the back, in his studio, a skinny man in a Windsor swivel chair, scratching his bony head in puzzlement. There he sits for the thousandth time, with his paints and his rags and his long maulstick, and there rests his large canvas in all its glaring whiteness. It's not completely "blank," as the title suggests. The logo of *The Saturday Evening Post* has been stenciled across the top, cleverly so, an image of a magazine cover framed by an actual magazine cover.

You can tell, even from the back, that the neck of Rockwell's powder-blue shirt is open wide. The left collar is sticking out and pointing westward, as if it were eager to depart from the studio. Discarded sketches are heaped on a wooden crate that serves as a side table. How does he get ideas? Perhaps by swiping them; art books are propped open to images he has consulted in desperation. Real artists purportedly cull their inspiration from their experience of the world, as opposed to thumbing through a fat volume of readymade images of DOG CLIPS, the title of a book whose spine is visible in Rockwell's wooden crate.

It is interesting that Rockwell was moved to paint his first self-portrait after the ordeal of his wife's abortion. The painting abounds with covert references to pregnancy, such as "due date" affixed to his easel as well as the little kachina doll tacked to the top, inside a curvy horseshoe-womb. Perhaps the experience in England had made him feel that he, too, was consumed by questions of conception and creative birth. And sometimes he could not deliver.

•

When an artist paints his own portrait, he is likely to hang a mirror next to his easel and pause every so often to study his reflection. This accounts for the sharp side glance endemic to the genre of self-portraiture. But how does an artist paint himself *from the back* with any anatomical rightness?

*Blank Canvas*, 1938 (Norman Rockwell Museum, Stockbridge, Massachusetts)

Rockwell's secret was revealed in an article that appeared in the local paper in October 1938, in connection with his self-portrait: "Dick Birch photographed the illustrator, who worked from the photo."[21] Birch was a struggling Broadway actor who lived in an apartment in New Rochelle and took photographs on the side.

It was not the first time Rockwell had worked from photographs. They could be useful as a visual reference, especially if you were trying to draw a chicken or a mutt, or a boy not inclined to hold still. But only now, in 1938, did he publicly acknowledge his use of photographs, perhaps because *Life* magazine had made them a mark of journalistic sophistication.

At the *Post*, Wes Stout was bringing in a younger generation of illustrators who considered photographs crucial to their craft. Their work was distinguished by vertiginous angles—high-angle views, low-angle views, everything but eye-level views. You would think modernism had been achieved by the simple act of tilting a camera.

Rockwell thought of the younger illustrators as "the invasion from the Middle West,"[22] referring to Al Parker, Stevan Dohanos, Emmet Clarke, and John Falter. Falter was the wunderkind of the group.[23] A Nebraska native, he was known for his "pulled-back" panoramas, which means that instead of showing figures in close-up (as Rockwell did), he typically rendered sweeping views in which the figures seemed like an afterthought. After coming east to study art, he and his friends rented a studio in New Rochelle. They thought of it as Rockwell's town and the unrivaled capital of magazine illustration.

Rockwell could see the advantages of working with photographs and felt compelled to experiment. "Now I am painting every other picture with the help of photographs," he wrote in a letter in March 1939.[24] "The younger generation of illustrators (damn 'em) are all drawing from photographs but I can't get over the feeling it is cheating." He did not operate the camera himself. He preferred to have professional photographers take his reference photographs for him, which left him free to direct a scene.

The previous summer, he was mortified when Joe Leyendecker dropped by his studio and glanced at the floor. Hundreds of photographs were scattered about. They talked for an hour that day, with unrelieved awkwardness, both of them conscious of the other's effort to keep his gaze level and refrain from noticing the pictures on the floor. "Neither one of us

appeared to notice them," Rockwell noted, "but it was just as though a fresh corpse I had just murdered lay there."[25]

Rockwell was hardly the first realist painter to suffer pangs of camera guilt. The history of shame over using photographs is almost as long as the history of the use of photographs by painters. Art-historical scholarship of the past generation, as everyone knows, has unveiled the use of photographs by all kinds of master realists who were loath to acknowledge their dependency. In 2001 the British artist David Hockney caused an uproar with his book *Secret Knowledge: Rediscovering the Lost Techniques of the Old Masters*, which accuses artists of having used cameras and the optical devices that preceded them (namely, lenses) for some four hundred years.

Granted, the notion that Jan Vermeer had used a camera obscura in seventeenth-century Delft to create his scenes of solitary women in crystalline rooms was already widely accepted by scholars. But Hockney pushed the argument back in time. The development of realism, he argued, paralleled breakthroughs in lens making, starting in 1420. "From that moment," he told an interviewer, "you never see a badly drawn basket again in Western art. They are suddenly all perfectly woven, in perfect perspective."[26]

When Rockwell began using photographs, he still needed to go through the elaborate steps with which he had always begun a painting. He still needed to isolate himself in a room to generate an idea for a picture, to think of a lamppost and boys, to rough out his idea on a small sheet of paper and show his sketch to an art editor, to get approval. He still needed to locate models, to rent or buy costumes and track down the right props, to scout out locations, to stand in front of his chosen model and raise his eyebrows sky-high to simulate an expression of surprise, or drop his head weightily in his hands and look sad, to do his acting bit and convey the expressions and poses he wanted.

He could be the most finicky director. Richard Gregory, who posed for the illustrations for *Tom Sawyer*, recalled an afternoon in 1936 when he and Rockwell headed into the backyard. "He had all these guys there and all this equipment," Gregory noted. The yard was set up for a photo shoot, but Rockwell abruptly cancelled it. "Forget it," he said. "The sky isn't right."[27]

When Rockwell drew from a photograph, the process was scarcely one of simple mechanical transcription. He once said he used an average of one hundred photographs for a single *Post* cover, and they raised problems and complications of their own. His technique required that he combine

and recombine parts of dozens of photographs to come up with an image that had never existed in a photograph. Over the years, people who prided themselves on having posed for a particular Rockwell painting often expressed surprise and disbelief upon learning of the existence of strangers who claimed to have posed for the very same painting. He used them all, a blond head from one photograph, a pair of skinny legs from another, assembling disparate parts into bodies and scenes that do not correspond to reality.

In the end, the use of photographs allowed Rockwell to become more himself as a painter, more persuasive as a storyteller. The paradox is that photographs served his instinct for fiction. The advent of *Life* magazine, which could have crushed him, encouraged him to make his *Post* covers more realistic and less cartoony. This was a positive development. It helped spawn the mature phase of his work, in which he was able to express his interior visions with a level of preciseness that made his painted world all the more compelling.

# ARLINGTON, VERMONT

## (NOVEMBER 1938 TO SUMMER 1942)

In the fall of 1938 Rockwell and Mary decided to buy a summer house in southern Vermont. Rockwell knew about the village of Arlington from his friends Fred Hildebrandt and Mead Schaeffer, who fished there every spring. It was on the Batten Kill River, which wound down from the Green Mountains and was said to be the best trout stream in Vermont. "Fred Hildebrandt got everyone to Vermont," Schaeffer later recalled, "but I talked Norman into *staying* in Vermont."[1]

Burt Immen, a local realtor, showed the Rockwells a farm in West Arlington—the old Parson's House, as the locals referred to it, a modest farmhouse set on sixty acres of meadow and apple orchard. It sat amid mountains, the Green Mountains and the Red Mountain, on land that ran along the western bank of the Batten Kill River. That was key: the Batten Kill, which flowed right through the property, the clear water rushing over rocks, gurgling loudly. Rockwell bought the house that day—November 9, 1938—for $2,500. There were two red barns a few hundred feet from the house, toward the bottom of the broad sloping lawn, and he arranged to have the smaller one remodeled into a studio.

Winter passed, and soon it was May 1939. Rockwell and Mary and the boys were living in their farmhouse, which, from the outside, looked better than they had remembered, a rectangle of white glowing against the green hillside. The front lawn ran down to the river. The Rockwell boys were now eleven, nine, and six years old, and their new swimming hole was "about three times bigger than we expected it to be," as Mary

Rockwell wrote in a letter. An ancient rowboat was docked in the yard and the children learned to row the first day.

As isolated as Arlington was, Rockwell had in fact brought a small entourage of friends with him. That June, Mead Schaeffer and his wife, Elizabeth, purchased their own farmhouse in Arlington.[2] Located at the end of Sandgate Road, it wasn't habitable year-round, at least not yet, but here they were for the summer: Mead and his wife and their two lovely daughters, who were a little bit older than the Rockwell boys, almost teenagers.

Fred Hildebrandt visited for much of July and he amused Rockwell's young sons with his daredevil stunts, like climbing up to a barn rooftop and walking along the ridgepole.[3] He surfaces in Mary's correspondence as someone whose presence she had come to enjoy. He brought in the mail, helped with errands, and, above all, coaxed Rockwell out of his studio. One Sunday, Hildebrandt, along with Rockwell and Mary and their two older sons, squeezed into the rowboat and traveled two miles downriver, over rapids, stopping for a picnic dinner.[4] "You would have died," Mary wrote to her sister on July 10, "if you could have seen us five in that little leaky boat with sides about three inches above the water! But I never had more fun."[5]

Rockwell, his friends insisted, did not have a deep connection to nature. He didn't plant flowers or put down down a vegetable patch. And he didn't make the Vermont countryside a subject of his work. Unlike his fellow illustrators in Arlington, who turned out magazine covers that abounded with deer, pine trees, and autumn leaves, Rockwell declined to paint a landscape in the fourteen years he lived in Vermont. Hildebrandt recalled an occasion when he and Rockwell were out fishing and someone remarked on a commanding view in the distance. "Yes, isn't it beautiful?" replied Rockwell. "Thank heavens I don't have to paint it!"[6]

His friends were aware that he did not get a house in Vermont because he wanted to paint scenes of nature. Rather, he wanted to experience small-town life, to counter a feeling of staleness in his work, to work with new models. Models who were not models, just ordinary people devoid of pretense. He was a painter of human faces, of figures in space.

True, there was one outdoor activity he liked in Vermont. He often went for long walks in the mountains that rose steeply behind his house. He would climb through the apple orchards and then into the woods, a

lean silhouette with a walking stick, trailed by his dog. Walking uphill appealed to the part of him that valued discipline. Most people go uphill to enjoy the reward and release of going down, but Rockwell preferred the uphill part, the exertion it required.

His walks were made even more arduous by shoes that pinched his toes. Mary once commented: "He buys his shoes too small."[7] Interesting. A dissertation could be written on the subject of Rockwell and shoes. He squeezed his feet into tight shoes, as if trying to keep the dirtier parts of himself constrained. As mentioned, he could not shine his shoes enough, even on fishing trips. Yet in his art he painted footwear without inhibition. The novelist John Updike once observed that Rockwell had "a surreally expressive vocabulary of shoes."[8] He was attentive not only to different styles, but to the signs of wear they acquired over time (and in those days, Americans kept their shoes for a longer time than they do now, repairing and resoling them rather than throwing them out). Rockwell painted brown leather loafers that could use a coat of polish. He painted boots with frayed laces. He painted red Keds with scuff marks on the white trim, and penny loafers whose permanently upturned toes have been molded over time by the particular gait of the owner. What they have in common is that they look comfortable. They are sensible shoes, the sort that allow toes to expand. They are precisely what his own shoes were not.

•

The first painting he completed in Vermont, *Marble Champion*, graced the cover of the *Post* on September 2, 1939. A redheaded girl of perhaps eleven or twelve kneels on the ground and prepares to pitch a gray marble, her face tense with concentration. Two schoolboys peering over her shoulder look a little worried, not least because by 1939 girls had begun to receive acknowledgment in citywide marbles tournaments. Rockwell's detractors accuse him of catering to the stereotypes of a mass market, but in fact he helped topple stereotypes. His marble-shooting girl, with her pigtails and worn leather shoes, is not some delicate sugar-spun creature, but a toughie, a reflection of his sense of women as forceful competitors.

*Marble Champion* represented a break from Rockwell's magazine covers of the previous decade. Once he acquired his house in Vermont, he shifted away from his Colonial obsessions, from Yankee Doodle and Ye Olde Sign Painters, from patriots with their wigs and ruffled shirts and buckled shoes. Instead of burrowing into American history, which he had done for

about a decade, he now favored contemporary (albeit invented) scenes featuring people who lived in a New England town, his town. It was the *Our Town* view of America, and it seems likely that Thornton Wilder's play helped him forge a way forward in his work by reminding him of the drama and meaning that inheres in everyday life.

Wilder's masterpiece, *Our Town*, had opened on Broadway in February 1938 and won a Pulitzer Prize that spring. It is set in Grover's Corners, New Hampshire, the most famous nonexistent village in New England. Staged without scenery and with the curtain always up, it relates the stories of Emily Webb and George Gibbs and life among such staple characters as a milkman, a town doctor, and a newspaper editor. It prompted an inundation of articles about the virtues of New Englanders, who, purportedly, were understated and self-sufficient, who stoically accepted their freezing winters.

Wilder, who was three years younger than Rockwell, had little in common with the characters in *Our Town*. Born in Wisconsin, he was reared in China and spent a good amount of time in Hollywood. He lived for many years with his unwed sister, on Deepwood Drive in Hamden, Connecticut, and enjoyed close friendships with younger men.

Rockwell, too—he did not resemble the characters who inhabit his paintings. Like Wilder, whom he knew in later life as a casual acquaintance, Rockwell created a body of work that says something about an odd-duck artist yearning for normalcy and community. He began identifying himself, starting now, as a man who lived in Vermont, a New Englander just like his neighbors, although he invariably made his point in the nasal and accented voice of a Noo Yawker.

What does it mean to be a New Englander? In contrast to the characters who would proliferate in his paintings—people who live in towns where time passes slowly and idle away afternoons playing checkers—Rockwell didn't have ten seconds to spare. Not the most typical Vermonter, he drank Coca-Cola for breakfast and declined to swim in the Batten Kill River flowing through his front yard, insisting that the water was too cold.

•

When September came, the summer people dispersed. Rockwell and Mary decided to stay in Vermont through the fall. They left the radio on all the time to follow the urgent bulletins out of Europe. Poland was burning to

the ground and Britain finally declared war on Germany. Prime Minister Neville Chamberlain broke the news ("You can imagine what a bitter blow it is to me that all my long struggles to win peace have failed") in a voice that sounded unnaturally calm.

That September, Rockwell and Mary enrolled their sons in public school, a quaint one-room schoolhouse on the West Arlington Green. It had "two grades totaling forty-eight children in one room," as Mary noted. Rockwell agreed to be a guest lecturer at a monthly PTA meeting. It was held on a Thursday evening in October. He delivered his talk perched casually on the top of a desk, with one knee clasped in his hands. "I'm not a public speaker," he began, with the charm and adroitness of a born public speaker.[9]

Mary was glad to be away from New Rochelle, where her neighbors, she felt, were "not interesting." In Arlington everyone was new and she couldn't believe how nice the people seemed. Although the Rockwells did not join a church, Mary became a member of the guild of the St. James' Episcopal Church. In September she was elected to the board of the Martha Canfield Library and over time she would help expand the children's section. In photographs from the period, she wears skirts that fall below her knees, ankle socks, saddle shoes, and large glasses. She could pass for a librarian.

For a small town of only fourteen hundred residents, Arlington had a sizable creative population. "There are lots of artists and writers up here but they are all serious people and not at all the Greenwich Village type," Rockwell wrote approvingly on October 11, 1939. He mentioned Mead Schaeffer, "one of my best friends." Dorothy Canfield Fisher, a novelist and critic, "is the patron saint of the village, and her vigilance has kept the town as simple and lovely as it is. It is not a tourist or summer place, but a genuine American New England town."

His comments were made in a letter to Clyde Forsythe, on stationery engraved with his wife's name. "I've been doing much better up here in Vermont," Rockwell continued. "It is getting colder up here but we love it so much we just can't leave until we are frozen out. The kids are going to school here and look like real country-folk."[10]

Two days later, the local newspaper announced that Rockwell was a "permanent resident" of Arlington.[11] But that depends on what you mean by the word *permanent*. By the end of October, Rockwell and Mary had decided to pull their sons out of school and return to New Rochelle for the

winter, largely because their new house had no source of heat besides two wood-burning Franklin stoves. Throughout that winter, he and Schaeffer would drive up to Arlington about once a month to supervise the renovation of their homes. They stayed with Miss Sadie F. Hard, a sixtyish spinster who owned a cozy boardinghouse on Main Street and was famed locally for her recipes, most of which called for one cup or more of Vermont maple syrup.

•

Rockwell had no difficulty finding friends who were inordinately devoted to him. He had the pull of celebrity, and people were flattered when he asked for their help. "I never had a friend I loved more," Schaeffer later commented. He was four years younger than Rockwell, a trim adventurer with blue eyes and a Charlie Chaplin mustache. Although relatively unknown today, he was once prominent as a book illustrator. Much as Charles Scribner's Sons had enlisted the formidable N. C. Wyeth to illustrate the classics it published, Dodd, Mead & Company initiated a similar series with Schaeffer doing most of the titles, starting with *Moby-Dick* in 1922. His illustrations, Rockwell once noted with admiration, "gave one a real sense of robust, swashbuckling manhood."

Their friendship had begun in New Rochelle, and was sufficiently evolved by May 1939 to merit a mention in *Time*. A reporter who spotted Rockwell at the latest Society of Illustrators annual costume ball in Manhattan noted: "He and Mead Schaeffer, his good friend and fellow romancer, turned up at last week's ball in costumes they were then engaged in painting."[12]

A confusing sentence. Presumably the reporter meant that Rockwell was wearing a theatrical costume from his own collection, a costume in which one of his models had posed. Something Colonial, perhaps a ruffled white shirt and long waistcoat, a tricorn hat. "He really liked costume parties," the illustrator George Hughes recalled of Rockwell.[13]

•

After the two men settled in Arlington, Rockwell would frequently call Schaeffer for advice on a particular painting in progress. Schaeffer would be in his studio within minutes, in front of his easel. "He wanted confirmation," Schaeffer later said, "not an opinion. He was so boyish."

As Rockwell became closer to Schaeffer, his friendship with Hildebrandt

frayed. Hildebrandt felt hurt, displaced. In addition to being Rockwell's studio assistant for about a decade, he had posed for more than a dozen paintings, accompanied Rockwell across the country, taken him up to the peak of Mount Whitney, and shared a bed with him in a cabin in the Canadian wilderness. He had introduced him to Mead Schaeffer, and now Rockwell, it seemed, desired Mead's company exclusively.

Perhaps it was just that Rockwell had tired of using him as a model, much as he had once tired of using Billy Payne. He needed new faces and figures to keep his art fresh. Whatever the cause of their rift, it was lasting. Rockwell failed to mention Hildebrandt in his autobiography, a conspicuous omission. And when Rockwell sold his house in New Rochelle, a few years after moving to Vermont, he left one painting in his studio.[14] The new owners loved having it even if it wasn't by him. It was a portrait of Rockwell painted years earlier by someone they had never heard of, Frederick Hildebrandt.

•

In September 1940, the U.S. Congress passed the Selective Training and Service Act, inaugurating the first peacetime draft. Most Americans wanted nothing to do with the calamity in Europe. But as Hitler's armies continued their invasions, President Franklin D. Roosevelt saw fit to prepare.

On October 4, 1941, an Army private by the name of Willie Gillis made his first appearance on the cover of *The Saturday Evening Post*. Willie was a soldier in the U.S. Army—a short, sweet-faced young man who is shown leaving an Army camp post office with a wrapped parcel. He peers nervously over his shoulder as a group of six (larger) officers walk in unison behind him, casting predatory glances at his booty. Is it a ham? The oval package is wrapped in white paper and tied with twine. It is addressed, in a mother's neat script, to Private Willie Gillis, at the Army base in Fort Dix, New Jersey. And so Willie was introduced to America, name and all.

Willie is a boyish figure, an American innocent, and readers of the *Post* were enchanted. Here was their absent brother and absent son. When you look at his face—the chubby cheeks, the jug ears, the open, honest expression—it is unimaginable that anyone could think of harming him.

Rockwell decided to turn Willie into a regular character, which he had never tried before. There would be a series of Willie Gillis covers, eleven in all, spaced out over the war years. "The artist credits his wife Mary with the idea of repeating the Willie Gillis character and also with naming the

inductee," a reporter noted in 1941.[15] Mary named Willie after a character in one of two books she read to her children. Some have made the case for *Wee Gillis*, an under-recognized picture book about a Scottish orphan that won the Caldecott Honor Award in 1939. But probably it was Rudyard Kipling's short story, "Wee Willie Winkie," whose protagonist is a soldier-naif. He does not use his real name—the dreaded Percival—any more than Norman Perceval Rockwell did.

At any rate, many *Post* readers mistook Willie for an actual resident of Vermont, though of course he was a fictional character. The boy who modeled for him, Robert Otis Buck, of West Rupert, Vermont, was a high school student of sixteen. Rockwell first spotted him in the summer, at one of the regular square dances held on the West Arlington village green, and could not stop staring. Buck stood five foot four, with a young face and a lock of brown hair falling down his forehead.

The life of Willie Gillis, as related by Rockwell, ran counter to the nation's dominant military narrative. It shifted attention from glamorous military men—from marines and sailors and pilots seated in open cockpits with their long, white scarves fluttering behind them in the sky—to the lowly, unsung infantryman. Just two weeks after Willie Gillis made his debut, a young cartoonist named Bill Mauldin introduced a soldier named Willie into a strip that had previously featured only Joe,[16] perhaps following Rockwell's lead. In the next few years, Mauldin's *Willie and Joe* moved to the military newspaper *Stars and Stripes* and its two disheveled "dogface" protagonists became household names. The journalist Ernie Pyle noted, "War makes strange giant creatures out of us little routine men who inhabit the earth." *Little routine men*—they were the heroes not only of war but of all of American life. That was Rockwell's view certainly and it would acquire the force of a national credo in 1942, when Vice President Henry Wallace paid homage to the "Century of the Common Man."

•

In the fall of 1941 Rockwell was visited by a feature writer for *Family Circle* magazine. The article, "He Paints the Town," characterized him as a beloved citizen of Arlington.[17] Photographs taken on a crisp fall day showed the five members of the Rockwell family fetching their bicycles from the barn, the image of sporty togetherness. There were also photographs of Arlington residents who had posed for Rockwell—including Sheriff Harvey McKee; Bob Buck (of Willie Gillis fame); Dan Walsh, who

drove a mail truck and did an occasional Santa for Rockwell; and Nippy Noyes, the town's jowly and full-bellied postmaster, whose corpulence made him a favorite Rockwell model for doctors and judges. The article conveyed the impression that Rockwell's work was a communal effort in which most of the town participated on a day-to-day basis. By the time it appeared, Rockwell had been basking in the California sunshine for four months.

●

He left Vermont in early November, and missed the whole drama of a New England winter, staying away until the snow melted and the trees began to bud. By then, he had made extensive improvements to the house and hired live-in help, a capable middle-aged couple, just as he had in New Rochelle. In Vermont, Bessie Wheaton cooked and took care of the Rockwell boys, and her husband Thaddeus, a former sewing-machine salesman in his fifties, became Rockwell's handyman and gardener and occasional model. But now that the house was finally winterized and fit to be occupied year-round, Rockwell decided he had to get out. Like most everything else he genuinely wanted, he also longed to be free of it.

He flew out west by himself. "Norman, who has badly needed a vacation for some time, suddenly decided he would like it in California," Mary wrote in a letter, on November 11, 1941. "So he is on his way and the children and I leave Friday."[18]

It was his first trip to California since 1935 and, as usual, he stayed with his in-laws in Alhambra. The local art scene had changed since his last visit and lost its most talented painter. Frank Tenney Johnson had died suddenly of spinal meningitis, in 1939, at age sixty-four. He supposedly contracted the disease one week after kissing the hostess of a Christmas Eve party, an anecdote that has somehow outlived medical plausibility.

Vinnie Johnson, the artist's widow, was still residing on Champion Place, next door to the building that had served as her husband's studio. This is where Rockwell now settled in, 24 Champ, sharing the space with Forsythe and displaying his usual gift for transplanting himself and his artistic production to a new atelier three thousand miles from his home without missing a day of work. He could burrow in anywhere. He was astoundingly portable.

His friendship with Forsythe had been sustained without effort since

the long-ago days when they had rented Frederic Remington's studio in New Rochelle. Now they were in the studio of another painter of the Old West and Frank Johnson's paintings as well as his cache of Indian artifacts—jugs, blankets, arrowheads—were still there. The memorabilia was freighted with meaning for Forsythe, a painter of desert landscapes.

Rockwell, by contrast, had no interest in romanticizing the West in his paintings. He spent a good chunk of his life among western painters who were fixed on visions of distant horizons and heroes on horseback, and who never could have anticipated that Rockwell would be the one whose work came to define the essence of America.

It was on this trip that Rockwell inaugurated a casual friendship with Walt Disney, who was seven years his junior. Then forty years old, Disney was at his creative zenith, a middle-aged wunderkind whose film studio had released a string of animation hits: *Pinocchio, Fantasia,* and *Dumbo.* His first feature-length animated film, *Snow White and the Seven Dwarfs,* of 1937, had landed him on the cover of *Time,* where in a photograph he is both dashing and amusing. He sits at a desk in an open-necked shirt, a dark-haired man with a long, lean face and a toothy smile, playing with figurines of Happy, Grumpy, Doc and the rest. Like Rockwell, Disney was an intuitive populist who had enormous faith in the taste of the American public. When asked if he was an artist, he inevitably demurred, claiming his only goal was to enchant the public.

Although Disney seemed to derive pleasure from little besides work, he did have at least one pastime: he played polo, describing his skill as middling to poor. He gave it up in 1938, after injuring his neck in a match.[19] Instead, at the invitation of Forsythe—friend and fellow cartoonist—he joined Los Rancheros Visitadores, a riding club that allowed wealthy businessmen to play at being "cowboys" and apparently was less dangerous than polo. Once a year the group took a weeklong camping trip along the old trails in the Santa Ynez Valley, north of Santa Barbara. Rockwell, who was afraid of horses, was not a member, but Disney harbored a great admiration for his artistry and asked Forsythe to bring him by for a tour. So Rockwell went to see the sprawling, state-of-the-art Disney studio compound in Burbank, a horse-free zone.

While he was in California that winter, Rockwell undertook portraits of Walt's two young daughters. Eight-year-old Diane Disney and five-year-old Sharon posed for a photographer in their father's office and in a

matter of days Rockwell had finished and delivered two lovely charcoal drawings. Diane, the dark-haired daughter, gazes out with a curious, almost pinched somberness, while Sharon smiles sweetly beneath her blond bangs and big hair ribbon.

Writing to Rockwell on December 31, Disney thanked him for "the swell portraits of my kids,"[20] which he hung in his office. He seemed more moved by the portrait of Diane. "You captured a mood in my older daughter that I think is wonderful because at times she is such a serious thing and has often given me that same look that brings me off my high horse."

Rockwell also gave Disney a copy each of *Tom Sawyer* and *Huck Finn*, the Heritage editions he illustrated, and Disney shelved them with care. As he wrote: "You may rest assured that they are in good company, along with the works of Pershing, H. G. Wells, Mussolini and many other famous guys!"

Benito Mussolini? "Good company" is not the first phrase that comes to mind. The attack on Pearl Harbor had occurred only three weeks earlier. The day after President Roosevelt asked Congress to declare war on Japan, Hitler and Mussolini announced they were at war with the United States.

•

In March 1942 Rockwell returned home to Vermont and the quiet of the countryside. "Well, I've been back a week and it's fine but I sort of miss all the excitement of the Champion Place studio," he wrote to Forsythe on the 23rd, using his wife's engraved stationery as usual.[21] "Everyone seems less excited about the war here than out there. When I do get the dope on the poster situation, I will let you know." He and Forsythe were itching to contribute to the war effort by designing recruitment posters.

His letter continued: "I guess you read about the big shake-up at the Post. Everyone out and a whole new editorial staff in." Wesley Stout, whom Rockwell had always disliked, had been fired on March 12, after displaying an egregious lapse of judgment. He had somehow allowed into print a foolish and offensive article, "The Case Against the Jew."[22] It was written by Milton Mayer, a thirty-three-year-old journalist, left-winger, and conscientious objector who himself was Jewish. It excoriated Jews for abandoning their ancient faith to assimilate into America's materialistic gentile culture, and claimed they had sacrificed their soul in the process. A tone-deaf "editor's note" at the start of the piece read: "Mr. Mayer's

scorn for his fellow American Jews is exceeded only by his scorn for the gentiles."

Overnight, subscriptions were canceled, advertisements were pulled, and the board of directors of Curtis Publications held an emergency meeting at which it was decided to sack Stout, effective immediately. Newspaper accounts of his departure were vague, claiming he resigned because of "a firm but friendly disagreement with the Curtis Publishing Company on policy."[23] In came Ben Hibbs, who would turn out to be a surprisingly effective editor. He was relatively young (forty-one), unpretentious and sensible, a former Kansas newspaperman who moved over from *The Country Gentleman*, another Curtis publication.

His first task was to try to regain the trust of readers. He wrote a formal apology that was published in the *Post* as well as in costly three-quarter-page advertisements in *The New York Times* and other major newspapers. "The *Post* never has been, is not now and never will be anti-Semitic in belief or expression," Hibbs wrote in the ad. "It is not anti to any group."[24] He pledged to publish articles that would affirm the magazine's commitment to racial and religious tolerance.

To compensate for the loss in advertising, the *Post* was forced, for the first time, to raise the price of a newsstand copy. It went from a nickel to ten cents, starting with the issue of May 30. Far more ominous was the loss of the *Post*'s circulation lead. In 1942 *Life* pulled into first place and became the largest-circulation weekly in the country, with 3.4 million subscribers. The *Post* had 3.3 million and it would never regain the lead.

•

For Rockwell, the contretemps over the article was deeply disturbing, in part because there were rumors that the *Post* was about to fold. When he thought about the *Post* going under, he wasn't sure whether his career would be over, or whether he would be better off. At least his life would be in his own hands. Tired of answering to *Post* editors, he wanted to do something major, to alter his fate. He imagined doing a poster that could define his times, his country in wartime.

He saw, in retrospect, that he had acted immaturely during World War I. Unlike Clyde Forsythe and the Leyendecker brothers and other artists he had known in New Rochelle, he had neglected to create war posters, had contributed nothing, besides his brief time drawing cartoons in the Navy. And what could be done now? Perhaps the moment had already

passed. Anyone could see that the future belonged to photography. Looking back on his career, he thought of his paintings of boys and dogs and shuddered. He wanted to restore illustration to greatness. He wanted to be as heroic as Howard Pyle. He wanted to create one great image, and this is what he was up against: a world that had become far more image laden since the last war. A generation of *Life* photojournalists on the one hand and fine artists on the other, thousands upon thousands of image makers, were competing to abet the war effort.

# THE *FOUR FREEDOMS*

## (MAY 1942 TO MAY 1943)

On May 21, 1942, Rockwell was in the other Arlington—Arlington, Virginia, threading through the halls of the new, low-lying Pentagon building. He had gone there seeking final approval for a poster design. Through an organization called the Artists Guild, he had been assigned to promote the U.S. Army Ordnance Department, which was responsible for distributing weapons.[1]

Rockwell's poster was predictably martial. Actually, it's more Leyendecker than Rockwell, a nighttime scene in which a hunky, helmeted solider crouches on a hill and fires his last round of bullets. "Let's Give Him Enough and On Time," the poster urges, referring to ammunition. Robert Patterson, the undersecretary of war, liked it enough, but requested that Rockwell portray the soldier in a pair of slacks rather than in juvenile breeches and leggings.[2]

That day in Virginia, Rockwell visited the Graphic Division of the War Department's Office of Facts and Figures, which sounds like something out of George Orwell's *1984* but was not at all nefarious. The agency oversaw the production of war-themed posters and billboards. Rockwell met with an official, Thomas D. Mabry, a former administrator at the Museum of Modern Art, who recalled telling him: "One of our most urgent needs and one that was most difficult to fill was a series of posters on the four freedoms."[3] He was referring to the Four Freedoms, a wartime variation on the Bill of Rights that had been laid out by President Franklin D. Roosevelt in a ringing speech before Congress and incorporated, in the summer of 1941, into a declaration he drafted with Winston Churchill.

Rockwell returned to Vermont with a printed copy of the Atlantic Charter, as the declaration was known, intending to read it over and pick out choice sentences to illustrate. But when he read the text, the language was nebulous and abstract ("First of all, their countries seek no aggrandizement, territorial or other") and hardly visual. What does a picture of "no aggrandizement" look like? Or, for that matter, how do you paint a defense of the democratic world? How do you visualize freedom without resorting to such staples of patriotic illustration as Uncle Sam in his top hat or Lady Liberty with her long Greek robe and outstretched arm? Those were the images that had beckoned from posters during World War I.

Rockwell often told the story of how he conceived his *Four Freedoms* in the middle of the night, how they came to him almost unbidden as he was lying in bed in Arlington, at three in the morning. He had recently attended a town meeting at which an acquaintance, Jim Edgerton, stood up to criticize a decision to rebuild a school that had burned down.[4] Nobody agreed with him, but everyone listened. "That's it," Rockwell thought to himself. "That is Freedom of Speech." He was in his studio at five that morning, roughing out sketches and spinning them into large drawings in which ordinary people (his neighbors) are shown doing ordinary things that affirm basic American freedoms and implicitly knock totalitarianism.

In mid-June Rockwell bundled up four oversize charcoal studies and set off with Mead Schaeffer on the long train ride back to the capital. Schaeffer, too, hoped to design war posters and had prepared some drawings of soldiers in action. They stayed at the Mayflower Hotel, near the White House, and were joined there by Orion Winford, an emissary from Brown & Bigelow, the company in St. Paul that published the annual Boy Scouts calendar. He had the odd, occasionally hellish job of having to coax a new painting out of Rockwell once a year and had come to Washington in the interest of oiling their relationship.

In the morning Rockwell and his entourage met with Patterson, the undersecretary who had admired his poster for the Ordnance Department. The poster of the machine gunner. But posters were no longer foremost in his thoughts and when he looked at the four charcoal drawings, he was distracted. So Rockwell visited another office. "The sketches were on big paper, which we would roll out like an Armenian displaying a rug, and then stand there grinning with expectation," Rockwell later told an interviewer.[5]

At the time, President Roosevelt had just created the Office of War Information, a centralized propaganda agency that replaced assorted federal bureaus whose functions had overlapped. The OWI would exploit every available medium, from leaflets and pamphlets to radio programs and feature films, to foster support for the war.

One of the agency's self-declared missions was "to assist American artists who wish to take part in the war effort." But when Rockwell visited the office, he received a painful snub. An official declined to look at the charcoal studies he had brought with him. "The last war you illustrators did the posters," the official said without apology. "This war we're going to use fine arts men, real artists."[6]

Rockwell, who always avoided confrontation, let the comment slide. In public, he declined to disclose the man's identity. In all likelihood, it was Archibald MacLeish, the poet and editor and versatile intellectual. He had previously served as an editor at Henry Luce's *Fortune* magazine,[7] a rival of the *Post*, and contributed to the mission statement for *Life*. Known among his friends as Archie, he was, by temperament "a cold fish, rather pompous and, for all his poems celebrating the democratic virtues, a snob,"[8] as the novelist Thomas Mallon notes.

With the founding of the OWI, on June 13, 1942, MacLeish became assistant director of the agency. He was able to commission work from any artist he admired. Perhaps to be provocative, he invited Yasuo Kuniyoshi, the Japanese-born American artist, to design a poster for the OWI just six months after Pearl Harbor. He was also interested in Stuart Davis, Reginald Marsh, and Marc Chagall, the last of whom was not American.[9]

By the end of the summer, MacLeish had hired one of his *Fortune* colleagues, art editor Francis Brennan, to oversee the OWI's Bureau of Graphics. What did Brennan hope to achieve in that capacity? "Certainly now, in this greatest of all wars, is the time to find out if another Goya is fumbling in Iowa, or another Daumier sketches acidly in Vermont," he told *The New York Times* on August 9, upon starting the job.[10]

The comment grates. Why would the government pretend to be looking for "another Goya"? Goya, who painted bullfights and witches, whose message was one of cumulative anguish, is not the first artist you would necessarily choose to compose posters exhorting Americans to buy a war bond or plant a victory garden, to do with less, give it your best and consider becoming a nurse. It made no sense. It was simply a case of a

government official strutting his cultivation, and it is distressing to think that the petty biases of cultural snobbery existed even at the Office of War Information.

Put another way, patriotic art carried a stigma in the very agency charged with commissioning patriotic art during World War II. Mac-Leish and Brennan, failing to recognize the graphic virtues of many of the posters for World War I, believed they could entice avant-garde artists to subordinate their gifts to the demands of patriotic posters. But the designs eventually submitted to the OWI by various modern artists— including Kuniyoshi and Salvador Dalí—were never made into posters and MacLeish would leave his job after eight months, vaguely citing policy differences.

•

Rockwell, in the meantime, unable to interest the OWI in his *Four Freedoms*, started back to Vermont with Schaeffer. They got off the train in Philadelphia, for a meeting with Ben Hibbs. Their timing was excellent. Hibbs, who had accepted his job only three months earlier, was trying desperately to repair the damage inflicted by his predecessor, to restore the *Post* to good editorial standing after the debacle of the crass article about American Jews. When he looked at Rockwell's four charcoal drawings, he believed he saw the solution to his problems.

Here, he saw, was a tribute to President Roosevelt and his administration. Here was a chance for the *Post* to mend relations with the White House and erase the animus created by George Horace Lorimer and his rants against the New Deal. Hibbs instructed Rockwell to hurry up and finish the paintings in two months, at the latest. Rockwell promised he would. Hibbs was sufficiently new and unknowing in his job to actually believe him.

Rockwell once told a reporter he conceived his *Four Freedoms* series on July 16, 1942, a date that has stuck. But he had a habit of mangling dates and June 16—a month earlier—is no doubt what he meant. On June 26, James Yates, the art editor of the *Post*, wrote to inform him that the magazine was already working on the layout for the four (not-yet-painted) paintings and was thinking of asking President Roosevelt to write an accompanying essay.[11]

•

After returning from Philadelphia, Rockwell put everything unnecessary aside. He resolved to refuse all advertising work, to turn down the admen who were always hovering, offering him serious money to do paintings to help sell Schick razors or Bosco chocolate drinks or Green Giant canned vegetables. He used every dodge he could think of. He claimed to be traveling. He claimed to be gravely ill. Leo Burnett, who owned the leading agency in Chicago, wrote to Rockwell, "Naturally, we're greatly disappointed to get the news contained in your letter of July 9 regarding your inability to do the Niblets corn picture for us. We hope that your visit to the hospital is as pleasant as such an experience can be and that you have a good-looking nurse."[12] There was, of course, no trip to the hospital, no nurses of either the attractive or homely variety.

He had told his editors that the project would take eight weeks, a calculation based on a wishful equation of one painting every two weeks. Instead the project consumed seven months, during which time he was reduced to a state of nervous exhaustion.

Many people see the *Four Freedoms* as the crowning achievement of Rockwell's career. Others feel that, as works of art, they pale beside his magazine covers and represent an exercise in patriotic boosterism devoid of his trademark humor. Yet you need not talk about them as a foursome. They are four interrelated but self-sufficient paintings. I would say that one is a complicated masterpiece, one is marred by excessive earnestness, one is as famous as the Statue of Liberty, and one is a conventional interior. They are discussed here in the order in which they were created.

•

*Freedom of Speech* came first and did not come easily. It turned out to be a harrowing ordeal that took Rockwell two months to complete. He did four versions before he decided that he was done. They all portrayed the same subject: a swarthily handsome, working-class man standing up to speak at a crowded town meeting. Different versions of the painting show the speaker from different angles. In the end, Rockwell went with a composition that imbues the speaker with a looming tallness and requires his neighbors to literally look up at him.

The speaker is dressed casually, in the clothes of a laborer. He wears a blue-and-black plaid flannel shirt, unzipped a few inches to expose his neck, and over that a suede jacket. His hands are dirty and his complexion is the darkest in the room. You wonder if he is supposed to be an immigrant.

*Freedom of Speech*, 1942 (Norman Rockwell Museum, Stockbridge, Massachusetts)

The men around him are dressed in white shirts, ties, and jackets and presumably have wives and children—in the lower right, a man's pale, plump fingers and wedding ring receive undue visual emphasis.

But the speaker isn't wearing a ring. He is unattached and sexually available, unbuttoned and unzipped. So what we have here is a scene of town fathers listening respectfully to a swarthy, sunbaked, blue-collar neighbor, an outsider from the working class and maybe a person of ethnicity (Italian? Greek?) who isn't afraid to think for himself or to stand alone and who represents both the promise of the town and a threat to its genteel homogeneity.

The model for the speaker was Carl Hess, who in fact was married at the time. He owned a one-pump gas station in Arlington and his father, a German immigrant from Hannover, is also pictured in the painting. Hess had "a noble head," according to Gene Pelham, a young artist from New Rochelle who worked for Rockwell during this period, taking reference photographs and helping out in the studio. It was Pelham who had initially spotted Hess and brought him to Rockwell and who owned the suede jacket that figures so prominently in the painting.

Rockwell had Hess pose, by himself, on eight disparate occasions. "I stood up several times at every sitting," Hess recalled.[13] The many other figures in the painting posed by themselves as well, and some would wind up, in the finished version, visible only as a fragment: a forehead or an eye or a shapely ear glimpsed in a crowd.

Is the painting credible? Not completely. It seems unlikely that established banker types would be trying to glean wisdom from an ordinary worker. Moreover, with his eyes cast skyward, the speaker looks a little frozen, as if he belongs to another painting; he could be standing in a field of corn at night, or preaching to the birds along with St. Francis of Assisi. *Freedom of Speech* remains an extraordinarily popular painting and can be described without hyperbole as the defining image of American democracy in progress. On the down side, it is compromised by a near absence of women, making it look as much like a meeting of aging male Elks or Rotarians as of the varied citizenry of an American town.

•

The next painting, *Freedom of Worship*, also took a long time to get right. The first version was set in a barbershop and showed a handful of men representing various religions getting haircuts. But Rockwell felt that the

*Freedom of Worship*, 1942 (Norman Rockwell Museum, Stockbridge, Massachusetts)

intended message—religious tolerance—did not come across. The paint-
ing consumed him for all of October and most of November. The final
version features eight heads crowded together in a shallow space; they are
shown in profile, facing westward. They represent people of different
faiths coming together in a moment of prayer. The man in the lower
right clasps a Bible and is supposed to be Jewish. The old, abundantly
wrinkled woman toward the center is Protestant. The pretty, auburn-
haired woman beside her, whose face appears lit, is supposed to be Catho-
lic. When Rockwell asked Rose Hoyt, the model for the Catholic woman,
to pose with the string of rosary beads she is holding in the painting, she
informed him that she was Episcopalian. He asked her: "Would you be a
Catholic for today?"[14]

*Freedom of Worship* is, in the opinion of this viewer, the weakest of the
four paintings. It is too didactic to satisfy. The heads, which overlap in a
flat plane with not an inch of space between them, essentially amount to
a wall of flesh that leaves no place for your eye or your imagination to
wander.

•

The third painting in the series, *Freedom from Want* (see color insert), is one
of Rockwell's most accomplished works. It takes you into the dining room
of a comfortable American home on Thanksgiving Day, and you can tell
from the light coming through sheer curtains that it is still mid-afternoon.
The guests are seated at a long table, and no one is glancing at the massive
roasted turkey or the white-haired grandma solemnly carrying it—do
they even know she is there?

Mrs. Wheaton, who was employed as the Rockwells' cook, modeled
for the grandmother and also prepared the turkey on Thanksgiving Day.
Rockwell arranged to have it photographed. Then the family sat down to
eat. He later said it was the first time he consumed one of his models.

Not that the painting bears much relation to Thanksgiving dinner as it
actually unfolded in the Rockwell manse. The nine adults and two chil-
dren who appear in the painting were photographed in Rockwell's studio,
nowhere near a turkey leg or stuffing, over the course of several days be-
fore Thanksgiving. Afterward, their cheerful faces were painted into the
picture. Rockwell's mother, Nancy, the old lady with chalk-white skin, sits
across from Mary Rockwell, whose face is barely visible.

Note the man in the lower right corner, whose wry face is pressed up

against the picture plane. He glances out at us with a playful, slightly conspiratorial expression, an implicit wink-wink. He has the air of a larksome uncle who perhaps is visiting from New York and doesn't entirely buy into the rituals of Thanksgiving. He seems to be saying, "Isn't this all just a bit much?" In contrast to traditional depictions of Thanksgiving dinner, which show the premeal as a moment of grace—heads lowered, praying hands raised to lips—Rockwell paints a Thanksgiving table at which no one is giving thanks. This, then, is the subject of his painting: not just the sanctity of American traditions, but the casualness with which Americans treat them.

The painting, notes the art critic Robert Hughes, has a "Puritan tone confirmed by the glasses of plain water on the table."[15] But Rockwell eventually came to see *Freedom from Want* as just the opposite. He believed he had erred on the side of overabundance, making the turkey too big. In the fifties, the painting would be criticized overseas as an example of American consumer gluttony.

With this painting, Rockwell achieved a new level of descriptive realism. Yet the painting doesn't feel congested or fussy; it is open and airy in the center. Extensive passages of white paint nicely frame the individual faces. The dinner plates, the freshly ironed linen tablecloth, the woman's apron, the diaphanous curtains—these various white objects make the painting one of the most ambitious plays of white-against-white since Whistler's *Symphony in White, No. 1*.

·

*Freedom from Fear*, the last of the four pictures, is the most anecdotal. It invites you into an upstairs bedroom with a low, slanting roof, and is usually described as a painting about a mother and father putting the kids to bed. Actually, the boy and girl are already asleep—they share a narrow bed, their heads heavy on their pillows, and their parents are looking in on them before they turn in for the night. And, as any parent knows, watching children sleep can elicit a powerful, almost primitive sense of well-being. Here, the mother bends forward and delicately lifts the edge of a bedsheet with both hands, to better cover the children. (It echoes the painting he had done during his first marriage of a mother covering a daughter.) Her husband appears in shirt sleeves and suspenders, standing by her side, a classic Rockwell onlooker, a viewer surrogate, passively observing the scene as you observe him observing. You suspect that he has

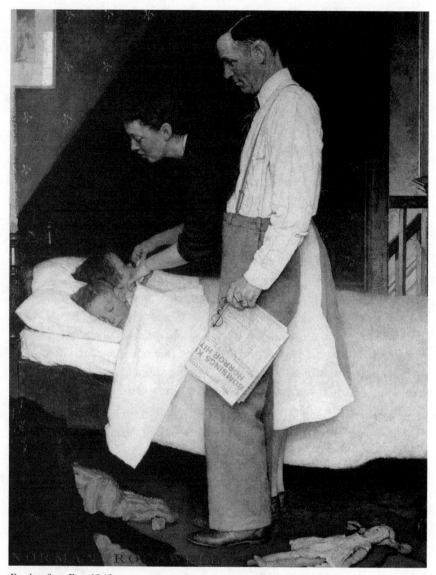

*Freedom from Fear*, 1942 (Norman Rockwell Museum, Stockbridge, Massachusetts)

spent the evening reading the newspaper, in a comfortable chair in the living room, because he's holding his wire-rimmed glasses and a folded copy of the *Bennington Banner*, whose partially visible headline (BOMBINGS KI . . . HORROR HIT) refers to the bombing of London. The scene has some of the feeling of a French interior, with lovely haut-art touches. Note the light visible in the hall outside the bedroom, coming up the stairs from an unknown source on the first floor (a lamp?) and thinning as it goes. The blanket is a lyrical object, a fuzzy, soft-edge rectangle of white that amounts to its own abstract painting.

•

By the end of December, after nearly seven months of continuous labor, the quartet of paintings was finally finished. "He was broke because he spent so much time on the Four Freedoms," Schaeffer recalled. Rockwell put them on display for a few days at the West Arlington Grange, before having them crated and shipped to Philadelphia. Each one was sizable, about four feet tall and three feet wide, big enough to fill the space above a fireplace.

The *Post*, in the meantime, was already at work on "one of the greatest promotional campaigns since the coming of Burma-Shave."[16] The publicity for the four paintings began prior to their publication. President Roosevelt was solicited by the magazine to write a letter of praise, and he actually agreed to do it. "I think you have done a superb job in bringing home to the plain, everyday citizen the plain, everyday truths behind the Four Freedoms," he wrote in a letter to Rockwell dated February 10.[17]

The White House gave a draft of the letter to Forrest Davis, a *Post* reporter in the Washington bureau. The president said he was leaving it up to the magazine to revise the letter and produce an "official" version to thank the *Post* for publishing the *Four Freedoms*. So the *Post* wrote a thank-you letter to itself, signed by President Roosevelt.[18]

It also enlisted the promotional skills of Eleanor Roosevelt, who, on February 21, could be heard in a national radio broadcast, commenting in her strong, careful voice about freedom of speech. In advertisements for the event, the *Post* left it unclear whether she would be speaking about her husband's text-only "Freedom of Speech," or Rockwell's painted interpretation of it, perhaps hoping they would blur into one.

The *Four Freedoms* were published in four consecutive issues of the *Post*, starting on February 20. Each painting appeared on page 13, in a "full color bleed" (running off the edge of the page, without borders), in the

words of the art editor. The opposite page (page 12) carried a short text by a famous writer who had been asked by the *Post* to airily ponder the meaning of basic freedoms. The novelist Booth Tarkington wrote the first piece, an unaccountably awful short story in which the young Hitler appears as a character. The next week, the historian Will Durant supplied a genuinely eloquent meditation on religious freedom. *Freedom from Want* came with an essay from the young Filipino poet, Carlos Bulosan, whose inclusion represented a welcome if transparent attempt on the part of the magazine to appear more ethnically diverse than it was. The poet Stephen Vincent Benét furnished the essay for *Freedom from Fear*, which ran in the issue of March 13, and died of a heart attack, at age forty-four, on that very day.

•

As the *Post* had anticipated, Rockwell's *Four Freedoms* were a huge sensation. Susan Sontag once noted that "sentiment is more likely to crystallize around a photograph than a verbal slogan."[19] An image allows you to linger, to look at it again and again, until it acquires a defining power. And, for many Americans, World War II made sense precisely because they had the chance to linger with reproductions of Rockwell's four paintings. To be sure, his work did not attempt to explain the battles or the bloodshed, the dead and injured, the obliteration of towns. But the war wasn't just about killing the enemy. It was also about saving a way of life.

The *Post* boasted that Rockwell's paintings elicited some sixty thousand letters from readers. Countless others responded to them with feelings that were never recorded, or never even verbalized, sitting in their living rooms or their kitchens as they studied the pictures in the *Post* and felt a little jolt of recognition from seeing their own lives somehow mirrored in them. The paintings tapped into a world that seemed recognizable and real. Most everyone knew what it was like to attend a town meeting or say a prayer, to observe Thanksgiving or look in on sleeping children.

Most of the mail pouring in was positive, and gifts arrived from people Rockwell had never met. Among them was the president of the Pioneer Suspender Company in Philadelphia. He sent Rockwell three pairs of galluses and noted that he especially admired *Freedom from Fear*, in which the father standing by the bedside of his children is shown in shirt sleeves and a clearly recognizable pair of Pioneer suspenders. "Of course he has freedom from fear," said the letter accompanying the gift. "His trousers are held up by a pair of our suspenders."[20]

At least one admirer tried to buy the original paintings. Hiram C. Bloomingdale, a vice president of his family's department store in New York, wrote to Rockwell to obtain a price. The artist replied that the paintings were not available at the moment, politely adding he would let him know should the situation ever change.[21]

•

In what was surely the greatest marketing coup in its history, the *Post* was able to sustain the buzz generated by Rockwell's paintings long after they were published. The March 13 issue, in which the final painting appeared, included a triumphant editor's note: the Office of War Information, which had initially declined to consider the paintings, had just agreed to print 2.5 million poster images of them.[22]

Moreover, the four originals would be the stellar centerpiece of a traveling war-bond sales campaign that the *Post* had pulled together in conjunction with the U.S. Treasury Department. In those days, Americans were expected to pay for their wars, and President Roosevelt was counting on the sale of bonds to bring in the enormous sum of $1 billion a month.

In some ways, it is surprising that President Roosevelt and his loyal friend Henry Morgenthau, Jr., the secretary of the treasury, agreed to cooperate on a project that would mingle the financial well-being of the country with that of the *Post*. Morgenthau, a quiet, bespectacled man who was often accused of being cold and suspicious, made enemies easily. He had good reason to dislike the *Post*, whose editorial page had railed against the New Deal and criticized his tax policies as an exercise in socialism. "I wouldn't cross the street for them," Morgenthau said of the *Post*.[23]

But the Treasury was about to embark on a new bond campaign, and Morgenthau's interest in the *Post* was nakedly transactional. With its three million-plus subscribers, the *Post* could be useful in getting the word out. Tellingly, Morgenthau had boasted in 1942 that sponsors of the bond program had made it possible for the Treasury to avoid spending "one penny on paid advertising in newspapers and magazines."[24]

Despite the scant funds for magazine advertising, the U.S. Treasury did have a budget for promotional films, and in April 1943, a five-minute newsreel called "Four Freedoms" began playing in theaters across the country. The OWI had arranged to send a film crew to Rockwell's studio in Vermont. Most of the footage shows him at his easel, fake painting. In one shot, the eleven models for *Freedom from Want* gather around a dining

room table, as if reenacting the scene in the painting, even though no such scene had ever occurred and some of the models had never met one another until the Paramount News crew showed up.

•

On April 1, 1943, Mary Rockwell left home by herself and flew across the country to attend her sister's wedding in Southern California. She would be gone for three weeks, staying with her parents, who had since moved from her girlhood home in Alhambra to smaller house in nearby Pasadena. It had been thirteen years since her own April wedding, in the garden in Alhambra. Looking back, she saw how bold she had been then, marrying an older artist she had just met, a man who, it was now clear, seemed to want nothing but to work.

She returned home to Vermont in time to accompany Rockwell to Washington for the "World Premier of the Four Freedoms War Bond Show," as it was called with a grandiosity worthy of P. T. Barnum. A reception was held on a Monday evening, April 26, at the Hecht Co., the city's premier department store, and visitors who rode the elevator to the fourth floor found, in place of the usual home furnishings—the upholstered club chairs, seven-piece dinette sets, and innerspring mattresses—a so-called Victory Center outfitted with more original artwork than anyone had ever seen gathered in one spot.[25] Rockwell's four paintings were hung behind a gilded rope, amid an ocean of a thousand-odd works, cartoons, illustrations, and even typed story manuscripts lent by a generation of contributors to the *Post*.

All of official Washington, it seemed, turned out for the opening on that Monday night. The invitations, which were issued by the Treasury, listed about two dozen "patronesses" including Eleanor Roosevelt, Mrs. Henry Wallace, Mrs. Hugo Black, and Mrs. Harold Ickes—Washington's most celebrated spouses, except for poor Frances Perkins, the pioneering secretary of labor, who got stuck on the wives-only list in an era when men had no idea where to put accomplished women.[26] William O. Douglas, who had been on the Supreme Court for four years, was the main speaker and his comments were broadcast by radio. They were not exactly art related, as the page-one headline in the next morning's *Washington Post* indicated: DOUGLAS CALLS JAPS DEGENERATE AS 4 FREEDOMS EXHIBIT OPENS.[27]

Rockwell did not mention the ceremony in his autobiography, perhaps because it did not elicit warm memories. A department store reception

with the tone of an anti-Japanese rally is hardly an ideal setting for the contemplation of works of art. Besides, Morgenthau made a point of being out of town that day, in Grand Rapids, Iowa, speaking to a group called We, the People. Members of his staff quietly took note of his absence, and commented among themselves that his antipathy toward the *Post* remained unabated. Stepping in for his boss, Daniel Bell, undersecretary of the Treasury, presented a citation to Rockwell.

The next morning the exhibit opened to the public and was mobbed from the start. Rockwell was chaperoned back to Hecht's to help with publicity. He gave a brief talk at eleven and again at three.[28] In the hours between, he autographed reproductions of *Freedom of Speech* for shoppers who waited in line for their turn. Those who purchased a bond—prices started at $18.75, for a bond that would be worth $25 when it matured in a decade—received a free set of reproductions. In a news photograph taken that day, Rockwell looks a bit harried as he sits behind a table, wedged into a corner with tall house plants whose leaves are practically poking him in the head.

He had been invited by the government to travel with the war bond show, in a caravan that would go to Philadelphia and Boston and cities fanning out across the country in the next ten months. He declined, an easy decision. On May 4, after a little more than a week in Washington, he returned to Vermont. The show at Hecht's would close four days later on May 8, with local officials boasting that the sale of bonds had reached the $1 million mark, far surpassing the city's quota for that period.

•

It was spring and he was glad to be back in his studio, his red-painted barn, with cool, pellucid mountain air streaming in through the open door. He had hired a carpenter to install a tall, two-story window that admitted the sort of light he favored (northern, shadowless). As always, he refused to paint by electric light, which played tricks with the colors on a canvas, made them harsh, lit up a picture like a Christmas tree.

When he wasn't painting, it seemed, he was cleaning. He found it soothing to sweep the wide-plank floor of his studio and wash his brushes in a metal sink he had installed expressly for this purpose. He swept four or five times a day and tidied up at the sink just as frequently.

He was well aware that he was compulsive about cleanliness. He went through dozens of paint rags every day, using them for wiping his brushes

and his palettes. He insisted on diaper cloth, claiming it was "more absorbent" than regular cotton. He ordered it by the yard and it arrived by mail, on a two-foot-wide bolt. His correspondence from this period refers to a product called Birdseye Diaper Cloth, which he purchased from the textile company where his father had worked. His children later recalled the sight of him sitting at the kitchen table on more nights than anyone would believe, tearing the cloth into six-inch-square swatches and then carefully picking off the linty fluff around the edges.[29]

Samuel Beckett once said, "To find a form that accommodates the mess, that is the task of the artist now."[30] The mess, he implies, is a given. The mess is the content of art, the stuff of life. But what form does art assume if an artist is not at peace with the mess of art, keeps sweeping it away, refuses to let it show? Rockwell's life is a reminder that a squeaky clean surface can contain its own unknowable depths.

In the week after returning from Washington, Rockwell finished work on a past-due painting called *Patriots on Parade*, for which his gardener had posed. A native of Vermont, Thaddeus Wheaton was then fifty-six and an obliging model, with an ability to hold a facial expression for several hours. When he put on a waistcoat and a stovepipe hat, you could not ask for a better Abraham Lincoln, of whom Rockwell would paint many likenesses.[31]

He had the canvas crated and shipped off on a Friday evening, May 14, 1943. He never forgot the date, because in the morning, when he went outside and gazed out over his property, his studio was no longer there.

•

On that Friday evening, Rockwell and Mead Schaeffer had gone into town to hear a lecture at the high school. They were well-acquainted with the guest speaker, Lee Wulff, an artist who trained in Paris and had a second career as an authority on salmon fishing. He wrote handbooks and designed hair-wing dry flies and lived on the banks of the Batten Kill, across the state line in Shushan, New York. After the lecture, the three men returned to Rockwell's studio and talked until the party broke up at half past eleven.

In the middle of the night, Rockwell was abruptly awakened by ten-year-old Tommy, who was banging on his bedroom door, hollering. The boy had seen leaping flames out his window. Rockwell picked up the phone to call for help, but the line was dead; apparently, the wires had burned.

As Mr. Wheaton came hurrying out of his bedroom, Rockwell asked him to drive to the nearest neighbor, a half mile away, and use their phone to call the fire department.[32] By the time Fire Chief Safford responded to the call, the studio was a ball of flames, lighting up the pitch-black countryside around it. By dawn, the chimney was all that was left of it.

Several years would pass before Rockwell publicly acknowledged the cause of the fire. Initially, newspapers stated: cause unknown. In an interview with *The Boston Globe*, Rockwell declined to speculate and Mr. Wheaton, who was with him at the interview, said, "It's a mystery."[33] Neighbors wondered if the fire had been caused by squirrels chewing on electrical wires.

In 1945 *The New Yorker* reported that Rockwell believed the fire "started from a pipe he had left near some curtains when he went to bed."[34] In his autobiography, he adjusted the story, suggesting that lit ashes had fallen out of his pipe and onto the cushion of a built-in window seat when he bent over to turn off the lights that night. "It was my fault," he wrote, and there is no reason to disbelieve him. The ashes fell. He did not see them.

He lost about thirty original paintings and hundreds of preparatory sketches. He was no less upset by the incineration of some two hundred costumes he had stored in the upstairs loft of his studio, a handpicked collection of vintage costumes and (near) contemporary hats and clothing he had bought off the backs of strangers. He lost brushes in all sizes, countless tubes of pigment, his palette table, his easel, his Balopticon projector, all of which would have to be replaced. And then there was his reference library—books, hundreds of art books with good-quality full-page reproductions, books he had lugged home from Paris and elsewhere. "All my brains," he lamented in a letter to Clyde Forsythe, describing his art books.[35]

On May 17, a Monday, just a few days after the fire, Rockwell and Mary said goodbye to their children and left home for a week. They were headed to Washington, where he was eager to redo a series of sketches destroyed in the fire. He had done them on his last trip to the capital, in the White House waiting room, and still needed them for a forthcoming article called, "So You Want to See the President!"[36]

As the train rattled south, Rockwell sat and sketched with his customary mulish silence. He had to turn the fire into an amusing story, if not for himself, then at least for the readers of the *Post*. He did a wonderful drawing, *My Studio Burns*, that features a wide cast: a horrified Mr. Wheaton glancing out the window, volunteer firefighters rescuing bicycles from the barn,

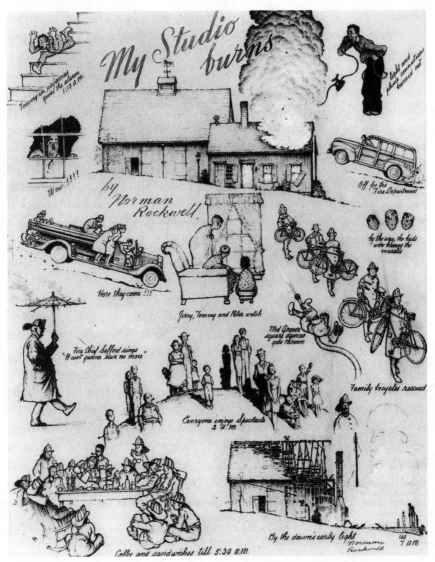

*My Studio Burns*, 1943, relayed news of a catastrophe as so many charming vignettes.

neighborly onlookers, the artist's three sons, who appear in their pajamas, alternately gathered in front of the window or displaying faces spotted with measles.

•

On their way to Washington, Rockwell and Mary stopped in New York for a few days, to replace supplies destroyed by the fire. Receipts indicate that he went to Saks and bought a hat and five pairs of socks. He also visited Brentano's book store, on Fifth Avenue, where he purchased fourteen art books. It had always been his habit to thumb through art books during the day, leaving two or three propped open on the floor, near his easel. It was one reliably positive thing he could do when he felt depleted and devoid of ideas. Among the books he bought that day were monographs on Pieter Bruegel, Manet, and Matisse. He had lost so much, his entire studio. But he could not be rendered ineffective or inactive if at least he had a hat and socks and art books.

At that point, the Four Freedoms War Bond Show had just opened in Philadelphia, at Strawbridge & Clothier, drawing huge crowds. As the show continued to travel that summer and fall, Rockwell's reputation changed in substance. Once known as the Boy Illustrator, he now became enshrined as America's leading Painter-Patriot. He had succeeded in his greatest desire, in making illustration matter. In the eyes of millions of Americans, his scenes set in the New England village where he lived amounted to an inspired defense of national values, a pictorial rebuke to fascists the world over. When his fellow Americans thought of Rockwell they thought of the man they had seen in the newsreel: a friendly and relaxed Vermonter. They thought of someone he did not know.

# "SLOWLY FELL THE PICKET FENCE"

## (JUNE 1943 TO SUMMER 1947)

Many people erroneously believe that Rosie the Riveter was created by Rockwell. It is true he turned her into a household name, but there were other Rosies before his. She made her first public appearance in a song composed in New York in the autumn of 1942 by John Jacob Loeb, with lyrics by Redd Evans.[1] The Four Vagabonds, an African-American vocal harmony group that had just emerged as a radio sensation, released a recording of the song on Bluebird Records in February 1943. The song begins:

> *All day long, whether rain or shine*
> *She's part of the assembly line*
> *She's making history, working for victory*
> *Rosie, brrrrrrrr, the riveter*

Rosie was a symbol, of course, of the millions of women who took on factory jobs during the war years, while the men were away. Many of the slots were for riveters in aircraft factories and Rosie gained currency along with such now-forgotten characters as Winnie the Welder and Glenda the Glue Spreader. Rockwell began his cover in response to a government campaign. The War Advertising Council, a subdivision of the Office of War Information, was charged with persuading newspapers and magazines to run stories that would help recruit women for defense work. Rockwell's editors requested that he produce a special cover about Rosie for the Memorial Day issue, which appeared on May 29, 1943.

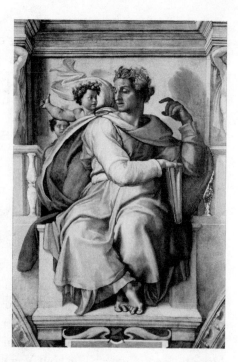

The result was wild: a comically muscular redhead posed against a backdrop of red and white stripes, sitting on a crate eating her lunch, her riveting gun laid across her lap, her right penny loafer resting on a copy of Hitler's *Mein Kampf* as if to crush it. It was an incredibly inventive interpretation of a potentially clichéd theme. For help, Rockwell turned to the Hebrew prophet Isaiah as Michelangelo had depicted him on the Sistine Chapel ceiling circa 1509. Isaiah didn't have a lunch box or buttons from the Red Cross, but he sits in the same twisting pose as Rosie, with the same dramatic torque.

The model for the painting, Mary Louise Doyle, was a petite, Irish-Catholic telephone operator in Arlington. She was nineteen years old and lived with her widowed mother, who managed the local office of New England Telephone (NET) out of their house on Main Street. Rockwell first spotted her when he came in to pay his phone bill. For the first sitting, she wore a white blouse beneath her overalls and a pair of saddle shoes. His studio assistant, Gene Pelham, took the photographs and after he saw them, Rockwell decided the clothes were wrong. He had Mary Doyle pose a second time wearing more convincing workaday clothes, namely, a short-sleeved denim shirt and scuffed penny loafers.

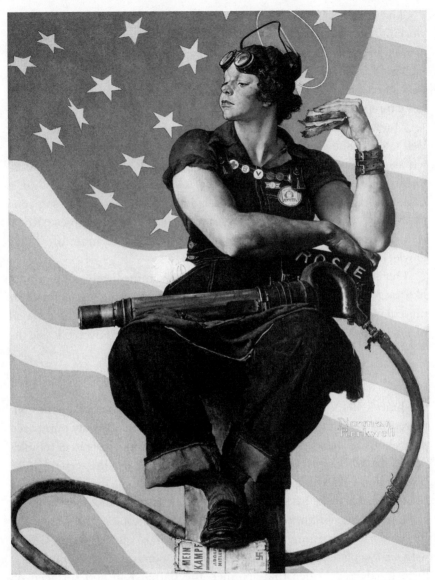

*Rosie the Riveter* (Crystal Bridges Museum of American Art, Bentonville, Arkansas) riffed on Michelangelo's figure of Isaiah on the Sistine Chapel ceiling (*opposite*).

The paradox is that Rosie, a worker, is pictured in the painting not working. She is on her lunch break, relaxing. Her knees, instead of being crossed in a ladylike fashion, are spread apart, as red waves pulsate in the background. Her protective goggles are pushed up on her head to reveal her closed eyes (a departure from Isaiah's downcast but open eyes), and her expression is one of intense satisfaction.

Mary Doyle was stunned and a little hurt when she first saw Rockwell's cover. She was expecting to see an attractive young woman, not a female behemoth sprung from the dark lagoon of Rockwell's imagination. "Mary has slender arms," reported the *Bennington Banner* on June 3, in a page-one exposé that noted that her head had been grafted onto someone else's body, with arms that could have belonged to Jack Dempsey.[2] Rockwell called her up to apologize for making her look so mannish. Mary Doyle, he said, "should sue me."

Outside of Arlington, Rockwell's Rosie was immediately popular and, like the *Four Freedoms*, was turned into a poster advertising war bonds. Her muscular physique served the national cause. As the playwright David Mamet puts it, "The American icon, for me is Rosie the Riveter. Rosie the Riveter beat Hitler."[3]

•

On June 4, 1943, with the citizens of Arlington still consumed by the controversy over Mary Doyle's upper arms, Rockwell impulsively purchased a new house. It had been three weeks since the fire, and instead of rebuilding on the ashes of his old studio, he had decided to flee the scene. Unlike his first house in Arlington, which was sequestered on a dirt road and too isolated for his taste, his second house, an eleven-room Colonial dating to 1792, was located in the town's social hub. When he opened his front door, he could see a charming New England view: the West Arlington Green, with its steepled church and one-room schoolhouse. Just beyond lay a historic covered bridge that spanned the Batten Kill and surfaced on Vermont-themed postcards and travel posters.

Rockwell already knew the family next door, the Edgertons, who owned a dairy farm. He liked Jim Edgerton and his handsome, square-jawed son, Buddy, who was thirteen and would be the first boy to pose for Rockwell in his new studio. The Edgerton house was the architectural twin of Rockwell's and stood just fifty feet away, separated by a strip of grass. As a result of the fire, Rockwell wanted neighbors living as close by

as possible, a family he could depend on. In the coming decade he was always walking over to the Edgertons' house, seeking help from Jim or Buddy or Buddy's two sisters and paying them to pose for him or perform myriad errands.

Mary depended on the Edgertons, too, Clara especially, who had blond hair that fell to her shoulders and was about as sturdy as a farm wife could be. In a photograph from this period, Clara Edgerton stands outdoors, wearing a bulky, red-plaid hunting jacket and smiling as she displays her kill: a dead buck hanging upside down in a tree, its antlers almost grazing the ground. After the Rockwells moved in, Mary would make her way to the Edgertons' at all hours to talk to Clara, sitting down at the kitchen table and speaking in a way that led their children to believe that moms had more secrets than anyone. Clara was a good listener. She was amused when Mary went through her "church hopping phase," sampling a different denomination every few weeks and claiming each was as unfulfilling as the next.

The Edgertons quickly realized that Rockwell was more tightly wound than his genial manner suggested. Buddy sometimes spotted him standing at the incinerator in his yard, a lean man in a blue chambray work shirt discarding canvases he had already cut up, the pictures he deemed to be failures. "He would throw pieces of his paintings in the incinerator," Buddy Edgerton recalled. "Partially burned pieces of canvas would blow through the fields."

Rockwell, he also noticed, was constantly straightening up the studio, as if nothing was ever right. "He would sweep the studio floor four or five times a day," Edgerton recalled. "He would take walks to get away from things."[4]

•

With the arrival of 1944, Rockwell found himself mired in depression. On January 17, he was "getting over the flu," according to an item in the local paper. The excitements of the previous year—the *Four Freedoms, Rosie the Riveter*, the fire, the radio interviews, the sacks of fan mail deposited on his doorstep—had left him physically and emotionally exhausted. To compound his unease, on February 3, he turned fifty.

To be sure, in the immediate aftermath of the fire, he had rallied. But his usual efficiency eluded him now. He tried to produce covers for the *Post*, but nothing emerged from his labors. He spent January and February on a single cover, *The Armchair General*, thinking it wasn't very good. "Norman had

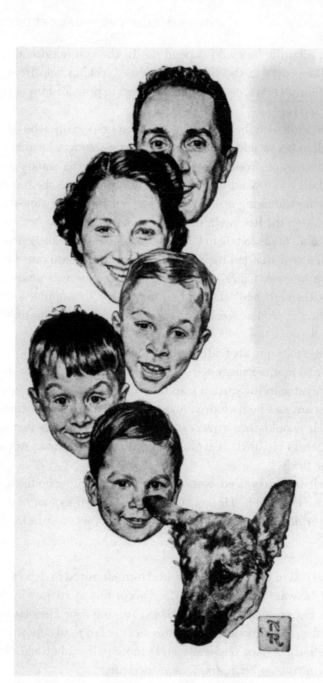

The Rockwell family: Norman, Mary, Jerry, Tommy, Peter, and
Raleigh, circa 1940

been having one of his monumental depressions for three months," Mary reported in a letter to her sister in March, betraying a slight impatience with his problems. "Two covers in four months is the total of work lately!"[5]

Writing to Clyde Forsythe, Rockwell corroborated Mary's assessment: "Seems as tho every once in a while I get into one of those slumps."[6] His confidence was at a low ebb, and the one person who might have helped was not around. "Mead Schaeffer has been in New York all winter so it's been lonesome up here . . . Next winter tho I swear we're going to New York. I miss having someone to help me with criticisms and encouragement." Even his dog was gone. He was heartbroken when Raleigh, his thirteen-year-old German Shepherd, was put to sleep by a veterinarian a week after the fire, a victim of smoke inhalation.

•

In July 1944 a new illustrator settled in Arlington, largely at Rockwell's behest. He and John Atherton had met just that year at a Society of Illustrators event in New York. When he heard that Atherton was a passionate fisherman, Rockwell insisted that he drive up for a weekend with his rods and fly-tying gear and test the trout in the Batten Kill. Atherton and his wife, Maxine, were then living with their daughter in Ridgefield, Connecticut, whose atmosphere, he believed, had been despoiled by a plethora of socialites. His daughter Mary later remembered his indignation whenever he drove past the local country club, which had a "Restricted" sign posted outside the front gate.[7]

And so he moved away with only minimum inducement. "Brand-new Vermonter," *The Saturday Evening Post* announced in the July 8, 1944, issue, whose cover featured an Atherton illustration that still feels clever and contemporary. It shows a clown's large, grinning face springing into close view from behind the ripped surface of a circus poster.

Atherton disliked having to bend his talent toward commercial art, which he did to pay the bills. He thought of himself as a fine artist and he won deserved support in the art world. Julien Levy, the Manhattan art dealer, gave him a one-man show in 1938 and a second one in 1942, and described Atherton in his memoir as "a top commercial artist who suddenly was converted to serious Surrealist painting."[8] Disdainful of the term *Surrealism*, Atherton preferred to call himself a Magic Realist. Even as a

magazine cover artist obliged to paint farm scenes, he leaned toward the hyperreal. He played around with the scale of objects, painted giganticized ears of corn.

Atherton, who was six years younger than Rockwell, was a great defender of his work in public. But privately, he would razz him about his Boy Scouts calendars. Atherton had distrusted commercial art ever since his Bon Ami calamity—he had been assigned to create a series of drawings of a blond housewife cheerfully scrubbing her sink with Bon Ami, the cleansing powder. The drawings came back to him with instructions to revise them—to redo the woman and give her red hair and a more voluptuous chest. "That really floored Jack," his wife, Maxine, recalled. "They wanted a big, bosomy redhead using Bon Ami. He said, 'To hell with commercial art.'"[9]

Rockwell included a likeness of Atherton in one *Post* cover—the 1945 April Fool's cover, which contained a slew of errors. (That was the joke.) Atherton, a tall, blue-eyed, prematurely bald man, is shown slouched against a tree trunk with his banjo and his books, his fishing rod and his skis. He is smoking both a cigarette and pipe. He looks certifiably crazy. It is, admittedly, one of Rockwell's goofiest covers and Atherton grumped about the likeness. "Jack had no sense of humor about that at all," his wife, Maxine, later recalled. "Norman gave him the picture and Jack gave it back to him."[10]

The previous year, Mead Schaeffer had posed for a far better painting. In *Tattoo Artist*, he is shown from the back, seated on a stool, a short, shaggy-haired man in a pink striped shirt, a vest, and matching socks. He leans forward with his tattoo needle, decorating the muscled arm of a consenting sailor. When Schaeffer saw the finished painting, he complained that Rockwell exaggerated the size of his rump. (See color insert.)

On weekends, if everyone was in town, the illustrators and their wives would gather for drinks and dinner. Usually they met up at the home of Mead and Elizabeth Schaeffer, for five o'clock cocktails. Rockwell, whose drink was a rum and coke, referred to the soirees as "children's hour." Drinks might be followed by dinner at the Green Mountain Pine Room, on the southern edge of town. Frank Hall, the owner of the restaurant, hung the main room with paintings and drawings by the famous illustrators in town. There were now four of them—Rockwell, Atherton, Schaeffer, and George Hughes—and everyone agreed that Arlington had reached critical mass as an art colony.

Rockwell's reputation was larger than that of his friends. Early in 1944

he signed a one-year contract with the *Post*, "at a swell figure."[11] He would now receive serious money ($2,500 per cover) in exchange for working exclusively for Curtis Publications. After the success of the *Four Freedoms*, the *Post* wanted him to itself. His contract allowed him to continue with only one other illustration commitment, the Boy Scouts annual wall calendar, which he had been doing since the first one was published in 1925, by Brown & Bigelow, the calendar company in St. Paul, Minnesota. It certainly paid well. At this point Rockwell was earning about $50,000 a year, and the Scouts calendar—which required just one painting from him every year—guaranteed him a minimum of $10,000 for reproduction rights. (He got to keep the painting.) By the 1940s the Boy Scouts calendar was the nation's bestselling calendar, outstripping the one featuring the Dionne Quintuplets, those five Canadian girls whose birth in 1934 had inspired a craze for photographs of them. "As the girls got older, the interest in them waned," explained William D. Smith, then president of Brown & Bigelow. But the Scouts that Rockwell portrayed stayed the same age from one year to the next, those beautiful boys with clear skin and caring expressions bandaging the paw of a dog or teaching each other how to tie knots. Every year another boy, different but the same.

In the forties Scouts calendars were hung on the walls of 2 million schoolrooms, offices, bakeries, dairies, life insurance companies, clothing stores, and funeral homes. The calendars designed for homes (meaning kitchens) were smaller than the poster-sized ones displayed in stores and public places, but both types consisted of a piece of cardboard with a Rockwell painting reproduced on the top and a tear-off pad of Januarys, Februarys, and the rest stapled to the bottom.

Rockwell often expressed annoyance with his Boy Scouts assignments, which had to be conceived nearly two years before the calendars were published. Dr. James West, who was chief Scout, and the rest of the Boy Scouts of America's executive committee didn't hesitate to dictate subject matter to Rockwell or demand the most picayune changes. In each painting, the Scout's uniform had to be immaculate no matter what ordeal he was facing, and his neckerchief had to be tied correctly.[12] For the 1941 calendar, for instance, Rockwell, shaken by the hurricane of 1938, roughed out a sketch of a Scout carrying a child to safety in the midst of a lashing storm. But Dr. West vetoed the idea of a Scout in a wet uniform, perhaps because there is something fundamentally unheroic about soggy clothing. In the end, *A Scout Is Helpful* shows a Scout walking through

knee-high water in the tranquil aftermath of a storm, his sandy-colored shirt and shorts perfectly dry and crisp.[13]

On the other hand, every Scout uniform as rendered by Rockwell had to look convincingly lived in and not like a costume acquired that day. Buddy Edgerton, the boy who lived next door to Rockwell, appeared on the 1945 calendar, in a tan uniform and navy neckerchief as he solemnly raised his right hand and took the famous oath ("On my honor I will do my best to do my duty"). When he modeled for the picture, Buddy changed into a uniform that came out of a box and Rockwell's assistant Gene Pelham snapped photographs. At one point, Rockwell told Buddy to take a break and go outside and do Boy Scout things, so the uniform would look less stiff and more natural. "I didn't have a clue what a boy in a Boy Scout uniform would do," Buddy later recalled, "because I was never a Boy Scout."[14]

All this Boy Scout role playing was not lost on Rockwell's illustrator friends in Arlington, who cast a mocking eye on his work for the Boy Scouts and could not understand why he persisted in taking assignments from them. "Norman did it with ease," Schaeffer recalled. "He could turn around and do a Boy Scouts calendar. He would close the door and hope I wouldn't come around."[15] Schaeffer, like Atherton, split himself between commercial art and fine art. The way they saw it, the commercial part was what you did to finance your real work, your painting, the pictures you made to satisfy no one besides yourself. "I could not imagine that Rockwell would ever do that," Schaeffer said, "wake up in the morning and have some fun playing around with shapes."

They found it incredible that Rockwell remained an artist at the *Post* while leaving himself with no time to make art on his own. Whether such art would have been aesthetically superior to his *Post* covers is a question no one asked. Or whether his *Post* covers might themselves be art was another never-raised possibility. The assumption was, even among his fellow illustrators, that art occupied a higher plane than illustration, and they wondered why he did not reach for it.

It's not as if his *Post* covers paid all that well. For a magazine illustrator, Rockwell was cursed, or rather blessed, with a lack of efficiency. It took him so long to complete his large and obsessively worked covers for the *Post* that he wound up losing money on paintings that were supposedly commercially driven. The Boy Scouts calendars—those were profitable, but not the magazine covers.

Still, Rockwell was loathe to undertake a painting that wasn't assigned to him by a magazine or an advertising agency. He could work only when he was facing a deadline, fulfilling an obligation.

One evening, Rockwell's son Peter, who was sick in bed, asked his father to entertain him by drawing some clowns. Rockwell resisted his son's entreaties, claiming he could not draw without looking at a model or a photograph. He needed to gather objects in front of him, an array of things to look at. He went cold when he tried to draw an image from his head, as he said. He was afraid of what might come out if he allowed himself to fall prey to his imaginings. He was the most nervous of realists, a painter who felt vulnerable when he shut his eyes.

•

In October 1944 Rockwell purchased a cabin and twenty acres in Sunderland, a few miles from his house.[16] It consisted of one room and allowed him to go into seclusion when his studio became too chaotic. Sometimes it was all he desired: a refuge from his refuge, to be alone again, to be in bed by ten, to fall asleep without having to hear the noise—the late parties,

The Rockwell and Schaeffer families socializing in Arlington, Vermont

with their laughter and slamming car doors—coming from the village green. It was widely reported that Rockwell was an excellent square dancer, and served as an officer of the West Arlington Grange, which planned the dances. Even so, he was likely to take to his cabin on Saturday nights, when the dances and live music went on until midnight.

He was interviewed in great depth that fall for a profile in *The New Yorker*. It was written by Rufus Jarman, a gifted young journalist from Tennessee. *The New Yorker* was aimed at an urban readership rather than what editor Harold Ross called "the old lady in Dubuque"—the comment was presumed to be a jab at *The Saturday Evening Post*. Rockwell himself was the first to agree that the *Post* lacked literary substance and sparkle. "He always read *The New Yorker*," his son Jarvis recalled, adding pointedly, "He never read *The Saturday Evening Post*."

The first part of *The New Yorker* profile ran in the March 17, 1945, issue, the second part a week later. Perhaps no one was more surprised by it than Rockwell's three sons. The piece made passing reference to his first wife, Irene O'Connor, "an upstate girl," whose existence came as news to his children. Tommy, the middle child, then a sixth-grader and the most studious of the Rockwell boys, read every column inch of the article and provided a careful synopsis for his incredulous brothers. It seemed beyond belief that their father, with his penchant for storytelling, had somehow neglected to mention the story of his fourteen-year marriage to a woman named Irene. Now when they looked at him, they saw a man with an elaborate hidden past, a stranger.

Rockwell emerges from the profile as a man given to amusing anecdotes, especially of the kind told at his own expense. In a typical moment, he relates a story about a time when he was visiting Los Angeles and received an invitation from the office of Josef von Sternberg. The stylish European director was apparently eager to make his acquaintance. So Rockwell showed up on his film set and a publicist perkily introduced him, saying, "Meet Norman Rockwell!" Sternberg appeared horrified. "Not Rockwell Kent?"[17]

Over the years, Rockwell Kent often provided Rockwell with a convenient punchline. In interviews and lectures, he insisted that he had benefitted royally from the comedy of errors that led countless people to confuse him with Kent, his hugely gifted contemporary. Kent was a painter, book illustrator, and self-proclaimed socialist.[18] The two artists never met, but for years kept up an amiable correspondence. Every so often, Kent would

forward Rockwell a packet of letters, most of them praising *Post* covers he had neither painted nor seen.

Rockwell claimed in *The New Yorker* article that he had "hung around southern California off and on for quite a while," but no longer went there. Actually, he was in Southern California when *The New Yorker* profile appeared.[19] As usual, he stayed with his in-laws and set up an easel at 22 Champion Place, in Frank Tenney Johnson's former studio. He presented himself as a Yankee artist, a self-reliant Vermonter living on a village green and shivering through another winter when in fact he was nowhere near snow.

•

Rockwell was still in Los Angeles on April 12, 1945, when President Roosevelt, who was visiting his second home in the resort town of Warm Springs, Georgia, complained of a pain in the back of his head and collapsed at his desk. He was sixty-three years old and his death came as a terrible shock. That evening, Vice President Harry S. Truman of Missouri, standing gravely in the Cabinet Room of the White House, his wife, Bess, beside him dabbing at her eyes with a handkerchief, put his hand on a Bible and took the oath of office.

On May 8 President Truman announced that the Germans had surrendered. By then, Rockwell was back in Vermont and had already delivered a resonant, extra-timely cover for the May 26 issue of the *Post*. *Homecoming G.I.* shows a Yank soldier-son who has just walked up to an apartment building and whose relatives are ecstatically rushing out to greet him. (Their beagle is a few steps ahead of them.) In the center of the composition, a redheaded grandmother opens her arms as if to welcome not just her boy, but all the sons who served in the war. America welcomes you home, she seems to be saying.

Interestingly, the soldier stands with his back to us and we cannot know his precise mood. The painting is less about his feelings than the burst of joy his safe return inspires among a small crowd of neighbors who pause at what they are doing to observe him. A workman fixing a shingle on the roof turns around, a married couple appears in a door frame, faces gaze down from second-story windows. Schoolboys climbing a tree freeze. They are part of the same circle, one that implicitly includes not only the folks looking at the soldier but a wider circle comprised of *Post* readers looking at the folks looking on the cover.

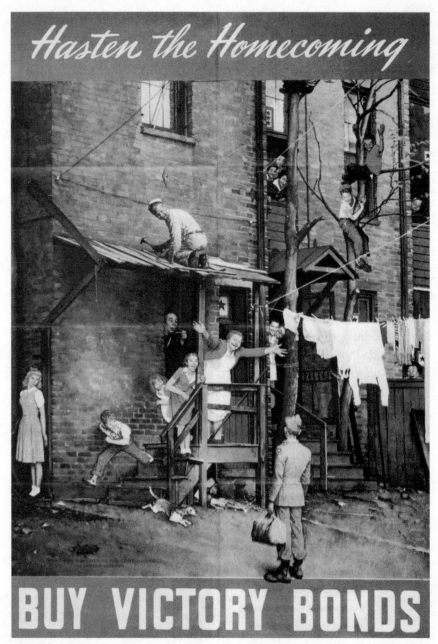

*Homecoming G.I.* was used by the federal government to help promote the final War Loan Drive.

*Homecoming G.I.* is Rockwell's first painting to be set in a scrappy urban neighborhood. He found the building in Troy, New York, near Albany, after trolling the city for two days with John Atherton.[20] The painting is often described as a scene in which a redheaded soldier is being greeted by his redheaded relatives, but the sixteen figures dispersed across the stage-like space cannot be so easily categorized. The schoolboy waving hello from the top of the tree is African-American, as is the repairman on the roof. The three dark-haired women leaning out of a second-floor window are supposed to be Jewish.[21] It seems almost certain that Rockwell conceived the painting after looking closely at Eastman Johnson's well-known *Negro Life at the South* of 1859, a sympathetic portrayal of a group of American slaves on an ordinary day in Washington, D.C. Rockwell borrowed many elements from the Johnson painting: the back alley, the dingy red bricks, the wooden overhang in need of repair.

If Rockwell was becoming sensitized to the plight of minorities, it would be a while before race became an explicit subject of his work. For now, even his own children posed for him infrequently and accused him of favoring facial types. They believe he preferred the sons of the plumber or the coal dealer or the insurance agent in town. "Increasingly, as we grew up, we came to seem more dissatisfactory to him," Jarvis Rockwell said years later. "He wanted freckles and red hair."

Jarvis, a future artist, was the oldest of the Rockwell boys and the one who had the prickliest relationship with his father. In September 1945, his parents sent him off to a Quaker-run boarding school, the Oakwood Friends School in Poughkeepsie. Two Septembers later, he was joined there by his brother Tom. When Mary filled out the application, she gave Dorothy Canfield Fisher, who was on the board, as a reference. Asked about the family's church membership, Mary wrote: "None."

"My father didn't want us to grow up to be Vermont people," Jarvis said. "He was using Vermont for his gene pool. He was using it for his models. The minute he saw someone, either they became part of a painting, or he had no use for them. As a family we stood shoulder to shoulder, and faced out. There was a hollowness where the family was supposed to be."

•

In the fall of 1946 Arthur L. Guptill published the first-ever monograph on Rockwell. Entitled *Norman Rockwell, Illustrator*, it was better than it had to be.

Guptill, an artist-professor with a goatee, was an authority on art technique. His book on Rockwell remains useful as a look at Rockwell's process, stroke by stroke.

Dorothy Canfield Fisher furnished the preface. She was the first writer to assert that Rockwell created his work from "inner necessity." Defending him from the disdain of unnamed snobs, she argues that the humor and optimism of his work should be viewed as a courageous stand against aesthetic fashion. He is original, goes his own way, shrugs off critics. If he were merely trying to please and pander, she posits, he would portray "the beauty of Nature," trees and red barns and glowy pink sunsets, the sort of rustic imagery that remained alien to his work.

The book sold poorly, perhaps because Guptill could not be bothered to advertise it. Moreover, it was expensive (ten dollars), about four times as much as your average nonfiction book. In a letter to Rockwell, Guptill mentioned his disappointment at having sold only fifteen thousand copies.[22]

•

At some point when no one was looking, Mary Rockwell began drinking heavily. Later, her sons were vexed to think how little notice they had taken of their mother's alcoholism, which they attributed to a variety of factors. Besides being relegated to the background of her marriage, she was overwhelmed with tasks that Rockwell expected her to perform. She still managed the business side of his career, which required that she answer his correspondence and get him out of assignments he regretted accepting. She also took care of his finances. Working in a small office behind the dining room, she recorded his credits and debits in the ruled columns of ledger books, the kind with red imitation-leather covers. Four times a year, she would submit her books to an accountant, who would calculate the estimated tax and invariably send her stern letters asking for receipts that she could not locate and making her feel wholly inadequate to the task.

So, too, Mary was responsible for any errand that involved driving. Rockwell, in general, disliked driving. But because he owned a station wagon, he, or rather Mary, was the first person teachers thought of when they needed a parent to do the chauffeuring on a school trip. Additionally, Mary drove her sons to school every day and picked them up and, in the hours in between, she frequently drove around trying to locate whatever latest crazy prop her husband needed for a painting. Sometimes Mary actually delivered a finished painting to the *Post*, which

entailed driving to the Albany train station and getting on the train to Philadelphia.

On top of all this, Mary oversaw the care of her mother-in-law, who was still living in Providence, Rhode Island. She liked to spend her summers in Vermont, and Rockwell always paid to lodge her in the area, anywhere but in his house. It was Mary who drove to Providence to ferry the senior Mrs. Rockwell to Vermont every spring and to take her back at the end of the summer. Four hours each way. The Mass Turnpike did not yet exist, so she took local roads as she crossed from Vermont into western Massachusetts and zoomed clear across the state, toward Boston, and then down into Rhode Island, smoking her Lucky Strikes and keeping her eyes peeled for cops.

Baba, as she had taken to signing her letters, was almost eighty now. She rented a room in Providence from the Arnold sisters, four middle-aged spinsters who still lived in the same narrow Victorian house at 25 Blackstone Boulevard, where they had grown up. In February 1946, as snow tumbled outside her window panes, Baba lamented in a letter to Mary, "I don't hear the radio unless Florence wishes." Even if she owned her own radio, which she didn't, "I would have to shut myself in my room, for I have to have it loud, being deaf, and that irritates them."[23]

That spring, Baba suffered a paroxysm of "upset nerves" and "had a sort of exhaustion trying to throw it off," as she wrote. She was eager to return to Vermont. On May 10 Mary dutifully drove to Providence to fetch her. It was arranged that the old woman would live that summer at a nursing home in North Bennington. "This is a grand location—in the mountains," Baba wrote to her niece, "about 15 miles from Norman and Mary, but she comes down very often."[24]

•

Mary's drinking began to spin out of control early in 1947. Although Arlington, Vermont, was a dry town without any bars, she and Rockwell would sip cocktails at home before dinner. Mary usually had daiquiri or two, which helped her to relax. But her drinking was not confined to cocktail hour. The Edgertons' daughter, Joy, later recalled a night when Mary came over after her parents had gone to sleep, walking over to the liquor cabinet and pouring herself a drink.[25] "Norman is busy with people," she said sadly, waving her hand in the direction of the studio and sitting down at the kitchen table to talk to Joy into the night.

On February 3, a Monday night and her husband's fifty-third birthday, she drank so much she passed out. She was taken to Putnam Memorial Hospital, in Bennington, and remained hospitalized for a week. Rockwell told the local paper that she was there for "ear trouble."[26]

Mary was then thirty-nine years old, and among her frustrations was her lack of progress with her writing. During her college days, she had come to believe she was one of those people meant to write stories. But in the years since, her efforts had been erratic, at best. She belonged to a writing group in Bennington that met on Tuesday evenings and, in a letter to her sister, mentioned reading one of her stories aloud. "When I read it last night at the writing group, they all said I should send it to the New Yorker or Atlantic or etc.—at least for a criticism."[27] She enclosed a carbon copy of the story, soliciting her sister's opinion.

The story recounts a train ride that turns into a nightmare for its protagonist, a girl whose name and age are not given. She is in her "red plush seat" when she has an anxiety attack. She stands up and runs down the aisle of the train, only to feel herself "falling, falling into the blackness of a night without a bed she knew, or any star beyond the window." The reader is left with an image of her "heavy, tear-stained face."

A poem written by Mary during this period, "The Question," is similarly desolate. It describes the collapse of a clapboard house that cannot "defend" itself against the weather. Again, there is imagery of things tumbling down: "Slowly fell the picket fence."

•

Rockwell decided they would go away for the summer, for a real vacation. The plan was to leave his mother in the nursing home in Vermont and take Mary and the boys to Cape Cod, to Provincetown, where he had gone as an art student so many moons earlier. Although Rockwell had no affinity for the ocean, Mary had sailed in her girlhood and could captain a Portuguese sloop by herself. They rented a house at 75 Commercial Street, right in the middle of everything. But they had barely unpacked when the problems began.

During the long fourth of July weekend, at 7:30 on Sunday evening, Mary was stopped by the police in the town of Orleans for drunken driving.[28] The report said she "operated a vehicle in an improper fashion." It was not her first offense and, on July 31, her license was suspended in the state of Massachusetts for one year.

*Boy with Baby Carriage*, 1916, was Rockwell's first cover for *The Saturday Evening Post*. Billy Payne posed for all three boys.

(Norman Rockwell Museum, Stockbridge, Massachusetts)

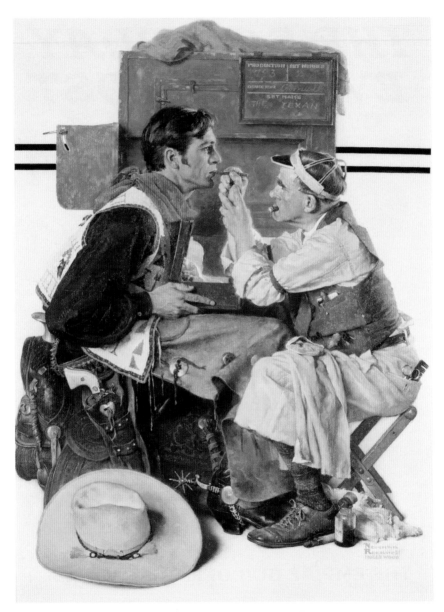

***Gary Cooper as The Texan***, 1930

(Collection of Steven Spielberg)

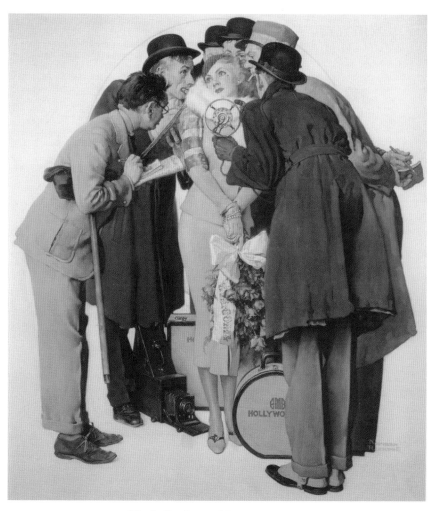

***Movie Starlet and Reporters,*** 1936

(Collection of Steven Spielberg)

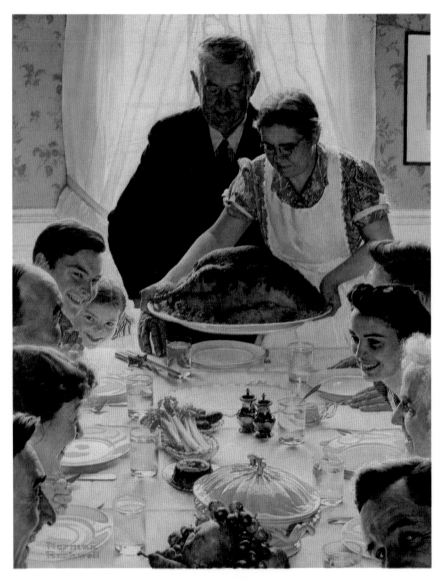

***Freedom from Want*, 1943**

(Norman Rockwell Museum, Stockbridge, Massachusetts)

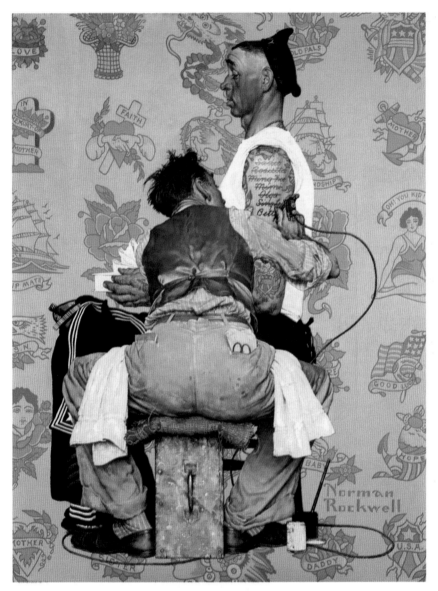

***Tattoo Artist,* 1944**

(Brooklyn Museum, Brooklyn, New York)

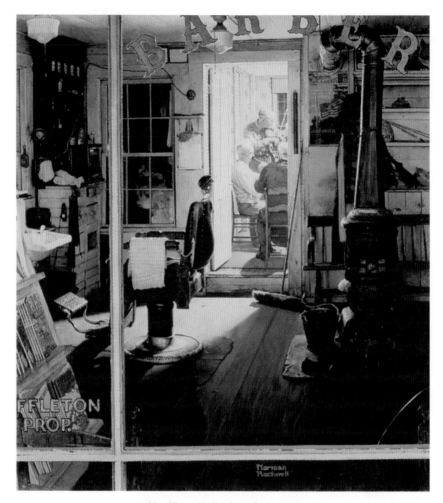

***Shuffleton's Barbershop***, 1950

(Norman Rockwell Museum, Stockbridge, Massachusetts)

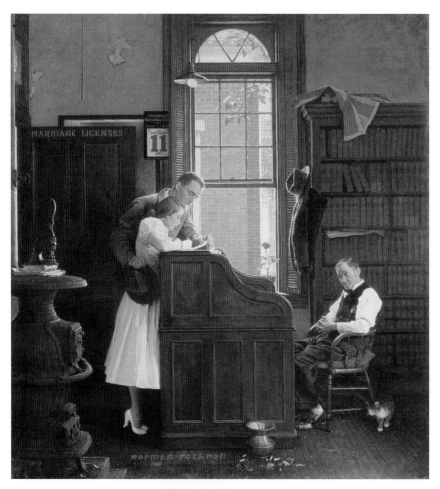

***Marriage License***, 1955

(Norman Rockwell Museum, Stockbridge, Massachusetts)

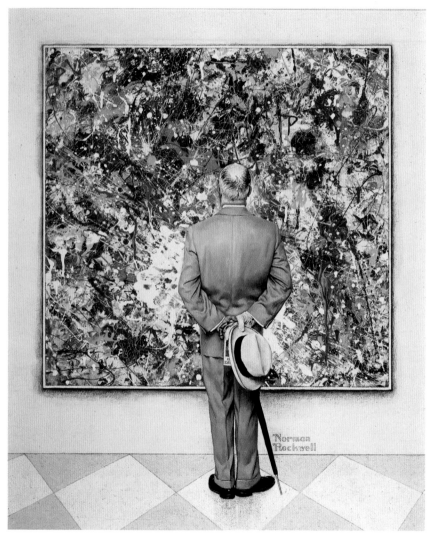

*The Connoisseur,* 1962

(Collection of Steven Spielberg)

Rockwell had his own misadventure. On July 19, the *Bennington Banner* reported in a page-one headline: NORMAN ROCKWELL WON'T BE ABLE TO TALK FOR AWHILE. He had rented a bicycle in Provincetown and taken a bad spill. "He landed on his jaw, fracturing it. He had to go about 30 miles to a good surgeon."[29] Indeed, he broke his lower jaw and had to have his mouth wired shut by an oral surgeon in Hyannis.

Two days later, the newspaper amended its report, saying he had suffered "a slight mishap on a bicycle." Clearly, Rockwell wanted to downplay his injury and not turn his jawbone into a subject of national media attention. His vacation turned out to be a month shorter than planned. At the end of July, after Rockwell honored a long-standing promise to help judge a grand costume ball organized by an all-male artists' group called the Beachcombers, he returned to Vermont.

By coincidence, that was the summer in which Rockwell painted *Going and Coming*, a casual masterpiece that captures something profound about family outings. A two-panel, before-and-after affair, it is one of his very few *Post* covers that portrays three generations of a typical-seeming American family and it is probably telling that no one is talking or looking at anyone else. The family consists of a mother, a father, two boys dressed in matching orange-and-blue striped T-shirts, two girls, and a grandmother. There is also a springer spaniel—Butch, who was Rockwell's new dog. In the top panel, you see a buoyant clan starting off on a trip, presumably to a lake; a rowboat (*Skippy*) is tied to the roof. In the bottom panel, the same seven people reappear, sitting in basically the same seats but facing the opposite direction, heading home, their faces drooping with fatigue.

The grandmother is the exception. She is the only one who stays the same both ways. Shown in profile, in her little hat and wire-rimmed glasses, she is as immobile as a statue, unchanged by her day at the lake.[30]

The mother, by contrast, is less resilient. On the ride back, she sleeps, her head resting heavily against the window frame. She is absent even when she is present.

The car, a 1933 Ford Model B, was borrowed from John Benedict, who built cabinets and stairs for Rockwell. Which means that the car was fourteen years old when it appeared in the painting and suitably unflashy.

Rockwell frequently chose to depict the prelude or the afterward of a scene instead of the scene itself. He paints the moments at the periphery of the action—the tensely expectant slip of time before the prom, or before the date, or before a boy dives into a pool. Maybe he thinks that

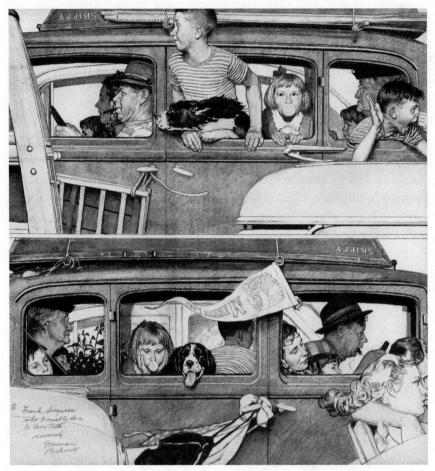

Rockwell's new dog, a springer spaniel named Butch, appeared in *Going and Coming*. This is a charcoal sketch for the painting. (Collection of George Lucas)

anticipating an event can be more dramatic than the event itself. Maybe the anxiety that comes before an event *is* the event. He also did his share of after-the-event scenes, such as his *Homecoming G.I.*

In *Going and Coming*, you get both at once. A twofer. Before the fall and after. The joke, of course, is that there's nothing more exhausting than a day off with your family. You leave home refreshed; you return home needing a break from your break.

*Going and Coming* remains one of Rockwell's most popular paintings and it had the unintended consequence of piquing interest in Rockwell's summer vacation. A *Post* staffer wrote to him to request information about his trip and also asked for "a summer photograph of the Rockwells," thinking it would make for an interesting article. Not surprisingly, Rockwell declined to send one.

# "WE'RE LOOKING FOR PEOPLE WHO LIKE TO DRAW"

## (OCTOBER 1948)

After the war, home-study courses came into vogue. Magazine advertisements exhorted readers to fill out the coupon and become a success, to earn "big money," to train for a career in radio repair, watchmaking, or "plasticating" (plastics?), to imagine themselves earning their livelihood engraving jewelry or raising hardy "chinchilla rabbits." It was not just the dream of a well-paying job that was newly available. It was the chance to become someone new, to make yourself over as a gracious and cultured presence. You could take dance lessons from Arthur Murray, correct your stammer, master a musical instrument in six weeks.

Send coupon for FREE bulletin NOW! No obligation!

Rockwell was a founding member of the Institute of Commercial Art, which officially opened on October 4, 1948, and later changed its name to the Famous Artists School.[1] It was located in Westport, Connecticut, in the old Sasco mill, a low, rambling red-painted building overlooking a brook, and described itself as a school "whose campus is the U.S. mail." Advertisements that became ubiquitous in the back pages of magazines and comic books showed Rockwell in his studio, paintbrush in hand, gazing out warmly and beckoning the reader to join him on his merry art adventure. As the text read:

Norman Rockwell Says:
We're Looking for People Who Like to Draw

The ads took many different forms but usually included a tiny coupon where you could write your name and address on three black lines that weren't long enough and left you squeezing the last five letters into the margins. Then you cut out the coupon, went rummaging in a drawer for a three-cent stamp and an envelope, and mailed your request for more information to the Famous Artists School, no apostrophe, in Connecticut. Some aspirants were actually turned down. "I couldn't seem to draw a simple fish to their satisfaction," recalled the design critic Steven Heller, who was crushed when he received a rejection letter in his youth.[2]

Despite the hucksterish advertisements and much-derided status of correspondence schools in general, the Famous Artists School had something substantial to offer.[3] In coming years, it would instruct tens of thousands of children and adults in the rudiments of art, illustration, and cartooning, helping to raise the level of visual literacy in America. Its students ranged from housewives and small business executives to Carol Burnett, Tony Curtis, and museum founder Joseph Hirshhorn, all of whom received in the mail overly large, four-ring binders and twenty-four lessons intended to make them proficient at drawing the figure, the foundation of all art education.

Veterans could use their G.I. benefits to cover the tuition, which was initially two hundred dollars, payable in monthly installments. It entitled students to have their work graded and critiqued on a regular basis. They would mail their finished assignments to a team of artist-instructors who would "correct" them on an overlay of tracing paper, then promptly send them back. The enterprise was intriguing enough to inspire J. D. Salinger to make the protagonist of his short story, "De Daumier-Smith's Blue Period" just such a mail-order instructor, poring over student work and laboring to draw "recognizable trees" on overlay paper.[4]

The Famous Artists School could have been called, if factual accuracy had been the goal or even a vague concern, the Somewhat Famous Artists School. Rockwell was the only household name among the original faculty members, a group of accomplished illustrators who were more familiar to the profession than to the public. Most of them lived near the school's headquarters in Westport, on the fashionable Connecticut shoreline, and turned out illustrations for the *Post* or *Collier's* or *Ladies' Home Journal*. Some (such as Stevan Dohanos) favored Rockwell-style genre scenes, but others pursued more glamorous subjects, such as sinewy cowboys (Harold von Schmidt); race cars (Peter Helck); stylish mother-daughter couples (Al

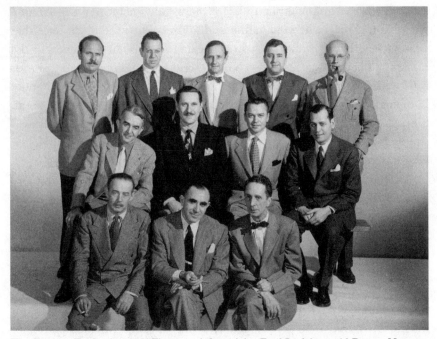

The Famous Twelve in 1949. First row, left to right: Fred Ludekens, Al Dorne, Norman Rockwell; second row: Peter Helck, Al Parker, Jon Whitcomb, Stevan Dohanos; back row: Ben Stahl, Austin Briggs, Harold von Schmidt, Robert Fawcett, and John Atherton (Courtesy of the Famous Artists School)

Parker); or sexy blondes with powdered noses and too much lipstick (Jon Whitcomb).

Albert Dorne, who founded the school and served as its president, was a decade younger than Rockwell and not nearly as down-to-earth. He belonged to the tradition of the illustrator as self-made playboy and night-club fixture. Raised in a tenement on Manhattan's Lower East Side, he saw himself as a dashing exemplar of the American dream. In photographs Dorne is a short, stocky man with slicked-back hair, heavy caterpillar eyebrows and the inevitable cigar. His studio, at 322 East Fifty-seventh Street, was in one of those top-of-the-line New York artists' buildings with cavernous rooms and double-height windows. From there he commuted back and forth to his school in Westport in a Mercedes sedan whose varnished walnut dashboard was conveniently equipped, in the case of an impromptu cocktail party or a sudden desire for self-obliteration, with a pull-out bar. He made his fortune drawing advertisements and created his most

winning advertising campaign on behalf of himself—it was Dorne who came up with the clever catchphrase, "We're Looking for People Who Like to Draw," one of the most effective pitches of the fifties.

Dorne initially tried to launch his correspondence school under the auspices of the Society of Illustrators, where he was elected president in April 1947. When the plan failed, he called up Rockwell, whom he knew casually from the society, and proposed that they start their own institution. Rockwell, he believed, could imbue a school with both star power and an aura of integrity. Dorne thought of him as a genteel figure, an "old-fashioned Boy Scout type of guy" who did not curse, except for an occasional "damn."[5]

Initially, Dorne offered Rockwell and his fellow faculty members stock in the school, instead of money. It would turn out to be a lucrative arrangement, although the payout did not come until much later, until 1961, when the school became publicly owned.[6] For now, Rockwell's main responsibility was to furnish educational material for the home-study course books and pose for publicity photographs.

In his letters to Rockwell, Dorne addressed him as "Dear Professor" and signed off with "love and kisses."[7] His affection for Rockwell was genuine, if clouded with professional jealousy. In promotional literature for the school, Dorne identified himself as "a brilliant illustrator" while characterizing Rockwell as merely "popular." Once, in the middle of a squash game with Elliot Caplin, the younger brother of cartoonist Al Capp, Dorne mentioned having heard a rumor about a new comic strip. "I hear you're doing something with Normie," Dorne remarked cuttingly. "It takes Normie a week to draw a finger nail!"[8]

Rockwell refrained from publicly criticizing Dorne's work, which leaned toward the cartoony. "Dorne was not chained by the classical traditions of art production," as David Apatoff notes in his monograph on the artist.[9] He forsook the slow-drying medium of oil on canvas for the quicker satisfactions of colored ink and paper. He insisted it was foolish to hire models and have them pose when you could obtain more-than-adequate human figures by copying pictures from a Sears catalog. A proto-Warhol, he claimed that the greatest art was making money, although he was no slouch in the draftsmanship department either. His elongated figures and jumpy crowds would later be held up as an important influence on a generation of *Mad* magazine artists.[10]

•

Rockwell had one close friend on the faculty, John Atherton, who would accompany him on the trip to Westport for meetings that were held perhaps two or three times a year. He always went by taxi and had the car wait until he was done, so he and Atherton could get back to Arlington, a nearly four-hour ride, on the same day.[11] Rockwell was also fond of Al Parker, whom he met through the school, and whom he treated with great professional chivalry. "While the rest of us are working knee-deep in a groove you are forever changing and improving," Rockwell wrote to Parker in 1949, going on to compliment a recent (unnamed) illustration of his.[12]

Although Rockwell was the public face of the Famous Artists School, he had little desire to teach. He certainly wasn't trying to spread a certain art philosophy or win acolytes. Rather, he had always been content to follow in the tradition of Howard Pyle, who articulated the rules that remained dominant during the Golden Age of Illustration. His approach came out of high art, out of academic history painting, which assumed that an artist was steeped in knowledge of his subject. Pyle's love of verisimilitude seemed obsolete to a generation of younger illustrators who put a premium on efficiency. Rockwell was working at the end of a tradition—not starting a new one.

Moreover, Rockwell had little faith in his ability to convey anything instructive in words. Like most painters, he thought of line and color as his preferred language. If he had been able to express himself fully by speaking or writing, he wouldn't have had to sink his life savings into the construction of studios and the constant replenishment of his supply of exorbitantly priced tubes of cadmium yellow and cadmium red.

When Rockwell wrote up his ideas and strategies for a chapter of the Famous Artists home-study course books, he was obliged to adopt a practical tone. This came to him naturally. He exhorts students to draw from life models at every opportunity. He recommends the use of costumes and props. Proffering a bit of advice not likely to be widely followed, he urges: "Keep a list of people you know who have guns, stuffed animals, sporting equipment or other props you are likely to need in your pictures."[13]

At Dorne's request, Rockwell visited New York the first week of October 1948, to help promote the opening of their school. Interviewed by a syndicated columnist in the restaurant of the New Weston Hotel, he neglected to mention the Famous Artists School, or perhaps the reporter just

skipped over it because he sensed it wasn't foremost in Rockwell's thoughts. Puffing on his pipe, speaking "softly and hesitantly" and sipping on a cup of tea, Rockwell came across as the anti-Dorne. He volunteered that he disliked nightclubs. He expressed an impatience with New Yorkers in general, saying he found them too guarded, too attached to their social poses and masks, to make for good models. The exception, he said, were "underprivileged slum dwellers," who are less practiced at self-presentation and more likely to express a flicker of character in their faces.[14]

When his interviewer tried to goad him into attacking Cubism and Surrealism, Rockwell politely declined. He did not think of modernism as an infidel movement that threatened what he had. To the contrary, part of him wished he could be a modernist, lead a freer life, escape from the straitjacket of rules he imposed on himself and his art. "Every time they come out with a new art movement," he joked to his interviewer, "I try grimly to follow it. However, when I put brush to canvas, alas, it always comes out Rockwell."[15]

# GRANDMA MOSES

## (1948 TO 1949)

On February 14, 1948, Rockwell was in Kansas City, Missouri, visiting with Joyce C. Hall, a tall, soft-spoken man with a bald pate and wire-rimmed glasses. His company was on Grand Avenue, in the Overland Building, and he considered it a point of pride that he had his lunch every day in the sixth-floor cafeteria. A high school dropout from Nebraska, Hall traced the origins of his company to the moment in 1910 when he arrived at the Kansas City train depot carrying two shoe boxes filled with picture postal cards. That was his entire inventory: postcards which he would sell out of his room at the YMCA.

Later, after he became a celebrated businessman, Hall spoke about his greeting-card company as if it was right up there with the telegraph or the telephone as a crowning achievement of modern communications. He maintained that greeting cards kept Americans connected in an era of mobility and constant change. His own life lacked stability; he could not forgive his father, a Methodist minister, for saddling him with a girlish name and running off. Soon after, he began collecting picture postcards and acquired them obsessively, as if to fill a void.

Hall had brought Rockwell out to Kansas City to help garner publicity for a new project.[1] In contrast to his usual greeting cards, most of which featured pastel-colored roses and pansies drawn by staff artists, he was inaugurating a deluxe line of cards known as the Hallmark Gallery Artists Group. Rockwell agreed to create four humorous paintings in time for Christmas, the most popular of which would show Santa Claus snooz-

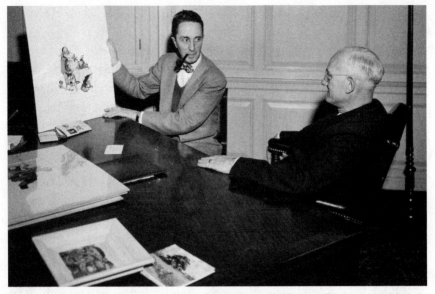

Rockwell displays his Christmas card designs to Joyce C. Hall, on February 14, 1948, in Kansas City. (Courtesy of Hallmark Cards)

ing on the job as his staff of craftsy elves took over for him. His cards, according to Hallmark ads, put Rockwell in the company of Leonardo, Michelangelo, and other artists tapped for the series. YULE CARDS TO DISPLAY GREAT ART, trumpeted a headline in *The Washington Post*, which explained that the project was "designed to bring fine art into the American home" for prices starting at ten cents.[2]

It's been said that Hall was the first person to put famous art on Christmas cards, but that is incorrect. The National Gallery of Art in Washington, for instance, was already selling a good number of radiant madonnas by Raphael or Fra Filippo Lippi every December. What set Hall apart, by his own admission, was that he understood the possibilities that inhered in display fixtures. He credited his success to his patented "Eye-Vision" contraption, a walnut rack that allowed stationery shops to display his greeting cards standing up, or rather tilted at a natural reading angle, instead of lying flat on countertops or concealed in a drawer.[3] In 1947 Hall acquired the right to reproduce Grandma Moses's snowy farm scenes on Christmas cards. She was a runaway marketing phenomenon, and he moved 16 million of her cards that year.

•

It was Hall who introduced Rockwell to Grandma Moses. She lived on a dairy farm in upstate New York, in a hamlet called Eagle Bridge, about twenty miles from Rockwell's house in Vermont. He routinely drove by her house on his way to the train station in Troy. At the time they met, Rockwell was fifty-four and she was about to turn eighty-eight. But he had been painting much longer than she had. As nearly everyone in America then knew, Anna Mary Robertson Moses was a late bloomer.

"Grandma," as the whole country called her, had taken up art at age seventy-six, in her idle widowhood. At the time she was living with her youngest son, Hugh Moses, and his wife, Dorothy, who had moved in with her to take over the management of her farm. She did her painting in the upstairs bedroom, turning out pictures of what she referred to as "old-timey things."[4]

Officially, she was a primitive artist, unschooled in art and its history. But she did have an elite art dealer. In 1940 she had been given her first show at the Galerie St. Etienne in Manhattan. It was owned by Otto Kallir, an Austrian-Jewish émigré who had shown modern art at his gallery in Vienna until the Nazis shut him down. In New York, he alternated shows of self-taught artists with those of Oskar Kokoschka, Lovis Corinth, and the German Expressionists, first-rate modernists whom Grandma Moses came to overshadow in terms of popularity. A tiny woman who stood just over five feet, she enchanted the public with her plainspoken style and stories of farm life. Here was a poet of rural America who seemed to represent a new kind of master: sane, practical, fond of making raspberry jam.

A few months after they met, Hall asked Rockwell to participate in the elaborate festivities he was planning for Grandma's upcoming birthday. At the time, his new line of Christmas cards was about to go on sale and he was trying to drum up national publicity. Naturally, there was no possibility of media appearances by most of the fifty-odd artists who appeared on his cards—El Greco and Gauguin were dead and Picasso might as well have been, considering his inconvenient Paris address. But Rockwell and Grandma Moses had the advantage of being accessible. Hall anointed them the twin stars and public face of the Hallmark Gallery Artists Line.

The story ran in papers across the country: ROCKWELL IS BAKER FOR GRANDMA MOSES, one headline read.[5] Rockwell purportedly spent Labor

Day weekend designing a cake—a white-sponge, seven-layer confection that measured two feet across, weighed fifty-five pounds, and contained 228 eggs.[6] It was actually baked by the pastry chef at the Green Mountain Pine Room, in Arlington, one of Rockwell's haunts. Frank Hall, who owned the restaurant, was not related to Joyce Hall, except by virtue of their business transactions and Hallmark's willingness to pick up the tab for Grandma's elephantine cake. It was decorated with a scene from one of her Hallmark cards, "Bringing in the Xmas Trees," complete with ice skaters and horse-drawn sleighs rendered in the slippery, hard-to-control medium of cake frosting.

September 7, 1948, fell on a Tuesday. When Rockwell arrived in Eagle Bridge that morning, the two front parlors in Grandma Moses's house were mobbed. Her son Hugh, a farmer, helped Rockwell maneuver the bulky cake out of the car and through the narrow door of the farmhouse. The guests included Joyce Hall from Kansas City; Otto Kallir, the art dealer with the Austrian accent from Manhattan; and a throng of reporters and photographers.[7] As Grandma entertained her guests, a cameraman from Paramount shot footage for a newsreel. "Every visitor was treated to a piece of a seven-layer cake brought by Norman Rockwell," *The New York Times* reported the next morning, making him sound like the kind of guest who never went anywhere without bringing a homemade dessert.[8]

Although their acquaintanceship began as a PR stunt, Rockwell genuinely liked Grandma Moses. She was the only female artist he ever counted as a friend. Her advanced age removed any risk of sexual entanglement and allowed him to feel comfortable in her presence. He gave her his highest compliment when he gushed to a reporter, "Grandma Moses is the cleanest-looking woman I have ever seen. Her skin is clear as a young girl's."[9]

It amused him to recall the first time he asked to see her studio. She flatly declined, joking that no respectable woman would allow a gentleman in her bedroom. Rockwell eventually did gain access to her sanctum. Instead of standing at an easel, Grandma worked sitting down at a table in front of a window. Rockwell told her she was doing herself a grave disservice by allowing light (southeastern) to pour into the room and cast shadows all over the place. He also expressed his disapproval of her thrifty materials—she favored pint-size cans of regular house paint.

He sketched a wonderful portrait of her at work, depicting her in

perfect profile, a studious woman sitting at her little table, a coffeepot at her feet. He was surprised to realize that "she drank black coffee incessantly."[10] When his drawing was published in a magazine, Grandma complained. She was unhappy about the presence of the coffeepot, not caring to disclose her caffeine habit to all the country.

•

By October, the summer people had vanished from the Vermont hills and the air was surprisingly chilly. On some mornings, when Rockwell walked along the short path from his house to his red-painted studio in the yard—always at the same hour, shortly before eight o'clock—the grass was stiff with frost and he could see his breath. The studio was his true home, but it no longer offered the usual sense of refuge. Mary's drinking problem could no longer be ignored and was increasingly the topic of town gossip.

That month, Mary appeared on the cover of *The Saturday Evening Post*, as the protagonist of another illustrator's work. George Hughes, a neighbor in Arlington of whom she was fond, specialized in light comedies that had a period look. Mary posed for his cover, *Readying for First Date*, which shows a mother (in cinch-waisted green dress, her hair pulled back in a ponytail) in her teenage son's unkempt bedroom, helping him with his bow tie.[11] Inside the magazine, in an editor's note, the models are identified as Mary and Tommy Rockwell. It unsettled Rockwell, perhaps because he had failed to give Mary a similarly prominent role in his own work. So far, the only cover in which she could be conclusively identified was *The Gossips*, which had appeared earlier that year and remains his most mordant cover. It features five rows of adult heads—a frieze of busybodies, most of them middle-aged and lumpy-looking and taking a bit too much pleasure in receiving and repeating a rumor that in the end circles back to the original busybody. Rockwell said he included a likeness of Mary to dispel any suspicion among his neighbors that he was mocking them.

He had a scare on the last Saturday in October, when Butch, his black-and-white springer spaniel, disappeared. He walked several miles along the muddy banks of the Batten Kill, calling out the dog's name. Returning home at nightfall, he learned to his immense relief that the police had found Butch—he was in the woods, ensnared in a fox trap. A reporter from the *Bennington Banner* called to get the story, and Rockwell relayed it with an empathy he found easy to summon for animals. Butch, he

said, was curled up at home with "a contented look" as he nursed his injured paw.[12]

Just a few days later, Rockwell decided impulsively that he needed to leave home. He felt exhausted and depressed, and it pained him to think that, in 1944, he had signed a contract with the *Post* that obligated him to do at least six covers a year and made him feel like a kept man. Seeking to be released from his contract, he wrote a check for $10,500—the amount he had received in settlement of his previous year's contract—and mailed it to the editor, Ben Hibbs. Responding with a lengthy, enormously caring letter, Hibbs returned his check and assured him: "We hit on the contract idea as the best possible method of proving to you that we loved you and wanted you to continue as our number one artist."

It had been a long while—six years—since Rockwell had visited Los Angeles and worked on Champion Place, with its row of artists' studios and eucalyptus trees. He decided to return to California now. His two older sons were at boarding school, and he told Mary, somewhat impatiently, that she and their youngest son, Peter, could join him in California if she stopped drinking. An impossible if. To justify the trip, he came up with several ideas for California-themed *Post* covers and submitted rough sketches to his editors. They gave him the go-ahead.

The day after Election Day, which returned Harry Truman to the presidency, Rockwell headed west. As usual he traveled in style and enjoyed the ride. In Chicago he boarded the Union Pacific's City of Los Angeles, whose streamlined design and yellow exterior were regarded as a vast improvement over the squat, clanky trains of the past. "My boss is sending me to Hollywood because they're tired of people in Vermont," he told a reporter on the platform in Salt Lake City, where he managed to complete an interview in the space of a fifteen-minute stop.[13]

Arriving in Los Angeles on November 15, Rockwell checked into the Hollywood Roosevelt Hotel, which billed itself as the site of the first Academy Awards. From there he telephoned his mother-in-law in Alhambra and asked in a teasing voice, "Do you know who this is?" Mrs. Barstow had no idea. She was delighted when he invited her and her husband to join him for dinner that night at the hotel.

"He told us about the men he met on the train," Mrs. Barstow reported of the dinner, in a letter to her daughter.[14] "The friendly Jews and how they showed pictures of their families and regretted that he had none of his." Mrs. Barstow urged Mary to remedy the situation by giving

Rockwell "a leather folder with pictures of all of you" for Christmas. She did not realize that husband and wife wouldn't be celebrating Christmas together that year.

•

During his stay in Los Angeles, Rockwell worked out of a spacious studio at what is now the Otis College of Art and Design,[15] one of the country's top art schools. The space was offered to him rent-free by the school's longtime dean, E. Roscoe Shrader, an illustrator with whom he was casually acquainted. Rockwell was named the school's first artist-in-residence. The title was strictly honorary, obliging him to do little more than show up at his third-floor atelier in the morning and tend to his own work. He was touched when the faculty mounted a small show of his paintings, which stayed up through December. It was a relief for him to be among people who admired him, who waved hello when he passed them in the hall, who knew nothing about his troubled life in Vermont.

Although Rockwell did not actually teach at Otis, he gave several well-received lectures that winter. One was held at the Art Center School in Pasadena; a surviving audiotape captures Rockwell as witty, raconteurish, and self-deprecating. His deep voice, New York accent, and frequent laughter, his habit of punctuating his observations with "See? See?"—at times he sounded as animated as a man recounting a run-in with a bear.

"I'm certainly not going to talk about 'What is art?' or anything like that," he said at the opening of his lecture. "I am just going to tell you very briefly how I make pictures and you can learn from that horrible example at least how *not* to make pictures."[16]

He alighted on his usual themes, such as his difficulty generating ideas. "I've never had one that came to me the way they're supposed to come in movies and novels. I never woke up in the middle of the night and had a whole new idea." Still, the gestation process was easier for him than it had been in the twenties and thirties. "I don't do the stuff with the lamppost anymore that Mr. Millier spoke about," he said, referring to Arthur Millier, the art critic for the *Los Angeles Times*, who introduced him that night and presumably based his comments on information gleaned from outdated articles.

Rockwell came as close as he ever would to articulating a philosophy of art when he said that he saw himself primarily as a storyteller in the Dickensian mode. He wanted his every daub and gesture in a painting to

contribute to the story. A story that was funny but not *too* funny. "If it's just a complete gag, it doesn't stay with people at all. You have to have a little pathos in it. Dickens was the great man for that."[17]

Of course, all this put him at odds with a generation of abstract artists who snubbed storytelling. "People tell me 'You have no right to do that,'" Rockwell said. "I've actually had fellows tell me you can do that in watercolor, but you have no right to do things like that in oil." The audience cracked up.

"It's ridiculous. What I say is, 'To deuce with them! I like to do it.' That's an awful thing to admit. The story is the first thing and the last thing." He added that he often judged the success of a painting not by the strength of its composition or color, but by whether visitors to his studio laughed when they saw it. "If you came in," he told the audience, "I would just wait to see if you laughed or not. I just love that. That isn't what a fine-art man goes for. I don't care whether it is art or not."

Loud laughter, applause.

"And by the way, I always say that, and then I have to put in an argument that it IS art. You see, how many of the very finest paintings were superb illustrations? That is a gold mine, to bring that subject up." But then he didn't bring it up, he dropped it, not caring to identify the innumerable masterpieces from the Sistine Chapel ceiling on down that were conceived to illustrate a story.

•

Back in Vermont, Mary Rockwell was having an exceedingly difficult winter. Although Norman had often been absent, disappearing into his studio or leaving town for days and even weeks at a stretch, he had never been away for this long. Secluded in the drafty farmhouse, Mary read novels and wrote letters and chain-smoked her latest brand, Chesterfields, stubbing them out in clunky glass ashtrays. At least her driving privileges had been reinstated. When she walked outside to her car, she could see the red-painted studio, unoccupied now, the windows dark, the door padlocked.

For November and most of December, Mary lived in the house with eleven-year-old Peter. Her two older sons were away at the Oakwood Friends School in Poughkeepsie, and she drove there every so often to take them to dinner at a nice restaurant, along with a few chosen classmates. Jarvis, a high school senior, had been suspended for a few days the previous spring after he was caught smoking and now, in December, Joseph

Shane, the new school principal, informed Mary that Jarvis had been caught again. Shane held Mary somewhat culpable, mentioning in a letter that "Jerry told me that he did smoke when he went out with you to dinner . . . and this made it harder for him to give it up."[18]

The principal asked Mary to forbid her son from using tobacco. She answered in a touching six-page letter in which she strains to understand Jarvis's behavior rather than to condemn it. "I most certainly *am not* going to forbid him to smoke," she wrote pointedly to Mr. Shane. "He's got to decide that for himself and will only be a free person when he takes the responsibility for his own actions."[19]

It was at this fraught moment that *Christmas Homecoming*, the defining image of toasty holiday togetherness, graced the cover of the *Post*. It is the one and only painting in which all five members of the Rockwell family appear—and are cast as themselves, more or less. A Christmas-day gathering is interrupted by the arrival of a son (Jarvis), whose back is turned toward the viewer. He receives a joyous hug from his mother (Mary Rockwell) as a roomful of relatives and friends look on with visible delight. Although you can't see the boy's face, you imagine he is a college student who packed his bags in a hurry (note the pajama string hanging out of his bulging suitcase). Rockwell tells the story by capturing the reactions of the onlookers; he switches the spotlight from the actor to the audience. The picture plane is a sea of smiling, bobbing heads, and the expressions are oddly undifferentiated. For once he is painting people he knows and cares about, but somehow he fails to individuate them. A sense of one-mood-fits-all warmth prevails, compromising the painting.

Grandma Moses also makes an appearance in the painting, a petite old lady in wire-rimmed spectacles standing on the left. She is wearing the same black dress, with a lacy white collar and cameo pin, that she is wearing in the photographs from her eighty-eighth birthday party, suggesting that Rockwell used the party photographs to obtain his likeness of her. Unlike the other figures in the painting, with their Crest-white smiles, Grandma Moses appears meditative. Rockwell also offers a self-portrait, inserting himself into the scene with a pipe in his mouth. You can tell by the way his eyebrows are lifted that he intends some kind of merriment.

In reality, there was no family gathering for Rockwell that Christmas. There was only distance and separation. He was living out of a suitcase at a hotel in Hollywood while Mary was snowbound in Vermont, writing rambling personal letters to a principal she had not met.

*Christmas Homecoming,* the defining image of holiday togetherness, appeared on the cover of *The Saturday Evening Post* on December 25, 1948.

Grandma Moses had her heartbreaks, too. In February, just six months after she had her cameo in the *Christmas Homecoming* cover, her son Hugh suffered a fatal heart attack. He was forty-nine years old. Although Grandma had been on the cover of the *Post*, in that picture showing a strapping boy coming home for Christmas, in real life, Hugh would never come home again.[20]

•

At the end of December Mary Rockwell left Vermont to join her husband in California. She made the trip by train, and was accompanied by eleven-year-old Peter, who was well aware that his mother had promised to stop drinking. But soon after they were on their way, Peter took a walk through the train and returned to the Pullman car he was sharing with his mother to find her lying unconscious on the bed. Strangers were fluttering around her, speaking in grave tones. It seems she had passed out from drinking. Later, going over the incident countless times with each other, her children suspected it was brought on as much by the strain of their father's absence as their mother's nervousness about rejoining him in California.

The Rockwells remained in California for another eight months, eventually moving out of their suite at the Hollywood Roosevelt Hotel and into a house they rented in the Hollywood Hills. Despite the balmy weather and lush scenery, little about their lives seemed to change. During her months in California, Mary haunted bookshops, continued drinking, and wrecked a Buick in an accident downtown.[21] And Rockwell became inseparable from a new, much-younger best friend—Joseph A. Mugnaini (pronounced moo-NI-ni), a handsome, Italian-born artist who taught life drawing at Otis and later became the primary illustrator for Ray Bradbury's novels. Rockwell started spending most of his time with him. He mentored Mugnaini as he had once mentored Fred Hildebrandt and other male artists, loving them less for themselves, perhaps, than for the caring feelings they stirred in him.

Mugnaini makes a cameo appearance in Rockwell's painting *Traffic Conditions*,[22] an operatic scene triggered by a simple incident. An obstructive white bulldog plants himself in the middle of a narrow alleyway, blocking a moving van and attracting a crowd of onlookers. Mugnaini posed for the mustachioed artist who leans out of a second-story window, pointing emphatically at the little dog. Some thirty Otis students and fac-

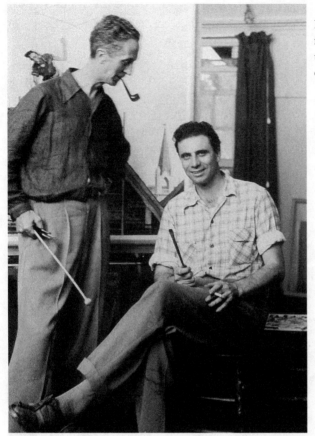

Rockwell with his friend Joe Mugnaini, a teacher at Otis College of Art and Design

ulty members modeled for the picture, but Mugnaini was the one who Rockwell hoped would be given a shout-out in the *Post*. As he wrote to his editors: "Could you possibly mention his name? He is having a one-man show here this summer and it would mean a lot to him."[23]

Rockwell was genuine in his desire to advance his friend's career. When Mugnaini's show opened in August, at the Chabot Art Galleries, the Pasadena *Independent* carried a photograph of Rockwell standing beside him. The caption explained, with more candor than was strictly necessary: "Let's hope this is a boost. Rockwell asked the Independent to run this picture in order to bring attention to Mugnaini's one-man art show."

In the weeks before he left California, Rockwell completed one of his best covers. *The New Television Set*,[24] like *Traffic Conditions* before it, mingles

*The New Television Set,* 1949 (Los Angeles County Museum of Art, Los Angeles)

figures and architecture, but it is airier and more inviting. A middle-aged man with suspenders leans out of the attic window of a Victorian house shouting to the young service guy installing an antenna up on his roof. The homeowner is so excited he has knocked over a pot of geraniums in the window box. A black-and-white TV is visible through the open window and you imagine the man is hollering, "The picture is coming in clear!" Rockwell understands the excitement. He is a maker of clear pictures that require no antenna.

The house is sharply outlined against the cloudy sky, which fills the top half of the painting. In the far distance, a Gothic church spire is visible through the mist. The church is ghostly, as if old pieties are about to be superseded by the new religion of television.

•

In Arlington, Vermont, a rumor circulated that the Rockwell family had moved to California and wasn't coming back. Neighbors wrote to ask if the rumor was true. So did editors at the *Post.* "It is not impossible for you to work in California, but it is a long way," Ken Stuart, the *Post*'s art editor informed Rockwell, "and if you do stay there, we'd better arrange for me to come out at least three times a year."[25]

It was hardly what Rockwell had in mind. He was angry at Stuart for overstepping his bounds and altering a painting without telling him. When Rockwell received an advance copy of the September 24, 1949, issue of the *Post,* he was in disbelief. Stuart had taken it upon himself to paint a horse out of the picture. This was *Before the Date,* a split-screen painting in which a man (right side) and a woman (left side) are shown in their own bedrooms, peering into mirrors, arms raised as they fix their hair. Rockwell had intended to suggest that the twosome were dressing for a country square dance; he had painted a horse outside the window, to emphasize the rural setting.[26]

Rockwell called Stuart to let him know how unhappy he was. In a follow-up letter, the editor tried to defend himself by claiming that the disappeared horse was an isolated incident. Earlier covers, he contended, had remained untouched, more or less. "You will remember they were not changed at all except to raise your signature. We do that because we feel your signature is very important to the public. If it isn't about three-eighths of an inch from the bottom in reproduction, it gets clipped off in seventy percent of the run."[27]

It was a lugubrious end to the California trip. On September 1 Rockwell boarded the train east. Three days later, he was back in his studio in Vermont. It is not surprising that he decided to return. You could live in the hills of Hollywood for only so long and still get away with calling yourself a Vermonter. And he was not sure what he would be, even to himself, without his Vermont address and the Yankee character it implied.

Besides, another birthday was rapidly approaching. Not for him, but for Grandma Moses, who was about to turn eighty-nine and was planning yet another birthday extravaganza. It had been a year since Rockwell met her and helped out with the cake. Now, in 1949, she was scheduled to have her party at a restaurant, the Green Mountain Pine Room, in Arlington. It would be a "surprise party," as *The New York Times* announced the day before, more or less negating the possibility that anyone in the free world, Grandma included, could be surprised by it.[28] Apparently, Rockwell had become Grandma's designated baker, and news photographs taken that day show him in a white chef's hat, aiming a frosting gun at a cake that was thankfully smaller than the one from the year before.

Over the years, Grandma Moses has often been compared to Norman Rockwell, perhaps because they both painted idealized scenes of American life. By 1949 they were the two most famous artists in the country and they had made their reputations without any help from museums. Their fame owed almost everything to mass reproduction of their work. The millions of Americans who loved Rockwell's covers never saw an original Rockwell painting.

Rockwell was a far better artist than Moses, whose work was relatively unsophisticated. She composed her pictures as if she were jotting down words, or keeping a diary, recording images of horses or sleighs and giant snowflakes as they occurred to her and giving little thought to how the parts relate to the whole. And her ground was white, like a sheet of paper. Her pictures are flat in the modern way, but "it is flatness by default," as John Currin, the contemporary artist, once observed. "She is not a picture constructor with a grand sense of space, which is why you can only look at so many of her scenes before they start to seem alike."[29]

Rockwell was hardly oblivious to Grandma's artistic limitations. He remarked, in a lecture: "The one problem I have with Grandma Moses is that there are two Grandma Moses pictures that sell. There's a spring scene, where it is all green, with lambs gamboling and green and white farmhouses, and then there's a snow scene. Both of those, as I understand,

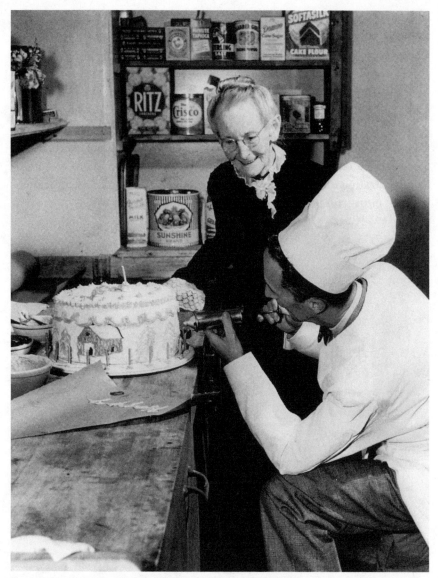

Rockwell decorates a cake for Grandma Moses's eighty-ninth birthday in 1949. (Norman Rockwell Museum, Stockbridge, Massachusetts)

get $1,500 apiece. There's a waiting list for them." Although she occasionally strayed from her formula, her "whole family is devoted to one thing, to get Grandma back in the groove."[30]

As it turned out, Grandma, "the real primitive," as he said, was a bona fide art star with a list of New York collectors jockeying to own her paintings and a talent for turning her every birthday into a national media event. Rockwell noted the irony of it: the primitive artist earned more money for the sale of a painting than America's most popular illustrator. It was hardly a crime or even an injustice. Just a reminder that the boundaries separating different kinds of art—primitive art, magazine illustration, fine art, etc.—can be flimsy indeed.

NINETEEN

# SHUFFLETON'S BARBERSHOP

## (1950 TO 1953)

He felt exhausted much of the time and wondered if he was anemic. In January 1950, visiting his physician in New York for a general checkup, he complained of stomachaches and "abdominal tension." Dr. Russell Twiss, writing to Rockwell on January 20, diagnosed the problem as a "a spastic, irritable colon." He wrote a prescription for antispasmodic pills and advised him to take the vitamin Theragran as well, to offset his feelings of fatigue. Rockwell, who had always accused his mother of hypochondria, could be similarly consumed by his aching body and spent a good deal of time visiting doctors up and down the East Coast.

On February 3, 1950, he turned fifty-six, apparently without fanfare. "Norman Rockwell has been confined to the house by illness for several days," the *Bennington Banner* noted that week.[1]

Through the winter, he worked on a painting that ranks as one of his five or six best works. It marks a sharp break from his earlier work, reflecting a desire to erase the element of caricature from his work, to banish the grimacing faces, the boys with their saucer eyes and elastic mouths twisted in surprise. He turned to the great realists for guidance. In the course of the fifties, Rockwell would produce his most contemplative paintings, the first of which was *Shuffleton's Barbershop*, which graced the cover of the *Post* on April 29, 1950. (See color insert.)

A barbershop is, among other things, a site of licensed physical contact between men, a place where men touch other men. Yet Rockwell has chosen to depict the barbershop at a moment when the leather chair is empty. It is evening, and the shop has been closed for the day. The picture's

action occurs in a small, lit room behind the main barbershop, where three older, silver-haired men sit playing music. You imagine they do this regularly, perhaps once a week. Rob Shuffleton, who actually owned a barbershop on Maple Street in East Arlington and cut Rockwell's hair, has traded his scissors for a cello—he's the player with his back to the viewer. Bernie Twitchell is on the violin, and Germ Warner is at the clarinet. Is their ensemble credible? Not very. Music historians point out that clarinet, violin, and cello trios are exceedingly rare.

In real life, Shuffleton did not in fact play cello,[2] did not play any instrument at all. Perhaps Rockwell invented the detail of the musical ensemble to underscore the harmony that prevailed at the barbershop. Shuffleton was seventy when Rockwell's picture was published, and was perplexed by the black cat portrayed on the premises, another fictional embellishment.[3]

*Shuffleton's Barbershop* is remarkably evolved for a magazine cover. With its cigar-box-brown tones and meticulous detail, it transports seventeenth-century Dutch realism into a mid-twentieth-century town in New England. Some viewers look at the painting, with its shaft of lemony light spilling into a darkened shop, and think of Vermeer. But the picture is probably closer in spirit to Vermeer's contemporary Pieter de Hooch, who loved to paint distant views of a room behind a room and extracted a surprising pictorial drama from the play of multiple windows and doors.

It can also put you in mind of American trompe l'oeil painting, with its catalog of humble detail. The novelist John Updike, himself a master of descriptive realism, confessed that he had a poster of *Shuffleton's Barbershop* hanging in his bathroom and loved to rake its surface for old-fashioned details—the wooden broom; the white towel draped over the arm of the barbershop chair; the big combs submerged in the jars of Barbicide; the clippers and scissors and tonics on the shelves.[4] On the newsrack in the lower left corner, you can make out the covers of several then-current magazines and comic books, including *Crime Does Not Pay* and the December 1949 issue of *Walt Disney's Comics and Stories*, in which Donald Duck peers over a fence at his mischievous nephews.[5]

Although the painting is typically described as a meditation on the coziness of small-town life, it can also be viewed as a painting about loneliness and exclusion. The viewer, standing on the sidewalk on a winter night and looking through the window, is shut out of the magic circle inside:

the toasty-warm, lighted room where embers glow in a coal stove and men make beautiful music. The painting suggests that looking is not the same thing as living, that looking is a kind of exile or death.

•

When summer arrived, Rockwell could no longer depend on the company of Mead Schaeffer. After a decade in Vermont, Schaeffer longed to be near the ocean and moved to Sea Cliff, Long Island.[6] In his stead, Rockwell had the company of his son Jarvis, who had become an art student. Rockwell, with his love of renovating buildings, converted a former chicken coop on the property into a private studio for him. Claiming that Jarvis could benefit from the presence of fellow students, Rockwell also decided to start an art school in the shuttered one-room schoolhouse on the West Arlington Green. He asked William McNulty, an instructor at the Art Students League, to hand-pick some students for the coming summer. In July six young men moved into the schoolhouse. They found Rockwell to be immensely likable, if not exactly a born teacher. He invited them to join him at tennis—he had built a clay court beside his studio a few years earlier—and to accompany him on his treks along the Batten Kill.

As amiable as Rockwell could be, Jarvis felt his father's sense of artistic identity was too precarious to allow him to tolerate potential rivals, particularly among his children. "It was clear that my father didn't think it was a good idea that I make art. He thought N. C. Wyeth was a nut. He thought the Wyeths were even crazier than we were."

The comment refers to N. C. Wyeth, the brilliant illustrator who had looked upon art as a kind of ecstatic family business. He educated his five children in his studio in Chadds Ford, Pennsylvania, and insisted that they stay around afterward. When Andrew Wyeth decided to marry, his father offered him a bribe to delay it. He went ahead with the wedding, but remained under his father's watch, moving into a converted schoolhouse near the foot of N.C.'s driveway.

Rockwell had a good deal in common with N. C. Wyeth, who was a bit older than he and best known for his illustrations of books like *Treasure Island*. He and Wyeth belonged to the same extended art family spawned by Howard Pyle, with whom Wyeth had actually studied. By the time Rockwell started his "art school" in Vermont, N. C. Wyeth had died, the victim of a car accident (in 1945) at a railway crossing near his home.

Rockwell had once visited him in Chadds Ford, driving down with Schaef-fer to see the Brandywine Valley. In his autobiography, Rockwell took an uncharacteristic jab at N.C.'s work, claiming that it lacked the "authority and research," the factual amplitude, one finds in the work of Pyle.

But then, the Wyeths were hard on Rockwell, regarding him as a com-mercial artist whose work could not possibly endure. It's relevant that N. C. Wyeth denied the greatness of his own illustrations, had a separate career as a fine artist and sourly maintained: "Painting and illustration cannot be mixed—one cannot merge from one into the other." This was a common plaint among twentieth-century illustrators, for whom discom-fort with illustration was nearly a career prerequisite. Wyeth's unease over the aesthetic worth of illustration was not shared by Rockwell, who did not doubt the value of illustration, only his own ability to live up to its exalted past.

•

By now Mary Rockwell had turned for help to Dr. James P. O'Neil, a gen-eral practitioner in his early thirties who had recently settled in Arlington. He was one of the few people in Vermont whose conversation she enjoyed. He was better read than other men in Arlington, most of whom were blue-collar types who worked in farming or light industry. Once when Mary suffered an "acute episode," Dr. O'Neil sped over to the house and gave her an injection of epinephrine, which she claimed saved her life.

Rockwell must have felt appreciative of the doctor as well. Early in 1951, when he was asked to make a poster for the National Committee for the Observance of Mother's Day, he chose the doctor's wife as his model. He depicted her as a fresh-faced brunette nuzzling her young son and daughter. The painting graced the cover of *Parents'* magazine in May 1951, and Rockwell, who frequently gave away his paintings to the people who posed for them, presented it to the family as a gift. "My best to the O'Neils," he wrote in the lower right corner.

Mary and Dr. O'Neil occasionally had coffee together at George Howard's general store, which had a little lunch counter. "My mother had a crush on him," recalled her son, Tom, "and she would go to this coffee shop because he was there." It seems unlikely that the physician might have returned her affection or regarded her as an object of romance. To him she was merely a patient, the troubled wife of a famous artist. One day Mary went to the lunch counter in the hope of seeing Dr. O'Neil, and

TOP: Rockwell and Mary in his studio. With its knotty-pine walls and a reproduction of Pieter Bruegel's *The Peasant Dance* hanging over the mantelpiece, the studio was more elaborately decorated than his home (*above*). (TOP: photograph by Arthur Johnson; ABOVE: photograph by Bill Scovill, courtesy of the Famous Artists School)

when he failed to materialize, she was so distressed she started screaming and crying. She was taken by ambulance to Putnam Memorial Hospital in Bennington.

Dr. O'Neil thought she needed to spend some time drying out at a retreat, and he referred her to the Austen Riggs Center, a small psychiatric hospital in Stockbridge, Massachusetts. Unlike other institutions, with their straitjackets and locked wards, their electric-shock therapy and corseted nurses in white uniforms, Riggs was an open hospital. Patients could come and go as they pleased and the goal was to teach them to be responsible for their well-being. It catered to well-off patients who could afford months and even years of care. Rockwell drove Mary down for her first visit, on February 22, 1951, a Thursday, and they each went in to meet with Dr. Robert P. Knight, the center's imposing medical director. Mary saw the doctor first, for an entrance interview from three to four; then Rockwell came in for a half hour.[7]

Mary was admitted the following Monday would remain at Riggs for four months, in treatment for alcoholism. Her children believed her stay was prompted by a suicide attempt, although their father did not discuss the matter with them and they did not feel comfortable pressing for explanations.

Mary was then forty-two, a stocky woman with tortoiseshell glasses and frizzy brown hair pulled into a ponytail. She dressed casually in button-down blouses and below-the-knee skirts. During her hospitalization, she lived in Foundation Inn—the Inn, as the patient residence was known, a white-brick mansion right on Main Street. Although she was not a candidate for analysis because she was still drinking, she did gain great comfort from her sessions with Dr. Knight, a handsome midwesterner who had graduated from Oberlin and taught high-school English in Ohio before becoming a psychoanalyst. Six years older than Mary, he shared her devotion to books as well as to smoking. He had a three-pack-a-day habit, and was known to smoke even in the shower.[8]

During the months when Mary was away, her two older sons were off at school. Rockwell remained in the house with Peter, who was now in tenth grade. In the evening, their cook, Marie Briggs, would set a couple of steaks on the table. As the weeks and then the months passed and the hillsides glowed with new growth, Rockwell barely took note of spring. His sons believed he was consumed by feelings of resentment and was vexed not only by Mary's drinking but by the fact that she had, in effect,

deserted him. With Mary gone, there was no one to screen his phone calls and track down props for his paintings and he felt overwhelmed. "He was a needy person," recalled his son Tom. "He thought the world was unmanageable."[9]

His children claim that their father never visited their mother in Stockbridge that spring. "She was at that period anti-my-father," Peter recalled. "She wanted time apart. She believed he was not helpful to her recovery."[10] But we know from Dr. Knight's appointment books that Rockwell frequently spoke to him by phone and drove to Stockbridge about once a month to meet with him in his office, sometimes sharing the hour with Mary.[11]

Just two weeks after Mary was admitted, Dr. Knight sent Rockwell a thoughtful letter on her progress. She was faring well in both her therapy sessions and overall adjustment to her new surroundings. Her stay, he noted, "takes a considerable burden off of Dr. O'Neil, I am sure, and also will probably cause that relationship to come into more realistic perspective on your wife's part."[12]

Rockwell was worried about the gossip swirling around him in Arlington, where everyone, it seemed, knew about Mary's crush on Dr. O'Neil. Dr. Knight assured him: "the gossip element in the situation will soon die down and you should not be concerned about that. All small towns are alive with gossip." The doctor, responding to another of Rockwell's stated concerns, advised him to feel feel free to embark on a trip to England he was considering at the time, assuming his health improved. Rockwell had "a touch of the flu," and Dr. Knight noted sympathetically: "I am sorry to know you are laid up, especially when you have a deadline on a picture coming up."[13]

Mary permitted her children to visit her at Riggs and every few weeks Peter made the ninety-minute bus ride from Arlington down to Stockbridge to see his mother. Usually he stayed for the weekend, in a room in a guest house, and enjoyed the visit. He played croquet with the patients and joined them for lunch in the dining room of the Inn, where the tables were set with good china and silverware and a warm atmosphere prevailed. Returning home on Sunday nights, Peter would report to his father on his mother's state. "I would tell him how she was doing, and my father would bemoan his fate," Peter recalled years later. "Sometimes, when I came back from Riggs, I would sleep in the same room as my father and we would talk. And one day he said to me, 'Oh, I was so miserable

today. If it weren't for you boys, I would have committed suicide.' But, my father was a self-dramatizer. I didn't believe a word he said."[14]

Still, there can be little doubt that Rockwell felt drained by the demands of trying to sustain his career while his wife remained hospitalized. Treatment at Austen Riggs was costly: room and board ran to $170 a week, which did not include such ancillary expenses as phone calls and medication. After years of declining outside work, Rockwell began to accept advertising assignments again to bring in extra revenue.

Through his meetings with Dr. Knight, Rockwell became aware of mood-lifting drugs and ways to tackle his own depression. He asked Dr. George Russell, his physician in Vermont, to write a prescription for Dexamyl, a small green pill of the combination sort, half Dexedrine, half barbiturate, wholly addictive. It was a perfect artist's drug—both a stimulant and a relaxant—until you tried to get off of it and felt near-dead. Rockwell was so enamored of it he met with representatives from Smith, Kline & French Laboratories and agreed to help with a national marketing campaign. He produced six polished drawings "of your typical Dexamyl patient"[15]—four women and two men looking like sad sacks—for use in glossy brochures and full-page advertisements in medical journals.

When he went to New York for his annual checkup, his longtime doctor was surprised to find him in poor health. "You have lost six pounds during the past year," Dr. Twiss wrote in a follow-up letter on May 21, 1951, "and there was more evidence of exhaustion than I have seen at any time for many years."[16] He instructed Rockwell to stay on his "nerve medication"—the Dexamyl, perhaps not realizing that the pills could cause weight loss as well as exhaustion. Dr. Twiss also suggested that he avoid "undue exertion" and take off from work on Wednesday and Sunday afternoons, advice that was duly ignored.

Mary was released from Riggs in mid-June, in time to partake of another Vermont summer, with her husband and three sons around her. But she was not the same person. Mary, the supposed caretaker, needed extensive care herself. She returned to Riggs at least once a week to receive counseling from Dr. Knight and Rockwell occasionally joined her. The doctor instructed him to hire a business manager to free Mary of the onerous task of paying bills and balancing the books and rushing to assemble hundreds of receipts whenever his federal income tax was due.

"His books were a mess," recalled Chris Schafer, a former Chicago banker (not to be confused with Mead Schaeffer) who lived on a farm in

Arlington and now stepped in as Rockwell's bookkeeper. He came into the studio a few mornings a week and sifted through the mounds of bills. "Norman wrote checks and kept no records," he continued. "He depended on Mary to do it. But neither of them kept the books balanced."[17]

It was the summer of Dwight David Eisenhower's presidential campaign and the *Post* wanted a portrait of him for its cover. Eisenhower was then far ahead of Adlai Stevenson in the polls, and a catchy jingle from an animated commercial—"Do you like Ike? I like Ike"—had become a national refrain. Commentators insisted that Americans craved change after twenty years of Democrats in the White House. One morning in mid-July, Rockwell received a phone call informing him that Eisenhower and Mamie were willing to sit for a portrait at 8:30 the next morning, presuming he could be in their suite by then, in the Brown Palace Hotel, in Denver, Colorado. So Rockwell hurriedly packed a bag, went to New York City, and caught a plane from La Guardia Field.[18]

It was Rockwell's first portrait of a presidential candidate, an admittedly limited art genre. But he warmed instantly to Eisenhower and found him visually engaging as well, despite the bald pate and prominent forehead that made his head seem larger than it was. "Eisenhower had about the most expressive face I ever painted," Rockwell recalled. "Just like an actor's—very mobile. When he talked, he used all the facial muscles. And he had a great, wide mouth that I liked." Not immune to personal vanity, he asked Rockwell to airbrush one of his gold fillings. Rockwell's solution was to paint the future president with his lips closed (but smiling).

Rockwell received sad news on July 25, 1951. His onetime hero, J. C. Leyendecker, suffered a heart attack and died at his home, at the age of seventy-seven. Rockwell drove down to New Rochelle to pay his respects. "The coffin was in his studio," he noted later, and the room had hardly changed since the long-ago days when he had been a regular visitor to the mansion on Mount Tom Road. Leyendecker's smock was still hanging on the outside of the closet door; his brushes were laid out on the table. Hardly anyone turned out for the obsequies in the studio, just Charles Beach, Augusta Leyendecker, and a couple of cousins.

Leyendecker's last cover for *The Saturday Evening Post* had appeared in 1943, eight years before his death. "And that was the end of it all," Rockwell observed.[19] "It scared me. Joe had been the most famous illustrator in America. Then the *Post* had dropped him, the ad agencies had dropped him, the public had forgotten him. He died in obscurity."

Returning to his studio in Vermont, Rockwell glanced at the unfinished painting on his easel and thought, "it wasn't a reassuring sight." So few artists were able to survive over time and the number of illustrators was even smaller. It was chilling to contemplate how many of the brightest artistic reputations turned to dust.

•

It was in the shadow of Leyendecker's death that Rockwell completed *Saying Grace*, which has been called his most popular painting. It is set on a drizzly afternoon, at a greasy-spoon diner at a train station, where an old lady in a daisy-bedecked straw hat and her small grandson count their blessings during the lunchtime rush. As they bow their heads and say grace, they attract the slightly stunned gaze of a handful of diners, a typical Rockwellian clan made up of well-intentioned strangers, men of different ages and backgrounds who look up from their conversations and their newspapers. The painting is a ballet of gazes, a delicate interplay of actions and reactions that together affirm the power, the jolt of connection, afforded by the act of looking.

The little boy is portrayed from the back, his white shirt glowing against the somber, tobacco-brown tones of the painting. He has taken off his blazer, which is bunched up behind him on the red cushion of his bentwood chair. Rockwell lavishes great tenderness on the back of the boy's neck, the luminous, baby-soft skin extending from his white shirt collar up to the razored line of his reddish-gold hair and occupying the focal center of the composition. The boy seems to be breathing a purer kind of air than the figures around him. He harks back to earlier Rockwell paintings that offer a vision of youthful male beauty lying beyond reach. The cigar-smoking man in the lower left is a spatial marker, occupying the foreground and keeping the boy safely in the middle distance. Although only a sliver of the man is visible, the objects on his table—used silverware, a folded copy of *The New York Times*, a sludgy cup of coffee— suggest he has been sitting there for a while. He's a watchman, keeping Rockwell at a distance from the warm, beating heart of the painting.

The cover ran on November 24, 1951—the date matters, because it was timed to coincide with Thanksgiving. The grandmother and grandson are dressed up for the holiday. Are they at the end of a train journey, or the beginning? Presumably the latter. The grandma has her knitting bag to keep her occupied for the ride. The boy's railroad ticket is tucked

When the *Post* did a survey asking readers to name their favorite Rockwell cover, *Saying Grace* won hands-down. (Norman Rockwell Museum, Stockbridge, Massachusetts)

into the ribbon of his hat, which he has taken off and hung on the handle of an umbrella. Outside the plate-glass window, a dense fog settles over the buildings in the railroad yard. A smattering of backward, Cubist-style lettering on the window—"TNARU"—spells the end of the word *restaurant* while containing the anagram UN-ART and suggesting the self-mocking message U R an ANT.

To obtain authentic-looking details, Rockwell consulted a variety of sources. He made several trips to the train station in Troy. He arranged for an actual Automat in New York City to deliver an assortment of chairs, tables, and dishes to his studio. ("A truck pulled up, deposited the furniture, then took it away a few days later," recalled his cook, Marie Briggs.) The painting did not come easily. He did only three *Post* covers that year and *Saying Grace* ate up months. The illustrator George Hughes remembered a night when Rockwell threw the canvas into the snow in a fit of disgust, only to retrieve it the next morning.

The seven figures who appear in the painting posed in his studio, in separate shifts. They included his photographer (Gene Pelham), his son Jarvis, and eight-year-old Don Hubert, Jr., whom Rockwell plucked out of a third-grade classroom at the Arlington Memorial School. The little boy turned out to be a fidgety model, unable to hold still even for a photograph. "He Scotch-taped my feet to the floor of his studio," Hubert recalled later, without bitterness. And poor May Walker, the widow who posed as the grandmother, her hands clasped in prayer. She did not live to see the cover, dying just a few days before it appeared on newsstands.[20]

In 1955, when the *Post* did a survey asking readers to name their favorite Rockwell cover, *Saying Grace* won hands down. Perhaps it appealed to America's sense of itself as a nation of believers, in stark contrast to the Soviet Union and its ranks of godless Communists. As President Eisenhower once remarked, "Our government has no sense unless it is founded in a deeply felt religious faith, and I don't care what it is."[21]

•

The fall of 1952 saw the election of General Eisenhower to the White House, but in Arlington, Vermont, it was a season of loss and mourning. On September 15, Rockwell's dear friend John Atherton died in a drowning accident in New Brunswick, Canada, where he and his wife, Maxine, had gone on a salmon-fishing expedition. He was only fifty-two.

Just the year before, Atherton had published *The Fly and the Fish*, which was dedicated to his wife, and would become a classic of angling literature. It was a love letter to the Batten Kill, on whose banks Atherton lived. There he built himself a house, "the most modern house in Arlington," as Maxine described it, a low, horizontal structure that seemed to blend with the hillside.[22] Maxine buried his ashes behind the house, beneath a maple on the riverbank. For a few weeks that fall, not wanting to be alone, she stayed with Rockwell and Mary. She found him diverting and appreciated his sense of humor. "Norman was very amusing," she recalled. "He would call me in and ask for comments and I loved it. Once he took my advice by destroying a painting."[23]

His marriage was a protracted struggle, however, and people in Arlington felt sorry for him. That fall, Mary had another car accident. It was Halloween; she was driving home from an appointment at Riggs at 5:30 in the evening when she rounded a curve and hit a stalled car. The front end of her brand-new Chevy station wagon was "badly smashed," according to the accident report, and she suffered various cuts and bruises. After that, Rockwell arranged for her to take a car service to her appointments at Austen Riggs.

On November 10 Rockwell joined the rest of Arlington in mourning the death of an eleven-year-old boy in a hunting accident near his house. Jon Stroffoleno was in the woods, raccoon hunting, when a shotgun carried by his twelve-year-old sister, Jo, discharged.[24] He was the nephew of Rockwell's next-door neighbor, Buddy Edgerton, who later recalled that Rockwell attended the funeral and paid a sympathy visit to the boy's parents carrying a parcel neatly wrapped in brown paper. It was a charcoal portrait of their son. "I'm sorry it's not so good," Rockwell stammered. "I did it from memory."

•

He received a bit of good news that month when a painting of his was "purchased" by the Metropolitan Museum of Art. It was his first painting acquired by a museum; the negotiations had been more intricate than anyone could have imagined. He had first been contacted two years earlier by Frederic Price of the Ferargil Galleries, who was a friend of Robert Beverly Hale, a curator who had been hired by the Met to organize a department of contemporary American art. Although Hale was himself

an abstract painter, he was sufficiently ecumenical as a curator to be sympathetic when Price, trying to drum up business, suggested that he buy a Rockwell for the collection.

In a letter intended to introduce himself to Rockwell, Hale offered effusive praise. "I feel that you are the most thoroughly American of all of our painters today," he noted, then took a witty if unconvincing jab at artists who favored abstraction. "At this time, I feel, the so-called international style has overcome all the boys for better or worse and unless something is done about it nobody will ever know what our country looked like when we are dead."[25]

Rockwell offered the museum an oil-on-board study for *Freedom of Speech*, which, like the finished painting, portrays a Lincolnesque man standing up to speak at a packed town meeting. The rough sketch, as Rockwell called it, is twenty-one by seventeen inches, smaller than the finished version and more casually composed; the central figure is devoid of the looming quality that distinguishes the later work. But the sketch is lovely nonetheless, with a visceral feeling and relatively loose brushwork. Rockwell let it go for the severely reduced price of one hundred dollars.

The *Post* ran a photograph of him gaily waving a jumbo-sized palette beneath the headline, ROCKWELL MADE IT.[26] The item noted that Rockwell uttered "a gladsome yelp" when he learned that the Met had bought his painting, for an undisclosed price.

•

By now Rockwell's contact with the Austen Riggs Center in Stockbridge had broadened considerably. Bills came in not only for Mary's care but for that of eighteen-year-old Tom as well. As a freshman at Princeton, overwhelmed by academic pressure, Tom had developed an ulcer and dropped out midterm. "My mother wanted me to see her psychiatrist," he recalled. So Tom went to see Dr. Knight, who recommended that he be admitted to Austen Riggs as an inpatient and be treated for an anxiety disorder. Tom entered Riggs on March 24, 1952, and would stay for four months. The upshot was that he left Princeton and transferred to the less orthodox Bard College.

In January 1953, alarmed to realize that Mary was drinking heavily again, Rockwell sent a letter special delivery to Dr. Knight at Austen Riggs. It was decided that Mary would return to Stockbridge and be admitted to

Riggs as an inpatient for a few weeks, in order to dry out. Dr. Knight assured Rockwell, on the 29th: "I am trying to help her come to a redefinition of social drinking on a much reduced basis, and to accept the idea that there is to be no drinking at all except under legitimate social drinking conditions."[27]

Today, it might seem peculiar that a doctor would advise an alcoholic patient to continue her custom of pre-dinner cocktails instead of trying to get her off alcohol altogether. But such measures were standard in the bibulous fifties. Dr. Knight believed Mary was making "good progress," and he seemed less concerned about her drinking than her dependence on sleeping pills. "At the present time she is taking more sedation than we would like to see continue very long," he apprised Rockwell. "However, she apparently needs it. She is taking up to six grains of Seconal to get to sleep at night. She is also taking two dexamyl tablets a day."[28]

Rockwell's mother, too, was ailing and making demands that struck him as impossible. At the time she was living in Providence, Rhode Island, with her nephew John Orpen, a retired ice dealer who owned a rambling old house on University Avenue. Rockwell sent him a weekly check of sixty dollars to cover his mother's room and board. On February 17, after suffering a stroke that left her bedridden, she was moved into a nursing home in West Warwick, Rhode Island, where she died three weeks later, the day before her eighty-seventh birthday.[29]

Rockwell left no comment about his mother's death, and their relationship, which had been strained, at best, was misrepresented in the wire-service obituary that was published in newspapers across the country. "Mrs. Rockwell had made her home with her son in Arlington, Vt., until 15 months ago, when she went to live with a nephew in Rhode Island." This was untrue. Whether the reporter made an innocent mistake or Rockwell provided incorrect information, Mrs. Rockwell never lived with her artist-son.

When Mrs. Rockwell died, her obituary left readers with a touching image, a vision of her milling about her son's farmhouse, as integral to family life as the elderly figures who populate his paintings. In reality, he relegated responsibility for his mother's care to his wife and the array of relatives and strangers with whom she boarded over the years. In a telling omission, he never painted a portrait of his mother, and her only appearance in his work is as a table guest in *Freedom from Want*.

•

In the weeks following his mother's death, Rockwell completed a memorable *Post* cover, *The Shiner*,[30] which stands with *Rosie the Riveter* as an enchanting representation of female strength. It shows a girl with red braids and a black eye sitting in a school corridor, outside the principal's office. You assume she is about to be reprimanded and possibly suspended for an infraction, perhaps a fight with a boy. Nonetheless, she smiles defiantly and occupies the center of the painting with the pluck and sturdiness of a true heroine. In the distance, behind an open door, a bespectacled principal and his pencil-thin secretary appear somber and even grave as they discuss the girl's transgression.

The model for the painting was ten-year-old Mary Whalen of Arlington, Vermont, the daughter of Rockwell's lawyer. In trying to furnish her with a black eye, Rockwell faced an unprecedented challenge. Initially he tried brushing charcoal over Mary's left eye, but a bruise is composed of many colors, and his charcoal bruise didn't look convincing. He checked the hospital in Bennington for eye-injured patients, but there were none, so he broadened his orbital search. He went to Pittsfield General Hospital, which led to an article in *The Berkshire Eagle*. He told a reporter that he would accept a black eye in any of its "ripe" stages of discoloration—brown, taupe, red, saffron, or yellow-green, "just so it's vivid and realistic."[31] Several hundred people responded, many of them prisoners. Finally, the father of two-and-a-half-year-old Tommy Forsberg, of Worcester, Massachusetts, who had fallen down a flight of stairs that left him with two shiners, drove the boy to Rockwell's studio and had him pose.[32] The desired results were achieved when Rockwell painted a bruise onto Mary Whalen's trusting young face.

•

In the course of discussing the psychological problems of his wife and their son Tom with Dr. Knight, Rockwell became increasingly interested in entering therapy himself. Dr. Knight, who had overseen Tom's four-month hospitalization at Riggs the previous year, thought it would be inappropriate for him to treat so many members of the same family. He referred Rockwell to an analyst on his staff: Erik Erikson, a German émigré who had been an artist in his wandering youth and was one of the best-known psychoanalysts in the country.

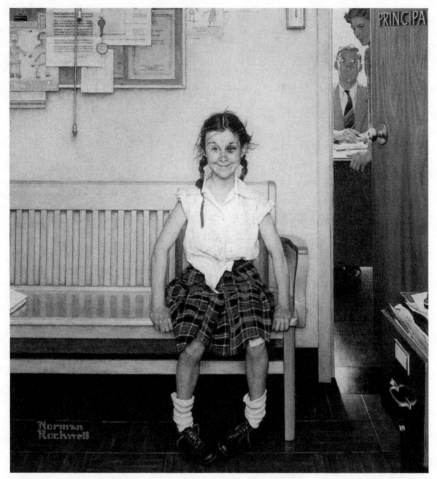

*The Shiner*, 1954, stands with *Rosie the Riveter* as a protofeminist representation of female strength. (Norman Rockwell Museum, Stockbridge, Massachusetts)

In an internal memo written on July 15, 1953, Dr. Knight noted that Rockwell "is very happy at the prospect of working with a therapist who is also an artist. He is reluctant to give up time to appointments from his work, and prefers a late afternoon appointment so that the day will not be mixed up too badly."[33] It was arranged that Rockwell, who was on a quick assignment in Northern California, helping to promote the Boy Scouts' third National Jamboree, would phone Riggs and make an appointment with Erikson's secretary when he returned.

His bookkeeper remembers an afternoon when Rockwell casually mentioned that he was thinking of relocating to Stockbridge for the winter. Schafer, who was about to leave for Cape Cod for the weekend, said, "Let's talk about it when I get back." By the time he returned on Monday, Rockwell and his wife had left Vermont and were living in the Homestead Inn, a boardinghouse in Stockbridge.

It was reported in the Vermont papers, a bit too optimistically, that Rockwell planned to return home in the spring. ("This is not the first time that this topnotch artist has been away from his Arlington studio for several months."[34]) But in fact he would never return to the house on the village green, except to sell it a year later.

He had lived in Arlington, Vermont, for fourteen years and, in many ways, the town and its residents had served him well. In the eyes of millions of Americans, his scenes of everyday life in this typical-enough New England village said something important about our collective character as a nation. It was here that he had painted his epic *Four Freedoms* and become America's painter in chief. Moreover, it was here that he had painted *Shuffleton's Barbershop* in 1950 and *Saying Grace* in 1952, masterpieces of illustration that Americanized Dutch realism.

After he moved away from Arlington, Rockwell put its residents out of his mind almost instantly. "If someone had been a very close friend," Chris Schafer recalled, "when Norman moved, or when they moved, it was as if they had never existed. Everyone complained that he never kept in touch. People said, We were his best friend, and now we don't hear from him."[35]

Rockwell later claimed that he moved to Stockbridge so his wife could be treated at Austen Riggs. It became part of his chronology and his mythology, making him sound like a solicitous husband who put his wife's interests ahead of his own. What he did not say is that he, too, now had a reason to go to Stockbridge, an inconvenient, ninety-minute drive from

Arlington, Vermont. He moved to Stockbridge to begin his therapy with Erikson, to become an Austen Riggs outpatient, much like many other residents of Stockbridge. He could not have chosen to live in closer contact with psychoanalysts and psychiatric patients had he institutionalized himself.

# THE AGE OF ERIK ERIKSON

## (1954)

In mid-October 1953 Rockwell rented a studio in Stockbridge, in a second-floor space overlooking the little shops along Main Street. It was directly above Sullivan's meat market, smack in the middle of town. His plan, he told a local reporter, was to stay for the winter and then return to Vermont in the spring. But probably he knew he was never going back north. He felt happy to be somewhere new, as if an invisible string had been cut. His neighbors were in disbelief when he had a mammoth hole hacked through the front wall of his studio and glassed over. They would have been more surprised yet if they knew that the picture window cost him five thousand dollars.[1]

In coming years, he loved to stand at the window, puffing on his pipe and observing the street scene below, the ongoing hum of old-timers and schoolchildren and housewives steering their big cars into the angled parking spaces in front of the stores. The commercial part of Main Street was two blocks long and lined with the kind of shops whose doors had bells that jingled when a customer came in. Just one block over, to the west of the stores, was the Austen Riggs Center, whose principal building, a white-brick mansion set back on a scrubbed emerald lawn, gave it the aura of an unknowable fortress. Past Riggs, Main Street became residential and was lined on both sides with neatly kept-up wood frame houses, some of which had been standing since the days of the American Revolution.

"Norman's studio is beautiful and serene with almost white walls

where he has hung Degas prints, the drawings we got in Paris," Mary wrote in a letter from Stockbridge.[2] "How he does love being right in the center of things, where he can look out and see people instead of mountains!"

When he first lived in Stockbridge, Rockwell was far from settled. Although he set up his studio in a matter of days, he and Mary were living at the Homestead Inn, two joined-together clapboard houses occupied mostly by Riggs outpatients. She liked the freedom of boardinghouse life, where she had "no responsibilities in the household sense," as she noted. Curiously enough, Rockwell, who had lived in boardinghouses in his youth, with a mother who fell ill as frequently as opportunity permitted, was now living in somewhat similar circumstances—in temporary lodgings, with a woman who suffered from depression and left him longing for care.

No sooner had he pulled up to the curb than he met Louie Lamone, who would be his devoted studio assistant until the end of his life. Lamone was then in his twenties and was doing repair work at the Homestead Inn. Rockwell enlisted him to unpack the station wagon, which was jammed with his easel and cartons of art supplies. Lamone had never heard of Rockwell. But he could see he was an artist. He told Rockwell that he was "kind of late" because all the shimmering autumn foliage had already vanished from the tree branches. Rockwell laughed, and politely explained that he wasn't a landscape painter.

Within a few days, Rockwell hired a photographer, Bill Scovill, who had moved to Stockbridge to be treated for severe depression at Riggs and taught a photography class there. A handsome man with prematurely white hair and thick black eyebrows, he harbored a fear of travel and was glad to confine his sojourns to Rockwell's studio. For the next decade, he would shoot the reference photographs for Rockwell's paintings and develop the film, the thousands of pictures of models dressed a certain way and working to hold this pose or that.

When Rockwell moved to Stockbridge, with its old houses and views of the Berkshire Mountains, he went against the demographic trends of the 1950s. Americans who purchased houses then were more likely to wind up in a "major metropolitan area," as the Census Bureau called it, referring to areas that lay within commuting distance of a city. The goal was to live an orderly suburban life that came equipped with a dishwasher and a washing machine and one of those new upright Hoover vacuum

cleaners, to sport fresh-smelling clothes while you sat around your dust-free house wondering whether the world was just days away from burning up in a nuclear conflagration.

The quest for self-improvement also spawned an interest in psycho-analysis among the educated middle class. Although Rockwell was never a suburbanite, he did exemplify America's new fascination with Sigmund Freud. By coincidence, the November 30, 1953, issue of *Newsweek* carried a lengthy feature story on the Austen Riggs Center and the explosion of the mental health industry. A photograph showed a room with a helter-skelter of tall wooden easels and four "maladjusted patients," as the caption said, standing absorbed in their work. Among them is Mary Rockwell, who, though shown from the back in her calf-length smock and black pumps, turns her head just enough to make her profile instantly recognizable.

The headline of the article, A WINNING FIGHT ON "NERVOUS BREAK-DOWNS," was a revealing mixed metaphor, harking back to the national unity bred by war in the forties and the growing inclination of Americans in the early fifties to define their battles in psychological terms rather than in political ones.

•

Explaining the chaos of his living situation those first months in Stock-bridge, Rockwell once said, "We stayed at the boardinghouse. I got sick of that. My wife went to live at Riggs, so I bought the little yellow house."[3] He purchased it on March 24, 1954, a sweet little clapboard on the west end of Main Street, a cane-yellow house with white shutters and a split-rail fence in front.[4] He didn't pay much for it ($19,000), mainly because it was adjacent to the town graveyard and required that he eat his breakfast while looking at a field of tilting white tombstones. Acting with his usual impulsiveness, Rockwell bought the house without bothering to dispose of his previous one. His farmhouse in Vermont would remain unsold for another six months despite the interventions of a real-estate broker who placed exclamatory advertisements in *The New York Times* ("The home of a famous artist!") and dropped the price more than once.

The new house was notable for its its proximity to Mary's psychia-trist. Dr. Knight had his office on the same street, just three doors down, in the so-called Purinton House. It had been remodeled by Riggs as an administration building and was a short walk from the main campus. Rockwell felt reassured living in the midst of so much professional medical

help. In addition to having Dr. Knight as a neighbor, Dr. Donald Campbell, the town's much-loved family physician and a man whose office would prove handy as a setting for various paintings, lived directly across the street.

By May 3 Mary had joined her husband in the yellow house and was sending off cheerful letters. "We LOVE our new house," she wrote to her sister, on one of those country afternoons pervaded with a spring chill.[5] "It's a rainy day outside, but lights are on in the living room, and there's a fire burning away in the Franklin stove, which is now complete with andirons with twinkling brass knobs on top, which we gave to each other on our 24th wedding anniversary." She still wanted to believe that things could work out "for the best," and her stated affection for the stove seems touchingly indicative of a family where warmth did not come easily.

•

As the citizens of Stockbridge became personally acquainted with Rockwell, many of them felt surprised by his unassuming demeanor. He did not look like one of the robust, sanguine people in his magazine covers. With his narrow face, receding chin and stringy neck, he was thinner than people expected and less sure of himself. "He was an extraordinarily modest man," recalled the playwright William Gibson, whose major works include *The Miracle Worker* and *Golda's Balcony*, and whose wife, Dr. Margaret Brenman-Gibson, was a psychoanalyst at Riggs. "He didn't just act modest. He *was* modest. Everyone liked him because he was unpretentious and never imposed himself on you in any way."[6]

Mary Rockwell, by contrast, struck people as fragile, with no natural gift for small talk. "She was nervous about social encounters because she was struggling with alcoholism," Gibson recalled. Her neighbors found her vague and elusive, a shadow walking along Main Street and disappearing into the buildings at Riggs. Knowing she was an outpatient who spent most of her time at the hospital, neighbors made a point to wave at her when she passed and to try to engage her in conversation. "But she wouldn't stop," recalled Elizabeth White, her next-door neighbor. "She would just keep walking. I imagine she had friends within that little unit, that family of Austen Riggs."

By now, Mary had taken up painting as part of her day-to-day treatment. She worked in an upstairs studio in the Lavender Door, a barn-shaped building that was home to the "activities program" (the term

*occupational therapy* had been discarded). Mary's artwork consisted of gestural abstractions, pastels and paintings undertaken without the reassurance of preparatory sketches. Most of her works are intense, churning compositions in which strokes of bright color—yellows and oranges flecked with white—toss and tumble in rhythmic circles. They evoke waves and hurricanes, nature at maximum force. Although well-informed about abstract art, she downplayed her painterly sophistication, as if to keep from intruding on her husband's domain. "I feel very lucky to be the complete amateur," she wrote to her sister, "and so able to follow each feeling that appears about my work."[7]

She made no attempt to exhibit her pictures, except on the walls of her studio, where she would tack up her finished works and mull them over. She once gave a painting to Dr. Knight and his wife and inscribed it wittily. "From Mary Rockwell," she wrote on the back, "who couldn't find a place to sign it on the other side."

•

The Austen Riggs Center had only recently emerged as one of the country's leading psychiatric hospitals. It had gotten off to a wobbly start, in 1913, under Dr. Austen Fox Riggs, a German-born internist who denounced Freud as a quack and subjected his patients to a regiment consisting largely of crafts (especially weaving) and rest. After his death, the Austen Riggs Center fashioned itself as a groundbreaking center of Freudian psychoanalysis. Dr. Knight—the medical director of Riggs and Mary Rockwell's therapist—was responsible for the transformation. In 1947 he came to Riggs from the Menninger Foundation in Topeka, Kansas, where he had served as chief of staff, and he brought along half the psychoanalysts in Kansas, or so it seemed. An impressive group, they represented the creative core of Menninger and included Allen Wheelis, David Rapaport, Roy Schafer, and Margaret Brenman-Gibson. In May 1951 Erik Erikson, who had just published his bestselling *Childhood and Society*, arrived at Riggs from Berkeley, drawn by the promise of a light clinical load and ample time to spend writing his next book.

•

Rockwell took an instant liking to "Mr. Erikson," as everyone called him. Eight years younger than Rockwell, Erikson was then in his early fifties

and a forceful physical presence: a handsome European émigré with blue eyes, a ruddy complexion, and a nimbus of white hair. He spoke English with a German accent and had an impish smile.

It was Erikson who coined the phrase *identity crisis*, of which his own youth was a case study. Born in Frankfurt, Germany, to Danish parents, he was the son of a Jewish mother (Karla Abrahamsen) and a still-unknown man who disappeared before Erikson was born. He was just a baby when his mother fell in love with his pediatrician, Theodor Homburger, whom she married on Erik's third birthday. He became a boy named Erik Homburger and grew up believing that the pediatrician was his biological father. "All through my earlier childhood," he later wrote, "they kept secret from me the fact that my mother had been married previously; and that I was the son of a Dane who had abandoned her before my birth."[8] Perhaps that explained his wild blond hair. His acquaintances wondered how a Jewish boy could wind up with so much Scandinavian hair and, as he later wrote, "I acquired the nickname 'goy' in my stepfather's temple." As a teenager he began to glean the truth about his origins from relatives in Denmark.

At that point, he saw himself as artistic and intractably different. After high school he studied art at the Kunst-Akademie in Munich. His specialty was woodblock prints, and he worked in the intense, unfiltered, figurative style of the German Expressionists. His broad interests eventually led him to Vienna, where he taught in an experimental school and met Anna Freud, who practically invented the field of child psychology. She selected Erikson for training as an analyst at the Vienna Psychoanalytic Institute, where he was able to follow the path of lay analysis championed by Sigmund Freud in his later years.

In October 1933, nine months after Hitler came to power, Erik Homburger sailed to America with his dancer-wife, Joan, a Canadian whom he met in Vienna. He was thirty-one, a German Jew fleeing his homeland, an artist turned "psychoanalyst," a profession few had heard of or could define. He listed his occupation as "writer" in the passenger records he filled out on the ship. Six years passed before he was naturalized as an American citizen and it was then, on September 26, 1939, three days after the death of Freud, that he changed his surname.[9] It was a dramatic gesture, an act of autogenesis. He made up his surname. The man with no father became his own father—Erikson, as in "Erik's son." In coming

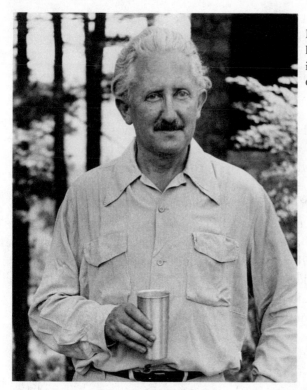

Erik Erikson, soon after
he moved to Stockbridge,
in his yard (Photograph by
Clemens Kalischer)

years, his great achievement was to turn his own identity crisis into that of
the entire culture. He came into possession of his identity by acknowledg-
ing he had no identity.

•

Although Erikson worked mostly with children and adolescents during his
decade at Riggs, he did have a handful of adult patients. Rockwell came
into his office, which was located upstairs in the main medical building
and looked out on Main Street, twice a week. Much of what Erikson did
in the therapeutic hour resembled counseling. He guided and instructed
based on his sharp insights into a patient's needs. In contrast to Freud,
who believed that childhood determines who you are, Erikson identified
eight stages of development that unfurl over the length of a lifetime. This
led him to pitch to a patient's strengths and posit that change is possible.
Moreover, his "capacity to understand the sense of crisis and confusion
of those he treated was remarkable," notes his biographer, Lawrence
Friedman.[10]

For Rockwell, the immediate crisis was his marriage. As Erikson now learned, Rockwell was tethered to an alcoholic whose drinking made her petulant and critical of his work. What distressed Rockwell the most was the absence of any known cure. It seemed to Rockwell that Mary's illness had won. Her alcoholism negated any possibility of peaceful living, and yet she was not sick enough to be hospitalized on a permanent basis. And so he was mired in a debilitation that had no end. Moreover, her therapy and hospitalizations were expensive and to pay the bills Rockwell had grudgingly taken on advertising assignments, including a campaign for Kellogg's Corn Flakes. It required that he paint a series of smiling heads, boys and girls lit up by visions of breakfast cereal.

Rockwell was a dependent man who tended to lean on men, and in Erikson he found reliable support. "All that I am, all that I hope to be, I owe to Mr. Erikson," he once wrote.[11] The sentence echoes a line from his favorite president, Abraham Lincoln, who once wrote in a poem: "All that I am, all that I hope to be, I owe to my mother."

Rockwell wrote the comment inside of *The Adventures of Tom Sawyer*, the Heritage edition he illustrated in the thirties. In the copy he gave to Erikson, he also drew a droll sketch. It shows Tom Sawyer in his floppy straw hat and faded overalls, a grinning, gap-toothed boy smoking a corn pipe as he takes time off from his usual escapades to try to comprehend the eight stages of human development. Tom is avidly reading *Childhood and Society*, Erikson's first and most popular book, which Rockwell now came to know intimately.

•

Once he began therapy with Erikson, Rockwell's work became more overtly psychological. *Girl at Mirror*,[12] the first painting he completed in Stockbridge and one of his most beloved *Post* covers, appeared on March 6, 1954. It shows a girl on the cusp of what Erikson called Stage Five, adolescence, in the throes of "Identity vs. Role Confusion." Mary Whalen Leonard, the red-headed girl in Vermont who had posed for *The Shiner*, was also the model for the far more somber *Girl at Mirror*, which Rockwell had begun before he moved to Stockbridge.

A girl of twelve, scantily dressed in a white cotton slip trimmed in eyelet, is shown from the back, perched on a footstool in a shadowy attic. A comb and brush lie to the left of her bare feet, as does a tube of bright-red lipstick—note that the cap is off. She has just completed what is perhaps

her first attempt at applying lipstick, and stares nervously at her reflection in a full-length mirror, as if waiting to step out of her skin and metamorphose into someone new, someone lovely, someone a man might want to kiss. An issue of *Movie Spotlight* magazine resting on her lap is flipped open to a full-page photograph (head only) of Jane Russell, who was celebrated for her bustline (38D) and who offered a vision of voluptuousness beside which no woman could measure up, especially the pancake-flat girl in Rockwell's painting. Deploying the kind of self-referential cleverness today known as meta, Rockwell has given us a magazine image about a magazine image.

Despite the painting's popularity, Rockwell later said on several occasions that he regretted including the image of Jane Russell, who had recently appeared in her best film, *Gentlemen Prefer Blondes*, and was added to the painting only as an afterthought.[13] He came to feel that her presence seriously compromised the work, allowing only one interpretation of it—a story about a girl who realizes she will never be a movie star—and killing off any hint of metaphor or nuance.

Hardly. *Girl at Mirror* remains riveting as an image of ambivalent womanhood, with its sensitively rendered female figure. Actually, seen from the back, she could be a boy; her left shoulder bulges a bit, and her adjacent trapezius muscle (to the left of her spine) is also beefy. But glimpsed from the front—in her mirrored reflection—she is slim and unmistakably girlish. In other words, there are two girls in the painting. There's the real girl, perhaps a tomboy, who has sneaked upstairs to the attic with her *Movie Spotlight* fanzine (do her parents even allow her to read it?), propped a mirror against a chair, and put on her mother's lipstick. Then there's the other girl, the reflected mirror image that she confronts across a dark divide.

Who is that girl in the mirror? Covering her breasts with both arms as she raises her hands to her chin, she appears vulnerable and even fragile. Her toy doll, dressed in layers of ruffles and tossed on the floor, is a bizarrely sexualized object. A series of oil sketches indicate that Rockwell originally situated the doll behind the mirror, sitting up primly, and it was only in the final painting that he moved the doll to her position of smashed innocence. She is shown bent over, legs splayed, her rump lifted into the air and pressed against the hard edge of the mirror. With her right hand buried in her petticoats, the doll could almost be masturbating. She adds to the sense that *Girl at Mirror* is a painting about a girl who seems both excited and shamed by the call of adolescent sexuality.

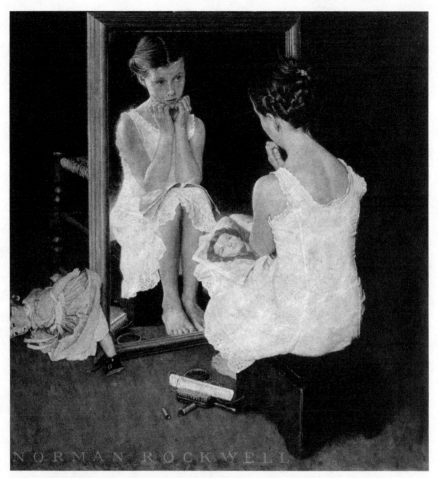

*Girl at Mirror,* 1954 (Norman Rockwell Museum, Stockbridge, Massachusetts)

You wonder if Rockwell was influenced by Picasso's *Girl Before a Mirror*, from 1932, which he would have seen on his many trips to the Museum of Modern Art. For all the glaring differences between Picasso's and Rockwell's mirror-gazing girls—one is an icon of Cubist fragmentation, the other of American realism—the paintings have a similarly Freudian feeling. Tellingly, Picasso's sexy demoiselle appears in a bright room with vibrant wallpaper, while Rockwell's girl is sequestered in an attic, a reminder of the secrecy and tension that once surrounded sexual awakenings in American life.[14]

Where exactly in America is this painting set? Rockwell never specifies, although you can be sure that his mirror-gazing girl is not in Levittown, New York, or any other postwar suburb. In 1950, when middle-class Americans were leaving their urban apartments for mass-produced tract houses with picture windows and backyard patios, David Riesman published his sociology classic, *The Lonely Crowd*, initiating a decade-long critique of suburban conformity and alienation. Although Rockwell's work has often been viewed as an affirmation of suburban-style normalcy, this is a misconception. Much as he declined to chronicle the massive shift from the proverbial sticks to the city in the twenties, he never acknowledged the shift out of the city and into the suburbs in the fifties. His pictures continued to be set in a small-town arcadia of his own imagining, a place he was searching for not only in his work but in his life as well.

•

In the summer of 1954 the yellow house overlooking the cemetery filled up with visitors. Finally, it seemed, there was a family in sight. The Rockwell boys came home for what would be their first summer in Stockbridge. Although Mary had often felt overwhelmed by the infinite obligations of running a household, she decided to dispense with live-in help that summer in the interest of familial closeness and solidarity. In a letter to her sister, she put her customary gloss on her day-to-day life and sounded almost rhapsodic on the subject of her appliances: "I am hearing the heavenly sound of my new dishwasher in operation. This is a pleasure practically unparalleled in my experience!"[15]

Rockwell and Mary were amused when their two younger sons went into business that summer in the Berkshires. Tom and Peter opened a secondhand bookshop in a narrow building in Lenox, behind the Lenox

Hotel. It was written up in the local paper, which noted: "An old antique shop started the boys in business by selling them 500 books for $4."[16] Their inventory expanded to include thousands more books arranged neatly in every available nook and cranny, and among the finds were first editions of works by Henry James and John Dos Passos as well as Arthur Guptil's book on Norman Rockwell, which the artist happily agreed to autograph.

It was a classic New England summer, made all the more convivial by the appearance of a girlfriend. Tom returned home with Gail Sudler, a willowy art student at Bard whom he would marry a year later. Her father, Arthur Sudler, owned an advertising agency in New York (Sudler & Hennessy) and also dabbled in painting. Gail was welcomed warmly into the family by Mary, who seemed to enjoy having a female ally in the overwhelmingly male precincts of her household. She reported chirpily, in a letter to her sister: "Gail and I are really good friends—she made a great success of her first job, in the Buck's gift shop."[17]

She also made encouraging comments about the state of her marriage: "*We* are doing nicely, toots, I should say all crises were things of the past. Stockbridge is certainly a much better place for us than Arlington, more life and movement."

In reality, Rockwell was not well at all. He was despondent over a bitter disagreement with his wife. It was set off when Gail's parents, the Sudlers, invited him to Europe that September as their guest. Arthur Sudler was planning to stay abroad for a while, in connection with the expansion of his advertising agency. Rockwell had not been to Europe since the early thirties, and Mary liked the idea, too. She could see herself, in tantalizing glimpses, visiting the Cassel Hospital in Richmond, England, a pioneering force in the history of psychotherapy. It was at Cassel that Dr. Thomas Main had devised the concept of "therapeutic community." Mary told Rockwell that she intended to visit the hospital as "an emissary" from the Riggs community.

But Rockwell believed she ought not undertake the trip, lest she resume drinking and prove unmanageable. Besides, he thought, she had trouble harmonizing with anyone besides psychiatrists. By now he had been in therapy for a year and Erikson was sympathetic to his feelings. Agitating on behalf of his patient, Erikson wrote a pointed letter to Dr. Knight, Mary's psychiatrist, to ask for his assistance in persuading Mary to stay home.[18]

His letter begins: "Norman Rockwell is now rather depressed, to the point of suicidal ideas. Behind this is, of course, the general feeling that Mary will never be well enough to live with in reasonable peace, and never sick enough to be sent away." Erikson explained that his immediate concern was preventing Mary from joining the trip to Europe. As Erikson states, "He desperately needs such a vacation *without Mary.*" (Italics his.)

Erikson's letter is a startling document. He asks Dr. Knight to place Rockwell's interests before those of Mary Rockwell. Moreover, he expresses little faith in the Rockwells' marriage. An artist who emphatically refuses to take a vacation with his wife perhaps should not be married to her. Yet divorce is not touched upon. Rockwell regarded his marriage as his cross to bear.

In a fleeting acknowledgment of Mary's situation, Erikson conceded that September was not an ideal month for travel—by then, the Rockwell boys would be back at school, leaving Mary alone in the house. "Yet this period will be a trying one for Norman, too, and I am now definitely worried for him," Erikson wrote.

Mary did what her husband desired. She withdrew from the proposed trip. Writing to her sister on September 8, she noted calmly: "Norman is going off for a month to Europe on the 13th of October, and I am going to stay here and take a long breath. So—why don't you come down in October . . ."[19]

Then, at the eleventh hour, Rockwell bowed out of the European adventure. Instead he took a sudden side trip to the hospital. He was admitted to St. Luke's Hospital in Pittsfield with "a painful condition" involving his back and was absent from his studio for a week.

•

During this period, Rockwell did one of his most affecting pictures, *Breaking Home Ties*, the defining image of empty-nest despondency.[20] It appeared on the cover of the *Post* on September 25, 1954, to coincide with the new school year. Set at a railroad crossing in the Southwest, the painting shows an aging rancher and his son seated on the running board of an old Ford pickup, waiting for the train that will take the boy off to college. A red flag, and an old-fashioned red-globe lantern, rest on a trunk—they are there to get the train conductor to stop. The father, a hunched, weary figure dressed in a worn denim shirt and jeans, is losing his favorite ranch hand. Even the family collie, which rests its chin on the boy's thigh, looks

*Breaking Home Ties*, 1954 (Norman Rockwell Museum, Stockbridge, Massachusetts)

heartbroken. The son, by contrast, is a bright-eyed, straight-backed presence in a crisp beige-and-white suit, gazing down the railroad tracks with barely suppressed anticipation. The suitcase resting at his feet is already branded with a red STATE U decal. Best detail in the painting: the boy's tie, a red-and-white polka dot eyesore, a mile wide and at least two years out of date, adding a trace of humor to this poignant scene of imminent separation.

Initially, in his pencil sketches, Rockwell pictured the boy sitting with his mother and his father. But as he combined photographs of the three models in an effort to compose the best painting, he dropped the mother from the picture and left a large void in her place, on the left. All in all, the rancher is probably the most sad-looking man to appear in a Rockwell painting and it seems relevant that he painted the picture at a time in his life when he was feeling "rather depressed, to the point of suicidal ideas," as Erikson had written. No wife at his side, only a red flag, signaling for help.

# CRACK-UP

(1955)

A new year arrived in Stockbridge, and the Rockwells spent the holiday at home, in the yellow house overlooking the town cemetery. It was an unhappy time for Mary. On January 12, a Wednesday, she staged a confrontation at her therapy session.[1] Rockwell accompanied her to her appointment, in the Purinton House, which was just a few doors away. It had been four years since Mary first met Dr. Knight, her dramatically tall (six foot five), always-calm doctor and the medical director of the Austen Riggs Center. A man with a large, compassionate face, his body leaning forward.

Mary was upset because she had learned that Dr. Knight, a husband and father, had fallen in love with his secretary, a much younger woman named Adele Boyd.[2] Mary was well-acquainted with Adele, an elegant brunette whose office was across the hall from Dr. Knight's, and who said hello warmly whenever Mary walked by. "I remember that last appointment day when she—she really had a blowup," Boyd recalled. "Clearly, she had a great transference problem."[3]

Rockwell did not hold the doctor accountable for Mary's problems. On January 13, the day after the confrontation, he dropped off a letter that read in its entirety, "Dear Dr. Knight—I have complete confidence in you. Last night I slept twelve hours. Sincerely yours, Norman Rockwell."[4]

Mary refused to continue her therapy with Dr. Knight, for reasons that made sense to her, but probably not to her husband. Dr. Knight referred her to Dr. Margaret Brenman-Gibson, one of the younger doctors at Riggs and the only female psychotherapist on the staff. A short, curly-haired woman of Russian-Jewish descent, Dr. Brenman-Gibson was an

earthy presence, her long sun dresses flowing about her solid frame. She met with her patients in her plant-filled home office on Clark Street. Mary Rockwell was already acquainted with her husband, William Gibson, who ran a drama group for Riggs patients. As he said of acting: "Being someone else is a great cure."[5]

Suddenly, it seemed to Rockwell, every member of his family was acting out and leaving him uncomfortably exposed. On January 19, just a week after the Dr. Knight incident, Peter Rockwell, a freshman at Haverford College, ran away from school with a friend. "We didn't want to take final exams," Peter later explained.[6] Rockwell was mortified when a local reporter called to ask if Peter had officially dropped out of college. Hanging up, he called Ben Hibbs, hoping the *Post*'s editor could use his influence to squelch the story. "After you telephoned me," Hibbs wrote the next day, "I made some inquiries and quickly found that the story about Peter had already gone too far to stop. It had gone out on the wires to other papers, and the radio people also had it."[7]

Among the millions of Americans who heard the news was Rockwell's brother, Jarvis, who was still working as a toy designer in Kane, Pennsylvania, and had never fully recovered from the indignity of losing his job on Wall Street during the Depression. Reading about his nephew in the local newspaper, he was taken by surprise. Norman Rockwell, he was grieved to realize, had never informed him that Peter was living in Pennsylvania, a student at Haverford, or even that the family had moved to Stockbridge. For all he knew, they were still in Vermont.

"Publicly I'm supposed to be very close to you," Jarvis wrote on January 30, 1955, in a bitter letter.

To know when your next Post cover will appear. To know what schools your boys attend. To know where you live. Actually I don't know any of those things. I suppose you don't know similar things about me. About the only times we have met in recent years has [*sic*] been due to some family misfortune . . . This last newspaper story about Peter made me realize that you and your branch of the family are really more foreign to me than the families of my business friends. I'd like to think that we can correct this drift into nowhere . . . I'm happy to be "Norman Rockwell's brother" but I cannot tell others how little it has meant to me. They would not believe me, or they would think we have had a serious family row.[8]

They were painful accusations, but Rockwell had little time to dwell on them. On February 1, less than two weeks after his runaway escapade, Peter was injured in a fencing match at Haverford. A pointed blade "pierced his right armpit, just above the edge of the padded chest protector," as the papers reported. Rockwell and Mary drove through the night to Bryn Mawr Hospital and, after four days there, Rockwell noted with relief: "Peter out of danger."[9]

He made the comment in his 1955 date book, which was spiral-bound with a faux-leather cover, a freebie from a Maryland insurance company. He became inclined at this point to record his daily activities, briefly and at times pungently. He spent his sixty-first birthday in Bryn Mawr and returned home to Stockbridge on a Monday, while Mary stayed on for another three weeks to oversee Peter's hospitalization. She visited her son every day and, by chance, befriended an elderly patient named Betty Williams, in room 454, stopping by to chat with her and "bringing her paper and artist colors to work with."[10] It's a touching image: the sick trying to comfort the sicker.

It was during this turbulent winter that Rockwell produced *Art Critic*, which ran as a *Post* cover on April 16. Set in an unnamed art museum, in a gallery of seventeenth-century Dutch portraits, it shows not an art critic, but a young art student in paint-splattered sneakers who is eager to learn from his predecessors. As he leans forward to better study a woman in a Frans Hals painting—she is the "critic" of the painting's title—she returns his interest with comically exaggerated disapproval. With her raised eyebrows and wide, popping, cartoony eyes, she seems to be saying to the young painter, "How dare you?"

*Art Critic* can be read in various ways. Many viewers see it as a mildly salacious joke about a young man who incites the scorn of a comely redhead in an Old Master painting by ogling her cleavage. But it seems more likely that Rockwell, who revered Rembrandt and the Dutch masters and drew so much inspiration from them, intended the picture as a form of self-mockery in which he sends up his overly fussy techniques. Rockwell has portrayed the art student as an egghead, a guy so consumed by the careful, close-up observation of particulars (note his magnifying glass and museum guide book) that he is blinded to the pleasures of oil paint, to all that is bold and immediate and sensual. No wonder the three bearded Old Masters in ruffled white collars, peering out of another painting, are laughing at him behind his back.

*Art Critic*, 1955 (Norman Rockwell Museum, Stockbridge, Massachusetts)

Bill Scovill, who photographed the models for the painting, claimed that *Art Critic* gave Rockwell more trouble than any other painting ever.[11] At least twenty drawn and painted studies of the female head preceded the painting. Perhaps it was the risqué subject matter that threw him. His artist-son Jarvis posed for the art student and Mary Rockwell posed for the Dutch flirt. As was also true of Rockwell's earlier *Christmas Homecoming*, the picture pairs mother and son in an encounter fraught with sexual innuendo and it would leave Jarvis incensed.

•

Everyone in his family, it seemed to him, wanted something from him, something he could not deliver, and he was beset with feelings of unhappy obligation. Readers of the *Post*, by contrast, could not praise him enough and he felt gratified by the attention. That spring, the *Post* organized a fresh round of tributes to Rockwell. The March 12 issue included a special insert called "Rockwell's America," a color album featuring reprints of nine golden-oldie *Post* covers. The issue sold out at newsstands virtually overnight. To promote it, the the *Post* volunteered Rockwell for everything from an appearance on *Arthur Godfrey and His Friends*—the CBS variety show whose host liked to strum his ukelele and sing jingles promoting his advertisers—to a museum exhibition at the Corcoran Gallery of Art in Washington, D.C.

Astoundingly, it was the *Post*'s marketing department that proposed the exhibition at the Corcoran. The museum, in turn, offered up the first available slot on its exhibition calendar, with the caveat that the *Post* was to foot the bill. In an internal memo on January 10, Corcoran curator James Breckenridge assured the museum's director, Hermann Williams, Jr., that: "The *Post* frames and mounts the exhibition ready to install, and would pay all expenses connected with the show, including that of an opening. It is understood that the Gallery would be placed at no expense for the exhibition."[12] These days, the idea of an art museum accepting an exhibition from a magazine whose marketing department chose the works and picked up the tab would be considered a serious ethical lapse. Museums are supposed to exercise their authority and connoisseurship without interference from the business world. But backroom compromises were standard practice in a more casual era of museological administration, and Rockwell's show at the Corcoran said less about his artistic standing than about the *Post*'s deftness at PR.

On May 5 Rockwell dined at the White House at the invitation of President Eisenhower, who was throwing a "stag party" for nineteen guests. Most of them (such as Leonard Firestone of rubber-tire fame or Doubleday publisher Ken McCormick) were the sort of self-made, influential businessmen whose conversation and company Eisenhower preferred to that of politicians. Worried he would be tongue-tied at the party, Rockwell flew down to Washington with a Dexamyl in his jacket pocket. The story he told about that evening goes as follows: Before dinner, standing in the bathroom of his room at the Statler Hotel, he accidentally dropped the pill in the sink. To his dismay, it rolled down the sink, forcing him to face the president and sup on a meal of oxtail soup, roast beef, and lime sherbet ring in an anxiously unmedicated state.[13]

Rockwell returned to Washington a month later for the opening of his show at the Corcoran, on the evening of June 16. Accompanied by the *Post*'s top brass (Ben Hibbs and art director Ken Stuart), he was greeted at the museum by an appreciative throng. "Successful," he noted that night in his date book. "1,400 handshakes." As the *Post* intended, the reception seemed more like an Independence Day celebration than an art vernissage. A military band, compliments of the Marine Corps, was brought in to entertain and guests comparing notes on Rockwell's paintings and charcoal sketches had to shout above the blare of trumpets and tubas. News stories singled out the least imaginative painting in the show—a campaign portrait of Eisenhower that had appeared in the *Post* in 1952 and now was owned by his wife, Mamie—as the highlight of the exhibition.

The most recent painting in the show, *Marriage License* (see color insert) had just appeared in the *Post* (June 11) and captured Rockwell at the peak of his talents as a realist painter. An aging town-hall clerk sits in his musty office, waiting as a young couple fill out an application for a marriage license. They're happy to be playing their assigned gender roles. The woman, who is up on her high heels, reaching for the desk, is wearing a daffodil-yellow dress with a cinch waist and puff sleeves. Her strapping fiancé wraps his arm around her in a protective, ur-fifties way.

Most everyone in Stockbridge recognized the man who posed for the clerk, Jason Braman, who in real life ran a variety store. As he sits in town hall, a cat by his chair, his eyes averted from the marrying couple, he seems to be thinking about something else, perhaps with regret. He's the epitomy of diminished expectations; note his collapsed socks. The image is humorous enough, but Rockwell is striving for more than a joke. With

its cigar-brown hues and dramatic light-against-dark contrasts, the picture betrays his fondness for Old Master painting, his desire to transport the luminous interiors of Dutch painting onto an American magazine cover.

·

As it so happened, a marriage was about to take place in the Rockwell family. Tom, the middle son, returned home from Bard College for the summer with his fiancée, Gail Sudler. As he had done the previous summer, Tom opened a bookshop in a narrow building, this time on Main Street in Stockbridge; his inventory consisted of used books he had purchased by the pound, at auction. Peter, who had recovered from his fencing injury, manned the clunky black cash register up front. Sue Erikson, the daughter of Rockwell's therapist, also put in time as a clerk.

Rockwell painted a witty sign to hang outside the shop. It portrays a stern, bespectacled man engrossed in a book, in the style of a turn-of-the-century poster by Edward Penfield. "Rockwell Brothers: Books & Prints" the wooden sign announces in faux-Victorian lettering, making it sound as if the boys had been in business for at least two-and-a-half generations.

Within only a few weeks, everything fell apart. "That was the summer my mother had a nervous breakdown," Tom recalled. It had been six years since her previous collapse and it took the family by surprise. "Mother was managing the house, and there were all those people there, and it must have been a terrible burden on her. My father never told us what happened. We came home in the afternoon and she was gone. Bang. I always had the idea that she had tried to commit suicide."[14]

Indeed, she had taken an overdose of pills. Deemed too troubled to continue to be treated at Riggs, she was sent off to a different hospital, a place of straitjackets and electric shock therapy. She told her therapist, Dr. Margaret Brenman-Gibson, that her goal had been to "revenge myself on Dr. K."

·

On June 30, Mary entered the Institute of Living, a grand-looking psychiatric hospital set high on a riverbank in Hartford, Connecticut. Landscaped a century earlier by Frederick Law Olmsted, the nation's preeminent park artist, it catered to well-off patients who could afford long-term care. Mary would remain hospitalized for four months. As

summer faded into fall, she lived in Ellsworth Cottage, "a nice old white house" where she took her meals with other patients and read and reread her favorite Jane Austen novels on the screened porch. Sometimes, as the afternoon progressed, she longed for a cocktail, but had to settle for iced tea. At night, before the lights were turned out, a Mrs. Plude brought a first sedation and a second sedation and maybe a third. "I break one and only one rule consistently," Mary confessed in a letter. "I do smoke in bed."[15]

In a letter to Dr. Brenman-Gibson composed five days after her arrival, Mary sounded displeased with her surroundings. There were so many rules and restrictions; she couldn't even go for a short stroll in a nearby park without "signing out," and the nightly lockdown took place at eight o'clock sharp. Moreover, she felt that the staff was no match in sophistication for the doctors at Riggs. In Hartford, "there are no analytical men on the staff (a large shock)"—she respected the wisdom of psychoanalysts even if her own treatment never went much beyond counseling. "It's just as well you didn't describe the Retreat or I might never have come here," she noted to Dr. Brenman-Gibson, "though I did feel a little resentment that you hadn't, and I do need the respite."

She was, by her own admission, still obsessed with Dr. Knight, who had been in contact with Dr. William Zeller, her new psychiatrist in Hartford. She was touched to hear that the doctors at Riggs were conferring about her, and "tears did come to my eyes when Dr. Z. told me Dr. K. had written a letter to him about me—I felt guilty to feel so pleased."

She was trying to sound positive, even when the subject turned to suicide and her recent overdose. "I've found and proved that what you said was true. I have no black hostility in me because no matter how much I thought about it and I certainly examined every possible method, I am constitutionally incapable of committing suicide."

She claimed that her depression was ebbing, as if such matters were simply a matter of making up one's mind. But a week after her arrival in Hartford, she capitulated to electric shock therapy. She was taken to a special room and given general anesthesia before receiving a massive electric jolt to her brain. "I had my first treatment" she wrote to her sister, on July 12, "and it was not at all difficult—though odd when you wake up at first."

Just four days later, on Saturday, Tom married Gail Sudler. Mary left the hospital for the day to attend her son's wedding, in New York. The ceremony was held at the Little Church Around the Corner and the bride's

parents, who lived on the Upper East Side, hosted a reception at their apartment. Janet and Arthur Sudler tried to be understanding, but it was a sorry spectacle. Mary consumed too many cocktails and embarrassed everyone, not least of all herself.[16]

The next morning, as the newlyweds set off for a honeymoon in Mexico, Rockwell drove his wife back to the hospital in Hartford. Then he continued in his station wagon on the long road to Stockbridge, arriving home to an empty house. "Exhausted from Tom's wedding," he jotted on his calendar. "Mostly slept."[17]

•

By then Rockwell was also trying to absorb a review that ran in *The Washington Post* on July 10. It represented a negative milestone—it was the first article in a major newspaper to deride Rockwell as a hack. Leslie Judd Portner, the art critic for the *Post*, argued that the paintings and drawings in his show at the Corcoran could hardly be considered art and, even as illustration, "have no more than a sentimental and topical appeal." The article was accompanied by a reproduction of *Marriage License*, which took a direct hit. "No view of an interior could be duller or more pedestrian than Rockwell's marriage bureau scene."[18]

Her review compared the Rockwell show to a second show then at the Corcoran, *The Family of Man*, a historic show of contemporary photography organized by Edward Steichen. Mixing apples and oranges, Portner wrote that Rockwell's paintings "have none of the emotional impact of Steichen's show."

This was something new. A decade earlier, Rockwell had been America's artist in chief, the noble champion of *The Four Freedoms*. Now, it was decided that his work lacked "emotional impact." The problem was that emotion comes in many varieties and, in the fifties art world, angst was the preferred form. Jackson Pollock, Willem de Kooning, and their fellow Abstract Expressionists glamorized direct and unmediated gestures—the drip, the splash, the juicy brushstroke that didn't try to stay inside an outline.

Their paintings, it might be said, went against the shiny surfaces proliferating in new appliances. What was Abstract Expressionism? In a way, it strove to be the opposite of a vacuum cleaner—devoid of practical value, spewing out particles of color rather than pulling them in, unaccompanied by user directions, incomprehensible to the average person.

By those measures of artistic greatness, Norman Rockwell failed to qualify. The Corcoran review was the first of many hits he would take in the fifties, when realism was written off as retrograde. And if realism was suddenly passé, illustration—a subdivision of realism that came with the added stigma of a regular paycheck—was sub-passé.

Of course, there was no shortage of independent-minded artists who remained unfazed by fashion and rhetoric. But they didn't get much media attention. That summer, Rockwell met Lyonel Feininger, a leading abstract painter, New York born, Europe addicted, whose woodcut *Cathedral* had served as the cover of the 1919 Bauhaus manifesto. By now Feininger was in his mideighties, a hyperarticulate man with furry white eyebrows. He and his wife, Julia, a German-Jewish immigrant, rented a summer house in Stockbridge and later recalled that they first met Rockwell when he knocked on their door, collecting money for an Austen Riggs fund drive.

"We've met Norman Rockwell several times, and we like him first-rate," Feininger noted on August 13, in a letter to the artist Mark Tobey.

> I think it "takes some doing," "some sterling quality," to envisage humans as kindly and subtly as he has kept on doing ever since forty years, leaving exhibitionism to those whose urge pushes them into that track . . . He achieves what certainly no photograph ever could in an expressively human way, and that compels my admiration and respect. There's nothing "arty" about the work or the man: a pure miracle, when one considers the epoch we are undergoing.[19]

•

Rockwell did not have the sturdiness to withstand much criticism, even now, when he had Erik Erikson to hear him out and provide perspective. The old doubts that were never far below the surface led him to wonder anew whether he should leave the *Post* and try to become a fine artist who exhibited in galleries and was part of the art world, whatever that was. Pan Am, by a nice coincidence, had offered Rockwell an advertising gig that promised two months of expense-paid foreign travel. Erikson, who had wandered Europe as a young artist and continued to regard the nomadic life as a source of self-enlightenment, encouraged Rockwell to take the trip despite Mary's hospitalization. Rockwell was amused when Erikson

speculated, in his German-accented English, "Perhaps you will have a revelation over the Formosa Straits."[20]

Not that Rockwell's trip exactly qualified as a *Wanderschaft*, to borrow Erikson's lofty term. Pan Am was then trying to broaden the audience for its round-the-world Clipper flights, to convince middle-class Americans that foreign air travel did not have to be an exclusive affair. The air carrier turned to Rockwell to help Americanize the image of foreign travel. He was commissioned to do a series a sketches that would be used in a Pan Am advertising campaign, linking the local corn-fed boy to the world across the Atlantic.

Rockwell saw Erikson not only for twice-a-week therapy, but on social occasions as well. They both belonged to the Marching and Chowder Society, a small and somewhat goofy men's club that gathered over lunch every Tuesday at the Morgan House in Lee. The group's stated mission was to converse about politics and current events. It had been founded by Harry Dwight,[21] a Stockbridge blue blood who lived across the street from Rockwell and served as president of the Housatonic National Bank.

Rockwell socializing with Erik Erikson and other members of the Marching and Chowder Society, circa 1960

Rockwell, who liked to refer to himself as "the world's worst businessman," admired Dwight's financial savvy. He was tickled when Dwight presented him, as a going-away present, with a "short snorter," a chain of taped-together banknotes that began as a tradition during World War II.[22]

It might seem surprising that Rockwell would choose to go abroad for two months when his wife was hospitalized, struggling for sanity. But Erikson put Rockwell's interests first and the trip came less than a year after Erikson had argued in that letter to Dr. Knight that Rockwell deserved to travel abroad without his wife.

Before leaving for Europe, Rockwell spent three days in Hartford, visiting Mary. He stayed at the Hotel Statler, in a room overlooking the leafy expanse of Bushnell Park. He and Mary met for walks around the sylvan duck pond. Once word of his presence got around, a reporter from *The Hartford Courant* requested an interview. Rockwell actually assented and met the reporter in a quiet corner of the Statler lobby. Asked what he was doing in Hartford, he said that he had come to "limber up" his sketching arm, in preparation for the Pan Am trip.

"Why Hartford?" the reporter persisted, knowing nothing of Mary Rockwell's hospitalization.[23]

"Hartford has a foreign atmosphere," Rockwell bluffed. "The State Capitol could be another Taj Mahal if it were located in India or Siam."

He paused to pack some tobacco into his straight brown pipe, and then continued: "The Hartford High School with its pointed spires are reminiscent of early French architecture. I'm not really a landscape man and need a little practice on scenes like these."

If Mary resented her husband for leaving the country during her hospitalization, she was not likely to say so. Her son Peter was struck by her jarringly positive attitude. "Shock treatment makes you lose your memory, and she couldn't remember things," he recalled later. "What was depressing was her pretending that shock treatment was a good thing. She always had this thing, that everything was for the best."[24]

•

On September 2 Rockwell boarded a Pan Am Clipper at Idlewild Airport in New York. In those days, it took twelve hours to cross the Atlantic. He was traveling with two chaperones provided by Pan Am, one of whom, Blackie Kronfeld, was the company's in-house photographer. Their first stop was London, where he stayed at the tony Savoy Hotel for five days

and then, apparently, repacked his bags with his usual haste. "A blue shirt, a white shirt, and a vest were found in the room you occupied here," the hotel manager informed him in a letter the day after he left. A funny detail. So often in his paintings of travelers there is something—a pajama string, whatever—poking out of their suitcases.

From there he traveled to Paris, where he wrote a short letter to Erikson on stationery from the Hotel Montalembert, in the Seventh Arrondissement. His greatest disappointment, he said, was finding himself without adequate time to sketch. "I tried it in England but our stops are so short that I must make the 'sketch' book mostly from photos we are taking." Reporting on his anxiety level, he added that he had felt "apprehension" the night before, when he was walking back to his "obscure hotel" and couldn't find a taxi. "But nothing like panic."[25]

He next wrote to Erikson from the Hotel Metropole in Karachi, Pakistan, which was "Picturesque beyond words. Camels, turbans, veils. But poverty I never dreamed existed."[26] He had not reached any decisions about his work: "no revelation from above on my future in the art world."[27]

Two weeks later, writing to Erikson from the Peninsula Hotel in Hong Kong, he reiterated his failure to make any decisions about his work. "I haven't had time to consider my future or anything but the work at hand. But you said, 'Perhaps you'll have a revelation over the Formosa Straits.' We fly over the Straits this Sunday so I have hopes."[28]

A twenty-minute newsreel released by Pan Am after the trip shows Rockwell strolling through the capitals of the world, his oversized sketchbook tucked beneath his arm. There he is, browsing in the bookstalls in Paris, riding in a rickshaw in Hong Kong. Disembarking from the plane in Honolulu, on October 25, he was greeted by a bevy of dark-haired, hip-swaying hula girls. As one of the girls pecked him on the cheek and tossed three flowery leis around his neck, he worried about sneezing. "They don't even ask you whether you have allergies or not," he noted with a straight face.

•

On November 1 Rockwell returned from his Pan Am whirl; the newsreel concludes with footage of him in his studio, showing off his new souvenirs, including a Buddha figure from Siam, some Japanese dolls, and an old-fashioned French pistol. Mary was released from the hospital, joining him at home. Although her four months in Hartford had been restful, the

salutary effects did not last long, and within a month, as winter descended and brought darkness in the afternoons, she returned to her old habits. She mixed daiquiris to boost her mood before dinner and sneaked sips of rum from bottles she hid around the house. Bills from December 1955 itemize in a clerk's neat cursive the toxic purchases—Taylor dry sherry, Club bourbon, eight bottles of Bacardi rum, cartons of Pall Mall cigarettes.[29] "She never got better," her son Jarvis recalled years later. "She was on her way down. She really was on an inclined plane."[30]

As Mary faltered, Rockwell took refuge in his studio, allowing the prod of deadlines to drive out rogue thoughts. Mary had not been cured by her years of therapy and he could hardly pretend that his own sessions with Erikson had led to life-changing disclosures. No, there had been no great revelation over the Formosa Straits. "Art heals," the maxim goes, but Rockwell had no illusions about the curative power of art. Rather, he made art because he couldn't be healed.

At the same time, he valued his therapy sessions with Erikson, who was an indisputable ally. He could not say the same for Dr. Knight, who had treated Mary and Tom and was professionally obligated to stand beside them in family conflicts. Tom was about to turn twenty-three, and Rockwell wrote a witty birthday poem for him, part of which reads:

> *Mosquitoes sting and bedbugs bite.*
> *Reminds me much of Dr. Knight.*
> *But thoughts that make me very lyric*
> *Come from good white-haired Uncle Erik.*[31]

# YOUNG MAN LUTHER

## (1957 TO 1959)

Doctors and senior staff at the Austen Riggs Center were expected to divide their time between the care of patients and research. But sometimes the two could not be balanced. Erikson received a grant in 1956 that allowed him to leave Riggs altogether and tend to what he called "this writing business."[1]

On October 1, 1956, Erikson began a yearlong sabbatical. He arranged for Rockwell to be treated in his absence by Dr. Edgerton Howard, the associate medical director at Riggs. Unlike Erikson, Dr. Howard wasn't well-known in intellectual circles or even in psychoanalytic ones; he was just a sturdy, self-effacing professional, all but unpublished except for a few book reviews.[2] Although Rockwell was loath to switch therapists, he soon assured Erikson that he was making the best of things. "You told me not to underestimate Dr. Howard and you were absolutely right. He's very fine but let's be honest. There's only one Erik Erikson."[3]

Erikson, at the time, was living in Mexico, in the tiny fishing village of Ajijic. This is where he wrote *Young Man Luther*, one of the first books to qualify as psychobiography. It offers a conceptually daring interpretation of the life of Martin Luther, who, according to Erikson, suffered a late-adolescent identity crisis of such mammoth proportions that the only way to resolve it was to reject 1,500 years of Roman Catholicism and invent a brand-new religion. The outcome of his identity crisis was not only a new Luther, but the Protestant Reformation, which favored inward soulfulness over the old regimen of rules and rituals.

For all its obvious limitations, including the absurdity of attempting to psychoanalyze a German preacher five centuries after his death, *Young Man Luther* abounds with tossed-off profundities and entertaining asides. Some of Erikson's thoughts spring from his status as a painter manqué attentive to the visual world. Thoughts on faces, for instance. He claims that the quest for religious faith represents an attempt to recapture the lost visual gratifications of infancy—in particular, "the smiling face" of an appreciative parent. The recognition bestowed by a welcoming face represents "the beginning of all sense of identity."[4]

The search for "mutual recognition, the *meeting face to face*," he contends, is common to monotheistic religions. God is the caring face that religion projects onto the sky and that allows faith to flourish. "In the beginning are the generous breast and the eyes that care," Erikson writes in reference to a mother's love for her baby. "Could this be one of the countenances which religion promises us we shall see again, at the end and in another world?"[5]

Countenances, faces, "eyes that care"—Erikson's emphasis on the face serves to remind us that Rockwell was, among other things, a painter of faces. All his paintings are figure paintings, ones in which the facial expressions are likely to be distinct and legible. A Freudian might point out that Rockwell, who complained that his mother failed to look at him in his neglected childhood, made up for the loss by devoting his life to the creation of a gallery of interlocking, hyperattentive faces. In the process, he was able to direct the gaze of the American public onto himself and find a respite from the ache of invisibility.

•

On April 12, 1957, Erikson wrote to Rockwell from Mexico, and his tone is openly caring ("I miss you and Stockbridge"). He was enjoying his stay, sitting in his yard in the shade of banana trees, slowly making his way through Luther's tracts in scholastic Latin. But the writing part of his efforts was more complicated. "The job is going well," he informed Rockwell, almost deferentially, "but who knows the ups and downs better than you do?"[6]

With the letter came a ten-page travelogue intended to be read aloud or merely circulated at the next gathering of the Marching and Chowder Society. ("It's of course written primarily for you," Erikson notes sweetly, "but I thought you would want to include the friends.") Ajijic was then

fashionable as an artists' colony and Erikson was surprisingly critical of the American bohemians he met there. "Some of the 'painters' and 'writers,'" he notes with patronizing scare quotes, "do seem arty in a homeless, pathetic way; and some of those who have money, drink themselves into a nostalgic stupor day after day; but there are also quite a number of people who do some work in apparently contented and heterosexual monogamy."

Interesting choice of words. He could have written that there were artists who do work in "contented monogamy." Why the qualifier, why contented "heterosexual monogamy"? Perhaps he was trying to steer Rockwell away from his homoerotic desires. Like most psychoanalysts of his era, Erikson regarded homosexuality as a consequence of arrested development and believed it needed to be treated.

Rockwell wrote back to Erikson in Mexico, in a letter in which he acknowledges his overly intense relationships with men. His latest adventure or rather misadventure was with his photographer Bill Scovill, a Riggs patient who suffered from severe depression. Although he was descended from the Scovill family of brass-button fame, his resources were not unlimited and he was crushed when he lost his job at the Riggs workshop, where he taught photography.

"After threatening me with his self-destruction," Rockwell wrote, "he swung over to the idea of my taking over the full responsibility for his financial and spiritual life. In fact he was forcibly crawling back into my womb but found it was already overcrowded. Now, believe it or not, he's doing fine."[7] Rockwell had often joked in the past about feeling weak or womanish, and his very first cover for the *Post, Boy with Baby Carriage,* had derived its humor partly from the milk-bottle nipple poking out from the boy's breast pocket. But the notion that Rockwell himself was equipped with female reproductive organs and the obligations of maternal care— this is a new one.

Granted, he had been protective of Scovill, who continued to work as his photographer and to keep him company in the studio. "We built a darkroom up there," Scovill recalled later, "and Mrs. Guerrieri was upset when we moved the enlarger in."[8] She was the landlord and perhaps it was the acrid, vingary scent of the photographic chemicals that made her unhappy. Rockwell's relationship with her deteriorated so severely he felt he had to move out of the studio, which still occupied a second-floor space over the butcher shop on Main Street.

*Before the Shot*, 1958 (Norman Rockwell Museum, Stockbridge, Massachusetts)

On May 7, 1957, Rockwell signed the deed on the place formerly known as the Loomis house. It was just down the road from his house overlooking the cemetery. He moved partly to get away from the cemetery, the view of which his wife found intolerable. But his first priority was to put up a studio, or rather remodel the red barn tumbling down in the yard, which he expected to take two months. "We are having the studio finished first and when that is completed I am going to give a whiz bang party with two bars going full tilt," he wrote to Erikson, "one in the studio and one on the lawn. It'll be about July 1st."[9] The new studio would include a built-in darkroom for Scovill.[10]

It had been only three years since he had acquired his previous house in Stockbridge and he probably set some kind of record for buying and selling houses and moving around the New England countryside, which is supposed to be a place where you put down roots. On the other hand, his new house—it was on Route 7, which turned into South Street as it entered town—would be his last. It was the kind of house he had always favored: a chunky white-painted Colonial, creaking with two centuries of history and enhanced by the rumor that a famous patriot, Aaron Burr, had been a former occupant. It was across the street from the Red Lion Inn and as close to the Austen Riggs Center as a house could be.

Moreover, his new house was near the Stockbridge elementary school, and he still, at this late point, was on the lookout for new child models. Escorted by the principal, he would wander the halls on weekday mornings and peer into brightly lighted classrooms, in search of boys with the right look. He would wait until the children had broken for recess or filed into the lunchroom before making contact with them, not wanting to intrude on their lessons.

"He would come during our lunch hour and pull you into the hall," recalled Eddie Locke, who first modeled for Rockwell as an eight-year-old boy, in October 1957. Locke is among the few who can claim the distinction of "posing somewhat in the nude," as *The Saturday Evening Post* reported in a bizarrely sanguine item on March 15, 1958. The comment refers to *Before the Shot*, which takes us into a doctor's office as a boy of around eight stands on a wooden chair, his belt unfastened, his corduroy trousers lowered to reveal his pale backside. As he nervously awaits an injection, he bends over, ostensibly to scrutinize the framed diploma hanging on the wall and reassure himself that Dr. Campbell is sufficiently qualified to perform this delicate procedure. (That's the joke.) The doctor,

a gray-haired man in a white coat who has his broad back turned to the patient as well as the viewer, is an ominous figure. He seems to have little in common with earlier Rockwell pediatricians, like the avuncular one from 1929 who indulges a schoolgirl by listening through his stethoscope to the pretend-heartbeat of her doll.

*Before the Shot* remains the only Rockwell cover in which a boy exposes his unclad rear. Locke recalls posing for the picture in Dr. Campbell's actual office on an afternoon when the doctor was gone. Rockwell asked the boy to drop his pants and had his new photographer, Clemens Kalischer, take the pictures. "He instructed me to pose how he wanted it," Locke recalled. "It was a little uncomfortable, but you just did it, that's all."

One night, Rockwell surprised the boy's family by stopping by their house unannounced. He was carrying the finished painting and apparently needed to do a bit more research. "He asked for the pants," Locke recalled years later. "This is what my parents told me. He asked for the pants to see if he had gotten the color right. They're kind of a grey-green."[11] It's an unsettling anecdote. Once again we are made to wonder whether Rockwell's complicated interest in the depiction of preadolescent boys was shadowed by pedophilic impulses. But an impulse is not a crime. There is no evidence that he acted on his impulses or behaved in a way that was inappropriate for its time.

At one point, he bought Louie Lamone a Polaroid camera and asked him to go around town taking pictures of potential models, children whom he might want to contact after seeing their photograph. Lamone found the process unnerving. "It was risky," he recalled, "going around taking pictures of little boys and little girls and I almost got killed. People think you are a pervert or something."[12]

•

A few months after Eddie Locke posed for *Before the Shot*, he posed for a second *Post* cover, *The Runaway* (September 20, 1958), one of Rockwell's most beloved paintings. The theme is one he had first tackled in 1922, in an earlier *Runaway*, a mud-colored painting in which a boy who had hoped to join the circus sits crying as a sensitive clown dabs away his tears. The later *Runaway* is more austere. It takes us into an old-fashioned diner, where a boy of perhaps seven or eight is sitting at the counter with a beefy policeman. The boy's possessions are on the floor, wrapped in a red

*The Runaway,* 1958 (Norman Rockwell Museum, Stockbridge, Massachusetts)

bandana that is attached to a hobo-style "bindlestick" hinting at his cross-country fantasies.

At the time, *On the Road* had just been published. Unlike Jack Kerouac's Sal Paradise, who takes a wild road trip across America, Rockwell's runaway got no farther than the town limits before he was apprehended by a caring cop. Curiously, in an age when grown-ups and kids still went about their lives as if separated by a language difference, the cop decided against returning the boy to his inevitably scolding mother and sat down to talk things over with him at the diner.

The boy and the officer are shown from the back, on adjacent stools covered in green vinyl. The officer gazes intently into the boy's eyes and tilts his upper body toward him, as if to emphasize the bond of understanding and even tenderness that can form between a grown man and a little boy. To undercut the hint of homoeroticism, Rockwell includes the usual gimlet-eyed onlooker—in this case, a lanky counterman who leans forward with a lopsided grin, his thinning hair slicked against his skull, a ribbon of smoke rising from the cigarette stub pressed between his lips.[13] In its time, the cover was received by readers of the *Post* as a touching tribute to American values. The officer represents the warm arm of the law, authority at its paternal best; he's the quintessential Officer Friendly. On closer reading, however, the cop can also be seen as a figure of tantalizing masculinity, a muscle man in a skintight uniform and boots. There is something sensual about the expanse of his massive back, the sharp creases in his shirt formed where the fabric pulls. His tapered waistline is highlighted by the sheen of his wide leather belt and, all in all, the picture is infused with a sneaking admiration for uniforms and regalia.

The model was Dick Clemens, then a thirty-one-year-old state trooper who lived down the road from Rockwell. After Rockwell called him at home one day, they arranged to meet at the Howard Johnson's in Pittsfield. Clemens recalled that he posed for the photographs—in his own uniform, with his own .38 Smith & Wesson revolver—after his fellow model, little Eddie, went outside to play in the patrol car. "You could see the 28 flavors in the background, until Rockwell painted them out," Clemens recalled later.[14] Indeed, charcoal sketches for the picture offer a glimpse of the HoJo list, although Rockwell also had a few other restaurant interiors photographed for reference.

For years, it was reported that the picture is set at Joe's Diner, in the

blue-collar town of Lee, a myth fostered in no small degree by Joe Sorrentino, who claimed his tiny eatery as the inspiration for the painting. You could always find a reproduction of *The Runaway* tacked to the wall. But that is true of many diners across the country, where *The Runaway* is displayed over the counter, usually in a cheap frame, reminding us that the American desire for on-the-road freedom has always been accompanied by an opposing desire for security and safety, a desire to find refuge at a welcoming counter where cherry pies gleam in a glass case.

•

In December 1957 Rockwell decided against sitting out the holiday in Stockbridge. Although he had moved into the house on South Street only six months earlier, all it took was an invitation to judge the Rose Parade to rouse his barely suppressed wanderlust and get him on a train bound for California. Not much is known about the trip, but details gleaned from news clippings provide some sense of his movements. On January 1, 1958, he was in Pasadena, selecting the best floats in the Sixty-Ninth Tournament of Roses Parade, whose theme that year was "Daydreams in Flowers."

A few days later, accompanied by a Hollywood photographer, Pete Todd, he visited the Santa Ana Park. There, he "made his first racing bet" and arranged for Eddie Arcaro, a celebrated jockey, to pose for sketches and photographs. *Weighing In*, which would run the following June 25, is one in a long line of Rockwell covers pairing physically opposite male figures. It depicts the jockey as a tiny, doll-like figure in a pink-and-white diamond-pattern jacket, standing on a scale as a beefy steward hovers over him, checking his weight.

From there Rockwell continued north to San Francisco, where he spoke at the Art Directors' Club and visited with his oldest son. Jarvis was then twenty-six, a shaggy-haired art student who was renting an apartment on Fillmore Street, the headquarters of beatnik culture. He had settled in San Francisco two years earlier at the suggestion of Erikson, who felt that Jarvis needed to put a protective distance between himself and his parents and enter therapy with someone unconnected to the family, or at least sort of unconnected.

Peter, the youngest of the Rockwell boys, by then had become serious about art as well. He waited more than a year before disclosing his ambitions to his father. Finally he could not wait any longer. He had found his

calling and it was sculpture. "That's nonsense," Rockwell told his son, without the least hint of irony. "Jarvis is a painter, Tom is a poet, and the only thing I can think of that is commercially worse than painting and poetry is sculpture. There aren't more than three sculptors in the continental U.S. making a living from sculpture."

By now Erikson was back from his sabbatical in Mexico and Peter suggested that his father talk it out with his therapist. He was confident that Erikson, who had been an artist in his youth, would support him. "If Erik thinks it's all right, will you relax?" Soon afterward, Peter himself became a regular visitor to Erikson's office at Riggs, hoping to make his desires understood both to himself and his doubting father.

A bill that survives among Rockwell's papers indicates that in December 1958 he and two of his sons had separate therapy sessions with Erikson. "You know, I think your family has logged more hours of psychiatric care than any other family in America," Erikson joked to Rockwell.[15]

In Rockwell's mind, no one needed a special reason to go into psychotherapy. His children went to their therapy appointments the way other children went to the dentist. There was something admirable about his openness to therapy, with its implicit quest for emotional clarity. On the other hand, therapy, too, at times seemed like a form of emotional avoidance, a way for Rockwell to outsource responsibility for the mental well-being of his wife and sons. "He wanted someone else to take care of it," his son Tom recalled years later.

# ROCKWELL TELLS HIS LIFE STORY

## (1959)

By now Rockwell was working on his autobiography, at the suggestion of Ken McCormick, the editor in chief of Doubleday. The project had begun haltingly. In May 1957 McCormick invited Rockwell to lunch in New York. Although Rockwell had never cared for writing, McCormick, who described him as an "old sweetie," suggested that he do a book that would require no writing. He could tape-record his large store of anecdotes and someone else could assemble them into book form.

A few days later, the editor had a Dictaphone shipped to Stockbridge, a bit too optimistically. Rockwell ignored the deadline for his book much as he ignored any deadline that did not pertain to his *Post* covers. In a letter to Rockwell in November, McCormick nudged: "How does it go with the patent word machine? I visualize you with a brush in one hand and a microphone in the other—I do hope the sound inscriber hasn't turned into a sound torture machine."[1] Six months later, Rockwell still had not turned on the Dictaphone. His editor thought a ghostwriter was needed and signed on Hawthorne Daniel, who had written some old-style biographies of explorers and seafarers, and who spent the first two weeks of July 1958 interviewing Rockwell at his home in Stockbridge. But Rockwell found it discomfiting to confide his life story to a relative stranger, and Daniel was ditched in short order. "Thank you for being a gentleman and understanding our position," McCormick wrote to the dismissed biographer.[2]

Instead, Tom Rockwell, the writer in the family, was brought in to cowrite his father's book. Tom was then twenty-five and working as an

editorial assistant at *Flower Grower* magazine. He was glad to have a job at least nominally related to writing. He and his wife, Gail, lived in a reno-vated barn in Poughkeepsie, New York, about an hour and a half from Stockbridge. They would drive up on weekends so that Tom could inter-view his father, whom he found entertaining if not quite credible as he sat at the kitchen table, recounting a lifetime's worth of anecdotes. As Tom put it, "His memory was the Norman Rockwell version of his life."[3]

In place of introspection, Rockwell narrated his adventures with a folksiness that was perhaps meant to recall Mark Twain or one of the fiction writers at the *Post*, like Ring Lardner. He wanted his book to be a pageant of Americana, with childhood gangs, boardinghouses, and Model T's. He takes us through Prohibition, the two world wars, McKinley and all the other presidents.

Rockwell was loath to reminiscence about the more personal aspects of his past. "He said hardly anything about his relationship with his par-ents," Tom recalled later. "It was sort of startling. I had to push to get even what is in there." Indeed, his loyal son, who spent countless hours listening to his anecdotes, chuckling at his jokes and writing it all up without delay, was about as much family as he could take.

•

On Friday night, February 6, 1959, Rockwell was interviewed on Edward R. Murrow's *Person to Person*, a hit television talk show that invited viewers into the well-appointed living rooms of the famous, nearly all of whom chose to appear on their upholstered chintz sofas, in front of floor-length floral drapes. *Person to Person* was criticized in its time as too lightweight for a news-man of Murrow's depth and his interview with Rockwell was indeed fluffy.[4]

The excitement began the day before the telecast, when CBS sent a twenty-five-man crew up to Stockbridge along with truckloads of equip-ment. A large van containing five cameras was parked in Rockwell's yard and would serve as a makeshift control booth during the show. Murrow, as always, remained in his Manhattan studio—his custom was to appear on camera sinking into a comfy armchair, leisurely "visiting" his guests by chat-ting them up long-distance, starting at 10:30 p.m. He smoked throughout the show, favoring Kent, "with its full filter action," as the commercials boasted.

The first guest that evening was Fidel Castro, who along with his rebels had overthrown the Batista government only a month earlier. Dressed in his pajamas, with a straggly beard, Castro stared cockily at the

camera. Then came the feature on Rockwell, which lasted for eleven minutes and implicitly reassured viewers that no one was about to topple the machinery of American democracy, not least because the streets were quiet and devoid of Communists. The black-and-white segment opened with a long shot of Main Street in Stockbridge, which looked poetically deserted, the bare tree branches casting shadows on the empty sidewalks. The road was encrusted with snow, and the rows of windows at the Red Lion Inn, which had closed for the winter, were dark.

Soon viewers could see Rockwell in his library, an attractive, well-lighted room filled with bookshelves and antique American furniture. His framed reproduction of Pieter Bruegel's *The Peasant Dance* had been moved for the occasion out of his studio and into the library, as if to reiterate his regard for the European masters. In addition to Rockwell and Mary, their son Tom appeared on the show, joshing with his father and giving the impression that the normal tone of their family conversations was one of intense affection and wit.

Tom, as Murrow informs viewers, "is helping Pop with his autobiography."

"It's going to be a long one because he is sixty-five," jokes Tom. Rockwell, who is wearing a jacket and striped bow tie, fake scolds: "Did you have to tell?"

"Good evening, Mr. Murrow," Mary says in a soft voice, looking a bit heavy as she sits in a wing chair. Her reticence emphasizes her husband's volubility.

The idea here seemed to be to talk about the house.

"I think the house is prerevolutionary," Rockwell volunteers. "They tell us Aaron Burr lived here. I don't know if that is much of a distinction inasmuch as he was the man who killed Alexander Hamilton."

Then he goes outside and walks along the short path to the studio. Inside, the wooden floors are polished to a high gleam and paintings and sketches from different periods of his life lean against the white walls.

When asked by Murrow how he spent his evenings, he gave the most clumsily personal answer. He confessed to spending countless hours tearing bolts of diaper cloth into paint rags. "We use a lot of rags to wipe the paint off with," he explained. "I use this diaper cloth. It's a wonderful cloth. It's not only absorbent, but it doesn't go through."

Murrow replied, "But I'm sure you're eager to get back to doing it right now!" And that was the end of the interview.

Three weeks after the show, a humorous "Talk of the Town" item in *The New Yorker* reported that the Aaron Burr Association had taken offense at Rockwell's televised comments. Rockwell received a thick packet of information from the group, "whose members are dedicated to revising upward the generally low opinion in which our third vice-president is held."[5]

The show also generated what might be called the Rockwell-Nabokov mystery, which continues unabated. At one point during the interview, Murrow asked: "Who's your friend there beside you?" He was referring to a long-limbed dog curled up at one end of the Victorian couch. "We call her Lolito—Lolita," Rockwell replied, correcting himself, in a moment of televised gender confusion.

None of his children recall a dog named Lolita. What led him to summon up Vladimir Nabokov's nymphet? Surely he had read his novel *Pnin*, which includes many clever asides on modern art, including this one: "Dali is really Norman Rockwell's twin brother kidnapped by gypsies in babyhood."[6] What was intended as a put-down of Salvador Dalí is also an implicit elevation of Rockwell, whom Nabokov, in a brilliant if acidic insight, viewed as the equal of Dalí. They both used a style of impeccable realism to render imaginary worlds—be it the hypersexual fantasies of Surrealism or Rockwell's desexed Americana.

And surely he had read *Lolita*, or read about it. It had been published in the United States the previous summer and generated a firestorm of controversy. Apparently, it inspired Rockwell to nickname a dog after Nabokov's twelve-year-old seductress. He didn't appear to be joking. In a way Rockwell was Humbert Humbert's discreet and careful twin brother, roused by the beauty of children but (thankfully) more repressed.

•

In the summer of 1959 the house in Stockbridge filled up once again with visitors. Peter arrived in mid-June with Cinnie, who was pregnant with their first child. He had just completed a year at the Pennsylvania Academy of Fine Arts and was still passionate about sculpture. "My hero was Donatello," he recalled, adding that he rented a studio in Stockbridge that summer and continued his work in clay.

Mary was gracious to her daughter-in-law and appreciative of her company. The two women could often be found in the kitchen, the sun flooding through the curtained windows as they read the local news in *The Berkshire Eagle* and talked. Cinnie smoked Viceroys and Mary had

switched to Pall Malls. "We talked about the coming baby," Cinnie re-
called. "Mary was loving and permissive. I had this feeling that she
wished me well, as in, you should do your thing."[7]

Cinnie knew not to expect too much of her mother-in-law, who avoided
the subject of her personal problems but could not completely conceal
them, either. "There were times when you could tell she was fragile," she
recalled. "Toward the end she developed this funny thing where her
tongue was moving about of its own accord, as if she didn't have control.
The speech was slightly slurred." Her family assumed the dragging words
were a side effect of too many drugs. She had been using sleeping pills
(Seconal) for years and they had taken their toll.

At lunchtime, Rockwell would promptly appear in the kitchen door-
way, creating a certain tension as the women turned their attention to
him. Mrs. Bracknell, a cheerful, snowy-haired woman in her seventies,
came in every day to cook for the family when they moved to Stockbridge.
In addition to steak, roast beef, and lamb chops, her repertory included
Yorkshire pudding, which Rockwell described as "a marvel—soft on the
inside, crisp on the outside." Those recipes were reserved for dinner, over
which Rockwell was likely to recount amusing stories and needle his son
Peter as if he were still a schoolboy. Later, after the dishes were cleared
and put back in the cabinets, Mary would drive Mrs. Bracknell home.

•

For most of that summer, Rockwell had been working on a single cover for
the *Post*, his clever and intricate *Family Tree*, in which twenty-three small,
bouncy heads chart a fictional American family over three centuries. The
tree starts chronologically at the bottom of the page with "a good, strong
pirate head right out of Howard Pyle," as Rockwell described it.[8] It mean-
ders through several generations of long-gone relatives in bonnets and
tricorn hats, and ends in the glorious present with a nine-year-old boy
(born 1950) grinning at the top of the heap.

Rockwell decided to make the last chapter of his autobiography a
diary of a painting in progress. He would record his *Family Tree*. It is under-
standable that he wanted to draw attention to his process. Fashionable
opinion in the fifties held that a picture was not just something to hang on
a wall but a record of a performance, "an arena in which to act," as Har-
old Rosenberg famously wrote. Magazine feature articles about Willem
de Kooning, Franz Kline, and their Abstract Expressionist ilk inevitably

dwelled on the angst of creation. In that department, the department of doubt, Rockwell could compete with the best of them.

He started his diary on April 27, 1959, and the tone is one of constructive misery as he attempts to generate an idea for a new work. Three days later, he still hasn't found one. "Groped around awhile. Found nothing. No ideas, not even a glimmer of one. Gave it up early and tore some paint rags from a bale of diaper cloth to distract myself."[9]

Through that summer of 1959, Rockwell spoke into a Dictaphone every few days—this was the form his diary took. His comments were transcribed by his son, who picked out short, salient excerpts for the autobiography. The Dictaphone recordings run to more than eight hours and provide a valuable glimpse into Rockwell's creative rhythms. They amount to a badinage with himself, in which he describes, only half-jokingly, how the sense of possibility he feels every morning is overtaken by regret and discouragement by the day's end. So many afternoons seemed to end the same way: He laments that he did not "get anywhere with the picture." He couldn't solve this pictorial problem or that, often one having something to do with the correct proportions of a figure or an object.

He usually recorded his comments in the evening, after dinner, sitting alone in his studio with his Dictaphone recorder. He found it easy to speak without notes. When he signed off, he might say, "Good night, my friend," or "I will bore you no longer. Good night all."[10] Or, if he was feeling playful, he might sign off on hot summer nights by saying, "Merry Christmas, my friends."

The recordings reveal, among other things, the degree to which Rockwell depended on "my dear friend" and "my great counselor" Erik Erikson to help him think through a particular painting. Erikson's early training as an artist made him a perfect sounding board for Rockwell. During this period, their sessions were held away from Austen Riggs, in Rockwell's studio. And their conversations sounded less like a session of traditional psychotherapy than an art-school crit.

Typically, speaking into a Dictaphone on July 25, a Saturday, Rockwell mentioned that Erikson dropped by the studio at ten that morning to push their scheduled eleven a.m. appointment back by one hour. Then Erikson returned at 12:20, prompting Rockwell to joke about his therapist's chronic lateness. For the duration of their fifty-minute session, the two men contemplated *Family Tree* and talked about specific problems Rockwell was having with it. Erikson had suggested in a previous meeting

that Rockwell reduce the size of the tree and Rockwell now showed him the results. "It doesn't obtrude," Rockwell was pleased to note, referring to the tree. "It doesn't look as if these heads are hanging on a live tree. Now it looks like they're more or less on a document,"[11] a piece of old parchment.

Rockwell's conversation with Erikson that day also covered more general problems. As Rockwell recalled: "I ask him, What is it anyway? Why do I have all this trouble with these pictures? He's very comforting. He says just what I want him to say. He says, Well, that's the way it is. You want to be an artist? You have to suffer like this." Rockwell concluded: "This is the old crap, but I guess it's true."[12]

By August, four months after he started the picture, Rockwell wasn't sure whether *Family Tree* was finished or not, an inevitable coda to his every composition. Mary had been through this too many times to give much weight to his reservations. "Norman," she told him, "Wrap up the picture. You're being silly." Ernie Hall, who ran the local taxi service and was at times enlisted to deliver finished paintings to the Curtis Building in Philadelphia, was summoned to Rockwell's studio. This was on August 19, 1959, at ten in the evening. The autobiography ends there, on that night. In a conspicuous omission, there is no reference to the tragedy that befell the Rockwell family six days later.

•

August 25 fell on a Tuesday, a day reserved for meetings and routines. In the morning, Rockwell was visited by his longtime bookkeeper, Chris Schafer, who, as usual, sat at the desk in the studio and calmly sifted through piles of bills. At noon, Rockwell and Schafer drove to Lee to have lunch with fellow members of the Marching and Chowder Society. When Rockwell returned from lunch, his daughter-in-law told him that Mary had been feeling unusually fatigued and had gone upstairs for a nap.

At 2:30, Mary received a phone call and Norman went upstairs to wake her. He saw her lying very still in their rumpled bed. He could not bring himself to look for more than a few seconds. He went downstairs. Cinnie, who was six months pregnant, was in the kitchen.

"I think there is something wrong," he told her, and he asked Cinnie to go back upstairs with him.[13]

"Mary looked as if she was asleep, but very thoroughly asleep," Cinnie recalled years later. "She was so still. She didn't seem wake-up-able. We

both kind of knew. He was flustered, not really knowing what was going on, fearing the worst. We called the doctor, and he came right over."

•

On her death certificate, the cause of death is listed as "coronary heart disease." That was the official explanation that was furnished to the locals in Stockbridge and the interested parties in the wider world: Mary Barstow Rockwell had suffered a heart attack at the age of fifty-one, dying peacefully in her sleep.

Friends wondered whether she had taken her own life. "We never knew the cause of her death," wrote her friend and neighbor Helen Morgan. "It was obviously unexpected, and whether she had taken an overdose of some medication or whether her heart had just stopped, we never knew."[14] At Rockwell's request, no autopsy was performed; the quantity of drugs in her bloodstream at the end remains unknown.

Suicide was not out of the question. In the past, she had taken at least two overdoses and been sent off to psychiatric hospitals. At the time of her death, however, Mary was on the wagon and her family believed that she was feeling better, looking forward to the birth of her first grandchild.

In a letter to Rockwell, Mary's kid sister contemplated the possibility of an overdose. "You know, Norm," she assured him, "even if an autopsy had shown that Mary had taken an overdose of sleeping pills, nothing could have convinced me that it happened in any way but by accident . . . Nothing could be easier than to take too much by accident, when already doped up."[15]

Her sons felt that their mother's death was almost certainly natural and that it was terribly unfair. It occurred at a time when blessings were piled up around her.

•

Sympathy letters poured in, including one from Mary's therapist, Dr. Margaret Brenman-Gibson, who at the time was away on vacation. "I wept when I heard of Mary's death and thought then for several days of her valiance," she wrote to Rockwell. "I thought too of the pleasant phone conversation she and I had had the week before when she told me a little of the development in her painting."[16]

Rockwell, who was then sixty-five, spoke little about his wife in the weeks and months following her death, perhaps because he was generally

unable to talk about death. After three turbulent decades of marriage, Mary had been eradicated from his life without warning, without even time to say goodbye. She went upstairs after lunch and never came down for dinner. "He didn't talk about his feelings," recalled his son Peter. "He did some of his best work during that period. He did some fabulous paintings. I think we were all relieved by her death."

If he was unable to articulate a sense of loss, he did make a charitable gesture in his wife's memory. Before the year was out, he donated one thousand dollars to the Stockbridge Public Library for the purchase of children's books.

He drew a lovely pencil-and-ink sketch of Mary and arranged for it to run as the dedication page of his soon-to-be-published autobiography. The drawing shows her in profile, a graceful woman in a buttoned white blouse, her hair pinned up. She turns her back toward the viewer, as if turning away from the demands of the world and into a cocoon of solitude. She appears to be around forty, a slender and youthful version of her later self. He based the drawing on a set of photographs that had been taken of her in 1948, when she posed for *The Gossips*.

By mid-September he had submitted the drawing to Doubleday, just as the book was going to press. It would appear on an otherwise blank page, framed in a rectangle of powder blue, above a line of appreciative prose: "To Mary, whose loving help has meant so much to me."

The dedication is a bit misleading. It does not acknowledge the fact of Mary's death; it does not say "in memory of." In coming months, the thousands of readers who picked up Rockwell's brand-new autobiography—a substantial work running more than four hundred pages—would have no reason to doubt that Mary was anywhere but at home in her kitchen in Stockbridge, chuckling at her husband's droll anecdotes and offering her "loving help," as always.

# WIDOWHOOD, OR *THE GOLDEN RULE*

## (1960)

In the autumn of 1959 Rockwell settled into the life of a widower. But *settled* is not the right word. *Unsettled* is closer. For all his misgivings about family life, he was reluctant to be alone in his drafty Colonial house in Stockbridge and asked people to stay with him. His son, Tom, and Tom's wife, Gail, remained until the end of October, sleeping in the guest bedroom, across the hall from his. Tom was helping him make the final corrections on the proofs of his soon-to-be published autobiography.

In the process, Rockwell grew closer to his son and shared confidences that sometimes seemed overly personal. He liked to report on what had transpired in his therapy sessions, as if his conversations with Erikson were of universal interest and his children were expected to receive them attentively. Tom was surprised when his father complained that Erikson confiscated a pistol he had purchased in the interest of keeping Rockwell from visiting harm upon himself. "I'm so mad at Erik," he used to say. "He took my gun and won't give it back." Tom couldn't tell if he was joking or not.

Once, during one of Rockwell's therapy sessions at Austen Riggs, Erikson glanced out the window and commented neutrally that someone they knew was walking by. That, too, became fodder for a joke. "When I talk to Erik," Rockwell would lament, "he is always looking out the window."

Rockwell very much liked his daughter-in-law, the former Gail Sudler, a distinctly beautiful artist with green eyes, porcelain skin, and light brown hair cut in a pageboy style. During this period, she took over the

job of running the household and helped Rockwell in the studio as well. He painted a portrait of her that ran in the *Post*, to illustrate a sexy short story called "Another Man's Wife."[1] She wondered if Rockwell had a crush on her, a perverse desire to steal her away from his son. Once, when he spotted her silk slippers in the hallway, lined up neatly outside the bathroom, he mentioned "how cute"[2] they looked. Soon after, he asked her to marry him and she considered it for at least ten minutes before declining.

Anxious about Tom and Gail's departure, Rockwell imagined having a family board with him. In short order, he converted a space on the second floor of his house into a two-bedroom apartment. It required that he empty out Mary's former studio, the large room over the garage, which became the central room of the unfurnished apartment. A small kitchen was built and outdoor stairs were constructed to provide an entrance from the yard.

Rockwell asked Dr. Knight to offer the apartment to one of the young doctors at Austen Riggs. A family moved in almost immediately. "I've fixed up the rear of the house as an apartment and a Dr. and Mrs. Philip are occupying it," Rockwell wrote to Clyde Forsythe.[3] "I'm just no good at living alone in this big house."

His new boarder was Anthony F. Philip, who had moved to Stockbridge to continue his training at Riggs. A soft-spoken man of thirty-two, he was, officially, a postdoctoral fellow in clinical psychology. (He later became the director of counseling services at Columbia University.) He and his wife and two young daughters would stay in Rockwell's house for three years. Although the artist had them sign a lease (rent: sixty-five dollars a month), what he sought from the arrangement was hardly financial. He desired to have an emissary from the field of psychology sleeping in the bedroom down the hall from his, available should he find himself, in the middle of the night, in need of rescue. Rescue from what, exactly? An accidental fire, a heart attack, his own agitated thoughts—it hardly mattered. "He didn't want to be alone," Dr. Philip recalled. "He felt shaky and it made him feel better to have someone from Riggs around. It was somehow reassuring for him."[4]

Dr. Philip came to see Rockwell as an extremely sympathetic and complicated man. In the beginning, Rockwell would sometimes come upstairs to have tea with him and his family. Dr. Philip had heard on the grapevine that his wife had been a handful, had shuffled along Main Street reeking of whiskey and cigarettes. He imagined what he must have endured and did not hold Rockwell accountable. "I was at Riggs and I heard about

Mary Rockwell," he later recalled. "I don't think it was a direct suicide, but she was depressed, and sometimes people just want to die."

Despite his genial exterior, Rockwell, the doctor could see, was a panicky man who demanded a lot of himself not only as an artist but even in his relatively unimportant obligations as a landlord. Once when Dr. Philip mentioned that the stairs to his apartment were slippery, Rockwell arranged for them to be covered in outdoor carpeting by the end of the day. Another time, a new clothing dryer arrived with similarly confounding speed. "He was a very compulsive guy, very organized. Everything had to be in its place. He had an obsessive-compulsive character style."

Asked if Rockwell was obsessive-compulsive in medical terms, the doctor replied, "As a style, I don't mean as a disorder. They key thing is control. People who are obsessive want to be in control of themselves and their impulses."

In later years, when Dr. Philip thought of Rockwell, the same picture always came to mind. He thought of him on the phone in his studio arranging to have someone come help him with one thing or another. "He paid people well to do things," Dr. Philip recalled. " He wanted someone he could depend on."

He certainly had a good deal of help. In addition to his twice-a-week sessions with Erikson, he had Mrs. Bracknell to cook his meals. Chris Schafer still drove down from Vermont on Tuesdays to sift through Rockwell's bills and get his books in order. Louie Lamone came in on weekends to stretch canvases and build sets and move stuff around. Bill Scovill, the clinically depressed photographer, had been joined by Clemens Kalischer, a German-Jewish émigré and accomplished photojournalist. While Scovill was a quiet man who lived alone, collected camera equipment and claimed to be afraid of taking trips, Kalischer had worked all over the world. He, too, became accustomed to answering his home phone and hearing a male voice inquire, "Are you free? Can you come over?"

Kalischer later recalled Rockwell as "a limited man" who seemed terrified of touching pencil to paper without having a black-and-white photograph to consult. "He had very good art books," Kalischer recalled. "Once, he took out a book of Flemish paintings and said to me, 'Can you make a photograph of one foot?' "[5] Kalischer was puzzled by Rockwell's request, his desire to draw a foot only from the greatest possible remove.

•

In February 1960 Rockwell's autobiography, *Norman Rockwell: My Adventures as an Illustrator,* was published in hardcover by Doubleday—price, $4.95. It was a new decade, and the senator from Massachusetts, John F. Kennedy, had just announced his bid for the presidency, but in many ways the fifties remained intact. For starters, Eisenhower was still in the White House and he sent Rockwell a personal note the day he received *My Adventures as an Illustrator.* "While I have not yet had an opportunity to more than glance at the book," the president wittily wrote, "I understand, with some regret, that I have been indirectly at least responsible for several of your memorable experiences with pills of one sort or another."[6] He was referring to the now-famous incident when Rockwell's last Dexamyl disappeared down the hotel-sink drain.

*My Adventures as an Illustrator* struck a modest tone, starting with its title, which made it clear that Rockwell did not think of himself as an artist with a capital *A* or even an artist with a lowercase *a.* No, he was an illustrator, preferring to link himself in his book and in his insecure mind with a history of American illustrators that went back to Howard Pyle and his swashbuckling pirates.

The reviews of the book were mixed, at best, and reflected probably less on Rockwell than on an era in which abstract art was still believed to be more emotionally authentic than realism. Phoebe-Lou Adams of *The Atlantic Monthly* found the book "good-humored" and "clever," but was disappointed that Rockwell did not expose more of himself and his creative agonies.[7] The harshest review was by Benjamin DeMott, who, writing in *The Nation,* branded Rockwell an apologist for capitalism. Forcing Rockwell's career into a Marxist frame, DeMott charged that the artist's subjects—working-class people in plain, thrifty-looking settings—were designed expressly to distract Americans from the reality of their growing affluence and provide "a device to quiet their guilt."[8]

Under instructions from editor Ben Hibbs, *The Saturday Evening Post* gave the book a generous launch by serializing it in eight installments that kept it on the minds of readers through the spring. The first excerpt, on February 13, 1960, came with a wonderful cover illustration: *Triple Self-Portrait* (see frontispiece), a triumph of self-burlesque in which Rockwell portrays himself in the midst of painting his self-portrait and taking liberties with the truth.

Although the artist is shown from the back, at his easel, his anxiety is conveyed with full frontal force. His black socks are falling down. A glass

of Coke tips precariously on an open art book whose bookmark-studded pages attest to the hours spent searching other artists' work for ideas. Post-card reproductions of four master self-portraits—a Dürer, a Rembrandt, a van Gogh, a Picasso—are tacked in a vertical row along the right edge of his canvas, contrasting the lofty accomplishments of the European past to his limited American self, an identity indicated by the gilded bald eagle crowning his reflection in the mirror. (In reality, the mirror in Rockwell's studio was eagle-less.)

The joke lies in the comical perfection of the self-portrait resting on his easel. The artist has cast himself, in the easel self-portrait, as a self-possessed prince of the studio. His glasses are gone, and his expression is one of manly self-control and suaveness. He projects an absence of fear. Even his pipe seems more assured, rising from its once-dangling position into an erect horizontal. *Triple Self-Portrait* deserves to be seen as the artist's manifesto. His "realism," he is saying, has nothing to do with the reflection in the mirror. Art is not a mirrored version of reality. It is an invention, an idealization, a willful falsification. What makes *Triple Self-Portrait* so winning is that Rockwell outs himself as a maker of illusions, allowing the viewer to feel superior by seeing through his act of deceit.

Tellingly, the lenses of the artist's glasses are opaque—he can't see out. In his visually incapacitated state, he debunks his own supposed powers of vision; he declines to embrace the popular myth of artists as heroic seers.

•

What was perhaps the most disturbing attack on Rockwell appeared in April 1960, just as the *Post* was about to run the last of the eight parts of his autobiography. Dwight Macdonald's now-famous essay, "Masscult and Midcult," was published in two parts in *Partisan Review*, the influential literary magazine. The essay, as the critic Louis Menand notes, "was not Macdonald at his most coherent or persuasive,"[9] but it tends to be reissued and anthologized at regular intervals, perhaps out of nostalgia for an era when intellectuals were public figures who could afford to live in Manhattan.

Briefly: Macdonald's takedown of Rockwell came in the context of a sweeping denunciation of mass culture, which he believed contaminated the air around it. He refused to consider the possibility that a painting made for a wide audience might reflect artistic impulses. Moreover, he was the type of critic who would burn most anything to fuel an argument and he uses even Rockwell's artistic sincerity against him. "There seem to

be two main conditions for the successful production of *Kitsch*," he writes. "One is that the producer must believe in what he is doing. A good example is Norman Rockwell."[10]

As many critics have since pointed out, Macdonald's article is reminiscent of Clement Greenberg's "Avant-Garde and Kitsch," which had appeared in *Partisan Review* a generation earlier and similarly argued that culture is an elite affair reserved for the happy few. While Greenberg divides culture into opposing halves (high and low) and emphasizes the unbridgeable distance between them, Macdonald focuses more on the spongy, everyone-onto-the-bus center—that is, middlebrow culture, or midcult as he called it, which he believes is wrecking cultural values.[11]

Astoundingly, Macdonald initially wrote the article, in a shorter form, for *The Saturday Evening Post*. The magazine killed the piece over an editorial disagreement.[12] The problem was that editor Ben Hibbs felt it was unfair for Macdonald to criticize *The Atlantic Monthly* and *Harper's Magazine* in his article as examples of middlebrow magazines without mentioning *The New Yorker*, where Macdonald was a staff writer and maintained an office. Asked to consider including *The New Yorker*, Macdonald declined.[13]

Once he realized his article would be killed, Macdonald asked to be paid for it in full—$2,500. But he received only the kill fee, $1,000. On November 9 he composed several drafts of a long, grieved letter to Ben Hibbs: "I've waited a week to write this letter, not wanting to trust the heat of the moment. But I still feel ill-used."[14] Claiming he was capable of assessing *The New Yorker* despite his status as a staff writer, he charged that "the Post and not I is at fault and the Post owes me $1,500."

Journalists, as everyone knows, are supposed to avoid conflicts of interest, as well as the appearance of conflict. A critic who goes to great lengths to demolish the star illustrator at a magazine that killed his story and declined to issue a check for $1,500 he thought he was owed—this is a critic who has a conflict.

But even if one were to give Macdonald the benefit of the doubt and assume that his opinions of Rockwell's work were based on nothing besides the pure force of his taste and reasoning, his article is tainted by outlandish snobbishness. His pronouncements are sour and unkind. He is too much concerned with classification and categorization, and not enough with the pleasures of looking.

•

In the summer of 1960, almost a year after Mary's death, Rockwell began dating Peggy Worthington Best, an artist herself and an old family friend. An attractive and charismatic divorcée in her late fifties, with dark hair and large glasses, she owned the Peggy Best Studio and Gallery. It occupied the ground floor of a light-blue clapboard house on Pine Street and its commodious front room served as the site of both art classes and exhibitions of contemporary art. The gallery also had a little alcove where visitors could sit and browse through exhibition catalogs and oversize art books and it was the closest thing Stockbridge had to an art school.

Peggy Best had initially moved to Stockbridge with her two children in 1949, after separating from her husband, the editor Marshall Best. She was hired by Austen Riggs to start an art program. A warm, well-read woman whose searching ways led her to convert to Catholicism,[15] she quickly befriended Mary Rockwell, among other patients. In May 1957, when Peggy opened her own studio-gallery and offered her first sketch class—which was not a class so much as a casual gathering where everyone drew from a (clothed) model seated in the center of the room—both Mary and Rockwell attended.[16] "I go to Peggy Best's class on Wednesday afternoon," Rockwell had announced to the entire nation when he appeared on Edward R. Murrow's *Person to Person* in 1959. The statement brought her so much attention she had to hang curtains and close them when Rockwell was on the premises.

Once he became a widower, Rockwell's relationship with Peggy Best changed. As most everyone in Stockbridge was aware, he was "the most eligible bachelor in town," and Peggy was his most persistent female admirer. She frequently had him to dinner, and she enlisted his participation in various art projects around town. That summer, in addition to the show at her gallery—an impressive array of works by David Park, Joan Brown, and other Bay Area figurative painters—she organized an exhibition of local artists for the upstairs lobby of the Berkshire Playhouse. Rockwell gladly lent her a painting.

Peggy's two children found Rockwell to be a "very, very sweet man with a twinkle in his eye."[17] Once, he took Peggy and her sixteen-year-old son, Jonathan, out for a fancy lunch at the Morgan House in Lenox. "It was the first time I ever ate a whole lobster," Jonathan Best recalled, "bib and all, and he very patiently showed me how to go about it."[18]

Rockwell still attended her sketching class, favoring a morning class that met on Thursdays.[19] At this point one might reasonably wonder why

a gifted illustrator with decades of work behind him would attend an ama-
teur sketch class. Rockwell's explanation was that he wanted to try work-
ing without photographs. He wanted to draw in a freer style, to sacrifice
his tightly bound, detail-stuffed surfaces to a looser, hairier, scribbly way
with the pencil. Erikson, at Rockwell's recommendation, attended a few
of the classes as well. Once, as a joke, Rockwell dashed off a painting en-
titled *Nymph*, in which Erikson, squeezed into the space behind a young
woman's shoulder, grins maniacally and appears quite deranged.[20]

•

The summer of 1960 arrived and he had more work than usual. On the
morning of June 11, a month before the Democratic National Convention
anointed Senator John F. Kennedy as its nominee, Rockwell arrived at
the Kennedy compound in Hyannis Port, on the opposite side of Massa-
chusetts. In recounting the visit, Rockwell always mentioned that Ken-
nedy was ambling around upstairs in his pajamas when he arrived. The
senator called down to Rockwell and his photographer to make them-
selves comfortable. At the time, political observers were concerned that
Kennedy, at forty-three, was too young to seek the office of the presidency.
He implored Rockwell, in his portrait for the cover of the *Post*, to make
him look "at least" his age.[21] Between sittings, Rockwell and the senator
strolled to the dock to see Kennedy's boat. It was a memorable two hours
and Rockwell was charmed by the senator, believing there was already a
golden aura about him.

Rockwell had met with the Republican nominee, Vice President Rich-
ard Nixon, the previous February 25, arranging to see him in the then-new
Senate Office Building in Washington. As much as he admired President
Eisenhower, Rockwell did not care for his vice president, who, despite his
self-professed centrism, was immoderate in his political tactics and had
already been dubbed Tricky Dick. It bothered Rockwell that the ever-
conservative editorial board of *The Saturday Evening Post* planned to endorse
Nixon for president and it is telling that the *Post* photographer who accom-
panied Rockwell on the photo shoot that day—Ollie Atkins—would wind
up, a decade later, as the official White House photographer during the
Nixon administration.

In those days, Rockwell, much like any journalist, was obliged to strive
for impartiality in his portraits of politicians. In his studio, he worked on
the portraits of Senator Kennedy and Vice President Nixon side by side,

scrupulously avoiding any hint of his political preferences by making collars, coats, ties, and backgrounds almost identical. He made sure that neither candidate flashed a millimeter more of a smile than the other. And he endowed both men with a wide, determined jaw. It was tedious work, not least because Nixon's face posed unique challenges. As Peter Rockwell recalled, "My father said the problem with doing Nixon is that if you make him look nice, he doesn't look like Nixon anymore."[22] Rockwell declined to tell his sons whom he planned to vote for. But he did disclose his choice after he officially left the *Post*. In 1963 he described himself to a reporter from *Pageant* magazine as a "moderate Republican who voted for Kennedy."

•

He wanted to do something large, something lit with social significance. Something in keeping with the spirit of the New Frontier that Kennedy had laid out in his acceptance speech at the Democratic convention in July. On August 19, 1960, after finishing the two presidential candidates' portraits and having them driven down to Philadelphia, Rockwell began work on *The Golden Rule*, which would occupy him for five months. It is, in many ways, a turning-point picture, the moment when he became intent on making art that carried an overt liberal message.

The painting might be seen as a tribute to Erikson, who himself was an intermittent scholar of comparative religion and had already published his *Young Man Luther*. Moreover, Erikson was a neighbor and friend of the celebrated theologian Reinhold Niebuhr, one of his patients. For Erikson, who was more socially minded than most psychoanalysts, the quest for identity was not limited to the pursuit of your individual goals. It also required that you acknowledge the rest of the human race. In his essays, he championed the Golden Rule—"Do unto others as you would have them do unto you"—as if it represented not just a biblical injunction but a revolutionary new concept. He felt "the rule," as he called it, was underappreciated, that "students of ethics often indicate a certain disdain for this all-too-primitive ancestor of more logical principles."[23] Yet he believed it was as useful as any social doctrine in trying to defuse tensions between nations and foster "a more inclusive human identity."[24]

This is the implicit theme of Rockwell's *The Golden Rule*, a paean to multiculturalism, or what was called circa 1960, with similar vagueness, humanitarianism. The painting is a love-thy-neighbor manifesto in paint.

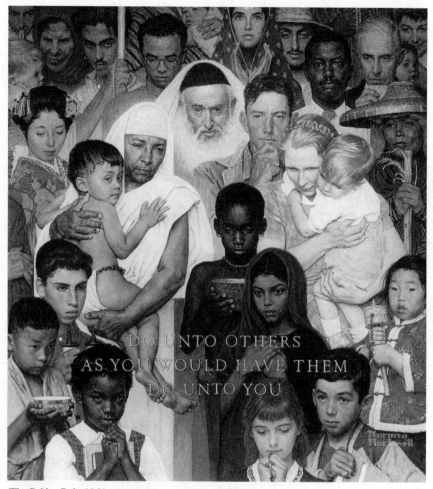

*The Golden Rule,* 1961 (Norman Rockwell Museum, Stockbridge, Massachusetts)

(Many people know it through the mosaic copy displayed at the United Nations headquarters in New York.[25]) It consists of a tightly packed field of twenty-eight overlapping faces and torsos belonging to people of different religions and nations. A Chinese laborer in a bamboo hat, an Egyptian mother sheathed in white cotton, a Catholic schoolgirl with shiny red bangs who is clutching a cross and rosary beads to her pale chin—the people of the world have been brought together to share a moment of prayer.

In the upper right corner, Mary Rockwell makes a cameo appearance. She is shown holding a cherubic infant: Geoffrey, her first grandson, born a few months after her death.

Rockwell's best paintings draw you in with their minute particulars and storytelling force, but *The Golden Rule* is not a story. It's a painted slogan. Still, it is easy to feel sympathetic when you see what the artist was trying to accomplish. He wanted to imbue his work with a sense of social importance. In explaining the origins of *The Golden Rule*, Rockwell once said, "I'd been reading up on comparative religion. The thing is that all major religions have the Golden Rule in common."

In assembling models for his painting, Rockwell enlisted his nonethnic neighbors in Stockbridge to pose as ethnic types. Note, for instance, the lean, elderly rabbi who comes complete with a snowy beard, black yarmulke, white tallis draped over his head, and lively brown eyes gazing from bony sockets. In real life, he was not a rabbi but the retired postmaster of Stockbridge: William Lawless, a Catholic who did not have a beard.

The rabbi, interestingly, is depicted as the senior figure in the painting. He is decades older than the people around him, and Rockwell has positioned him at the apex of a pyramid. Perhaps the rabbi was a stand-in for Erikson, who had been raised in a Jewish home and whose most noticeable feature was his corona of thick white hair. Erikson was the closest Rockwell, a nonbeliever, ever came to having a spiritual leader.

•

The Golden Rule may not sound very daring as far as personal philosophies go. But when it was published on the cover of the *Post*, *The Golden Rule* jarred many readers. In 1961 it was still controversial for a mainstream magazine to have blacks and whites mingling as social equals on a cover, not to mention in the traditionally all-white precincts of a Norman Rockwell painting. Of the twenty-eight figures in *The Golden Rule*, three are

black. A sweet African-American schoolgirl in a white blouse and plaid jumper, who appears to be about six years old and who glances up at the viewer from the lower left of the canvas, evokes the bitter battles over school desegregation. The theme would become central to Rockwell's work in coming years.

The inclusion of the little African-American girl would barely be noticed today, but it was received as pure provocation when the painting first appeared on the cover of the *Post*, on Easter Sunday, 1961. Letters fell into two opposing camps. "It should heal many sick segregationists," wrote Edward F. Kryter of Indianapolis. But nearly as many letters came from readers in the Deep South who felt rankled by what they saw as Rockwell's intrusive moralizing.

•

By now Erikson felt marooned in Stockbridge and eager to leave. His mother, Karla Abrahamsen, died in Israel in January 1960, an "overshadowing" event that drastically diminished his chance of learning his father's identity.[26] On some basic level, Erikson did not know who he was. He was thrown back into the thicket of questions that come from being an orphan, or at least a paternal orphan, and realized, in short order, that he wanted to rejoin an academic community. His professor friends at Harvard, led by the sociologist David Riesman, took up his cause but met with opposition. Some faculty members grumbled that Erikson was an intellectual celebrity unqualified to join their scholarly ranks. It was pointed out derisively that he had been too busy "wandering" Europe to go to college or get a PhD, and his most recent book, *Young Man Luther*, was not a volume of psychoanalytic theory but a speculative biography that reflected his penchant for hopscotching among disciplines. McGeorge Bundy, then dean of the Harvard faculty, worked out a clever compromise. He offered Erikson, whom he referred to as "a pleasant oddball,"[27] a special professorship outside of any academic department.

And so, in September 1960, Erikson arrived in Cambridge, a tall, distinguished figure padding around campus in his blue shirt, check-patterned jacket, and white moccasins. That first semester, the course he taught on the eight-stage life cycle, "Social Science 139," was swamped with more than a hundred undergraduates, many of whom assumed that his writings on adolescence and "the identity crisis" constituted an invitation to confide their own crises in him during his office hours. He felt harassed when

students walked up to him in Harvard Yard in hopes of discussing their childhood traumas and latest strange dreams and expected him to be receptive, to furnish them with on-the-spot Freudian insight. He sought to be a major thinker, not an insight machine.

When Erikson moved to Cambridge, a two-hour drive from Stockbridge on the opposite side of Massachusetts, he no longer was able to treat Rockwell. Although they would see each occasionally in coming years, their seven-year therapeutic relationship was, in effect, over. Rockwell was bereft. "He was very dependent on Erikson as a therapist," recalled Dr. Philip. "When Erikson left for Harvard, that was a big loss for him."

Before leaving, Erikson arranged for Rockwell to be treated by Dr. Edgerton Howard, the associate medical director of Riggs. He had treated Rockwell before, in 1957, filling in when Erikson was in Mexico writing *Young Man Luther*. Since then, Rockwell had relied on Dr. Howard for casual counsel. Once, when Rockwell was out bicycling and took a spill, he asked the police to summon Dr. Howard to his home. The police weren't sure why he wanted to see a psychiatrist as opposed to an orthopedic surgeon, but Dr. Howard was happy to oblige.[28]

When Dr. Howard first started seeing Rockwell, he asked Dr. Philip, the psychologist who rented the apartment in Rockwell's house, to provide additional therapy. "Ed is the one who asked me to do this, to see him at home at night," Dr. Philip recalled.[29] "Norman saw Ed during the day and this was something that was added to it because he was particularly upset. I was asked to see him on a supportive basis during this difficult period." Dr. Philip met with Rockwell in his house, after dinner, two or three times a week. "We would sit in there, in front of the fire, talking and it was good. It helped him."

What did they talk about? "In my conversations with him, he would talk about the day, his work, what was going on. I don't remember that women or children were presented as a problem." He recalled that Rockwell brooded about the difficulty he had finishing *The Golden Rule* and displayed hypochondriacal tendencies. "At one point he was seeing a doctor for some medical thing up in Pittsfield, Dr. Paddock, and he was talking about that. He was quite concerned about his health. His health was generally very good in reality, but he worried about it."

In November 1960 Rockwell was elected to the board of trustees of the Austen Riggs Center,[30] joining an unlikely group of heiresses and mental-health professionals. Although hardly in a position to donate large

sums of money to Riggs, he was eager to show his appreciation and of-
fered a wonderful gift: a suite of six charcoal portraits of the senior staff, to
be hung permanently in the lobby of Riggs. This required little effort or
input on the part of the six psychoanalysts, only that they drop by Rock-
well's studio at their leisure to pose for photographs and some quick
sketches.[31] Before beginning work on Erikson's portrait, Rockwell mailed
him a copy of the photograph he wanted to use, seeking his approval.
Erikson wrote back: "The picture you sent for the Riggs Gallery of Senile
Cases was as good as could be expected." However, he and his wife, Joan,
both lamented that the photograph was taken on a day when his left eye
was inflamed and wondered whether Rockwell could work around it.

Rockwell naturally obliged. The finished portrait shows Erikson in all
his Nordic glamour, a handsome man with thick white hair combed off
his high forehead. And flawless eyes.

# MEET MOLLY

## (1961)

A heavy snow had fallen on Washington the night before, making the city look fresh and squinty-bright as the new president appeared on the steps of the Capitol to take the oath of office. He was the image of political vigor, a man of forty-three who declined to wear an overcoat that day, his breath visible in the frigid air as he spoke about the change that was coming to America.

It was the first presidential inauguration to be broadcast on color television, but Rockwell, who had visited John F. Kennedy in Hyannis Port the previous June and painted a portrait of him for the *Post*, was not much of a television watcher. Instead, he listened to the inaugural address on the old Philco radio in his studio. However thrilling it was to be personally connected to an event of such epic significance, he could hardly expect the new administration to alter his day-to-day life. He was sixty-six years old, a widower living in a drafty house with his dog, Pitter, a beagle mix named for the city in which he was found, Pittsfield.

He kept to his usual routines that winter. Every morning around eight, he took two bottles of Coca-Cola from the refrigerator and crunched his way through his snowy yard to his studio. He broke for a sandwich at lunch and his daily oatmeal cookie. When he finished up his work day, it was earlier than usual, because daylight seemed to vanish in midafternoon, forcing him to stop. By the time he washed his brushes and his palette and swept the floor, he was surrounded by deep winter darkness.

On some days that January he felt like he saw no one but therapists. Dr. Anthony F. Philip, the clinical psychologist who had arrived a year

earlier, was still renting the apartment in his house. He continued to visit Rockwell at least one evening a week for a therapy session in front of the fireplace. And Erik Erikson had returned to Stockbridge for the holidays. He scheduled a few visits to Rockwell's studio, which must have counted as therapy sessions, if only because Rockwell paid him for his time; checkbook stubs indicate that Erikson's fee had risen from thirty-five to fifty dollars an hour.

A recurring theme of their conversation was Rockwell's displeasure with the *Post*. On January 8, after five months of near-continuous work on the crowded field of figures that comprise *The Golden Rule*, he had the painting driven to Philadelphia. But the *Post* let it languish for months, for reasons that remain unknown. Rockwell had nothing in the magazine in January or February or March, which made him feel invisible. *The Golden Rule* finally ran in the April 1 issue, supposedly in connection with Easter Sunday, but since the painting was intended as a call for religious and racial tolerance, the timing made no sense to him, except that by coincidence it was also April Fool's Day. Rockwell felt like the joke was on him.

He continued to see Peggy Best over that winter and into the spring, but the scene at her Studio Gallery on Pine Street had begun to grate on him. In addition to her daytime sketching sessions, she also hosted evening "slide parties," at which she projected images of museum masterpieces—Chinese bronzes, Rembrandts, Cézannes—onto the walls of her darkened gallery. The slide parties were by invitation only and tended to draw a crowd of local artists, most of whom worshiped Pollock and de Kooning and large-scale abstract painting, making Rockwell feel marginal.

Moreover, as he lingered in the gallery and watched Peggy smoking her Winstons and consorting with other artists, he saw how animated she became at parties and how large a role alcohol played in her life. Rockwell himself never had more than one drink at a time. A photograph from this period shows him milling about the gallery, listening politely to a middle-aged woman who appears to have cornered him. He is sipping a cup of hot tea.

People close to them became aware that Peggy Best seemed to depend on Rockwell more than he depended on her. "Unfortunately for my mother she began treating Norman as her strong right arm or rock in a storm," her son, Jonathan, later recalled. "I read a packet of notes they exchanged over this period. She was drinking a lot and not very stable and I am sure he did not want a repeat of the problems he had had with Mary."[1]

At the same time, he was developing feelings for Molly Punderson, a retired English teacher. He had signed up for her class, "Discovering Modern Poetry," after Erikson insisted he join a group and get out of the house. The poetry class had started the previous October and met on Monday nights at the Lenox Library.

The spring term started on March 6, 1961. Molly Punderson was then sixty-four, a year younger than Rockwell. Although she had inherited what her relatives termed derisively "the Punderson nose," she had clear blue eyes and a gaze that seemed exceptionally alert. She wore her white hair pinned up in a bun, with a stiffly lacquered curl on each side of her face. In June 1959, after thirty-nine years of teaching at the Girls' School of Milton Academy, she had retired and moved back to Stockbridge.

Molly knew a class clown when she saw one. "He was no great student," she recalled of Rockwell. "He skipped classes, made amusing remarks, and livened up the sessions."[2]

She was surprised that someone as famous as he was could be so free of self-importance. She could not have known that his mood, his way with people, could turn stone cold in a matter of seconds. For a widower, he struck her as uncommonly genial, buoyant even, with his barely repressed playfulness and ceaseless pipe smoking, which continued in her poetry class. As she stood in the front of the room posing earnest questions about T. S. Eliot's "Love Song of J. Alfred Prufrock," she tried not to be distracted by his fussing with the pipe.

From the beginning, he found her appealing, this older school teacher, wife of no one, mother of no one, disciplined memorizer of thousands of poems. He had always admired English teachers, admired their learning, their familiarity with novels he wished he had read. He admired women who could recite passages from Shakespeare from memory, as if in compensation for his own lack of reading or scholastic accomplishment. Molly Punderson was no doubt one of the best-read individuals in Stockbridge. She had majored in English at Radcliffe (class of 1919) and spent her junior year in England, which she considered life-changing.

Molly, obviously, had a good deal in common with Rockwell's deceased wife. Like Mary Rockwell, she harbored a passion for literature and occasionally wrote a poem herself, in daring free verse. But unlike Mary,

Molly was sturdy and self-contained, flinty in the classic New England manner. She was the sort of woman who was always deploring things with visible conviction, one whose ancestors had delivered fiery sermons in black Puritan garb. Her righteousness made her both likable and unlikable, depending on whom you asked. She was said to be popular at Milton Academy, where successive generations of Milton girls from established families who had first encountered the *Canterbury Tales* and *Hamlet* under her demanding tutelage spoke kindly of Miss Pundy, as everyone called her. She was well-versed in the modernists, too. Her favorite poet was T. S. Eliot and she felt honored to be teaching at the very prep school that young Tom had attended years earlier.

But within her own family, Molly commanded less admiration. She clashed frequently with her older brother and only sibling, Frank Punderson, a good-natured businessman who ran a coal and wood company in Springfield, Massachusetts. Molly disapproved of his (Republican) politics and the books he read. He and his wife, Beulah, had three children, and one Christmas when Aunt Molly made a rare appearance at their home, the children realized with crushing disappointment that she had arrived from the fashionable, shop-lined streets of Boston without a single gift— except for a bag of dusty, brown pine cones that she had collected on country walks. As she distributed the booty between her niece and two nephews, she cheerfully decried "the ugly display of commercialism under the Christmas tree."[3]

True, she made efforts toward her niece, Nancy Punderson. In the summer, when Molly was back in Stockbridge, she would invite Nancy to visit for a few days at a stretch. Even as a teenager, Nancy knew that Aunt Molly was not like other aunts. Here was a woman who, as if in defiance of the rules of auntdom, declined to bubble with affection and encouragement. "She was an Anglophile with a British accent, and she said I had such ordinary intelligence," Nancy recalled years later.

When it was time for Nancy to apply to college, Molly personally administered the SATs to her. "She gave me a 300 on the test," she recalled. Molly was qualified to grade the test because she had served for many years on the Committee of the College Entrance Examination Board,[4] which required her to attend meetings in Princeton, and come up with questions on grammar and vocabulary.

For their first date, Rockwell invited Molly to a play that had just

opened in Pittsfield. This occurred one evening in June, on the cusp of summer, after Molly's poetry-discussion group had ended for the season and Peggy Best had flown to Paris with her two teenage children. It had been arranged that Rockwell's son Peter would run Peggy's gallery in her absence. She planned to remain abroad all summer, leaving Rockwell free to court Molly without feeling like a traitor.

By October, he would be married again.

•

Molly is not known to have had any male suitors before she met Rockwell. Rather, her closest relationships were with two single women: Dorothy Kendall, who taught history at Milton; and Helen Rice, an accomplished violinist from Stockbridge. Her sense of being on her own, of being a woman without a man, had come early. "I was too shy or solemn or something to be socially any kind of light," she recalled of her childhood in Stockbridge. "I loved Sunday school, even. I am ashamed to admit it."[5]

She had grown up in modest circumstances, at 51 Main Street, in a narrow wood house that was close to the road, not set back like the grander houses. Her father was the manager of the Red Lion Inn and stayed in the job for six decades. In the winter, when the inn was closed, he replaced old floorboards and plastered chipped walls and tended to broken things. His wife, sadly, was beyond repair. Molly described her mother as a "semi-invalid" who seldom left the house. According to family lore, Clara Edwards, a descendant of the great theologian Jonathan Edwards, gave birth to Frank (in 1895) and Molly (on September 15, 1896) in the space of only seventeen months, then blithely announced: "I've done my duty to God and the world, and now God and the world can take care of me." She took to her bed and got up in coming years as infrequently as possible.

Later, once she moved away, Molly thought of Stockbridge as the provinces, earnest but largely irrelevant, inhabited by the townspeople of her childhood and their small, unchanging problems. Granted, she did venture home every summer for the long break, staying in a two-room cottage she and her father built together in 1936. Topside, as she called it, was located on her parents' property, halfway up the steep, grassy hill that constituted their backyard. With its screened porch and gardens all around, the cottage had a certain dwarfish charm.

In June 1959, when Molly retired from teaching, she moved back to Stockbridge. By then her parents were no longer alive. Having no desire

to live in the house of her childhood, she continued to rent it out and reside in her little backyard cottage.

Truth be told, she had a grand ambition. She wanted to write what used to be called a "grammar"—it no more needed the word *book* appended to it than did the Holy Bible. She believed her grammar would be a wholly original production. "She invented a system of diagramming sentences that was different from the traditional one," recalled Kate More, a former student of hers (Milton '49) who edited the school literary magazine and grew up to become an English teacher herself. "She made it look like architecture that would fall down if you did it wrong." Molly believed that the careful dissection of a sentence was a lofty exercise, one that could teach a student the intricacies of not only parts of speech but of thought itself. Over the years, generations of Milton girls had been called up to the blackboard by Miss Pundy and instructed to mark the subject, the verb, the predicate, and the object complement. With the eyes of their classmates concentrated on their backs, they drew their tidy diagrams in white chalk, lines extending in every direction.

True, grammar was the bane of countless students who wished they could just read a sentence instead of having to spend what felt like half their lives separating appositives from gerunds and hortatory subjunctives. But it is worth noting that sentence diagramming was once extremely popular as a pedagogic tool. It was beloved by, of all people, Gertrude Stein, and Molly Punderson might have agreed with Stein's assertion that, "I myself do not know that anything has ever been more exciting than diagramming sentences."[6]

This, then, was Molly's great aspiration: to have her name perpetuated in the vast unseeable future not by a line of Punderson descendants, but by a single book. A grammar she had yet to write.

For most of her teaching career, Molly lived with Dorothy Kendall, a history teacher with a sharp tongue who has been described by her students as a "violent presence."[7] No sooner had the girls in her class raised their hands and prepared to speak than Miss Kendall would admonish them, "Be brief!" Dorothy was older than Molly and in the decade after she retired she was listed in the Stockbridge phone book as a resident of Molly's cottage, Topside.[8]

They had much in common, Molly and Dorothy, two natives of Massachusetts who enjoyed books and travel. They were both athletic and gifted at tennis and horseback riding. Neither woman, apparently,

ever had a grand romance with a man; neither woman was known to have been courted by even a second-rate suitor. All this raises the question of whether they were lovers. Simply answered, there is no way to know. They had a "Boston marriage," in the style of many women of their era whose intellectualism and professionalism were an obstacle to marriage.

Molly was looking forward to having the time, in her unhurried retirement, to complete her grammar. The sooner she finished it, she believed, the happier she would be. "Time (and quiet) have been alarmingly hard to come by," she wrote to her former student, Kate More, seven months into her retirement, "but I've tentatively finished and typed a few opening chapters for the grammar and am sending you a copy."

Still, the months of her retirement passed and the grammar remained unfinished. The days seem to blend into one another as she busied herself with other projects. She taught a class at St. Paul's Episcopal Church, entertained her friends from Milton, and renovated her kitchen. She went to the beauty parlor for permanents. She wrote college recommendations for her former students and chatty letters to female friends in which she proved to be a rather precise observer of the weather ("It's like a bad April, not a bad June," she wrote one June.) When she read fiction, it was mainly at mealtimes, because "after dinner, I'm sorry to say, I simply can't keep awake—an awful blight."

•

In her retirement, Molly ended her friendship with Dorothy Kendall and took to spending time with her best friend from childhood, Helen Rice, a violinist who had retired as head of the music department at the Brearley School in Manhattan in 1950. She was known in classical music circles as the founder of the Amateur Chamber Music Players, and divided her time between her apartment in Manhattan and her house in Stockbridge—Rood Cottage, as it was known. It had been built by her grandfather, Ogden Rood, a professor of physics and expert on color theory whose writings were cited admiringly by Georges Seurat and may have helped shape the advent of pointillism.

Although Molly claimed to be "very ignorant in music," she would often accompany Helen to Tanglewood and listen appreciatively as her friend lauded or damned the latest efforts of the Boston Symphony Orchestra at its summer home. The two women also liked a certain playhouse in Pittsfield, where, during the season, the plays changed every

week. They preferred going later in the week, when the actors knew their lines better.

Helen was startled one day when Molly woke her up at dawn. "Molly had a key to my house," she explained, "and she came up one morning and said she had something to say to me." Helen assumed it was something about the ceremony for a new greenhouse at the Berkshire Garden Center, which would be named after her mother; Molly had offered to make remarks. "But when I came downstairs and sat down on the sofa, she looked at me with those blue eyes of hers, and said, 'Don't you know what I am going to say?'"

"No," Helen said.

And then Molly said it. *I am going to marry Norman Rockwell.* Helen later recalled her reaction as something close to shock. "I was so taken by surprise that I heard myself saying, 'Noooo,'" she said. "And then I pulled myself together quickly and said, 'I hope you are going to be very happy.' But it really did take me by surprise, because I had only seen them together once."[9]

Indeed, everyone in Stockbridge was incredulous when they heard. It seemed to defy reason. They had known Molly forever and thought of her as a sober, grounded woman not built for the fluttery ways of romance. They could not remember her without white hair.

•

Rockwell wondered how best to break his news to Peggy Best. On September 28, one day before his wedding announcement appeared in the local paper, he wrote to her as frankly as he could. "Dear Peggy," he began, "Since we are such good friends, I just don't want the news to reach you secondhand. Molly Punderson and I are engaged to be married." He signed off, perhaps because of nerves, with a nonword: "Affectionally, Norman."

Peggy was startled by his news. "Molly was the complete opposite of my mother," recalled her son, Jonathan Best. "Once the dust settled, they all went back to being good friends, but on a different level. My mother made one uncharacteristically catty joke about the marriage. She would say, 'As far as Norman and Molly's marriage is concerned, my imagination stops at the bedroom door.'"[10]

When Molly hinted to Rockwell that she wanted an engagement ring, he urged her to buy one for herself. On the Wednesday before their

Norman and Molly Rockwell, photographed in 1962 by his assistant Bill Scovill

wedding, she called Rockwell from Parenti Sisters, a jewelry shop on Newbury Street in Boston, to say she had found the most stunning ring—a blue sapphire with a small marquise diamond on each side. When she lamented that the price, $1,800, was too high, Rockwell insisted that she splurge.[11]

They were married on a crisp fall day, October 25, 1961, a Wednesday, at 2:30 in the afternoon, at St. Paul's Church in Stockbridge. Molly was given in marriage by her brother, Frank. Her childhood friend Helen Rice was her maid of honor ("really, there was nobody there," Helen later recalled). Rockwell tapped as his best man Harry Dwight, his friend from the Marching and Chowder Society. Afterward, a reception was held around the corner, at Honeysuckle Hill, the home of Miss Alice B. Riggs, whose father had founded the Austen Riggs Center and who spent her adulthood breeding German shepherds. "When the couple return from a four-week trip to Hollywood, they will live in Mr. Rockwell's home on South Street," it was reported in *The Berkshire Eagle*. And so Molly Rockwell, much like Mary Rockwell some three decades earlier, began her one

and only marriage in a house that another wife had furnished and that reflected another woman's taste.

•

It was, in fact, a working honeymoon. It began in New York City, two days at the Plaza Hotel that were devoted to the not exactly romantic endeavor of granting interviews and garnering publicity for his latest book. *The Norman Rockwell Album* was an oversize compendium of color reproductions intended as the pictorial companion to his autobiography and similarly published by Doubleday. To help promote it, Rockwell did a taped interview that would run shortly before Christmas, on NBC's *Update*, a news program for high school students. Dressed in his customary tweed jacket and bow tie, (unlit) pipe in hand, Rockwell gamely took questions from a high school student, Betsy Thresher of Montclair, New Jersey, who looked the part with her blond bangs, high ponytail and plaid jumper.[12]

To what degree, she asked Rockwell in a whispery voice, does a person's face reflect his or her character?

"I think it is mostly in the eyes and the mouth," he replied. "After all, the nose doesn't make a big difference."

Before the segment ended, he unfolded a large reproduction of *The Golden Rule* and joked, "I just happen to have my violin with me."

The next day, October 27, after granting an early-morning interview to Frank Blair of the *Today* show, Rockwell flew off to California with his bride. The trip began in San Francisco, where they visited his son Jarvis. Then it was down to Los Angeles, where "he will spend the next few weeks completing a series of assignments," as a paper reported.[13] The honeymoon was similar to his previous honeymoon, a reversion of sorts, awakening in him what appeared to be a fear of being alone with his wife, of losing the camaraderie of his male friends. He had so much trouble with all of it, the stuff that was not his art.

"I am getting married to Mollie Punderson on the 25th and am coming out to California soon after," Rockwell had written to Clyde Forsythe.[14] "Mollie and I are coming to see you two but we'll give you fair warning. Love, Norman." That was the whole letter.

By then Forsythe was in his midseventies and suffering from various ailments. Rockwell ended up spending his honeymoon chumming around with a much-younger artist, Joe Mugnaini, whom he had befriended

during his semester as a resident artist at the Otis Art Institute a decade earlier. Mugnaini had since become head of the Otis drawing department. Rockwell happily worked out of his friend's studio. He even sat in on a few classes, "working with plastics and learning about modern techniques," as a local paper reported.

"Norman was very playful with my dad," recalled Diana Mugnaini, who was then in high school. "He was with our family all the time."[15] On Thanksgiving he joined them for dinner at a restaurant in Los Angeles, the Captain's Table. There was always a part of him that preferred other people's families to his own.

•

Mary Leete Punderson, once she became Molly Rockwell, found satisfaction in her new identity. In a letter written to a former student, Kate More, after she returned from California, she confided: "I wanted to write to you, particularly, because I had a feeling I could make you understand, more than anyone else, how really wonderful this marriage is . . . As the initial slight stiffness and strangeness wears away, the real marvel of it all is sometimes overwhelming. Norman is an extraordinary person."

She could see that he had his dark moments, an "artistic temperament" that could bring on bouts of despair and distraction. "I doubt though," she noted, "that many artists are so understanding and considerate and so *humanly* tempered by experience."

In her letters to her friends from Milton, she mentioned his goodness, his house, even his help. An "extremely kind and attractive" woman came from Pittsfield three times a week to keep house and Mrs. Bracknell still came in every night to cook. Louie Lamone, "a big and able Lincolnesque man comes every Saturday and Sunday to do absolutely anything wanted— quite an order, since Norman suddenly wants a closet turned *immediately* into an open cupboard, all freshly painted and provided with magazines and objets d'art."[16]

When people commented to Molly that she married late, she always said the same thing: "Norman was worth waiting 62 years for," coyly slicing three years off her age.

If Molly was delighted to find herself married, to be rescued from the prospect of spinsterhood, Rockwell felt gratified as well. At last he had found his feminine ideal: an elderly schoolteacher who was unlikely to make sexual demands on him. Instead of sleeping in his bedroom, as

Mary had done, Molly slept across the hall, in a small, sparsely furnished room.[17] She satisfied his desire for intelligent companionship and asked little in return, perhaps because she had already enjoyed an estimable career and was not looking for excitement.

In an apologetic letter to Kate More, Molly confided: "Norman is frightened of meeting my Milton friends, and I can't bring myself to put on pressure when he will probably be exhausted anyway. So I don't know when we will get down there."[18] Although she wrote the letter only nine days into 1962, her calendar for the next couple of months was swamped with his professional obligations: "February and March are already shot to pieces by long-since promised trips to Philadelphia, Atlantic City, New York, Boston."

If there was one aspect of his life he was capable of sharing, it was his business affairs, into which she entered enthusiastically. She answered his correspondence, got him out of assignments he had never intended to

Rockwell reads a toast to Erik Erikson on March 31, 1962, at a dinner for the Berkshire Art Center. Molly is on Rockwell's right, Joan Erikson is on his left, and Peggy Best, who organized the event, is sitting to the left foreground, back to camera. (Courtesy of Jonathan Best)

accept in the first place, and pushed away callers whom she believed would take advantage of his generosity. She loved travel as much as he did and trained over time to be his official photographer when they were away from Stockbridge.

His third marriage could not have come at a better time, coinciding as it did with the collapse of his career at *The Saturday Evening Post.*

# ROCKWELL DEPARTS FROM THE *POST*

## (1962 TO 1963)

In the early sixties, as its advertising continued to decline, *The Saturday Evening Post* tried to reinvent itself. Its editors joined with members of the business staff in devising changes intended to attract advertisers. They made changes to the magazine's cover, to its typeface, and to its content, and then changes back to the way things had been before the changes ever started. They changed the staff and even the city in which the editorial staff was based, moving their offices from Philadelphia to New York.

The magazine, of course, had always been a champion of Republican politics and the American Way. But even that changed. In the spring of 1961 Robert Fuoss, who replaced Ben Hibbs as editor in chief, went so far as to publicly apologize for the magazine's endorsement of Nixon during the presidential campaign. "If I had been editor last fall, the Post would have voted for Kennedy," Fuoss told *Time* magazine.[1]

Could the *Post* recover? Unclear. Television had been siphoning advertising revenue away from magazines for about a decade. People in the magazine world, many of them shaken by the closing of long-established and seemingly invincible publications—*Liberty* magazine had shut down in 1950, and *Collier's* in 1956—wondered if their industry had become unsustainable.

Circulation was not the problem. In 1961 the *Post* had more readers than ever. Its circulation surpassed that of any weekly magazine today—6.6 million paid subscribers, which placed it right behind *Life* (6.9 million subscribers) and *Look* (6.7 million subscribers). But advertisers were not

about to place ads in all three magazines, and the *Post*, with its continued embrace of yesteryear, was out of step with the New Frontier.

In the summer of 1961 the top brass of the *Post* announced that a "new" *Post* would be coming in the fall. On August 14 Fuoss and Ken Stuart, the magazine's art editor, gave a presentation at the Savoy Hilton Hotel, for "an audience of 264 top-level advertising executives," as *The New York Times* reported. The idea was to offer the businessmen "a peek" at the new *Post*, and this is what was coming: "Innovation in art work accompanying the articles, which will reflect the 'feeling' of a story instead of illustrating an episode—i.e. a 'clinch scene.' Some of the art work will be considerably more abstract than anything that has appeared in the magazine."[2]

Interesting that this was considered progress, a selling point. The magazine thought it could attract advertisers by *claiming a devotion to abstract art*, by banishing from its pages the barbershops and drugstore counters and the reassuring light of storefronts, the small-town settings where Rockwell's figures had flourished for four decades. In the place of realism, the magazine was promoting art about "feeling," the implication being that art tied to a realistic setting was somehow less emotionally affecting than an image of a red rectangle or a cerulean square that made no reference to the world beyond its own edges. It says something about the rhetoric attached to abstract painting, and its fashionable status circa 1961, that an institution as conservative as the *Post* was promising its readers more abstraction.

It's true that the younger generation viewed the quest for facts as passé compared to the quest for feeling. The popular art movements of that era—Abstract Expressionism, Beat poetry, bop, and hard jazz—glorified impulse and improvisation. Rockwell's work was rooted in meticulous, even persnickety observation, the scrutiny of particulars. And what no one seemed to recognize is this: looking is a form of passion if you look long and hard enough.

•

It was against this backdrop that Rockwell created his masterpiece, *The Connoisseur* (see color insert). It takes us inside an art museum, where an older gentleman is shown from the back as he holds his fedora in his hand and contemplates a "drip" painting by Jackson Pollock. His gray hair, gray

suit, and general air of quietude offer a sharp contrast with the crackling intensity of the Pollock.

Unlike most other covers, *The Connoisseur* doesn't rest on a joke and its meaning is pleasantly elusive. The man gazing at the Pollock is a mystery man whose face remains hidden and whose thoughts are not available to us. Perhaps he is a stand-in for Rockwell, contemplating not only an abstract painting, but the inevitable generational change that will lead to his own extinction. Some writers have suggested that he is turned away to conceal his rancor over the growing popularity of abstract painting. But Rockwell had nothing against the Abstract Expressionists. "If I were young, I would paint that way myself," he said in a brief note that ran inside the magazine.

At the time he made the comment, Rockwell could not have imagined that his work would one day be collected by some of the same museums and individuals who also collect Abstract Expressionism. Pollock had died in 1956, in a car wreck in East Hampton, New York, and his death at age forty-four seemed to seal his reputation as a renegade. In a way, Rockwell and Pollock represent opposite sides of the same coin: Rockwell exemplifies the American desire for safety and security as much as Pollock exemplifies the opposing need for flight and rebellion.

*The Connoisseur* required, among other things, that Rockwell paint a fake Pollock as part of his preparatory process. He had seen the famous photographs in *Life* of Pollock in his denim jacket, tossing paint from a stick onto a sheet of canvas that had been laid on the floor. Now Rockwell tried to duplicate Pollock's vaunted "drip" technique. As photographs reveal, he placed his canvas on the floor and created an imitation Pollock. He knew he was putting on a show and saw the inherent paradox of it—meticulously re-creating an image of free-wheeling spontaneity.

Pollock, in photographs, is invariably shown in his paint-splattered shoes. A photograph of Rockwell, by contrast, shows him padding around the studio in his stocking feet. Presumably he was trying to avoid getting paint on his shoes.

•

On September 16, 1961, the *Post* introduced its redesigned self, at a new price: twenty cents, a five-cent increase. To help readers acclimate, Rockwell did a witty cover illustration portraying graphic designer Herb Lubalin

from the back, admiring the new logotype he has created for the *Post*. Everything about him, including the Plycraft bentwood chair in which he is seated, attests to his youth and sophistication. It reminds us, among other things, that Rockwell was a master of the human back and was able to convey character without showing a face.

The *Post*, as he knew it, vanished in June 1962, when the family of Cyrus Curtis lost control of the magazine and corporate raiders took over. Ken Stuart, the magazine's longtime art editor,[3] was fired that month. "I left a dozen approved Rockwell cover sketches behind me, but the new editors decided not to use them," Stuart recalled. "Instead they assigned Norman to a series of portraits of celebrities."[4] Actually, he was assigned to produce portraits of politicians and statesmen and only one celeb (Jack Benny), but Stuart's anger is justified nonetheless.

For decades, millions of Americans had looked forward to taking in the mail and finding a Rockwell cover. But now, when the *Post* arrived, one might find a color photograph of Elizabeth Taylor in emphatic eyeliner, decked out as Cleopatra in the film of the same title. Or a tightly framed close-up of Marlon Brando in the British-style naval bicorn he wore in *Mutiny on the Bounty*.

Rockwell had celebrated the small and local, not the global and cinematic. But the emphasis on the common man that was central to America's sense of self in twentieth-century America gave way, in the television-centered 1960s, to the worship of celebrities, whose life stories and marital crises replaced those of the proverbial next-door neighbor as subjects of interest and gossip. Television provided its audience with a level of proximity to celebrity that could not be matched by magazines, whose fortunes continued to decline.

•

It was in this context that Robert Sherrod, the latest editor of the *Post*, asked Rockwell to join him on an international reporting project. Sherrod, a soft-spoken native of Georgia and former war correspondent, dozed through office meetings and was eager to return to the peripatetic life of a reporter. In 1962 he decided to write a series of in-depth profiles of foreign statesmen—Nehru in India, Tito in Yugoslavia, Nasser in Egypt—that would require extensive interviewing. He asked Rockwell to come along to produce a definitive portrait of each man.

It was, in its way, an enviable gig, providing Rockwell with expense-

paid travel and privileged entry into the armored quarters of heads of state. Moreover, he and Sherrod had both just remarried and Molly Rockwell and Margaret Sherrod accompanied their husbands on the trips. But such perks were not enough to compensate for the loss of everything he loved. After forty-six years at the *Post*, he was no longer making stand-alone illustrations. He was no longer a storyteller, but a "portraitist," as the *Post* announced, shoehorning him into an identity that did not fit.

Rockwell's last cover for the *Post* appeared on May 25, 1963. It was a portrait of Gamal Abdel Nasser, the president of Egypt, whom Rockwell later described as vain, a playboy enamored of his handsome face. During the sketching session in Cairo, Rockwell wanted him to hold his head a certain way and appear thoughtful, but Nasser ignored the stage directions. He kept turning to face Rockwell and flashing his broad smile, to display "his wonderful white teeth." It was only when he was back at his easel in Stockbridge that Rockwell got to close Nasser's mouth and arrange his face in sharp profile, like a figure in ancient Egyptian art.

However compromising his relationship with the *Post* had become, the idea of leaving, of "cutting the knot," induced in Rockwell something verging on terror. His acquiescence in the *Post*'s stratagems frustrated him, but he wasn't sure he was capable of making a break. On May 19, unable to sleep, he got out of bed at 3:00 a.m. and took "2 more pills." Feeling frazzled, he jotted six pages of notes in which he tried make sense of his situation. For a moment it all seemed clear: he longed to leave the *Post*, whose new editorial regime had treated him shabbily, and take up meaningful work—he was thinking, in particular, of doing a painting to honor the Peace Corps, which had been founded a few years earlier to send volunteers to third world countries.

"All of this debasement, depression, unsatisfaction. Isn't this the answer—If necessary, die doing something worthwhile. A worthy end . . . not humiliating fear and groveling. Have I got the sustaining courage to cut it though? Cut the knot myself not die groveling."[5]

His notes mention Harris Wofford, the future U.S. senator who over-saw the Peace Corps in Ethiopia and Africa and who had encouraged Rockwell to consider doing a painting in tribute to the organization. As Rockwell noted: "Isn't a Peace Corps picture the answer? Youthful dedication. Something bigger than yourself. Maybe not art but my only answer."

Molly's belief in his work emboldened him, and he addressed her in his

mind as his stream of notes continued: "You will help, be with me, admire me, I have the courage with you . . . Above and beyond all I have faith in you. Your steadfastness and courage. Have I the steadfastness? *With you.*"

Three weeks later, feeling more certain about the required course of action, Rockwell wrote to Sherrod and asked to be excused from future *Post* assignments. He cited health reasons. He told his editor that he had returned from Egypt "completely exhausted," and was still recovering.[6] "I write this letter only after a lot of thought and consultation with my doctor, Frank Paddock, and my friend Dr. Howard, who is a psychiatrist on the senior staff of the Riggs Foundation."

In September, when the *Post*'s new art editor, Asger Jerrild, contacted him about illustrating an article on the Bible, Rockwell declined without hesitation. "I have come to the conviction," he wrote, "that the work I now want to do no longer fits into the *Post* scheme."[7] It was the closest thing he wrote to a letter of resignation.

He had published 323 paintings on the cover of the *Post*, whose editors did not bother to announce or even acknowledge his departure. Neither did he. He was sixty-nine years old and, in interviews, he declined to cast stones at the *Post*. He had never felt comfortable expressing anger; in this case, it certainly would have been justified. He could have pointed out, had he been a combative person or even a nominally confident one, that the *Post*'s readers were still 7 million strong, and they consisted mostly of older readers who loved his work. He could have argued that, of all the contributors to the *Post*, he was the only one whose reputation had broadened into what marketing people call a brand. He was, in short, the only enduring creation of *The Saturday Evening Post*. When he left, he didn't get a cent.

•

On the morning of November 19 Rockwell appeared again on the *Today* show. The segment was designed to showcase portraits of the Kennedys as well as their creators. Rockwell was joined by Philippe Halsman, the French photojournalist, and Milt Caniff, whose comic strip *Steve Canyon* included a character (Lt. Peter Pipper) fashioned after the president.

No footage of the show survives, but it is easy enough to imagine Rockwell on the set. You can bet money that he wore a bow tie and one of his tweedy jackets. A pipe—as integral to his body as his right hand—would have been present. Over a period of maybe fifteen minutes, there would

have been some questions about President Kennedy and Jackie, some comments, general laughter, the sound of accomplished men chuckling at each other's piquant observations. Maybe even chuckling a little too loudly in acknowledgment of the gratitude they felt at that moment, when they were on national television reminiscing about their personal encounters with the U.S. president and feeling unexpectedly connected to something larger than their anxious and itchy creative selves.

Three days later, the convivial banter on American television stopped abruptly. And television screens filled up with the never-to-be-forgotten images of the open-top limousine proceeding slowly through the streets of Dallas. The president and his wife were in the backseat, smiling gamely at the crowds, when the car delivered them into the crosshairs of a waiting assassin.

•

On December 14, 1963, *The Saturday Evening Post* put out a memorial issue to honor a slain president. Arthur Schlesinger, Jr., his trusted adviser, wrote a moving eulogy and there was also an interview with the new president, Lyndon Johnson, to whom Americans were trying to reconcile themselves. Unlike competing magazines, which ran grisly photographs of the assassination, the *Post* went with an illustration—it reprinted the Rockwell portrait of JFK that had run in 1960, before he was elected president. There he was again, with his blue eyes and thick hair and boyish Kennedy grin that seemed to promise that all would be well in America.

Rockwell sent a charcoal study to Jacqueline Kennedy as a gift. "Dear Mr. Rockwell," she responded, "I was deeply touched to receive your beautiful charcoal drawing of The President. It is an excellent likeness and a portrait that I shall especially treasure."[8]

# RUBY BRIDGES

## (1964)

In the end, it was liberating for him to leave *The Saturday Evening Post*. At the age of sixty-nine, he could have retreated into retirement, or taken up golf, or made a fortune accepting commissions from the likes of Jerry Lewis and Bob Hope, whose portraits he had recently completed. Instead, he entered a new phase of his career. Call it his "late period." Starting in January 1964, when his first illustration appeared in *Look* magazine, Rockwell began treating his work as a vehicle for progressive causes. Kennedy had been buried in Arlington National Cemetery and President Johnson had taken up the cause of civil rights as if it had been his mission all along. Rockwell, too, would help drive the Kennedy agenda forward. You might say he became its premier if unofficial illustrator.

It was quite astounding. He went from doing gently humorous paintings about everyday moments to unsettling images of the world and its woes. In coming years, he did paintings about school desegregation and the violence against civil rights workers in the American South. He did paintings of Peace Corps volunteers in African villages, ministering to the poor. He did a painting of a defiantly raised fist, in observance of LBJ's declaration of a war on poverty.

What lay behind his newfound assertion of social idealism? His detractors accuse him of opportunism. They say he was acting out of expediency, trying to salvage a wrecked career. His original editors were dead, much of his original audience was dead, and the *Post* had dropped him. He was well aware that no magazine was eager to commission paintings of Santa Claus or solicitous policemen at a time when a new generation

was turning on the radio and hearing Bob Dylan admonish in a vaguely pissed-off voice that the times they are a-changing. And so Rockwell took up social realism—belatedly, perhaps. It had been more than a generation since Ben Shahn had turned social realism into a reputable chapter in American art.

Yet Rockwell's lateness should not be held against him. With his new work, he pushed his art in surprising directions and risked alienating a public that had long turned to him for humor and diversion. Now he had to cultivate a new audience in a new venue. Unlike his paintings for *The Saturday Evening Post*, Rockwell's paintings for *Look* ran inside the magazine, not on the screaming cover, and they did not have the same visibility at corner newsstands, in doctors' waiting rooms, or in the culture at large.

The truth is that in the sixties he became a political being, a man whose views put him squarely in the group known as the New Left. He was influenced to some degree by his liberal acquaintances in western Massachusetts, including his wife Molly and Erik Erikson.

But he also came to the discovery and formulation of his own liberal sentiments through the nuclear disarmament movement. The founding of the antiwar movement is sometimes traced to 1957, when the escalating arms race led Norman Cousins to organize the National Committee for a Sane Nuclear Policy, the group known as SANE. The goal: a reduction in nuclear weapons. Rockwell agreed to become a "sponsor" of the organization in January 1962. His name was listed on SANE's letterhead, along with those of such prominent peace activists as Benjamin Spock, Jules Feiffer, and Martin Luther King, Jr.[1]

Rockwell and Molly sent off pointed telegrams to the White House, calling for a ban on the testing of nuclear weapons. Moreover, Rockwell volunteered to design the group's poster. It was to be a collaboration with his intellectually distinguished neighbors, the playwright William Gibson and the theologian Reinhold Niebuhr. But nothing is simple when geniuses get together. "Reinhold wouldn't sign it," Gibson recalled. "He didn't think humanity could save itself, so the whole thing was scratched because Reinhold couldn't be upbeat enough."[2]

Once Rockwell had been a symbol of the establishment, a man who had helped define the optimistic mid-twentieth century. Now he wondered what was wrong with The Establishment, which acquired upper-case emphasis in the antiestablishmentarian sixties. He wondered what could lead a country to build nuclear weapons, risk the possibility of annihilation.

He wondered what kind of country could be complicit for so long in the systematic wickedness of racial segregation.

•

On January 14, 1964, Rockwell published his first illustration in *Look*. *The Problem We All Live With* was spread over two pages inside the magazine. It had a wonderful directness to it, in part because it appeared without a caption or a chunk of explanatory text. True, it was introduced by a tan-colored page with minimal type: "Painted for *Look* by Norman Rockwell."[3] As readers turned to page 21 and came upon the painting, they must have wondered, "What is this?" There she was, an African-American girl—a six-year-old in a chaste white dress, a matching bow in her hair—walking to school. She is escorted by four uniformed officers in lockstep.

The background of the painting conveys the background of the story. A defaced, dinged stucco wall is inscribed with a slur ("nigger") and, in the upper left, the initials KKK, the creepiest monogram in American history. The girl, we can see, is a person of exemplary dignity. She stares ahead as she walks, declining to acknowledge the graffiti or the still-dripping mess in the center of the wall, a tomato that was tossed by a demonstrator and which thankfully missed the girl's head.

Ruby Bridges was the first African-American to attend the all-white William Frantz Elementary School in New Orleans, as a result of court-ordered desegregation. And Rockwell's painting chronicled that famous day. On the morning of November 14, 1960, shortly before 9:00 a.m., federal marshals dispatched by the U.S. Justice Department drove Ruby and her mother to her new school, which was only five blocks from their house. It was her first day of first grade and, according to news accounts, she had to walk by a crowd of crazy hecklers outside the school, most of them housewives and teenagers. She did this every day for weeks, and then the weeks became months. In retaliation, white Louisiana parents withdrew their kids from school and only one teacher was willing to help Ruby, the sainted Barbara Henry of Boston. So Ruby sat alone with Mrs. Henry in an empty classroom and learned how to read and how to add numbers.

It is interesting to compare Rockwell's painting with the wire-service photographs on which it was loosely based. Even when he was depicting an event out of the headlines, he was not transcribing a scene but inventing

one—he added the tomato and the defaced wall and changed various details. In the news photographs, for instance, which were taken a few days after she started school, Ruby is carrying a plaid book bag that resembles a small briefcase. In Rockwell's painting, she carries instead a small stack of school supplies—a red pencil, a blue pencil, a notebook with a blue, star-spangled cover, and a wooden ruler—that echo the design of the American flag.

In news photographs of the scene, Ruby and the federal marshals enter or exit the school through a glass door and a short flight of steps. But Rockwell dispenses with the entranceway and frames the figures against a stucco wall that stretches horizontally across the canvas, an abstract painting within the painting. The writer Zora Neale Hurston once observed, "I feel most colored when I am thrown against a sharp white background,"[4] and Rockwell's background, if not exactly white, is sufficiently light-toned to make Ruby's color the unmistakable theme of the work.

More important, Rockwell has achieved an intensification of meaning through the process of cropping, with all that implies about close-up views and sliced-off heads. Although the original news photographs show the U.S. marshals from head to toe, some of them wearing hats, Rockwell has cut them off at the shoulders. We see their polished shoes, the legs of their pants, their jackets—that's it. Only Ruby has a face, and this detail is essential. She is spared the indignities heaped on Ralph Ellison's *Invisible Man*, who is invisible, of course, not because he is a ghost but because no one bothers to look at his black face. By granting us the chance to see her face, Rockwell has depicted Ruby as a heroic representative from the ranks of a black America that was prepared to face—and even to outface—the bullies out there.

·

One of the odd facts surrounding the painting is that Rockwell painted it three years after the event it chronicles. Why did he turn to the subject so belatedly? Perhaps it was brought to his attention by John Steinbeck's engaging memoir, *Travels with Charley: In Search of America*, published in the summer of 1962. Driving across the country with his elderly French poodle, Steinbeck happened to arrive in New Orleans in time to witness the events of November 14, 1960, the scene outside the school, the shouting segregationists, "the littlest Negro girl you ever saw, dressed in starchy white, with new white shoes on feet so little they were almost round."[5]

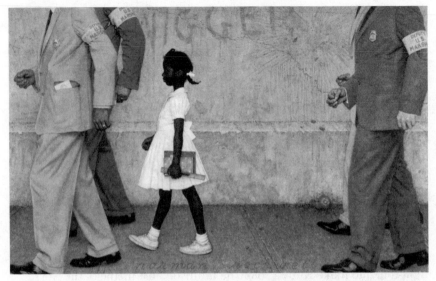

*The Problem We All Live With*, which appeared as a two-page spread in *Look* magazine on January 14, 1964, remains the single most famous painting of the civil rights movement. (Norman Rockwell Museum, Stockbridge, Massachusetts)

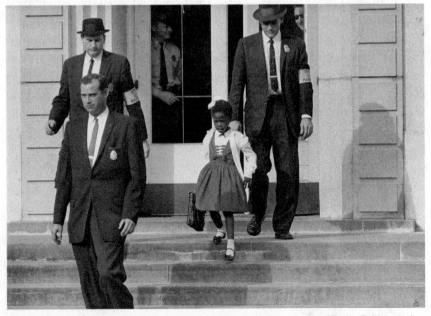

Rockwell's *The Problem We All Live With* echoes a news photograph of Ruby Bridges being escorted from school by U.S. deputy marshals. (Courtesy of AP)

But probably Rockwell was more influenced by an account provided by the child psychiatrist Dr. Robert Coles. He and Rockwell would become friends a few years later, through their mutual friend Erik Erikson, but at the time Dr. Coles was a graduate student doing research in the Deep South. Dr. Coles, too, had witnessed the scene outside the school. In November 1960 he was driving to "a shrink conference,"[6] as he says, in New Orleans when he came upon the crowd of people screaming invectives at a black girl. In the next two years, Dr. Coles provided regular counseling to Ruby Bridges and a handful of other African-American children trying to endure the strains of desegregation.

He published his findings in the October 1963 issue of *The American Journal of Psychiatry*[7] and Rockwell, who was still a trustee at Austen Riggs, almost surely saw his article. It focused attention on, among other things, the ordeal of black school children forced to confront "the explosion of words of hate and deeds of violence by certain white persons."[8]

•

When Rockwell needed to find a model who was African-American, he did not have to look far. There were only two black families in Stockbridge. One was presided over by David Gunn, Sr., who lived right on East Street and worked as a head coach at various private high schools. He was also a social activist and at the time served as the executive chairman of the Berkshire County chapter of the NAACP. Part of his job was to recruit new members and Rockwell signed on as a "life member," the highest membership category, for five hundred dollars. Attending a meeting of the NAACP on the last Monday in October 1963, "Mr. Rockwell was presented a life membership pin in the NAACP by David Gunn," as the local paper reported on page one. Rockwell was only the fifth person in the Berkshires to become a life member, and his name was promptly added to a bronze plaque in the New York offices of the NAACP.

Rockwell liked to visit Gunn at his house, where they would smoke their pipes on the porch. Their meetings were at least partly about business, if painting is a business. Usually Rockwell would bring a few pencil sketches for paintings he was thinking about doing. Gunn would look at the sketches and focus on the figures. He had a large extended family and could usually furnish the name of a possible model from among his own relatives. He and his son, David Jr., had already posed for *The Golden Rule*.

For the Ruby Bridges painting, Gunn referred Rockwell to two of his

granddaughters, Lynda Gunn and Anita Gunn, who were first cousins. They were both eight years old and thrilled at the prospect of posing for Rockwell. The artist warned both girls up front, "You might not be the chosen one," but they were still happy to pose.

First he visited Anita Gunn, who lived in Great Barrington. Her dad worked for the State of Massachusetts, in the maintenance department. One day she came home from school and Rockwell was milling in the living room, talking to her mother, Elaine. "He was a very warm and gentle man, especially with the children," Mrs. Gunn recalled years later. "He would just get down when he talked to them. He got on their level."[9] Noticing that Anita had returned home from school that day carrying a violin case, he asked her if she would like to earn some money to pay for her violin lessons. Mrs. Gunn thought that was a charming way of asking her daughter to pose.

He mentioned to Mrs. Gunn that he liked the dress Anita was wearing— a blue cotton dress with a Peter Pan collar and puff sleeves. It tied in the back, plain as could be. Mrs. Gunn was surprised when the artist asked her: "Could you have two made like that in white for me?" One for Anita, one for Lynda. He said he would reimburse her, and she said yes on the spot even as it occurred to her that she had never had a dress made. "I knew that the Methodist minister's wife was a dressmaker," she recalled, "so I asked Aunt Sinclara to ask Mrs. Durant to make the dresses."

Anita modeled for Rockwell on a Sunday morning in October, arriving at the studio with her parents and siblings in tow. "He had had chairs set up for all of us," Mrs. Gunn recalled. "Anita was dressed in the white dress. He asked everybody if they would like a Coca-Cola. He kept a case of Coca-Cola under the stairs in his studio. He went back there and got a bottle of Coke for each of us." They were touched by the gesture, and watched with barely concealed pride as Rockwell directed Anita to look this way and that as his photographer snapped away.

In the end, he went with her cousin Lynda, perhaps, it was surmised, because she was a little thinner. That's what the family said anyhow. To spare feelings, Rockwell insisted the girl in the painting was actually a composite, but no one believed him.

•

*The Problem We All Live With*, which was the official name of the Ruby Bridges painting, marked a sharp break from the representation of race in

popular culture. Rockwell recalled having been directed by the *Post* to remove a black person from a group picture because the magazine's policy dictated showing black people only in service-industry jobs. (And the magazine was by no means alone in perpetuating racial caricature. Advertisements in newspapers and magazines were regular offenders. There was Aunt Jemima and her maple syrup; Uncle Ben and his long-grain rice; Rastus in his floppy chef's hat on the Cream of Wheat box, each of them smiling, teeth flashing against dark skin, as if nothing in their experience was more rewarding than cooking up hearty, starch-laden dishes for white folks.)

When radio and then television came along, the stereotype of the servile black was adopted for shows like *Amos 'n' Andy* or *Beulah*, a now-forgotten sitcom starring a bosomy, apron-clad maid. It was not until 1968 that the show *Julia*, in which Diahann Carroll played a widowed nurse who barely seems aware of her race, made history by being the first sitcom to have a nonsubservient black character in a title role.

<center>•</center>

In some ways, it might seem unlikely that Rockwell's painting of Ruby Bridges owes its existence to *Look*, a slick biweekly whose pages were filled with jumbo-sized photographs and short-verging-on-nonexistent articles. It had been founded in 1937, a year after Henry Luce founded *Life*. Three decades later, when Rockwell started publishing his work in *Look*, it was still part of the conservative Cowles Communications empire, still a pic-ture magazine competing with *Life*. The articles in *Look* could be fairly puffy: hagiographic profiles of actors ("Dick Van Dyke, Family Man"), dispatches on nonburning social issues ("Will Fraternities Survive?"), endless fashion forecasts and football forecasts and recipes for fettucini. "They wasted a lot of money sending photographers over to Paris to photograph an artichoke," the journalist Christopher S. Wren recalled years later.[10]

But it also managed to run some excellent pieces of social and political reportage. In 1956 editor Dan Mich had assigned the first major maga-zine article on Emmett Till, the fourteen-year-old schoolboy whose death became a heart-rending symbol of racial injustice in the South. *Look*'s story about his assassins' trial, "The Shocking Story of Approved Killing in Mississippi," remains a landmark of civil rights reportage.

*Look*'s New York office was located in midtown, at 488 Madison Avenue,

at Fifty-first Street, up on the eleventh floor, with windows facing the back of St. Patrick's Cathedral. Rockwell would drop by the office when he was in the city, and his main ally there was Allen Hurlburt, the magazine's talented art director, a thin, stylish guy in horn-rimmed glasses who was then in his midfifties. It was Hurlburt who sanctioned Rockwell to create a series of illustrations chronicling the civil rights movement, a brilliant gambit.

By the time his painting of Ruby Bridges being escorted to school by federal marshals appeared in *Look*, Rockwell had been out of the country for three weeks. "I went to Russia and they had it in the newspaper that the guards were taking her to prison," he recalled, referring to a story that *Pravda* ran about the painting.

A few days before Christmas 1963, he had flown to Moscow to take part in a cultural exchange program sponsored by the U.S. Information Agency. It was run by Edward R. Murrow, the CBS newsman who had been a hero of the liberal establishment at least since the climactic on-air moment when he dispensed with his usual journalistic impartiality and expressed his outrage over Senator Joe McCarthy's anti-Communist witch hunts. Sadly, his stay in the Johnson administration was short. A chain smoker, Murrow would soon be diagnosed with lung cancer and it was in his last few months on the job that he tapped Rockwell as a "specialist." His assignment was to travel to Moscow along with Graphic Arts USA, a giant road show made up of some two thousand works that included fine-art prints, magazine illustrations, cartoons, preposterous advertisements—basically anything that had been created in the United States through the process of printing.

At this point in the Cold War, Premier Nikita Khrushchev had already sent missiles to Cuba and made headlines by taking off his shoe at the United Nations and banging it on a table. But unlike Stalin, who closed off contact with the United States, Khrushchev welcomed cultural exchange, which led to a quaint chapter in U.S. history when exhibitions of art and other objects were curated by the government and sent abroad.

The Soviets dawdled in granting Rockwell permission to visit. He submitted his application on November 20, just two days before the Kennedy assassination. On December 11, he was in Washington, "awaiting Soviet visa," according to State Department records. He would have to wait in Washington another week. The Soviet Union was hardly enamored of American art and was still spooked by an incident in 1959, when Pollock's

drip paintings had arrived in Russia as part of the massive American National Exhibition. To quell fears about the possibility of more subversive "drip paintings" arriving on Soviet soil, an officer at the State Department emphasized in a telegram to his aides in Moscow: "Embassy may find it helpful to remind ROMCOM that failure to issue visa to Rockwell would result in keeping out of USSR an American exponent of representational rather than abstractionist art."

Rockwell, accompanied by Molly, arrived in Moscow on December 20, 1963, on a flight from London. They stayed for a month, at the Budapest Hotel, an old, slightly tattered place not far from Red Square and the Kremlin. Every morning at eight, instead of the punctual walk to his studio in Stockbridge, Rockwell walked briskly through subzero weather to the building at the Soviet fairgrounds where Graphic Arts USA was installed. Then he worked all day, much as he always did. A wire story filed from Moscow on Christmas Day describes him sitting in the middle of the exhibition, sketching a portrait of a Russian girl. "He plans in the next three weeks to sketch about four Russians a day—some in black and white, some in color," the article reported.

Secluded on a little balcony, he was basically on exhibit himself. See the American artist, with his relentless work ethic! With the help of translators, Rockwell picked Russians out of the crowd to pose for him. He sketched old men in their furry *ushanka* hats, old women with kerchiefs tied under their chin. He painted most everyone in partial profile, looking away from him, perhaps for his own comfort. Onlookers oohed and aahed as faces materialized on his pad. "In about five minutes he had it down,"[11] recalled Jack Masey, the head of the exhibitions program for the USIA, remembering how dazzled he was by Rockwell's ability to capture a likeness in so little time.

During his month in Moscow, Rockwell came to feel that the myth of Communism bore little relation to the reality. He was upset by the presence of Russian officials who watched to see whom he picked to model, wanting him to paint only the most physically attractive Russians. "They didn't like the fact that Norman chose the poorer types of people instead of the prettiest ones," Molly later explained.[12] "They created such a fuss about the peasants and older people Norman selected that he just gave up and let them determine who his models were to be. He was quite unhappy about the whole thing."

One day Rockwell pulled Masey aside and tensely mentioned that he

wanted to paint a portrait of Nikita Khrushchev. He said it could run in *Look*. He had already met Mrs. Khrushchev, a plump, round-faced woman who, on a tour of the graphic arts show, had stopped by Rockwell's workshop and said hello in heavily accented English.[13] He found her charming and told her he would like to paint her portrait before he left town.

Masey thought the idea was nuts, but Rockwell was persistent and Masey agreed to see what could be done. He called a colleague at the American Embassy, who in turn requested a meeting with the Soviet minister of culture. Sometime that January, a meeting was held. There were five or six men, including translators. Seated at a long conference table, on the side reserved for Americans, Rockwell pushed samples of his work across the table to where several Soviets were arrayed and said, "I would like to do a portrait of your president."

"I knew there was no way in the world they would ever say yes," Masey later recalled. "Khrushchev had never posed for a non-Communist."

After some more negotiations, Masey had to break the news to Rockwell: the Russians had said *nyet*. No explanation had been offered. "I've never seen such a disappointed person," Masey said.[14]

•

During his stay in Moscow, Rockwell exhibited his own work in Graphic Arts USA, and the reaction was mixed. He had brought the original *Four Freedoms* with him, rolled up in a metal tube, and displayed them at the fair. *Freedom from Want*, the scene set at the Thanksgiving table, evoked sharp criticism in *Pravda* and *Izvestia*, the official gazettes respectively of the Communist Party and the Soviet government. The painting, it was said, showed affluent Americans gorging themselves on mountains of food while the rest of the world went hungry.

Other pictures were seen as too humorous to appeal to sober Russian sensibilities. "For Russians, Rockwell is a new product," reported an unsigned AP article.[15] "He makes gentle fun of American life. He does not fit into the pattern of Soviet realistic art."

That opinion, by the way, contrasts sharply with that of Rockwell detractors who persist in likening his work to Soviet socialist realism, a style of art which offers rosy portrayals of life under Communism—women in kerchiefs standing and smiling amid bushels of wheat, muscular men with their shirtsleeves rolled up, building factories and waving red flags. Interestingly, Russians did not think that Rockwell's work was allied with their

own tradition of socialist realism. They saw skepticism, jokiness. They saw a style of realism in which the most real thing was the humor that undercut the realism.

Rockwell's Boy Scouts paintings were the exception. They lack irony. They are straightforward and propagandistic. They were created for calendars. On December 6, at the opening reception for the Graphic Arts USA exhibition, Aleksandr Kuznetsov, the deputy minister of culture, ridiculed an abstract print by Boris Margo, comparing its flattened disk shapes to "blinis." But he paused to admire a Rockwell calendar illustration showing "a wholesome Scout leader surrounded by his happy charges."[16]

•

The Rockwells left Moscow on January 20, 1964, and on the way home made a little seven-thousand-mile detour to Africa. For some time, Rockwell had been thinking about visiting a Peace Corps operation in rural Ethiopia, for a possible feature in *Look* magazine. He had first heard about that corner of the world from his bookkeeper, Chris Shafer, whose son John was a Peace Corps volunteer. Flying into Addis Ababa, the country's capital, Rockwell and Molly were met by Harris Wofford, who led Peace Corps efforts in the region, and drove them to a hospital to receive yellow fever shots. From Addis Ababa they headed out to the bush, traveling in an old airplane with no roof. They stayed overnight with the young volunteers, in facilities with outside toilets and no running water, and later their hosts commented on how funny they were, how gracious, how alert to small things.

They arrived home in Stockbridge on February 1, 1964, two days before his seventieth birthday. Rockwell was pleased with the sketches of the Russian people he had done on his trip. He exhibited them at the Stockbridge library that spring and allowed them to be reproduced in the magazine *American Artist*. It was how he defined himself now, a man who looked at the people of the world and offered them his empathetic gaze. A man who could talk at length about "Contemporary Art and Social and Political Conditions in Russia and Ethiopia," to borrow the title of a lecture he gave to a high school history class in Stockbridge that March.

To be sure, his open embrace of civil rights irritated more than a few Americans, and when Rockwell returned home from Russia, he found sacks of disapproving mail that *Look* had forwarded to him. Countless subscribers to the magazine, especially those whose letters were mailed

from the South, had not cared for his Ruby Bridges painting. *Look* published a letter from one Joe E. Moore, Jr., of Bedford, Texas, who doubted that Rockwell was sincere in supporting racial integration: "Just where does Norman Rockwell live? Just where does your editor live? Probably both of these men live in all-white, highly expensive, highly exclusive neighborhoods. Oh what hypocrites all of you are!"[17]

Over time, *The Problem We All Live With* would come to be widely appreciated as a defining image of the civil rights struggle in this country. What makes it so powerful is that its central figure is both a symbol and a real person, a little girl slicing through all the injustice in the world. She would reappear in many guises in American culture, even in musical comedy. "That painting he did about the little black girl walking—that's in *Hairspray*," recalled John Waters, the director and writer of the film. "That inspired L'il Inez in *Hairspray*."[18] L'il Inez is the charismatic African-American girl in Baltimore who helps break down racial barriers by being the best dancer in town.

For a long time, the public had no idea of Ruby Bridges's name. Instead people thought of her as that "little Negro girl," as *The New York Times* described her in 1960,[19] withholding her name from articles out of concern for her safety. It was not until 1978 that Ruby Bridges was first mentioned by name in the *Times*,[20] in an article about the child psychiatrist Dr. Robert Coles, and by then she was a woman of twenty-two who had skipped college and was working as a travel agent trainee in New Orleans.

When did she become aware of the existence of Rockwell's painting of her? "I was about 17," she recalled years later. "Someone showed me a picture of it. I think it's a great piece of work. He was sort of taking a risk, I think, by making such a stand when he did."[21] She and Rockwell never met.

# LYNDON BAINES JOHNSON, ART CRITIC

## (1964 TO 1967)

On July 2, 1964, six months after Rockwell's painting of a heroic black girl walking into a white school appeared in *Look*, the Civil Rights Act became law. Finally, there could be no more separate lunch counters or hotels or theaters, no more discrimination in public places such as schools and libraries, no more inhumane banishment to the bumpy back row of the bus. This is not to say that the new legislation was universally acclaimed. The South was predominantly Democratic, but Democrats there bore little relation to the ones up north. They were so uncomfortable with the Civil Rights Act that they were threatening to vote President Lyndon Johnson out of office in November.

That summer Rockwell was assigned by his editor at *Look* to paint portraits of the president and his opponent for an Election Day issue. He flew out to San Francisco in mid-July, when the Republican National Convention was underway at the Cow Palace. Barry Goldwater, the Arizona senator and hero of conservative Republicans, sat for his portrait at campaign headquarters in his trademark horn-rimmed glasses. He had opposed the new civil rights law, claiming it violated the sanctity of states' rights, a phrase that many considered a lame cover for institutionalized racism. "I didn't vote for him," Rockwell later said of Senator Goldwater, "but he was a very cooperative model."[1]

That same week, on July 16, at 11:30 a.m.,[2] Rockwell was ushered into a portrait session with President Johnson at the White House. It was their first meeting. It was held precisely two Thursdays after the president had signed the Civil Rights Act into law and Rockwell found him impatient

and crotchety. The president appeared dismayed when Rockwell asked for an hour of his time, saying the most he could spare was twenty minutes and instructing Rockwell to "get cracking."[3] So Rockwell proceeded much as he always had, sketching away, making amusing comments, instructing his subject to look this way or that while a photographer took pictures from every angle. "I decided to do the best I could, but he was just sitting there glowering at me," Rockwell recalled.[4]

With only a few minutes left, Rockwell tried to reason with his subject. "Mr. President," he said, "I have just done Barry Goldwater's portrait and he gave me a wonderful grin. I wish you would do the same." So the president indulged him, or at least tried. For the last minute, he forced his mouth into a manifestly fake smile, "like he was competing for the Miss America title,"[5] as Rockwell later recalled.

The portraits appeared in *Look*, on inside pages, on October 20, 1964, two Tuesdays before Election Day. FULL COLOR, the magazine boasted with uppercase excitement on its cover, as if color photography, which was still fairly new in popular magazines, somehow mirrored the revolution in sexual mores and offered a lusty antidote to the camouflage of the gray-flannel fifties. The portrait of Johnson, with his long face and droopy hound dog ears, cannot be said to have rehabilitated the tired tradition of the presidential portrait. But it is probably as appealing as a portrait of Johnson can be: psychologically astute, devoid of pomp. He is shown from the neck up, a middle-aged Texan with deep creases around his mouth, a hint of shadow beneath his cleft chin, his thinning hair combed straight back. Instead of gazing assuredly at the viewer, as American politicians are almost professionally obligated to do, he looks off to the side, a bit sadly. This is LBJ not as the champion of the Great Society, but as a man who feels anxiously aware of the gap that separates his proposals for reform from the enormity of the problems facing the country.

Ever since painting his first portraits of presidential candidates (Dwight Eisenhower versus Adlai Stevenson) for *The Saturday Evening Post*, Rockwell had always presented the paintings and accompanying sketches as gifts to the candidates, by which time they were no longer candidates but winners or losers. President Johnson thanked him for the portrait, however perfunctorily, in a letter composed on September 15, 1965: "I am glad to have the original of the painting that you did of me last year."

None of this would suggest that President Johnson loved Rockwell's portrait of him or enjoyed the ordeal of posing for it. But he did in fact

love it, as he realized in an art epiphany six weeks after receiving the gift, when an established painter named Peter Hurd unveiled for him yet another portrait—the so-called official presidential portrait. Hurd, a native of New Mexico known for his hilly, adobe-colored scenes of the Southwest, was part of the exalted Wyeth clan. He had studied with patriarch N. C. Wyeth, the great book illustrator based in Chadds Ford, Pennsylvania, then married his daughter, Henriette, the sister of Andrew Wyeth and herself a painter.

Much like Rockwell, Hurd felt exasperated by the time allotted, or rather not allotted, for his portrait of President Johnson: he was given only two sittings. One took place at Camp David, the retreat in Maryland, where the president was posing in a chair when his head slumped onto his chest and he appeared to nod off for a few minutes, depriving Hurd of any view except for the pomaded strands of gray hair combed across the top of the presidential scalp.

At the end of October,[6] Hurd and his wife transported the painting to the LBJ ranch in Texas hill country for a private unveiling. Truth be told, it is not a great painting—a three-quarter-length affair, in which the president looks mannequin-stiff as he stands outdoors in a dark suit, gazing off as if trying to read cue cards located just beyond the left edge of the painting. He is holding a book whose generic title (*History*), visible on the cover, remains unaccompanied by any hint of the book's author, perhaps because this is a book that no one ever wrote. Behind him, in the distance, the white dome of the U.S. Capitol glows against an early evening sky streaked with purple. President Johnson did not hesitate to share his opinion of the painting with the artist. He took one look and pronounced it "the ugliest thing I ever saw."[7] When Hurd asked, "Just what do you like, Mr. President?" Johnson rushed to his desk and pulled out from a drawer an old *Look* magazine, shouting, "I will show you what I like!" Then he waved the portrait that Rockwell had done.

Hurd countered derisively, "I wish I could copy a photograph like that." The president insisted the portrait was not a copy of a photograph, that he had in fact posed for it. He added that Rockwell had managed to produce it after only one, inordinately efficient twenty-minute audience with him, which is perhaps what the president liked best about the portrait.

Lady Bird, in the meantime, took it upon herself to provide Hurd with what she believed were well-founded criticisms of the painting. She recalled in her diaries "a gruesomely uncomfortable half hour"[8] in which she

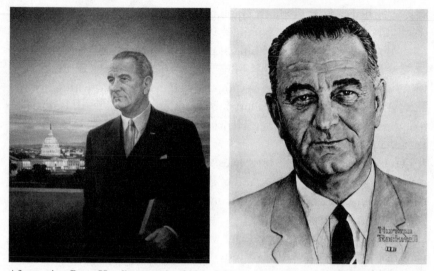

After seeing Peter Hurd's portrait of him, LBJ denounced it and decided retroactively that he liked Rockwell's earlier portrait of him.

proposed several major changes. For one thing, the painting stood four feet high—too big in Lady Bird's estimation. She found the sunset garish and was particularly bothered by the portrayal of the president's hands, which she felt were not the "gnarled, hardworking"[9] presidential hands she knew and loved but a bland simulacrum. Hurd, she noted, "was the first to admit that the body, and especially the hands, were not good, because he had not had enough sittings."[10] Her verdict was that Hurd should go back to his studio and make a smaller portrait in order to omit the president's hands altogether. Then the Johnsons would look at it again.

For all his stated affection for Rockwell's portrait of him, President Johnson was willing to part with it for political gain. He used it as a chit to please a supporter. Unknown to Rockwell, Johnson regifted the painting in 1966 to a friend in Texas. "Norman Rockwell sent me a portrait I thought you might like to have,"[11] he wrote that April to Robert Kleberg, Jr., who owned the King Ranch and had just embarked on a dubious plan to establish a wildlife refuge stocked with deer and nilgai antelopes on the site of the president's own birthplace. "I am sending it to you, suitably inscribed, for your home."

Peter Hurd, in the meantime, eventually lost interest in undertaking a second portrait of the president. He decided instead to put the original

one on public view, seeking the small satisfactions of revenge. The story broke on January 5, 1967, in a women's page feature in *The Washington Post*,[12] and was quickly picked up by newspapers and magazines all over the country. Speaking to reporters by telephone from his ranch in New Mexico, Hurd cheerfully denounced the president's behavior ("very damn rude"[13]). It turned out that a majority of Americans sympathized with Hurd and agreed that the president had treated him shabbily. The story of the callously rejected portrait seemed to confirm LBJ's reputation as a man who was insulated from the public and had no patience for opinions other than this own, not least when the opinions came from his various advisers who thought the country should get out of Vietnam.

Hurd was happy to expound on his art and his technique for his new following. He explained in interviews that he favored the quaintly ancient technique of egg tempera. Consequently, his portrait of President Johnson had taken him a total of "400 hours," the implication being that the quality of a painting, not unlike homework, is directly related to the amount of labor expended on it.

The most irksome part of his experience with the President, Hurd arrogantly told *The New York Times*, was having to hear his work compared unfavorably to that of Rockwell, whom he dismissed as a "good commercial artist." It might seem hypocritical that Hurd, who worked in the realistic style of his hero N. C. Wyeth and himself did an occasional portrait for *Time*, would malign Rockwell as a commercial artist. His comment suggests that the Wyeth clan considered itself artistically superior to Rockwell, who had never denied his status as an illustrator or tried to escape the stigma. There was no Helga in his life, no secret desire to forsake illustration for more reputable kinds of painting.

Moreover, Hurd maintained in the *Times* that Rockwell copied from photographs, whereas "I've never learned to copy photos."[14] *The Washington Post* carried a similar accusation: "Rockwell's genius lies partly in being able to to turn out slick, speedy, glossy copies of photographs in record time to meet magazine deadlines, Hurd insisted."[15]

Sadly, no one came to Rockwell's defense, including Norman Rockwell, who had never bothered to answer his detractors over the years. But someone, anyone, might have pointed out that he did not copy photographs. Rather, he used them to lend greater credibility to his fictions.

Rockwell was unable to express whatever resentment he may have felt over the incident. He almost never went on record criticizing another

illustrator and he was not about to pick a fight with the brother-in-law of his colleague Andrew Wyeth. In fact, he actually defended Hurd in his one public comment about the incident. In the summer of 1967, speaking at the National Press Club in Washington, he blamed the affair of the rejected portrait on the White House. President Johnson may have considered Rockwell's portrait of him the epitome of artistic excellence, but, as Rockwell told the audience with his usual self-debunking humor, "President Johnson is a terrible art critic."[16]

# THE VIETNAM WAR

## (1965 TO 1967)

In the eyes of the townspeople, Molly and Norman seemed touchingly companionable. They were often spotted riding their bicycles through town, even in the winter, whizzing past in the bright noontime sun. Weather permitting, they set out every day at 11:30, immediately before lunch, and might be joined by Rockwell's studio assistants. In his cycling, as in so much else, Rockwell adhered to an unvarying routine. His preferred bike route took him west on Main Street, away from the little shops; when he reached the town cemetery, he turned right onto Route 102, which wound through open fields. The route, as he noted, was 4.7 miles long and blessedly flat, except for one part near the Berkshire Gardens Center that required him to pedal standing up. He called it Cardiac Hill.[1]

By now Rockwell had been married to Molly for four years and in some ways he remained fundamentally unchanged. His 1965 calendar shows he was still in therapy with Dr. Howard and relying on antianxiety drugs ("took Miltown after lunch") to get through the day and to sleep through the night. He still tended toward hypochondria and imagined himself host to every cold, flu, and cough that passed through Stockbridge. Yet compared to the debacle of his two previous marriages, his union with Molly was a ringing triumph. He noted on his calendar one Thursday in May: "Molly gone lonesome," and then, three days later: "Molly coming home Hurray!"

It helped that Molly continued to view her marriage as a late-life gift. Unlike the first two Mrs. Norman Rockwells, she was able to tolerate the solitude entailed in sharing a life with him. There was so much she

genuinely enjoyed, from the red-carpet treatment they received when they traveled to the hours at home devoted to gardening (asparagus was her specialty) and caring for Pitter, their beagle mix. Once when she was asked to name the woman she most admired, she cited the novelist Jane Austen, explaining: "She contented herself with wherever she found herself."[2]

Rockwell still disappeared into his studio by eight, closing the door behind him. Molly had an uneasy relationship with his assistant, Louie Lamone, who found her stiff and imperious, no match for Mary Rockwell. Early in her marriage, Molly frequently went out to the studio; she would bring the mail as soon as it arrived, usually at nine in the morning, and went back and forth throughout the day to discuss small matters as they arose. But then Rockwell installed an intercom system and requested that she buzz from the house with her questions. "She very seldom came in after that," Lamone recalled.[3]

She did rap on the studio door every day around eleven o'clock, to remind him to break for their bicycle ride. "If I didn't," she said, "he'd probably work through dinner."

She especially cherished their trips out of town, which were numerous and usually undertaken for his work. Once, asked by a reporter to name her favorite material possession, she replied, "My cameras, which provide my entree on Norman's work trips." She owned two Leicas and a Rolleiflex, and although he already had a well-equipped darkroom in his studio, he converted an old icehouse on the property into a photography studio for Molly. Moreover, he arranged for her to receive lessons from one of his photographers, Walter H. Scott, a young artist who had recently "emigrated,"[4] as he said, to the Berkshires from San Francisco. Her old friends and former teaching colleagues felt surprised and perhaps a little betrayed by the ease with which she had slipped out of her moorings as an English teacher and cottoned to her new VIP life. She seldom had time to visit Milton, Massachusetts, the site of her professional triumphs. In Stockbridge, her priorities rearranged themselves. She no longer taught her Monday night poetry class at the Lenox Library, in part because she was frequently out of town. "Her life took a very different turn," her friend Helen Rice recalled. "I was very sorry that she didn't have time after she married to continue with this."[5]

•

On June 28, 1965, as Stockbridge filled up with summer residents and visitors assumed their positions in the wicker chairs outside the Red Lion Inn, Rockwell and Molly flew west. For a few weeks they were in Los Angeles, where Rockwell had been invited to exhibit a small group of his paintings at the municipal art gallery. He made sure to include his Ruby Bridges painting as well as *Murder in Mississippi*, a sketch of which had just appeared in *Look*, memorializing three young civil rights activists—Andrew Goodman, James Earl Chaney, and Michael Schwerner—killed by a gang of Klansmen. "Times are changing now, and people are getting angry," Rockwell told a wire-service reporter a few days after his arrival in Los Angeles. "I'm beginning to get angry too."[6]

He again sounded like a socially engaged citizen when he taped an interview with archconservative Art Linkletter for his new CBS show, *Hollywood Talent Scouts*. While he amused Linkletter by recounting how crotchety President Johnson had been during his portrait session, Rockwell mentioned that he voted for him. He could be public about those things now. He could say he voted Democratic.

The main incentive for the trip was a lucrative assignment from the film producer Marty Rackin. He had persuaded Rockwell to put aside his regular work to undertake the movie poster and "lobby cards" for *Stagecoach*, a not-awful remake of the John Ford Western. Rockwell and Molly spent two weeks that July in Denver and Boulder and on location at Caribou Ranch in the Colorado Rockies, where he went around with his paint box and and she followed with her Leica camera, and together they had the film's cast members pose for them, in full costume, one by one. Bing Crosby played alcoholic Doc Boone in what would be his last motion-picture role.

To his surprise, Rockwell was cast in a bit part in the film. As he jotted on his calendar, on July 6, "8:15 a.m. I begin my acting career." In one sense, he had always been something of an actor, with an actor's ability to create a range of characters and moods. Over the years, to show his models what he wanted from them, he had twisted his facial features into countless grimaces. But this was surely the first time a director asked him to don a cowboy costume and play cards in a barroom during a fight scene. His crowning moment in the film comes when he leans across the table, gazes at a dead body, and straightens up without showing a flicker of emotion.

In the fall Rockwell was surprised when Crosby contacted him about

acquiring the paintings for *Stagecoach* for his private collection. "He wanted to buy all of the pictures," Rockwell recalled. "He wanted to pay me $20,000, but, you know, I'd never have them again."[7] Although Crosby sent him a nudging letter in October ("I do hope I hear from you soon with some favorable news"[8]), Rockwell, who tended to be months behind schedule on assignments, hadn't even started his portrait of Bing for the movie poster, figuring there was no hurry since the film wasn't opening until the following June.

Over Thanksgiving weekend, he finally set to work on an oil-on-canvas portrait of Crosby as the scruffy, unshaven Dr. Boone. "Painted Bing Crosby head and hat and layered in full pict,"[9] he noted on his calendar. The next day was Sunday. "Worked on Bing. Put in stethoscope." In the end, at Molly's insistence, Rockwell kept the set of *Stagecoach* paintings for himself. And Crosby, who resolved to display Rockwell's portrait of him in the den of his Northern California mansion, had to settle for a copy.[10]

•

In the evenings, when the Rockwells turned on the television, they heard reports on the napalming of peasant villages. The bombing of North Vietnam in 1965 touched off a round of peace activities and brought national prominence to the antiwar movement. The first march on Washington was held that spring, and it was followed by sit-ins and be-ins and rallies staged in parks around the country, enormous gatherings of college kids in their uniform of work shirts and jeans, swaying gently to folk music or appearing defiant as they chanted along with raucous, bullhorned voices, *Hell no, we won't go.*

Rockwell openly expressed his opposition to the U.S. invasion of Vietnam. It has been reported that he turned down an offer during the war to do a recruiting poster for the Marines. True enough, but his antiwar gestures were more substantial than that. He deplored what he saw as an unnecessary war and he regularly sent telegrams to President Johnson. *Please push for negotiations. Please try for peace.* Like many people who called themselves doves, Rockwell was in favor of a unilateral withdrawal of U.S. forces from Vietnam.

In a telegram sent on January 3, 1966, Rockwell and Molly informed the president: "We fully approve your efforts toward negotiation and hope you will continue to press in every possible way for peace."[11] It was sent in response to a pause in the bombing of North Vietnam that be-

gan Christmas Day. Rockwell sent another telegram three weeks later and asked that "our country spare no effort or patience in pressing for negotiations."[12]

As much as he embraced the political values of the sixties, Rockwell remained curiously impervious to the accompanying sexual revolution. He was not inclined to toss off his old prudishness and suddenly admit frank sexuality into his work. His illustrations often portray people who feel great affection for one another, but sexual love is never overtly part of their bond.

Once when Rockwell was interviewed by Jinx Falkenburg, a Spanish-born actress who wrote a gossip column for the *New York Herald Tribune*, he remarked: "If I try to do a picture of a girl with a low-cut dress on, full of allure, she just winds up looking the way you'd want your daughter to look—safe. Or if she's an older woman, she'll never look like Marlene Dietrich. Every time, she'll look as though she should be out in the kitchen, peeling potatoes. Sex appeal seems to be something I just can't catch on a piece of canvas."[13] He made the comment in 1951 and repeated a version of it in his autobiography, making it sound as if he himself was perplexed by the ineradicable wholesomeness of his work.

Only once in his life had he published an image that was considered risqué—an awful, goofy, prefeminist *Post* cover in which an old lobster fisherman trudges home with his catch of the day: by mistake he trapped a redheaded mermaid, who is flashing a bit of white breast through the wooden slats of a lobster trap. *A Fair Catch*, as it was titled, appeared in 1955 and created predictable controversy. After a woman from Worcester, Massachusetts, sent an irate letter to the *Post* about "the obscene picture on the cover," the magazine polled its readers and triumphantly reported that very few readers agreed with her. "In poor taste": 11 letters. "Obscene": 21 letters. "Not obscene": 245 letters. ("Norman Rockwell couldn't draw an obscene picture," wrote Mrs. James L. Gaston, from Fairhope, Alabama, affirming the opinion of the majority.)[14]

Now it was a decade later, it was 1966, and Arthur Paul, the art director of *Playboy*, was writing to Rockwell, imploring him to do an illustration for the magazine. Not clear what he thought Rockwell should illustrate. Perhaps the events of the civil rights movement. Certainly not Varga Girls. They were the work of Alberto Vargas, who stripped his name to Varga and made airbrushed paintings of springy and well-endowed women clad in diaphanous lingerie.

Rockwell had no trouble turning down *Playboy*. "I'm sorry I opened the mail this morning," Arthur Paul joked in a letter sent to Rockwell that June.[15] "But should you reconsider, please let me know."

He did not reconsider. He remained uncomfortable about overt sexual references. Asked once by *Esquire* magazine about his worst temptation, Rockwell replied enigmatically, "As I grow older the terrible temptation seems to recede."[16]

•

Among the art directors pursuing Rockwell were those at *Ramparts*, a new magazine based in San Francisco that quickly became the house organ of the New Left. The magazine was among the first to oppose the Vietnam War and, in December 1967, ran a now-famous cover that showed four white hands raised in solidarity, each one holding a burning draft card belonging to a *Ramparts* editor. Their names were legible on the draft cards and one of them was that of Dugald Stermer, the young art director of the magazine.[17]

One day Stermer telephoned Rockwell to ask whether he might consider doing a portrait of Bertrand Russell for the cover. Rockwell replied: "One old guy portraying another, right?" Bertrand Russell, the British philosopher, was then ninety-four years old and enjoying new prominence as an antiwar activist.

Rockwell had always been a connoisseur of the faces of old men and his portrait of Bertrand Russell still astounds with its frankness. There he is, the philosopher, his corona of frizzy white hair gleaming against a loosely brushed, brick-red ground. The *Ramparts* cover actually consisted of two heads, as if to capture a range of moods. The head on the right shows an old man with snowy eyebrows, the image of quiet intelligence. The head on the left is crazily intense. The philosopher frowns as if in contemplation of some infuriating truth, his eyes watchful and accusing, his chin lifted to expose an unobstructed view of an old man's neck, possibly the stringiest neck in all of art.

•

*Look*, in the meantime, was planning a special issue to commemorate the fiftieth anniversary of the Bolshevik Revolution. Rockwell was enlisted to provide an illustration of a typical Russian classroom and he and Molly traveled to Moscow for the second time, staying for two weeks in June.

Arriving at the airport, they were met by Christopher S. Wren, an American journalist then covering the Soviet Union for *Look*. From the first, he found Rockwell "very accommodating and laid back. I was surprised how nice he was."[18]

Wren, who was fluent in Russian, used his translator's skills to help Rockwell gain access to a Moscow school. He later recalled that Rockwell was in the midst of photographing a group of students, "all sitting there in their Pioneer scarves,"[19] when Russian officials intervened. They objected when he asked one of the students to look out the window, to pose as a kid who could not sit still, a child as distracted as he had once been.

The school administrators, however, wanted the children depicted as studious little Communists. "Everyone had to be depicted looking straight ahead," Wren recalled, "and they wondered what kind of anti-Soviet Norman was to have a student looking out the window."

Both Rockwell and Wren, who were traveling with their wives, were staying at the National Hotel, just off Red Square, and the two couples got along well. One day Wren offered to take Rockwell and Molly to see Lenin's tomb, where visitors were waiting in long lines in the June heat. Inside, the air was frigid, and the atmosphere was reverent as visitors silently filed past the open sarcophagus in which Lenin lay embalmed in a dark suit and red tie. When they stepped outside, Wren asked Rockwell what he thought of the display.

"Wax," Rockwell deadpanned.

Years later, Wren recalled Rockwell as a man who had little room in his brain for anything but his art. "He didn't want to do a lot of great sightseeing," Wren said. "He didn't want to have a long discussion about politics, although he did have a couple of derogatory snickers about Lenin. What he wanted was that picture. He wanted to get the right picture."

•

During his trip to Russia, Rockwell kept meeting people who mentioned how much they loved seeing his paintings hanging at the Hermitage. He was nettled to be confused yet again, even in remote Russia, with Rockwell Kent, a Communist who had donated hundreds of his works to the people of the Soviet Union. Just that April, Kent had won the 1967 Lenin Peace Prize and, courting controversy, announced that he was donating his prize money to the "suffering women and children of Vietnam's Liberation Front."[20] Rockwell, in turn, was "more than a little disturbed"

about the publicity Kent received for his ten thousand dollar cash gift to the Vietcong.[21]

Rockwell, of course, also opposed America's involvement in Vietnam, but he did not provide charity to the enemy, which was illegal, not to mention poorly advised. It was annoying to be mistaken for an artist who was constantly proclaiming his love for Communists and relishing his transgressions against American values.

It hardly helped that Rockwell was also being confused in the sixties with George Lincoln Rockwell, who founded the American Nazi Party and proudly flew a swastika over his headquarters in Arlington, Virginia. When a newspaper in Newport News, Virginia, ran an editorial opposing the gubernatorial campaign of "Fuehrer Norman Rockwell," the artist immediately sent a letter, requesting a correction.

In public, Rockwell recycled the confusions for their full comic potential. Shortly after returning from Moscow, he went down to Washington, to speak at a luncheon hosted by the National Press Club, and he mentioned in his opening remarks that he was neither George Lincoln Rockwell nor Rockwell Kent. This got a big laugh. Such was his nomenclatural fate: he had to share his surname with a demented white supremacist on the one hand and a Communist-smitten painter on the other.

•

His own politics continue to be defined by the New Left and his main cause was civil rights. In his youth, he had thought of America as a "we," one nation indivisible or at least basically in sync; everyone had wanted the same things, it seemed. But the civil rights movement, and especially the battle to desegregate public schools, had forced Americans to confront the existence of two Americas and the inequality between them. As Rockwell once said, "I was born a white Protestant with some prejudices which I am continuously trying to eradicate. I am angry at unjust prejudices, in other people or in myself."

His third major civil rights painting, *New Kids in the Neighborhood*, appeared in *Look* in May 1967, accompanying an article on white flight.[22] Spread over two pages, the painting is set on a scrubbed-looking suburban street and shows an African-American brother and sister, whose family is still unloading the van, encountering a few white kids. They survey each other with a mixture of wariness and shy curiosity, and you assume they

will soon find common ground. Racial lines have already been blurred by the integration of a fluffy white cat that belongs to the black kids and the black dog that belongs to the white kids.

That summer—1967—Rockwell befriended Dr. Robert Coles, the prominent child psychiatrist and Harvard professor. They were introduced by Erik Erikson, who suggested to Dr. Coles, his former student and protégé, that he ask Rockwell to illustrate a children's book he was writing. *Dead End School*, as it was titled, is the story of a sensitive black boy who is bused to a white school; it grew out of Dr. Coles's experience working in the Deep South with black children caught in the throes of desegregation.

Later, asked what he thought of Rockwell's portrayal of children, Dr. Coles said: "I think he gets a lot into them. I like that he takes reality and gives it a subjective boost, a kind of connecting what's visible with what's inside the head."[23]

Rockwell first met Dr. Coles on June 28, when the psychiatrist, visiting Stockbridge to lecture at Austen Riggs, dropped by the studio to discuss the illustrations for his manuscript in progress.[24] Rockwell cautioned Dr. Coles that his process would involve models. "I cannot do a picture without seeing someone," Rockwell insisted. "We're going to have to find some children who fit in with what this story is about."[25]

Dr. Coles could not imagine why Rockwell needed to look at yet another model. God knows he had drawn thousands of figures by now. But Rockwell was adamant on this point. He wanted to draw the characters in the book "from life," or at least from their imagined counterparts in life. It was a kind of humility, perhaps, this need to subordinate his gaze to the visual actuality of all he drew.

"The next thing I knew," Dr. Coles recalled, "I was driving him to Springfield, Massachusetts, because he couldn't find anyone in Stockbridge." Meaning, he could not find the right models and needed a larger pool. About two months later, Rockwell sent Dr. Coles a pack of photographs of people posing as the characters in the book. "I think the poses turned out very well and I will enjoy making the drawings,"[26] Rockwell noted, asking Dr. Coles what he thought. Dr. Coles, who felt baffled by the intricacy of Rockwell's process, didn't think anything, except that it was all fine and good if it worked for Rockwell.

The finished book includes seven illustrations, vivid ink drawings of Jimmy and the other characters. Grandma recites "one of her long, preachy

prayers" with her hands up in the air, and Ma stands on a protest line, a slender woman dressed neatly in a skirt and a raincoat, holding a sign that says, "This is *our* school."[27]

Dr. Coles was personally acquainted with Ruby Bridges. He had been down in New Orleans, providing Ruby and her parents with free counseling in the early sixties, while studying the toll that integration was taking on black families. "He was enormously interested in Ruby," Dr. Coles recalled of Rockwell. "He wanted to know more about Ruby's family than almost anything else."[28]

Once when they were talking about Ruby, Rockwell appeared to be crying and took a handkerchief out of his pocket. He dabbed his eyes, then commented: "This handkerchief is torn and I need a new one."[29] Dr. Coles chuckled and wondered if Rockwell was capable of being overwhelmed by emotion or whether his obsession with cleanliness always intervened somehow.

# ALICE'S RESTAURANT

## (1967)

The Back Room occupied a tiny space in an alleyway off of Main Street, and was fragrant at lunchtime with the scent of homemade wheat berry bread. Its proprietor, chef, sous-chef, and waitress happened to be one person: Alice May Brock, a Sarah Lawrence dropout in her midtwenties who strode around town in long dresses and love beads and boots. The menu at the restaurant changed every few days and was composed mostly of thick soups and casseroles—chicken divan, lasagna, moussaka—that could be spooned out or sliced up to accommodate any number of people and that helped popularize the thrift-is-beautiful school of cooking. "Any chance you get, take wooden ice cream spoons from the market," Alice urged in her cookbook. "They're free."[1]

She and her husband, Ray Brock, an architect, had moved to the Berkshires in 1962, to work at the Stockbridge School, which had been founded by a practicing socialist on property overlooking a lake. Ray taught the shop class and Alice was the school librarian. There she met Arlo Guthrie, one of the students. In April 1966, by which time Arlo was a high school graduate and Alice had quit teaching, she opened her café on Main Street. Arlo decided to promote it by writing a song about it, which is not to say that his reputation as a musician extended beyond his school friends.

"Alice's Restaurant Massacree" made its radio debut in February 1967, when Guthrie performed it live on WBAI-FM, a noncommercial, listener-supported station in New York City that itself was a symbol of the countercul-ture. The song was an instant sensation, despite its daunting length—it takes more than eighteen minutes to sing in its rambling, tangent-upon-tangent

entirety. Only nominally about Alice or a restaurant, "Alice's Restaurant" (as it is called, from the title of Guthrie's album) is mainly an account of Guthrie's picaresque clashes with government authorities and remains one of the great protest songs of the sixties. It lavished enduring fame on Alice Brock, as well as on the Stockbridge chief of police, William J. Obanhein, who is better known as Officer Obie and who, on Thanksgiving Day 1965, had arrested the eighteen-year-old Guthrie for illegally disposing of a load of garbage left over from the turkey dinner that Alice had prepared. (He and a friend had offered to take the garbage out, only to realize that the town dump was closed for the holiday.) In a tale of spiraling absurdity, the song relates how Guthrie received notice from the Selective Service Administration to report for induction. At the draft board, asked if he had ever been convicted of a crime, he mentioned his littering offense and, to his immense disbelief, was reclassified as unfit for service in the Vietnam War.

On the surface, Rockwell and Guthrie might seem to have stood at opposite poles from each other. In 1967 Rockwell turned seventy-three and, despite his late-life embrace of liberal politics—his despair over segregation, the civil rights paintings he did for *Look*—he continued to appeal to an older generation that believed in the essential greatness of America. Guthrie represented freedom from that, freedom from the phoniness he perceived in American life. He was easy to spot on the streets of Stockbridge, a stick-thin man of twenty in billowing paisley shirts and jeans, a brown felt hat atop his shoulder-length curls.

He and Rockwell met at least a few times. Guthrie said the introduction was made by his physician, Dr. Campbell, *the* Dr. Campbell, a longtime friend (and onetime model) of Rockwell. "All of the people Norman used as models were friends of mine," Guthrie remarked years later.[2]

It has been reported that the Officer Obie who arrested Arlo on Thanksgiving Day is the same well-intentioned, broad-backed cop seated at the lunch counter in Rockwell's *Runaway*. This is incorrect; a state trooper had posed for *The Runaway*. But Chief Obanhein did pose for several other Rockwell works from the fifties, including *The Jury* and *Policeman with Boys*, the latter a pencil drawing that appeared in advertisements for a life insurance company. Surely Chief Obanhein's best-known role was playing himself in the film version of *Alice's Restaurant*, which came out in 1969. "In the end, if someone was going to make a fool out of me, it had better be me," he explained at the time, and wound up winning critical acclaim for his performance as a gruff comic villain.

Alice Brock claims that Rockwell never ate at her restaurant, which is not surprising. A fussy eater who did not experiment and avoided vegetables, especially asparagus, Molly's specialty, he preferred nothing for dinner so much as a plate of "good thick roast beef" and roast potatoes, with either an oatmeal cookie or a scoop of Breyer's vanilla ice cream for dessert. Which left him in no great hurry to sample Alice's spicy casseroles or famous "Hot Meat and Cabbage Borscht."[3]

Even if they weren't among her customers, Alice was well aware of Rockwell and Molly, in part because her father, Joe Pelkey, had taken Molly's poetry class at Lenox Library and thought it was first-rate. ("My father loved Molly," Alice later recalled.) Alice kept what she considered a necessary distance from people of her parents' generation. "Most Berkshire people over the age of thirty didn't like me," she later recalled. "It was the sixties; kids were dropping out of college and becoming rebels. I was a symbol of all that."[4] She didn't think much of Rockwell's work, nor did she think much about it, believing it had as much relevance for her generation as Sinatra songs or victory gardens.

Guthrie, by contrast, was more sympathetic to Rockwell's work. He could see that it captured something true about America, an ideal of fellowship. "I'll tell you something that's honestly true," Guthrie recalled years later. "I was over in Sweden or Norway a while ago. I was by myself; I was lonely; I had done a few shows but I didn't know a soul. I walk in to just get a beer and a sandwich somewhere and I'm sitting there and I look up on the wall and there was that picture of Dr. Campbell and the kid and a couple of other Rockwell paintings. I suddenly looked around and I thought, 'You know what, I know all of these people' and it made it so freaking nice."[5]

•

Rockwell and Guthrie had more in common than either man might have cared to acknowledge. They were both native New Yorkers who left the big city for countrified Stockbridge as if to tap into some truer, less urbanized state of being. Both were raconteurs, humorous storytellers who favored rambling narratives and who, coincidentally or not, got an astonishing amount of creative mileage out of the theme of Thanksgiving dinner. Both were folk artists of a sort, unrepentant populists who took their material from everyday life in America. In Rockwell's world, ordinary people encounter small frustrations but are saved from despair by the goodness of their fellow citizens; in Arlo's worldview, the entrenched ridiculousness of

institutions wins out over reason every time. The cop locks you up over-night for littering, instead of escorting you to a diner and talking sense into you at a counter bedecked with homemade cherry pies.

It was perhaps his desire to claim Stockbridge as his own that led Rockwell to create one of his best-known paintings, *Stockbridge—Main Street at Christmas*, which offers no hint of the town's burgeoning hippie population or the VW Beetles parked along its curbs. Instead, we tour an old-fashioned New England street on a dead-cold winter afternoon, when darkness starts descending too early and overhead lights are turned on in the shops; windows shine out with a golden-yellow brightness. We glimpse all this from across the street, from an elevated vantage point that suggests we are looking down from a second-floor room. Main Street is an extra-wide road encrusted with days-old, flattened snow, less of a thoroughfare than a frozen swath separating the viewer from the shops beckoning on the east side of the street.

Rockwell had begun the painting and abandoned it a decade earlier, in 1956, when his studio was still located in a second-floor space on Main Street. In 1960, asked to participate in a group show of local scenes held at the Stockbridge library, he sent along a "very rough sketch for a pro-jected painting of our main street."[6] Now it was 1967, and when a reporter visited Rockwell that September in his studio-barn adjacent to his house, he found "a huge, elongated canvas" resting on his easel, waiting to be finished. The eight-foot-long painting was scheduled to be featured in a three-page foldout section in the December issue of *McCall's* magazine, for which he furnished an occasional illustration.

The painting is the only one of Rockwell's to overtly identify Stock-bridge as its setting. His other major paintings are consistently set in unnamed cities and supposed to represent Anywhere, USA. But when he submitted *Stockbridge—Main Street at Christmas*, he asked his editors to iden-tify the location in their text. Another first, or almost first: the painting is a landscape, one of very few he ever completed. In the top half of the canvas, mountains are silhouetted against a vast sky streaked with pastel pinks and blues. This is not to suggest that Rockwell suddenly awoke to the plea-sures of plein-air painting. He continued to have as little interest in ren-dering mountains as any artist who ever lived. To compose the scenery, he used photographs taken in the Berkshires as well as in Vermont and the Swiss Alps; he consulted prints of Siberian winter scenes to help him por-tray the snowy street that lay just outside his window.[7]

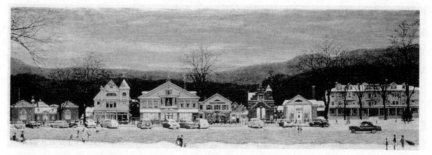

Rockwell painted *Stockbridge—Main Street at Christmas* in 1967, after Arlo Guthrie's "Alice's Restaurant Massacree" made its radio debut on WBAI-FM. (Norman Rockwell Museum, Stockbridge, Massachusetts)

He seems to identify more with the buildings than with the landscape around them. Here he renders the buildings along Main Street, each a different style and size, in razor-sharp detail, as if his goal was a plank-by-plank reassembly of them. You can make out the outline of every red brick on the crenellated facade of the old town hall, every fish-scale shingle on the white-painted Queen Anne building that is second from the left, every wooden window frame at the Red Lion Inn, which was closed for the winter, its long porch empty.

Perhaps he was thinking of Edward Hopper, the cantankerous realist who had died that May, at age eighty-four. Hopper knew how to bring intense emotion to portrayals of architecture, and Rockwell's *Stockbridge—Main Street* can put you in mind of Hopper's *Early Sunday Morning*, of 1930. Both paintings offer a bluntly frontal view of a row of stores and small businesses; both exploit an elevated vantage point. Some of the windows in the Rockwell painting—such as the grid of darkened rectangles fronting the Red Lion Inn—feel like Hopper windows, meaning you stare at them but cannot see through them; they appear almost to stare back.

But the elegiac quality of *Stockbridge—Main Street* was probably Rockwell's own entirely. He was seventy-three, his knees ached, he was having trouble hearing. (He had recently obtained an Audiovox hearing aid, at the Pittsfield Hearing Center.[8]) He renders Stockbridge in the days before Christmas not as the twinkling haunt of Santa and his artisanal, toy-designing elves, but as a place where daylight is fading and the street is emptying out, where one is made to feel the intense quiet of Rockwell's own landscape. Here, in the center of the composition, is the upstairs space on Main Street that had once served as his studio. Here on the far

right is his white-painted Colonial house, lights ablaze in the windows. Here is the block he had trod a thousand times, prodigious walker that he was. The painting is "an autobiography written in architectural land-marks," as the art historian Karal Ann Marling puts it.[9]

•

One establishment, by the way, remains curiously absent from Rockwell's painting of the town: the Back Room, better known as Alice's Restaurant. Nowhere in the painting can one discern the wooden sign that hung dis-creetly on Main Street, directing passersby into the alley where the restau-rant was tucked away. Rockwell, however, cannot be blamed for the omission. Alice's Restaurant proved to be short-lived, lasting from one April to the next. In a case of bad timing or rather bohemian timing, it closed just months before *Alice's Restaurant* was released as an album. By then, Alice had divorced her husband and moved out of their artfully renovated church; she was living with her mother in Boston. "I felt that instead of owning it, it owned me," she said later of the restaurant, explaining why she gave it up.[10]

•

In a way, *Stockbridge—Main Street at Christmas* is as much a symbol of the sixties as *Alice's Restaurant*, if only because it captures an America on the brink of vanishing. It was painted at a time when mom-and-pop shops were being annihilated by the advent of malls, which were pulling stores away from Main Street and into the uninhabited, unzoned areas on the outskirts of towns. But it wasn't just downtowns that had broken apart. It was also the great narrative that had allowed the nation to believe that old-school democratic values had created a country where every person, young and old, black and white, had a voice, a place, a sense of belonging, that Americans shared a common identity.

That dream was replaced in the sixties by another dream of together-ness, at least for a younger generation. Instead of community, the talk was of communes, of love-ins, be-ins, and utopian experiments of all kinds. The communal order envisaged by the counterculture was supposed to be based on tolerance and free love, but unkindly excluded everyone over thirty. When the high wore off, housemates bickered over who contrib-uted more for the groceries or washed the most dinner dishes.

Rockwell did not leave behind any comments on Alice Brock or Arlo Guthrie and it is not known whether he ever saw the film *Alice's Restaurant*.

But faced with the film's giddy apotheosis of youth culture, he might have agreed with Erik Erikson's student Robert Jay Lifton, a psychiatrist who writes in his memoir: "One thinks of the sixties as a time of the young, and it was certainly they who released most of its energies. But not enough attention has paid to the experience of those of us who were adults."[11] Indeed, Rockwell was among those adults who became a political being in the sixties and excoriated the values of an older generation of which he himself was a prominent member.

Molly Rockwell, in the meantime, made her own contribution to the literature of the counterculture that year. She and Rockwell collaborated on a children's short story—her first—that ran in the April 1967 issue of *McCall's*.[12] "Willie, The Uncommon Thrush," as written by both of them and illustrated by Rockwell, tells the story of a hippie thrush who disavows the song characteristic of his breed. An unrepentant nonconformist, the bird composes his own cadenzas and trills. Gawky and "pigeon-toed," plagued at times by a "desolating loneliness," Willie is vaguely reminiscent of Rockwell. "The drive to create had subsided, leaving him empty and bored," Molly writes of the bird.[13]

It is worth noting that Willie the Thrush has the same first name as Willie Gillis, the endearingly boyish soldier who clutched at his package from home in Rockwell's World War II covers. In the generation since, Willie had become a very different character, one willing to trumpet an ethic of difference.

# ANDY WARHOL & COMPANY

## (FALL 1968)

One afternoon in July 1968 Rockwell picked up the phone in his studio and heard a voice at the other end talking intently about mounting a show of his work. He was taken by surprise and assumed the caller had confused him with Rockwell Kent. "I'm sorry," he said, "but I think you have the wrong artist."

He was speaking to Bernie Danenberg, a young art dealer who was in the process of renovating a space in New York that would open that September. His speciality was established American masters of the nineteenth and twentieth centuries and his personal style was intense. A trim, voluble man in his thirties with oversize glasses, he owned a Bentley convertible ("Ming blue," as he described it) and was seldom without a cigarette.[1]

The next morning Danenberg drove up to Stockbridge with Larry Casper, the low-key manager of his gallery. Rockwell had instructed them to drive straight to the Red Lion Inn, across from his house, where he stored about a dozen paintings. The arrangement allowed him to minimize interruptions from people who insisted on seeing his work. It was peak vacation season in the Berkshires and tourists in wicker chairs were on the inn's long porch when the dealers arrived. "The paintings were in there, in that room right by the entranceway," Casper recalled. "Important pictures were hanging all over the place."[2]

Using the pay phone in the lobby of the inn, the dealers called Rockwell and said they were across the street. Could they come over and see him? Within a few minutes, they were striding into his red-barn studio. They explored the place as if it represented a never-excavated archaeological site,

seeing treasures everywhere. A small, lovely painting was lying on a table, *Lift Up Thine Eyes*. Set outside a Gothic church in Manhattan, it portrays a crowd of urbanites rushing by with lowered heads, oblivious to the uplifting message that a young man on a ladder is posting on a sign outside the church. Danenberg offered $2,500 for it. Rockwell told him to just take the painting and he may have actually meant it. "I got paid for it once. I don't need to be paid again." He meant he had been paid by the *Post*.[3]

Danenberg was persistent, and by the end of the visit, Rockwell had agreed to not only accept a check for *Lift Up Thine Eyes* but to allow the dealer to schedule an exhibition of his work at the gallery that October.

Rockwell still owned most of his paintings, especially the major ones, and Danenberg needed to figure out which pictures to borrow for the exhibition. Rockwell referred him to the Berkshire Museum in Pittsfield, where he kept a few dozen works. Then he made a phone call to Stuart Henry, the museum's director. "I have a misguided art dealer here who thinks I am an artist," Rockwell said in his deep voice. "Humor him. Open the museum."

•

In earlier years, he had resisted the attention of the art world as much as it had resisted him. From time to time, he had received a solicitous letter from a dealer specializing in American painting, such as Frederic Newlin Price, of the Ferargil Gallery in New York, and he had chosen to back away for reasons that represented a complicated tangle of principle, indecision and insecurity.

To be sure, there had been exhibitions of Rockwell's work, but most of them had been organized by the PR department of *The Saturday Evening Post*, including his one and only show at a major museum, the Corcoran Gallery of Art in Washington, D.C., in 1955. That was the show at which a U.S. Marine band had performed in the galleries. The problem was that the *Post* assembled art shows not to elucidate the strengths of Rockwell's work but to try to promote the magazine as a bastion of conservative values, values which encouraged a false reading of his work. Of course he could have said no to all that *Post* promotional nonsense. But saying no was not his forte. Decades ago, he had submitted to his desire for fame and acceptance and he could not reasonably complain about the consequences.

He liked the idea of the Danenberg show, a show in New York, the

much-ballyhooed art capital of the Western world. He already had an audience, of course. An audience numbering in the many millions, and it is not unreasonable to wonder why an artist whose magazine illustrations were known to most everyone in America needed to have a gallery show on Madison Avenue, to sell his paintings to collectors who would take them home and sequester them in living rooms or dining rooms where they would be seen only by the inhabitants of the home and, perhaps, a maid instructed to dust both painting and frame with a soft cloth (and *no* Windex) once a week.

But the art world is not just a vehicle of conveyance, of moving paintings from the private space of an artist's studio to the similarly sealed-off space of a collector's home. It is also the sum of all the rooms in the world where art is publicly shown, that is, in galleries and museums, in addition to the magazines where it is reproduced and reviewed. It offers any object a meaningful context, the possibility of being judged as art, of being defined in relation to other objects whose aesthetic worth is believed to be knowable.

In other words, one reason there was no real discussion of the aesthetic worth of Rockwell's paintings was that he had seldom exhibited them, seldom subjected them to the scrutiny of critics. At this point, his paintings could be had for a song, meaning a few thousand dollars, or even a few hundred dollars. They had not undergone that art-market alchemy whereby an artist publicly exhibits a painting that is purchased by a collector who, after a certain length of time, resells it on the secondary market, perhaps at auction, perhaps for a sizable profit. It is the sale and resale of paintings that establishes their market value.

Danenberg's gallery was located at 1000 Madison, at Seventy-seventh Street, next door to the Parke-Bernet auction house. That stretch of Madison Avenue seemed to operate at a calmer pace than the rest of the city. It was lined with boutiques and shops whose windows invited lingering glances at jewelry and designer dresses, at Picasso etchings and star-strewn Miró lithographs and Calder's bolder, Americanized abstractions, with their clanging reds and yolky yellows. Beyond the display windows, the interiors of the galleries seemed eternally empty, as if each sale netted such a substantial profit it was sufficient to have only a few sales a year.

Which is not to say that Madison Avenue was stuffy, or reserved for the leisurely peregrinations of tourists. The Leo Castelli Gallery, just around the corner from Danenberg, at 4 East Seventy-seventh Street, was the

headquarters of the Pop art movement. That Rockwell was offered a one-man show in New York in 1968 was not a coincidence. His reception was helped immeasurably by the advent of Pop art, which had restored realism to the avant-garde and marked an end to the reflexive worship of abstract painting that had prevailed in the art world for nearly half a century.

•

In order to assemble a Rockwell retrospective at his gallery, Danenberg had to buy or borrow enough pictures to fill two rooms. Rockwell furnished him with information to help him trace paintings and drawings to their owners, who were not officially art collectors so much as people who, for various reasons, happened to have a few Rockwells—his former brother-in-law, his former art editor at the *Post*, his former neighbors in New Rochelle and Vermont. Danenberg sent a truck up to Stockbridge to retrieve the pictures from the storage racks in Rockwell's studio and other places he had deposited them.

Rockwell was not the only illustrator to be "discovered" by the art world in the boundary-crashing sixties. By a nice coincidence, just as he was preparing for his first one-man show in a New York art gallery, a Maxfield Parrish memorial exhibition arrived at the Berkshire Museum in Pittsfield. Parrish had died in 1966, aged ninety-five. Rockwell was asked to review the show for *The Berkshire Eagle*. During his days at the Art Students League, he had looked to Parrish as a tutelary god, one of the giants of the Golden Age of Illustration, an artist who had furnished beautiful illustrations for *Mother Goose* and *Arabian Nights* and other extra-large children's books that had to be held with two hands.

Rockwell was casually acquainted with Parrish and once, circa 1938, visited him at the Oaks, his hillside estate near Cornish, New Hampshire. He had asked Parrish why he never came down to New York to attend events at the Society of Illustrators. Parrish was frank. On his one and only visit to the Society, illustrators loudly blamed him for the loss of ideal-ism in American illustration.[4]

It was true, to some extent. Parrish was the first major American illus-trator to descend from book illustration into the trough of advertising. He became a household name in the twenties, when the Edison Mazda Lamp Works, a lightbulb manufacturer later absorbed into General Electric, published some 20 million Parrish calendars. This was his girls-on-rocks

period. Every month, you tore off the previous month's picture and got a new one—a new girl lolling around between dusk and twilight, as if to suggest that Edison Mazda oversaw not only lightbulbs but the manufacture of sunrise and sunset as well.

In 1931 Parrish announced that he was done being a purveyor of lightbulbs. His true ambition, he said, was to paint landscapes. He devoted himself to imaginary vistas bathed in hues of coppery orange, sulfuric yellow, and cobalt blue, the last of which he used in such large quantities it came to be known as Parrish blue. The landscapes were published in calendars by Brown & Bigelow, which also published Rockwell's Boy Scouts calendars. Although Parrish severed his contract with General Electric, his colors retained their distinctly GE quintessence, emitting a light that bore no relation to nature but rather seemed almost electric. During the Depression, his work was seen as an icon of gaudy abundance, and he fell into obscurity.

Just a few years before he died, Parrish was gratified to find himself rehabilitated by a generation in thrall to his psychedelic colors and unreal worlds. "He was amazingly ubiquitous in college at apartment marijuana parties," recalled Michael Crawford, the longtime cartoonist for *The New Yorker*.[5] Art historians eager to devise an ancestry for Andy Warhol cited Parrish as a legitimate forebear, mainly because he had smudged the line between art and advertising. Lawrence Alloway, a scholar of Pop art, organized a much-discussed Parrish exhibition at Bennington College in 1964. The following year, the Metropolitan Museum of Art purchased its first-ever Parrish (*The Errant Pan*), giving the reputation of the ninety-four-year-old artist an instant upgrade.

When Rockwell visited the Parrish retrospective at the Berkshire Museum that August, he saw a painting he desperately wanted to own. He contacted the Vose Gallery in Boston, which represented the artist's estate, and purchased *A Good Mixer*, a small, striking self-portrait that had run on the cover of *Life* in 1924. You wonder whether it influenced Rockwell's early self-portrait, *Blank Canvas*. Parrish portrays himself in stark profile, face to face with a blank canvas, in the tensely expectant slip of time that comes after a palette is loaded with pigment but before the first stroke is applied. With six fresh, blond-haired brushes in one hand, and a medium-sized brush poised for action in the other, he has everything one needs to make a painting. Everything except the foggiest idea of what to paint.

•

On October 1, after returning with Molly from a last-minute vacation in England and Portugal, Rockwell went down to New York to appear as a guest on *The Tonight Show*. It was Johnny Carson's sixth anniversary as host and Rockwell had been commissioned to paint a portrait of him and deliver it on-air as a surprise. The kind of surprise that is scripted down to the last arched eyebrow. Although a tape of the show seems not to exist, one suspects that Rockwell held his own beside his fellow guest, John Lindsay, the mayor of New York, a fixture on the Carson show who somehow maintained his glamorous demeanor as his city slid into financial trouble and became the subject of comedians' jokes about piled-up trash on the sidewalks.[6]

The following week, Rockwell was in New York again for a day of tightly scheduled appointments. He saw Danenberg at the gallery, Allen Hurlbert at *Look*, and had a portrait session with two acclaimed rock stars: Al Kooper and Mike Bloomfield, who hoped to use his work on the cover of their next album. As Kooper recalled in his memoir, "All of a sudden it hit me. Let's get Norman Rockwell to paint a portrait of me and Michael. Is that fucking beautiful or what?"[7]

Kooper, a singer and organist for two rock groups—the Blues Project and Blood, Sweat & Tears, as well as a legendary studio musician who contributed to work by Bob Dylan and the Rolling Stones—was then teamed up with the guitarist Michael Bloomfield, recording a series of blues jam sessions. Rockwell agreed to do the cover for their second album, *The Live Adventures of Mike Bloomfield and Al Kooper*, one of the seminal albums of the sixties.

The portrait session was held in a photography studio at Columbia Records, in midtown Manhattan. Kooper and Bloomfield were excited to meet Rockwell. Bloomfield, who had flown in from San Francisco and was not averse to popping pills, talked a blue streak. He kept saying that Rockwell *must*, just *must*, come out to Haight-Ashbury and paint the people there. "He couldn't really shut up,"[8] Kooper recalled years later. "It must have been speed or something.

"Norman was able to deal with any situation," Kooper continued. "This was the time of hippies. I thought he fit in quite well with that. He was very calm and nothing fazed him. He photographed us and then off he went."[9] A week later, Kooper was surprised when he took in the mail

and found an invitation to a Rockwell exhibition that was opening soon at a gallery on Madison Avenue.

•

The show at the Danenberg gallery opened on October 21, and stayed up for three weeks. People strolling along Madison Avenue in the cool autumn air could see *Saying Grace*, with its grandmother and little blond boy praying in a railroad-station luncheonette, displayed in the gallery's big front window. In other words, a painting of a restaurant storefront visible in a Madison Avenue storefront. Glass upon glass. A reminder of Rockwell's thematic complexity, an image of boyhood innocence beckoning from the unreachable space behind the glass wall.

An opening reception was held, a six-to-eight-o'clock affair attended by a throng of illustration people and advertising people. Moët & Chandon had offered to donate champagne for the occasion in exchange for permission to photograph Rockwell sipping on a flute of it, for use in an advertising campaign. Danenberg agreed without consulting Rockwell and

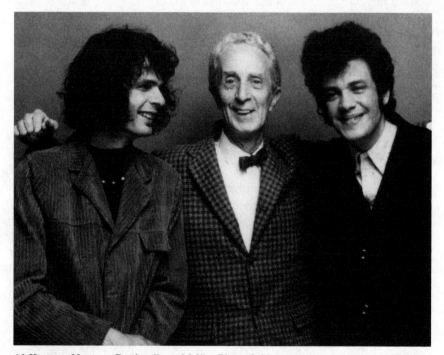

Al Kooper, Norman Rockwell, and Mike Bloomfield (Photograph by Bob Cato; courtesy of Al Kooper)

a shipment of boxes arrived in short order. ("I had champagne for seven years," Danenberg recalled gleefully.[10]) Dressed in his customary tweedy jacket, with a plaid bow tie, Rockwell arrived at the reception half an hour late and, by most accounts, felt embarrassed by the fuss.

Among the visitors was Al Kooper and his musician-wife, both of them in flamboyant rock-star clothes. They knew no one and made their way around the perimeter of the room, pausing to look at each painting and drawing. "My favorite thing was his painting of Bertrand Russell,"[11] Kooper recalled later. "He looked like a chicken. It killed me. That was the high point of my night."

When Rockwell spotted Kooper, he pulled him aside and led him to a small office in the back of the gallery. "I don't really like these things," Rockwell confided, lowering his voice. "So I think I am going to stay here as much as I can. But I wanted to see you and apologize and say that I am very close to finishing"—finishing his much-delayed album cover, that is.

•

The show received a friendly enough mention in Grace Glueck's Friday Art Notes column in *The New York Times*. "Mad Avenue's least Minimal show is—brace yourself—a Norman Rockwell retrospective," she noted. "Some 50 rich, ripe, hand-painted oils by the folksy SatEvePost color illustrator are packing them in."[12] Rockwell spoke to her by phone and she got some good quotations out of him. "I'm overcome," he told Glueck. "It's the first real show I've ever had in New York. I've always wistfully thumbed through art magazines, hoping that even one critic would use me as a whipping boy. But no."

In the end, he was not to have his desires fulfilled. The show was ignored by most art critics, except for a lone reviewer at *Arts Magazine*, who was complimentary. Rockwell promptly sent him a thank-you note. Thomas S. Buechner (pronounced BEAK-ner), the young director of the Brooklyn Museum and a figurative painter himself, wrote a lovely "review" that appeared in *The New York Times*.[13] The article was in fact an advertisement. "I paid for it," Danenberg confessed later.

The paper's art critics, in the meantime, remained silent. Rockwell had long been demonized as an entertainer rather than an artist, and neither Hilton Kramer nor John Canaday was willing to dignify his efforts by writing even a thoughtful dismissal. They believed they had to save their time for ennobling encounters with high art. Yet the divide between

middlebrow art and high art was never as wide as certain people pretended and Rockwell's work made a strong impression on countless artists who visited the show and found themselves surprised. Here was one more woefully misunderstood artist.

Willem de Kooning, who was then his midsixties and acclaimed as the country's leading abstract painter, dropped by the show unannounced. Danenberg, who was there to greet him, recalled that he especially admired Rockwell's *Connoisseur*, the one in which an elderly gentleman contemplates a Pollock drip painting. Rockwell had gone to great lengths to replicate the precise chaos of a Pollock canvas and de Kooning noticed. "Square inch by square inch," he announced in his accented English, "it's better than Jackson!"[14] Hard to know if the comment was intended to elevate Rockwell or demote Pollock.

Warhol also came in to see the show. "He was fascinated," Danenberg later recalled. "He said that Rockwell was a precursor of the hyperrealists."[15]

In the next few years, Warhol purchased two works by Rockwell for his private collection. The first was a smallish portrait of Jacqueline Kennedy, from 1963, in which the first lady is a sweet- if somewhat vacant-looking figure with wide-set doe eyes and bouffant hair, a strand of pearls around her neck.[16] Warhol also bought a print by Rockwell, *Extra Good Boys and Girls*,[17] in which a red-clad Santa sits on a ladder, plotting his Christmas Eve route on a world map unfurled on the wall behind him. Santa, like Jackie, was known by his first name and no doubt qualified in Warhol's star-struck brain as a major celebrity.

Rockwell's art, compared to that of the Pop artists, was not only accessible but actually popular. The Pop artists had admired it to varying degrees since they were kids. In interviews, they cited Rockwell and *The Saturday Evening Post* as an important influence on their work, as did many other artists who first saw Rockwell's work in the magazines to which their parents subscribed.

What's interesting is that by 1968 Rockwell was suddenly in line with a younger generation whose work shared and thus validated his interest not only in realism, but in crisp edges and photographic precision. Much of the new work stood at an opposite pole from the undulating skeins of dripped paint and blazing stimuli of Pollock, whose imagery evoked something cosmic and flowing (the night sky, the beginning of the world), as well as hidden interiors—jangling nerve fibers, axons and dendrites, pure

emotion. "We are making it out of ourselves, out of our own feelings," Barnett Newman, the talkiest of the Abstract Expressionists, once said.[18]

Rockwell, by contrast, was always latching onto the legible world, onto disparate objects, each one distinct from the next. The same held true of the Photo-Realists, who emerged circa 1968 as a subset of Pop and whose methods were uncannily similar to those of Rockwell. They, too, had darkrooms built into their studios and made photographs an essential part of their painting process, variously copying them by hand or using (as Rockwell did) a Balopticon to enlarge and project them.

To be sure, many European masters—Manet, Degas, Vermeer, and Canaletto—had used cameras and camera obscuras as painting aids, but the Photo-Realists were probably the first group of painters to publicly admit it, to out the camera in art history. "Everyone had used cameras and denied it," notes Richard Estes, an early Photo-Realist known for capturing fleeting reflections in the glass and metal surfaces of the city. "I own up to it. I consider my camera a sketchbook. I think that with Rockwell, it's the same way."[19]

Audrey Flack, another pioneering Photo-Realist, then exhibited with French & Co., which was located in the building adjacent to the Danenberg gallery. She had never given much thought to Rockwell but wandered next door to see the show. "I loved it,"[20] she said years later. "I thought Rockwell was a terrific painter. You know, Andy Warhol is not a good painter. He is a graphic artist, a designer." Indeed, Rockwell drew with a fierce concision that harked back to the academic tradition of anatomical correctness, whereas Warhol seized on the basic strategy of graphic design, subordinating drawing to the demands of the quick visual punch.

Put another way, Warhol used the techniques of commercial art to make high art, whereas Rockwell used the techniques of high art to make commercial art.

Of the four dozen paintings in Rockwell's gallery show, the majority were not for sale. Rockwell had no interest in parting with the ones he owned, in part because Molly had been talking about starting a museum in Stockbridge. A few paintings did get away, at prices that today seem indecently low. *The Problem We All Live With* was sold for $15,000, to Jack Solomon, who owned the Circle Gallery; he also purchased *The Russian Schoolroom* for $8,000.[21] Larry Casper, the codirector of the Danenberg gallery, bought *Night Watchmaker* for $6,000. At the time, works by first-tier

American realists such as Edward Hopper or George Bellows were selling for ten times that much.

Arthur Teichmann, who was better known as Arthur Murray and had retired from teaching ballroom dancing a few years earlier, saw the show and tried to buy a painting for his wife. There was one he wanted desperately: *Girl at Mirror,* for which he offered $15,000, but Rockwell declined to sell.[22]

•

Two Tuesdays after the opening of his exhibition, Election Day arrived. Rockwell was assigned to paint a portrait of the new president for *Look* magazine. He had expected to be painting Hubert Humphrey and remained incredulous that Richard Nixon had won. Rockwell's editors at *Look,* despite their generally liberal leanings, were exhorting him to be kind to the president, if only to help them cultivate sources in the new Republican administration. As Rockwell explained, "*Look* said, 'We want to have a relationship with the White House, so you better do him looking at his best.' So boy I fixed him up."[23]

Rockwell had painted Nixon three times since 1957 and his previous encounter with him—a portrait session at the Plaza Hotel during the 1968 campaign—had been tense.[24] He lost patience when Nixon paused in the hotel hallway to chat up two cleaning women and invite them to visit him at the White House should he win the election. Standing in the carpeted hallway, watching Nixon awkwardly ingratiate himself with the maids, Rockwell thought about the thin line separating a charming gesture from a phony one.

Now, on November 14, Rockwell was driven to New York for a portrait session scheduled for the next day. He had been instructed to meet the president-elect at the Pierre Hotel, in a suite that served as the Nixon transition headquarters. Rockwell never did get in to see him. He waited fruitlessly on the thirty-ninth floor as Nixon remained tied up in a series of meetings until emerging at the end of the day, a Friday, to fly off to his place in Key Biscayne for the weekend. This is not to suggest that Rockwell was the object of a presidential snub. Nixon declined to pose for any portraitist during his presidency.

Faced with an immobile deadline, Rockwell improvised. He painted a head-and-shoulders portrait jiggered together from various visual sources. He basically grafted Nixon's head—which came from photographs taken

by *Look* a year earlier, during the campaign—onto the shoulders and hands of a man who posed for Rockwell in Stockbridge. What was intended as a portrait of Nixon seated on a couch instead looks like a painting of Nixon's head visited by an unrelated hand.

Nonetheless, it is relatively flattering, as far as portraits of Nixon go. The thirty-seventh president had a "pear face,"[25] as the writer Garry Wills observes, a face that appeared heavier about the mouth and jowls and seemed to recede from you about the brow and eyes. His sloping nose was the stuff of easy caricature. In Rockwell's portrait, Nixon assumes a partial Rodin-*Thinker* pose, meaning hand raised to chin, a clever maneuver on Rockwell's part that allowed him to conceal Nixon's jowls behind his left hand and give him a more angular and attractive jaw.

He delivered the painting to *Look* on November 25, the Monday before Thanksgiving, and gave thanks that it was finally finished. It was eventually acquired by the Smithsonian Institution's National Portrait Gallery, in Washington, D.C., which was desperate to find a noninflammatory likeness of the president to hang in a room previously reserved for Peter Hurd's portrait of LBJ. When Larry Casper at the Danenberg gallery initially called Rockwell to inform him that the National Portrait Gallery was interested in buying what it called a "done-in-life portrait" of Nixon, the artist was surprised. Nixon, after all, had declined to pose for the portrait and his shoulder and hands belonged to a total stranger. But the curators at the National Portrait Gallery apparently thought the painting was at least in the "done-in-life" ballpark.

"See how much you can get for it," Rockwell instructed Casper, departing from his customary practice of allowing presidents to keep his portraits of them at no charge. He was pleased when the National Portrait Gallery offered him $6,500, with help from Nixon's private foundation. "He was happy to let it go," Casper recalled.[26]

●

With Nixon out of his studio, Rockwell returned to the album cover for Al Kooper and Mike Bloomfield. He had already sent a charcoal sketch of the two musicians to Columbia Records, seeking approval before continuing. There was always a chance that a client might bail after seeing the sketch. Kooper loved it, even as he acknowledged that his physique could stand some improvement. "At the time I was very thin, like a Bangladesh poster boy," Kooper recalled. He asked Rockwell if he could paint him

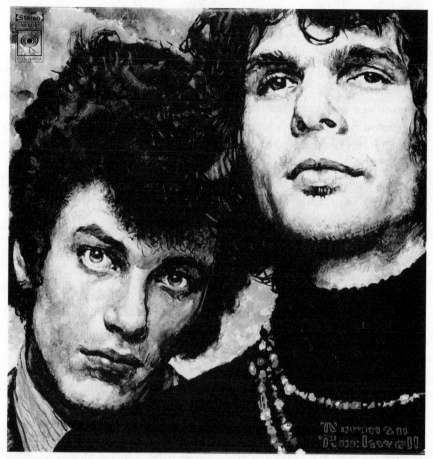

In 1968 Rockwell provided the portrait for the album jacket of *The Live Adventures of Mike Bloomfield and Al Kooper.* (Courtesy of Al Kooper)

"10 pounds heavier."[27] In the end, the album cover of *The Live Adventures of Mike Bloomfield and Al Kooper* shows the two musicians in cinematic close-up, their bushy-haired heads framed against a sky-blue ground that is unusually loose and brushy for a Rockwell. Bloomfield is on the left, a thin man with pouty lips and a dreamy-stony gaze. He tilts his head toward Kooper, his chin resting lightly on his friend's shoulder. Kooper appears more assured, larger—Rockwell has indeed added the requested ten pounds. He lifts up his chin as if to glance out from greater heights, or perhaps to better display his black turtleneck and three strands of love beads.

The cover can put you in mind of another album that had just been released by Columbia records: Simon & Garfunkel's *Bookends*, which had come out in April, and whose arresting cover, with its black-and-white portrait by Richard Avedon, resists the psychedelic imagery of its era in favor of the moodily poetic. Rockwell's album cover shares much with that of *Bookends*: the same close-up view of two male faces, the same aura of silence.

•

On December 31, 1968, Rockwell and Molly flew to Nassau for a vacation. She could see how much he needed a rest. His show at Danenberg had barely closed when Danenberg started pushing him to schedule a second show for the following October. Moreover, Danenberg was imploring him to put aside his commercial work and try painting for himself, try to be an official American Master instead of just an overworked illustrator.

Rockwell said he would try, and maybe he meant it at the time. In the past, his sporadic efforts to make "real art"—to undertake a painting that had not been assigned to him by a magazine or an advertising agency—hadn't worked out. His last effort had been made a decade earlier, in 1958, when he had publicly announced that he was taking a sabbatical from the *Post* and going off to be a real painter. There were, to be sure, the portraits he had done in Peggy Best's sketch class; he had shown them at the Berkshire Museum in 1958. The show had garnered no reviews, except for a piece in *Newsweek* that carried a painful headline—NORMAN ROCKWELL ASTRAY—and assessed his nonillustration paintings as roughly comparable to "the work of a competent amateur."[28]

He felt inadequate enough being an illustrator trying to get his assignments in on time without shouldering the added burden of art. That was

the deal with commercial illustration: if you were lucky, you were permanently overbooked with assignments, and deadlines arrived faster than your ability to dispense with them, likes flies too numerous to swat. Rockwell felt as if he was working from "exhaustion to exhaustion," as he told a local reporter.

Danenberg was thinking about ways to enlarge Rockwell's reputation as a fine artist, which is what dealers are professionally obliged to do. But Rockwell had no illusions about his longevity. Picasso, Pollock, even Warhol—those guys would still be known in a hundred years, carrying the contorted face of the twentieth century into the future. He could hardly expect the same for himself. Popularity was a losing game in the long run. He had only to think back to his dear friend J. C. Leyendecker, a household name after World War I, to know that even the most dazzling careers in magazine illustration eventually fade to black.

# THE BROOKLYN MUSEUM

## (1969 TO 1972)

On February 3, 1969, Rockwell celebrated his seventy-fifth birthday. His big plan for the day, he told a reporter, was to get a haircut. He was scheduled to fly down to Cape Kennedy in Orlando the next day, accompanied by Molly, to do some preliminary research on a painting of the moon landing for *Look*. The haircut got top priority, he joked, because "I don't want to disgrace Stockbridge down in Florida." He added that he was very grateful that he still had a few strands of hair to cut.

As Rockwell continued to accept assignments and produce new work, he paid little attention to the older drawings and paintings collecting dust in his studio. Like most artists, his creative relationship with a painting ended when it acquired a frame. Molly Rockwell, on the other hand, had begun to contemplate the possibility of keeping his paintings together in Stockbridge, on display at the Old Corner House, which was about to open to the public.

The project had begun in June 1967, after a developer threatened to despoil the old Dwight House, a handsome white clapboard right on Main Street, at the corner of Elm. His plan was to erect a supermarket on the lot. There is nothing like the mention of a new A&P to spawn alarm among preservationists, and the members of the Stockbridge Historical Society quickly raised $40,000 to buy the house. At first the Old Corner House didn't have much to do with Rockwell. It was conceived as a home for the historical society, which was then squatting in the basement of the town library. Its collection included papers and

assorted *objets* going back to 1734, when the first white man, the Rev. John Sargeant, settled in Stockbridge and persuaded Indians to join his congregation.[1]

On May 31, 1969, two summers after it was purchased, the Old Corner House opened quietly to the public. By then Rockwell had agreed to place some thirty-five paintings on "permanent loan," including his *Four Freedoms, Marriage License, Stockbridge—Main Street,* and *Shuffleton's Barbershop.* Molly Rockwell was on the board of directors (second vice president), along with Mrs. Clement Ogden (president) and Mrs. James Deely (first vice president). Rockwell himself kept an unambiguous distance from the project, declining to serve as an officer. He claimed to find the attention embarrassing and over time visited the historic house as infrequently as possible.

Rockwell appreciated the Old Corner House even less as the number of visitors doubled and then tripled. Thousands upon thousands of people who had Rockwell images lodged in their brains like dimly remembered family photographs would be thrilled to rediscover them and see how large the original paintings were, much larger than a magazine cover. Some of the visitors saw fit, during their trip to Stockbridge, to stroll by Rockwell's studio in hope of getting a peek at him, requiring him to close his curtains during the day. Some even knocked and tried to say hello, their faces lit up with reverent wonder as he stood in the doorway trying to appear calm. "In the later years, it got to be crazy," recalled Lamone. "We had to put a sign up outside: 'Please go to the Old Corner House.'"[2]

•

As Molly Rockwell and the matrons who oversaw the Old Corner House held regular meetings and were pleased to learn of a steady increase in the number of visitors—admission was a dollar and went toward the upkeep on the house—Bernie Danenberg sat in his gallery on Madison Avenue, pursuing an opposite vision. He wanted to sell as many Rockwell paintings as he could, to disperse them among collectors. In addition to mounting a show at his gallery, he believed he could burnish Rockwell's salability by arranging for certain tributes and events, the kind that most people assume originate on the basis of pure merit and without interference from the Bernie Danenbergs of this world.

First, he called his friend Harry N. Abrams, the venerable art-book publisher, and proposed Rockwell as the subject of a monograph. The idea was clever, because Abrams was known for its sumptuous monographs on artists ranging from Michelangelo to van Gogh to Jasper Johns and was able to confer the luster of art history on living artists. A suave, stylish man in his sixties, Abrams was London-born and Brooklyn-reared. He had grown up working in his father's shoe store, an aesthete pondering two-toned oxfords.

In October 1968, on a Sunday afternoon when Rockwell's show was still up at the gallery, he was called in for a meeting with Abrams. It was on this occasion that Danenberg proposed that he and Abrams jointly publish a Rockwell monograph. The key word was *jointly*. Abrams recoiled at the notion, and said bluntly, "Bernie, you don't know anything about the book-publishing business."[3] Abrams, in fact, wanted to do the book on his own. He offered Danenberg a 3 percent commission on sales, suspecting it would satisfy the art dealer's need for involvement. "I lived for about five years on that commission," Danenberg later said.[4]

As the two men conferred on the details of the Rockwell monograph, Rockwell stood off to the side of the room as if the project had nothing to do with him. He did not even request royalties. Everyone agreed that his role in the book would be minimal. Of course he had made the art, but never mind. "Why should he get anything?" Danenberg asked years later with apparent sincerity. "The book was my idea and I got Tom Buechner, my friend, to do the text."

Indeed, Buechner, the director of the Brooklyn Museum, was commandeered to produce an authoritative essay. He was perfect for the task, an accomplished art historian and figurative painter whose views were appealingly iconoclastic. Rejecting the familiar narrative that reduces modern art to the birth and unfurling of abstraction, he believed realist painting had been criminally neglected at least since the Armory Show of 1913 and that Rockwell deserved much better treatment.

It might seem odd that a museum director would write such a book promoting an artist who was not part of the museum's collection. Solution: add a Rockwell to the collection before anyone notices the absence. In January 1969 *Tattoo Artist* was delivered by truck from the Danenberg gallery to the unloading dock of the museum.[5] Trustees voted to add it to the permanent collection one week later. That was the painting, from

1944, that is set in a seamy tattoo parlor, where a sailor is having "Betty" inscribed on his left arm by a male tattooist who is seen crouching from behind on a crate. The sailor's arm is covered with a list of crossed-out names belonging to former girlfriends: Sadie, Rosietta, Ming Fu, Mimi, Olga, and Sing Lo, a testament to his numerous romances.

*Tattoo Artist*, by the way, was a perfect acquisition for the Brooklyn Museum. It is among Rockwell's most urban works, and he had done the research for it in an actual tattoo parlor on New York's Bowery. The painting's relevance would only increase in the twenty-first century, as tattoos spread from the bulging muscles of Navy seamen to the yoga-toned flesh of a generation of hipsters.

•

*Norman Rockwell: Artist and Illustrator* was published in October 1970, two years after the show at the Danenberg gallery. The first book on Rockwell to include the word *artist* in the title, it weighed more than a chubby baby (thirteen pounds) and measured a foot by a foot and a half. It was Abrams who had forced the word *artist* into the title. "Norman maintained he wasn't an artist," recalled Bob Abrams, son of Harry and himself an art-book publisher, "and there was concern over the title of the book. He considered himself a working stiff."[6] With 588 illustrations, the book was one of those art-book behemoths whose exaggerated size is intended to signal the promise of a big art experience. "This is not a coffee-table book; it is the table itself," noted one reviewer. "One need only add legs."[7]

The book garnered enormous publicity and outsold every book Abrams had ever published. Despite the forty-five-dollar price tag (sixty dollars after Christmas), more than 200,000 copies were in print a year later. "He got two Christmas seasons out of it," recalled Christopher Finch,[8] a British critic who would soon be tapped to write the prefatory essay for yet another Rockwell monograph.

The publication of the Abrams book made Rockwell's work newly visible and encouraged an all-new reading of it. Suddenly, although his paintings had never been seen as a realistic view of the American present, they were held up as a realistic view of the past. Critics reviewing the book spoke of it as a social document that captured America before the fall—a world devoid of pollution, drugs, and violent crime. A world composed of decent individuals who convene in barbershops and auto-repair shops and always have time to hear your story.

In other words, Rockwell portrayed an America rich in "social capital," to borrow a phrase from political science that refers to the bonds people forge through friendship and shared citizenship. His work offered indelible images of ordinary citizens who felt connected to one another in the decades before the 1960s. Political scientists would later describe the seventies as a time when social ideals gave way to selfish individualism, the Me Decade, as Tom Wolfe pithily put it. Robert D. Putnam elaborated on the phenomenon in his book *Bowling Alone*, which bemoaned the loss of communitarian ideals and portrayed America as a nation of solitaries. In the seventies, his research found, Americans became less likely to join clubs, vote in national elections, or even invite a friend for dinner.

It was at this point that Rockwell's message came to seem so distinct that his name became an adjective. The word *Rockwellian* first appeared in print in August 1971, when a reporter for *The Christian Science Monitor*, visiting a church picnic in Sharon, Connecticut, commented, "Its pastoral setting could only be described as Norman Rockwellian." Over time, the word *Rockwellian* would come to denote a world purged of darkness and evil, life at its most sanitized and G-rated. What's interesting is how Rockwell, a repressed man who feared dirt and mud, a neat freak who washed his brushes with Ivory soap and polished his shoes on fishing trips, created a vision of human connectedness that dovetailed with the American fantasy of civic togetherness, which similarly required that baser urges (xenophobia, racism, killer competitiveness, etc.) be scrubbed out of the picture.

•

The PR department at Harry N. Abrams sent Rockwell on what publicists call a "national author tour," flying him and Molly around the country for more than a month. On the way to Los Angeles, they stopped in Dayton, Ohio, where Rockwell was mortified when a stewardess who noticed him hobbling off the plane offered him a wheelchair. He was exhausted by the tour and contracted a chest cold that he could not shake. But somehow he was able to muster his usual folksy charm for interviewers. When they asked him about the new book, he fake-objected vigorously to the word *art* in the title, protesting, "I'm an illustrator, not an artist."[9] Asked by *The Washington Post* what his sons thought of his work, Rockwell replied without missing a beat, "I've never asked them. I suppose they'd hold their noses."

In New York, he did the talk-show circuit—Dick Cavett, Mike Douglas, and David Frost—which required that he stay up later than he appreciated and tolerate the other impositions of live television, "where you have to wait, usually in the cellar surrounded by pipes, until your time comes to go on."[10]

Television interviews, unlike newspaper stories in which a stream of rambling conversation can be edited down into a few choice quotations, betrayed the toll that age had taken on Rockwell. On December 2, when he appeared on *The David Frost Show*, the recollection of key dates completely eluded him. Medical doctors or discerning viewers might have noticed that he sounded generally disoriented. In fact he was in the early stages of dementia.

As Frost flipped through *Norman Rockwell: Artist and Illustrator* and stopped at well-known paintings, hoping to elicit entertaining anecdotes about their genesis, Rockwell struggled for words and at times was able to furnish only non sequiturs.

David Frost: "What was the origin of *Doctor and Doll*, this one? It was 1929."[11]

Rockwell: "1929. Well, you see, you can't in America, you can't show a priest or a rabbi. So you use a doctor, because they have the respect of the public. I cannot remember who posed for it. I think the little girl is most likely grown and has children."

Frost jokes lamely: "1929? We hope she's grown!"

The host then asks Rockwell about more dates. "This was 1946," he says, pointing to a painting in the book.

"It was?" Rockwell asks. "I don't know."

A moment later, Frost says: "This is 1957, I think, wasn't it?"

"Gee, I wouldn't know. I can't remember."

In reference to *The Problem We All Live With*, Frost says, "This is what, 1964?"

Rockwell mumbles, "I wouldn't know."

Frost counters awkwardly, "I think you would."

By now anyone could see he was frail. His weight had dropped to 115 pounds, which was alarming for a man who stood five foot eleven and had seemed rail-thin even in his heavier days. "Once I weighed 145 pounds," he said, "but it all went to my belly."[12]

By now it had been twenty-five years since Arthur L. Guptill published his *Norman Rockwell: Illustrator*, the first-ever monograph on Rockwell.

Guptill was no longer alive. But the company he founded, Watson-Guptill Publications, refused to give Harry N. Abrams a monopoly on Rockwell books and reissued its own that fall. The text went only as far as World War II and the illustrations included nothing more recent than the *Four Freedoms*. But at $14.95, it was one-third the price of the Abrams book and outsold it. For one week, it even appeared on *The New York Times* bestseller list, right behind *The Sensuous Woman*, by the author who listed herself as J, and *Everything You Always Wanted to Know About Sex*.[13]

•

Danenberg planned to follow up his Rockwell exhibition with a second one-man show at the gallery. In the course of a year, several dates were reserved and scratched out in short order. Rockwell kept pushing the show back, as if it were possible to push it into oblivion. "Dear Norman," Danenberg wrote in January, "I am disappointed that you are once again postponing your exhibition to the fall."[14] He had been hoping that Rockwell would produce a group of paintings that were not magazine illustrations, but that could be marketed as 100 percent art.

"Obviously it cannot be financial need that compels you to accept additional commissions," Danenberg continued, in a tone of annoyance that verged on bullying. "If you are at all concerned with securing a permanent place for yourself in the mainstream of American art, you should give serious thought to my suggestion."

It was Molly Rockwell who answered Danenberg, in a pointed letter. The 1968 gallery exhibition, the Brobdingnagian Abrams book, the cross-country book tour, the many interviews—they had taken their toll on Rockwell, burdening him with a level of "exposure that has brought the world about his ears. For any man of his age (he will be 77 this week) it would be confusing, and for him, with his particular temperament, it has proved overwhelming and painfully bewildering."[15]

It is artists, not dealers, who are supposed to feel insufficiently appreciated. But Danenberg, irritated by Rockwell's repeated refusals to have a second show, became unhinged when he heard that Rockwell was contemplating doing a new project with Abrams and allowing the book publisher to issue a portfolio of prints. He tried to turn Rockwell against Abrams, reminding him that the big monograph, with an initial print run of 56,000 copies, had quickly sold out—yet failed to provide the artist with a penny in royalties. "His publication of your book was not an act of

charity," Danenberg noted three months after the book came out.[16] "He has probably made half a million on the first edition, and will most likely do better on future editions. How much royalty are you getting?"

Nothing, actually. As Molly wrote to Danenberg, Rockwell "was so pleased to have it brought it out that he himself declared that he did not want any royalties. Mr. Abrams is in the process of drawing up a legal contract to pay him generously in spite of his renunciation."[17]

Who ever heard of an author or artist who doesn't want royalties? Rockwell was not exactly a shark when it came to negotiating on his own behalf and Molly's comment that Rockwell had done the Abrams book without even a contract makes one realize how little stamina he had for business dealings.

Although Abrams finally drew up a contract, it was not generous, promising a small royalty payment (fifty cents per book, or less than 1 percent of the cover price) on future sales. Never mind the tens of thousands of books that had already sold. The contract also provided for a variety of new projects that were tacked on like so many congressional riders. Perhaps the most frivolous was a "Special Edition" of the monograph, a "numbered leather-bound edition" of one hundred copies, each of which would have to be signed by the artist.[18]

Toward the end of the summer, Danenberg once again tried to persuade Rockwell to have a second show at the gallery. Rockwell again declined, testily informing the art dealer that such an exhibition would be deleterious to the pace and progress of his work. "May I repeat that I just want to paint, uninterrupted, more and better pictures."[19]

•

By then Danenberg was dreaming up Rockwell exhibitions on an ever grander scale. In April 1971 he took it upon himself to suggest to the Brooklyn Museum that it join him in co-organizing a Rockwell retrospective that could travel around the country and earn money for both Danenberg and the museum. He did this without Rockwell's permission. He hoped that he might convince Rockwell to lend the *Four Freedoms* and a few other of his best paintings to the retrospective, but by now the art dealer owned or knew enough people who owned enough Rockwell paintings to do the show without Rockwell's participation if he had to. Which, sadly, is exactly what happened.

On April 22, Danenberg drove his Bentley convertible to the Brooklyn Museum, where he met with Buechner and curator Sarah Faunce. He told them he was "a Brooklyn boy," a native whose love for the museum was so deep as to be almost tribal. After the meeting, Faunce wrote up the proceedings in a memo, noting that Danenberg proposed to organize a Rockwell exhibition that would open in Brooklyn and then "circulate to several (perhaps as many as ten) museums around the country." He hoped to benefit financially: he would receive one-third of all ticket sales, and tickets were one dollar apiece.[20]

Just a few weeks later, Buechner, who had grown exasperated trying to run a museum amid the shaky finances of Mayor John Lindsay's New York City, left Brooklyn to take a job upstate, as president of the Corning Museum of Glass. Danenberg wasted no time in writing a letter to the museum's new director, Duncan Cameron, a hard-nosed Canadian businessman. The new director wrote back: "I am glad to report that we would like to take the exhibition on the terms you state, namely on a non-fee basis with one-third of the admissions receipts returnable to the [Danenberg] Gallery to cover expenses."[21]

At the same time, Cameron wondered about the propriety of the arrangement. Two weeks after officially approving the show, he wrote for advice to his friend Evan Hopkins Turner, the director of the Philadelphia Museum of Art, "to raise the question about museum ethics."[22]

Turner answered him immediately. The Brooklyn show, he informed Cameron with admirable frankness, struck him as unethical. He was surprised the museum would allow its premises to be commandeered, even temporarily, by Danenberg. His own museum, the Philadelphia Museum, Turner pointed out, "has a policy that it presents no exhibition that has been done entirely by a commercial dealer. We have the inevitable fear of the vested interest the dealer must have, often to what degree unbeknownst to the institution. Thus, we have a carte blanche rule."[23]

In the end, the Brooklyn Museum went ahead with the show as planned. It was Danenberg who selected the pictures and did basically everything other than write the reviews.

•

The Brooklyn Museum retrospective should have been the capstone of Rockwell's professional life. Finally, after a half century as an illustrator,

he was being celebrated as an artist whose paintings were fit to appear not only on magazine covers but in a leading American art museum whose holdings went back to the art of ancient Egypt and whose Beaux Arts building, at 200 Eastern Parkway, was of the exalted Greek-temple variety, complete with a colonnade of iconic Ionic columns out front.

But Rockwell wanted nothing to do with the exhibition. It was almost impossible for him to view it as a meaningful event. It had sprung less from an interest in his work than from the stark pursuit of profit. It had been conceived by a Madison Avenue art dealer interested in raising the value of Rockwell's paintings by having them gain the imprimatur of the Brooklyn Museum, which, in turn, had taken on the show not to provide visitors with an aesthetic experience but to capitalize on the artist's popularity, draw throngs to its premises, and relieve its crippling money headaches.

Which is hardly a crime. But it is unsettling to realize that the museum exhibition was no more rigorous than the ones organized over the years by *The Saturday Evening Post*, which promoted Rockwell for its own gain. The *Post* belonged to the world of consumerism, of efficient refrigerators and new cars, whereas an art museum is a nonprofit institution that ostensibly extricates itself from the demands of consumerism in order to better arbitrate aesthetic and ethical issues.

Six weeks before the show opened, Cameron wrote to Rockwell to invite him to the opening reception. "It would mean a great deal to all of us if you could be present on this occasion," the museum director wrote.[24]

"Dear Mr. Cameron," Rockwell replied tersely on February 8. "My schedule is so crowded it is just out of the question . . . I am very sorry that I cannot accept the invitation."[25]

Buechner, the former director of the museum, was summoned to do a Rockwell intervention. He personally liked Rockwell and was reluctant to prevail on him for a favor, but did his halfhearted best. "The fact that your schedule is too full to permit your attending the opening at Brooklyn means, to them at the least, that you don't consider the exhibition very important," he reminded Rockwell in a letter. "As they have chosen you as the artist to follow last year's extraordinarily successful exhibition of Van Gogh's paintings lent by the Dutch government, you can imagine their feelings. Please reconsider."[26] Rockwell did reconsider. His decision was to fly to Europe the day the show opened. He and Molly took a week-

long vacation, visiting his son Peter in Rome and continuing on to Tunis and Spain.

Another source of friction was Rockwell's refusal to lend his best pictures to the show. He declined to share the *Four Freedoms*. At the last minute, at Buechner's urging, he did relent on *Marriage License* and *Shuffleton's Barbershop*, both of which were on loan to the Old Corner House. One condition: the paintings could be shown only in Brooklyn and would have to skip the yearlong tour that would be taking the Rockwell retrospective to some ten museums. Just two weeks before the show opened, Rockwell called a taxi and had the two paintings driven down to Brooklyn. "I'll be glad to send down for them when the exhibition is over," he pointedly informed Cameron.[27]

•

*Norman Rockwell: A Sixty Year Retrospective* opened at the Brooklyn Museum on March 22, 1972, and stayed up for two months. It was accompanied by a glossy catalog of the same title, which acknowledged up front that the show had been organized not by the museum, but by Danenberg. Abrams stood to profit from the show as well. In addition to publishing the exhibition catalog, he conveniently became a Rockwell collector moments before the show opened, acquiring a cache of Rockwell paintings whose value was likely to rise as a direct result of the exhibition.[28] (No painting ever went down in value by being put on view at an art museum.) Six paintings in the exhibition catalog were identified as belonging to the "Collection Harry N. Abrams," among them *The Flirts*, *Weighing In*, and *A Time for Greatness*, which depicts JFK in a room jammed with delegates, receiving the acclamation of his party at the Democratic National Convention. Abrams presumably acquired the paintings with the intention of selling them and, over time, the Rockwells he lent to the show would find their way into the first-rate art collections of Steven Spielberg and George Lucas.

Although Rockwell missed the opening reception, the PR department at the museum was eager to have him pay a visit. A staff publicist drew up a memo entitled, in earnest, "Luring Norman Rockwell to the Brooklyn Museum."[29] The memo noted, "If we can get him down here for one day, we can arrange a Channel 5 interview . . . perhaps a Gabe Pressman interview."

Rockwell never did see the sixty-year retrospective. Perhaps he and Molly felt uneasy about the commercial thrust of the show, which was less an homage to his artistry than his potential salability. Or perhaps his absence was more of a reflection of a general exhaustion with the madding crowd. On some days he felt as if his memory was going and it did not take much to make him feel overmatched.

•

The most important review of the retrospective appeared long after the show closed at the Brooklyn Museum. Peter Schjeldahl, a poet-turned-art-critic in his early thirties who lived on St. Marks Place in the East Village and was known as a champion of new art, reviewed the show in his Sunday column in *The New York Times* on June 24, 1973, beneath the amusing headline STILL ON THE SIDE OF THE BOY SCOUTS—BUT WHY NOT?[30]

By then the retrospective had traveled to nine museums and become "an abbreviated remnant" of its original self. Schjeldahl saw it at its final stop, the Danenberg gallery on Madison Avenue. His review was groundbreaking, a litany of firsts—the first nonhostile review of Rockwell's work by a hip young art critic, the first to find an exhibition catalog as "irresistible as a can of salted peanuts," the first to acknowledge the commonalities between Rockwell and the seventies art scene, one of them being that Rockwell's method of rendering from projected photographs was similar to that of the Photo-Realists, whom Schjeldahl described as "the most radical wing of current American painting."

Nimbly dismissing a line of (unnamed) critics going back at least to Clement Greenberg and snobs who believed that art should be limited to the happy few, Schjeldahl calmly concluded that "the gap between Rockwell and modernism is just a gap, not a battle line."

His comment implicitly acknowledged the respect that Rockwell commanded among a new generation of artists. Photo-Realists, Pop artists, and at least one stray Abstract Expressionist had seen his debut gallery show in 1968 and come away impressed. Schjeldahl was personally acquainted with de Kooning and later recalled visiting him, circa 1972, at the artist's studio-barn in East Hampton. Noticing a hefty new monograph lying on a table, he asked with more than a bit of surprise: "Rockwell?"

De Kooning replied in his accented English, "Yes, Rockwell," and proceeded to open the book and show him something. He handed Schjeldahl a magnifying glass and made him look at the almost infinitesimal but energetic brushwork in the corner of one reproduction. "See?" de Kooning said, *Abstract Expressionism!*"[31]

# "BUT I WANT TO GO TO MY STUDIO"

## (1972 TO 1978)

In 1972 Rockwell was well aware that he was losing his memory. He often felt confused and discombobulated. It has been widely reported that he was suffering from Alzheimer's disease, but the only reliable test for determining Alzheimer's is a biopsy of brain tissue; no autopsy was performed when Rockwell died. It does not diminish his disease to refer to it as plain, lowercase dementia.[1] However it is characterized, it descended like a dense fog and he drifted in and out of it.

Magazine editors, aware of his condition, no longer called much. Nor did the art directors at advertising agencies who had pursued him for years. But there were a few people who wanted to have their portraits painted. In the past, Rockwell had declined such requests; there was not enough time for them. But Molly now welcomed the interruptions, so long as the sitters could afford his fee, which started at around $5,000. While some of Rockwell's friends criticized Molly for committing him to un-challenging work, she did, to her credit, bring in assignments that enabled him to keep working for most of the last six years of his life. It was not a glorious conclusion to his career, but it helped stave off despair.

And so they came, American icons who wanted to have their portrait done by an American icon. In August 1972 Rockwell was contacted by the golfer Arnold Palmer, who had been hoping for a full-length likeness. "I can only do a head and shoulders," Rockwell replied.[2] Two weeks later, Arnold and Winnie Palmer traveled to Stockbridge by private jet and brought along an entourage of Winnie's awestruck female friends, housewives from Latrobe, Pennsylvania, where Palmer's operation was

based. The portrait session lasted for a few hours, during which time Rockwell told Palmer to turn his head this way and that as Louie Lamone took photographs that would be used as reference material.

In one of the photographs from that day, Rockwell and Palmer are standing outside his studio, straddling bicycles. Palmer is wearing a spiffy golfer's cardigan. He is in his prime, his early forties, a well-built man with massive shoulders. Rockwell is waif-thin and has wavy white hair. He stares dully at the camera. No more humor in the eyes.

An inexplicable chunk of time—two years—elapsed before Rockwell finished the painting. It is a decidedly imperfect object that shows Palmer dressed in a white button-down shirt, with a disproportionately large seventies-style collar rising up like an iceberg from the oceanic surface of his chest. His carmine-red cardigan is unbuttoned at the top. The background, which appears unfinished, consists of three horizontal bands of green. It consists, in other words, of enough green to cover a golf course. Palmer loved it and hung it outside his office.

Dementia, it is generally believed, damages the portions of the brain required for forming and storing new memories and planning complex tasks. By 1973 Rockwell still had enough motor control to hold a pencil and draw with relative fluidity. But his work depended on a high degree of organization and he no longer had the patience or concentration to undertake the series of descriptive refinements his work required of him. When he lost that, he pretty much lost everything, because no form had ever moved him until he captured it with as much verisimilitude as a pencil would allow.

Dementia, of course, does not necessarily prevent an artist from working. Willem de Kooning is the famous example of an artist whose dementia was accompanied by a remarkable period of fecundity. When he was in his eighties, he produced a group of paintings that were hailed as genuinely inventive. They spawned intense questions about the link between a faltering brain and creativity. Some doctors speculated that the deficit in semantic memory that characterizes Alzheimer's was offset by backup memory systems, such as working, procedural, or episodic memory.

In Rockwell's case, there was no final eruption of creativity, only a slow and frustrating decline. Perhaps abstract painters afflicted with dementia have a better chance of continuing their work than realist painters do. An abstract painter can mold space intuitively and go wherever his

hand takes him, whereas a realist painter is obliged to track already-existent structures, to make trees that look like trees and not like sailboats.

On September 18, 1972, just two weeks after Palmer's visit, Rockwell was visited by Frank Sinatra. A photograph that appeared in *The Berkshire Eagle* shows the artist in the doorway of his studio, pipe dangling, holding open the screen door as he shakes Sinatra's hand.[3] Rockwell appears tired, but Sinatra is grinning and visibly pumped. He has just flown in from Palm Springs to sit for a portrait. He was fifty-six years old, a generation younger than Rockwell. "When I found out Rockwell was going to paint me, I felt like I was dipped in gin," Sinatra later noted in a letter, using a Vegasoid metaphor to express his delight.[4]

Since Rockwell was too weak at this point to leave his home for out-of-town portrait sessions, celebrities from all over the country made their way to western Massachusetts to sit for him. If they stayed overnight, Jane Fitzpatrick, who owned the Red Lion Inn, provided accommodations. She later recalled seeing John Wayne on the premises. "What a wonderful guest," she said. "I saw him walking down the front steps on a Sunday morning, buckling on a gun. He was nice to all the kids, whereas Frank Sinatra was just awful. He came into town in a long black limousine, spent twenty minutes over at Norman Rockwell's posing for pictures, and left."[5]

Colonel Harland D. Sanders, by her estimation, was an exemplary guest. "He stayed at the Red Lion Inn and gave out Kentucky Fried Chicken gift certificates to the kids he ran into."[6]

•

Rockwell had never been nostalgic for his own childhood and the process of aging did not change him in that regard. He had only one sibling and he did not go down to Florida for his brother's last illness or funeral. In 1955 Jarvis had written that astounding letter to his brother, the one in which he lamented not knowing where Norman lived or where his sons went to college. When Jarvis died, on May 9, 1973, the brothers had not spoken for a long time. Rockwell jotted on his calendar: "Jarvis died in Florida, Dick"—who was Jarvis's son—"called and told me."

Although Rockwell declined to articulate his feelings over his brother's death, he did make a painting during this period that seems to hint at their complicated relationship. He referred to it as his Reverend and Indian picture. It would consume him for many years and might be seen

as a symbolic portrait of Rockwell (the prissy Reverend) and his brother (the strapping Indian).

Rockwell began the painting in 1972, but a year later, had made almost no progress on it. As he noted on his calendar page for May 12, 1973: "Very mixed up today but I will work it out. Tomorrow I get to work on Reverend and Indian picture. Bewildered."

The painting, which remains untitled and unfinished, is based loosely on an incident in Stockbridge history. It shows the Rev. John Sargeant in his house, a Colonial-era gentleman sitting on a hardwood chair across from his visitor, Chief Konkapot, a bare-chested Indian in fringed white pants. In his ruffled white shirt and buckled shoes, Sargeant appears diminutive and almost doll-like beside the Indian chief. In the fireplace behind them, embers glow and the stones are stained with soot, suggesting that the two men have been talking for a while. These are familiar themes in Rockwell's work: two men, one disproportionately larger than the other, bond in a realm sealed off from women. In a typical Rockwellian gesture involving an onlooker, Sargeant's wife, Abigail, in a little white bonnet, peeks in on the scene from the next room, her face a mask of worry.

He turned eighty on February 3, 1974. To avoid the inevitable fuss, the

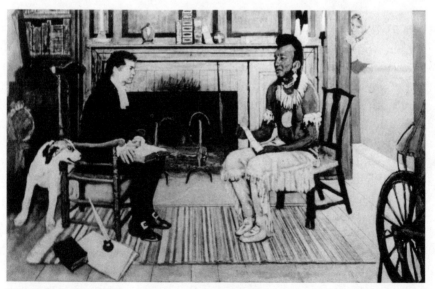

Rockwell's last painting portrays a scene from local history, and brings together a missionary and an Indian.

people traipsing into his studio with oversize cakes, he and Molly took refuge in Little Dix, in the British Virgin Islands, on the long, skinny island of Virgin Gorda, which they had first visited four years earlier as guests of friends. Rockwell did some sketching on the trip and he could still get a likeness with ease. A small drawing of a rocky shoreline looks as if it was done quickly, with a soft pencil.

One evening, he set off on a bicycle ride by himself. After the sun went down and the hotel gates were locked for the night, Molly went out in search of him—she found him sitting on a rock, exhausted. He seemed to have no idea of how to get back to the hotel. His bicycle was still at the bottom of the ditch where it had landed after he steered off the edge of a rutted road in the half-light of the evening.

Once he returned to Stockbridge, Rockwell tried resuming his bicycling on a curtailed basis. "Took first bike ride down to Town Hall only," he noted on March 11. The next day, he was bicycling again when he took another fall, this one very serious. He apparently fractured his pelvis. He lay flat in bed for much of March and April, under the care of private nurses. When he stood up, his legs felt weak and he worried about falling over. A stationary exercise bicycle was installed in the back of his studio, bolted to the floor. To get around, he began relying on a walker.

•

One day, Rockwell received a phone call from David Bowie, the British rocker, who was in his late twenties and about to release the album *Young Americans*. Although he had never met Rockwell, he needed a portrait for the cover and was hoping Rockwell could produce one quickly. It was Molly who answered the phone. "I am sorry," she said in a voice that struck him as elderly and quavering, "but Norman needs at least six months for his portraits." Bowie was impressed to learn that an artist could spend that much time on a single painting. "What a craftsman," he recalled later. "Too bad I don't have the same painstaking passion. I'd rather just get my ideas out of my system as fast as I can."[7]

As Rockwell's condition deteriorated, Molly hired a few people who lent a certain cheer to the house. In June 1974 she chose a new director for the Old Corner House: David Wood, a former English teacher at the Lenox School for Boys, who was in his early fifties. He moved into the little apartment above the garage that Rockwell had offered in previous

years to various young doctors and trainees at Austen Riggs. As much as Rockwell relished the company of doctors, Molly preferred the company of teachers. She was gladdened immeasurably by Wood's presence and proposed to him that they cowrite her long-postponed grammar. "She was always irritated by the quality of grammar books," Wood recalled, although her own book never did get done.

Evenings, around six, when Rockwell hobbled in from the studio and sat down for tea in the library, he and Molly were now joined by Wood. "Tea," of course, was shorthand for an event that typically involved one and possibly two whiskey sours consumed in front of a crackling fire. "Well, professor," Rockwell used to say to him, perking up, "what went on today?" And Wood would chat about developments at the Old Corner House, which was still a very modest museum. His first goal was to buy back *The Problem We All Live With*, the Ruby Bridges painting. It had been sold by Bernie Danenberg, for $15,000 at the time of Rockwell's gallery show in 1968. Danenberg said he could get the painting back—for $35,000. Molly wrote the check.

That summer, Wood supervised a group of new volunteers at the museum. He thought they should meet Rockwell and see the sacred space of his studio. "The guides felt this added a dimension to their work," he later recalled, "to be able to get into his workplace and actually meet the man. Because he never came to the Old Corner House, or almost never."

•

In December 1974 Molly hired a new cook, Virginia Loveless, a graceful woman with three grown children. Just a few weeks earlier, she had finalized her divorce from David Loveless, a potter who oversaw the art-therapy program at Austen Riggs and who had run off with the weaving teacher. With the collapse of her marriage, and her unattached status echoed uncomfortably by her last name, Virginia Loveless, at forty-six, was relieved to obtain the job of Rockwell's cook. It provided her with an identity as well as a new circle of acquaintances whom she found very likable if admittedly elderly. She was inordinately appreciative of both Norman and Molly, so much so that she would stay on at the house after he died, to become Molly's caretaker and companion.

True, the cooking part of her job was not exactly easy. She quickly realized that Rockwell was a fussy eater and adhered to a dietary regimen

that left no room for experimentation or even normal variety. Every morning he had the same thing: two soft-boiled eggs, cooked for precisely six minutes. He would chop them in a bowl, along with his toast.

His lunchtime menu had barely evolved from the time he was a schoolboy. It didn't matter whether it was Monday or Tuesday or Easter Sunday; for lunch he liked a cup of Campbell's tomato soup and a peanut butter sandwich with raspberry jam on toasted whole wheat bread. For dessert he would have an oatmeal cookie, just one. Loveless baked the cookies in medium-sized batches and kept them in the freezer.

"He was very difficult to feed," she commented.[8] "He didn't like anything with too many things in it. Nothing too complex. No casseroles or sauces." He made an exception for lamb stew, Craig Claiborne's recipe, which she considered her best entrée. It was the one she usually prepared when relatives or other guests came for dinner. On those occasions, she might serve ice cream for dessert, though Rockwell liked only one kind, Breyer's vanilla.

After the dinner plates had been washed and before she left for the day, Virginia Loveless would carry a silver tray laden with coffee and trimmings upstairs and leave it in the hall outside Rockwell's bedroom. She had already measured out the coffee grounds and cups of water, and he or Molly had only to turn on the coffee pot the next morning to set everything percolating. She made sure to lay out "enough sugar lumps for Norman,"[9] who preferred his beverages on the sweet side. As often as not he found himself up at first light, eager to get going, and he would go fetch Molly from across the hall, from her room with a narrow bed.

Molly was sturdy and adroit and uncomplaining. She was the one seated behind the steering wheel whenever she and Norman went out for a drive in the green Chevy. Earlier that year, when Pitter, the part-beagle, died, Molly visited her friend Elizabeth Blodgett Hall, the founder of Simon's Rock College and an amateur dog breeder, and came home with a new puppy[10]—Sid, a corgi, in keeping with her predilection for all things British. It was she, and not her husband, who walked Sid, in the morning and after supper.

Rockwell, as always, kept himself free for his work, even when he could no longer work. She could see that he was frustrated, but tried not to dwell on disappointments. "Norman is slipping into more and more confusion," she wrote to a friend on April 16, 1975, "and it's harder to avoid irritation, though it passes very quickly."[11]

•

In his last years, Rockwell was also afflicted with emphysema, a lung disease likely brought on by his pipe-smoking. It saddled him with colds and coughs that were hard to shake. Few people knew what Rockwell was facing, in part because he was portrayed in the media as a paragon of elderly stamina. GOING STRONG AT 82, a headline announced wishfully in the February 23, 1976, issue of *People* magazine.[12] In a photograph, he sits in a wheelchair at his easel, leaning forward, implicitly avid. His painting arm—the right one—is extended to add a detail to a portrait in progress. The caption emphasizes his American-style industry and resourcefulness. He still paints "seven days a week," using a wheelchair to move about his studio.

Although the article acknowledged some of the inconveniences of aging—it reported that Rockwell had become a bit "reclusive" since he stopped riding his bicycle two years ago—it did not mention his memory problems. Only that Molly sometimes mangled recipes. "We always have a whisky sour," she notes amusingly of their evening ritual, "and I always forget one ingredient."

Rockwell did not say much and his comments were a bit disjointed. Oddly or not, he mentioned Billy Payne out of the blue. "He posed for all three boys," Rockwell intoned, referring to *Boy with Baby Carriage*, his very first cover for the *Post*. Billy Payne had posed for the shamed schoolboy who pushes the baby carriage and also for the two chubby bullies laughing at him. Suddenly, Rockwell is thinking of Billy, the beautiful New Rochelle boy who tragically tumbled from a third-story window ledge at the age of fifteen. The boy whose death he almost never mentioned.

In one of the photographs accompanying the article, Norman and Molly are shown from the back hobbling along the broad upstairs hallway in the house, arms around each other. Sid, their adorable corgi, sits at the top of the stairs with his head turned, watching them intently, ears perked, as if waiting to lead them downstairs.

By then, Rockwell's illness had progressed to such a degree that he had trouble recalling events that had transpired within the hour. He suffered from "a really severe lack of memory," as Molly wrote to her old friend from Milton Academy, Kitty More.[13] "He still goes regularly to the studio, but tends to do and undo minor details, and to put off major and

important matters, and this, of course, makes him as distressed as the rest of us."

He took his last trip in May 1976, when he and Molly flew to Rome to visit his son Peter. David Wood accompanied them. On the Pan Am flight out of New York, a stewardess mentioned that she would love to have Rockwell's autograph but was prohibited by company policy from asking favors of customers. So Wood asked on her behalf. Rockwell drew a wonderful sketch of a dog and signed his name and gave it to her.

Somewhere, at the margins of his consciousness, he might have been aware of honors and awards that continued to come his way. He did show up when the town selectmen declared a holiday, Norman Rockwell Day, and held a parade on May 23. He watched the proceedings from a white-wicker chair atop a flatbed truck, alongside Molly and two of his sons, Jarvis and Tom, who by then were living nearby with their wives and children.

He still went into the studio every day but he no longer felt comfortable painting. He puttered around, listened to classical music on the radio, neatened up the drawers where he kept his brushes. "He would clean and do everything . . . anything to stop painting or not to paint," Louie Lamone later recalled.[14] He still washed his brushes with Ivory soap, and once, when he was shown an old painting of his that the museum had purchased—*Checkers*, with its wonderful clown—Rockwell told Louie, "It looks awfully dark. Let's go out and scrub it with Ivory soap."[15]

Lamone would say, "'Norman, you have got to get these paintings done.' He had one painting there that he had been working on, the Rev. Sargeant, and he never did finish that. He would keep saying, 'Well, I have not sold this thing.' Finally, one day, he told me that he was kind of afraid to paint, which shocked me."

•

November 2, 1976, was Election Day. President Gerald Ford was running against a newcomer from Georgia, Jimmy Carter. Norman and Molly went to the polls and before he entered the voting booth he turned to her and said, "Now who is it I am supposed to vote for?"[16]

In January 1977, just ten days before leaving office, President Ford awarded Rockwell the nation's highest civilian honor. He was given the Presidential Medal of Freedom for his "vivid and affectionate portraits of

our country and ourselves." Rockwell would have been gratified to join Joe DiMaggio and his long-ago detractor, the poet and and cultural custodian Archibald MacLeish, at the ceremony in the East Room of the White House. Unable to travel to Washington to accept the medal, he sent his son Jarvis in his place.

Every few days that fall, Rockwell would announce to Molly that this was the day he was going back to the studio to finish the painting of the Reverend John Sargeant and Chief Konkapot; it was still resting on his easel. But the trip along the flagstone walkway from his house to his studio was no longer easily navigated. It required the effort of two people to maneuver his wheelchair along the path, especially when there was ice underfoot.[17]

Lamone left his longtime job working as Rockwell's studio assistant early in 1977. He believed that Rockwell wanted him to stay, but there wasn't much for him to do. Probably no one worshiped Rockwell more than Lamone, who once said, "He was a prince. They don't make them any better."[18]

Another winter came and went. The spring of 1978 arrived, by which time he was cared for by around-the-clock nurses. But he was still insistent about going out to the studio. Wood recalled a disturbing afternoon when he and Molly pushed Rockwell in his wheelchair through the yard, unlocked the door of his red-barn studio, and let themselves in. The room was immaculate, the paint tubes and brushes in their proper places, but the air was chilly and pervaded with the exaggerated stillness of a shutdown establishment. Rockwell sat for a while and appeared to survey the contents of the room. It held some of his fondest memories, but sadly, he could no longer access them, and the room itself had in fact become terra incognita.

"But I want to go to my studio," he said.[19]

•

He died that autumn, on November 8, 1978, at home in Stockbridge. It was late on a Wednesday, close to midnight. His cause of death was officially given as emphysema. He was eighty-four years old. Neither Molly nor his sons realized it was time to gather at his side, so no one was with him at the time. "Norman died peacefully in bed and asleep, just as the nurses were changing shift," Molly wrote to a friend. "We were all thankful.

He had very little physical pain, only the pain of weakening strength and the inability to communicate."[20]

For the rest of the week, flags in Stockbridge flew at half-mast. The funeral was held on Saturday afternoon and shops along Main Street closed from two to three. The whole town, it seemed, descended on St. Paul's Episcopal Church, which could accommodate only a few hundred people. The sky was overcast, but the air was unseasonably warm for a November day, and outside the church, a crowd estimated at four hundred people stood silently, paying their respects, until the service ended. It lasted thirty minutes, which some felt was surprisingly brief. But then Rockwell had never been eager to spend time in church.

The bells tolled as the crowd streamed out of St. Paul's on that autumn afternoon, one of those days when color seems to have been drained from the world. Rockwell's sons and his daughters-in-law and his seven grandchildren walked west along Main Street, beneath the giant elm trees, toward the entrance to the Stockbridge Cemetery. None of them had been asked to speak at the funeral. Molly, who had planned the service, bestowed the honor on only one person: her friend David Wood, who stood up and read a poem that Rockwell liked, "Abou Ben Adhem" by Leigh Hunt, a nineteenth-century Englishman. It was not a service that left Rockwell's sons feeling very included, but then Molly was not their mother, just their busy and sometimes insensitive stepmother. The boys hardly needed to be reminded that the world they inhabited was not the one shining forth from their father's work, but the real world, where people don't always notice you or care about your feelings.

It was, in the end, Rockwell's great theme: the possibility that Americans might pause for a few seconds and notice each other. The people in his paintings—the daring schoolboys and rumpled old men, the black schoolgirl in New Orleans and the white schoolgirl with a black eye, the young runaway seated in the diner, and bride-to-be in the yellow dress standing on her toes as she signs her marriage license—they all require the presence of another pair of eyes to complete their story. The interested gaze might belong to someone eating lunch in a diner, or a neighbor, or to anyone at all who cares enough to interrupt what they are doing and glance up.

•

Norman Rockwell had never been enamored of farewells, especially of the flowery sort. Friends who had known him in his earlier years, whether

in New Rochelle or in Arlington, Vermont, had puzzled over the abruptness with which he moved away and his failure to come back and visit. Unlike the figures in his work, who have all the time in the world to linger and talk, he was a man given to sudden flight. He died much as he lived— essentially alone, with no time for love, and no time to say goodbye.

# NOTES

## ABBREVIATIONS USED IN THE NOTES

| | |
|---|---|
| MR | Mary Barstow Rockwell |
| *My Adventures* | Norman Rockwell as told to Thomas Rockwell, *Norman Rockwell: My Adventures as an Illustrator* (Garden City, NY: Doubleday, 1960) |
| NR | Norman Rockwell |
| NRM | Archives of the Norman Rockwell Museum, Stockbridge, MA |

## INTRODUCTION: WELCOME TO ROCKWELL LAND

1. Deborah Solomon, "In Praise of Bad Art," *The New York Times Magazine*, January 24, 1999, pp. 32–35.
2. Harold Johnson, "Why Parsley?" *The Boston Sunday Globe*, September 5, 1948, p. 43.
3. Kai Erikson, e-mail to the author, August 8, 2012.
4. NR, letter to Dr. Robert Knight, January 13, 1955, fMS Am 2249, Houghton Library, Harvard University.
5. *My Adventures*, p. 49.
6. Anne Hollander, *Seeing Through Clothes* (Berkeley: University of California Press, 1993), p. 391.

## I. THE BIRD MAN OF YONKERS (1830 TO 1888)

1. Donald Walton, *A Rockwell Portrait: An Intimate Biography* (Kansas City, MO: Sheed Andrews and McMeel, 1978), pp. 29–30.
2. NR, letter to Joseph Kelly at Parke-Bernet, February 28, 1967, NRM.
3. Birth certificates of Susan Ann (born October 1852, can't read date) and baptized on January 2; Thomas (born October 24, 1855); and Amy Eliza.
4. *New York Tribune*, April 28, 1865, p. 4.
5. Classified ad, *The New York Herald*, March 8, 1869, p. 2. See also ads on August 9, 1869, and December 1, 1868, p. 12.
6. 1870 U.S. Census.

7. Yonkers City Directory, 1877, lists him at 285 Woodworth.
8. He was included in the spring annuals at the Academy in 1881, 1884, and 1885, according to catalog entries, and in the winter show of 1883.
9. Ann Hill's death certificate, April 25, 1886; courtesy of Yonkers courthouse.
10. He died on Tuesday, August 17, 1886. The funeral was held on Friday at 3:30 at St. Paul's Episcopal Church.
11. Howard Hill's death certificate, March 6, 1888; courtesy of Yonkers courthouse.
12. Yonkers City Directory, 1886, p. 27.
13. According to the 1880 census, Waring was twelve and two "servants"—an Irish maid and a butler—were living in the family's house.
14. "Rockwell-Hill," *The Yonkers Statesman*, July 24, 1891, p. 1.
15. Genealogy courtesy of Edward Mendelson; see also Auden's "Family Ghosts" website.
16. Rockwell never met Captain Perceval, who died in 1902.
17. Rockwell's mother, letter to her daughter-in-law, February 26, 1946, NRM.

## 2. NOT A NORMAN ROCKWELL CHILDHOOD (1894 TO 1911)

1. NR, unpublished interview with Thomas Rockwell, 1959, compact disk, NRM.
2. Rockwell said they moved in after the death of his grandfather's mother, Mrs. Orilla J. Sherman Rockwell, who died on January 30, 1902, aged ninety-four. His grandmother Phebe died on March 28, 1903.
3. NR, unpublished essay, 1952, from a writing class in Bennington with Francis Golffing; courtesy of Thomas Rockwell.
4. Obituary of Grace W. Johnson, *The New York Herald*, February 19, 1901, p. 1.
5. Grace was married to Ephriam Sherman Johnson.
6. They belonged there until October 1906, according to records from St. Thomas Episcopal in Mamaroneck, to which they then switched.
7. NR, unpublished interview with Thomas Rockwell, 1959, compact disk, NRM.
8. *My Adventures*, p. 41.
9. Phebe Jessup Taylor, letter to *The Saturday Evening Post*, April 9, 1960, p. 6.
10. *My Adventures*, p. 48.
11. Ibid.
12. *The New York Herald*, December 31, 1905, Magazine Section, p. 16. The item mentions that he was living at 832 St. Nicholas Avenue.
13. Quoted in David Michaelis, *N. C. Wyeth: A Biography* (New York: Alfred A. Knopf, 1998), p. 35.
14. Ibid., p. 36.
15. Ibid., p. 37.
16. He claimed in his autobiography that he moved to Mamaroneck in 1903, which is incorrect. He was still in New York in December 1905, when he won the *Herald* contest.
17. At the time, the address was 121 Prospect Avenue.
18. "Norman P. Rockwell Making a Success at Illustrating," *Evening Standard* (New Rochelle), February 19, 1916, p. 1.
19. Office of St. Thomas Episcopal Church, e-mail to the author, January 20, 2012. The Rockwells joined the church on October 24, 1906; Norman was confirmed on April 15, 1908, when he was fourteen years old.
20. *My Adventures*, p. 52.

21. *My Adventures*, p. 54. According to the 1910 census, Frank F. German lived at 102 Prospect Avenue; the Titus family lived at 108.
22. *My Adventures*, p. 49.
23. Quoted by Michiko Kakutani, in *The New York Times* on August 10, 2001, in a review of John F. Kasson, *Houdini, Tarzan, and The Perfect Man: The White Male Body and the Challenge of Modernity in America* (New York: Hill and Wang, 2001).
24. "Norman P. Rockwell Making a Success at Illustrating," *Evening Standard* (New Rochelle), February 19, 1916, p. 1.
25. "Noted Artist has Regular 'Audience' of 6,000,000 People," February 4, 1931, unidentified newspaper clipping from the artists' files of the New Rochelle Public Library.
26. NR, unpublished interview with Thomas Rockwell, 1959, compact disk, NRM.
27. According to his Mamaroneck High School transcript, he completed his junior year.

## 3. THE ART STUDENTS LEAGUE (SEPTEMBER 1911 TO 1912)

1. NR, unpublished interview with Thomas Rockwell, 1959, compact disk, NRM.
2. *My Adventures*, p. 75.
3. League registration cards; courtesy of the Art Students League.
4. Quoted in Gail Levin, *Edward Hopper: An Intimate Biography* (New York: Alfred A. Knopf, 1995), p. 39.
5. *My Adventures*, p. 72.
6. Ibid., p. 68. Art Young later became a well-known political cartoonist whose work appeared in *The Masses*.
7. Fogarty lived on West Seventy-first Street, according to the 1910 U.S. Census, within walking distance of the League.
8. *Brooklyn Daily Eagle*, May 17, 1912. Also, "News and Notes of the Art World," *The New York Times*, May 19, 1912, p. SM15. In his autobiography, Rockwell incorrectly described his winning drawing as that of a boy confined to his bed with mumps on July 4, watching as fireworks explode in the sky outside his window. It would be one of Rockwell's abiding themes: a kid's feeling of having missed out on something, of being unable to experience pleasure except as an observer on the sidelines.
9. In 1912 the Rockwell family was listed in the Mamaroneck City Directory at 269 Palmer Avenue, which was then a nursery owned by John and Victoria Hallett. The Rockwell family rented rooms here for a brief period before moving back to New York City.
10. *My Adventures*, p. 97.
11. Thomas Rockwell, in a letter to Ken McCormick, on September 8, 1959, assured him, in reference to the boardinghouse: "all the names but Mrs. Frothingham have been changed"; box 115, the Ken McCormick Collection of the Records of Doubleday & Company, Manuscript Division, Library of Congress, Washington, DC.
12. *My Adventures*, p. 106.
13. Ibid.

## 4. THE BOY SCOUTS VERSUS THE ARMORY SHOW (SEPTEMBER 1912 TO DECEMBER 1913)

1. National Academy of Art school registration card; courtesy of the National Academy of Art. The card indicates that on October 28, 1912, he entered a life-drawing class taught by Francis C. Jones and George Maynard.

2. *My Adventures*, pp. 94–95.

3. Spring 1919 interview, clipping from unidentified newspaper in the artists' files of the New Rochelle Public Library.

4. Although Rockwell devotes many pages of his autobiography to his opera experiences, the Metropolitan Opera has no record of him as an extra. His roles were probably less substantial than he recalled.

5. Marjorie Garber, *Vested Interests: Cross-Dressing and Cultural Anxiety* (New York: Routledge, 1992), p. 171.

6. Cave is listed in the 1912 Mamaroneck city directory at 53 Palmer Avenue.

7. It was published by Doubleday, Page in 1913.

8. *Boys' Life*, January 1913, p 2.

9. Although Cave was replaced as editor by Walter P. McGuire in July 1913, Rockwell continued providing illustrations for *Boys' Life* after Cave left.

10. It has been reported incorrectly in several books that Rockwell did a cover for *Boys' Life* every month; his covers were intermittent.

11. Rufus Jarman, "Profiles: U.S. Artist" (a profile of Norman Rockwell), part 2, in *The New Yorker*, March 24, 1945, p. 40.

12. NR, unpublished essay, 1952, from a writing class in Bennington with Francis Golffing; courtesy of Thomas Rockwell.

13. According to the records of the Art Students League, Rockwell signed up for just three monthlong classes in the 1912–1913 school year: "Morning Life" on October 2, "Afternoon Life" on January 6, and "Afternoon Illustration" on February 17.

14. *Lippincott's Monthly Magazine*, November 1912.

## 5. NEW ROCHELLE, ART CAPITAL OF THE WORLD (1914 TO 1916)

1. "Catalog of Paintings on Exhibition," May 9 to May 23, 1914; courtesy of the New Rochelle Public Library.

2. Unsigned article, "A Champion of Mere Man in Art—Artist Leyendecker Supplies Companions for Gibson Girls," *The Sun* (New York), July 13, 1913, p. 8.

3. Illustration for "The Magic Football," by Ralph Henry Barbour, *St. Nicholas*, December 1914, p. 131.

4. *My Adventures*, p. 44.

5. Rockwell said his studio was in the Clovelly Building at 360 North Avenue; although the 1914 city directory lists his studio at 78 North Avenue.

6. A letter to Jarvis at Edgewood Hall is dated July 19, 1915. A letter written the previous April was sent to him at 17 Prospect Street. So they moved to Edgewood Hall between April 26 and July 19.

7. *New Rochelle Pioneer*, October 2, 1915, p. 5.

8. Adelaide Klenke, "Who's Who," *The New Rochelle Tattler*, February 9, 1916.

9. *New Rochelle Pioneer*, February 19, 1916, p. 1.

10. Address provided in the 1907 city directory.

11. NR, unpublished interview with Thomas Rockwell, 1959, compact disk, NRM.

12. *My Adventures*, p. 131.

13. Ezra Pound, *The Cantos of Ezra Pound* (New York: New Directions Publishing, 1996), p. 539.

14. *Life*, January 24, 1969, p. 53.

15. Donald Walton, *A Rockwell Portrait: An Intimate Biography* (Kansas City, MO: Sheed Andrews and McMeel, 1978), p. 87.
16. Roger Butterfield, "The Best Years of a Long, Full Life," *Life*, January 24, 1969, p. 55.
17. Collier Schorr, *The Essential Norman Rockwell* (New York: Harry N. Abrams, 1999), p. 24.
18. "Rockwell's Kid Cartoons Are Making a Hit," *Evening Standard* (New Rochelle), August 4, 1916, p. 1.

## 6. IRENE O'CONNOR, OR UNCLE SAM WANTS YOU (1916 TO 1918)

1. Richard Rockwell (son of Jarvis and Norman's nephew), interview with the author, February 11, 2000.
2. His height is given as five foot seven on his World War I draft registration card.
3. Jarvis Rockwell, letter to Caroline Cushman; courtesy of his son, Richard Rockwell.
4. Irene O'Connor was born on July 2, 1890, in Watertown, New York.
5. The 1900 census lists the family in Potsdam, on Prospect Street, along with Irene's maternal grandmother and paternal grandfather.
6. "Engagement Announced," *Watertown Daily Times*, September 8, 1914, p. 2.
7. "Sylvan Falls," *Watertown Daily Times*, July 25, 1912, p. 5.
8. Marriage license application, Westchester County archives, White Plains, New York.
9. "Events in the Social Whirl," *New Rochelle Pioneer*, July 1, 1916, p. 5. On July 8, 1916, p. 5, Irene is described as "formerly a teacher at Weyman School."
10. *My Adventures*, p. 135.
11. Ibid.
12. Quoted in Robert Hughes, *The Shock of the New: The Hundred-Year History of Modern Art—Its Rise, Its Dazzling Achievement, Its Fall* (New York: Alfred A. Knopf, 1980), p. 58.
13. "Norman Rockwell Is Here on Ten-Day Leave from Charleston, S.C.," *Evening Standard* (New Rochelle), September 23, 1918, p. 1. Also, personals column, *New Rochelle Pioneer*, September 28, 1918, p. 5.
14. *My Adventures*, p. 146.
15. "Rockwell Back, So War Stops," *Evening Standard* (New Rochelle), December 13, 1918, p. 1.
16. Forsythe celebrated his thirty-third birthday on August 24, 1918, the day after Rockwell left for Charleston.
17. "Local Illustrators Workers in U.S. Division of Pictorial Publicity," *Evening Standard* (New Rochelle), December 16, 1918, p. 5.

## 7. BILLY PAYNE (MAY 1919 TO SUMMER 1920)

1. Theodore Pratt, "A Visit with Norman Rockwell," undated article, circa May 1919, from the clipping files of the New Rochelle Public Library.
2. "New Rochelle Boy Scout Figures in Rockwell's Posters," *Evening Standard* (New Rochelle), June 25, 1919, p. 7.
3. Irene Rockwell, letter to Everett, July 20, 1921, NRM.
4. *My Adventures*, p. 117.
5. "Norman Rockwell's Favorite Boy Model as School Graduate," *New Rochelle Pioneer*, July 1, 1918, p. 1.

6. *My Adventures*, p. 125.

7. Billy Payne's school application, September 28, 1919; courtesy of the Tome School.

8. Supplemental application, September 26, 1919; courtesy of the Tome School.

9. Obituary, *Evening Standard* (New Rochelle), February 26, 1920.

10. "Falls from Third Floor, Fractures Skull: William Payne in Unconscious Condition at Hospital," *Evening Standard* (New Rochelle), January 2, 1920, p. 1.

11. Paid obituary notice, *The Sun and New York Herald*, February 27, 1920, p. 9. His body was initially taken to Beechwood Cemetery, but in June 1920 was moved to Wood-lawn Cemetery in the Bronx, where he was buried near his maternal grandparents. His father died in 1934; his mother, Mabel P. Payne, died in 1937. They are buried beside him.

12. Obituary, *Evening Standard* (New Rochelle), February 26, 1920. Also, Billy Payne's death certificate, February 26, 1920; City of New Rochelle, NY.

13. *My Adventures*, p. 125.

14. *My Adventures*, p. 281.

15. (William) Armstrong Perry, "The Boy on the Cover," *American Boy*, December 1920. Rockwell was acquainted with Perry, a former editor at *Boys' Life*.

16. "Draws Boys and Not Girls," *The Boston Globe*, August 5, 1923, p. 70.

## 8. MISS AMERICA (1922 TO 1923)

1. Paul Thompson (photographer), rotogravure section of the *Chicago Sunday Tribune*, May 2, 1920, p. C5.

2. They moved in in 1919; Frederick Smythe was the owner.

3. "New Rochelle Artist's First Drawings Seen in Public School's Paper" (a profile of Walter Bench Humphrey), *Evening Standard* (New Rochelle), April 23, 1924, p. 16.

4. NR, interview with John Batty, 1972, cassette tape; courtesy of Thomas Rockwell.

5. Franklin Lischke, interview with Susan Meyer, 1980, NRM.

6. Charles Rosen and Henri Zerner, "Scenes from the American Dream," *The New York Review of Books*, September 10, 2000, pp. 16–20.

7. The collage ran in *Broom*, an avant-garde magazine, in March 1923.

8. Rockwell misspelled his name in his autobiography as T. J. MacManus. Thomas J. McManis was born July 23, 1885.

9. Rockwell applied for his first passport on October 24, 1921; see www.ancestry.com.

10. Passenger record, Ellis Island Foundation.

11. "Miss Columbus Wins Beauty Crown Again," *The Washington Post*, August 8, 1923, p. 1.

12. *My Adventures*, p. 206.

13. "Entered into Rest" (Henry O'Connor obituary), *Watertown Daily Times*, August 10, 1922, p. 16.

14. "Notes from Louisville Landing," *The Massena Observer*, November 2, 1922.

15. Passenger record, Ellis Island Foundation.

16. "Crowd Sees Plane Crash," *The New York Times*, September 9, 1923, p. 1.

17. NR, unpublished interview with Thomas Rockwell, compact disk, 10:32; NRM.

## 9. THE ARROW COLLAR MAN (1924 TO 1925)

1. "A Little Portfolio of Good Interiors," *House & Garden*, October 1918, p. 35–37; "The Rose Garden of Two Popular Artists," *House & Garden*, November 1918, p. 34;

"Home of the Messieurs J. C. and F. X. Leyendecker on the Mount Tom Road," *Country Life*, June 1919, pp. 52–53.

2. F. Scott Fitzgerald, "The Last of the Belles," in *The Short Stories of F. Scott Fitzgerald: A New Collection*, ed. Matthew J. Bruccoli (New York: Scribner, 1989), p. 451, orig. published in *The Saturday Evening Post*, March 2, 1929.

3. Arnold Gingrich, *Nothing But People: The Early Days at Esquire—A Personal History, 1928–1958* (New York: Crown, 1971), p. 243.

4. *My Adventures*, p. 192.

5. Ibid.

6. Ibid., p. 194

7. This incident is known to us only because it is related in Rockwell's autobiography. The Leyendeckers do not receive extended attention in any other memoir or autobiography. Rockwell's account is fascinating although probably skewed to emphasize his own largeness. For instance, Rockwell described Joe as a "trim, tight little man" (p. 196) and "a small compact figure" (ibid.). He remembered that the brothers "were quite short and walked in step." Yet, according to Leyendecker's application for a U.S. passport, he stood five foot nine and a half inches. Frank's application indicates that he stood taller, at five foot eleven.

8. *My Adventures*, p. 196.

9. Ibid.

10. *The New York Times*, February 28, 1925, pp. 17 and 28.

11. "Sweet Kitty Bellaires Given Place of Honor in Hangings at Leyendecker Exhibition," *Standard-Star* (New Rochelle), no date, Leyendecker file, New Rochelle Public Library.

12. Regina Armstrong, "Frank X. Leyendecker: An Appreciation," two-page brochure, December 9, 1912, Leyendecker file, New Rochelle Public Library.

13. An item in the *New York Herald Tribune* on January 25, 1925, p. C4, reported that Rockwell and his wife had left for California.

14. NR, unpublished interview with Thomas Rockwell, 1959, compact disk, NRM.

15. NR, letter to Franklin Lischke, undated, NRM.

16. *My Adventures*, p. 258.

17. Ella Van Brunt obituary, *The New York Times*, December 23, 1923, p. 21.

18. Laurence S. Cutler and Judy Goffman Cutler, *J. C. Leyendecker: American Imagist* (New York: Harry N. Abrams, 2008).

19. An ad in the *New York Herald Tribune* on November 9, 1924, stated that Rockwell was teaching an afternoon class that began on November 17. The following semester, in January, he switched to an evening class; *The New York Times*, January 4, 1925. On April 4, the *Brooklyn Daily Eagle* reported on a "Norman Rockwell costume ball" held at the New School of Design, to mark the end of the term.

20. Ruth Brindze, "Famous Magazine Cover Artist Reveals His Ideas About Pretty Girls," *Brooklyn Eagle* Sunday magazine, June 14, 1925, p. 7. She referred to the location as the Beaux Arts Building, the name of the famous restaurant on the ground floor.

21. "Surprise Party for Emil Fuchs," *The New York Times*, May 21, 1925, p. 23. Also, "Artist Surprised by Sitters," *New York Herald Tribune*, May 21, 1925, p. 17.

22. The address was 20 Chatham Road, which is now Coventry Avenue.

23. A letter written by Irene Rockwell on December 23, 1925, indicates that Rockwell was back at 40 Prospect Street, in the Lischke barn.

24. NR, letter to Franklin Lischke, undated, NRM.

25. William Sundermeyer was born on May 15, 1911, and, like Lischke, was of German descent.

26. Associated Press, "Ex-Model Reminisces on Rockwell," interview with Franklin Lischke, *New Haven Register*, February 1991.

## 10. DIVORCE (1926 TO 1929)

1. William P. Kelly, conversation with the author, May 30, 2012.

2. "A House with Real Charm," *Good Housekeeping*, February 1929, p. 49.

3. It ran on July 23, 1927.

4. Lorimer to NR, June 30, 1927, box 2, Wesley Stout papers, Manuscript Division, Library of Congress, Washington, DC.

5. NR, letter to Lorimer, July 6, 1927, box 2, Wesley Stout papers, Manuscript Division, Library of Congress, Washington, DC.

6. "Society Notes," *New York Herald Tribune*, July 29, 1928, p. E3.

7. *My Adventures*, p. 265.

8. "Hearst Sails on Olympic," *The New York Times*, July 21, 1928, p. 29.

9. *My Adventures*, p. 263.

10. See Irene Rockwell, U.S. immigration records, www.ancestry.com. Also, "Society Notes," *New York Herald Tribune*, June 2, 1929, p. E13.

11. "Shubert Hit Collegian; J.J. Objected to Hartley Accosting a Winter Garden Girl," *The New York Times*, June 19, 1916, p. 6.

12. *The Massena Observer*, September 19, 1929.

13. Cited in William Graebner, "Norman Rockwell and American Mass Culture: The Crisis of Representation in the Great Depression," *Prospects*, October 1997, p. 349.

14. In his autobiography, Rockwell mentions that he moved into the Hotel des Artistes after Irene announced she was divorcing him in the summer of 1929. But he also says he was living there at the time of Emil Fuch's suicide, in January 1929. This is unlikely. He knew Fuchs from an earlier period in his life, circa 1925, when they both had studios in the Bryant Park Studio Building.

15. *My Adventures*, p. 286.

16. Fred Hogue, "State's Artists in Salon: Dedication Ceremony at Biltmore Gallery Features Twenty-Five Southland Painters," *Los Angeles Times*, December 15, 1923, section 2, p. 1.

17. Unsigned editorial, "The Biltmore Salon," *Los Angeles Times*, January 5, 1924, p. A4.

18. NR, letter to Clyde Forsythe, August 22, 1931; courtesy of Marianne Hart.

19. *My Adventures*, p. 287.

20. "Rockwell Divorce to Be Soon," *Reno Evening Gazette*, December 19, 1929, p. 12.

21. "New Yorkers Win Divorces at Reno; Mrs. Rockwell Gets Decree on Charge That Artist Said They Were Unsuited to Each Other," *The New York Times*, January 14, 1930, p. 19.

22. "Mrs. Irene Rockwell Weds Belmont Man," *The Boston Globe*, January 19, 1930, p. A31.

23. "Mrs. Irene Rockwell Wed; Married to Francis Hartley Jr., a Chemist of Belmont, Mass.," *The New York Times*, January 19, 1930, p. 36.

24. Death certificate, November 2, 1934, town clerk, Brookline, Massachusetts. She was buried at Mt. Auburn Cemetery in Cambridge, but was disinterred on November 19, 1942, and moved to Mt. Zion Cemetery in Webster, Massachusetts. Hartley wanted the Mt. Auburn plot for other relatives, including stillborn twins from his next marriage.

## 11. MARY BARSTOW (SPRING 1930 TO SEPTEMBER 1932)

1. Office of the registrar, Stanford University.
2. Mary Rhoads Barstow was born on November 26, 1908.
3. Peter Rockwell, interview with the author, June 22, 2000.
4. "Cover Artist to Wed Here," *Los Angeles Times*, March 20, 1930, p. A3.
5. "Father and Son Honored," *Los Angeles Times*, March 20, 1930, p. 14.
6. "Artist Takes Alhambra Bride," *Los Angeles Times*, April 18, 1930, p. A5.
7. He lived at 140 Verdun.
8. Insurance appraisal, January 7, 1931, NRM.
9. *My Adventures*, p. 299.
10. Fred Hildebrandt was born on September 26, 1899, in Chicago.
11. Fred Hildebrandt, "Our Guest Exhibitor," *Manor Club Bulletin* (New Rochelle), October 1948.
12. MR, letter to Muriel Bliss, May 7, 1931, NRM.
13. Fred Hildebrandt wrote: "Just got back from climbing to the top of Mt. Whitney. Some job. Lots of snow. Going to Death Valley from here." Postcard to his parents postmarked June 4, 1931; courtesy of Alexandra Hoy, his daughter.
14. Undated newspaper clipping from the file of Fred Hildebrandt; courtesy of Alexandra Hoy.
15. MR, letter to her parents, April 1932.
16. NR, letter to Clyde Forsythe, August 22, 1931; courtesy of Marianne Hart.
17. Richard Rockwell, interview with the author, February 11, 2000.
18. NR, letter to Nancy Barstow, February 1, 1932, NRM.
19. Alissa Keir, "Our Famous Neighbors: Norman Rockwell," *The Daily Argus* (Mt. Vernon), February 4, 1931, p. 3.
20. MR, undated letter to her parents; courtesy of Thomas Rockwell.
21. Ibid.
22. Ibid.
23. Ibid.
24. MR, letter to her parents, April 11, 1932.
25. "Flatbush Boy Paddles Thru Holland to Paris," September 17, 1931; clipping courtesy of Jo Haemer, the artist's daughter.
26. Jo Haemer, interview with the author, March 15, 2012.
27. Ibid.
28. MR, undated letter to her parents.
29. Haemer, interview with the author, March 15, 2012.
30. Haemer left from Le Havre on September 24, 1932, aboard the SS *Waukegan*.

## 12. THE NEW DEAL (1933 TO 1935)

1. Westchester County election records, White Plains, New York; 1932 was the first time Rockwell had voted in an election since 1924.
2. NR, fishing diary, September 3, 1934, NRM.
3. Ibid.
4. The dog, born on Christmas Eve, 1934, was acquired from Medor Kennels on West Forty-seventh Street, in New York, NRM. It was Rockwell's second German shepherd. In 1926, the *Post* reported that he walked to his studio every day with his German shepherd.

5. Norman Kreisman, interview with the author, September 26, 2004. He lived at 140 Verdun, which Rockwell rented for a month or two in 1930.

6. "To 'California,'" clipping dated May 18, 1935; from Fred Hildebrandt's papers; courtesy of Alexandra Hoy.

7. David Rakoff, e-mail to the author, March 15, 2012.

8. Tax return, July 31, 1937, NRM.

9. Charlie Schudy, interview with the author, November 14, 2003.

10. "Teacher Recalls Days as Rockwell's Tom Sawyer," *The Pittsburgh Press*, February 6, 1985, p. N6.

11. Mark Twain, *The Adventures of Tom Sawyer* (1876; New York: Grosset & Dunlap, 1994), p. 89.

## 13. HELLO *LIFE* (FALL 1936 TO 1938)

1. "The Press: Lorimer Out," *Time*, September 7, 1936.

2. F. Scott Fitzgerald, letter to Zelda, April 18, 1940, published in several letter collections.

3. *My Adventures*, p. 334.

4. Wes Stout, letter to NR, December 4, 1936, NRM.

5. Alan Brinkley, *The Publisher: Henry Luce and His American Century* (New York: Alfred A. Knopf, 2010), p. 219.

6. Ibid., p. 215.

7. *Magazine Circulation and Rate Trends, 1937–1955* (New York: Audit Bureau of Circulation, 1956), p. 13; courtesy of the American Society of Magazine Editors.

8. Brinkley, *The Publisher*, p. 208.

9. Ibid., p. 214.

10. Clive James, "Somewhere Becoming Rain," *The New Yorker*, July 17, 1989, p. 88.

11. Mead Schaeffer, unpublished interview with Susan Meyer, September 30, 1980, cassette tape, NRM.

12. Fred Hildebrandt, journal entry, April 15, 1936; courtesy of his daughter, Alexandra Hoy.

13. Unsigned item (by Franklin P. Adams and Harold Ross), "Came/Went," *The New Yorker*, July 17, 1937, p. 12.

14. "Mostly, Pet Dog, Is Very Much Lost," *The Daily Argus* (Mt. Vernon), August 28, 1937, p. 4.

15. Florence Emily Currie, New York Passenger Lists, 1820–1957. The family traveled first cabin while she traveled tourist class, or third cabin; see www.ancestry.com.

16. They left on March 29, 1938, according to immigration records at www.ancestry.com.

17. Morton Kutner, letter to NR, April 5, 1938, NRM.

18. Cynthia Rockwell, the artist's daughter-in-law, e-mail to the author, September 26, 2002.

19. Receipt, New Rochelle Book Store, September 1, 1938, NRM.

20. *The Saturday Evening Post* cover, October 8, 1938.

21. He was Richard Wryley Birch.

22. *My Adventures*, p. 315.

23. Kay Ross, "County Artists Paint and Pose for Covers," *The Herald Statesman* (Yonkers), September 7, 1935.

24. NR, undated letter to Nancy Barstow, probably March 1939, judging from internal evidence and reference to Al Barstow's upcoming marriage, in April 1939.
25. Ibid.
26. Quoted in Andrew Marr, "What the Eye Didn't See . . . ," *The Observer* (London), October 6, 2001, p. 5.
27. Richard Gregory, interview with the author, November 14, 2003.

## 14. ARLINGTON, VERMONT
## (NOVEMBER 1938 TO SUMMER 1942)

1. Mead Schaeffer, unpublished interview with Susan Meyer, September 30, 1980, cassette tape, NRM.
2. June 10, 1939, land deed, clerk's office, Arlington, Vermont.
3. Thomas Rockwell, e-mail to the author, November 25, 2012.
4. Incidentally, on Friday, July 14, Rockwell had a small fire in his studio, perhaps when he and Fred were carousing; Vermont Mutual Fire Insurance Co., letter to Rockwell on July 22, 1939, NRM.
5. MR, letter to Nancy Barstow, July 10, 1939; courtesy of Thomas Rockwell.
6. Fred Hildebrandt, "Our Guest Exhibitor," *Manor Club Bulletin* (New Rochelle), October 1948.
7. Nanette Kutner, "If You Were Mrs. Norman Rockwell," *Good Housekeeping*, February 1943, p. 31.
8. John Updike, "An Act of Seeing: Norman Rockwell," *Art & Antiques*, December 1990, p. 96.
9. Lois Henderson Bayliss, "Artist Likes Rural Folks for Models," *Bennington Banner*, October 13, 1939.
10. NR, letter to Clyde Forsythe, October 11, 1939; courtesy of Marianne Hart.
11. Bayliss, "Artist Likes Rural Folks for Models."
12. "Art: U.S. Illustrators," *Time*, May 1, 1939.
13. George Hughes, unpublished interview with Susan Meyer, November 17, 1980, cassette tape, NRM.
14. "Rockwell's Studio: 25 Years in New Rochelle," *Standard Star* (New Rochelle), February 7, 1963. The house was sold on June 19, 1945, to Sidney Gaston, who is interviewed in the article.
15. "Norman Rockwell 'Rests' in Alhambra, Snowed Under with Job of Painting," *Los Angeles Times*, November 28, 1941, p. 14.
16. Mauldin's Willie made his debut in the *Oklahoma City Times* on October 14, 1941.
17. Stewart Robinson, "He Paints the Town," *Family Circle*, March 6, 1942, p. 20.
18. MR, letter to her sister, November 11, 1941, NRM.
19. J. Michael Barrier, *The Animated Man: A Life of Walt Disney* (Berkeley: University of California Press, 2007), p. 134.
20. Walt Disney, unpublished letter to NR, December 31, 1941; courtesy of the Disney Archives, Burbank, CA.
21. NR, letter to Clyde Forsythe, March 23, 1942; courtesy of Marianne Hart.
22. It appeared in the issue of March 28, 1942.
23. "Wesley W. Stout Resigns," *The New York Times*, March 13, 1942, p. 21.
24. Ben Hibbs, "*The Saturday Evening Post* reaffirms a policy," advertisement, *The New York Times*, April 15, 1942, p. 17; *The Saturday Evening Post*, May 16, 1942, p. 18.

## 15. THE *FOUR FREEDOMS* (MAY 1942 TO MAY 1943)

1. Donald Hyde, War Department, Ordnance, letter to NR, May 23, 1942, NRM.
2. "Biography of A Poster," *The New York Times Magazine*, August 14, 1942, p. SM16.
3. Mabry letter, quoted and discussed in Maureen Hart Hennessey, "The Four Freedoms," in Hennessy and Anne Knutson, *Norman Rockwell: Pictures for the American People* (New York: Harry N. Abrams, 2000), p. 96.
4. According to Bill Budde, Arlington town historian, the Arlington Memorial School burned on November 9, 1940. Construction began in 1941 on a fireproof building to replace it.
5. Rufus Jarman, "Profiles: U.S. Artist," *The New Yorker*, March 17, 1945, pp. 38–45 (part 1); March 24, 1945, pp. 36–47 (part 2).
6. *My Adventures*, p. 341.
7. MacLeish had also been Librarian of Congress and head of the short-lived Office of Facts and Figures.
8. Thomas Mallon, "A Career Careerist," *Los Angeles Times*, June 28, 1992, p. BR2.
9. MacLeish to Kuniyoshi, dated June 24, 1942; Kuniyoshi papers, Archives of American Art; cited in ShiPu Wang's dissertation on Kuniyoshi, University of California, Santa Barbara, 2000.
10. "Artists' War Work Centralized in OWI," *The New York Times*, August 9, 1942, p. 42.
11. James Yates to Norman Rockwell, June 26, 1942, NRM; quoted in Virginia M. Mecklenburg, *Telling Stories: Norman Rockwell from the Collections of George Lucas and Steven Spielberg* (New York: Harry N. Abrams, 2010), pp. 106–7.
12. Leo Burnett, letter to NR, July 22, 1942, NRM.
13. Joseph F. Sinneen, "Inside Boston," *The Boston Globe*, June 24, 1932, p. 9.
14. Tom Burton, "A Model American," *The Orlando Sentinel*, August 17, 1997.
15. Robert Hughes, "The Rembrandt of Punkin Crick," obituary, *Time*, November 20, 1978, p. 110.
16. Jarman, *The New Yorker*, part one, p. 38.
17. Quoted in Stuart Murray and James McCabe, *Norman Rockwell's Four Freedoms* (New York: Gramercy Books, 1998), p. 60.
18. Ibid.
19. Susan Sontag, *Regarding the Pain of Others* (New York: Farrar, Straus and Giroux), p. 85.
20. "Freedom from Fear," *Bennington Banner*, August 5, 1943, p. 1.
21. J. M. Schoenwald, secretary to H. C. Bloomingdale, letter to NR, December 12, 1944, NRM.
22. *The Saturday Evening Post*, March 13, 1943, p. 10.
23. Murray and McCabe, *Norman Rockwell's Four Freedoms*, p. 78.
24. John Morton Blum, *Roosevelt and Morgenthau* (New York: Houghton Mifflin, 1972), p. 428.
25. Hecht's, various display advertisements, *The Washington Post*, 1942.
26. "Norman Rockwell to be Honor Guest at Reception," *The Washington Post*, April 21, 1943, p. B7.
27. *The Washington Post*, April 27, 1943, p. 1.
28. "Four Freedoms Artist to Get Bond Citation," *The Washington Post*, April 26, 1943, p. 8.
29. Thomas Rockwell, interview with the author, December 17, 1999.

30. Samuel Beckett, interview with Tom Driver, Columbia University Forum, summer 1961.

31. William Clark, "Norman Rockwell Sometimes Jumps Out of Bed to Sketch," *The Boston Globe*, May 30, 1943, p. D3.

32. Later accounts say that Rockwell drove to get help, but the initial newspaper coverage reports that Thaddeus Wheaton was the one who went to get help from the Squiers family.

33. Clark, *The Boston Globe*.

34. Jarman, *The New Yorker*, part one, p. 44.

35. NR, letter to Clyde Forsythe, postmarked April 18, 1944; courtesy of Marianne Hart.

36. *The Saturday Evening Post*, November 13, 1943.

## 16. "SLOWLY FELL THE PICKET FENCE" (JUNE 1943 TO SUMMER 1947)

1. By Christmas of 1942, the sheet music for "Rosie the Riveter" was selling well enough on the West Coast to slide into last place (number 15) on *Billboard* magazine's bestselling sheet-music list.

2. *Bennington Banner*, June 3, 1943, p. 1.

3. David Mamet, *Bambi vs. Godzilla: On the Nature, Purpose, and Practice of the Movie Business* (New York: Random House Digital, 2008), p. 7.

4. Buddy Edgerton, interview with the author, October 2005.

5. MR, letter to her sister, March 1944, NRM.

6. NR, letter to Clyde Forsythe, April 18, 1944; courtesy of Marianne Hart.

7. Mary (Atherton) Varchaver, interview with the author, July 4, 2012.

8. Julien Levy, *Memoir of an Art Gallery* (New York: G. P. Putnam's Sons, 1977), p. 254.

9. Maxine Atherton, unpublished interview with Susan Meyer, December 8, 1980, cassette tape, NRM.

10. Ibid.

11. NR, letter to Clyde Forsythe, April 18, 1944; courtesy of Marianne Hart.

12. Willliam Hillcourt, *Norman Rockwell's World of Scouting* (New York: Harry N. Abrams, 1977), p. 150.

13. Ibid.

14. James A. "Buddy" Edgerton and Nan O'Brien, *The Unknown Rockwell: A Portrait of Two American Families* (Essex Junction, VT: Battenkill River Press, 2009), p. 77.

15. Mead Schaeffer, interview with Susan Meyer, September 30, 1980, cassette tape, NRM.

16. Land deed, October 24, 1944, clerk's office, Arlington, Vermont. Rockwell sold the house on March 16, 1946.

17. Rufus Jarman, *The New Yorker*, March 24, 1945, part 2, p. 37.

18. In 1936 the two illustrators first lamented their problem in an amusing pair of essays in the literary magazine *Colophon*.

19. "Famed Artist Working at Studio in Alhambra," *Los Angeles Times*, February 15, 1945, p. A7.

20. "Magazine Shows Artist's Picture of Scene in Troy," *Troy* (NY) *Record*, May 23, 1945, p. 2.

21. "Mr. Rockwell Scores Again," *Bennington Banner*, May 13, 1945, p. 1.

22. Arthur L. Guptill, letter to NR, May 16, 1947, NRM.
23. Nancy Rockwell, letter to MR, February 26, 1946, NRM.
24. Nancy Rockwell to Ida Hill, August 19, 1946, Cooper papers, NRM.
25. Edgerton and O'Brien, *The Unknown Rockwell*, p. 205.
26. "West Arlington," *Bennington Banner*, February 7, 1947.
27. MR, letter to Nancy Barstow, undated letter; courtesy of Thomas Rockwell.
28. State of Massachusetts, report, July 6, 1947, NRM.
29. "Norman Rockwell Won't Be Able to Talk for Awhile," *Bennington Banner*, July 19, 1947, p. 1.
30. The models for the husband and wife (John and Gladys Cross) were actually married; the stony grandmother was an Edgerton (Elva); and Billy Brown is the boy hanging out the window.

## 17. "WE'RE LOOKING FOR PEOPLE WHO LIKE TO DRAW" (OCTOBER 1948)

1. "13 Top-Flight Artists Prove They Have a Heart and Launch a School," *Bridgeport Post*, September 18, 1948, p. 27; "Art Institute Opens," *Bridgeport Post*, October 5, 1948, p. 30; advertisement in *The New Yorker*, December 4, 1948, p. 100.
2. Steven Heller, in his online "Daily Heller," February 2, 2011.
3. In the July 1970 issue of *The Atlantic Monthly*, Jessica Mitford published "Let Us Now Appraise Famous Writers," in which she accused the Famous Writers School of false advertising and unethical business practices. Her article did not take aim at the Famous Artists School, but left it tainted by association.
4. J. D. Salinger, "De Daumier-Smith's Blue Period," in *Nine Stories* (New York: Signet Books, 1954), p. 117.
5. Owen Kampen, "Today's Inspiration," on Leif Peng's blog about illustration, January 9, 2010.
6. In 1961 the school became publicly owned and listed on the stock exchange as FAS. In 1965 it was sold to Crowell-Collier & Macmillan, at which point Rockwell sold his shares and ended his involvement.
7. Al Dorne, letter to NR, August 24, 1950, NRM.
8. Elliott Caplin, *Al Capp Remembered* (Bowling Green, OH: Bowling Green State University Popular Press, 1994), p. 86.
9. See David Apatoff, *Albert Dorne: Master Illustrator*, with a foreword by Jack Davis and an introduction by Howard Munce (San Francisco: Auad Publishing, 2013).
10. Dorne's admirers at *Mad* included Jack Davis and Will Elder.
11. Walt Reed, conversation with the author, January 22, 2013.
12. NR, letter to Al Parker, dated February 25, no year. He said he admired the illustration on page 34 of "the current" issue of *Ladies' Home Journal*, probably the March 1949 issue, in which Parker illustrated the story "Under the Quiet Water."
13. "Models, Props, and Photographs," *Famous Artists Course*, introduction (Westport, CT: Famous Artists School, 1960), p. 16.
14. Mel Heimer, "My New York," nationally syndicated column, various newspapers, October 3, 1948.
15. Ibid.

## 18. GRANDMA MOSES (1948 TO 1949)

1. "Talent Array to Firm—Hall Brothers Signs with Famed Artist Group," *Kansas City Star*, February 15, 1948. Hall bought an art-card company founded by Harry N. Abrams, the future art-book publisher.

2. "Yule Cards to Display Great Art," *The Washington Post*, February 22, 1948, p. L2.

3. Joyce C. Hall, *When You Care Enough: The Story of Hallmark Cards and Its Founder* (Kansas City, MO: Hallmark, 1992), p. 77.

4. Grandma Moses and Otto Kallir, *My Life's History* (New York: Harper, 1951), p. 135.

5. "Rockwell Is Baker for Grandma Moses," *Bennington Banner*, September 7, 1948, p. 1.

6. Photo caption, *Bennington Banner*, September 15, 1948.

7. See Bruce Bliven, Jr., "Grandma Moses Has a Birthday," *Life*, October 25, 1948, p. 77.

8. "Grandmother Who Gained Fame," *The New York Times*, September 8, 1948, p. 31.

9. Nanette Kutner, "Norman Rockwell Talks About His Neighbor Grandma Moses," *McCall's*, October 1949, p. 82.

10. Ibid.

11. *The Saturday Evening Post*, October 16, 1948, cover.

12. "Norm's 'Butch' Fox Trap Victim," *Bennington Evening Banner*, November 1, 1948, p. 1.

13. "Norman Rockwell Stops to Visit 15 Minutes," *Salt Lake Tribune*, November 15, 1948, p. 17.

14. Grace Barstow, letter to MB, November 16, 1948; courtesy of Thomas Rockwell.

15. The school was then named the Los Angeles County Art Institute.

16. NR, "Contemporary American Illustration" (lecture), Art Center School, Pasadena, California, February 24, 1949; introduced by Arthur Millier; cassette tape, NRM.

17. Ibid.

18. Joseph B. Shane, letter to MR, December 10, 1948; by permission of the Oakwood School.

19. MR, letter to Joseph B. Shane, December 1948 (dated Thursday); by permission of the Oakwood School.

20. "Son of Famous Artist Dies After Heart Attack," *Troy* (NY) *Record*, February 11, 1949, p. 19; see also Moses, *My Life's History*, p. 136.

21. Police report, August 5, 1949, NRM.

22. *The Saturday Evening Post*, July 9, 1949.

23. NR, letter to Ken Stuart, May 31, 1949, NRM.

24. *The Saturday Evening Post*, November 5, 1949.

25. Ken Stuart to NR, August 18, 1949, NRM.

26. NR, letter to Ken Stuart, July 13, 1949, NRM.

27. Stuart to NR, August 18, 1949, NRM.

28. "Grandma Moses 89 Today," *The New York Times*, September 7, 1949, p. 27.

29. John Currin, conversation with the author, October 10, 2003.

30. NR, Art Center lecture, 1949, cassette tape, NRM.

## 19. SHUFFLETON'S BARBERSHOP (1950 TO 1953)

1. *Bennington Banner*, February 8, 1950.

2. Jim Shuffleton, e-mail to the author, June 8, 2012.

3. Emilie Jungschaffer (the barber's granddaughter), conversation with the author, June 9, 2012.

4. John Updike, "An Act of Seeing: Norman Rockwell," *Art & Antiques*, December 1990, p. 96. He also praised *Shuffleton's Barbershop* in "Tote That Quill," *The New Yorker*, August 14, 1978.

5. "Rob's Barber Shop Makes *Post* Cover," *Bennington Banner*, April 26, 1950, p. 1. Shuffleton, by the way, was also a "news dealer," who sold magazines at his barbershop.

6. House sold on June 3, 1950; town clerk, Arlington, VT.

7. Dr. Robert Knight's appointment book; courtesy of his widow, Adele Boyd.

8. Adele Boyd, interview with the author, August 25, 2008.

9. Thomas Rockwell, interview with the author, December 17, 1999.

10. Peter Rockwell, interview with author, June 22, 2000.

11. Dr. Knight's appointment book indicates that he met with Rockwell on March 1, March 3, April 23, May 14, and May 29, 1951; courtesy of Adele Boyd.

12. Dr. Knight, letter to NR, March 9, 1951; courtesy of Thomas Rockwell.

13. Ibid.

14. Peter Rockwell, interview with the author, June 22, 2000.

15. Warren Blair (art director of Smith, Kline), letter to to NR, November 9, 1951, NRM.

16. Dr. Russell Twiss, letter to NR, May 21, 1951, NRM.

17. Chris Schafer, interview with Susan Meyer, October 8, 1980, cassette tape, NRM.

18. Eisenhower Library, e-mail to the author, June 8, 2010.

19. *My Adventures*, p. 199.

20. Don Hubert, Jr., interview with the author, July 3, 2012; clipping from the *Bennington Evening Banner*, November 1951; courtesy of Don Hubert.

21. "President-Elect Says Soviet Demoted Zhukov Because of Their Friendship," *The New York Times*, December 23, 1952, p. 16.

22. The house was built in 1946; the architect was Dan Kiley, whom Atherton had met on a ski trip.

23. Maxine Atherton, unpublished interview with Susan Meyer, December 8, 1980, cassette tape, NRM.

24. James A. "Buddy" Edgerton and Nan O'Brien, *The Unknown Rockwell: A Portrait of Two American Families* (Essex Junction, VT: Battenkill River Press, 2009), p. 216.

25. Robert Beverly Hale, letter to NR, October 24, 1950; archives of the Metropolitan Museum of Art.

26. "Keeping Posted," *The Saturday Evening Post*, February 21, 1953, p. 144.

27. Dr. Knight, letter to NR, January 29, 1953; courtesy of Thomas Rockwell.

28. Ibid.

29. Mrs. Rockwell died at the Riverview Convalescent Home on March 5, 1953.

30. *The Saturday Evening Post*, May 23, 1953.

31. Unidentified clipping from a Pittsfield newspaper, January 22, 1953, NRM.

32. Associated Press, February 21, 1953.

33. Dr. Knight, "Norman Rockwell Summary," memo, July 15, 1953; courtesy of the Austen Riggs Center.

34. *Bennington Banner*, November 11, 1953.

35. Chris Schafer, interview with Susan Meyer, October 8, 1980, cassette tape, NRM.

## 20. THE AGE OF ERIK ERIKSON (1954)

1. A wire-service story on November 10, 1953, reported that he had been in Stockbridge for three weeks.

2. MR, letter to Nancy Barstow, May 3, 1954; courtesy of Thomas Rockwell.
3. NR, interview with John Batty, 1972, cassette tape; courtesy of Thomas Rockwell.
4. Land deed, March 24, 1954, Stockbridge Town Hall.
5. MR, letter to Nancy Barstow, May 3, 1954; courtesy of Thomas Rockwell.
6. William Gibson, interview with the author, March 18, 2005.
7. MR, letter to Nancy Barstow, May 3, 1945; courtesy of Thomas Rockwell.
8. Erik Erikson, "Autobiographic Notes on the Identity Crisis," *Daedalus*, Fall 1970, p. 743.
9. Erikson, certificate of naturalization; see www.ancestry.com.
10. Lawrence Friedman, *Identity's Architect: A Biography of Erik H. Erikson* (New York: Charles Scribner's Sons, 1999), p. 477.
11. NR, undated inscription, NRM.
12. *The Saturday Evening Post*, March 6, 1954, cover.
13. Susan E. Meyer, *Norman Rockwell's People* (New York: Harrison House/Harry N. Abrams, 1981), p. 154.
14. He writes in his autobiography, "If you asked Picasso and me to paint a picture of, say, a woman sitting before a mirror . . . The two paintings would be totally different, yet both would be of the same woman before the mirror."
15. MR, letter to Nancy Barstow, September 8, 1954; courtesy of Thomas Rockwell.
16. Madeleine May, "Lenox Gets a Second-Hand Book Shop," *The Berkshire Eagle*, August 7, 1954.
17. MR, letter to Nancy Barstow, September 8, 1954; courtesy of Thomas Rockwell.
18. Erikson, handwritten draft of a letter to Dr. Robert Knight, August 4, 1954, MS Am 2447, Houghton Library, Harvard University.
19. MR, letter to Nancy Barstow, September 8, 1954; courtesy of Thomas Rockwell.
20. *Breaking Home Ties* achieved a new fame in 2006, when the dramatic story of its whereabouts was revealed. Don Trachte, a cartoonist who befriended Rockwell in Vermont, was the first owner of the painting. He purchased it in 1960, from the Southern Vermont Art Center, for $900. A decade later, Trachte, worried about losing the picture in a divorce settlement, painted a copy that he hung in his living room. He hid the original behind a fake wall in the same room. Three decades passed that way, with the painting unseen in its secret compartment. The copy, in the meantime, circulated in museum exhibitions around the country. Trachte died in 2005, aged eighty-nine. Soon after, his children slid back a paneled wall in the living room and were astounded by what they found. They put the original up for auction and it brought $15.4 million, which remains as of this writing the highest price ever paid for a Rockwell.

## 21. CRACK-UP (1955)

1. Dr. Robert Knight's appointment book; courtesy of Adele Boyd.
2. Dr. Knight and Adele Boyd married in February 1956, with the Eriksons as witnesses.
3. Adele Boyd, interview with the author, August 25, 2008.
4. NR, letter to Dr. Knight, January 13, 1955, MS Am 2249, Houghton Library, Harvard University.
5. William Gibson, interview with the author, March 18, 2005.
6. Peter Rockwell, interview with the author, June 22, 2000.
7. Ben Hibbs, letter to NR, January 25, 1955, NRM.
8. Jarvis Rockwell, letter to NR, January 30, 1955, NRM.

9. NR's 1955 appointment book; courtesy of Thomas Rockwell.

10. John Williams (husband of Betty Williams), letter to MR, July 12, 1955, NRM.

11. Bill Scovill, interview with Annie Pettegrew, July 22, 1988, transcript, NRM.

12. James D. Breckenridge, two-page memo to Hermann Warner Williams, Jr., director of the Corcoran, January 10, 1955; courtesy of the Corcoran Gallery of Art.

13. Menu, May 5, 1955, box 49, White House Office, Social Office (A. B. Tolley), Records, 1952–61, Dwight D. Eisenhower Presidential Library.

14. Thomas Rockwell, interview with the author, December 17, 1999.

15. MR, undated letter to Dr. Margaret Brenman-Gibson that continued over several days; courtesy of Thomas Rockwell.

16. Thomas Rockwell, communication with the author.

17. NR's 1955 appointment book; courtesy of Thomas Rockwell.

18. Leslie Judd Portner, "Art in Washington," *The Washington Post*, July 10, 1955, p. E7.

19. Lyonel Feininger, letter to Mark Tobey, August 13, 1955, collection of the University of Washington Libraries; included in Achim Moeller (ed.), *Years of Friendship: 1944–1956: The Correspondence of Lyonel Feininger and Mark Tobey* (Ostfildern, Germany: Hatje Cantz; New York: D.A.P., 2006), p. 206.

20. NR, letter to Erik Erikson, October 13, 1955; courtesy of the Austen Riggs Center.

21. Officially, Henry W. Dwight.

22. NR, letter to Erikson, October 13, 1955; courtesy of the Austen Riggs Center.

23. Peter Sudarsky, "Rockwell Limbers Up by Sketching City Scenes," *The Hartford Courant*, September 4, 1955, p. 2X.

24. Peter Rockwell, interview with the author, June 22, 2000.

25. NR, letter to Erikson, September 8, 1955; courtesy of the Austen Riggs Center.

26. NR, letter to Erikson, September 29, 1955; courtesy of the Austen Riggs Center.

27. NR, letter to Erikson, October 13, 1955; courtesy of the Austen Riggs Center.

28. Ibid.

29. Receipts, December 1955, NRM.

30. Jarvis Rockwell, interview with the author, August 24, 2000.

31. NR, poem written for Thomas Rockwell, March 12, 1956; collection of Thomas Rockwell.

## 22. YOUNG MAN LUTHER (1957 TO 1959)

1. Erik Erikson, letter to NR, April 12, 1957, bMS AM 2031 (1227), Houghton Library, Harvard University.

2. Linda Zonana and Marion Willmott, Dr. Edgerton Howard's daughters, conversations with the author, July 2012.

3. NR, letter to Erikson, May 13, 1957; courtesy of the Austen Riggs Center.

4. Erik H. Erikson, *Young Man Luther: A Study in Psychoanalysis and History* (New York: W. W. Norton, 1993), p. 265.

5. Ibid., p. 117.

6. Erikson, letter to NR, April 12, 1957.

7. NR, letter to Erikson, May 13, 1957; courtesy of the Austen Riggs Center.

8. Bill Scovill, interview with Annie Pettegrew, July 22, 1988, transcript, NRM.

9. NR, letter to Erikson, May 13, 1957; courtesy of the Austen Riggs Center.

10. He bought a camera for Scovill, for $1,500, from Howard S. Babbitt, Jr., a photojournalist in Pittsfield who had taught Scovill photography.

11. Eddie Locke, interview with the author, April 14, 2005.
12. Louie Lamone, interview with Annie Pettegrew, July 22, 1988, transcript, NRM.
13. Don Johnson, one of Rockwell's assistants, posed for the oily-looking counterman. He is supposedly waiting to take an order.
14. Dick Clemens, interview with the author, April 14, 2005.
15. Peter Rockwell, interview with the author, June 22, 2000.

## 23. ROCKWELL TELLS HIS LIFE STORY (1959)
1. Ken McCormick, letter to NR, November 29, 1957, NRM.
2. McCormick letter to Hawthorne Daniel, July 14, 1958.
3. Thomas Rockwell, interview with the author, December 17, 1999.
4. *Person to Person*, CBS, February 6, 1959; collection of the Paley Center for Media, New York.
5. "Burriana," *The New Yorker*, February 28, 1959, p. 20.
6. Vladimir Nabokov, *Pnin* (1953; New York: Vintage International, 1989), p. 96.
7. Cinnie Rockwell, interview with the author, June 22, 2000.
8. NR, unpublished interview with Thomas Rockwell, July 25, 1959, compact disk, NRM.
9. *My Adventures*, p. 397.
10. NR, unpublished interview with Thomas Rockwell, 1959, compact disk, NRM.
11. NR, unpublished interview with Thomas Rockwell, July 25, 1959, compact disk, NRM.
12. Ibid.
13. Cinnie Rockwell, interview with the author, June 22, 2000.
14. Helen N. Morgan, "The Road to Tanglewood," self-published brochure, undated (circa 2000), p. 30.
15. Nancy Barstow, letter to NR, December 3, 1959; courtesy of Thomas Rockwell.
16. Margaret Brenman-Gibson, letter to NR, September 8, 1959, NRM.

## 24. WIDOWHOOD, OR *THE GOLDEN RULE* (1960)
1. Allan Seager, "Another Man's Wife," *The Saturday Evening Post*, October 14, 1961, p. 47.
2. Source asked to remain unidentified, e-mail from source to the author, October 4, 2012.
3. NR, letter to Clyde Forsythe, October 20, 1959; courtesy of Marianne Hart.
4. Dr. Anthony F. Philip, interview with the author, January 15, 2010.
5. Clemens Kalischer, interview with the author, December 10, 2012.
6. President Eisenhower, letter to Rockwell, February 9, 1960, NRM.
7. Phoebe-Lou Adams, "Reader's Choice," *The Atlantic Monthly*, March 1960, p. 117.
8. Benjamin De Mott, *The Nation*, April 2, 1960, p. 299.
9. Louis Menand, introduction to Dwight Macdonald, *Masscult and Midcult: Essays Against the American Grain*, edited by John Summers, (New York: New York Review Books, 2011), p. xvii.
10. Dwight Macdonald, "Masscult and Midcult," *Partisan Review*, April 1960, pp. 203–33.
11. The first half of Macdonald's essay is devoted to "masscult," the category into which he places Rockwell. But since Rockwell's *Post* covers obviously deploy the conventions of art, it would have made more sense to label Rockwell's paintings as "midcult," along with Thornton Wilder's *Our Town* and Ernest Hemingway's *The Old Man and the Sea*.

12. Dwight Macdonald, letter to Kobler, October 20, 1959, MS#730, box 44, folder 1099, Dwight Macdonald Collection, Yale University Libraries. Macdonald initially wrote the article for *The Saturday Evening Post*, after he was asked to contribute to a series called Adventures of the Mind. When he delivered the article, it was a year late. The *Post* asked him to include *The New Yorker* in his list of middlebrow examples. Macdonald took offense at the suggestion. In a letter to John Kobler, the *Post*'s special-assignments editor, on October 20, he protested "I cannot give you the right to tell me what to say."

13. Ibid.

14. Dwight Macdonald, letter to Ben Hibbs, November 9, 1959. Yale University Libraries.

15. Mary Alcantara, Peggy Best's daughter, interview with the author, January 24, 2010.

16. NR, check for ten dollars to Peggy Best, May 1957; check for twenty dollars, June 1957; courtesy of Thomas Rockwell.

17. Mary Alcantara, interview with the author, January 24, 2010.

18. Jonathan Best, e-mail to the author, February 2, 2010.

19. NR, *The Norman Rockwell Album*, with an introduction by S. Lane Faison, Jr., and a preface by Kenneth Stuart (New York: Doubleday, 1961), p. 70.

20. Mary Alcantara was the model. The painting was reproduced in *The Berkshire Eagle* on August 6, 1958.

21. Morgan Bulkeley, "Our Berkshires: Norman Rockwell, Painter of Presidents," *The Berkshire Eagle*, November 10, 1960, p. 23.

22. Peter Rockwell, interview with the author, June 22, 2000.

23. Erik H. Erikson, "The Golden Rule in the Light of New Insight," in Erikson, *Insight and Responsibility* (New York: W. W. Norton, 1964), p. 220.

24. Ibid., p. 242.

25. The mosaic was donated by the American government in 1985, on the UN's fortieth anniversary.

26. Lawrence Friedman, *Identity's Architect: A Biography of Erik H. Erikson* (New York: Charles Scribner's Sons, 1999), p. 300.

27. Dr. Robert Coles, interview with the author, May 13, 2010.

28. Linda Zonana and Marion Willmott (Dr. Edgerton Howard's daughters), interviews with the author, July 2012.

29. Dr. Philip, interview with the author, May 13, 2010.

30. "Mrs. Straus Named President of Riggs for Coming Year," *The Berkshire Eagle*, November 29, 1960, p. 20.

31. The six drawings, which each measure seventeen by fourteen inches, were presented at the annual board meeting on October 26, 1962.

## 25. MEET MOLLY (1961)

1. Jonathan Best, e-mail to the author, February 9, 2010.

2. "Mrs. Norman Rockwell," *The Boston Globe*, December 14, 1969, p. 30A.

3. Nancy Punderson (Molly's niece), interview with the author, January 31, 2010.

4. She served on the CEEB in 1932, 1935, 1938, and 1944, according to the organization's annual reports; courtesy of the College Board, New York.

5. Molly Rockwell, interview with the Stockbridge library, oral history project, March 19, 1975, cassette tape; Stockbridge library archives.

6. Gertrude Stein, *Lectures in America* (Boston: Beacon Press, 1957), p. 211.

7. The 1930 U.S. Census lists the two women at Upton House, at 105 Centre Street in Milton. Later, in the 1940s, they lived at 7 Whitelawn Avenue.
8. Dorothy Kendall was listed in the Stockbridge telephone directory as a resident of Molly Punderson's cottage from 1942 to 1952.
9. Helen Rice, interview with the Stockbridge library, oral history project, November 27, 1979, cassette tape; Stockbridge library archives.
10. Jonathan Best, e-mail to the author, February 9, 2010.
11. Punderson, interview with the author, January 31, 2010; receipt for ring, NRM.
12. *Update*, NBC, December 9, 1961; collection of the Paley Center for Media, New York.
13. *San Francisco Chronicle*, November 9, 1961.
14. NR, letter to Clyde Forsythe, October 8, 1961; courtesy of Marianne Hart.
15. Diana Mugnaini, interview with the author, January 30, 2008.
16. Molly Rockwell, letter to Kate More; collection of the author.
17. Various family members, communications to the author.
18. Molly Rockwell, letter to Kate More, January 9, 1962; collection of the author.

## 26. ROCKWELL DEPARTS FROM THE *POST* (1962 TO 1963)

1. "The Press: Pepping Up the *Post*," *Time*, August 4, 1961.
2. Peter Bart, "Advertising: A Peek Allowed at New Post," *The New York Times*, August 15, 1961, p. 45.
3. He started in 1944.
4. Unpublished essay notes by Ken Stuart; courtesy of Ken Stuart, Jr.
5. NR, pencil notes, May 19, 1963; courtesy of Thomas Rockwell.
6. NR, letter to Bob Sherrod, June 10, 1963, NRM.
7. NR, letter to Asger Jerrild, September 9, 1963, NRM.
8. Jacqueline Kennedy, letter to NR, January 25, 1964. He had done a small oil of Jackie for a story that ran inside the *Post* on October 26, 1963.

## 27. RUBY BRIDGES (1964)

1. Homer A. Jack, director of SANE, letter to NR, January 2, 1962, NRM.
2. William Gibson, interview with the author, March 18, 2005.
3. *Look*, January 14, 1964, pp. 21–23.
4. Quoted by Glenn Ligon, in Peter Schjeldahl, "Unhidden Identities: A Glenn Ligon Retrospective," *The New Yorker*, March 21, 2011, p. 76.
5. John Steinbeck, *Travels with Charley: In Search of America* (New York: Viking Press, 1962), p. 226.
6. Dr. Robert Coles, interview with the author, May 13, 2010.
7. Dr. Coles, "Southern Children Under Desegregation," *American Journal of Psychiatry* (October 1963), pp. 332–44.
8. Ibid., p. 332. This might explain why Rockwell painted the picture three years after the actual incident—the article by Dr. Coles could have brought it to his attention anew.
9. Elaine Gunn, interview with the author, September 16, 2010.
10. Christopher Wren, interview with the author, August 28, 2010.
11. Jack Masey, interview with the author, May 28, 2010.

12. Quoted in Donald Walton, *A Rockwell Portrait: An Intimate Biography* (Kansas City, MO: Sheed Andrews and McMeel, 1978), p. 233.
13. United Press International, "Mrs. K a Delighted Deviationist," *The Boston Globe*, December 28, 1963, p. 3.
14. Masey, interview with the author, May 28, 2010.
15. "Rockwell Draws Girl as Russians Look On," *The New York Times*, December 25, 1963, p. 30.
16. "U.S. Graphic Arts Shown in Moscow," *The New York Times*, December 7, 1963, p. 17.
17. "Letters," *Look*, February 25, 1964, p. 12.
18. John Waters, interview with the author, April 9, 2010.
19. Claude Sitton, "2 White Schools in New Orleans Are Integrated," *The New York Times*, September 15, 1960, p. 1.
20. Paul Wilkes, "Robert Coles: Doctor of Crisis," *The New York Times Magazine*, March 26, 1978, p. SM4.
21. Ruby Bridges, interview with the author, March 23, 2011.

## 28. LYNDON BAINES JOHNSON, ART CRITIC
## (1964 TO 1967)

1. NR quoted in Mildred Wallace, "Norman Rockwell, Travelling Portraitist, Recalls the World Leaders," *The Berkshire Eagle*, January 12, 1966, p. 1.
2. George Reedy, Johnson's press secretary, letter to Richard Wilson of Cowles Publications, June 30, 1964, LBJ Library.
3. Associated Press biographical service, unpublished "biographical sketch," March 1, 1971; retrieved from the clipping files of *The Boston Globe*.
4. Ibid.
5. Ibid.
6. The visit occurred on October 30, 1965, according to Lady Bird Johnson's diaries.
7. Nan Robertson, "Johnson Dislikes His Likeness," *The New York Times*, January 6, 1967, p. 35; see also AP and UPI stories, same date.
8. Lady Bird Johnson, *A White House Diary* (Austin: University of Texas Press, 1970), p. 332.
9. Ibid., 330.
10. Ibid., 331.
11. Lyndon B. Johnson, letter to Robert Kleberg, Jr., April 25, 1966, central files, LBJ Library.
12. Maxine Cheshire, "Very Interesting People," *The Washington Post*, January 5, 1967, p. E1.
13. Robertson, "Johnson Dislikes His Likeness."
14. Ibid.
15. Cheshire, "Very Interesting People."
16. John G. W. Mahanna, "Artist Norman Rockwell Proves to Press That He Really Is Not Two Other People," *The Berkshire Eagle*, July 25, 1967, p. 17.

## 29. THE VIETNAM WAR (1965 TO 1967)

1. Phil Casey, "Norman Rockwell: More than Half a Century Illustrating the Human Drama," *The Washington Post*, November 4, 1970, p. D1.

2. "Mrs. Norman Rockwell," *The Boston Sunday Globe*, December 14, 1969, p. 30A.
3. Louie Lamone, interview with Annie Pettegrew, transcript, July 22, 1988.
4. *The Berkshire Eagle*, January 12, 1976; Scott arrived in town in the fall of 1964.
5. Helen Rice, interview with Stockbridge library, oral history project, November 27, 1979, cassette tape; Stockbridge library archives.
6. "Artist Rockwell Joins Army of 'Angry' People," *The Boston Globe*, July 2, 1965.
7. NR, interview with John Batty, 1972, cassette tape; courtesy of Thomas Rockwell.
8. Bing Crosby, letter to NR, October 26, 1965, NRM.
9. NR calendar, November 27, 1965, NRM.
10. Gary Giddins, e-mail to the author, November 18, 2012.
11. NR, telegram to Lyndon B. Johnson, January 3, 1966, LBJ Library.
12. NR, telegram to Lyndon B. Johnson, January 23, 1966, LBJ Library.
13. Jinx Falkenburg, "The Postscript, by Jinx," *A.M. Globe*, April 21, 1951; retrieved from *Globe* clipping files.
14. *The Saturday Evening Post*, letters page, October 22, 1955.
15. Arthur Paul, letter to NR, June 17, 1966, NRM.
16. "NR by NR," *Esquire*, January 1962, p. 69.
17. Dugald Stermer, letter to NR, August 8, 1968, NRM.
18. Christopher Wren, interview with the author, August 28, 2010.
19. Ibid.
20. "Lenin Prizes Won by Dr. Niemöller and Rockwell Kent," *The New York Times*, May 1, 1967, p. 1.
21. John G. W. Mahanna, "Artist Norman Rockwell Proves to Press That He Really Is Not Two Other People," *The Berkshire Eagle*, July 25, 1967, p. 17.
22. The painting appeared as an illustration for Jack Star's article "A Negro in the Suburbs" in the May 16, 1967, issue of *Look*.
23. Dr. Robert Coles, interview with the author, May 13, 2010.
24. Dr. Coles, letter to NR, June 22, 1967.
25. Dr. Coles, interview with the author, May 13, 2010.
26. NR, letter to Dr. Coles, September 11, 1967, University of North Carolina at Chapel Hill, Wilson Special Collections Library.
27. Dr. Coles, *Dead End School*, with illustrations by NR (Boston: Little, Brown, 1968), p. 13.
28. Dr. Coles, interview with the author, May 13, 2010.
29. Ibid.

## 30. ALICE'S RESTAURANT (1967)

1. Alice May Brock, *My Life as a Restaurant* (Woodstock, NY: Overlook Press, 1975).
2. Arlo Guthrie, interview with the author, July 15, 2009.
3. Brock, *My Life as a Restaurant*, p. 79.
4. Brock, e-mail to the author, February 19, 2011.
5. Guthrie, interview with the author, July 15, 2009.
6. "Ten Artists Will Show Local Scenes for Library Week," *The Berkshire Eagle*, April 1, 1960, p. 21.
7. Linda Szekely Pero, *American Chronicles: The Art of Norman Rockwell* (Stockbridge, MA: Norman Rockwell Museum, 2007), p. 200.
8. Audiovox Service Identification Card, April 27, 1966, NRM.

9. Karal Ann Marling, *Norman Rockwell* (New York: Harry N. Abrams, in association with the National Museum of American Art, Smithsonian Institution, 1997), p. 147.

10. Alice Brock, interview with the author, February 17, 2011.

11. Robert Jay Lifton, *Witness to an Extreme Century: A Memoir* (New York: Free Press, 2011), p. 124.

12. "Willie, The Uncommon Thrush," was published as an eight-page feature in the April 1967 issue of *McCall's*. Two years later, it came out as a book, *Willie Was Different: The Tale of an Ugly Thrushling* (New York: Funk and Wagnalls, 1969).

13. *Willie Was Different*, p. 31.

## 31. ANDY WARHOL & COMPANY (FALL 1968)

1. Grace Glueck, "What Makes Bernie Run?" *The New York Times*, December 19, 1971, p. D27.

2. Laurence Casper, interview with the author, May 12, 2011; Bernard Danenberg, interview with the author, July 24, 2011.

3. Although the *Post* paid Rockwell for the painting, in 1957, it declined to publish it, perhaps because of its joking attitude toward the church. It ran in *McCall's* in March 1969. It is now owned by Brigham Young University.

4. NR, "Rockwell on Parrish," art review, *The Berkshire Eagle*, August 10, 1968.

5. Michael Crawford, e-mail to the author, May 2011.

6. According to Carson Productions, the tape for October 1,1968, does not exist.

7. Al Kooper, *Backstage Passes and Backstabbing Bastards: Memoirs of a Rock 'n' Roll Survivor* (New York: Backbeat Books, 2008), p. 140.

8. Kooper, interview with the author, April 10, 2011.

9. Ibid.

10. Danenberg, interview with the author, July 24, 2011.

11. Kooper, interview with the author, April 10, 2011.

12. Grace Glueck, "Art Notes: Don't Knock Rock," *The New York Times*, November 3, 1968, p. D32.

13. Thomas Buechner, "A Matter of Opinion," *The New York Times*, October 20, 1968, p. D26.

14. Danenberg, interview with the author, July 24, 2011.

15. Ibid.

16. *Portrait of Jackie Kennedy*, lot #2835, *The Andy Warhol Collection*, a six-volume catalog of the Warhol estate sale at Sotheby's in 1988.

17. Matt Wribican, archivist, Warhol Museum, e-mail to the author, May 31, 2011.

18. Barnett Newman, quoted in Clifford Ross, ed., *Abstract Expressionism: Creators and Critics: An Anthology* (New York: Harry N. Abrams, 1990).

19. Richard Estes, interview with the author, July 12, 2011.

20. Audrey Flack, interview with the author, July 6, 2011.

21. Danenberg gallery sales records; courtesy of Larry Casper.

22. Casper, interview with the author, May 12, 2011.

23. NR, televised interview with David Frost, December 2, 1970, NRM.

24. The session was held in December 1967.

25. Gary Wills, *Nixon Agonistes: The Crisis of the Self-made Man* (1970; New York: Mariner Books, 2002), p. 12.

26. Casper, interview with the author, May 12, 2011.

27. Kooper, interview with the author, April 10, 2011.
28. "Norman Rockwell Astray," *Newsweek*, September 8, 1958, p. 92.

## 32. THE BROOKLYN MUSEUM (1969 TO 1972)

1. "Historical Home Acquired," *Bennington Banner*, June 2, 1967, p. 5.
2. Louie Lamone, interview with Annie Pettegrew, July 22, 1988, transcript, NRM.
3. Bernie Danenberg, interview with the author, July 24, 2011.
4. Ibid.
5. On January 29, 1969, accession no. 69.8, Brooklyn Museum registrar's office.
6. Bob Abrams, interview with the author, July 11, 2011.
7. David Dempsey, "Norman Rockwell Illustrator," *The New York Times Book Review*, November 1, 1970, p. 283.
8. Christopher Finch, conversation with the author, July 25, 2011.
9. Phil Casey, "Norman Rockwell: More Than Half a Century Illustrating the Human Drama," *The Washington Post*, November 4, 1970, p. D1.
10. "Notes and Footnotes," *The Berkshire Eagle*, December 9, 1970.
11. Audiotape of *The David Frost Show*, December 2, 1970, NRM.
12. Casey, "Norman Rockwell."
13. *The New York Times Book Review*, list of bestsellers, January 10, 1971.
14. Danenberg, letter to NR, January 28, 1971; courtesy of Larry Casper.
15. Molly Rockwell, letter to Danenberg, January 31, 1971; courtesy of Larry Casper.
16. Danenberg, letter to NR, January 28, 1971; courtesy of Larry Casper.
17. Ibid.
18. Agreement between Harry N. Abrams, Inc., and Norman Rockwell, April 19, 1971; courtesy of Abrams, New York.
19. NR, letter to Danenberg, August 31, 1971, NRM.
20. Sarah Faunce to Tom Buechner, internal memo, April 22, 1971, Brooklyn Museum archives.
21. Duncan Cameron, letter to Danenberg, June 28, 1971, Brooklyn Museum archives.
22. Cameron, letter to Evan Hopkins Turner, July 6, 1971, Brooklyn Museum archives.
23. Evan H. Turner, letter to Cameron, July 13, 1971, Brooklyn Museum archives.
24. Cameron, letter to NR, February 4, 1972, Brooklyn Museum archives.
25. NR, letter to Cameron, February 8, 1972, Brooklyn Museum archives.
26. Tom Buechner, letter to NR, February 22, 1972, Brooklyn Museum archives.
27. NR, letter to Cameron, March 7, 1972, Brooklyn Museum archives.
28. He is listed as the owner of six paintings in the *Sixty Year* catalog.
29. Jan Henry James, publicist, memo to Cameron, March 23, 1972, Brooklyn Museum archives.
30. Peter Schjeldahl, "Still on the Side of the Boy Scouts—But Why Not?" *The New York Times*, June 24, 1973, p. 125.
31. Schjeldahl, conversation with the author, February 15, 2012.

## 33. "BUT I WANT TO GO TO MY STUDIO" (1972 TO 1978)

1. He was first identified publicly as an Alzheimer's patient in November 1984, in "The Disease of the Century," *Newsweek*, December 3, 1984, p. 56.

2. NR, letter to Patty Tang, then secretary at the Danenberg gallery, August 16, 1972; courtesy of Larry Casper.
3. "Celebrity Week," *The Berkshire Eagle*, September 18, 1972, p. 18.
4. Donald Walton, *A Rockwell Portrait: An Intimate Biography* (Kansas City, MO: Sheed Andrews and McMeel, 1978), p. 271.
5. Jane Fitzpatrick, interview with the author, September 1, 2000.
6. Ibid.
7. Quoted in Cameron Crowe, "Candid Conversation: An Outrageous Conversation with the Actor, Rock Singer and Sexual Switch-Hitter," *Playboy*, September 1976, available at www.bowiegoldenyears.com/articles/7609-playboy.html.
8. Virginia Loveless, interview with the author, August 22, 2011.
9. Ibid.
10. Ibid.
11. Molly Rockwell, letter to Kitty More, April 16, 1975, collection of author.
12. John Bryson, "Norman Rockwell, Beloved Painter of Homespun America, Is Going Strong at 82," *People*, February 23, 1976, p. 42.
13. Molly Rockwell, letter to Kitty More, March 1, 1976; collection of the author.
14. Louie Lamone, interview with Annie Pettegrew, July 22, 1988, transcript, NRM.
15. Louie Lamone, interview with Annie Pettegrew, November 5, 1987, transcript, NRM.
16. David Wood, interview with Annie Pettegrew, July 6, 1988, transcript, NRM.
17. Saul Pett, "Artist Won People but Not Critics," Associated Press, December 18, 1977.
18. Lamone, interview with Annie Pettegrew, July 22, 1988.
19. Wood, interview with Annie Pettegrew, July 6, 1988.
20. Molly Rockwell, letter to Ursula Niebuhr, undated, box 51, Reinhold Niebuhr Papers, Manuscript Division, Library of Congress, Washington, DC.

# ACKNOWLEDGMENTS

My greatest debt is to the children of Norman Rockwell, who, despite their own artistic leanings and creative undertakings, took time to nurture mine. Jarvis Rockwell, Thomas Rockwell, and Peter Rockwell encouraged me to embark on this project and have been wholly supportive of my desire to write a definitive biography of their father. They gave me access to a large body of unpublished material and granted me permission to quote from it. They signed a legal contract that authorized the release of their father's psychiatric records. Moreover, they agreed to be interviewed many times and provided me with essential insights into their father's art and life.

Although he is in his eighties now, Tom Rockwell also found time to patiently answer hundreds of e-mail queries and locate a long-missing suitcase filled with pertinent papers. His radiant daughter, Abigail Rockwell, a singer and songwriter, has become a valued friend. Among family members, I also wish to acknowledge the good-natured help of Nova Rockwell, Cinnie Rockwell, Richard Rockwell, John Rockwell, Sally Hill Cooper, Mary Amy Orpen, and Nancy Punderson.

In the course of my research trips to Stockbridge, Massachusetts, I benefited enormously from the exemplary professionalism of the staff of the Norman Rockwell Museum. A singular institution, it houses the bulk of Rockwell's artwork, as well as his writings and personal records. Museum director Laurie Norton Moffatt and chief curator Stephanie Plunkett could not have been more generous in sharing their time and expertise with me. Linda Szekely Pero, the former archivist at the museum, facilitated

my research and put many elusive documents at my disposal. Venus Van Ness, the current archivist, was unfailingly nimble in unearthing whatever seemingly vanished letter I needed. Thomas Mesquita, the museum registrar, helped locate image files of Rockwell's work and was always willing to go back and look for ever higher resolutions.

I am indebted to Nancy Fitzpatrick, the owner of the Red Lion Inn, who found room for me on many occasions there and elsewhere in Stockbridge. In the summer of 2008 she installed me in her mother's residence in The Knoll, a renovated apartment building on Main Street and the original home of Dr. Austen Riggs, the founder of the psychiatric hospital that bears his name. It was there that I had the good fortune to meet Adele Knight Boyd, an elegant widow who lived across the hall. As chance had it, she had been married to Dr. Robert Knight, who had been the medical director of the Austen Riggs Center in the years when Rockwell was treated there. Adele and I had many delightful conversations about Riggs and its colorful history. One day she surprised me by walking into her bedroom and pulling out, from beneath her bed, a large storage box that contained a complete collection of Dr. Knight's appointments books. She suggested I might want to take a peek.

Additional material pertaining to Rockwell's treatment with Erik Erikson came directly from the Austen Riggs Center in Stockbridge, Massachusetts. In particular, I am indebted to Dr. M. Gerard Fromm, the Evelyn Stefansson Nef Director Emeritus of the Erikson Institute for Education and Research. I also owe thanks to Dr. Allen Wheelis and Dr. Anthony Philip, who were associated with Riggs early in their careers.

Lawrence J. Friedman, who wrote a biography of Erik Erikson, gave freely of his time and research. Robert Coles and Stephen Schlein, both of whom studied under Erikson, went out of their way to help me better understand his approach to psychotherapy.

I am indebted to Kai Erikson, who, though burdened with his own writing deadlines, helped me gain access to his father's papers and granted me permission to quote from them. His sister, Sue Erikson, was also generous with her time.

A handful of art critics and scholars have written brilliantly about Rockwell's work and American culture. I have benefited from their insights and, in some cases, from inspired conversations over lunch or dinner. I refer chiefly to Dave Hickey, Robert Rosenblum, Adam Gopnik, Steven

Heller, Karal Ann Marling, Walt Reed, Richard Halpern, Michele H. Bogart, and Susan E. Meyer.

Collectors of Rockwell's work, especially George Lucas and Steven Spielberg, have been generous in allowing access to it. For their help in arranging interviews and furnishing me with reproductions, I am indebted to Connie Wethington in Lucas's office and to Marvin Levy and Elizabeth Nye in Spielberg's office.

Many other people agreed to be interviewed and provided valuable information, including Bob Abrams, Mary Alcantara, David Apatoff, Jonathan Best, Ruby Bridges, Anne Fitzpatrick Brown, Laurence Casper, Richard Clemens, Jan Cohn, Bernard Danenberg, James "Buddy" Edgerton, Joy Edgerton, Richard Estes, Sarah Faunce, Jane Fitzpatrick, Audrey Flack, William Gibson, Dan Grant, Richard Gregory, Elaine Gunn, Arlo Guthrie, Jo Haemer, Gary Hallwood, Don Hubert, Jr., Emilie Jungschaffer, Clemens Kalischer, Al Kooper, Norman Kreisman, Ed Locke, Virginia Loveless, Jack Masey, Diane Disney Miller, Helen Morgan, Diana Mugnaini, Howard Munce, Ross Perot, Nancy Punderson, Sherman Safford, Charlie Schudy, Jim Shuffleton, Ken Stuart, Jr., Patty Tang, Mary (Atherton) Varchaver, Scott Walton, John Waters, Elizabeth White, Marion Wilmott, Christopher Wren, and Linda Zonana.

I am grateful to the staff of various institutions for access to the letters and documents in their possession. I wish to acknowledge Matt Wribican, the archivist of the Andy Warhol Museum; Jillian Russo of the Art Students League; Diana Thompson at the National Academy Museum and School of Fine Arts; Corry Kanzenberg, the former curator at the National Scouting Museum (the official museum of the Boy Scouts of America); Marisa Bourgoin, archivist of the Corcoran Gallery of Art; Lewis Wyman, reference librarian at the Library of Congress; Christopher Abraham, archivist at the Dwight D. Eisenhower Presidential Library and Museum; Randy Sowell, archivist at the Harry S. Truman Library and Museum; Leslie Morris, curator at the Houghton Library, Harvard University; Kristen McDonald at Yale University Library; Barbara Allen, curator of the archives at the Stockbridge library; Diane Williams at Milton Academy; Sally Williams, Adam Husted, and Angie Park at the Brooklyn Museum; Lynne Crowley, archivist at the Larchmont Historical Society; Richard C. Leab in the local history department of the Berkshire Athenaeum; and John Favareau, local history librarian at the Yonkers Public Library.

Magdalen and Robert Livesey, who run the Famous Artists School in Wilton, Connecticut, opened their archives to me and turned up some wonderful photographs.

Warm thanks to Eric Himmel, the editor in chief at Abrams, who helped me understand Rockwell's relationship with the publishing house and retrieved decades-old contracts. Alexandra Hoy took the time to locate the diaries and fishing logs of her father, Fred Hildebrandt. Marianne Hart shared her extensive collection of unpublished letters between Rockwell and Clyde Forsythe. After I interviewed Katharine More, she sent me a cache of vivid letters from Molly Rockwell, offering them as a gift. Robert Berridge shared his collection of clippings from the *Bennington Banner*. Cheryl Gould helped me gain access to the historic footage in the NBC news archive, as did Yuien Chin. I have been fortunate to find talented research assistants, among them Kate Foster and Katya Mezhibovskaya.

My literary agent, Amanda Urban, makes decisions with remarkable speed. Yet she suspended judgment and waited more than a decade for me to finish researching and writing this book. Thank you, Binky.

And thanks, too, to Jonathan Galassi and the accomplished staff at Farrar, Straus and Giroux. Paul Elie was my first editor. After he decided to accept a job that would free up his time for writing, I was lucky to meet Ileene Smith, my second editor, who read my manuscript with eagle eyes and unstinting enthusiasm. Her assistant, John Knight, is a paragon of calm efficiency. Jonathan D. Lippincott, the designer of this book, wrote his own book about large-scale sculpture and has the sort of aesthetic sense that comes from a lifelong familiarity with art. Thanks, too, to Mareike Grover for her production smarts, and to Jeff Seroy and Stephen Weil for getting the word out.

I would like to thank the John Simon Guggenheim Memorial Foundation for granting me a fellowship in the field of biography.

I am indebted to my dear friends, who over the years submitted cheerfully to countless hours of Rockwell-themed conversation. Some of them took the time to read earlier versions of this book and offer valuable commentary, especially Steve Martin, Daphne Merkin, Jonathan Schwartz, Rafael Yglesias, Patty Marx, Bruce McCall, and David Rakoff, who is missed every day.

My inordinately modest friend Anne Stringfield possesses a daunting knowledge of grammar and fly-fishing. She read my entire manuscript

with a level of editorial attentiveness that amounts to its own art form. Thank you, Anne. You are sui generis with or without italics.

Alan Brinkley read the chapter on *Life* magazine, and Robert Caro read the chapter on Lyndon Johnson. Judith Gurewich, the publisher of Other Press, could not have been more supportive were I one of her authors. She was always willing to interrupt her day to look at a painting with me and talk it out, and she and her husband, Dr. Victor Gurewich, provided me with indispensable camaraderie at their homes in Cambridge, Massachusetts, and France.

My parents, Jerry and Sally Solomon, owned an art gallery in New York from 1969 until their retirement in the fall of 2006. I remain indebted to them for instilling in me an early appreciation for art and independent thinking.

For the first twenty-five years of his career, Rockwell lived in New Rochelle, New York, where, by coincidence, I grew up. It was a great pleasure to have the chance to return to New Rochelle in recent years to research its history as an art colony. I made ample use of the artists' files at the New Rochelle Public Library, one of the few suburban libraries with a first-rate collection on art monographs.

This book is dedicated to my sons, Eli and Leo Sepkowitz. Over the years I have benefited incalculably from the compassion, good sense, and quick wit, not to mention their willingness to spend the vacations of their childhoods in Stockbridge despite the absence of a major-league baseball team. Finally, thank you to Kent Sepkowitz, a wise and infinitely generous ally, who has been there for every word.

# INDEX

Page numbers in *italics* refer to illustrations.

Deborah Solomon is an American art critic and biographer. She is the author of *Jackson Pollock: A Biography* (1987) and *Utopia Parkway: The Life and Work of Joseph Cornell* (1997). Her articles, essays, and book reviews have appeared in many newspapers and magazines, and she served as the "Questions For" columnist of *The New York Times Magazine* from 2003 to 2011. Solomon is a graduate of New Rochelle High School and received her bachelor's degree from Cornell University, where she majored in art history. She received a master's degree from the Columbia University School of Journalism. Solomon lives in New York City with her husband, with whom she has two sons. She can be reached on Twitter at @deborahsolo.

Dear old Franklin

I will be home Saturday the 12 th.

Will you telephone Bill Sundermeyer and tell

hi...

...

...am

to...

...orn

X